THE PELICAN HISTORY OF ART

Founding Editor: Nikolaus Pevsner

Joint Editors: Peter Lasko and Judy Nairn

Jakob Rosenberg, Seymour Slive, and E. H. ter Kuile

DUTCH ART AND ARCHITECTURE: 1600 TO 1800

Jakob Rosenberg was Keeper of the Print Cabinet at the Kaiser-Friedrich Museum in Berlin before going to the Fogg Art Museum, Harvard University, where he became Curator of Prints and Professor of Fine Arts. His many publications in the field of Dutch art include the standard works on Rembrandt and Jacob van Ruisdael. The highly respected senior expert on anything connected with Dutch painting, Professor Rosenberg died in 1980. Seymour Slive is clearly his successor. He is Gleason Professor of Fine Arts at Harvard University, Director of the Fogg Art Museum, and has been Slade Professor in Fine Art at Oxford. His publications include books on Rembrandt and a monograph on Frans Hals.

E. H. ter Kuile, also a leading expert and the author of the chapters on architecture and sculpture, was Professor of History of Architecture in the University of Technology at Delft and a member of the Dutch Royal Commission on Historic Monuments. He is part-author of the companion volume on Belgium in the *Pelican History of Art* series.

Jakob Rosenberg, Seymour Slive, and E. H. ter Kuile

DUTCH ART AND ARCHITECTURE: 1600 TO 1800

Penguin Books

PENGUIN BOOKS

Published by the Penguin Group
27 Wrights Lane, London w8 5TZ, England
Viking Penguin Inc., 40 West 23rd Street, New York, New York 10010, USA
Penguin Books Australia Ltd, Ringwood, Victoria, Australia
Penguin Books Canada Ltd, 2801 John Street, Markham, Ontario, Canada L3R 1B4
Penguin Books (NZ) Ltd, 182–190 Wairau Road, Auckland 10, New Zealand

Penguin Books Ltd, Registered Offices: Harmondsworth, Middlesex, England

First published 1966
First integrated edition, revised, 1972
Third (second integrated) edition,
with minor revisions and additions to the bibliography, 1977,
Reprinted 1979, 1982, 1984, 1986, 1987, 1989

Library of Congress catalog card number: 79–128579
ISBN 0 14 0561.27 7

Printed and bound in Great Britain by
Butler & Tanner Ltd, Frome and London
Set in Monophoto Ehrhardt

Designed by Gerald Cinamon

To the memory of
Wilhelm von Bode (1845–1929)
Abraham Bredius (1855–1946)
Cornelius Hofstede de Groot (1863–1930)

CONTENTS

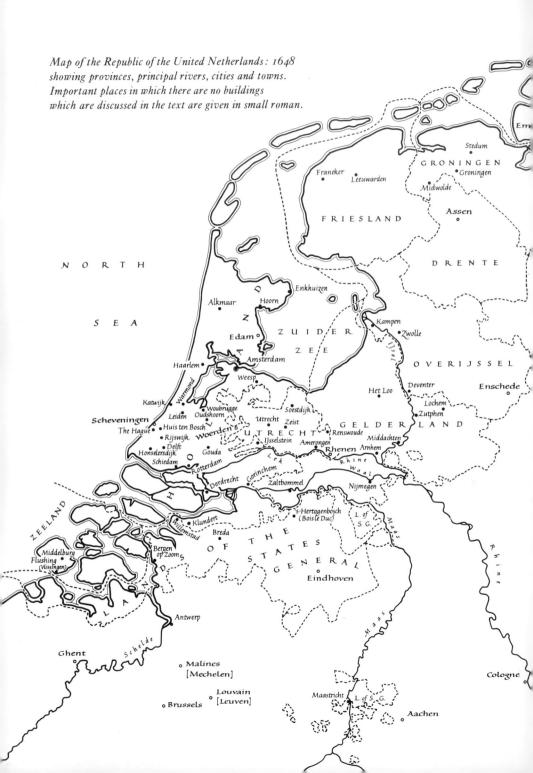

Map of the Republic of the United Netherlands: 1648
showing provinces, principal rivers, cities and towns.
Important places in which there are no buildings
which are discussed in the text are given in small roman.

DUTCH ART AND ARCHITECTURE
1600 TO 1800

PART ONE

PAINTING: 1600-1675

JAKOB ROSENBERG AND SEYMOUR SLIVE

CHAPTER I

INTRODUCTION

Dutch painting of the seventeenth century has such a distinctive character that one easily overlooks its ties with the Baroque style as an international phenomenon. Yet the moment one thinks of such artists as Rubens and Bernini, Frans Hals and Velazquez, in juxtaposition, one feels a common denominator. Baroque art, however, seems to defy an all-embracing definition. It finds more eloquent expression in the absolutist Catholic countries than in the Protestant Republic of the United Netherlands. Moreover, the phenomenon of classicism seems to interfere with the international scope of the Baroque movement. Seventeenth-century France is more classicistic than Baroque, and in Italy there is a frequent shift from one to the other, even in the careers of individual artists. Rudolf Wittkower, in his *Art and Architecture in Italy 1600-1750 (Pelican History of Art)*, used, we believe, the best way out of this dilemma by dividing the Baroque, as it has often been done, into three successive phases: Early (1600-25), High (1625-75), and Late (1675-1750) – and distinguishing between the classicistic manifestations in each of the three phases. In other words, he subordinates the recurrent classicism in Italian art to the pro-

gressive waves of the Baroque and allows to each form of classicism its special period aspect.

Holland finds its place in this concept of seventeenth-century art, however, with modifications. Dutch painting can be considered a part of Baroque art, since the latter embraces realism as well as classicism. In the case of Holland, realism is more important than classicism. In the field of painting this widened aspect of the Baroque can best be maintained when we realize that the European leadership lies with Italy only during the early decades (with Caravaggio), shifting in the second generation to Flanders (with Rubens), and about the middle of the century to France (with Poussin and then the style of Louis XIV). This is the course of development which Holland also follows, although at a certain distance and, as we said, with considerable modification. Holland's High Baroque phase (c. 1625-1645) is closer to Rubens' mature years than to Bernini's, and around the middle of the century the classical influence which found its most conspicuous expression in architecture in Jacob van Campen's great town hall at Amsterdam [312] was paralleled by certain classical tendencies in the painting of that time.

However, such classification in terms of successive phases of the Baroque does not adequately solve our problem of grouping the Dutch material. Holland's deviation from the international movement – owing to her national and cultural peculiarities – is at least as significant as her participation in it. In Holland alone was to be found the phenomenon of an all-embracing realism which was unparalleled in both comprehensiveness and intimacy. The Dutch described their life and their environment, their country and their city sights so thoroughly that their paintings provide a nearly complete pictorial record of their culture. However, it was more than mere reportage. A sensitive feeling for the painterly beauty of everyday life and nature not infrequently raised their production to the level of great art.

This new phenomenon of a comprehensive realism, along with a high standard of artistic craftsmanship, may explain the unusual degree of specialization in subject matter on the part of the individual artist, which in itself constitutes a striking feature of Dutch painting. While in a limited field genius could flourish – as the examples of Frans Hals and Vermeer show – the so-called 'Little Masters' often rose to a high rank of originality and quality unequalled in any other country. Thus the total aspect of Dutch painting is not determined by a few great artists, as in Flanders. Genius and talent both have their share, and this makes a simple grouping of the material by great personalities only, or by subject matter, inadvisable. A compromise in this respect does better justice to the situation in Holland. Rembrandt was no less a giant than Rubens, but he did not dominate the whole field in Holland. And Frans Hals and Vermeer had a limited range of influence, in local areas only. Thus the grouping of the material in the pages that follow will be partly by great personalities (Rembrandt, Frans Hals), partly by periods (Mannerism), partly by local schools (School of Delft), and most frequently by subject matter (genre, landscape, portraiture, etc.). This will lead to minor overlapping, but the authors thought it best to concede to the phenomena instead of holding rigidly to one system of grouping. The diversity of Dutch painting, which is an expression of Holland's democratic character, requires such flexibility. History, after all, should not be forced into classifications, but should itself determine the character of its presentation.

HISTORICAL BACKGROUND

During the seventeenth century the Republic of the United Netherlands developed a very individual culture which did not have much in common with the ideals that governed the art of neighbouring Flanders and the greater part of Europe.[1] After a long and heroic struggle under the military leadership of the princes of the house of Orange the Dutch freed themselves from the Spanish yoke. Fierce resistance by religious reformers, as well as by the nobility and burghers who maintained that their traditional rights and privileges were threatened by Philip II, began under William the Silent (1533-84). His valiant efforts to unify the seventeen northern and southern provinces of the Netherlands failed. Only seven of the northern provinces eventually won independence and formed a confederation: Holland, Zeeland, Utrecht, Gelderland, Overijssel, Friesland, and Groningen. Its foundation was the political compact known as the Union of Utrecht, signed by several of the northern provinces in 1579, which bound them, as if they were one province, to maintain their rights against foreign tyranny. This compact remained the basis for the organization of the country until Napoleon's armies conquered the republic in 1795. *De jure* recognition was only gained in 1648, when the Treaty of Münster was signed, but *de facto* recognition was achieved as early as 1609, when the United Provinces concluded a twelve-year truce with the Spanish. From 1609 onwards the Spanish were never really a dangerous enemy. Under Prince Maurice of Orange (1567-1625), son of William the Silent, stadholder of the provinces of Holland, Zeeland, Utrecht, Gelderland, and Overijssel, and captain-general of the Union, the United

Provinces rose quickly to be the greatest sea power in the world, with extensive colonial possessions in the East and West Indies which brought wealth and prosperity to the Dutch nation. During the century the house of Orange provided the Netherlands with some of her most capable leaders. All the descendants of William the Silent were endowed with extraordinary military and political ability, but they did not play the same role as the absolute monarchs of other European countries. Their authority was mostly limited to military leadership, and only in case of war, or when the nation was seriously endangered from outside, were they able to gain control over civilian authorities. Their significance in the cultural life of the Netherlands was negligible. Courtly life at The Hague, where the stadholders had their residence, was on a modest scale. Prince Frederick Henry (1584-1647), the younger brother of Maurice, who succeeded him as stadholder of five of the provinces and as captain and admiral-general of the Union, gave a few commissions to Rembrandt, but as far as we know neither he nor other members of the house of Orange patronized Frans Hals, Vermeer, Ruisdael, or Jan Steen, not to mention other outstanding Dutch painters. The plain fact is that there was little contact between life at The Hague and the bourgeois culture developing in other Dutch cities. On the one occasion when Amalia van Solms, widow of Prince Frederick Henry, wanted to decorate Huis ten Bos, her *villa suburbana* near The Hague, with paintings glorifying the life of her husband, she turned mainly to Flemish, not Dutch artists. Jacob Jordaens was given the lion's share of that commission.

Real opposition to an extension of the power of the house of Orange into the field of civilian administration came time and again from the more liberal and republican bourgeois elements. It was in the first place an antagonism between the principles of democracy and absolutism, but antagonism also extended to the field of religion. The burgher class favoured a milder form of Calvinism. They are often called Arminians, after the religious leader Arminius, or Remonstrants, because of their opposition to the very austere tenets of Calvinism, such as the dogma of predestination. These burghers stood for tolerance and a form of Christianity which was modified by humanism. They stood for more democratic principles of government, and as far as foreign policy was concerned, they favoured a peaceful course which did not interfere with their all-important trade. The house of Orange, on the other hand, tended towards a more militant policy, and towards the centralization of power in their own hands. They had their supporters in the country rather than the cities, and among the strict Calvinists who wanted strong authority in worldly as well as religious affairs.

Permanent tension between the burgher faction, which favoured a decentralized government and relative independence of the single provinces, and the orthodox, absolutist groups who followed the princes of Orange led to repeated clashes. The first serious one came in 1618-19, when Prince Maurice of Orange used the Synod of Dordrecht to wipe out his opposition and their leaders. The wise statesman Johan van Oldenbarnevelt, who had given invaluable counsel to Maurice during the decisive formative years of the Republic, was condemned to death and executed; the distinguished scholar Hugo Grotius was sentenced to perpetual imprisonment (through the ingenuity of his wife, however, Grotius managed to escape from prison hidden in a chest). A second less serious clash came in 1650, when Prince William II (1626-50) threatened Amsterdam with a siege because of the city's refusal to contribute sufficiently to the republic's military power. William's sudden and early death in the same year and the youth of his son William III (1650-1702) gave the patrician oligarchy a chance to come to the front and actually to enjoy a long period of prosperity under the leadership of a burgher, Johan de Witt.

The single provinces of the United Netherlands were very anxious to preserve something of the old decentralized form of government, and with it, their relative independence. Each province was liberal within its own borders and only loosely attached to any central power. They sent their delegates to the States-General, the body representing the United Provinces in foreign affairs, but since each of the provinces claimed sovereignty for itself, the States-General was more an assembly of sovereign provinces than of a sovereign country. This made it very difficult for governors of the republic to attain sufficient authority for speedy and united action. The province of Holland was by far the mightiest of the seven provinces. It was the largest in population and the richest. Probably this is why foreigners to this day refer to the entire nation as Holland, a name hardly calculated to please Dutchmen with strong loyalties to other provinces of their small country. The province of Holland was the centre of the Dutch colonial empire, and its merchants and bankers frequently contributed more to the budget of the republic than the other six provinces combined. In 1651 representatives of the seven provinces met and agreed that all sovereign powers belonged to them severally and that there was no need for a captain-general of the Union. The five provinces which in earlier years elected the Prince of Orange their stadholder agreed to leave this position open. These decisions in effect made Johan de Witt, representative (Grand Pensionary) of the dominant province of Holland

to the stadholderless republic, the leader of the Union. De Witt's régime (1653–72) was the period of the republic's greatest economic and cultural flowering.

De Witt favoured a peaceful policy in order to promote and protect a flourishing overseas trade. England, however, resented the leading position of the Netherlands. Two naval wars were fought with England, and in spite of great heroism on the part of the Dutch under Admiral Tromp and Admiral de Ruyter some overseas possessions were lost. One of the colonies surrendered was New Netherland, with New Amsterdam as its capital. In 1664 the name of both the colony and capital was changed to New York, a symbol of the growing power of England. During De Witt's régime the Dutch army was neglected. This suited the patrician oligarchy, for it relieved them of making heavy financial sacrifices for military precautions. De Witt paid dearly for this policy. Danger to the Netherlands became acute as soon as other European powers got their hands free and could think of extending their own continental possessions. When the struggle between France and Spain was decided in favour of France, the republic's hour of distress came. Louis XIV, angered by the attempt of the Dutch to resist his hegemony, sent his powerful armies to invade the Netherlands in 1672. The ill-prepared Dutch were taken by surprise, and town after town fell to the French. Once again there was a serious clash between the two antagonistic Dutch powers, the regent class and the partisans of the house of Orange. This time the Orangists were the victors. The Dutch turned to Prince William III for help and military leadership. In June 1672 he was elected stadholder of Zeeland and Holland and captain-general of the Dutch armies. Two months later an infuriated mob at The Hague tore Johan de Witt and his brother to pieces. William III swiftly organized the Dutch against their foreign enemies, and by 1673 the danger

of domination by France was over. At the Peace of Nijmegen, signed in 1678, the French agreed to give up virtually all their conquests. Ten years later William III and Mary became king and queen of England. Now the Prince of Orange's political and military genius was devoted to his new kingdom, and from this time onwards the Republic of the United Netherlands began to play a secondary role on the European stage.

The amazing rise to power of the United Provinces during a comparatively short period of their national history was due above all to the heroic Dutch navy and the bold spirit and bravery of the merchant fleet. The Dutch helped to break the supremacy of Spain with their sea power, created a world-wide empire, and even pushed England for some time to second place. The country's geographical situation helped to make her a centre of world trade. As she is situated on the sea and crossed by the Rhine and the Maas, two of Europe's most important waterways, from which a network of canals spread all over the country, traffic and communication were easier than in any other nation of Europe. The Dutch succeeded in closing the mouth of the Scheldt river to make it impossible for Antwerp to communicate with the sea. This ruined Antwerp as an important world trading centre, and Amsterdam rapidly became a greater commercial and political power than Antwerp had ever been. Extensive navigation on the highways of the sea as well as at home also helped the country to develop its democratic structure. A town culture with easy communication between communities evolved. Fisherman and peasant, sailor and merchant were the main professions, and the principal products of the country in those days were textiles, salt, soap, tar, and rope. In addition, there were large shipyards, breweries, refineries for sugar and tobacco, and extensive trade in fish, cheese, timber, stone, iron, and minerals. A wave of skilled refugees from the South

Netherlands, who fled to the northern provinces to escape religious persecution, helped to stimulate economic as well as artistic development. Tremendous gains were attained by the vigorous colonial trade, particularly by the import of spices. Throughout the century the country's economic system remained pre-mercantile. Essentially it was the old medieval system of unrestricted economic liberty for every individual community. These rights were jealously guarded. The upheaval against Spain was not only due to religious oppression. The Dutch also waged what became their war of independence because the economic privileges of the individual communities and provinces were seriously threatened by the enforced centralization imposed by the absolutist Spanish régime.

Another important reason for the United Provinces' elevated position during the first half of the seventeenth century was the general political situation of Europe. The small country could flourish so peacefully, because all the greater nations of Europe were either involved in war or had internal religious strife which was still an after-effect of the period of the Reformation. This was the case with France, where the Huguenots fought for their rights, and in England, where the Puritans stood against the Royalists, and in Germany, where the Thirty Years War paralysed foreign expansion. The young republic not only profited politically by remaining relatively undisturbed; it also gained commercially by becoming the banker of Europe at a time when princes were willing to pay high interest rates for money needed so badly for their endless and costly wars.

The sociological structure of the Netherlands was to a certain extent democratic during the first decades of the century. It showed little signs of militaristic or aristocratic character. Only slowly did the bourgeois circles take on aristocratic tendencies and habits. For a time the well-to-do families who monopolized the higher offices in the administration of the provinces remained in contact with the lower classes of the population by such organizations as the shooting companies (*doelen*) or the societies of rhetoricians (*rederijkerkamers*). The shooting companies gave ordinary burghers the privilege of belonging to a municipal militia; however, the officers were usually appointed from the governing classes. In the rhetorician societies each burgher could find an outlet for his literary ambitions. Both organizations helped to establish contact between the higher and lower classes. In the early seventeenth century the burgomasters and the higher officials of the city administration were still active merchants themselves. Only in the next generation, after the development of great family fortunes, did these patricians begin to adopt aristocratic manners. They bought estates in the country to which they retired during the summer months. Many tried to get some kind of title or sign of nobility. Within the towns and cities intimate contact with the greater mass of the people, which was so fruitful for the development of a genuine bourgeois culture, was lost. The Dutch army consisted mostly of mercenaries from all countries, whereas the navy was made up of native Dutchmen and the republic's great naval heroes - Tromp, De Ruyter, and Piet Hein - came from the middle classes. This was also the case with the numerous artists, who made their living because the art of painting was in great demand among all strata of the Dutch population. Peter Mundy, who travelled to Amsterdam in 1640, reported: 'As For the art off Painting and the affection off the people to Pictures, I thincke none other goe beeyond them, there having bin in this Country Many excellent Men in thatt Facullty, some att presentt, as Rimbrantt, etts, All in generall striving to adorne their houses, especially the outer or street roome, with costly peeces, Butchers and bakers not much inferiour in their shoppes, which are Fairely sett Forth, yea

many tymes blacksmithes, Coblers, etts., will have some picture or other by their Forge and in their stalle. Such is the generall Notion, enclination and delight that these Countrie Native(s) have to Paintings.'[2] In the following year John Evelyn visited Rotterdam at the time of the annual fair and was amazed by the great numbers of pictures he saw, 'especially Land-scips, and Drolleries, as they call those clownish representations'. According to Evelyn, 'The reason of this store of pictures and their cheape-nesse proceede from their want of Land, to employ their Stock; so as 'tis an ordinary thing to find, a common Farmor lay out two, or 3000 pounds in this Commodity, their houses are full of them, and they vend them at their Kermas'es to very greate gaines.'[3] The pre-dominance of painting over sculpture and architecture is largely explained by the lack of great patrons. There were no great princes, no cardinals, no grand seigneurs who wanted monumental sculpture and architecture. Dutch paintings were within the means of the large middle class. Rembrandt and Frans Hals painted not only burgomasters and magistrates, but also preachers, calligraphers, ship-builders, Jewish doctors, engravers, and goldsmiths.

The numerous portrait paintings of preachers are a good indication of how important religious life was in the Netherlands during the seven-teenth century. As with the artists, most of the preachers came from the middle class. This may be one of the reasons why the Church contribu-ted to the democratic spirit of the communities. The bulk of the people were probably Calvinists by the middle of the century – this is a guess, there are no statistics available. Calvinism never became a state religion in the strictest sense. Other religious groups – such as Luther-ans, Mennonites, Jews – were tolerated and allowed to lead their own religious life. Catho-licism was officially banned, but the authorities soon became lenient and priests were permitted to conduct religious services for Catholics

in concealed chapels. Since the days of Erasmus of Rotterdam and largely through the ideas of this great humanist, liberalism and tolerance flourished on Dutch soil, and most of the time the majority of the population remained in a state of benevolent passivity towards other religious groups.

The question how much Dutch culture and Dutch art owes to Calvinism is not easy to answer. Calvinism certainly strengthened the moral qualities of the people, as well as increased action and responsibility in public affairs. It may also be true that Calvinism gave a certain confidence and resoluteness to the fighting forces, in particular to the bold and adventurous naval heroes. But we notice comparatively little influence of Calvinism on contemporary Dutch science, philosophy, law. No one has convinc-ingly connected the great achievements of the Dutch in these fields with religion. As for art, one may perhaps admit that a general simplicity of taste has something to do with the moral attitude and Puritan spirit of Calvinism. How-ever, before any causal connexions are made between Calvinism and seventeenth-century Dutch painting, it should be noted that during the first half of the century the United Provinces were not as Calvinist as was main-tained by nineteenth-century historians, who assumed that the division of the Lowlands into the Dutch and Belgian Netherlands was the end of an inevitable historical process, and that differences in the national character of the Dutch and Flemish predestined them by their very nature to become separate nations adhering to Calvinism or Catholicism. On the contrary, it has been shown that the split in the Lowlands was principally the result of military and geo-graphic considerations and not of racial differ-ences. The great rivers brought a stalemate in the war with Spain which was confirmed by the truce of 1609. For the year 1609 it is not possible to speak of a Protestant north and a Catholic south. The final result of Catholicism

in the south and Protestantism in the north was an outcome of the course of the Eighty Years' War. It was the result, not the cause of the split. What became the frontier between the North and South Netherlands was the line the United Provinces were able to maintain against the Spanish. It did not mark a religious or linguistic boundary. Although the Catholic religion was suppressed and Catholic churches were purged of their altars and seized for the Reformed as soon as a town fell, the United Netherlands did not become a Protestant nation overnight. The change was a slow one, particularly in the country districts. More artists remained Catholic than is generally known.[4] Jan Steen and Jan van Goyen were Catholics; Vermeer became one too. Conclusions about the importance of Protestant creeds in the formation and achievement of seventeenth-century Dutch painting which do not take into account these facts are of limited value. Moreover, so much of what we recognize as especially Dutch in painting, its peculiar bourgeois taste and character, an interest in the effect of space and light, a concern for landscapes and interiors, and the special reticence which, in the works of the greatest Dutch artists, is transformed into a searching introspection, appears in fifteenth-century Netherlandish painting long before the birth of Calvinism. In the final analysis, the amazing pictorial gift of the Dutch remains as inexplicable as the genius of their great masters.

LATE MANNERISM AND INTERNATIONAL TRENDS: 1600–1625

Dutch painting in its prime is one of the great achievements in the history of art, and it has all the aspects of a truly creative period when sureness of instinct and quality of performance hold a safe balance. Yet the long and traditional acceptance of seventeenth-century Dutch painting as a culmination of realism in Western art, and its persistent influence on later periods, in particular the nineteenth century, may have hindered a fresh view in recent times and blunted our consciousness of its true originality and significance.

Naturally, we are eager to know how this phenomenon came into being and how Dutch painting was involved in its total course with the broader stream of European art. We shall see that even in its prime, during the so-called classical phase of the mid seventeenth century, a subdued influence of foreign art – in this case the Italian Renaissance as well as Baroque Classicism – is noticeable. But by then the Dutch character had expressed itself so independently and vigorously that Holland's artists could easily absorb outward influence with profit for themselves and without deeper disturbances. Not so during the first decades of the seventeenth century, when Italian art enjoyed a strong leadership on the Continent. At this time a consciousness of the value of the Northern Renaissance (Dürer, Bruegel) also dawned. Hence the growth of native trends within the still internationally minded artistic community of Holland did not come about without shocks and turbulences. Contrasting elements are found in the works and careers of single artists. To avoid injustice to such figures as Goltzius, Cornelis van Haarlem, Bloemaert, De Gheyn, and others who tried to absorb the successive trends of Late Mannerism and Early Baroque Classicism, we have to visualize their international situation. No doubt those moments in their life and work when they seemed least inhibited as straightforward realists are the most appealing ones. They occur more frequently in their drawings than in their paintings, and happen mostly in portraiture, genre, and landscape. They are also most significant for the future of Dutch art. This is equally true of artists like Miereveld or Moreelse when they concentrated on portraiture after their escapades into Mannerist mythology, or of the early genre painters and landscapists like Vinckboons, Buytewech, and Esaias van de Velde (these artists are treated later in the chapters on genre painting, landscape, and portraiture). The Utrecht School is in a class by itself, with its concentration on large-scale genre pieces and on chiaroscuro effects – both primarily derived from Caravaggio's vigorous art – and is not as alive to native instincts. There is hardly a trace of Dutch intimacy.

Thus the following account of this initial phase, while perhaps confusing by the diversity of trends and influences, may gain coherence if we keep in mind that both things happened: the strong influence of foreign, in particular Italian, art on Dutch painters, and a gradual moving on towards a unified native culture of high originality and distinction.

THE MANNERISTS

Eugène Fromentin, the nineteenth-century enthusiast of Dutch art, wrote that the Dutch right to a native school of painting seems to have been laid down as one of the stipulations of the

Twelve Year Truce which the Dutch concluded with the Spanish in 1609. Fromentin's formulation is an ingenious one. The unique interest in the everyday world and in nature that Netherlandish painters had shown since the fifteenth century, and which are the hallmarks of seventeenth-century Dutch painting, became more evident during the years of the truce. Landscape, genre, and still life, categories which hundreds of seventeenth-century Dutch artists made their speciality - a phenomenon without precedent in the history of Western painting – were firmly established and received their characteristic direction during the second decade of the century. Frans Hals, the first genius of the greatest period of Dutch painting, did not appear on the scene until the truce was signed. None of Frans Hals' extant works can be dated before about 1610, and these were made when he was almost thirty years old. Historical hindsight makes all this quite clear. However, it is hard to imagine that in 1609 any painter or patron thought that a national Dutch school would soon arise. To be sure, there was an indigenous style in the Northern Netherlands, which is best seen in portraits by Cornelis Ketel (1548–1616) and Cornelis van Haarlem (1562–1638). But there is reason to believe that these artists were a bit bored with, or even ashamed of, their paintings of faces. Cornelis van Haarlem confessed to one of his contemporaries that he did not enjoy making portraits, and around 1600 Ketel began amusing himself and his clients by using his toes instead of brushes to paint pictures.[1]

Around 1600 Dutch artists accepted the notion promulgated by Italian Mannerist theorists (Vasari, Lomazzo, Armenini, Federigo Zuccaro) that nature must be studied, but never slavishly copied. It was the artist's duty to improve upon it according to the 'idea' (concetto) he had formed in his imagination of perfected nature.[2] They also agreed with earlier theorists that the most noble subject a painter could

depict was a religious or historical theme, and that the sine qua non of painting was the representation of the idealized nude figure. These tenets are endorsed without reservation in Het Schilderboek, a handbook for artists published in 1604 by Karel van Mander (1584–1606), the oldest member of the group of Dutch painters called the Haarlem Mannerists. The label is not a very good one because none of them were exclusively Mannerists, but it would be hopeless pedantry to try to change the tag at this date.

Van Mander was born in Meulenbeke, a small town near Courtrai in western Flanders. As a young man he was more concerned with poetry than painting, and he never lost interest in literature. Van Mander is frequently called 'the Dutch Vasari'. The title is an appropriate one. Like Vasari, he was a painter of some distinction, but his main claim to fame rests upon his written works. He was in Italy from 1573 until 1577, where he was impressed by Vasari's Lives of the Italian Artists as by the Florentine Mannerist's paintings; the bulk of Van Mander's Schilderboek is modelled upon Vasari's Lives. The most important section contains biographies of Netherlandish and German artists from the time of the Van Eycks up to Van Mander's young contemporaries. It is the first extensive account of the lives of the major North European artists and is still our principal source for the history of northern fifteenth- and sixteenth-century painting. Another part of his book is a condensed Dutch translation of Vasari's Lives of the Italian Artists, and contains valuable original material about Italian artists who worked after 1568, the date of publication of Vasari's second edition. It is impressive to discover that some time before 1604 word reached Van Mander at his country estate, located between Haarlem and Alkmaar, where he retired to write Het Schilderboek, that 'a certain Michelangelo da Caravaggio was doing wonderful things in

Rome . . .' A third part is a long poem called *Den Grondt der Edel Vry Schilderkonst* (*The Fundamentals of the Noble and Free Art of Painting*), which lays down precepts for young artists on what and how to paint. It contains some original sections (e.g. the chapter on landscape painting is the first extensive treatment of the subject in occidental literature), but most of it codifies well-known Italian art theory and practice. In 1609 it would have been difficult to predict that as far as the leading Dutch artists of the following three generations were concerned – and this number includes Frans Hals, who was Van Mander's pupil, Rembrandt, and Vermeer – the *Grondt der Schilderkonst* fell still-born from the press.

Like many of his countrymen, Van Mander emigrated from Flanders to the Northern Netherlands because of troubled conditions brought about by the war with Spain. According to a scanty contemporary report, shortly after he settled in Haarlem in 1583 he met Cornelis van Haarlem and Hendrick Goltzius, the gifted printmaker and most influential artist of the period. The three men are said to have founded an academy where they could study from life ('om nae 't leven te studeeren'). The nature of the 'academy' has been much discussed, but its character remains a matter of conjecture.[3] However, one thing is clear: it was not an art school where the theory and practice of art was taught according to a set curriculum. Aspiring Dutch artists were trained and regulated by the guild system until well into the seventeenth century. The Haarlem 'academy' should not be confused with organizations such as the Accademia di San Luca of Rome, which was opened in 1593, or the Académie Royale de Peinture et de Sculpture established at Paris in 1648.[4] When the so-called Haarlem 'academy' was established, or how long it existed, is not known. Probably it did not function much longer than most informal arrangements between artists do. It is

noteworthy that Van Mander himself, who takes every opportunity to extol artistic activity in Haarlem – and who even invents some occasions to do so – never mentions the 'academy' in the *Schilderboek*.

More significant for the development of Dutch art than the nebulous Haarlem 'academy' were some drawings by the Flemish Mannerist Bartholomäus Spranger (1546–1611), brought to Holland by Van Mander. He wrote that shortly after his arrival he showed Spranger's drawings to Hendrick Goltzius. Goltzius was quickly seduced by Spranger's intensely Mannerist style. By 1585 he had made his first engravings after Spranger, and around the same time Goltzius began to incorporate the elegantly attenuated figures, the over-agitation and eroticism of Spranger's works into his own prints. Spranger's personal transformation of Italian Mannerism had a wide and immediate appeal in the Netherlands. Soon Cornelis van Haarlem, Abraham Bloemaert (1564–1651), Joachim Wttewael (*c.* 1566–1638), Jacques de Gheyn (1565–1629), and Jan Muller (1571–1628) adopted aspects of his manner.

The violent contortions and foreshortenings of the herculean nudes, the exaggerated tension and the forced perspective in Cornelis van Haarlem's life-size *Massacre of the Innocents* of 1591 (Haarlem, Frans Hals Museum) [1] are all characteristic of late-sixteenth-century Dutch Mannerism. But Dutch artists, like most people, were not fascinated by Mannerism for very long. Goltzius, for example, only worked in Spranger's style for about five years. His decisive rejection occurs in 1590, when he left Haarlem for a brief trip to Rome, where he made an intensive study of classical sculpture; more than forty of his drawings of ancient statues are now at the Teyler Foundation in Haarlem. Van Mander, who included a detailed and laudatory biography of Goltzius in *Het Schilderboek*, wrote that his ·friend was also impressed while in Italy by Raphael's grace,

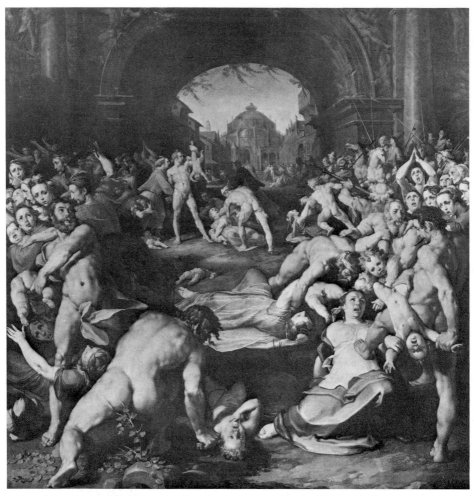

1. Cornelis van Haarlem: The Massacre of the Innocents, 1591. *Haarlem, Frans Hals Museum*

by Correggio, Titian, and Veronese, and when he returned to his homeland 'he was no longer satisfied with Netherlandish painting'. Goltzius was back in Haarlem late in 1591. He returned a changed artist. From this time onwards he no longer made prints after Spranger's extravaganzas. The monstrous muscle-men and over-elongated female nudes with tiny heads who contort in his prints and drawings of the late eighties are replaced by figures with more normal proportions and movements. A kind of classicism now enters his work – one of the earliest signs of a revival which became an international movement during the first decade

of the seventeenth century – and he also becomes conscious of the tradition of Northern Renaissance art.

Goltzius' fame rests on his work as a graphic artist. Notwithstanding his crippled right hand – fire maimed it, and he was unable to extend its fingers – he was an extraordinary technician and unsurpassed virtuoso of the engraver's burin and the pen. Uncanny sureness and infinite patience never failed him, and he dazzled his contemporaries with his performances. They were especially impressed by his pen drawings which simulate the swelling and tapering lines of engravings. Some are lifesize (*Federkunststücke*); the most sensational one of this type is the colossal pen drawing (it measures $89\frac{3}{4}$ in. by 57 in.) of *Venus, Ceres, and Bacchus with a Self-Portrait* done in 1604, now at the Hermitage in Leningrad. Goltzius also won international acclaim for a series of six engravings of the *Life of the Virgin* (called by print collectors the *Meisterstiche* or Masterpieces). Each print was deliberately done in the style of a different master. The set includes a *Circumcision* (Bartsch 18) which was mistaken for an original Dürer, and an *Adoration of the Magi* (Bartsch 19) which passed as a Lucas van Leyden until the artist issued impressions signed with his own monogram. His virtuosity also enabled him to include compositions in the style of Raphael and Parmigianino. Not without reason, Van Mander said Goltzius was the Proteus or the Vertumnus of art, who had as many styles as Ovidian heroes have disguises. Among Goltzius' most attractive and original works are his decorative chiaroscuro prints. His bold design, freedom in cutting, and sure use of tone blocks to describe forms without relying upon the black line block is seen in his coloured print of *Proserpine* [2]. The figure still has Mannerist proportions – the print can be dated around 1588, a few years before he went to Rome – and it is difficult to determine how the seated goddess manages to keep her balance, or to give a

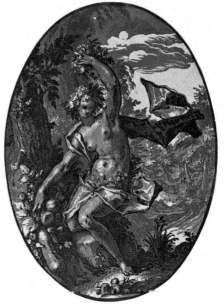

2. Hendrick Goltzius: Proserpine, *c.* 1588. Chiaroscuro woodcut.

rational explanation for the position of her fluttering draperies; but these are the liberties that delighted the artist and his public during this phase. Goltzius was also the first printmaker to design and cut chiaroscuro landscapes. Even more impressive are his numerous engraved portraits. The forceful characterization and

immediacy of the one he made of his teacher Dirck Volkertsz. Coornhert (1590) [3] must have been an inspiration to young Frans Hals.

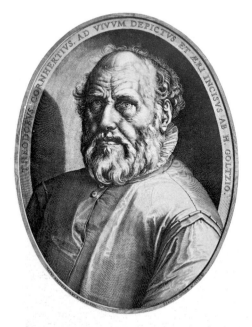

Goltzius also drew exquisite miniature portraits, mostly in metal-point, and made studies of animals and plant life marked by his acute power of observation and unfailing accuracy. Around 1600 he executed open-air drawings of clumps of trees and some panoramic views of the Dutch countryside (*View of the Dunes near Haarlem*, 1603, Rotterdam, Boymans-Van Beuningen Museum) [4]. These are among the earliest drawings of the scenery of Holland, and established Goltzius as a leading forerunner of later artists who specialized in depicting Dutch landscape. It is no accident that Van Mander does not mention these epoch-making

3 (*left*). Hendrick Goltzius:
Dirck Volkertsz. Coornhert, 1590. Engraving

4 (*below*). Hendrick Goltzius:
Dune Landscape near Haarlem, 1603. Drawing.
Rotterdam, Boymans-Van Beuningen Museum

5 (*opposite*). Jacques de Gheyn II:
Woman and Child looking at a Picture Book, *c.* 1599.
Drawing. *Berlin-Dahlem, Kupferstichkabinett*

nature studies in his lengthy biography of Goltzius. Van Mander praised what an artist produced from his imagination, not what he copied from nature. For the same reason he is silent about Goltzius' portrait studies and animal drawings, works which foretell more about the future development of Dutch art than the notorious *Federkunststücke* or *Meisterstiche*.

Goltzius' pupil, Jacques de Gheyn II, who was also active as an engraver and painter, matches his teacher as a draughtsman and at times even surpasses him. Like his teacher, De Gheyn was equally gifted with pen, metal-

point, and chalk, but he did not have Goltzius' compulsion to make an ostentatious display of his virtuosity. De Gheyn's pen line frequently resembles the technique of engraving in its swelling and diminution and extensive use of hatching and dots to model form, but his touch is more nervous and hence seems less impersonal. His choice of subject ranges from the weird to the tender (*Woman and Child looking at a Picture Book*, Berlin–Dahlem, Kupferstichkabinett, pen-and-wash drawing) [5]. If any of the early Dutch draughtsmen gives a foretaste of Rembrandt in spiritedness of line and vivacity of characterization, it is De Gheyn.

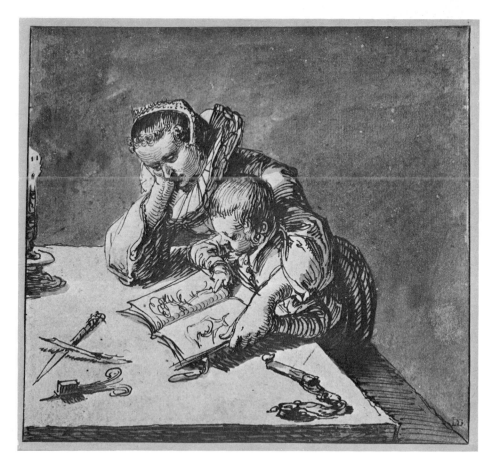

The kind of perfection Goltzius achieved in his engravings and drawings is not found in his paintings. Apparently he only began to devote his energy to this category of art around 1600.[5] The master engraver's earliest extant painting is small and done on copper (*Christ on the cold Stone*, 1602, Providence, Rhode Island School of Design). Numerous allegorical details frequently crowd his later lifesize (some are over lifesize) subject pictures, and these are not always well integrated into his compositions (e.g. *Allegory*, 1611, Basel, Öffentliche Kunstsammlung). He is more successful in paintings such as *Vertumnus and Pomona* (1613, Amsterdam, Rijksmuseum) [6], where the subject is limited to a few figures which fill most of the picture and the landscape is reduced to a backdrop. The figure of his Pomona is modelled upon Dürer's engraving *Das Meerwunder* (Bartsch 171),·but Goltzius was more classical

than his German prototype. He has rounded out all the sharp Gothic joints of Dürer's nude, and he also presents a more relief-like view of his model. The drapery worn by Vertumnus corroborates Van Mander's observation that while in Italy Goltzius was taken with the way Venetians painted textures.

Cornelis van Haarlem was apparently affected by Goltzius' early rejection of Mannerism. By 1594 he had begun to paint less athletic-looking nudes and his compositions became more planimetric (*The Judgement of Apollo*, Madrid, Prado), and before 1600 Cornelis worked out the kind of bland classicism to which he adhered until the end of his life. He remained impervious to the radical innovations made by younger Dutch painters. His *Christ blessing the Children* of 1633 (Haarlem, Frans Hals Museum) is painted in the style he formulated about four decades earlier.

6. Hendrick Goltzius: Vertumnus and Pomona, 1613. *Amsterdam, Rijksmuseum*

Van Mander's role as a painter was different from that of his Haarlem friends. The panoramic view of a village populated by carousing peasants in his *Kermis* (1600, Leningrad, Hermitage) [7] reveals a debt to Pieter Bruegel the Elder and his followers. The coarse subjects of his genre pieces indicate that he himself did not always follow the rules of decorum he wrote about in his *Grondt der Schilderkonst*. The picture also shows his importance for the development of seventeenth-century Dutch painting. Van Mander is a link between late-sixteenth-century Flemish genre painters and the artists active in Holland during the first decades of the new century (Frans Hals, Vinckboons, Esaias van de Velde), who laid the foundation for the great achievement of Dutch genre and landscape painting. Paintings by Van Mander are rare, but enough remains to reconstruct his development. Like the other

Haarlem Mannerists, he worked in more than one style. Paintings made before he settled in Haarlem show no trace of Spranger's influence (*Martyrdom of St Catherine*, 1582, Courtrai, St Maartenskerk); then he had Mannerist and Classicist phases. His sweet nocturnal *Adoration of the Shepherds* of 1598 (Haarlem, Frans Hals Museum, on loan) recalls the treatment of similar themes by the Bassani, but Van Mander makes the picturesque ruins and the mysterious light and shadow in his small painting play a more important part than late-sixteenth-century Venetian artists did. His *Adoration* shows that night scenes were painted in the Netherlands before the Dutch followers of Caravaggio returned to Holland around 1620. It is possible to point to even earlier examples. The predilection of the Dutch for nocturnal pictures can be traced back at least to Geertgen tot Sint Jans' *Nativity*

7. Karel van Mander: Kermis, 1600.
Leningrad, Hermitage

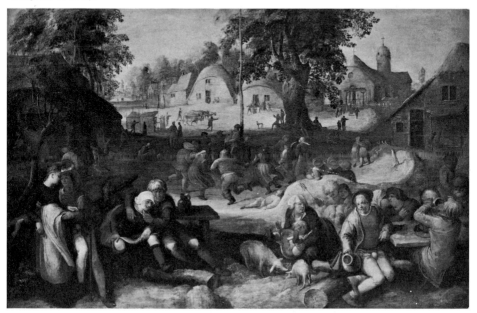

painted about 1485, now in the National Gallery, London.

Two Utrecht painters, Abraham Bloemaert and Joachim Wttewael, belong to the same generation as the Haarlem Mannerists. Both studied with Joos de Beer, a nebulous Utrecht artist whose pictures were probably a melange of Flemish Italianate painting and the style of the School of Fontainebleau. Wttewael was in Italy from 1586 to 1588; he lived in Padua, close enough to Venice to become familiar with the Venetian masters. He also studied works by the Tuscan Mannerists Jacopo Zucchi and Ventura Salimbeni. Wttewael returned to the Netherlands via France, and by 1592 he had settled in Utrecht. He painted portraits and kitchen scenes as well as subject pictures. His religious and allegorical pieces are frequently cabinet size, and are characterized by thin figures with nervous hands set in capricious poses. He painted in hard, metallic colours and had a predilection for chrome yellow, intense reds, deep greens, and browns. Wttewael was one of the few Dutch artists who did not abandon Mannerism after 1600; there is little difference between his early and his late works.

The same cannot be said of Abraham Bloemaert. During his long and productive life Bloemaert tried his hand at most of the styles used in Holland during the first half of the seventeenth century. After studying with his father Cornelis and Joos de Beer, Abraham Bloemaert went to France around 1580. Three years later he returned to Utrecht, and in 1591 he moved to Amsterdam. The works made during this decade mark his Mannerist phase (*Apollo and Daphne*, 1592, Wroclaw (Breslau), Museum). He returned to Utrecht again in 1593, and within a decade adopted the mild classicism that Goltzius had brought back from Italy. In Utrecht Bloemaert was remarkably successful as a teacher. His pupils include his four sons and three of the leading Dutch Caravaggesque painters (Honthorst, Terbrugghen,

Bijlert), and the Italianate painters Poelenburgh, Jan Both, and Jan Baptist Weenix were his students before they travelled to Rome – in fact, it is difficult to name an Utrecht painter of his day who did not receive some training from him. The number of Utrecht artists who went to Rome is also striking, and an index of the city's close connexion with the Catholic Church. Utrecht was the leading Catholic centre in the North Netherlands during the Middle Ages and the Renaissance, and even during the seventeenth century, when Catholicism was suppressed, it continued to keep something of its Catholic character.

Bloemaert learned as easily as he taught. His candlelight picture of the *Supper at Emmaus* (1622, Brussels, Musées Royaux des Beaux-Arts) is proof of his rapid assimilation of Honthorst's personal transformation of Caravaggio's style. The *Marriage of Peleus and Thetis* (1638, The Hague, Mauritshuis) [8]

8. Abraham Bloemaert:
The Marriage of Peleus and Thetis, 1638.
The Hague, Mauritshuis

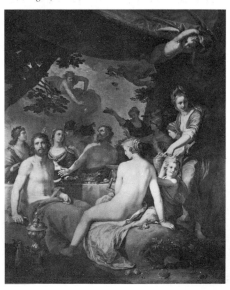

indicates that he was also a successful interpreter of Annibale Carracci's classicism. This picture was the kind of decorative painting that made the court at The Hague prefer masters of the Utrecht School to other seventeenth-century Dutch artists. There was a close affinity between the Catholic and the aristocratic tendencies of the Baroque period. Decorative paintings produced by the Utrecht artists, and by their Flemish contemporaries, were better suited to the purposes of a court – even a Protestant one – than those made by most of the other seventeenth-century Dutch masters. Bloemaert also made a contribution as a landscapist, creating outstanding fanciful and decorative works (see pp. 243-4 and illustration 193).

Michiel van Miereveld (1567-1641) and Paulus Moreelse (1571-1638) are two Utrecht artists best known for their traditional portraits (see pp. 314-15, illustration 248), but both started as history painters working in the international Late Mannerist style. Miereveld never left Holland; he apparently derived his clumsy Mannerism from his teacher, Anthonie Blocklandt, who settled in Delft after working with the Flemish master Frans Floris. Van Mander cites a few subject pictures by Miereveld, but the only one known today is *The Judgement of Paris* of 1588, now at the National Museum, Stockholm. It seems that he gave up history painting to become a portraitist, and if Joachim Sandrart is to be trusted, once he started to paint portraits he never stopped. Sandrart reports that Miereveld made more than ten thousand portraits.[6] Moreelse, who was Miereveld's pupil, was not such a pronounced specialist. He was active as an architect as well as a painter (see p. 391), and he made subject pictures throughout his career. The early ones (nothing is known before 1606) show the influence of Wttewael and Blocklandt. During the 1620s he did a series of shepherds and shepherdesses dressed in bright silk and bedecked with flowers. His late works (*Cimon*

and Pera, 1633, Edinburgh, National Gallery) show the distinct impact of Rubens. In general, his portraits have a little more splendour and softness than those of Miereveld.

ELSHEIMER'S INFLUENCE

Van Mander belongs to the group of art historians who are not afraid to write judgements on modern art and artists. He wrote in his *Schilderboek* that 'now in Italy there is a certain Peter Lastman who shows great promise'. Lastman (1583-1633) returned to his native town of Amsterdam not long after *Het Schilderboek* was published, and quickly fulfilled his promise by becoming one of the principal painters of religious and mythological subjects in the new republic. According to Van Mander, Lastman's teacher was Gerrit Pietersz. Sweelinck (1566-?), an obscure artist best remembered as the brother of the leading Dutch composer and organist Jan Pietersz. Sweelinck. Lastman's earliest studies have an affinity with works by Goltzius and Cornelis van Haarlem. Shortly after they were made he probably proceeded to Italy, where he was affected by the works of Hans Rottenhammer, who was active in Venice, and even more decisively by Adam Elsheimer (1579-1610),[7] a painter of German origin who settled in Rome after a brief stay in Venice. Like most painters active in Rome during the first decades of the seventeenth century, Elsheimer was stimulated by Caravaggio. The new feeling for sculptural values which is so impressive in Caravaggio's lifesize figures and the intense expression of mood through the pictorial means of light and shadow that distinguish his pictures are also found in Elsheimer's meticulously painted masterworks, mostly done on little copper plates. But Elsheimer made an important contribution of his own. He discovered the classical serenity of the ancients in the Roman Campagna and created a new type of landscape that

appealed to northern seventeenth-century artists, who were susceptible to his fine feeling for light and atmosphere. His paintings had a wide and immediate appeal and, as we shall see, they had a decisive effect upon the development of seventeenth-century landscape in Italy (see p. 244). Elsheimer's magnetic personality soon attracted a large group of artists from all over Europe. The talented Venetian Carlo Saraceni (c. 1580–1620) probably joined Elsheimer's circle even before Lastman arrived; Saraceni assimilated Elsheimer's miniature style with such perfection that it is sometimes difficult to distinguish their hands. Rubens became one of Elsheimer's most devoted admirers. Elsheimer's untimely death moved Rubens to write that the melancholy German painter 'had no equal in small figures, in landscapes, and in many other subjects . . . I have never felt my heart more profoundly pierced by grief than at this news. . . .'[8] There is some reason to believe that the Netherlandish artists active in Rome during the first decade of the century, who fell under Elsheimer's spell, worked together.[9] Besides Lastman, the group includes Jan Pynas (1583/4–1631) and his brother Jacob (active c. 1605–1650), their brother-in-law Jan Tengnagel (1584–1635), Nicolaas Moeyaert (1592/3–1655), and Moses van Uyttenbroeck (1584?–1647). The Delft painter Leonaert Bramer, who arrived in Rome after Elsheimer's death, was also affected by his work. Engravings of Elsheimer's pictures by Count Hendrick Goudt (active c. 1608–1630), an amateur Dutch printmaker, helped to disseminate the German artist's style and subjects in the north. Young Rembrandt had contact with some of Elsheimer's Dutch followers, and interest in this group was initially generated by a desire to learn more about Rembrandt's immediate predecessors and teachers; for this reason they are sometimes called the 'pre-Rembrandtists'. Lastman is the most interesting member of this group. He is also the most important. It was to

Lastman in Amsterdam that young Rembrandt was sent, about 1624, after a three-year apprenticeship with a minor Leiden painter. The six months Rembrandt spent with Lastman made a deep impression, and he may well have inspired Holland's greatest artist to become a history painter. The pupil surpassed his master with lightning speed. But this anticipates our story.

The paintings Lastman made shortly after his return from Italy – he was in Amsterdam certainly by 1607 – effectively use landscape to help in setting a mood (*Flight into Egypt*, 1608, Rotterdam, Boymans–Van Beuningen Museum). They clearly show the profound influence of Elsheimer. Around 1610 Lastman began to concentrate on pictures with many figures. At first his crowds were scattered, and it is sometimes difficult to distinguish protagonists from secondary figures; but by the end of the decade he was able to use a crowd to enhance the dramatic action of a story. *Nausicaa and Odysseus* (1619, Augsburg, Staatliche Gemäldegalerie) [9] is an example of Lastman's narrative power at its height. He depicts the moment when Odysseus emerges from the bushes and surprises Nausicaa and her servants. This is the kind of story Lastman continued to favour: a crowd reacting to a dramatic situation. He also liked scenes which allowed him to introduce many genre and still-life details; Nausicaa and her handmaidens have come down to the river mouth to do the family washing. Odysseus, the group of handmaidens, and the barking dog are grouped together. Only modest Nausicaa, who was given courage by Athena to stand alone before naked Odysseus, is silhouetted against the low horizon and light sky. The rather harsh outlines, the chiaroscuro and strong realism of Odysseus' figure indicate that Lastman was as attentive to Caravaggio as he was to Elsheimer. (Lastman probably saw the dirty soles of bare feet in pictures by Caravaggio, which the Italian master's critics made

9. Pieter Lastman: Nausicaa and Odysseus, 1619.
Augsburg, Staatliche Gemäldegalerie

such a fuss about in Rome; and two years before he painted *Nausicaa and Odysseus* he could have seen them once again in Holland; for Caravaggio's *Madonna of the Rosary*, now in Vienna, was in Amsterdam in 1617.) Late works by Lastman fall in quality; the lively movements of his figures become stereotyped, glossy paint surfaces turn dry, and his vivid colours acquire a certain harshness.

According to Arnold Houbraken, author of *De Groote Schouburgh* (1718–21), a work which is still our main source on the lives of seventeenth-century Dutch artists, Jan Pynas and his brother Jacob went to Italy with Lastman. Houbraken also wrote that after Rembrandt

had spent six months with Lastman in Amsterdam he studied for a few months with Jacob Pynas. He adds that some people maintain Jacob Pynas was Rembrandt's first teacher. Jacob Pynas remains a rather shadowy figure, but his rare pictures lend support to Houbraken's statement. He appears to have been influenced by Saraceni as well as by Elsheimer. His most interesting pictures are his small, carefully executed landscapes (*Paul and Barnabas at Lystra*, 1628, Amsterdam, Rijksmuseum). There is reason to believe that Jan Pynas' works also left a mark on young Rembrandt. Houbraken notes that Jan's 'brushwork tends towards the brown; therefore many believe that

Rembrandt aped him in this matter'. The composition and execution of the *Raising of Lazarus* (1615, Philadelphia Museum of Art, J. G. Johnson Collection) [10] is so close to Rembrandt's early works that one is tempted to

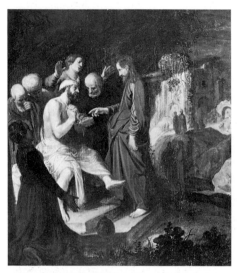

10. Jan Pynas: The Raising of Lazarus, 1615.
Philadelphia, Museum of Art, J. G. Johnson Collection

conclude that Rembrandt must have spent some months with Jan Pynas, and not his brother, after he left Lastman. It is also noteworthy that in the inventory made of Rembrandt's effects in 1656 three pictures by Jan Pynas are listed, but none by Jacob. Perhaps Houbraken, who gathered his information about seventy-five years after their deaths, confused the two brothers. Both are known to have signed their works 'J. Pynas', and this has not simplified the problem of separating their hands. However, about the attribution of the *Raising of Lazarus*, clearly inscribed 'Jan Pynas, f. 1615', there can be no question. Jan Pynas usually avoids the wild excitement which Lastman favoured. Christ seems to have performed the miracle with a flick of His finger; the Magdalen,

in the foreground, and the woman with outstretched arms behind Lazarus have not been given the emphatic gestures Lastman used to express amazement. The tangled vines and the patch of deep blue sky behind the ruins are further evidence of the indelible imprint Elsheimer placed upon those who came in contact with him, but the dramatically lit main group silhouetted against the dark, thinly painted background is quite original.

Jan Tengnagel, brother-in-law of the Pynas brothers, was in Rome in 1608. His history pictures set in a landscape (*Moses striking the Rock*, 1616, formerly Copenhagen, Moltke Collection) place him in Elsheimer's circle. He also made lifesize religious and allegorical pictures, and at least one group portrait (*The Banquet of Captain Geurt Dirx van Beuningen and Members of his Militia Company*, 1613, Amsterdam, Rijksmuseum). Tengnagel can be charming on a small scale, but his lifesize subject pictures are empty. About 1625 he apparently gave up painting; the loss to Dutch art was not considerable. Of greater interest is Nicolaas Moeyaert, a talented draughtsman and painter whose works confirm the report that he visited Rome and joined the group around Elsheimer. Moeyaert is known best for small pictures of bacchanals (*Triumph of Silenus*, 1624, The Hague, Mauritshuis) characterized by a silver-grey tonality. The animals in Moeyaert's lusty processions usually have as much character as the revellers who accompany them. The outstanding Italianate landscapists Nicolaes Berchem and Jan Baptist Weenix, who were also animal painters, were his pupils. Early works by Paulus Potter, the most famous of all seventeenth-century Dutch animal painters, are similar to Moeyaert's. This has led some students to claim that he was Potter's teacher; there is no documentary evidence for this assertion. Moeyaert, who settled in Amsterdam, was one of the rare pre-Rembrandtists who lived long enough to see

what Rembrandt accomplished; his *Calling of St Matthew* of 1659, now at Brunswick, shows that he had felt by then the impact of the younger master. Moses van Uyttenbroeck was an Elsheimer follower who represented the bucolic tradition at The Hague. He specialized in heavily wooded, idealized landscapes with mythological characters. Of greater originality was the Delft painter Leonaert Bramer (1596–1674), an interesting independent who cannot be easily pigeonholed.

Bramer began a ten-year study trip in 1614 which took him to Arras, Amiens, Paris, Aix-en-Provence, Marseille, Genoa, Leghorn, and finally to Rome. His itinerary was one of the main routes used by Dutch artists who made the pilgrimage to Rome. Bramer remained in Italy for six years. During his stay he also visited Naples, Parma, and Venice. Correggio,

the Bassani, and Domenico Feti, as well as Elsheimer, attracted him during his travels. His stay in Italy seems to have come to an abrupt end in 1627 when he got involved in a tavern brawl and had serious trouble with the Roman police. He found it judicious to leave Italy quickly. By 1628 he was back in his native town of Delft. Bramer is best remembered today for his small nocturnal scenes illuminated by phosphorescent colours and streaks of light [11]. In a work such as *Resting Soldiers* (1626, The Hague, Bredius Museum) he anticipates the romantic mood of Salvator Rosa. His contemporaries considered him an outstanding wall painter and he was commissioned by Frederick Henry (before 1647) to decorate his palaces at Rijswijk and Honselersdijk. At Delft he painted (1661) a ceiling for the Guild of St Luke which represented the Seven Liberal

11. Leonaert Bramer: The Queen of Sheba before King Solomon, *c.* 1635–40. *Formerly Dresden, Gemäldegalerie (destroyed)*

Arts; Bramer added 'Painting' as the Eighth Art. He also painted the main hall of the Prinsenhof at Delft (1667-9); part of the ceiling of the scheme is all that remains of his large-scale decorations. Bramer was one of the few seventeenth-century Dutch artists who painted frescoes in Holland; none have survived the Dutch climate. As far as we know he had no pupils of any significance, but his name has been invoked in connexion with Rembrandt's early phase. The question of whether Bramer's early night scenes influenced Rembrandt, or if Rembrandt inspired Bramer's late works, is best answered negatively. Both artists appear to have arrived at their results independently. Bramer's name is also linked with the greatest Delft artist: Jan Vermeer. When Vermeer was baptized a certain Peter Bramer was present; and when Vermeer had difficulty with his future mother-in-law because she did not want her daughter to marry him, it was Leonaert Bramer who sprang to his defence. It is tantalizing to think that there was even closer contact between the Delft artists. Vermeer's teacher is not known. Perhaps Vermeer studied with the man who was the most celebrated artist of his native town. If he did, Bramer's dark manner left no impression upon the artist who is best known as a painter of light.

THE CARAVAGGISTI

The Utrecht school of painting reached the height of its importance during the 1620s when Hendrick Terbrugghen (c. 1588-1629), Gerrit van Honthorst (1590-1656), Dirck van Baburen (c. 1590/5-1624), and other Dutch followers of Caravaggio were active there. These painters brought Dutch art into close contact with Caravaggio's achievement, and thereby introduced one of the main currents of Italian Baroque art into the Netherlands. Even the greatest masters of seventeenth-century Dutch painting, who were never in Italy - Hals,

Rembrandt, and Vermeer - received decisive impulses from the Caravaggesque style. Thus, for an understanding of the historical position of the development of Dutch painting some knowledge of the art of the great Italian innovator of Baroque painting is needed. It has already been noted that Caravaggio's fame and aspects of his style reached the Lowlands even before he died in 1610. Lastman and other Dutch artists who emulated Elsheimer during the first decade of the century in Rome learned how to look at Caravaggio in miniature. Of far greater importance was Caravaggio's effect upon Rubens, the principal representative of the High Baroque style in Northern Europe. When Rubens returned to Flanders, probably before the end of 1608, from his eight-year stay in Italy, Caravaggio's influence was paramount in his work.

Caravaggio belongs with those artists who had a recurrent influence upon succeeding generations. His power was also strongly felt in his own time, when he had an important mission to fulfil. He seems to have appeared at a turning point of history when the inner conflicts and the spiritual upheaval of the late sixteenth century were gradually giving way to a new reassurance of concrete values in life and nature. This vigorous trend in Baroque painting makes us feel that we have ground under our feet and blood in our veins, that life is powerful when seen close up in its physical and emotional reality, and that artists can dramatize it by the realistic intensity of their representation. Caravaggio achieved this, and his vast influence came from the fact that he showed a way to a new and much needed confidence in reality and the power of life itself. Caravaggio was also able to project his intense feelings about the virtues of humility and simplicity into his religious works. This disturbed most of his contemporary critics, and many of his later ones, who accused him of ruining art. They charged Caravaggio with depicting biblical subjects without

decorum or imagination, and failed to see that he used his bold and uncompromising naturalism, dramatized by strong contrasts of light and shade, to make deeply religious works that carry the stamp of the popular religious movements of his time.

Caravaggio's most radical stylistic innovation was his new use of chiaroscuro. Chiaroscuro, an Italian word which has been accepted in the English vocabulary, literally means bright and dark; in the literature on art it refers to the contrasting of light and shadow as a principal means of painterly expression. In a time of almost universal electrification, when everything is illuminated with nearly the same intensity during day and night, we no longer feel the mystery of darkness or the spell of those manifold, flowing transitions from light to shadow which candlelight produces in a darkened room. We can hardly imagine how sensitive Baroque artists were to the picturesque effects of chiaroscuro. They not only subtly observed the contrasts and transitions of light and shadow, but adopted the chiaroscuro effect as a means of composition to bind together the separate forms into one pattern and to achieve a unity that was attained during the Renaissance period largely by other means. The great Venetian masters, with their special gift for the pictorial, had already begun to use chiaroscuro effects in the sixteenth century, but Caravaggio was the first to create a style in which chiaroscuro became the dominating device. In his religious pictures it was one of the principal means of making Christian miracles palpable to a worshipping community.

To turn to Caravaggio's Dutch followers after seeing the master's work is a disappointment. Even Hendrick Terbrugghen, the most inspired of them, never matched the expressive power of Caravaggio's chiaroscuro and the unusual subdued glow of his colours, which give the Italian master's pictures a kind of magical attraction. Earlier students were not unaware of the qualities and the importance of Dutch Caravaggesque painters: indeed, some exaggerated them. Burckhardt claimed in his *Cicerone* that the *Entombment* (1617?, Rome, S. Pietro in Montorio) by the Utrecht *Caravaggista* Dirck van Baburen is a more noble work than Caravaggio's well-known painting of the same subject now at the Vatican. This assertion would find few supporters today. The reappraisal made of Caravaggio's achievement by twentieth-century historians, and the re-examination of his widespread influence on seventeenth-century painters in Spain, France, Italy, as well as the Lowlands, thoroughly changed earlier ideas about the accomplishment and relationship of the master and his followers. One fact has become evident: hardly any of the *Caravaggisti* actually studied under the master. We know, for example, that Baburen did not have even a glimpse of Caravaggio. As is the case with most Dutch artists who went to Italy, it is not known precisely when he arrived in Rome, but we do know that Baburen was still a student in Utrecht in 1611. Caravaggio died in 1610.

Caravaggio had settled in Rome around 1592, when he was hardly twenty. His spectacular Roman career was short. He fled from the city in 1606 after killing a man during a dispute about the score of a tennis game. From the time of his departure until his untimely death four years later he was constantly travelling because of difficulties with the authorities. From what is known about Caravaggio's explosive temperament, particularly during the final decade of his life, he hardly could be called a born teacher. He was not a Rubens or a Rembrandt, who always had a studio full of pupils and devoted followers. And finally, Caravaggio was not the man to set up a curriculum for budding artists, or even adhere to a set of guild rules designed for apprentices. It is not difficult to imagine him prescribing to a youthful artist the deceptively simple and enigmatic formula:

'Merely follow nature! Follow nature!' Dutch artists interested in assimilating Caravaggio's style had to study the master's works in the churches and private collections of Rome, or make contact with the Italian *Caravaggisti* such as Orazio Gentileschi (1563-1647), who came under Caravaggio's influence early in the century, Bartolomeo Manfredi (*c.* 1580-1620/1), who made Caravaggio's lifesize genre scenes common currency during the second decade of the century, or Carlo Saraceni, who had a Caravaggesque phase after 1610. These painters quickly assimilated Caravaggio's motifs, compositions, strong chiaroscuro and vivid colour harmonies - everything, it seems, except the intensity of the master's vision.

Hendrick Terbrugghen, who arrived in Utrecht in 1614 after a reported ten-year sojourn in Italy, was the first Dutch Caravaggesque painter to return to Holland. Very little is known about his early life. There is not much in the older literature about him. Terbrugghen's resuscitation is a phenomenon related to the rediscovery by nineteenth-century critics of the beauty of Vermeer's hushed world, and to the re-evaluation of Caravaggio's genius by twentieth-century writers. His art is now seen as an important link between Baroque Rome and the School of Delft. Terbrugghen was probably born at Deventer in 1588: a few years later his family moved to Utrecht, where he studied with Abraham Bloemaert. If he really arrived in Italy in 1604 - and there is good reason to believe that he did - he was one of the few Dutch Caravaggists who could have met the master himself. Apparently his experiences in Italy did not send him into a frenzy of creativity. Nothing painted during his stay in Rome has been discovered.[10] What he did during his first years back in Holland is not clear either. A firm fact is his entry into the Utrecht Guild in 1616. The rare pictures made from around this time until 1620, when he painted *The Crowning with Thorns* (Copenhagen, Statens Museum), are

most unusual works. To be sure, there are Caravaggesque elements in them; the composition of the *Calling of St Matthew* (Le Havre, Musée), painted about 1617, is unthinkable without Caravaggio's picture of the same subject at S. Luigi in Rome, and his lighting effects show knowledge of Caravaggio's chiaroscuro. But the northern sixteenth-century archaisms in the pictures of this early period are equally important. Terbrugghen used motifs from Dürer and Lucas van Leyden; some of his grotesque types are derived from Quentin Massys and his follower Marinus van Reymerswaele. His colour scheme of yellow-browns, greens, and pale violets recalls the Mannerist palette of his teacher Bloemaert, not Caravaggio. The multiplicity of details and hues of his early Dutch works and his obsession with nervous, brittle outlines is abandoned only after 1620. Perhaps the return of other Dutch *Caravaggisti* to Utrecht from Rome gave Terbrugghen courage to become more Italianate. Honthorst came back to the north in 1620 imbued with an uncomplicated kind of classicism which indiscriminately regularized and generalized forms; Baburen returned about the same time a converted Caravaggist. It is also possible that Terbrugghen made a second trip to Italy, when he made a more mature study of Caravaggio's works, and saw what the Italian *Caravaggisti* (Gentileschi, Saraceni, young Serodine) had accomplished after he had left Rome in 1614. In any event, Terbrugghen's most Caravaggesque pictures, for example the *Liberation of St Peter* (1629, Schwerin, Mecklenburgisches Landmuseum), were made during the last, not the early, years of his career. During his final phase he also painted works (*Duet*, 1629, Rome, Galleria Nazionale, Palazzo Barberini) which prefigure the shimmering light and cool, silvery tonalities of Vermeer. Another unorthodox thing about Terbrugghen is his archaisms. They never completely disappear. The *Crucifixion with the Virgin and St John*

painted *c.* 1625 (New York, Metropolitan Museum) recalls both late Gothic carving and Grünewald. All this makes it difficult to work out a precise chronology for Terbrugghen's pictures. However, his achievement and contribution to Dutch painting are quite clear. They are seen in the *Calling of St Matthew* of 1621 (Utrecht, Centraal Museum) [12]. The work is a revision of his own earlier picture of the same subject. This is also characteristic of Terbrugghen; he frequently copied and revised his own compositions. The relation to Caravaggio is still unmistakable, but the Utrecht *Calling of St Matthew* is not a slavish imitation. The life-size figures are half-length instead of full-length, and the large empty space in Caravaggio's version at S. Luigi, where the drama of Christ calling the tax-collector to his vocation echoes in the shadows above the figures, has been eliminated. The composition has also been reversed; Christ and his follower appear to the left as dark figures in the foreground. The main accent is on the brightly illuminated group on the right. Terbrugghen's original talent and old Netherlandish realism successfully merge here with Caravaggesque motifs and elements. The mercenary soldier pointing to the money on the table shows a profile which marks him as a descendant of types popularized by early-sixteenth-century

12. Hendrick Terbrugghen:
The Calling of St Matthew, 1621.
Utrecht, Centraal Museum

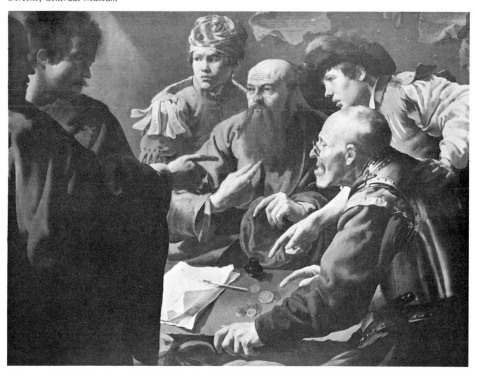

Flemish artists, and the six gesticulating hands in the centre are also a survival of an older tradition. Terbrugghen's debt to Caravaggio is seen most clearly in the manner of illumination. The light enters in a broad beam, and as usual in Terbrugghen's work, from the left. However, the quality of the light is original; it is lighter, richer, and more atmospheric than Caravaggio's, which seldom has the brightness or softness of real daylight. In this work of 1621 with its colour harmonies of cool blues, pale yellows, creamy whites, violets, and red-browns, as well as its soft silvery tonality, the effects of the Delft School are already anticipated. Terbrugghen's two half-length pictures of flute players at Kassel, also of 1621 (one is reproduced as illustration 13) are outstanding examples of the breadth, force, and beauty of his new pictorial manner. He made more intricate pictures than the Kassel companion-pieces, but

he never surpassed their poetic mood and delicacy. The effect of the dark-shadowed flute player before a bright wall in the background is another anticipation of an essential pictorial theme of the Delft School. Fabritius and Vermeer continued the scheme of painting dark figures against light backgrounds, which enabled them to make pictorial variations in a kind of open-air atmosphere. This device, first exploited by the ingenious Terbrugghen, relieves the dramatic tension and allows more room for purely pictorial still-life beauty.

Terbrugghen's ability to combine exquisite painterly effects with restrained emotion accounts for the power of his masterpiece, *St Sebastian tended by Irene and her Maid* (1625, Oberlin College, Ohio, Allen Memorial Art Museum) [14]. The women tenderly and efficiently go about their business of trying to save the life of the saint, who has been pierced

13. Hendrick Terbrugghen:
Flute Player, 1621.
Kassel, Staatliche Gemäldegalerie

14. Hendrick Terbrugghen:
St Sebastian tended by Irene and her Maid, 1625.
Oberlin College, Ohio, Allen Memorial Art Museum

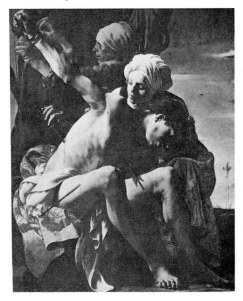

with arrows and left for dead. The large, full forms of the group have been knit together into a magnificent design, and what could have been hard and sculptural is remarkably softened by the cool silvery light which plays over Sebastian's half-dead, olive-grey body as well as the reds, creamy whites, and plum colours worn by the women who tend the saint. If Rubens really said on his visit to Holland in 1627 that 'travelling throughout the Netherlands and looking for a painter, he had found but one, namely Henricus ter Brugghen', he must have had pictures like the *St Sebastian* in mind. Terbrugghen made a few pictures of night scenes illuminated by artificial light (*Concert*, Ledbury, Eastnor Castle, Hon. Mrs E. Hervey-Bathurst Collection). He brought the same sensitivity to the study of nocturnal effects that he gave to daylight, but nocturnal pictures were never his speciality. They were popularized by Gerrit van Honthorst, who established his reputation in Italy with this type of painting. It was there that Honthorst was nicknamed 'Gherardo delle Notti'.

Honthorst was born in 1590 at Utrecht; there he was Abraham Bloemaert's pupil. He is said to have been in Rome as early as 1610–12, but no documentary evidence supports this claim. Nothing is known about his artistic activity until the last years of the decade, and not a work painted before he went south has been discovered. But unlike Terbrugghen's, a number of Honthorst's Italian works have been identified. He enjoyed the patronage in Italy of the grand duke of Tuscany, Cardinal Scipione Borghese, and especially the Marchese Vicenzo Giustiniani, one of the greatest collectors of his day, who had a flair for finding important pictures. An inventory of his collection made in 1638 lists names which range from Raphael, Giorgione, and Titian to Bramer. Giustiniani owned paintings by Caravaggio and the Carracci, and in his house Honthorst could also study works by the major Cinquecento

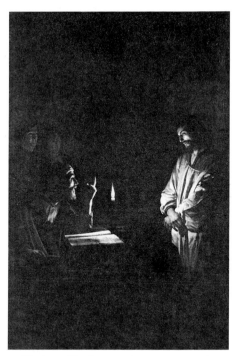

15. Gerrit van Honthorst:
Christ before the High Priest, *c.* 1617.
London, National Gallery

masters – including night scenes by Bassano and Luca Cambiaso. Honthorst, who became the best-known Dutch follower of Caravaggio, continued to find favour in court circles throughout his life. Terbrugghen, on the other hand, was always an outsider; he was not even awarded the minor distinction of election to an office in the Utrecht Guild, which he entered as early as 1616.

Honthorst's *Christ before the High Priest* (*c.* 1617, London, National Gallery) [15] shows the two special artistic problems Honthorst mastered in Rome. He found the solution for both in works by Caravaggio and his followers: one is the exact study of the expression on different physiognomies reacting in a personal

way to a dramatic event; the other is the chiaroscuro, which Honthorst developed in his own manner. Unlike Caravaggio, he preferred scenes illuminated by artificial light (frequently the source of light is hidden), and he is responsible for popularizing this trend in Dutch painting. Perhaps Georges de la Tour, the most original French Caravaggesque painter, learned about the dramatic possibilities of a nocturnal scene from works by Honthorst that he saw in Utrecht, not Rome. La Tour's connexions with Terbrugghen also lend support to the much-discussed hypothesis that the French artist had close contact with the Dutch *Caravaggisti*.[11]

Though Honthorst continued to depict biblical scenes after his return to Utrecht in 1620, the religious pictures he made for the churches of Rome are from many points of view the climax of his career. During the 1620s

he painted works (*Granida and Daifilo*, 1625, Utrecht, Centraal Museum) which show that he had looked at the Carracci as well as at Caravaggio while in Italy. He also made at least one illusionistic ceiling (*A Concert*, 1622, London, F. Stonor Collection) that indicates close familiarity with what Italian artists did in this field. Honthorst's ceiling was probably the first of this type painted in Holland. Seventeenth-century Dutch burghers, who had little taste for large-scale decorative works, were apparently unimpressed, and Honthorst's work in this category was of no consequence for the development of seventeenth-century Dutch painting.

Of far greater importance were his genre pictures of gay, light-hearted gatherings. Honthorst made such pictures while he was still in Italy. His *Supper Party* (1620, Florence, Uffizi)

16. Gerrit van Honthorst: Supper Party, 1620. *Florence, Uffizi*

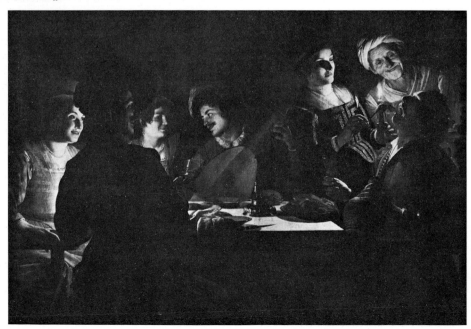

[16], painted during his last months in Italy, set a precedent for similar scenes done in the 1620s at Utrecht. Utrecht artists favoured the erotic rather than the ascetic side of Baroque art. The gay genre scenes they helped to popularize never disappear from seventeenth-century Dutch painting, although they take on a more refined character in the next generation. In the Uffizi *Supper Party*, which is a night scene, Honthorst uses two light sources that cast a warm golden glow on the strong reds, blues, and yellows of the picture. There is one open light on the right, where a young girl is putting a piece of chicken into the mouth of her friend. An old woman is enjoying the scene, and Honthorst took delight in studying the reflections of light on her withered face. The young man regards this action only as an interruption of another more important occupation, since he holds his glass and bottle ready for the next draught. The people on the left are interestedly watching the proceedings. On this side Honthorst uses a covered source of light, emphasizing by this kind of illumination the expression of joy and interest in the faces of his figures. Today all this seems a rather primitive form of art, and something that the camera can produce with equal or greater precision; yet it was a sensation in Honthorst's time to have a night scene so realistically rendered. The advantage of hiding the light source in the foreground is a double one. The foremost person who covers the light has the effect of a *repoussoir*: the large dark figure in the foreground causes, by contrast, the merrymakers behind him to recede in space, and thus enhances the illusion of depth. The second advantage is the vivid reflection of light thrown on the figures and, in particular, on their faces, which are painted in reddish-yellow colours. This helps Honthorst to overcome the harshness found in the work of other Caravaggio followers. But a residue of harshness remains, and it increases after 1625. Some of

Honthorst's followers incorporated this very quality in their work. Matthias Stomer, who was a close follower and active in Utrecht during the 1620s and then in Italy in about 1630–50, can be distinguished from Honthorst by the pronounced leathery quality of his flesh tones and the metallic colours of his draperies. Dutch painters of the following generation also learned from him. The way young Rembrandt depends upon pictorial devices introduced by Honthorst can be seen in his lifesize *Feast of Esther* (*c.* 1625, Raleigh, North Carolina Museum of Art) [45]. The motif of the *repoussoir* figure in the foreground, covering the source of light and showing a fancy Baroque silhouette, continues in Rembrandt's work for some time. Even in this very early and not completely successful work, one notices how much more lively and more intense the young Rembrandt's characterizations are than those of the older artist. *The Money Changer* (1627, Berlin-Dahlem, Staatliche Museen) [49], another of Rembrandt's early pictures, was also doubtlessly inspired by the art of Honthorst.

Not all the Utrecht Caravaggists were fascinated by nocturnal effects. Few seem to have been painted by Dirck van Baburen or Jan van Bijlert (1598–1671), the two painters who, after Terbrugghen and Honthorst, did the most to make Caravaggio's style known in Holland. Baburen was probably born in Utrecht, where he distinguished himself by studying with Moreelse instead of Bloemaert. There is reason to believe that he left for Rome as early as 1612. His most important Roman commission was the decoration between the years 1615 and 1620 of a chapel in S. Pietro in Montorio with another Dutch painter (David de Haen; d. 1622). His best-known contribution to the chapel is the *Entombment*, already mentioned as the work Burckhardt praised with such enthusiasm. Around 1621 Baburen returned to Utrecht; he died there in February 1624. Not much time to build a career, but time enough

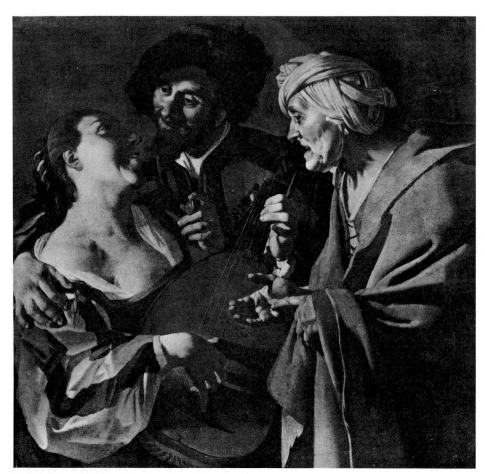

17. Dirck van Baburen:
The Procuress, 1622.
Boston, Museum of Fine Arts

to leave a considerable mark. When Constantin
Huygens, the secretary to Stadholder Frederick
Henry, listed the distinguished Utrecht history
painters in his diary around 1630, he named
Bloemaert, Honthorst, Terbrugghen, and
Baburen. Baburen's *Christ Crowned with Thorns*
(two autograph versions: Locko Park, Derby-
shire, Capt. P. J. B. Drury-Lowe, and Weert,

Franciscan House), a work done during his
Utrecht phase, is based on a lost painting by
Caravaggio. Its silvery light recalls Terbrug-
ghen's effects, but the narrow stratum in which
the figures exist and the irregular rhythms and
coarse types are peculiar to Baburen. While he
was in Utrecht Baburen seems to have been
more at home with genre subjects such as *The*

Procuress (1622, Boston, Museum of Fine Arts) [17] than with religious themes. Vermeer may have owned the Baburen now in Boston. It appears in the background of two of Vermeer's own works: *The Concert* (Boston, Isabella Stewart Gardner Museum) and the *Lady seated at the Virginals* (London, National Gallery). The diaphanous light, the clear tones, the yellow and sky-blue and white colour scheme, if not the exaggerated types in this ancient drama, must have appealed to Vermeer. Jan van Bijlert returned to Utrecht from Italy in 1624, a confirmed Caravaggist relying heavily on the Italian master's strong chiaroscuro effects, but by the early thirties he had adopted a lighter and more colourful palette – probably under the influence of the late Terbrugghen. After Bijlert abandoned Caravaggio's manner he failed to achieve a personal style.

Utrecht painters also popularized lifesize, single half-length genre figures vividly appealing to the spectator. These figures are usually shown with a cheerful, open expression, and the illusionistic effect is heightened by the use of realistic flesh tones and careful attention to the reproduction of the texture of stuffs. A favourite trick was to represent the model at a window or behind a balustrade with an outstretched arm reaching towards the spectator. Many of these subjects are musicians dressed in the costumes of professional actors, and are probably based upon characters who figured in theatrical performances. It is hard to say who invented this theme, but it is not difficult to see a relation between the musicians and drinkers painted by the Utrecht *Caravaggisti* and Caravaggio's early genre pictures of androgynous youths. It has been suggested that Terbrugghen's poetic *Flute Players* of 1621 at Kassel do not belong to this tradition but to an arcadian one, and that these boys are shepherds, not theatrical performers. But their costumes suggest that they are, in fact, actors. However, it is rash to try

to determine their occupation from such slim evidence; their clothes could have been studio props. In common with many other masterpieces of seventeenth-century Dutch painting, it is high pictorial quality and not subject that sets Terbrugghen's *Flute Players* apart. Next to them, Honthorst's *Merry Violinist* (Amsterdam, Rijksmuseum) [18] of 1623 looks trivial. A vogue for pictures of gay musicians and drinkers apparently started in the early 1620s, when both Honthorst and Terbrugghen began

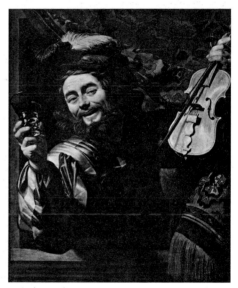

18. Gerrit van Honthorst:
Merry Violinist, 1623.
Amsterdam, Rijksmuseum

to turn out many – perhaps too many – of them. Bloemaert's serious *Flute Player* of 1621 (Utrecht, Centraal Museum) is one of the earliest extant dated works of this type. However, it is hardly likely that Bloemaert, who was never in Italy, invented the motif. Since Bloemaert's *Flute Player* shows the influence of Honthorst's nocturnal lighting, the assumption

that the picture is based on a lost Honthorst is a reasonable one. In 1622 Baburen painted a half-length lifesize *Singing Lute Player* (Utrecht, Centraal Museum), and in the following years other Utrecht painters followed suit. These pictures had a direct influence upon Frans Hals and the members of his circle, but it is to Terbrugghen, not Honthorst, that Hals probably owes the biggest debt. It was from Terbrugghen that Hals could have learned what rich effects could be achieved by allowing brilliant daylight to play over his subject; as far as we know, Hals never painted a nocturnal scene.

In its latest phase the Utrecht School lost its vitality, and it ended in a dry classicism. This is particularly true of Honthorst. However, his disintegration as a creative artist did not affect his international reputation. He continued to be in demand as a court painter, and was popular as a teacher. In 1628 he was invited by Charles I to England, where he painted the large canvas now at Hampton Court of *Mercury presenting the Liberal Arts to Apollo and Diana*, which includes portraits of the king and queen. He was apparently on trial in England as a court painter. Charles rewarded him handsomely, but did not keep him. The king did well to postpone the appointment. In 1632 he made Van Dyck 'principalle Paynter in ordinary to their Majesties'. After 1630 Honthorst made few pictures in his Caravaggesque manner, and his genre scenes become rare. In 1635 he received the first of a long series of commissions from Christian IV, king of Denmark, and two years later he was appointed court painter to the Stadholder Frederick Henry at The Hague. We have already noted that the Italianate painters were in favour at the modest court at The Hague: another sign of this was the purchase in 1627 by the Utrecht assembly of a picture from Cornelis van Poelenburgh, a Bloemaert pupil who travelled to Italy, where he adopted a minute landscape style based upon the arcadian pictures of Elsheimer (see p. 296 and illustration 235). The Poelenburgh landscape was bought for 575 guilders as a gift for Amalia van Solms, the wife of the stadholder. By the time Honthorst settled down to work at The Hague in 1637 he was a smooth, conventional portraitist. He made decorations for the palaces of Rijswijk and Honselersdijk, and in 1649-50 was commissioned by the stadholder's widow, along with other Dutch and Flemish masters with classicistic tendencies, to decorate the Oranjezaal in Huis ten Bos. These allegorical pictures are a document of the emptiness of official courtly taste at a time when Hals worked in increased isolation and Rembrandt was at the beginning of his mature period.

Long before the importance of the Utrecht School began to wane in the 1630s, national Dutch art flourished with a more independent character at Haarlem. Its first great manifestation is in the works of Frans Hals, whose vital personality seems to reflect the vigour, the joy of life, and the prosperity of the Dutch after they won peace and *de facto* recognition by the conclusion of the Twelve Year Truce with Spain. It is to his art that we turn in the following chapter.

FRANS HALS

EARLY WORKS: 1610–1620

Frans Hals, second only to Rembrandt in making seventeenth-century Dutch painting famous, was probably born in Antwerp between 1581 and 1585, the son of Franchoys Hals, a cloth worker from Mechelen, and Adriaentgen van Geertenryck of Antwerp. Most likely his parents, like thousands of other Flemings, immigrated from Flanders to the North Netherlands after Antwerp fell to the Spanish in August 1585. The earliest reference to Hals' parents in Haarlem, where the family settled, is of 1591, when the baptism of Frans' brother Dirck is recorded. Dirck made a name for himself as a painter of small genre pictures of figures in landscapes and interiors. Joost, a third brother, who was presumably born in Antwerp, was also a painter (d. before 16 October 1626); none of his works have been identified. Frans studied under Karel van Mander. A probable date for the contact between teacher and pupil is 1603, when Van Mander retired from Haarlem to a house near by, where he wrote most of his *Schilderboek*; he died three years later. As far as we can tell, he did not have much influence on his most famous pupil. Frans certainly did not follow the advice given to young artists by his teacher in *Het Schilderboek* to distinguish themselves by becoming history painters.

In 1610 Hals joined the Haarlem Guild of St Luke, and his earliest extant dated picture, the *Portrait of Jacobus Zaffius*, archdeacon of St Bavo, the principal church of Haarlem (Haarlem, Frans Hals Museum) [19], was painted during the following year. This port-

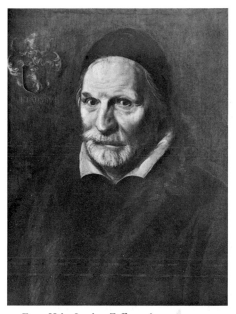

19. Frans Hals: Jacobus Zaffius, 1611.
Haarlem, Frans Hals Museum

rait is a fragment. The original composition showed Zaffius seated in an armchair with his left hand resting on a skull. What did Hals paint before he portrayed Zaffius accompanied by a commonplace symbol of the transitory nature of man's life? Students of Dutch art, who have assiduously searched for Hals' juvenilia, have found virtually nothing. What one of the most talented artists who ever lived did before he was about twenty-five or thirty years old – the age depends upon the birth-year

one accepts – remains an unsolved riddle. Perhaps Hals spent his early years travelling, or perhaps, like some other great artists who lived long, he was a slow starter. When Hals' hand is finally recognized around 1610–11, a debt to late-sixteenth-century Dutch portraitists (Dirck Barendsz., Cornelis Ketel, and Hendrick Goltzius) is evident in the roundness, the rigid poses, and the sharp delineation of his figures. The pasty pink and rose colours of the flesh in the Zaffius portrait recall hues used by the Haarlem Mannerists, but the archdeacon's keen glance, the daylight which is cast on his face, and the parallel brush strokes, which were soon to operate in combination with zigzag touches, are some indications of Hals' immediate future.

The problematic *Banquet in a Park* (c. 1610, formerly Berlin, Kaiser-Friedrich Museum, no. 1611, destroyed in the Second World War) [122] is now generally accepted as one of Hals' earliest known works.[1] If it was really painted by Hals – and it is difficult to name another Dutch artist who used such juicy paint and fluent brushwork around this time – it suggests that at the beginning of his career Hals painted pictures related to Van Mander's genre scenes (*The Kermis*, 1600, Leningrad, Hermitage) [7] and late religious paintings (*Dance round the Golden Calf*, 1602, Haarlem, Frans Hals Museum), as well as pictures of the Prodigal Son by David Vinckboons. In our discussion of genre painting we shall see that Willem Buytewech, Esaias van de Velde, and Dirck Hals soon developed outdoor banqueting scenes into a special category, but as far as we know Hals never painted another picture of small figures in a landscape. His *metier* was portrait painting, and during the rest of his long career all his genre pictures, and even his rare religious pictures,[2] keep a portrait character. The crowded, lifesize *Shrovetide Revellers* (New York, Metropolitan Museum) [20], painted

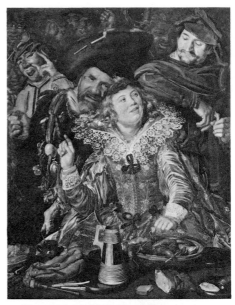

20. Frans Hals: Shrovetide Revellers, *c. 1615. New York, Metropolitan Museum of Art, Altman Bequest*

about 1615, shows the direction his genre painting was to take.

In Hals' hands genre painting became a kind of portraiture, but of a freer, bolder, and more revealing character than that of the commissioned portraits of his day. In these works he was independent of the conventions of formal portraiture. No painter before Hals had ever approached simple folk with the same sympathetic feeling and love for an unadulterated expression of the joy of life. Hals' genius was to introduce the vitality and spontaneity perfected in his genre pictures into his commissioned portraits. Pieter Bruegel the Elder is often called the originator of gay life and low life genre in Flemish and Dutch painting. As we have noted, Hals' teacher Van Mander formed a link between the Late Renaissance and the Baroque masters; but Van Mander's

rare genre paintings are closer to Bruegel's than to Hals'. Bruegel is still far from the kind of immediate expression of instantaneous life found in Hals' work. His approach to human beings continues an intellectual coldness which was typical of the Late Renaissance and resulted in more abstract forms and more severe stylization. There are, of course, additional intermediary stages between the genre painting of Bruegel and that of Hals. However, the fact remains that it was Hals who first gave an explosive vitality to genre subjects and that he expressed them in the most sympathetic spirit.

The merrymakers in the New York painting [20] are not ordinary revellers. We know from an inscription on a contemporary copy of it that the group is celebrating Shrovetide, and among them are some stock characters from theatrical companies of the period. The stout man on the left is Peeckelhaering, a stock comic type; the man on the right can be identified as Hans Worst, a well-known figure in the farces of the period, whose character resembles Brighella of the *Commedia dell'arte*. The cramped composition and over-exuberance of the details, as well as the loud, gay colours, indicate a comparatively youthful work. Hals' love of diagonals does not lead to a very spacious arrangement, and the fat painting in the ruddy faces is still far from the master's later lightness of touch. Yet the essence of his vigour and vitality is already in the work. As the *Portrait of a Nurse and Child* (*c.* 1620, Berlin-Dahlem, Staatliche Museen) [21] shows, in his early commissioned portraits Hals adhered more closely to the old technique and to accepted conventions than in his genre works. During the first decades of his career he continued to follow the ancient idea of adjusting his style to his subject. Only after 1640, when he virtually stopped painting genre pictures, did he begin to use the technique once reserved for genre pieces for commissioned portraits of

respectable burghers and their wives. Of course it is appropriate that the gestures and expressions of the nurse and the elegantly dressed child are more refined than those used by a boisterous group celebrating carnival. The double portrait is an excellent early example of Hals' subtle invention. The nurse, it seems, was about to present an apple to the child when both were diverted by the approach of a spectator, to whom they appear to turn spontaneously. This is one of the many ingenious devices used by Hals to give the impression of a moment of life in his pictures. The colour scheme still shows the dark tonality characteristic of his early commissioned portraits, and the minute execution of the child's richly embroidered costume is set off by a delightful vivacity in the brushwork on the faces and hands.

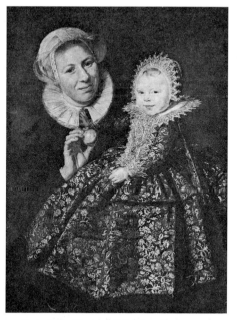

21. Frans Hals: Nurse and Child, *c.* 1620. *Berlin-Dahlem, Staatliche Museen*

In 1616 Hals painted the first monumental landmark of the great age of Dutch painting: the *Banquet of the Officers of the Haarlem Militia Company of St George* (Haarlem, Frans Hals Museum) [22]. The entire work exults in the healthy optimism and strength of the men who helped to build the new republic. There is no precedent for Hals' vivid characterization of his twelve models, or for the impression of immediacy he achieved in this group portrait. Hals had the advantage of knowing the character of the officers who served from 1612 to 1615; he was a member of the company during those years. Militia groups, originally organized as guilds under the patronage of a saint, had a long history in the Netherlands. Even during the Middle Ages Dutch burghers maintained a certain degree of independence, and in order to protect their towns against attack or encroachments formed militia companies. The Dutch word *doel* (plural: *doelen*), which is the generic name for companies of militia men, as well as for the buildings that serve as their headquarters, is also the Dutch word for target. Early in the sixteenth century the companies began to decorate their buildings with group portraits of their members.[3] Portraying these groups was not an easy task for the artists. Fundamentally there are two ways of approaching the problem. One way is to give equal prominence to every individual, and thus achieve little more than a monotonous row of separate portraits. The other is to subordinate the individuals to the aspect of a common action, and thus achieve unity for the composition. Between these two extreme possibilities one might expect others in which the artist tries to combine the emphasis on individual likenesses with a structural unity of the whole; but Dutch artists rarely achieved a really satisfactory combination of the two points of view. Their emphasis is always on the side of individual likenesses - perhaps the democratic spirit of the Dutch and their unique apprecia-

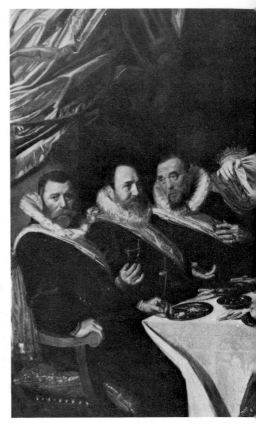

22. Frans Hals: Banquet of the Officers of the Haarlem Militia Company of St George, 1616. *Haarlem, Frans Hals Museum*

tion of the worth of every single man made it difficult for artists to subordinate the representation of an individual for the sake of artistic unity. In any event, only one Dutch artist decided to avoid all compromise and offered the radical solution of subordinating a group of militia men to a unifying dramatic action. This artist, as we shall see, was Rembrandt, the greatest of them all, and the picture is the *Night Watch*.

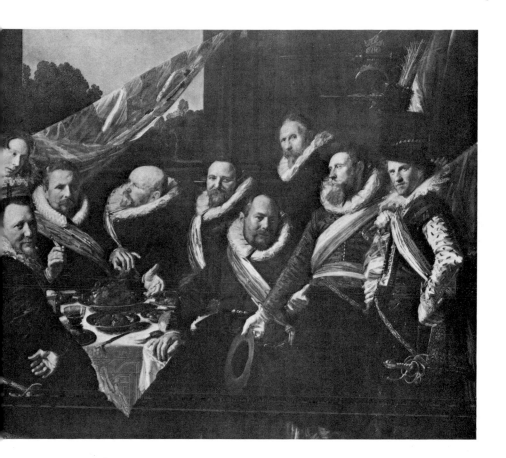

The significance of Hals' achievement in his group portrait of 1616 is better understood if we have some idea of what was done in this category by his predecessors. The *Braspenning-maaltijd* by Cornelis Anthonisz. (or Teunissen) of 1533, now on loan at the Rijksmuseum, Amsterdam, is one of the earliest examples of a group portrait of guardsmen seated round a banquet table. It shows a rather primitive juxtaposition of single portraits. The stiff, somewhat geometrical composition is characteristic of the early group pictures, and so is the bird's-eye view of the table. The arrangement is simple. Fifteen of the seventeen guardsmen have been lined up in two rows, with only a weak attempt to bind them together. Some of the men are looking towards the spectator, some of them elsewhere. This variety of movement slightly relieves the monotony of the setting, but it endangers the unity. The relief-like arrangement in planes parallel to the surface plane is characteristic of the Renaissance style. So is the accentuation of the straight horizontal and vertical directions, both giving a certain architectural firmness to the composition. After the middle of the sixteenth century painters of group portraits adopt a freer arrangement within a more

natural space construction. This is seen in Dirck Barendsz.' group of the banquet of the civic guard called the *Poseters* (eaters of bull-head) of 1566, now on loan at the Rijksmuseum, Amsterdam. Here the primitive view of the table from above is abandoned, and some natural loosening within the group has taken place. Smaller nuclei are formed, and the fore-ground is better distinguished from the back-ground. The turning of men, seated in front of the table, towards the spectator increases the illusion of space. In Barendsz.' work the progress towards a more convincing realism is remarkable, but a satisfactory unity among the figures is still lacking.

A new solution to the problem was offered in 1583 by Cornelis van Haarlem in his group portrait of the *Banquet of Haarlem Guardsmen* (Haarlem, Frans Hals Museum). The pre-dilection for movement, slanting lines, and the broken rhythm of irregularly formed groups interwoven in a curious way are all characteris-tic of Dutch Late Mannerism. Following the dynamic tendencies of this style, Cornelis creates a rather extravagant variety of move-ment throughout the picture, but achieves little cohesion. The arrangement around the table can hardly be recognized. Only by the prominent figure of the standard bearer, who is joining the group from the foreground, does the composition gain something of a centre, and the diagonal line of the ensign's banner lends the composition a certain asymmetrical order. Cornelis has not abandoned the aims of

23. Cornelis van Haarlem: Banquet of the Officers of the Haarlem Militia Company of St George, 1599. *Haarlem, Frans Hals Museum*

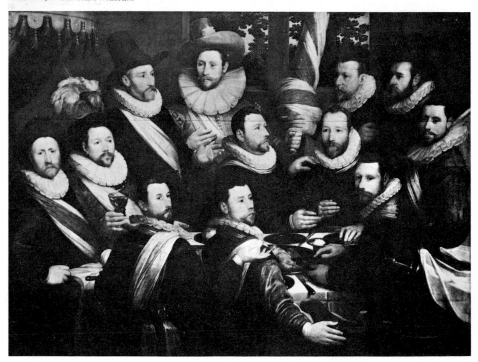

distinct clearness of every single portrait. What he actually achieves is the remarkable impression of a crowd without any clear, satisfactory interconnexion. We have already noted that Cornelis abandoned his Mannerist style during the 1590s for a mild kind of classicism. His group portrait of the *Banquet of the Officers of the Haarlem Militia Company of St George* (1599, Haarlem, Frans Hals Museum) [23] is an attempt to introduce this classicism into the portraiture of a group. It is composed in a completely different way, and as a result there is a gain in clarity and order. Cornelis abandoned the old tradition of lining up the guardsmen in rows, in favour of a distinctly pyramid-like composition. There is less overlapping and movement. The handshaking, drinking, and peering into mugs of his group of 1583 have been eliminated. Calmness has taken the place of riotous confusion. But the similarity of the poses and lack of differentiation of the officers' physiognomies produces a wearisome effect. During this phase Cornelis attempted to ennoble a model as well as make a likeness. He did this by generalizing the features of his patrons. This led to a kind of standardization of faces. Cornelis gives us the impression that the members of a large family took over the entire officer corps of the St George Company in 1599.

Rudiments of Hals' great composition of 1616 are found in Cornelis' group of 1599. It is striking how similar the two compositions are if, in our mind's eye, we delete the officer in the left foreground of Cornelis' picture. In both works four officers have been posed on the left, three standing men have been placed on the right, and a group has been constructed of the men seated in front of the table and behind it. The man painted out of Cornelis' picture in our imagination appears to have found a place in the group seated in the middle of Hals' painting. The similarities between the two compositions are proof of the close ties

that even the boldest innovator has with the art of the past. The relationship does not diminish Hals' achievement: on the contrary, it shows what a spectacular transformation Hals made of an established tradition. Hals kept the symmetrical arrangement of Cornelis' composition, but in his masterpiece, for the first time in the long history of Dutch group portraiture, Renaissance co-ordination of individual parts gives way to Baroque integration. Cornelis' composition contains prominent pairs of officers who retain their independence. They are not united into the group. Hals, on the other hand, by the use of great sweeping diagonals and by subtly arranging the heads of most of his models on the same level achieves a new kind of unity. Even his most animated groups have been subordinated to the whole. Hals has significantly enlivened the rigid compositions of his predecessors by various devices, particularly by the great diagonal formed by the flag which the young ensign holds upon his shoulder, the group of standing men on the right which repeats the dominant slanting accent, and also by the men sitting in front of the table. By these means he has also enhanced the illusion of space. His patrons have been given more elbow room than earlier sitters for Dutch painters enjoyed. The strong sculptural accents which model the heads still retain a good deal of the sixteenth-century style, and the technique of painting has not yet reached the freedom Hals was to achieve in the following decade; however, in various parts – particularly the faces, the hands, the ruffs, and the still-life on the banqueting table – Hals' detached brushwork begins to manifest itself. Among the colours a dark, warm harmony, somewhat reminiscent of Venetian painting, of black, red, yellow, and white prevails.

Little is known about the character and personality of the artist who painted the first monumental masterpiece of seventeenth-century Dutch painting. He did not leave a single

note or drawing[4] to give us an idea of his private thoughts or impressions of his milieu. This portraitist *par excellence* left only two self-portraits. An undisputed one appears in his large group portrait of the *St George Militia Company* of *c.* 1639[5] (Haarlem, Frans Hals Museum) [35]; the artist appears inconspicuously in the rear row, the second figure from the left. There is also reason to believe that he made a small self-portrait around 1650. This work is known today in a number of versions and variants; the best is now in the collection of the Clowes Fund, Indianapolis, Indiana. Neither of these self-portraits shows the man romantic biographers like to consider a kind of swashbuckling Cyrano de Bergerac of the brush. Attempts have been made to determine his way of life by identifying him with the jolly topers he painted. The method is not foolproof. To be sure, the earliest known reference to Hals' conduct, a note written by the German painter Mathias Scheits (*c.* 1630–*c.* 1700) in his copy of *Het Schilderboek*, states that Hals in his youth was 'wat lüstich van leven' (somewhat merry in his life).[6] Scheits probably received his information from his teacher, Philips Wouwerman, who was Hals' pupil. In 1718 Houbraken wrote that Hals was usually drunk every evening. Subsequent biographers embroidered this theme and by the end of the nineteenth century Hals was accused of being a wife-beater as well as a chronic alcoholic. It is true that a Frans Hals was summoned before the burgomasters of Haarlem in 1616 for drunkenness and beating his wife, but the authorities admonished a Frans Cornelisz. Hals, a weaver, not Frans Fransz. Hals the painter.[7] Moreover, Hals was a widower in 1616 and did not have a wife to beat. His first wife, Annetje Harmansdr., died in June 1615, and he was left with two children.

Hals seems to have held a respectable place in his community. His membership of the St George Militia Company was a sign of some prestige. From 1616 to 1625 he was connected with the Haarlem Society of Rhetoricians, 'De Wijngaertranken'. In 1629 he cleaned and 'changed' (*veranderen*) paintings from the convent of the Brotherhood of St John (did he work on pictures painted by Geertgen tot Sint Jans?). He was made an officer of the Haarlem Guild of St Luke in 1644. And, most important, from the beginning to the end of his career he was commissioned to make group portraits of militia companies and regents of charitable institutions, as well as portraits of distinguished Dutch theologians, university professors, civic leaders, artists, and merchants. It was the same kind of clientele that patronized Rembrandt.

Between 1616 and 1664 Hals painted nine large lifesize group portraits. No other leading artist of the period did as many. Yet it should also be noted that Hals' extant *œuvre* is not large. Not a single drawing, etching, or engraving has been discovered. Less than 250 paintings can be attributed to him, and about 200 of these are commissioned portraits. Of Rembrandt, whose life was about twenty years shorter than Hals', we know around 600 paintings, among which about 400 are portraits. Granted, Rembrandt's output in every branch of art was prodigious, but by any standard Hals' *œuvre* is not a tremendous one, and if one considers that it is the production of a man who must have painted as early as he breathed, its size is mysteriously small. How can we account for this? The best explanation is that a high percentage of his pictures have been lost. Not long after they were painted they were probably stored in attics, or suffered a worse fate, because they were appraised as merely another portrait of a great-uncle on the mother's side. They only began to be highly treasured around the middle of the nineteenth century. Probably by that time the bulk of them had disappeared.

In spite of the important commissions Hals received, he was repeatedly in financial difficulties. Even during the 1630s, when he seems

to have had as much work as he could handle, he was sued by his butcher, baker, and shoe-maker. There can be no question that he was not sufficiently rewarded or esteemed during his lifetime, but apparently the situation was not helped by the fact that, like many people, he was not very good at managing his personal financial affairs. The lengthy list of petty claims against him begins in 1616, the year he com-pleted his first large group portrait. In 1616 he was sued for not paying for the board of his two motherless children. He was not present to answer the complaint; it was said that he was in Antwerp. He was there from August until November – long enough to see what was happening in Rubens' studio. This is the only record that Hals ever left Holland. One of the children boarded in 1616 was Hals' son Harmen (1611–69), who became a painter. In 1617 Hals married Lysbeth Reyniers, who presented him with a daughter nine days after their marriage. His second wife, who was illiterate, was a vigorous woman. She was censured by the authorities for brawling more than once. Lysbeth Reyniers died when she was over eighty, thereby outliving many of her child-ren, as well as Frans by at least eight years. Estimates of the number of children of the second marriage vary. Birth-dates of eight are known, and at least three became painters: Frans Hals II (1618–69), Reynier Hals (1627–71), and Nicolaes (Claes) Hals (1628–86). Another son, Jan (Johannes) Hals (active c. 1635–1650), whose pictures can be deceptively close to his father's (*Portrait of a Man*, 1648, Frederiksstad, Nor-way, Kiaer Collection),[8] was probably a child of the second marriage. A daughter, Adriaentgien, married Pieter Roestraten, a minor Haarlem genre and still-life painter. Besides his five sons, Hals' pupils include his brother Dirck, Judith Leyster and her husband Jan Miense Molenaer, Adriaen van Ostade, and Philips Wouwerman. He had one pupil of genius, and that was Adriaen Brouwer.

WORKS BETWEEN 1620 AND 1640

During the 1620s, Hals perfected the rendering of vitality and spontaneity which characterize both his genre pictures and portraits. The so-called *Yonker Ramp and his Sweetheart* (1623, New York, Metropolitan Museum) [24] is an outstanding early example of this new phase.

24. Frans Hals: So-Called Yonker Ramp and his Sweetheart, 1623. *New York, Metropolitan Museum of Art, Altman Bequest*

The title was given to the picture late in the eighteenth century on the erroneous assump-tion that the lively model is one of the ensigns in the *Banquet of the St Hadrian's Militia Company* of c. 1627 (Haarlem, Frans Hals Museum) [30]. Whether the painting is a representation of the Prodigal Son (a picture by Hals of this subject is cited in seventeenth-century inventories) or is *genre pur* is difficult

25. Frans Hals: The Laughing Cavalier, 1624.
London, Wallace Collection

to decide. In any case, scenes from the life of the Prodigal Son were popular with Hals' predecessors, and about a decade later Rembrandt made a *Self-Portrait with Saskia on his Lap* [57], which is a similar conception. The colour scheme is now much cooler than in the *Shrovetide Revellers* [20], where red and yellow predominate. Here the leather jerkin and hat show fine grey tints, accompanied by a bright silvery blue in the sleeves and in the feather on the hat. Rembrandt's corresponding picture seems to show the influence of Hals in his striving for a gay, momentary expression and for a vivid, most immediate appeal to the spectator. But in this respect Rembrandt's painting does not have the same striking effect as Hals' composition, with its bold diagonal arrangement. Rembrandt's gaiety is somewhat forced, and instantaneousness does not really dominate. Also in this relatively early Rembrandt the technique still lacks breadth and fluidity, the composition is too involved, and the figures are a bit overburdened with romantic attire. It is only when Hals is compared with the mature Rembrandt that the Haarlem master loses somewhat in weight and significance.

The *Laughing Cavalier* (1624, London, Wallace Collection) [25], one of the most brilliant of all Baroque portraits, shows how successfully Hals conveyed a sense of immediacy in his commissioned portraits of the twenties. The handsome model's smile is a momentary one, the vivid characterization is indelible. The colours are brilliant: the embroidery on the gallant's black jerkin is orange, red, and yellow, white lace sparkles at his wrist and huge collar, and the splendid Baroque silhouette culminates with bravura in the outline of the black hat. The portrait is not handled as freely as *Yonker Ramp*; it was probably the patron's wish to have the embroidery, which has an emblematic character, meticulously rendered. But in some passages – particularly on the cuff – Hals allowed his brush great freedom. The spatial

arrangement is a daring one. The figure moves in and out with courageous foreshortening, and dashing diagonals organize the design. The light-grey background behind the cavalier and the silver tonality indicate that Hals had been impressed by the innovations of Terbrugghen. Hals' debt to the Utrecht Caravaggists is equally evident in his numerous lifesize genre pictures of musicians, drinkers, actors, and children of the 1620s and early 1630s. But there are some significant differences. Hals was never fascinated by the experiments the Caravaggesque painters conducted with dramatic chiaroscuro effects produced by artificial light. The instantaneous expressions of his subjects never freeze into grimaces, and even when his models are dressed in costumes (*Lute Player*, Paris, Alain Rothschild Collection), he never creates the impression that they are posing in a studio: he always convinces us that we are watching a fleeting moment of life. Superior examples of his studies of children are the *Boy holding a Flute* and the *Boy drinking* (c. 1626/8, Schwerin, Staatliches Museum) [26], probably part of a series representing the Five Senses.

26. Frans Hals: Boy drinking, c. 1626/8. *Schwerin, Staatliches Museum*

27. Frans Hals: The Merry Drinker, *c.* 1628–30. *Amsterdam, Rijksmuseum*

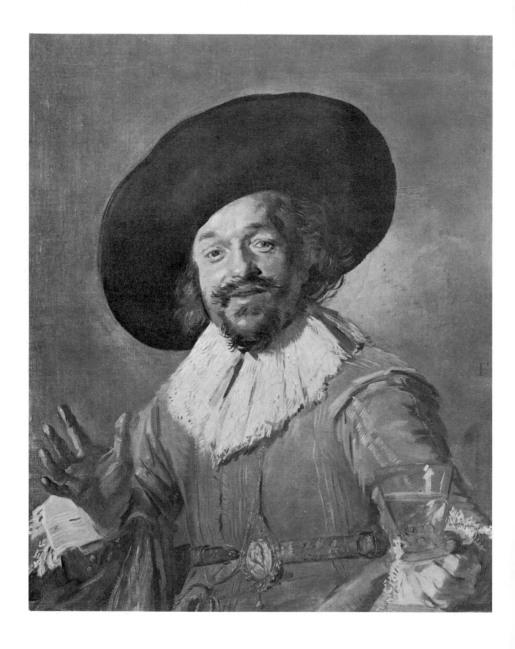

One likes to imagine that the models were Hals' own children. These fresh, informal sketches, which are highly animated by silvery daylight and are most fluid in painterly treatment, should be consulted before making attributions of pictures of laughing children to Frans Hals: too many old workshop copies and some modern forgeries in this category have been attributed to the master. Pictures by Hals' followers and imitators lack the sparkling accents which he himself is reported to have called 'putting in his handwriting' after the broader tonal relationships have been established for the expression of form. Every square inch of the surface of the Schwerin tondos is alive, and although the movement is complex and the composition condensed on a small surface, the planes are clearly distinguished, forms retain their full three-dimensionality, surfaces are of a convincing texture, and expressions have an unmatched vivacity. The fluid impressionistic treatment is consistent, and the swift brush strokes add life to the pictorial life of forms and textures.

The *Merry Drinker* (Amsterdam, Rijksmuseum) [27] of *c.* 1628–1630 is painted in a bright, blond tonality which anticipates nineteenth-century Impressionism in its most brilliant manifestations. Manet must have been particularly impressed by this painting. The picture also shows Hals' supreme mastery of one of the principal preoccupations of Baroque artists: the rendering of instantaneous emotion and movement. No seventeenth-century artist surpassed Hals in this field. The realism and illusionism of Caravaggio and his followers look forced compared to Hals, and Rubens and Van Dyck do not convey a comparable intensity in the suggestion of a fleeting instant packed with vitality. Hals' vigorous concentration on this was more than an ordinary rendering of reality. He selected moments when human nature reveals all its vital energy. Most frequently he shows the instant when the joy

of life is at its highest: the spontaneous laughter of a child, the smile of a courtesan, the wild shriek of an old crone [28]. To be sure, Renaissance portraits are not devoid of vitality

28. Frans Hals: Malle Babbe, *c.* 1630–3. *Berlin-Dahlem, Staatliche Museen*

either, but in them human nature manifests itself by restraint rather than outburst. Baroque portraitists, with their more dynamic tendencies, opened the way to a more immediate and instantaneous expression, but courtly convention and humanistic culture often had a restraining effect on them. Hals was the first Baroque artist repeatedly to depict human vitality in its most unadulterated form and in its most startling and instantaneous manifestations. He conveyed these ideas by a technique which was as original as it was adequate.

Hals frequently used the device of relating the figure represented to the spectator or some person outside the picture by a glance or gesture, in order to heighten the illusion of a moment. As we have seen, this trick was not unknown to the Late Mannerists, or to his

contemporaries in the Utrecht School. Another device – also employed by the Mannerists – was the violent use of diagonals to increase the impression of movement and of animation. Hals, however, used them with a consideration of the reality of space, whereas the Mannerists employed their diagonals in a more abstract and decorative fashion. But far more important than these two traditional schemes for producing the effect of a pulsating moment of life was Hals' revolutionary use of light. The sparkling and animating character of his light was hitherto unknown in painting. It is no longer the artificial, static light of the Caravaggio tradition, nor the rather idealizing light of Rubens: it is clear daylight of a silvery quality, floating all over, shimmering and animating surfaces, and comes very close to what the French Impressionists achieved. In Hals' works of the 1620s and early 1630s daylight becomes the life-giving element in nature, and its dynamic character is increased by his vigorous personality. The new character of his light ranks with the most radical stylistic innovations of Baroque painting. In his hands the emphasis shifts from the outlines and the sculptural quality of the subject represented to a most vivid surface play of values. Yet form and texture are never lost: they even gain in life under his new and brilliant surface treatment. It is Hals' revolutionary way of painting that gives his pictures a pictorial animation which make almost all previous painting appear frozen and lifeless.

An examination of Hals' technique helps to explain how he achieves the suggestion of palpitating life. A close-up of the head of the Amsterdam *Merry Drinker* [29] makes it appear a wild and rather loose combination of irregular strokes, patches, and daubs which tend to be sharp, broken, and angular; but seen at the right distance, this impulsive brushwork resolves itself into a coherent impression, suggests form and texture, besides a most amazing play of light for its own sake. This impressionistic principle of relying on the optical effect at a certain distance and upon the suggestiveness of spontaneous, disconnected brush strokes is one of the greatest discoveries in the history of painting. Both devices occur in sixteenth-century Venetian painting, but were never applied with Hals' consistency. It should be emphasized that there is no revolutionary change in the way Hals built up his portraits. He always begins by mapping the whole form in the middle tint. Then, upon this foundation, details are drawn with deft touches of light and shadow modelling the form and animating the surface at the emphatic points. The single stroke of his brush, although highly individual and spontaneous, is always adjusted to the character of the surface, and takes precisely the course needed to express the variety of surfaces and substances. Though each brush stroke retains its individual identity, there is never an abrupt break in the sequence of values, but a constant, subtle fusion of tones and a sensitive control over the value relationships. Form is consistently built up from the darks and the lights, and the painting increases in vivacity towards the highlights, where touches of impasto heighten the vibrating character of the whole.[9] The detail of the head of the Amsterdam *Drinker* shows two basic touches which are characteristic of the master. One is an angular or zigzag stroke which has a tendency to break up planes and to blur their edges; this counteracts roundness and isolation of forms and creates a steady surface movement. The other touch is hatching; these short parallel strokes create both a continuity of pictorial movement and vibration. The integration of these two devices and the seeming irregularity of his touch, together with its spontaneous character, are largely responsible for the brilliant surface life of his pictures. The irregularity of the touch is only an illusion: Hals' brush strokes are kept under absolute control. His works have the hidden order and

29. Frans Hals: The Merry Drinker, *c.* 1628–30. Detail. *Amsterdam, Rijksmuseum*

balance characteristic of the best Baroque paint-
ing. All his spirited surface treatment never de-
generates into mere pattern because he subtly
fuses the tones with an eye on the larger expres-
sion of form. As we have said, there is always a
basic consideration of the whole form and a
broad underlying tonal organization which
secures the expression of mass in space.

The way Hals fuses his impasto highlights
with the middle values and these again with
the deeper darks, and nowhere gives the
impression of an obvious transition or loses the
spontaneous *alla prima* character of his brush-
work, is perhaps the most miraculous feature
of his technique. He is, no doubt, one of the
greatest virtuosi in the history of painting, and,
one must add, a virtuoso who had an exception-
al feeling for his medium. Only Velazquez and
the late Rembrandt exploited the viscosity of
oil paint with equal ingenuity. Hals did not
create a technique which could be followed by
an average painter. With the exception of
Brouwer, none of his pupils grasped its
revolutionary aspects. Later seventeenth- and
eighteenth-century painters seem to have missed
the significance of his technical innovations. In
1774 Reynolds acknowledged that Hals' ability
to capture the character of an individual in a
portrait was without equal, but he thought he
lacked 'a patience in finishing what he so
correctly planned'. If he had finished his works,
Reynolds wrote, Hals 'might justly have claimed
the place which Van Dyck, all things considered,
so justly holds as the first of portrait painters'.[10]
Only during the nineteenth century did masters
such as Manet appear who understood his
technique and were able to express themselves
in his manner with the necessary skill and
spontaneity. But even a painter of Manet's
stature remains behind in some respects, and
does not achieve all the qualities found in the
Dutch artist's work. Such a quality is solidity
of form, which is often overlooked as a sub-
stantial part of Hals' painting. Art lovers of

our day who appreciate the merits of Impres-
sionist, Expressionist, and abstract painting
are easily fascinated by the vivid and lightning
brushwork which enlivens the surface of Hals'
pictures. However, it is the solidity of form,
animated by his technique, which distinguishes
a work by Hals, and sets it apart from one made
by a pupil or imitator. The forms of his follow-
ers disintegrate when they try to use his virtuoso
technique, and they are left with only a weak
imitation of his surface treatment.

It is hard to say precisely when Hals dis-
covered and perfected his new manner. As
we have already heard, germs of it are already
found in his earliest known works. A close and
continuous contact with nature must have
inspired him to his revolutionary achievement.
This close contact with nature accounts for
both his strength and his limitations. We have
seen his strength. His limitations extended to
dependence upon the model. This is not to say
that he never took a brush in his hand unless
he had a model in front of him: it is absurd
to think that he made a burgomaster of
Haarlem - or even *Malle Babbe* [28] - hold an
instantaneous expression or momentary gesture
until he transcribed what he saw into paint.
Hals achieved his effects by careful calculation
and selection, but the fact remains that during
a career which extends over a half-century his
range is limited to portraiture and portrait-
like genre pictures. Purely imaginary subjects
did not interest him. Thrown upon the resources
of his own imagination he must have been lost
and unable to proceed. On the other hand, not
everything he saw fascinated him. An idea of
what breathtaking things he could have accom-
plished as a still-life painter can be formed if
one compares the banquet on the table of the
group of 1616 [22] with the dry and rather naïve
still-life pictures painted by the contemporary
Haarlem specialists Floris van Schooten or
Floris van Dyck. A glimpse of a dune and a
patch of sky in the background of some of

Hals' genre pictures of fisher boys and girls made around 1630 shows what a landscape painter was lost in him. The highly praised landscapes painted in a broad manner by his Flemish pupil Brouwer suggest what Hals might have done in this field. But apparently Hals only felt inspired to paint when he was confronted by a fellow human being.

Outstanding examples of how carefully Hals calculated his candid effects are the group portraits of banquets of the *Officers of the Haarlem Militia Company of St Hadrian* (*c.* 1627, Haarlem, Frans Hals Museum) [30] and of the *Officers of the Militia Company of St George* (*c.* 1627, Haarlem, Frans Hals Museum). In a way, these paintings are the climax of Hals' impressionistic tendencies. Hals heightened the momentary quality of both pictures by interlacing the figures on the surface of the canvas and in depth. The impression is of a casual irregularity, but, as in his technique, a hidden order underlies his large compositions. In both banquet pieces he links up two principal groups by long diagonals, and each single group shows a central seated figure, around which the other men are arranged, some seated and some standing. The crossing of the main diagonals coincides with the head of a seated figure in the second plane, which gains through this scheme an added interest and becomes a kind of occult centre. Ingenious variety of position and movement relates the figures to each other or to the spectator. The final result is an unprecedented illusion of an

30. Frans Hals: Officers of the
Haarlem Militia Company of St Hadrian, *c.* 1627.
Haarlem, Frans Hals Museum

animated gathering. The impression that these guardsmen could consume gargantuan quantities of food and liquor is confirmed by an ordinance laid down by the municipal authorities of Haarlem in 1621. Town officials took cognizance of the fact that some of the banquets of the militia lasted a whole week. Considering that the municipality had to pay the costs, and that the times were troubled (the ordinance was written after hostilities with Spain had been resumed), it was decreed that the celebrations 'were not to last longer than three, or at the most four days . . .'

By creating a great diversity of attraction – perhaps too great a diversity in the portrait group of the *Officers of the Militia Company of St Hadrian* – Hals carefully avoided focusing attention upon one part of the picture at the expense of other parts. Value accents make the complexity of the spatial relationships as great as the richness and vividness of surface animation. The gaiety and freshness of the colour – there are bright pinks and blues, oranges and light greens, glittering greyish whites and shiny blacks – contribute to the brilliant vibrancy of the whole. This tremendous variety of devices gains pictorial unity largely through the silvery daylight which floods the interiors, flows over the faces and costumes, brightens the air, and throws a delightful sparkle over the surfaces. Though in both pictures the scene takes place indoors, one is tempted to speak of a plein-air conception. Only at this point of his career does Hals anticipate modern Impressionism in a fuller sense, because he combines plein-airism with intense bright colours and enlivens almost every single inch of his paintings with his spontaneous brushwork. We shall see that there were other moments of promising plein-airism in seventeenth-century Dutch painting. They are found in the landscape paintings of the 1630s and 1640s, and in the Delft School shortly after the middle of the century. But none were of long

duration; they were soon subdued by the predominant chiaroscuro trend of the century. Hals also succumbed to this general tendency. In the following decade he begins to show a gradual adjustment to a more monochromatic and darkened palette.

The portrait of *Willem van Heythuyzen* (Munich, Ältere Pinakothek) [31], which is usually dated around 1635 but upon the basis of style and costume should be dated about a decade earlier, is Hals' only known lifesize full-length. This type of portrait was not popular in seventeenth-century Holland. Most Dutch homes simply were not large enough for them. Moreover, it was a type which was still primarily used for state portraits, and probably not many Dutch burghers felt presumptuous enough to commission one. The Baroque trappings behind Van Heythuyzen are also unusual props in Hals' work. So is the sword. As far as we know Van Heythuyzen was a successful, generous merchant, not a military man. Hals' portrait of him appears to symbolize the confidence and vitality of the burghers who made Holland the wealthiest nation in Europe during the first half of the seventeenth century. It is one of those rare pictures which seem to sum up an entire epoch. A sense of Van Heythuyzen's energy is conveyed by the tautness the artist gave to his model's figure. His extended leg does not dangle, but carries its share of his weight. One arm juts straight out, stiff as the sword he holds; the other makes a sharp angle from shoulder to elbow to hip, and even his knuckles take part in the taut, angular movement. As in most of Hals' portraits of the 1620s, the light falls with equal intensity on Van Heythuyzen's alert head, and on his hands. Shiny highlights and sharp shadows heighten the sculptural effect, and the blended brush strokes that model the

31. Frans Hals: Willem van Heythuyzen, *c.* 1625. *Munich, Ältere Pinakothek*

flesh are set off by adjacent areas where there are distinct, detached touches of the brush. No portraitist before Hals dared use such a variety of brush strokes in a formal portrait, and although the props in the background are clearly subordinate to the figure, they are beautifully worked into the design. The vertical accent of the pilaster on the right reinforces the black, bolt-upright figure, and the violet drapery is incorporated into the great diagonal formed by Van Heythuyzen's elephantine knee-breeches and cape. About fifteen years later Hals painted another portrait of the same gentleman (Brussels, Musées Royaux des Beaux-Arts) [32]. In this small oil sketch Heythuyzen does not show a face or posture prepared for public encounters. Here Hals' instantaneous quality at its highest is successfully combined with his model's nonchalant attitude. Baroque dynamism and movement are expressed by the diagonal composition, the swift, angular brush strokes, and the highly developed flickering light, as well as by the precarious balance of the

tipped-back chair. The glimpse of an interior in the intimate Brussels picture is an exception in his work. Hals usually preferred vague, neutral backgrounds. But the size is not so extraordinary. Hals made small pictures, some of which can be held in the palm of one hand, from beginning to end of his long career. A few miniature portraits were painted as modellos for engravers (e.g. *Petrus Scriverius*, 1626, New York, Metropolitan Museum). Others were finished 'portraits in small'. The suggestion that some are preliminary studies for larger paintings is an attractive one, because not a single preparatory drawing can be attributed to Hals with absolute certainty.[11] It seems inconceivable that during the course of his lengthy career he never made a preliminary drawing or oil sketch. It also seems reasonable to assume that Hals, who saw the world in colour and tone, not line, made oil sketches more readily than drawings, and that some of his small oils were preparatory studies for larger works. The drawback to this hypothesis

32. Frans Hals: Willem van Heythuyzen, *c.* 1637–9.
Brussels, Musées Royaux des Beaux-Arts

is that, as has been said, not a single preliminary oil sketch for a painting has been discovered. Some lifesize copies were made by other artists after Hals' original small portraits: a prominent example is the famous *Portrait of Descartes* in the Louvre, which we consider an enlarged copy after the small original in Copenhagen. Followers also made reduced copies which have passed as authentic preparatory studies; e.g. the oil sketch on paper formerly in the H. E. ten Cate Collection, which in our opinion is a copy after the lifesize portrait of Stephanus Geraerdts [39], now at Antwerp, and not a preliminary study by the master himself.

During the 1630s, when Hals reached the height of his popularity, there was a marked shift in his style. His works acquired a greater unity and simplicity, and the bright colours of the 1620s gave way to more monochromatic effects. This shift was a general one in seventeenth-century Dutch painting, and can also be noted in Van Goyen's landscapes and Heda's still-life pictures. The change is also reflected in the fashions of the day. This was the time when stately black clothes replaced the multicoloured and richly embroidered garments worn during the first decades of the century. The knee-length portrait of *Feyntje van Steenkiste* (1635, Amsterdam, Rijksmuseum) [33] is a beautiful example of the modest grandeur and the new spaciousness and atmospheric quality Hals achieved during the 1630s. Black is predominant, and there are only a few subdued colour accents. A puritan character expresses itself in the simplicity of the costume and the pictorial restraint. The areas of attraction have been deliberately reduced, and there is also a higher economy in characterization than in the earlier works. This is the height of Hals' *valeur* painting which was so admired by the French Impressionists.

A similar tendency towards restraint is seen in the three large group portraits made during

33. Frans Hals: Feyntje van Steenkiste, 1635. *Amsterdam, Rijksmuseum*

1630s of the civic guards. The vivacity of the setting is already slightly subdued in the group portrait painted in the early thirties of the *Officers of the Militia Company of St Hadrian* (c. 1633, Haarlem, Frans Hals Museum) [34] by the subordination of the figures to a horizontal band, and this horizontal accent completely dominates the arrangement of the figures in the group portrait of the *Officers of the Militia Company of St George* (c. 1639, Haarlem, Frans Hals Museum) [35]. In both group portraits the figures are set in the open air, but they lose rather than gain in plein-airistic quality. This is particularly true of the picture of 1639, which is dominated by a warm golden olive tone, while the one of 1633 still retains a good deal of the colouristic vivacity and charm of the 1620s, with bright blues, dazzling whites, and oranges, and also some of the compositional

34. Frans Hals:
Officers of the Militia Company of St Hadrian,
c. 1633. *Haarlem, Frans Hals Museum*

35. Frans Hals:
Officers of the Militia Company of St George,
c. 1639. *Haarlem, Frans Hals Museum*

boldness and agitation of the earlier period. The picture of 1639, in which Hals' rare self-portrait is to be seen in the upper left corner, is the master's last representation of a militia group. The whole category virtually disappears in the Netherlands around the middle of the

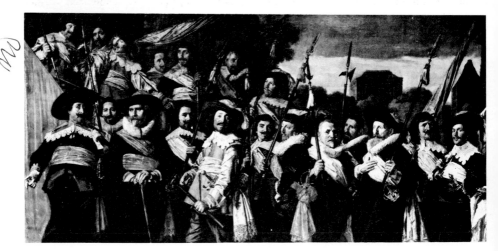

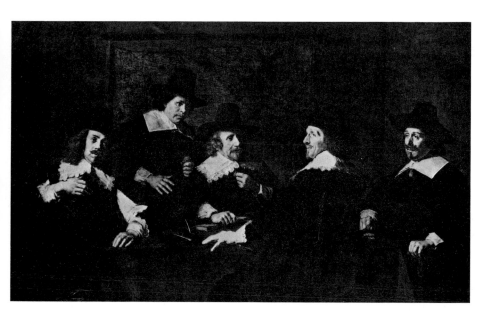

36. Frans Hals:
Regents of the St Elizabeth Hospital, *c.* 1641.
Haarlem, Frans Hals Museum

century. After the Treaty of Westphalia of
1648, which gave Holland *de jure* recognition
in the councils of Europe, Dutch burghers
were not as aggressive as their fathers had been.
They preferred to be seen as dignified syndics,
rather than boisterous soldiers. The third civic
guard picture Hals was commissioned to paint
during the 1630s is the so-called *Meagre Com-
pany* (Amsterdam, Rijksmuseum). He received
the commission from a group of Amsterdam
militiamen in 1633. The honour was a singular
one. Hals was chosen to paint the 'Corporalship'
of Captain Reynier Reael instead of the leading
Amsterdam portrait painter Thomas de Keyser,
or Rembrandt, who had established his reputa-
tion a year earlier with his *Anatomy Lesson of
Dr Tulp*. Hals followed the Amsterdam tradi-
tion of showing Captain Reael and his men as
full-length figures (all the Haarlem Militia

Companies are three-quarter lengths). The
commission gave him some difficulties. It seems
that he began the portraits of his patrons in
Amsterdam and worked them up in Haarlem.
Here surely is a case where Hals could have
made small oil sketches; but none have been
identified. In 1636 he was summoned to Am-
sterdam to complete the work. He refused, and
asked his patrons to sit for him in Haarlem. He
assured them that posing would not take long;
proof – if proof is needed – that Hals painted
rapidly. Hals was to receive sixty-six guilders
for each militiaman he painted. This is the only
extant record of the price Hals charged for his
work. The fee was a reasonably good one;
about a decade later, when Rembrandt was at
the peak of his popularity, he received about a
hundred guilders for each of the militiamen he
represented in the *Night Watch*. Hals never
finished the group, and it was finally completed
by Pieter Codde in 1637. Codde's hand is
clearly recognizable in the right half of the
picture.

THE LAST DECADES: 1640–1666

As Hals grew older, genre subjects disappeared from his *œuvre*. The mature artist limited himself exclusively to portraiture. At the same time he acquired an increased depth of expression, and a melancholic strain enters his joyful art. The dignified character of his group of the *Regents of the St Elizabeth Hospital* (Haarlem, Frans Hals Museum) [36] of *c.* 1641 sets the key for the last decades. The bravura and gaiety of an earlier generation is now replaced by sobriety. The five regents of the charitable institution gathered at the conference table appear to be discussing an important matter. A kind of intimacy is given to the group by the character of the light which is thrown into the interior by a side window and concentrated on the faces of the sitters. This kind of illumination allows a moderate chiaroscuro effect, and may reflect the influence of Rembrandt on the older master. But the darks do not dominate yet, and there is still enough brightness and brilliancy to remind us of Hals' plein-airistic period. However, the character of the colour has changed considerably. Nearly all pure colour has disappeared and the colour composition has become almost monochromatic, showing a subdued harmony of greyish blacks and subtle gradations of yellowish browns.

Hals began to receive fewer commissions during the 1640s. This was the time when there was a wave of elegance and aristocratic taste in the Netherlands and a considerable part of the Dutch public began to give preference to portraitists such as Bartholomeus van der Helst [252], who could give a sitter Van Dyckian airs. The sixty-year-old Hals did not slavishly follow the new mode. However, his loss of patronage during his last decades should not be exaggerated. More pictures are known by Hals the septuagenarian and octogenarian than by young Hals. There were still Dutchmen who preferred his subtle under-statement to the pretentious display which was the speciality of the more popular portraitists. Two of his lifesize family portraits (Lugano, Thyssen-Bornemisza Collection; London, National Gallery) can be dated in the late forties. In the same decade he painted four members of the Coymans family, one of the leading families of Haarlem; of 1643 is his *Paulus Verschuur* (New York, Metropolitan Museum), director of the largest textile mill in Rotterdam and one of that city's outstanding civic leaders; around 1649 he painted *Descartes* (on loan to the Statens Museum, Copenhagen), his most famous sitter. Until the end Hals' clientele included theologians, professors, artists, and intellectuals.

Hals' most penetrating characterizations date from the last decades. With uncanny subtlety, he grasped the personalities of all types: the strong and the vulnerable, the pompous and the meek, the brutal and the tender. The private dramas that can be read on the faces of his sitters anticipate the stories of Balzac or Chekhov. Unlike the other great portraitists of his age, he could paint portraits of women [37] as remarkable as those of men. Though he found some sitters more congenial than others, the aged master never seems to have been bored with his job. During these years he was perhaps most sympathetic to sitters of his own generation. The pictorial reserve of his last phase was particularly suitable for the portrayal of his peers, whose puritan tastes made them shun the new vogue for the ostentatious. But he could also be critical of them. He was, however, more devastating when appraising members of the younger generation who found themselves dissatisfied with their fathers' tastes, and began to imitate the manners and clothes of the English and French nobility [38]. Yet the artist was able to satisfy the desire of young patrons for over-rich effects without losing his extraordinary sensitivity to tonal gradations. A series of companion pieces of husbands and wives

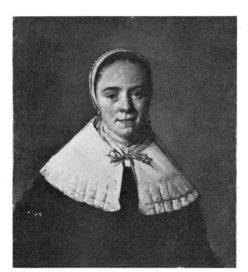

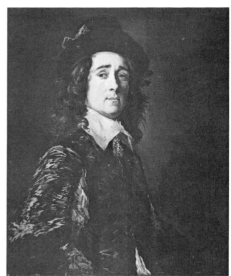

37. Frans Hals: Portrait of a Woman, *c.* 1655–60.
Hull, Yorks., Ferens Art Gallery

38. Frans Hals: Jasper Schade van Westrum, *c.* 1645.
Prague, Národní Galerie

39. Frans Hals: Stephanus Geraerdts, *c.* 1650–2.
Antwerp, Musée Royal des Beaux-Arts

40. Frans Hals: Isabella Coymans, *c.* 1650–2.
Paris, private collection

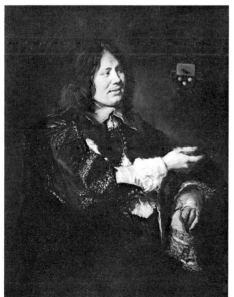

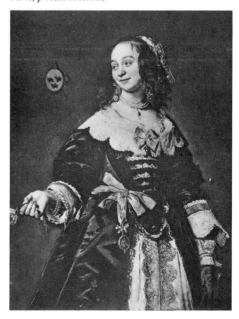

take a prominent place in the work of the forties and fifties. The most original pair is the portraits of *Stephanus Geraerdts* (*c.* 1650–1652, Antwerp, Musée Royal des Beaux-Arts) [39] and *Isabella Coymans* (*c.* 1650–1652, Paris, private collection) [40]. Of all the cases of the separation of Hals' companion pieces into different collections, the division of this couple is the most unfortunate; for in these pictures Hals not only related husband and wife by inventing compositions and using colour harmonies and brushwork which complement and complete each other, but he arranged an action between the two figures. The case is unique in Hals' work. Isabella stands and turns towards her husband to offer him a rose. Stephanus is not impressed. He remains seated with his arm outstretched. Apparently this fat alderman found it difficult to rise even when his wife approached him bearing a token.

After 1650 austere and even tragic moods are not uncommon [41]. The pictures become darker, the blacks richer and more predominant. Dark greys and deep golden olive-greens are now substituted more consistently for the light silver-greys and yellow ochres of the earlier works. The artist relies more and more for pictorial effects upon contrasting warm and cool tones which are close in value. His paint becomes thinner, his touch even broader and more summary. The frontal pose used for the impressive *Portrait of a standing Man* (1650-2) [42] is now favoured and helps to account for the new dignity and imposing grandeur of the last works. Incredibly subtle distinctions between the blacks of the man's suit, hat, and mantle in the Metropolitan Museum portrait make clear what Vincent van Gogh had in mind when he wrote, half in awe and half in envy, 'Frans Hals had no less than twenty-seven blacks.'

41. Frans Hals:
Portrait of a Man, *c.* 1660.
The Hague, Mauritshuis

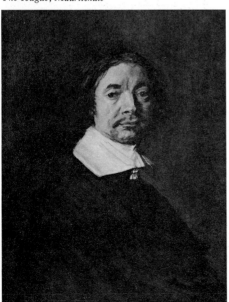

42. Frans Hals: Portrait of a standing Man, 1650-2.
New York, Metropolitan
Museum of Art, Marquand Bequest

43. Frans Hals: Regents of the Old Men's Home, *c.* 1664.
Haarlem, Frans Hals Museum

Portraits of the last years have some of the psychological penetration and restraint which characterize the majestic works of Rembrandt's mature phase. To be sure, Hals never touched Rembrandt's universal range; but it is frequently overlooked that Hals had Rembrandtesque moments – just as Rembrandt had his Halsian ones [57]. Rembrandt's chiaroscuro must have impressed Hals, because he found it an adequate expression for a more serious mood. There are, however, basic differences between the chiaroscuro effects achieved by Hals and Rembrandt during their late periods. Rembrandt's figures always seem to be more enveloped by space and atmosphere than Hals', because he made his light and dark areas interpenetrate each other by using still more subtle tonal gradations and reflections in his half-tones. Rembrandt also turned naturalistic Caravaggesque spotlighting effects into a pictorial device of deeper symbolic significance. He was able to add an inner glow to the outer animation, to express man's inner life. In Rembrandt's hands chiaroscuro became a magic device to express the intangible and invisible through the visible. For Hals, chiaroscuro was primarily a pictorial affair which reflected a change in taste rather than a means to reveal a deeper and more comprehensive grasp of human nature and its spiritual implications. It does not follow, however, that Hals was unable to plumb the depths of man's soul. His late portraits prove that he could. Nowhere is this more evident than in the incredible group portraits of the *Regents of the Old Men's Home* (Haarlem, Frans Hals Museum) [43] and the

44. Frans Hals: Regentesses of the Old Men's Home, *c.* 1664. *Haarlem, Frans Hals Museum*

Regentesses of the Old Men's Home (Haarlem, Frans Hals Museum) [44], painted about 1664, when the artist was over eighty years of age.

The painting of the women governors is perhaps the more impressive of the two, by the great simplicity of its composition as well as by the power of characterization. The characters of the women appear to range from iron strength and firmness – a quality which the old artist seems to have respected – to sheepish foolishness; but there is no distinction in social degree except for the servant on the right, who seems to bring in some message and who has the expression of a person accustomed to subordination. Like most of Hals' late works, the picture is done essentially in black and white. The whites are brilliant, the blacks deep and glowing. The impressionistic technique is fully developed, but can only manifest itself here in the lightest passages. Single strokes have gained still more in breadth and power. Some bold colour accents emphasize salient points, yet a general softness is achieved ial tones, and the individual come more fused with the surrounding areas. The group portrait of the male regents is less successful than its companion piece, but not because of a faltering hand, which some critics maintain they recognize in Hals' last works. Hals never lost his unsurpassed sureness of touch, which could simultaneously draw, model form, define texture, and create lively spatial and surface accents. In the group portrait of the men, an old characteristic of the master reappears: each person stands out with equal importance. This was a definite quality in his earlier work, when all devices co-operated to increase the impression of a casual variety, informality, and instantaneousness. But this principle is less fortunate when combined with chiaroscuro, a device which was used by Caravaggio as well as Rembrandt to focus the spectator's interest on a few essential passages, thereby creating concentration instead of animating diversity. Thus, one principle involved here stands for diversity of attraction, the other for concentration; the result is not fully satisfactory. However, lack of compositional coherence is quickly forgotten as soon as one examines the masterly painting and characterization of the six men, and when one discovers a passage like the broad touch of red on the knee of the man on the right, which brings a breathtaking colour accent to the monochromatic character of Hals' late palette.

The aged Hals may have been reasonably well rewarded for his late masterpieces. A year after they were painted, he was able to act as guarantor for his son-in-law for the large sum of 458 guilders, 11 stuivers. Perhaps this sudden affluence was due to the payment he received for his last two group portraits. But it would be a mistake to think that Hals' financial situation improved during the last decades of his life: on the contrary, in 1654 his meagre possessions were seized by a baker in payment for an unpaid debt, and during the final years of his long life he was apparently destitute. The Haarlem Guild of St Luke exempted the old master from the payment of dues in 1661 because of his old age. In 1662 the burgomasters of Haarlem awarded him a direct gift of 50 guilders and a subsidy of 150 guilders for one year. The following year the subsidy was increased to 200 guilders annually. On 1 September 1666 a grave was opened for him at St Bavo's Cathedral in Haarlem. If any of Hals' contemporaries appreciated the exuberance and joyful vitality of his early pictures or the depth and concentrated power of his late work, they failed to communicate their enthusiasm to posterity. Only in the nineteenth century, after Courbet and the Impressionists had rediscovered his genius, was Frans Hals generally recognized as one of the greatest Western painters.

REMBRANDT VAN RIJN

Rembrandt Harmensz. van Rijn was born on 15 July 1606 in Leiden, the son of the miller Harmen Gerritsz. van Rijn. His mother Cornelia (or Nelltgen) Willemsdochter van Zuytbroek was the daughter of a baker. The parents lived on the Weddesteeg, close to the 'Rijn-mill', and the family name 'van Rijn' was derived from this malt mill. On his mother's death in 1640 – his father died in 1630 – an inventory was taken of her estate which reflects fairly comfortable circumstances. In addition to half of the mill, she owned some houses. The total value of her estate, not far from 10,000 guilders, was to be divided among the heirs. While Rembrandt was the eighth of nine children, only four were alive at this time: Adriaen, a shoemaker, Willem, a baker, Rembrandt, and his sister Lysbeth. The facts of Rembrandt's origin are not unimportant. The harsh force in the master's nature, most obvious in his early works, and his inexhaustible vitality may have something to do with his ancestry. They should also be considered in connexion with the remarkable scope of his development. Rembrandt progressed, with powerful impulses, with extraordinary élan, and with an intensity hitherto unknown, from the rough to the sensitive, and from a somewhat brutal character in his art to the sublime. One wonders if a man who had been brought up from the beginning in wealth and in more cultivated surroundings would ever have been driven by such dynamic forces to the height of his activity.

According to J. Orlers,[1] Rembrandt's first biographer, the boy's parents destined their gifted son for a learned profession, apparently with the ambition of opening his way to a higher social sphere. He attended the Leiden grammar school for seven years, and on 20 May 1620 was enrolled as a student at the university of Leiden. It is not known how long Rembrandt studied there. It is certain only that his parents soon recognized their son's natural inclination towards art as too strong to be denied, and that the boy was allowed to give up his university studies. He was then sent to an artist to learn the rudiments of art. His first teacher has not been identified; his second was Jacob Isaacsz. van Swanenburgh (c. 1571-1638), an obscure Leiden painter of architectural views and scenes of hell. Rembrandt spent three years with Van Swanenburgh, but not a trace of his style can be seen in the youthful artist's early work. It is also noteworthy that, as far as we know, Rembrandt, who depicted almost every subject during the course of his career, never painted an architectural scene or a view of hell. Orlers tells us that Rembrandt's work with Van Swanenburgh showed such great promise that his father, in order to ensure his son's best advantage, sent him to Amsterdam to study for six months with the famous Pieter Lastman. The eighteen- or nineteen-year-old youth returned to Leiden about 1624-5 and set himself up as an independent master. The earliest works which can be attributed to him date from about this time.

THE LEIDEN PERIOD: 1625-1631

Rembrandt's development can be divided into four basic periods: the beginnings in Leiden, and three phases in Amsterdam. In Leiden, a university town and important centre of humanism and scholarship, there was a distinct local atmosphere, while in cosmopolitan Am-

sterdam Rembrandt was more strongly exposed to the great international trends of Baroque art. It was in Amsterdam during the thirties that he first reached a High Baroque phase, clearly under the impression of Rubens' art; and later – in the fifties and sixties – a more classical style which, though far from outright classicism, showed some influence of the tectonic and monumental character of Renaissance art. An intermediary period during the forties was a time of inner crisis and transition. This division of Rembrandt's career into four periods must, however, be applied with caution and judgement. Rembrandt's artistic development was not a rigid one. He could shift moods and modes

with great rapidity, and the style he used in one medium did not fully parallel one he used when he worked in another. Rembrandt's genius was flexible and sometimes explosive. There are fluctuations, cross-currents, premonitions, and recurrences in his *œuvre*.

His first period was a time of rapid growth, rich enough to fill out the whole life of a minor master, but in Rembrandt's career only a beginning which was followed by more important stages. From the moment he embarked on independent activity he began to make religious pictures, and during the course of his career he worked more from Scripture than from any other source. The amazing *Feast of Esther*

45. Rembrandt: The Feast of Esther, *c.* 1625.
Raleigh, North Carolina Museum of Art

(*c.* 1625, Raleigh, North Carolina Museum of Art) [45], bursting with energy, yet over-rich in detail and somewhat immature in its lack of control over forms in space, can be explained as an over-ambitious attempt by the youth to combine the lighting effects and the large scale of the Utrecht Caravaggesque painters with the style of his teacher Lastman.[2] The synthesis was not a complete success. Young Rembrandt was more at home with the new form of small realistic historical painting in the Early Baroque manner which Elsheimer's Dutch followers developed after their return from Italy. He did not attempt a lifesize historical composition again until he moved to Amsterdam, when he painted the *Holy Family* [58] now at Munich. Rembrandt's earliest extant dated work, the *Stoning of St Stephen* of 1625[3] (Lyon, Museum) [46], shows how impressed he was by Lastman's forcefulness based upon lively gestures and a vivid chiaroscuro. The young Leiden artist used the same kind of fanciful Italianate setting that his teacher employed, and depended on similar strong contrasts of light and shade to give his work a dramatic character. In his colouring Rembrandt also follows the example of Lastman in giving a hard brilliance to the illuminated figures. Rembrandt's immaturity is evident here in the overcrowding and confused spatial relationships; however, the young

46. Rembrandt: The Stoning of St Stephen, 1625.
Lyon, Museum

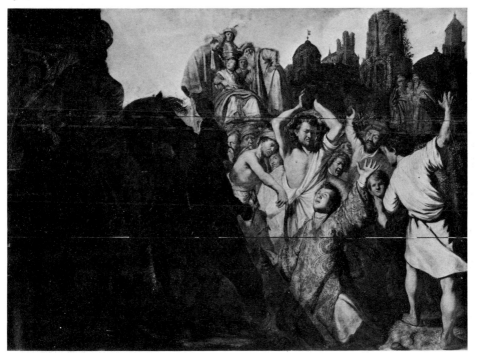

artist already surpasses his famous teacher by achieving a greater concentration in his composition. The horsemen and figures on the left have been massed into a group by a dark shadow which suppresses detail in almost half the painting. This device focuses attention on the main action and intensifies the mood. There is nothing comparable to it in the *œuvre* of Lastman or any of the other 'pre-Rembrandtists'.

One of the heads in the Lyon picture – the one looking at the scene in pained horror just below the arm of the man holding a rock with both hands high above his head – shows that Rembrandt was already making studies of his own physiognomy at this early date. It is a self-portrait, the earliest extant one by the artist, who represented himself more frequently than any other master. Almost one hundred self-portraits by Rembrandt are known. This unique autobiography presents Rembrandt's conception of himself from the beginning to the end of his career: as a gay gallant, a proper bourgeois, a majestic Titan, and finally, as the aged sage who plumbed the secrets of his innermost life. During his Leiden years Rembrandt also frequently used himself as a convenient model to study chiaroscuro effects and facial expressions. The results of these studies were incorporated into his more ambitious historical compositions. This experimental approach was not an uncommon one among Baroque artists; both Caravaggio and Bernini used themselves as models for their early physiognomical studies. The volcanic energy and bold originality of the young genius is seen in the early *Self-Portrait* [47] now at Kassel.[4] Rembrandt painted his powerful head and bust in deep shadow and silhouetted them against the light wall – a device reminiscent of the Utrecht *Caravaggisti*. But the distribution of light and shade in the self-portrait is unique. The upper part is deeply shadowed, and it requires a strong effort on the part of the onlooker to recognize the artist's questioning

glance. The effect is as dramatic as it is bold in the neglect of the portrait conventions of the time, and it shows how early Rembrandt began to exploit the variety of texture that can be achieved by altering the fluidity of oil paint. Here he used a heavy impasto for the accents of light on his shoulder, neck, and cheek; the grey wall was brushed in with thin paint; and vigorous scratches into the wet colour with the butt end of his brush were used to depict his wild mane. Such passages anticipate the master's later freedom in handling paint. The final result is one of intense realism and romanticism – a combination found frequently in Rembrandt's art.

Lastman's influence persists in the subject pictures painted during the Leiden years, and even during his first years in Amsterdam Rembrandt found it profitable to make drawings after his old teacher's paintings. But he quickly displayed more power than Lastman. Works

by the youthful artist already reveal on an intimate scale unmistakable signs of the complete master. No painter in Holland could have equalled the humanity and power of perception Rembrandt brought to his small picture of *Tobit and Anna* (1626, Amsterdam, Rijksmuseum) [48]. Nor is there a parallel for his conception of Joseph striding forward out of the mysterious night in the *Flight into Egypt* (Tours, Musée des Beaux-Arts) painted in 1627; fifteen years later, Rembrandt was to paint the lifesize figure of Captain Cocq, the central figure in the *Night Watch,* in a similar pose. Emphatic gestures used to enliven and dramatize the *Presentation in the Temple* (c.

47 (*opposite*). Rembrandt: Self-Portrait, c. 1629. *Kassel, Staatliche Gemäldegalerie*

48 (*below*). Rembrandt: Tobit and Anna, 1626. *London, Baroness G.W.H.M. Bentinck-Thyssen-Bornemisza (on loan to the Rijksmuseum, Amsterdam)*

1628, Hamburg, Kunsthalle) may still recall Lastman, but the depth of expression is Rembrandt's own.

During the Leiden years Rembrandt was also as much at home with the etcher's needle as he was with the painter's brush. Even his earliest prints have a radiance and intimacy of effect that exert a miraculous power. We not only read their stories; we increasingly feel their graphic charm and their spiritual flavour. Here, too, Rembrandt discovered his way with lightning swiftness. After making a few experiments with the technique he was able to exploit the potential of the medium with absolute surety. By the time he left Leiden for Amsterdam he was the outstanding etcher of his day.

There is, however, one important category of Rembrandt's later activity which is absent in his first period. Rembrandt did not execute portrait commissions until about 1631, his last year in Leiden. In his youth he aspired to be a history painter, not a mere face-painter. The portraits he made in Leiden of members of his family[5] and old people in fanciful guise were primarily studies of types for his subject pictures. The artist's mother, sister, and a model traditionally identified as his father, as well as Rembrandt himself, can be recognized in the *Music Party* of 1626 (Bredius 632). His mother served as the model for Anna in the *Tobit and Anna* of 1626 at the Rijksmuseum, as Hannah in the Hamburg *Presentation in the Temple,* and again as Hannah in the painting of the prophetess at the Rijksmuseum in Amsterdam, which is of 1631. But Rembrandt's interest in old people was not confined to making likenesses of his parents. To the youthful artist old age was the ideal age. It afforded him the best opportunity of showing the richness of inner life gained through experience and suffering. In this early period the meditative quality of old people attracted him. His preference for elderly faces and his keen appreciation of their potentialities for expression may

have come from his early familiarity with the Bible, in which the patriarchal type plays such a dominant role. *St Paul seated in Contemplation* (*c.* 1629-1630, Nürnberg, Germanisches National-Museum) [50] belongs to a group of outstanding paintings that Rembrandt made during his Leiden phase of saints, apostles, and philosophers in dimly lit interiors.

From the very beginning Rembrandt used chiaroscuro in his own individual manner. In the works by Caravaggio and his early followers the light and shade are intensely contrasted, and there is little penumbra transition. In their pictures, sharp borders between the illuminated and the shadowed parts create the effect of clear-cut contours, and in consequence of this, figures as well as separate objects stand out with a pronounced sculptural character against a dark and rather spaceless background. In the *Money Changer* of 1627 (Berlin-Dahlem, Staatliche Museen) [49] young Rembrandt takes up the problem of the light and shadow produced by the flame of the taper, covered by the old man's hand. Here he was no doubt inspired by Honthorst, who popularized this device. Rembrandt, following Honthorst's example, carefully studied the coloured reflections on the face of his model and the other objects in the room. There is, however, a difference in effect between this nocturnal scene by early Rembrandt and any by Honthorst. Rembrandt has already surpassed his model in unifying light and atmosphere throughout an interior. In his *St Paul in Contemplation* [50], painted a few

49. Rembrandt: The Money Changer, 1627. *Berlin-Dahlem, Staatliche Museen*

50. Rembrandt: St Paul seated in Contemplation, *c.* 1629-30. *Nürnberg, Germanisches National-Museum*

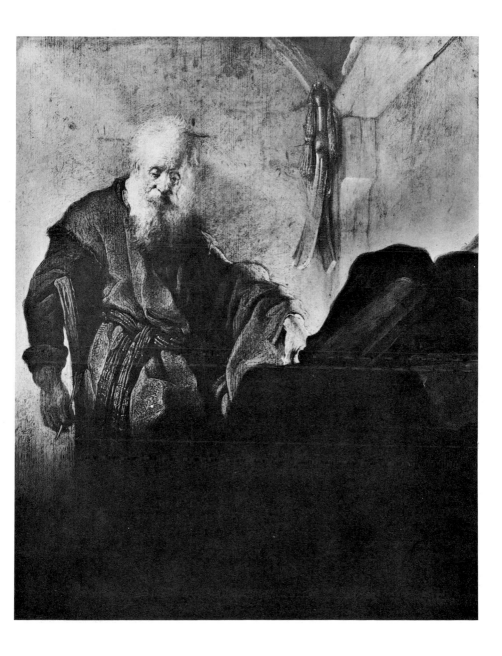

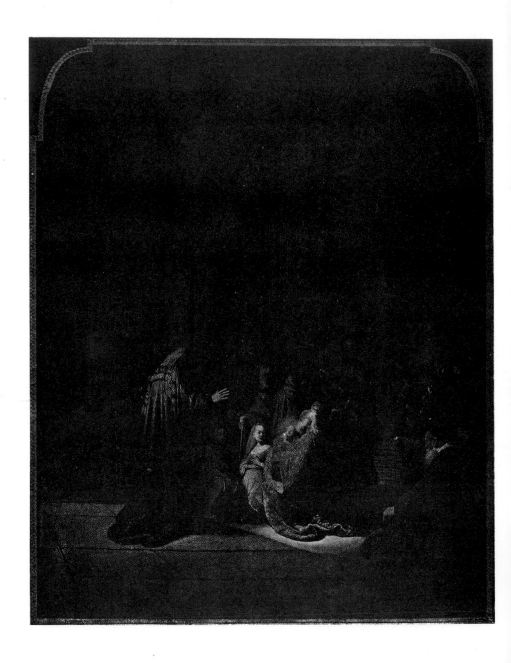

years later, the light and shadow are even more closely interwoven. A permanent fluctuation from the one to the other takes place, producing a tenebrous atmosphere, full of mysterious effect. But more than this is achieved: by the fluctuating light the figure is expressly connected with the surrounding space, and the space itself is drawn into the representation. It becomes a vibrant, living medium. Space and figure in Rembrandt's art now share one inseparable existence and are equally expressive. At this point of his development Rembrandt was already able to use chiaroscuro to give the atmosphere both a visual and a spiritual meaning. Throughout his career, chiaroscuro remained his most powerful means of expression. Of course, there are other important features of his art: his colouristic treatment, his draughtsmanship, his brushwork, his compositional devices; but in a way they are all subordinated to, or in any case co-ordinated with, his chiaroscuro.

During his last years in Leiden Rembrandt's style became finer and more intimate. A subtly diffused, yet dramatic chiaroscuro develops, and cool, delicate colours predominate. In some cases this precious style continues into the early years in Amsterdam. The dimly lit interior of colossal dimensions, the fantastic columns and deep shadows intensify the mysterious atmosphere of the *Presentation in the Temple* (1631, The Hague, Mauritshuis) [51], but the small figures of the main group gain distinctness by means of the sparkling sunlight which strikes them. The golden halo of the Christ Child who will be 'a light to lighten the Gentiles' makes a source of light within the beam. Around this time Rembrandt also painted historical scenes in expansive landscapes with a minuteness of attention recalling Elsheimer's pictures. There is almost the exquisite refinement of fifteenth-century Netherlandish painting in these jewel-like works (e.g. *The Rape of Proserpine*, Berlin-

Dahlem, Staatliche Museen), in which the dramatic possibilities of the Baroque style are still somewhat checked by the very small scale of the figures and the extremely subtle execution. The delicate connoisseur taste of a group of Dutch humanists apparently valued these qualities, and the tiny pictures by Elsheimer must have been treasured by them as one of the perfections of contemporary art. A leading figure amongst this group of connoisseurs was Constantin Huygens. Around 1630, Huygens noted in his autobiography that the miller's son Rembrandt and his friend Jan Lievens were on a par with the greatest painters, and would soon surpass them.[6] This was not routine praise. Huygens, a well-travelled, cultivated man who combined a full life of service to his country with a mastery of the polite accomplishments, was extremely familiar with the art world of his day. It was he who suggested to Rembrandt and Lievens that they should travel to Italy to perfect their art. But neither artist had a desire to go south. Huygens reports that the painters said that now, in the flower of their youth, they had no time for travel, and they did not want to interrupt their work. Moreover, they added, pictures by the finest Italian artists could be seen in Holland. They exaggerated. The quality of the Italian paintings which could be seen in the Netherlands around 1630 was not very impressive. But what is more important, they cared little for classical models during this period of their careers. Young Rembrandt was more attracted by the romantic and the picturesque than he was by a classical ideal of beauty. His predilection is clear in his choice of subjects, his models, the fanciful oriental attire of his subjects, and even his studio props. He was also interested in the mean and the ugly. Unlike his forerunners, he did not view poor people as quaint or amusing creatures. His early etchings and drawings of beggars represent them as pathetic and suffering. Nothing could be farther away from the classical ideal.

Huygens was keen-eyed enough to appraise the difference between Rembrandt and his gifted friend Jan Lievens. Rembrandt, he wrote, is superior to Lievens in judgement and in the representation of lively emotional expression. Lievens, on the other hand, has a grandeur of invention and boldness which Rembrandt does not achieve. Huygens selected *Judas returning the Pieces of Silver* (1629, private collection) [52] to show Rembrandt's superior ability to convey the expression of emotion in a small, carefully worked-out picture. He wrote at length how impressed he was with Rembrandt's skill in representing expression, appropriate gestures, and movement, particularly in the central figure of Judas, who appears ravaged and convulsed by despair. Huygens applauded Rembrandt's ability to paint biblical pictures, and adds that Lievens would not easily achieve Rembrandt's vivacious invention. Thus Rembrandt won recognition as a history painter – the most important branch of painting to Renaissance and Baroque critics and collectors of painting – even before he left Leiden, from one of the leading connoisseurs of his day. Huygens did more than write praise. He also helped the young artist get commissions from the Prince of Orange. It must have been with great confidence that Rembrandt decided to move from his native town to the principal city of Holland about the end of 1631 or early in 1632.

52. Rembrandt: Judas returning the Pieces of Silver, 1629. *Private collection*

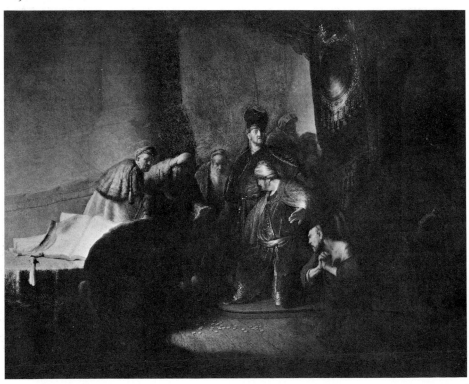

With Rembrandt's arrival in Amsterdam he embarked on the most successful epoch of his life – successful that is, in the eyes of his contemporaries. He became wealthy, and quickly acquired an international reputation. As his influence on Castiglione shows, his prints had even percolated down to Genoa by 1635. He experienced a kind of social ascent, thanks to his popularity as a portraitist, as a master in the field of biblical and mythological representation, and as a popular teacher who had as many pupils as he could handle. His marriage in 1634 to Saskia van Uylenburgh, the daughter of a

respected and wealthy family, introduced him to the patrician class of Amsterdam. He became active as an art collector, and in 1639 he bought a large house. This happy time of prosperity and of an exalted social position lasted about a decade.

The move to Amsterdam was an important one for his development. It was during his first years in the metropolis that Rembrandt came into closer contact with contemporary High Baroque art, an art in which he finally excelled. Here he discovered the monumental style of Rubens, who had become universally known by the engravings after his work. Now the young Rembrandt dared work consistently on a large scale, and in vigour of realism, as well as

53. Rembrandt: The Anatomy Lesson of Dr Tulp, 1632. *The Hague, Mauritshuis*

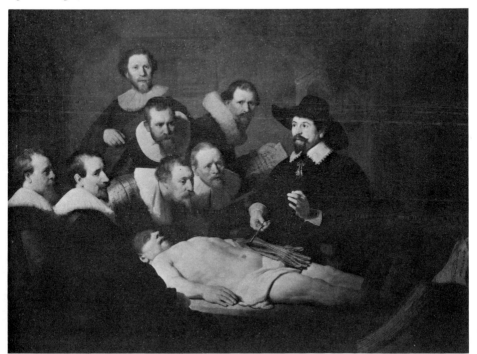

dramatic intensity, he soon outdid his Flemish model. It is a case of a man with a tremendous temperament throwing himself upon the contemporary ideals of his time and rapidly assimilating them. Only after he had mastered them did he become more fully conscious of his own inner leanings.

In Amsterdam Rembrandt's portrait production rapidly rose to unprecedented heights, and apparently there is some truth to the report that people had to beg him as well as pay him for a portrait. As we have noted, Rembrandt only began to work as a professional portraitist about 1631. His earliest dated commissioned portraits (*Portrait of a Scholar*, Leningrad, Hermitage; *Portrait of the Amsterdam Merchant Nicholaas Ruts*, New York, Frick Collection) are both of that year. The *Anatomy Lesson of Dr Tulp* (The Hague, Mauritshuis) [53] of 1632 shows how quickly he surpassed the smooth technique of the fashionable Amsterdam portraitists Thomas de Keyser and Nicolaes Eliasz. This group portrait probably established his reputation immediately. All Amsterdam must have been impressed by the new vitality and pictorial richness he gave to the portraits. The picture still impresses us today by the dramatic concentration of the figures on Dr Tulp's demonstration of a dissection. The corpse is the focus of the composition, by its intense brightness. From here, the eye of the spectator is led to the illuminated heads of the listeners, whose expressions and attitudes reflect different degrees of attention, and to the face and hands of Dr Tulp, who is a most convincing representation of a scholar absorbed in his subject. The illusionism is enhanced by the vivid characterization of the individuals as well as by the artist's great power in dramatizing the moment within a coherent group. Without the strong chiaroscuro and the fine atmospheric quality that is combined with it, the picture would lose its intensity, the sculptural quality of the forms, and all the excitement of the moment. Here,

psychological and pictorial tension combine to create the feeling of an extraordinary event.[7]

Rembrandt received other commissions for group portraits during this period, and for each one he found an original solution (*Portrait of a Couple*, 1633, Boston, Isabella Stewart Gardner Museum; *Jan Pellicorne and his Son Caspar* and *Susanna van Collen and her Daughter Eva Susanna*, London, Wallace Collection; *The Shipbuilder and his Wife*, 1633, London, Buckingham Palace). The majority of his single portraits are half-lengths, some are three-quarter, and there are a few full-lengths. Rembrandt distinguished himself from other Amsterdam portrait specialists by maintaining a high standard of characterization and pictorial execution throughout his vast production. He was able to satisfy the taste of the wealthy burghers for a full description of their elegant

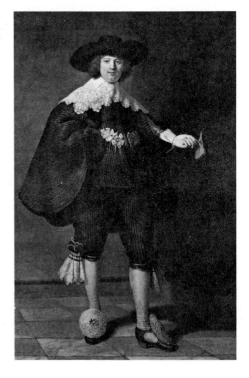

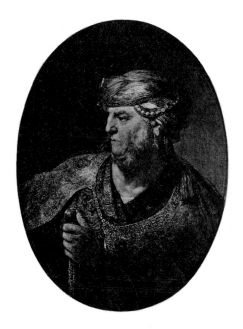

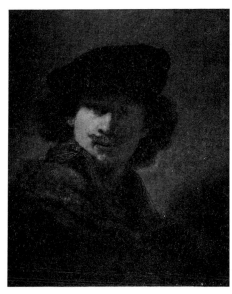

clothes, and could give a precise rendering of lace and embroidery without becoming trivial. Sometimes he enlivened a portrait (*Marten Soolmans*,[8] 1634, Paris, private collection) [54] with a momentary action in the way that Hals did, and he frequently employed his forceful chiaroscuro to enhance the illusionistic effect. There are also from this period character studies of old men and fanciful portraits of Orientals which are often freer in execution than the commissioned portraits. An excellent example is the *Portrait of an Oriental* (1633, Munich, Ältere Pinakothek) [55]. By means of a strong contrast of light and shade, Rembrandt made the powerful head stand out from the pictorial plane with a more pronounced sculptural character than in most commissioned works.

Rembrandt also continued to portray himself year by year. The self-portraits of the 1630s exhibit an air of bold confidence, and some are even aggressive. A few of the etched portraits show a more serious expression, but more characteristic is the intense painting of 1634 in

54 (*opposite*). Rembrandt: Marten Soolmans, 1634. *Paris, private collection*

55 (*above, left*). Rembrandt: Portrait of an Oriental, 1633. *Munich, Ältere Pinakothek*

56 (*above*). Rembrandt: Self-Portrait, 1634. *Berlin-Dahlem, Staatliche Museen*

the museum at Berlin–Dahlem [56]. Here, Rembrandt evidently enjoys the prosperity and enviable position he had acquired in Amsterdam society. He assumes the air of a cavalier, and he dresses himself preciously with his velvet beret and a silky blue-and-yellow scarf over a fur coat. The Baroque element is most obvious now in the forcefully curved silhouette of the figure and the pronounced chiaroscuro effect. By the vertical division of his face into one shadowed and one lit part, he cleverly conceals the inelegant breadth of his face and becomes an acceptable *gentilhomme*. The famous

and rather pompous *Self-Portrait with Saskia on his Lap* (Dresden, Gemäldegalerie) [57], which is related to the Netherlandish tradition of representations of the Prodigal Son in gay company, was painted a year or two later. Husband and wife are turned towards the spectator with an animated expression of gaiety, and the pattern made by the couple has the freshness and irregular lines of a wild flower. The over-rich attire of the figures betrays an extravagance of taste and a parvenu revelling in luxuriant dress which is frequently found in this period. The colours, however, are delicate and restrained. The red, which is a kind of copper colour, is still somewhat pale; a refined blue and yellows occur too. There is also, as we have seen, a touch of Frans Hals in the work. However, there is something forced

Saskia remained Rembrandt's favourite model from the time of their betrothal on 5 June 1633 until her death in 1642. Numerous drawings and etchings give intimate glimpses of the nine years they shared, and they also show her change from a radiant maiden to a sick, frail woman resigned to an early death. Saskia bore three children, who died in early childhood (Rumbartus in 1635, Cornelia I in 1638, Cornelia II in 1640). Only the fourth child, the boy Titus (baptized 22 September 1641), lived to young manhood.

The Baroque spirit of this period is most obvious in Rembrandt's biblical and mythological pictures, which are now often done on a monumental scale. In some cases direct traces of the influence of Rubens can be seen. The celebrated Flemish painter was the idol not

57. Rembrandt: Self-Portrait with Saskia on his Lap, *c.* 1635. *Dresden, Gemäldegalerie*

58. Rembrandt: The Holy Family, 163 [?]. *Munich, Ältere Pinakothek*

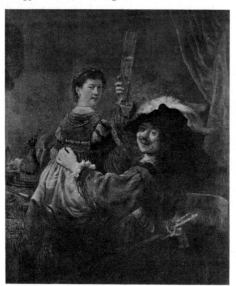

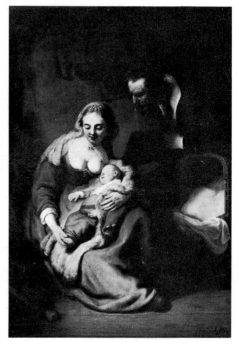

in the laughing face of the painter. Laughter was not as natural to Rembrandt as it was to Frans Hals.

only of Flemish, but also of Dutch society at this time. About 1630 Constantin Huygens called Rubens the greatest painter of the Netherlands. The picture by the Flemish master, among the many he has seen, which Huygens chose to discuss in an account of the history painters of his day was a horrific Medusa head, which created such terror that it was usually covered with a curtain. Huygens and his contemporaries were fascinated by the representation of the terrible and the sanguinary, the drastic and the erotic. They delighted in the display of physical strength and vigorous action in art, and praised the glorification of heroic personalities and grand gestures. No artist surpassed Rubens' mastery of all these effects. The large size and the unusual naturalism of Rembrandt's *Holy Family* (Munich, Ältere Pinakothek) [58], which can be dated in the early 1630s, is the first indication of Rubens' influence. Rembrandt has chosen a moment when the Child has fallen asleep after nursing. As in one of Rubens' paintings, the mother's breast is still uncovered, and Joseph leans over the cradle and watches the scene. The colours are relatively subdued and approach a monochrome effect, as in other works made around this time.

It was probably due to Huygens' efforts that Rembrandt received the enviable commission to paint a series of Passion pictures for the Prince of Orange during the 1630s. The five pictures which make up the series are of the same format and once hung in the Noordeinde Palace at The Hague; all are now in the Ältere Pinakothek, Munich.[9] *The Descent from the Cross* (c. 1633) [59] which belongs to this group is inspired by Rubens' famous picture of the same subject in the cathedral at Antwerp, known to Rembrandt by the engraving of Vorsterman. But Rembrandt's masterly arrangement of the figures in space, his treatment of mysterious light and dark shadow, and his incisive realism, which does not shrink from brutal veracity, have completely transformed

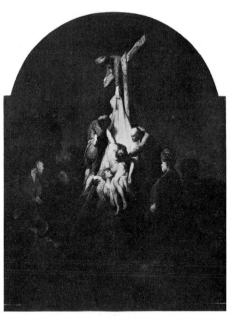

59. Rembrandt: The Descent from the Cross, *c. 1633. Munich, Ältere Pinakothek*

the Flemish master's conception. Rembrandt's picture is closer in spirit to Caravaggio than it is to Rubens. The artist daringly pushed the main action back to the middle distance, where supernatural light breaks the darkness and illuminates the central group. The body of Christ is a pitiful dead mass, sinking down on the shoulder of a supporter, instead of a heroic body with beautiful outlines, and the individual faces are different from the ideal types Rubens used. Rembrandt deepened and intensified the realistic content of the scene by a sharp individual characterization of the emotional reaction of the man devoutly concerned with the painful and complicated task of lowering the corpse. The artist made himself a participant in this scene; the shadowed face of the man on the ladder who clutches Christ's lifeless arm is Rembrandt's own.

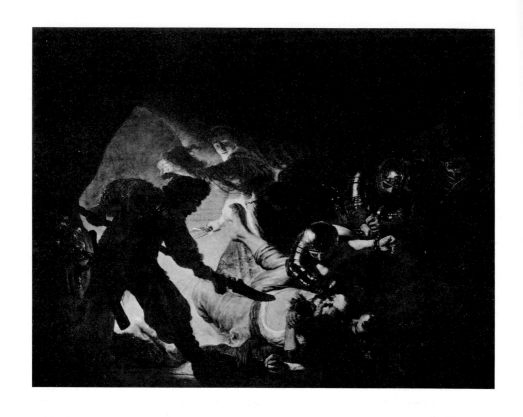

60. Rembrandt: The Blinding of Samson, 1636. *Frankfurt, Städelsches Kunstinstitut*

We know from a letter that Rembrandt sent to Huygens in 1636 that the prince asked Rembrandt to paint three additional scenes from the Passion (an Entombment, a Resurrection, and an Ascension of Christ) after he had received the *Descent from the Cross* and the *Elevation of the Cross*. Six other letters by Rembrandt are known,[10] and, like the first, they are addressed to Huygens and are mainly concerned with matter-of-fact business affairs pertaining to the Passion series. One of them (12 January 1639) contains a rare remark by the master about his own work. Rembrandt wrote that in his pictures of the *Entombment* and the *Resurrection* 'die meest ende die naetuereelste beweechgelickheijt' has been observed. The meaning of this phrase has been much discussed. The passage is interpreted by some students as 'the greatest and most natural movement'. Others follow H. E. van Gelder, who pointed out that seventeenth-century authors frequently use the word 'beweeglijkheid' to express 'emotion' and not 'physical movement'. They interpret the phrase as 'with the greatest and most innate emotion', and argue that Rembrandt wanted to tell Huygens that he did his utmost to express the emotions of the figures in accordance with their characters.[11]

The story of Samson, which had a great attraction for the Baroque public, is prominent in Rembrandt's production during the thirties. He painted *Samson threatening his Father-in-Law* (1635, Berlin-Dahlem, Staatliche Museen), *The Marriage of Samson* (Dresden, Gemäldegalerie), and in 1641 the miraculous announcement of Samson's birth in the *Sacrifice of Manoah* (Dresden, Gemäldegalerie) [68]. His *Blinding of Samson* (1636, Frankfurt, Städelsches Kunstinstitut) [60] more than any other work shows Rembrandt's unrivalled use of the High Baroque style to appeal to his contemporaries' interest in the sensational. It is significant that

Rembrandt presented this lifesize painting to Huygens as a reward for services rendered – probably in connexion with the paintings of the Passion. Rembrandt must have known about Huygens' interest in horrific pictures that had to be covered with curtains. In the letter Rembrandt sent to Huygens with the picture he wrote: 'My lord, hang this piece in a strong light so that one can stand at a distance from it; then it will show at its best.' The picture Rembrandt wanted seen from a distance is his most gruesome and violent work. It represents the bloody climax of the story. Samson has been overwhelmed by one of the Philistines, who has the biblical hero locked in his grip. Samson's right hand is being fettered by another soldier, and a third is plunging a sword into his eye, from which blood rushes forth. His whole frame writhes convulsively with sudden pain. The warrior standing in front, silhouetted against the light in the Honthorst manner, seems horror-stricken. Delila, with a look of terror mixed with triumph, is a masterful characterization seen in a half haze, as she rushes to the opening of the tent. Here again the chiaroscuro adds an element of mystery and pictorial, as well as spiritual, excitement. The whole scale of light, from the deepest shadows to the intense bright light pouring into the tent, has gained in power and gradations over the works of the Leiden period. The scene could not have been represented with more dreadful accents, and Rembrandt may have finished it with the triumphant feeling of having surpassed Rubens' dramatic effects; for this picture was also inspired by a work of the Flemish master: *The Capture of Samson* now at Munich (a painting designed by Rubens and executed by Van Dyck). Rubens chose to represent the moment when the Philistines invade the tent with torches and have caught hold of Samson as he rises from his couch. The herculean giant struggles against his tormentors and Delila

watches the success of her treachery with undisguised joy. But even in the most tense situations Rubens remained faithful to the classical ideals of the beautiful and the heroic. For Rembrandt, the moment of the Samson story chosen by Rubens was not violent enough. At this point of his career Rembrandt knew no restraint and did not shrink from the horrible or the bizarre. However, Rembrandt did not continue to exploit this aspect of the Baroque for very long. He did not represent this episode of the Samson saga again. The *Marriage of Samson* painted two years later shows a happier moment in the life of the Old Testament hero, and there are already indications in it of a softer pictorial atmosphere. The *Sacrifice of Manoah* of 1641, the last picture added to the Samson series, marks the beginning of a radical shift in Rembrandt's style.

Among the mythological subjects, the *Rape of Ganymede* (1635, Dresden, Gemäldegalerie) and the *Danaë* (1636, Leningrad, Hermitage) [61] are outstanding examples of Rembrandt's sense of high-pitched drama and expressive chiaroscuro. Both these pictures, done on a monumental scale, are of extreme originality and uncompromising realism. There have been various suggestions about the subject of Rembrandt's lifesize nude reclining on a bed, but it seems that the traditional title of Danaë is correct.[12] The servant draws the curtain back as if in expectation of a visitor. The fettered crying Cupid decorating the bedstead is an obvious allusion to the heroine's story. The bound Cupid, a symbol of chastity, alludes to the seclusion to which the maiden Danaë was condemned by her father. Rembrandt has substituted celestial light for the traditional golden shower indicating Zeus' arrival. The picture is relieved of an oppressive sensuousness by its pictorial beauty. It is the most attractive painting of this period. A pale golden light glorifies the body of the young woman and lends it warmth and brilliance. The Baroque character is evident in the undulating rhythm of the soft forms of the nude, which are exposed only for a moment. It is also evident in the curvilinear design of all the other objects, the overrich surroundings, the decoration of the bed, and the dramatic manner of illumination. The key of the whole composition is the woman's outstretched hand, which is beautifully illuminated by reflections. It is of the greatest significance for the spatial and pictorial organization of the picture; for it defines the intermediary plane between the nude and the background, and it relates the various light accents to a coherent design. The gesture also has psychological significance: more instinctive than conscious, it can be interpreted as a gesture of invitation for her approaching lover as well as one of protection against the blinding light.

The appearance of landscape painting after the middle of the 1630s coincides with the turn of Rembrandt's style to a softer tonal treatment. Rembrandt's painted landscapes are dominated by his romantic attitude. Most of them are imaginary views of great valleys and mountain ranges, gigantic trees and fantastic buildings and ruins. He reserved a realistic treatment of nature for his drawings and etchings, and some of the sites he depicted in his graphic work have even been identified.[13] We shall see that other seventeenth-century Dutch landscapists combined the romantic and realistic trends in their work, but only Rembrandt seemed to believe that different techniques demand a different approach to nature. In the panoramic landscape with the *Baptism of the Eunuch* (1636, Hannover, Landesmuseum) the influence of Hercules Seghers' imaginary rocky landscapes with half-bare pines clinging to steep slopes is obvious. The *Landscape with an Obelisk* of c. 1638 (Boston, Isabella Stewart Gardner Museum) [62] is a dramatic view with deep emotional undertones. Threatening storm

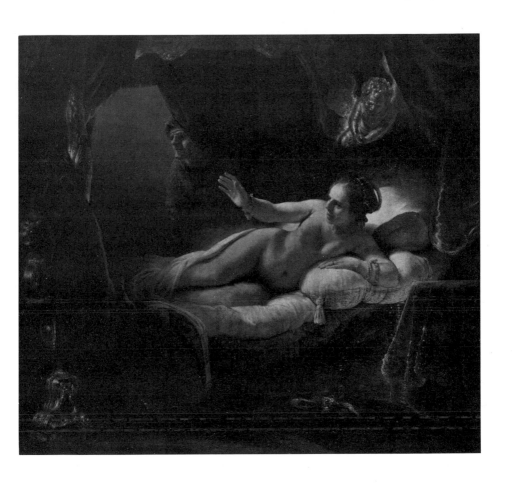

61. Rembrandt: Danaë, 1636. *Leningrad, Hermitage*

62. Rembrandt: Landscape with an Obelisk, *c.* 1638(?). *Boston, Isabella Stewart Gardner Museum*

clouds, pierced by brilliant bursts of warm sunlight, fill the land with darkness. In this work Rembrandt imposes his brilliant Baroque imagination upon nature. The drama of the chiaroscuro does not describe meteorological conditions, but embodies Rembrandt's reaction to the mysterious forces of the sky and the earth. Something of Rubens' exuberant response to nature can be felt, but Rembrandt's landscapes are always more mysterious and less colourful than those of the Flemish master. The colour remains fairly subdued, with a few brilliant contrasts of golden yellow and browns against greens, pinks, and greys.

The bulk of Rembrandt's landscape production sets in only about 1640. By then he must have felt that there was something theatrical and pompous in the High Baroque mode which did not correspond to his inner nature, and he began to oppose it.

THE MIDDLE PERIOD: 1640–1647

Even the greatest artist remains somewhat bound within the framework of his period, and within the general lines of the stylistic development of his century. Rembrandt is no exception. His work and development can be classified with the international development of Baroque art which is marked by its path from the flamboyant High Baroque of the second quarter of the century to more

classicistic achievements. Rubens is the most outstanding figure of the former, Poussin is representative of the latter. Rembrandt develops from one style to the other. This statement, however, only indicates in a very general way his position in the history of seventeenth-century art. For a deeper understanding we must try to discern his individual achievement in both these phases. This has been attempted in the discussion of Rembrandt's work of the 1630s. It is more difficult with his production of the forties, because at this time Rembrandt is much more unusual than he was at the beginning of his career, and it will be still more difficult in his last phase.

For the artist the years from 1640 to 1647 are a time of transition. At first the Baroque and classical tendencies run side by side and interpenetrate, but finally, about 1648, the latter gain precedence. It goes without saying that Rembrandt never became a classicist, but we shall see that during the forties he accepted certain classical devices which give a more adequate expression to his inner mood than the exuberance of his earlier style. But the Baroque character is not eliminated: it lives on in a deepened chiaroscuro and an increasingly fluid painterly treatment. This formal development is paralleled by an emotional change from ostentatious loudness and dramatic violence to stillness and calm. Tragic experiences in Rembrandt's life during this period – the death of his wife Saskia in 1642 and his decreasing professional popularity – are generally considered responsible for Rembrandt's decisive turn to the introspective, to a greater intimacy of feeling, and to a deepening of religious content. These events must indeed have had some influence on his development – although it should be emphasized that romantic biographers have exaggerated Rembrandt's loss of patronage during this decade. There is not a scrap of evidence to support the story that the men who commissioned the

Night Watch, completed in 1642, condemned it. Of course there is no question that in this painting Rembrandt's tremendous imagination broke the traditional way of representing a militia company; but we lack any proof that his patrons were dissatisfied and refused to accept it. On the contrary: contemporary records prove that Rembrandt was handsomely rewarded for it. Each man who figures in the composition paid him about 100 guilders; thus he received around 1,600 guilders for the picture. We also know that the *Night Watch* was never hidden in some obscure place. It hung in the great hall of the headquarters of the Amsterdam harquebusiers (the *Kloveniers-doelen*), where it was exhibited with militia pieces by other painters until 1715, when it was moved to the town hall of Amsterdam. The picture was trimmed probably to fit its new location; a horrible, but not an unusual fate for works of its dimension. Moreover, Rembrandt continued to receive important commissions after he had painted the *Night Watch*. In 1646 the Prince of Orange paid him 2,400 guilders for a small picture of the *Adoration of the Shepherds* (1646, Munich, Ältere Pinakothek) and a *Circumcision* (now lost). The fee the prince gave the artist was a good one if one considers what he was paid for the *Night Watch*. We shall also see that Rembrandt continued to have important patrons at home and abroad during the last decades of his life.

What then was the case? Did Rembrandt have an appreciative public and ample reward for his genius during his mature years? The answer is no. The legend about the refusal of the *Night Watch* veils a truth. The mature Rembrandt did not enjoy the success he had as a young painter. A shift in the appreciation of his work by his contemporaries did indeed take place: but the *Night Watch* did not cause it, and the alteration was neither as dramatic nor as complete as some of his critics have maintained.

There was a change of taste in Amsterdam during the 1640s, when the bright colours of Van Dyck and a superficial elegance came into fashion, and Rembrandt's former pupils followed this path with success. The new vogue must have made the dark manner of Rembrandt's pictures look old-fashioned. The fact that Rembrandt was now approaching the ripeness of middle age, which generally brings a more objective, calmer, and more comprehensive outlook upon life, should not be overlooked: it helps to explain his increased subtlety of feeling during this period. Rembrandt sought and began to find ways to establish the mood of a picture by more sensitive pictorial treatment of chiaroscuro, atmospheric effects, and colour. He became more concerned with man's inner life than his outer actions. Not many of his contemporaries were prepared

63 (*opposite, above*). Rembrandt: Six's Bridge, 1645. Etching

64 (*opposite*). Rembrandt: View on the Bullewijk looking towards Ouderkerk, c. 1650. Drawing. Chatsworth, Devonshire Collection

to follow him on this road, but Dutchmen still considered him one of their greatest masters, and Rembrandt's name continued to come easily to the lips of those of his countrymen who wanted to make a show of their knowledge of the arts.

Rembrandt began a more intimate study of landscape during these years. This new preoccupation seems to have given him inner balance as well as a broader outlook. Unhappy circumstances at home may have stimulated him to work out of doors. He roamed around the environs of Amsterdam, where he made drawings and etchings which capture the breadth of the Dutch plain and the brightness and airiness of the Dutch sky with an unprecedented economy of touch. An example of Rembrandt's masterly landscape etchings of the period is the so-called *Six's Bridge* of 1645 [63]. There is a tradition that Rembrandt made it in the neighbourhood of Burgomaster Jan Six's country house as the result of a wager that he would be able to finish it during the time a servant was sent to fetch mustard for a picnic. The story may be an invention, but the fact that Rembrandt succeeded in showing all the essential features of a landscape with the utmost brevity cannot be denied. Even the wind in the air is expressed by his suggestive touch. The numerous landscape drawings made during the forties are equally impressive. They are mostly pen-and-brush studies expressing the spaciousness, the diaphanous atmosphere, and the shimmering light of the homely Dutch countryside with matchless sensitivity [64]. The late landscape drawings grow bolder, the technique becomes more summary, and structural features are stressed without loss of luminosity or atmospheric effect. A few realistic painted landscapes date from the middle period. Outstanding is the tiny *Winter Scene* [65] of 1646 now at Kassel, which has the spontaneity and freshness of the etchings and drawings

after nature and seems to be a direct study of the effects of cold air and winter light. But it is an exception. In the main, Rembrandt's rare landscape paintings (less than twenty are known) are imaginary ones of a visionary character.

Substantial things came out of Rembrandt's experience with nature. The softer chiaroscuro of the forties was probably formed upon his open-air studies, and their atmospheric qualities soon appear throughout his work. Even the portraits begin to gain in spaciousness and transparency of tonality, and in so doing they show a deeper understanding of the sitter within his environment. The *Self-Portrait leaning on a stone Sill* of 1640 (London, National Gallery) [66] shows the new mood of the period as well as the new stylistic tendency. The artist still represents himself in precious attire, as he did formerly. He wears a richly embroidered shirt and a heavy fur-trimmed velvet coat. More important, however, is the seriousness, the reserved and critical glance of the man who has abandoned all signs of vanity and of sensational appeal to the spectator. The illumination serves to achieve a more objective rendering of his face, which is shown with unrestricted honesty. The arrangement of the figure is also changed. It is no longer close to the front plane, but recedes behind a stone sill. The figure has a firmer outline and can almost be inscribed into a triangle having the sill as a base.

65. Rembrandt: Winter Scene, 1646.
Kassel, Staatliche Gemäldegalerie

66. Rembrandt: Self-Portrait, 1640. *London, National Gallery*

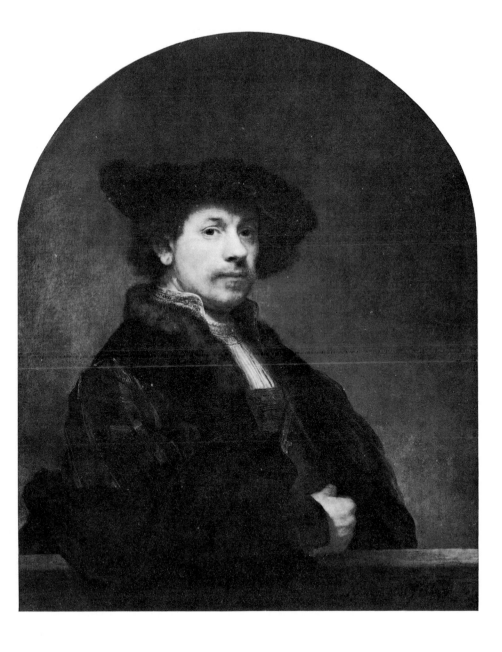

Instead of stressing the sweeping curvilinear silhouettes of the 1630s, here Rembrandt repeatedly emphasized the horizontal: in the sill, the position of the arm leaning on it, the main accents of the face, and even the position of the cap. These repeated horizontals lend the picture stability, firmness, and calm. This, as we have seen, is the period when classical influence makes its first appearance in Dutch painting, and in this particular portrait we know of definite links with Italian Renaissance art. There are reminiscences of Raphael's portrait of *Baldassare Castiglione*, now in the Louvre, which Rembrandt had seen at an auction in Amsterdam in 1639. He made a quick pen sketch of it (Vienna, Albertina) and noted the price the picture fetched, as well as the total amount of the sale. In the same year Rembrandt based an etched self-portrait on that sketch (Bartsch 21), but the London *Self-Portrait* of 1640 comes closer to the essence of Raphael's style than either the immediate sketch made after the Castiglione portrait or the etching. The buyer of Raphael's painting at the Amsterdam auction in 1639 was Alphonso Lopez, who worked as an agent in Holland for the French crown. Around 1640 Lopez also owned Titian's so-called *Ariosto* and *Flora*. There can be little doubt that Rembrandt had a chance to study both these pictures, as well as the Raphael. Distinct traces of the *Ariosto* are evident in the *Self-Portrait* of 1640 in the National Gallery, and also in his *Falconer* of 1643 (London, Trustees of the second Duke of Westminster); and the influence of Titian's *Flora* is seen in the *Portrait of Saskia* of 1641 (Dresden, Gemäldegalerie).[14]

Self-portraits were not very frequent during these years. A few, which follow the one in London, reflect in their rather sceptical expression the artist's unsettled condition. In the *Self-Portrait* of about 1645 (Karlsruhe, Kunsthalle) some Baroque features seem to be revived in the picturesque clothing of the artist, who even decorates himself with pearl earrings. This romantic vein of Rembrandt's art never disappears. Again and again he wishes to see himself or his subjects in a world of fantasy and of higher pictorial beauty. More significant than the rich trappings is his rather sad and slightly depressed expression. Saskia's death must have been a cruel blow. The posthumous portrait of her, dated 1643, in the museum at Berlin-Dahlem is a souvenir of the happy years they spent together. It is no accident that Rembrandt painted it on a rare, expensive mahogany panel – a support he seldom used. The painting is different from the etching (Bartsch 359) of a year earlier, which probably shows Saskia in the last stages of her illness. With admirable objectivity, Rembrandt renders her exhaustion in the etching.

During the year of Saskia's death, in 1642, Rembrandt finished his largest and most famous picture, the *Night Watch* [67]. The correct title of this masterwork, now at the Rijksmuseum, Amsterdam, is *The Company of Captain Frans Banning Cocq and Lieutenant Willem van Ruytenburch*. Its popular title is based on a false interpretation by early-nineteenth-century critics. The picture represents a day, not a night scene. This became very clear when the colossal painting was cleaned and stripped of its dark varnish and dirt shortly after it was taken from the shelter where it had been hidden during the Second World War. At that time journalists promptly baptized the picture 'The Day Watch'. But there is no foundation for that title either. As far as we know, the civic guards represented did not go out on day or night watches. However, the misinterpretation is understandable because of Rembrandt's brilliant transformation of the traditional Amsterdam group portrait into a highly animated, unified composition. Before the picture was cleaned the forceful chiaroscuro, as many will still remember, gave indeed a nocturnal effect.[15]

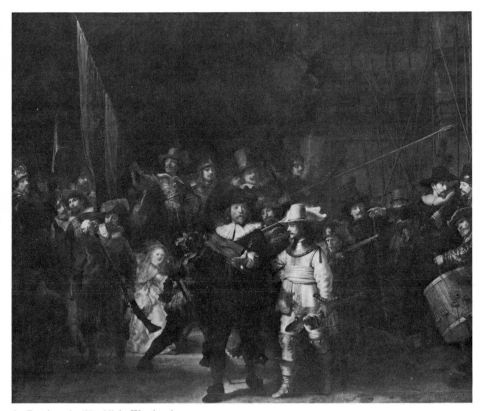

67. Rembrandt: The Night Watch, 1642.
Amsterdam, Rijksmuseum

Rembrandt's dynamic interpretation raises an insignificant event to a historical spectacle of extraordinary pictorial splendour. There is a maximum of action, with complex motion deeply set into space yet vigorously united by a dramatic chiaroscuro with intense colour accents. Light and shadow are powerfully contrasted, and in different degrees. Most effective is the centre group of the captain and lieutenant. These two figures, who appear to head the departure of the company, are also the focus of the colouristic arrangement. A brilliant lemon-yellow in the uniform of the lieutenant, a warm orange-red in the sash, and a deep black in the suit of the captain form the main accord. The red is repeated in the man with the gun on the left and in the drummer on the right. The brilliant yellow recurs in the figure of the girl running through the middle distance. There are some tints of blue and golden olive, and the whole background shows a golden olive-brown tone. Rembrandt gives the impression of increased activity by a variety of movement and direction in this large composition, which represents a revolutionary conception of a traditional subject in Dutch painting. It is easy to understand why Rembrandt's pupil Samuel van Hoogstraten singled it out for special

mention when he discussed the question of composing pictures in a handbook published for artists and dilettanti in 1678. Hoogstraten wrote that painters should not place their figures next to each other in a row, as one sees in so many Dutch militia pieces. True masters, Hoogstraten maintained, unify their work: 'Rembrandt did this excellently in his militia piece in Amsterdam . . . this work, no matter how much it can be censured, will survive all its competitors, because it is so painter-like in thought, so dashing in movement, and so powerful that, according to some, all the other pieces there [in the *Kloveniersdoelen*, where it hung] stand beside it like playing cards.'[16]

The Baroque effect of the *Night Watch* must have been even greater before the composition was cut on all four sides. Old copies of the picture show that the greatest loss was on the left, where two additional men and a child behind a parapet were once visible. In its original state the impression must have been of a much greater spaciousness around the figures, with a wider display of diagonals and also a wider range of chiaroscuro, better organizing the composition and lending it greater recession as well as dramatic pictorial life. A comparison with the *Anatomy Lesson of Dr Tulp* of a decade earlier shows the advance Rembrandt had made, and the change of style. The different character is not only conditioned by the greater multitude of figures: a new and more complex spatial and pictorial design is involved. The spatial design of the *Night Watch* is also more clearly thought out. The ground plan reveals a zigzag formation, a familiar Baroque device to lead the eye forward and back into space. As for the arrangement in depth, a succession of four planes constitutes the framework. This is most clearly distinguishable in the area where the composition opens up towards the brightly illuminated figure of the running little girl on the left. The first plane is marked by the glove that dangles from

Captain Cocq's outstretched hand; the second by the gun of the rifleman and the foot of the boy running to the right; the third by the little girl; and the fourth by the standard bearer above and behind her. Rembrandt has left no doubt about the extension of these four planes to either side, or their relation to one another, while in the *Anatomy Lesson* such spatial clarity is not attained. With it goes a higher compositional order, in which we should not overlook, in spite of the predominantly Baroque character, the slight classicistic elements that come into the composition through the three-fold division of the architecture in the background. It sets the group off on either side from the advancing stream of men in the centre.

About the same time that Rembrandt's High Baroque tendencies reached a climax in the *Night Watch*, he formulated in the *Sacrifice of Manoah* (1641, Dresden, Gemäldegalerie) [68] a composition of classical calm and simplicity, the first grand example of this new tendency. The painting announces the turn of the master's taste from vehement noise to silence, from external dramatic effect to inward contemplation, from Baroque entanglement to classical clarity. It is also the first monumental religious painting by Rembrandt that emphasizes the inner reactions of biblical personages to a miracle, instead of the sensational aspects of a supernatural occurrence. Manoah and his barren wife are represented offering their thanksgiving. A stranger has announced to them the birth of a male child, the future hero Samson. The very moment the sacrifice flames up, the divine messenger vanishes in the upper left corner. Deeply affected by the sanctity of the incident and dazzled by the heavenly appearance, the man and woman have closed their eyes and lifted their hands in prayer. It is a moment of silence and profound devotion. The new classical simplicity becomes obvious in the construction of the group, which is bound together in a triangular pattern. Within this group Rem-

68. Rembrandt: The Sacrifice of Manoah, 1641. *Dresden, Gemäldegalerie*

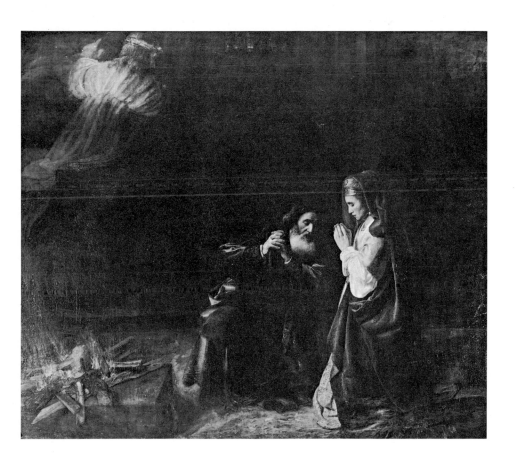

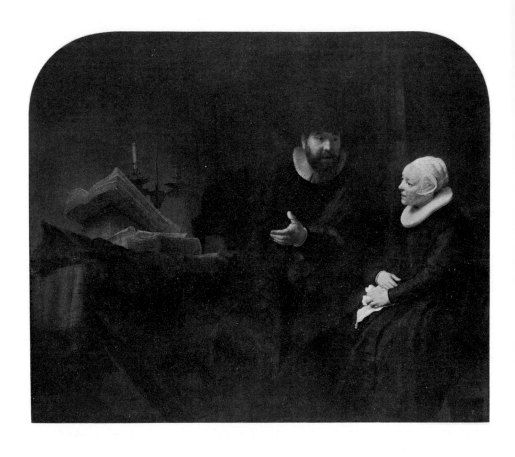

69. Rembrandt: The Mennonite Preacher Cornelis Anslo and a Woman, 1641.
Berlin-Dahlem, Staatliche Museen

brandt has given Manoah's wife the more prominent and static position. She is also more exposed to the light coming from the upper left corner, and she is distinguished by a strong colouristic accent of lemon yellow and deep red before a warm brownish background, an effect similar to that of the centre group of the *Night Watch*. Rembrandt probably made some radical changes in this painting after 1650. There is reason to believe that in the original version, the angel of the Lord who ascends in the flame was not included, and only a shaft of light symbolized the divine occurrence.[17]

Another picture of the beginning forties on a monumental scale is the portrait group of the *Mennonite Preacher Cornelis Anslo and a Woman* (1641, Berlin–Dahlem, Staatliche Museen) [69]. Rembrandt represented the preacher talking to a woman who holds a handkerchief in her left hand. He seems to be consoling her. The great Bible lies open on the table together with other books and a candle; this still-life part of the picture is distinguished by a fine play of light and shadow in golden brownish tones above the warm red of the tablecloth. On the other side, the most intense light is given to the head and hands of the woman. Rembrandt shows the moment when she begins to forget her sorrow and feel the effect of the preacher's words. It is a brilliant characterization of inner life. Here Rembrandt seems to have painted the kind of 'speaking portrait' which impressed his contemporaries so very much; he has suggested the power of Anslo's speech as well as giving a likeness. Rembrandt apparently has accomplished precisely what Vondel, Holland's greatest seventeenth-century poet, admonished him to do in the epigram he published in 1644 about a portrait of Anslo by Rembrandt:

O, Rembrandt, paint Cornelius' voice
The visible is the least important part of him:
The invisible one only learns through the ears.
He who wants to see Anslo must hear him.[18]

We have noted already that commissioned portraits were less frequent during the forties. Those from the beginning of the decade excel by their elegance and the golden warmth of their tonality. The companion pieces of *Nicolaas van Bambeeck* (1641, Brussels, Musées

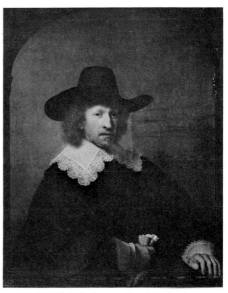

70. Rembrandt: Nicolaas van Bambeeck, 1641.
Brussels, Musées Royaux des Beaux-Arts

Royaux des Beaux-Arts) [70] and his wife *Agatha Bas*[19] (1641, London, Buckingham Palace) show how Rembrandt began to soften the chiaroscuro effect. The figures do not leap out conspicuously into the foreground: they recede into the circumambient air. The transparent atmosphere that surrounds them is characteristic of the period, and, as so often happens during the following decades, his subjects have been placed between the light and shade – precisely where the transition between the two takes place – and their faces have been given life by tender half-tones. The chiaroscuro has not only lost all hardness;

71. Rembrandt: The Visitation, 1640. *Detroit, The Detroit Institute of Arts*

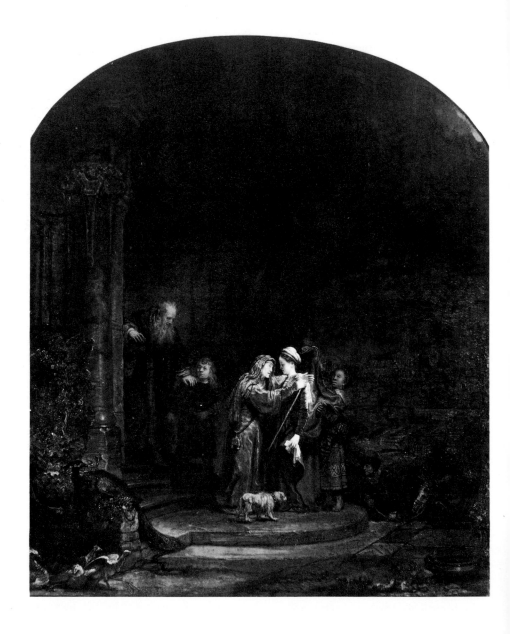

it creates a broader and more intimate union of figure and space. A kind of human atmosphere has been created. By the middle of the decade we already meet the unusual depth of characterization and the pictorial richness of the later portraits. A number of these are subjects chosen by the artist rather than commissioned works. Portraits of old men and of Jews begin to predominate.

Whether he deals with the Holy Family or episodes from Christ's childhood or from the Old Testament, Rembrandt's biblical representations during this phase show in general a preference for quiet, intimate, and tender scenes. Drama is not excluded (*Susanna and the Elders*, 1647, Berlin–Dahlem, Staatliche Museen), but the emphasis is shifted from outward action to inward reaction. Landscape settings often widen the scene and contribute to the expressive mood. This trend is announced in the *Visitation* of 1640 (Detroit, The Detroit Institute of Arts) [71]. Mary has crossed the mountains, and the happy moment of her arrival at the house of Zacharias and Elizabeth is represented. A negro servant takes off the mantle of the visitor. Old Zacharias lumbers down the stairs of his great house, aided by a boy, to greet his wife's cousin, and a friendly dog sniffs at the newly arrived guest. The intense light which falls upon Mary and Elizabeth focuses attention upon the glances exchanged by the pregnant women, and the dark shadows soften the realistic detail. It is a beautiful example of Rembrandt's easy, unburdened way of telling a story. Other biblical subjects of the middle phase also show Rembrandt's change to a more temperate style. The *Reconciliation of David and Absalom*[20] (1642, Leningrad, Hermitage) [72] represents the moment when rebellious young Absalom is forgiven by his father. Absalom weeps on the breast of the king, who does not lose his dignified attitude and embraces his son with a

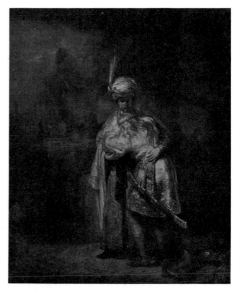

72. Rembrandt:
The Reconciliation of David and Absalom, 1642.
Leningrad, Hermitage

wonderful fatherliness. The two are given up to a moment of deep emotion. The colours contribute to the tenderness of the scene. The fair blond hair of the prince and the light pinks and lilacs of his dress are surrounded by transparent brown and olive tones in the background which are characteristic of the period.

The domestic happiness and intimacy denied to the master in his own home by Saskia's illness and her early death are created now in pictures of the Holy Family. This subject and other representations of the childhood of Christ occur frequently during the forties. The *Holy Family* (1640, Paris, Louvre) which shows the Virgin nursing the Child is already considerably less overpowering in size than the pictures Rembrandt made during the thirties under Rubens' influence [cf. 58]. The *Holy Family with Angels* (1645, Leningrad,

Hermitage) [73] glows with human warmth; small details contribute to this effect. A burst of divine light accompanies the angels who invade the chamber to witness the scene from the

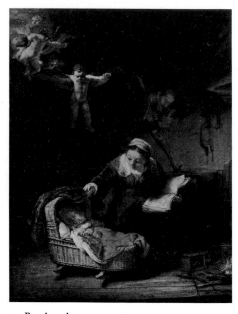

73. Rembrandt:
The Holy Family with Angels, 1645.
Leningrad, Hermitage

74. Rembrandt:
Two Women teaching a Child to walk, *c*. 1640.
Drawing. *London, British Museum*

75. Rembrandt:
Study of Lioness, *c*. 1641. Drawing.
London, British Museum

everyday life of the Holy Family. The tenderness of the young mother's movement accords with the deep, warm colours, among which the cherry-red of her skirt is the strongest accent. Another representation of the same subject made a year later (Kassel, Gemäldegalerie) is equally pervaded with the happiness of peaceful family life. This small picture is a rare case of pointed illusionism in the middle period; for the frame and curtain are painted too. The Virgin is seated before the cradle near a little fire to warm her feet. A cat crouches ready to snatch the remnants in the bowl. Joseph is working with an axe. Rembrandt convinces us that all this takes place in a humble interior sanctified by faith.

The representations of the Holy Family of the 1640s show that one thing remained permanent, even in this period of transition: Rembrandt's ever-increasing interest in and deepening observation of life around him. This quality comes out most strikingly in the master's drawings. In the quick chalk sketch of *Two Women teaching a Child to walk* (London, British Museum) [74] Rembrandt made a distinction between the old woman, who can only follow the child in a slow and bent attitude, and the mother, whose posture expresses youthfulness and elasticity. The structural quality which Rembrandt develops in his middle period is evident here in the powerful straight lines and the blocklike figures. It is combined with accents on all vital points, such as the anxious expression of the baby's face and the attention of the two women. Nobody but Rembrandt could express so much with so little. The drawing of a *Lioness* (British Museum) [75] is another example of a study from life from this period. The lioness holds food between her paws, but she still looks as if she wanted another victim. There is tension in her body and keenness in her glance. Her head is bent over, watching. An enormous vitality and force are conveyed with a few powerful strokes

of black chalk. Without a similar vitality in the master's own nature he would not have been able to seize the character of his subject with such striking forcefulness. Power and sensitivity are found side by side in Rembrandt's work of the middle period. Both qualities were to continue to increase and lead to the final height of his art and the fullest expression of his humanity in his mature phase.

THE MATURE PERIOD: 1648-1669

There is an aspect of Rembrandt's art which cannot easily be explained by an analysis of his composition, colouring, and pictorial methods. This is particularly true of the works made during the mature period. We feel there is something of a deeper meaning that lies behind their formal qualities, something we must grasp if we are to fathom the art and personality of this great master. What is it?

Rembrandt opened a new field in the history of painting. It is the world which lies behind visible appearances, but is, at the same time, implied. It is the sphere of the spirit, of the soul. One may ask, with good reason, what is this spiritual element? The terms 'spirit' and 'soul' are perhaps too vague; they can be interpreted in many ways. And we must admit that it is as difficult to give a simple, direct answer as it is to define the meaning of these words in connexion with Rembrandt's art. Perhaps, if we approach the question in an indirect way and consider the limitations of this spiritual sphere, and note what is not of interest to Rembrandt, in contradistinction to other artists, we may touch the centre of the problem.

It is worth noticing that Rembrandt usually does not express in the physiognomies of his subjects – especially in the mature stage of his art – either the power of the will or superficial emotions. In portraits like the one of an *Old Woman in an Armchair* (1654, Leningrad,

76. Rembrandt: Old Woman in an Armchair, 1654. *Leningrad, Hermitage*

Hermitage) [76] or of the *Man wearing a gilt Helmet* (Berlin-Dahlem, Staatliche Museen) [77], none of the forces that make up the so-called active life, by which we build our social position and careers, are accentuated. During his mature phase, the *vita activa* was of secondary importance to Rembrandt. He stresses what lies behind man's exterior activity and emphasizes the more contemplative side of life which is the domain of the spirit. This side, which is less conditioned by any social standard, is not always apparent, but men of every rank and station may possess it. Extremely revealing in this connexion is the magnificent picture of *Two Negroes* (1661, The Hague, Mauritshuis), which brings no suggestion of a stereotyped conception of a Negro – something that even Rubens and Van Dyck could not always avoid; in both heads Rembrandt has captured the spiritual and moral substance of these men.

77. Rembrandt: Man wearing a gilt Helmet, *c.* 1650–2. *Berlin-Dahlem, Staatliche Museen*

Our inner spirit is a very elusive element. As the Latin word *spiritus* suggests, it is a breath, deep-seated and concealed, easily disturbed and troubled by the forces of external activity. Nevertheless, the inner part of our life is the more basic one of our existence. And to this quality, which can be called the soul, the great religious leaders, above all Christ, have appealed. Rembrandt was born with a new, deep, and unique sense of it, and was able to probe with rare concentration through the external appearance of human beings, forcing us to participate with him in this, their most precious substance.

We have already noted that Rembrandt's development follows the international trend of the Baroque style, which proceeded from a flamboyant High Baroque phase to a more classicist one. The late Rembrandt, however, went far beyond contemporary and national ideals. He adopted, in a very personal and selective way, only those classical qualities which were of a deeply human value and corresponded to his own nature. Besides his peculiar classical tendency, the deepening of his conception of Christianity is an outstanding feature of his mature period. Both these tendencies have been fundamental in the development of Western civilization through the Middle Ages into modern times. They are still the main pillars of Western culture. The mature Rembrandt takes a definite and very personal attitude towards each of these basic conceptions. His synthesis of the two into a higher unity

78. Rembrandt: Christ healing a sick Person, *c.* 1655. Drawing. *Berlin-Dahlem, Kupferstichkabinett*

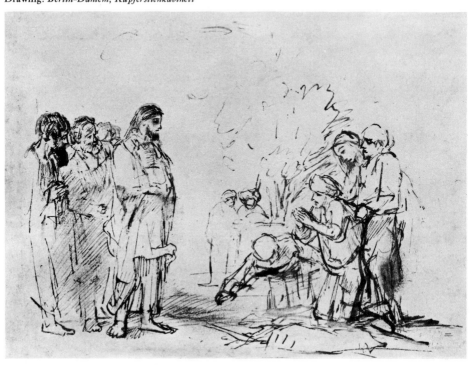

can be considered the real content of his late works – and in this synthesis the Christian element predominates, while the classical one only contributes some essential features.

The classical element can be studied in Rembrandt's beautiful pen-and-brush drawing of *Christ healing a sick Person* (Berlin–Dahlem, Staatliche Museen, Kupferstichkabinett) [78], which he made about 1655. A feature immediately apparent in the drawing is the dignity and nobility of the figures and the attitude of Christ, which recalls the great Renaissance masters, particularly Titian. However, one feature, which usually accompanies classical art, is missing: there is not a trace of a purely formal attitude. None of the figures seems to have struck a pose. Rembrandt's Christ does not gesticulate. He is silent, and the impression He creates on those around Him reflects His inner qualities. Another element of classical origin characteristic of the late works is the monumental character of the composition in this drawing. The simplicity of the rectangular formation of the left group and of the triangle in that of the right affords a great clarity and firmness. These qualities are, however, softened by a wonderful atmospheric treatment and are integrated with the spatial design. Rembrandt avoids the schematic abstraction and the rigidity of a strictly geometric formation often found in classical compositions. He also avoids the strict linear manner to which conventional classicists adhere. His line is interrupted, and the rhythm of the whole group is slightly broken. The dissolved forms add tonal accents and are imbued with atmospheric implication. They link the figures to the space around them. In brief, the mature Rembrandt avoids the posed attitudes, the rigid abstraction, and the isolation of the classical ideal. He takes only those formal elements which are suited to increase the monumentality, simplicity, clarity, and the ethical features of dignity, nobility, and calm. His character, it seems, prevented him from adopting any features of a conventional or academic nature.

Rembrandt's devotion to the chiaroscuro principle, which dominates his art from the very beginning, and to which he subordinated even the colourism of his late years, is another reason why he could never accept the classical style except for certain selected features. The concept that such intangible elements as light and shade are the most essential means of pictorial expression was thoroughly unclassical. For Rembrandt, the chiaroscuro device became a guiding stylistic principle by which he expressed not only pictorial, but also spiritual values. His development shows a steady increase in this direction in his portraiture as well as in his religious art. In his early paintings, for example the *Anatomy Lesson of Dr Tulp*, the chiaroscuro served primarily to dramatize the representation from the outside; it is a kind of sharp spotlight effect which Rembrandt derived from Caravaggio's Dutch followers. In his mature works the chiaroscuro is as powerful as it was during the thirties, if not more so. Intense lights are combined with the deepest shadows and have been deliberately interwoven into a rich harmony of tones, subtle and strong, and at the same time colourful and transparent. Rembrandt takes advantage of his earlier achievements, but lifts them to a higher plane. One great example is *Jacob blessing the Sons of Joseph* (1656, Kassel, Gemäldegalerie) [97]. Here, light and shade seem to be independent of an outside source, and take on a more ideal meaning. Faces, figures, costumes appear to glow from within wherever their significance requires special attraction. A general atmosphere is created in which we become aware of the most subtle inner emotions.

Rembrandt's colour, as well as his chiaroscuro, remains thoroughly unclassical. His colouristic power increases tremendously during his last period, although not all of his mature

79. Rembrandt: The Jewish Bride, *c.* 1666. *Amsterdam, Rijksmuseum*

80. Rembrandt: Family Portrait, *c.* 1668.
Brunswick, Herzog Anton Ulrich Museum

works display it; some of the single portraits remain largely monochromatic. Both the so-called *Jewish Bride*[21] (*c.* 1666, Amsterdam, Rijksmuseum) [79] and the *Family Portrait* (*c.* 1668, Brunswick, Herzog Anton Ulrich Museum) [80] belong to his most brilliant colouristic creations. Even in black-and-white reproductions it is possible to see something of the fluctuating quality of his late paint, the vibration of the tones and the harmonious fusion of the whole; but, of course, they can hardly suggest the brilliance and warmth of the fiery scarlets, the golden yellows, the delicate blues and olives, the powerful whites and deep blacks of his late palette. In both

pictures, the broad, calm, relief-like arrangement of the lifesize half-figures recalls a certain type of Venetian Renaissance painting. This reveals a touch of classical taste, but the use of colour in these portraits is quite unclassical. The classical function of colour is primarily a decorative one. In the works of Raphael, Poussin, or Ingres, colour is added in fairly flat areas of localized hues. With the mature Rembrandt, a radical change takes place. Rembrandt's colour not only acquires increasing warmth and intensity; it becomes a living, moving, substance which ebbs and flows through space. The fluctuating character of his colours, which is in a way very similar to

the interrupted line of his drawings, goes far beyond the limited function of colour in classicist art. It produces the impression of a dynamic inner connexion between all substances, and links the subjects with their mysterious dark background and even with infinite space. Rembrandt's ingenious brushwork also contributes much to the colouristic effect. He combines bold impasto passages with a subtle glazing technique, and this creates an up-and-down, or push-and-pull movement in the relief of the paint which heightens the floating character of the late works. Thus, it is chiefly in his colour and chiaroscuro that the Baroque dynamism lives on in his paintings, but it is restrained by a classical simplicity and dignity of setting.

During his last decades, Rembrandt's personal life was not an easy one. The sad situation at home after Saskia's death was not improved by the presence of Geertghe Dircx, a trumpeter's widow who served as a nurse for his young son Titus. She caused a great deal of trouble. On her dismissal in 1649 Rembrandt agreed to pay her a modest monthly pension, but Geertghe demanded more in a breach-of-promise suit. A decision was made in her favour and Rembrandt became vindictive; there is good reason to believe that he was responsible for having Geertghe arrested and confined to a women's reformatory in Gouda in 1650. Her friends managed to procure her release in 1655. The last known reference to Geertghe is found in the list of Rembrandt's creditors compiled in 1656 when the artist declared himself insolvent.[22] More comfort was brought into Rembrandt's life by the companionship of Hendrickje Stoffels, the daughter of a soldier. She seems to have joined his household about 1645 – or perhaps a few years later; the first reference to her is dated 1649 when she gave evidence on Rembrandt's behalf during the course of the artist's tribulations with Geertghe. Hendrickje remained, one may say, as his

second wife, although this relationship was never legalized because of certain conditions set forth in Saskia's will. A second marriage would have deprived Rembrandt of the badly needed income from Saskia's estate. In 1654 Hendrickje gave birth to a daughter, Cornelia, who was baptized on 30 October. On 25 June of the same year Hendrickje had been called before the church authorities because of her illegal relationship with the painter. She confessed, and was admonished and punished, but continued to live with the artist. There is every reason to assume that Hendrickje helped Rembrandt in many ways to overcome the problems of his later years. All the numerous portraits he made of her show a quiet, warm-hearted woman with rather attractive features. Her portrait at Berlin–Dahlem [81] excels by its compositional strength and rich pictorial beauty. Accents given to the window-frame

81. Rembrandt: Hendrickje Stoffels, *c.* 1658-60. *Berlin-Dahlem, Staatliche Museen*

upon which she is leaning impart a great firmness. Both her arms – one resting on the sill, the other pressed against the end of the frame – emphasize the tectonic character of the composition. In contrast, the movement of her head and the soft, deep glance of her eyes are most expressive. The mature Rembrandt knew how to combine an easy naturalness with greatness of style. The firmness of the composition is also softened by the warm depth and the broad fusion of the colours, among which a deep red contrasted with golden yellows, black, and white are predominant. After Hendrickje, the person he portrayed most frequently during this period was his son Titus. The portrait of 1655 (Rotterdam, Boymans-Van Beuningen Museum) [82] is the earliest identifiable one. Few portraitists have been able to suggest in pictures of venerable philosophers surrounded by a

82. Rembrandt: Titus, 1655.
Rotterdam, Boymans-Van Beuningen Museum

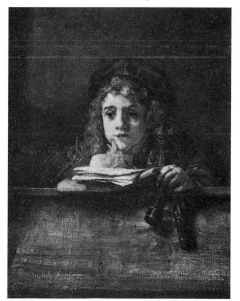

scholar's paraphernalia anything like the contemplative mood Rembrandt conveys in this portrait of his fourteen-year-old boy.

Serious financial troubles developed for Rembrandt about the middle of the fifties. Debts had accumulated upon his house. He borrowed more to avert disaster, and in 1655 he bought another, smaller house, partly in exchange for works of art. If the artist hoped to restore his situation by such speculation, it was in vain. In 1656 he had to transfer his large house in the Jodenbreestraat to Titus in order to save his son's inheritance, which had been entrusted to him. For the removal of debts on the house Rembrandt had to pledge all his property, resulting in the declaration of his insolvency. To avoid bankruptcy, Rembrandt asked the authorities to grant him a *cessio bonorum* (*bodelafstand*), a less degrading procedure, often granted on the basis of losses at sea. He received this permission, and the liquidation of his property was ordered. The inventory of his entire estate, drawn up on 25 July 1656,[23] gives a detailed insight into his extensive collections. Results of the public auctions of his effects, which took place in 1657 and 1658, were very disappointing. The proceeds were not enough to enable Rembrandt to pay off his debts. However, Hendrickje and Titus managed to protect him from his creditors by forming a business partnership in 1658 as art dealers and by making Rembrandt their employee. He had to deliver his entire production to them in return for their support. By this stratagem, the artist was able to save the earnings from his work.

Even a cursory examination of Rembrandt's collection as described in the 1656 inventory is instructive. The size of it suggests that his passion for collecting may have been partially responsible for his financial difficulties. There were arms, costumes, bowls, and baskets from the Far and the Near East, and things imported from Turkey, Persia, and Holland's new

colonies. One section consisted of natural curiosities: shells, minerals, antlers, a lion's skin, a stuffed bird of paradise, and other objects which were found in Renaissance and Baroque *Kunst- und Wunderkammern*. Sculpture was not wanting. Ancient busts of the Roman emperors are listed, and it is noteworthy that Rembrandt had them arranged in a room in chronological order; this is not the only evidence which suggests that he was interested in the study of ancient history. A *Small Child* (*Kindeken*) by Michelangelo is also listed; it may well have been a cast of the Christ Child from Michelangelo's group of the Madonna and Child at Notre Dame in Bruges. As for paintings and the graphic collection, the range was wide. The paintings include masters of the Italian Renaissance and the Early Netherlandish schools as well as contemporary Dutch masters. The names of Raphael, Giorgione, Palma Vecchio, Jacopo Bassano, Van Dyck, and Lucas van Leyden are met. By Adriaen Brouwer there were paintings and also a sketchbook. Among the Dutch seventeenth-century painters there were works by his teacher Lastman, and by Jan Pynas, Hercules Seghers, Lievens, Porcellis, de Vlieger, and others. Naturally, the various categories of Rembrandt's own work were represented. Three pictures by his son Titus are also listed; none of Titus' paintings have been identified, but two drawings can be attributed to him.[24] The graphic section contained prints by Mantegna and Lucas van Leyden, by Schongauer, Van Meckenem, Cranach, and Holbein. There were engravings after Michelangelo and Titian. The Bolognese school was represented by the Carracci and Guido Reni; the Netherlandish school included artists who ranged from Heemskerck, Frans Floris, and Pieter Bruegel to Rubens and Jordaens; Hendrick Goltzius and Abraham Bloemaert represented the Dutch Mannerists. There were only a few books – among them an old Bible, the *Jewish History* of

Flavius Josephus with woodcuts by Tobias Stimmer, and Dürer's treatise on *Human Proportions*. It was altogether an enormous accumulation, which shows that Rembrandt was truly a man of his time in his susceptibility to the curious, the exotic, and the picturesque, and that he availed himself, as an artist, collector, and probably as an art dealer, of the endless opportunities which the international art-market of Amsterdam offered. We have already seen that Rembrandt learned from Renaissance masters. We may also assume that his draughtsmanship was somewhat influenced by the spontaneous pen sketches of Adriaen Brouwer. That he owed much to Hercules Seghers' imaginary landscapes has never been doubted. But on the whole, as one might expect of an artist of Rembrandt's strong inner direction, the search for influences coming from his collections has not been very rewarding. A good example is Rembrandt's etching *Ecce Homo* (Bartsch 76), completed a year before the inventory was made. It has frequently been noticed that this print was influenced by Lucas van Leyden's *Ecce Homo* of 1510. The differences, however, between the works by Leiden's two greatest artists are more significant than the similarities, and the connexion which can be established between the two prints is excellent proof of Rembrandt's independence rather than of his dependence.

The last decade of Rembrandt's life brought no relief in his economic situation, and these were the years when the artist had to suffer most serious blows in his family life. Of the two large commissions which he received at the beginning of this decade, the group portrait of the *Syndics of the Drapers' Guild* (1661/2, Amsterdam, Rijksmuseum) [89] may have had some success, but the monumental painting of the *Conspiracy of Julius Civilis*, done for the town hall of Amsterdam, apparently did not meet with favour. It was hung in place for a short time, then was taken down,

and was finally replaced by an uninspired work by one of his pupils. Only a fragment of this important painting has survived (Stockholm, National Museum) [90]. However, Rembrandt still produced portraits in fair numbers, and it seems that many of these were commissions. There was also some demand for his work abroad. Don Antonio Ruffo, a Sicilian nobleman who lived in Messina, ordered a painting of a philosopher in 1653. Rembrandt sent him the incomparable *Aristotle with the Bust of Homer* (1653, New York, Metropolitan Museum) [83]. In 1661 Ruffo acquired an *Alexander the Great* (unidentified) from the artist, and in 1663 the *Homer* now in the Mauritshuis, The Hague, entered his collec-

83. Rembrandt: Aristotle with the Bust of Homer, 1653. *New York, Metropolitan Museum of Art*

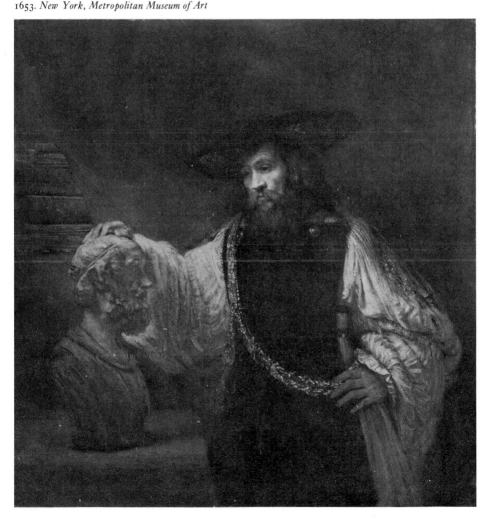

tion. The Sicilian collector ordered and received 189 of the master's etchings in 1669, the year of Rembrandt's death. But on the whole Rembrandt's late years must have been solitary and lonely ones. After his large house was sold, he moved with Hendrickje and Titus to one in the Rozengracht, in one of the poorer districts of Amsterdam. The devoted Hendrickje fell ill; she died in 1663. Titus continued to help his father, but he, too, was sickly around this time. The haunting expression in the pale portrait made of him during these years (Paris, Louvre, on loan to the Rijksmuseum, Amsterdam) presages his early death. Soon after Titus' marriage with Magdelena van Loo on 16 February 1668, he died. He was buried on 7 September 1668, and his property went to his young widow. A posthumous daughter, Titia, was born to Magdelena, and at the baptism in March 1669, Rembrandt was present as godfather. The artist's death came six months later, on 4 October 1669. He was buried on 8 October in the Westerkerk of Amsterdam.

The tragic events of the last years did not have an adverse effect upon his work. On the contrary, as outward circumstances became more difficult, his art gained in spiritual depth and power of expression. An artist who did not possess Rembrandt's extraordinary ethical and moral strength would probably have been crushed rather than inspired by the experiences Rembrandt had during his late phase. The self-portraits of the period are particularly revealing as to the maturity of his personality and art. The moods vary from a most assailable sensitiveness [84] to majestic calm, and from philosophic irony [85] and superiority to a mellow resignation. The late self-portraits are on the level of the greatest achievements of self-characterization in literature. They rank

84. Rembrandt: Self-Portrait, 1661.
Amsterdam, Rijksmuseum

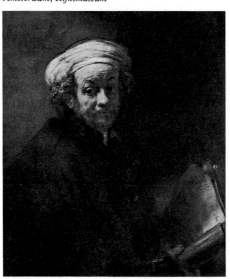

85. Rembrandt: Self-Portrait, *c.* 1665-8.
Cologne, Wallraf-Richartz Museum

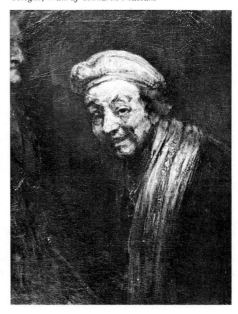

with the *Confessions* of Augustine or Jean-Jacques Rousseau's *Confessions*. Although closer in time to Rousseau, the late self-portraits seem to stand half-way between the autobiographies of these two; they show the humility of the great Christian thinker, and the directness and sincerity of the prophet of the Enlightenment.

In the *Self-Portrait* painted in 1659 (Washington, National Gallery of Art, Mellon Collection) [86], a man mightier than he appeared in any of the earlier ones speaks to us through a greater breadth of composition, a richer pictorial treatment, and, not least, the increased power and softness of the chiaroscuro. The light seems to glow from within. A rich inner life and many tragic experiences have left their mark on his features and have ennobled his expression. An imposing objectivity speaks from this self-analysis. The muscles of his face have already slackened, but, at the

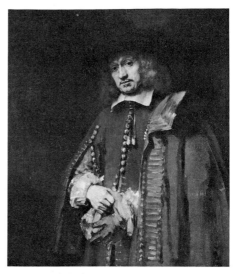

87. Rembrandt: Jan Six, 1654.
Amsterdam, Six Collection

86. Rembrandt: Self-Portrait, 1659.
Washington, National Gallery of Art

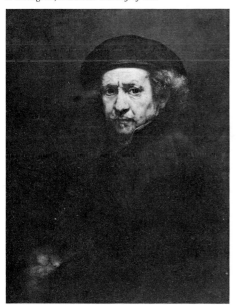

same time, an extraordinary sensitivity is evident. The old Rembrandt's eyes have grown large and dominating. They betray a most vulnerable human being, but we also feel that sorrow has deepened his understanding and human sympathy. We sense that he is free from resentment, self-pity, and any trivial sentimental reaction.

A number of commissioned portraits were made during the fifties and sixties, and some of these rank among the highest achievements of European portraiture. Particularly impressive are the *Portrait of a Young Man* (Portrait of Clement de Jonghe (?), Buscot Park, Lord Faringdon), *Nicolaes Bruyningh* (1652, Kassel, Gemäldegalerie), and the famous *Jan Six* (1654, Amsterdam, Six Collection) [87]. In the *Jan Six*, one of Rembrandt's most informal portraits, the colouristic splendour dominates the chiaroscuro effect. The distinguished Amsterdam burgomaster, humanist, and con-

noisseur wears a grey coat with gold buttons. His scarlet, gold-braided mantle is casually draped over his shoulder. He is pulling on – or taking off – his chamois glove. The greys form a beautiful contrast with the bright reds, gold, and creamy whites. But more moving than the matchless colouristic harmonies in this portrait and the freedom of the broad brushwork is Rembrandt's psychological grasp of the instant when a man's gaze has turned from the outer world to his inner self. The companion portraits of the last decade of the *Man with Gloves* and the *Woman with an Ostrich Fan* in the National Gallery at Washington show a further increase in power of characterization, and rich pictorial treatment, and even more impressive are the companion pieces in the Metropolitan Museum of the *Man with a Magnifying Glass*[25] and the *Woman with a Pink* [88]. The veiling and revealing function of chiaroscuro is employed in these portraits, as

88. Rembrandt: Woman with a Pink, *c.* 1665.
New York, Metropolitan Museum of Art, Altman Bequest

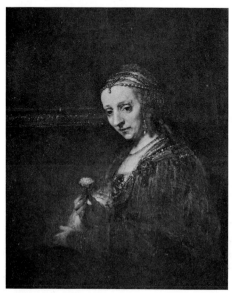

it is used in the late religious works; it helps to create a deep and comprehensive mood. This mood is sometimes characterized as meditative. But that term seems inadequate, because it refers chiefly to the work of man's brain, whereas in Rembrandt's late works, one senses that feeling plays the dominant role. One is reminded of Rembrandt's great contemporary, the French philosopher Pascal, who made the distinction between *raison* and *cœur* and put the work of the latter higher than that of the former.

The *Syndics of the Cloth Drapers' Guild* (1661/2, Amsterdam, Rijksmuseum) [89], Rembrandt's largest portrait commission during his late years, is an ideal solution of the principal problem of painting a portrait group. Equal importance has been given to each of the syndics, yet the whole is united by ingenious psychological and formal means. The subtle composition, the glowing colouristic harmonies, and above all the sympathetic interpretation and profound psychological grasp of the personalities of the six men make this Rembrandt's greatest group portrait. The total impression is of delicately adjusted harmony and tranquillity. An X-ray examination of the picture shows how Rembrandt struggled to attain the impression of equilibrium.[26] While he worked on the painting he shifted all the figures, but the person with whom he experimented most was the servant. He tried placing him in two different positions on the extreme right, he posed him between the two syndics on the right, and finally gave him his place, after taking some liberties with the laws of perspective, above the two seated syndics in the centre of the picture. Rembrandt brilliantly exploits horizontals – a classical rather than a Baroque device – for the unification of the group. Three horizontals run through the picture at almost equal intervals: the edge of the table and the arm of the chair at the left mark the lowest one; the middle one is established by the prevailing

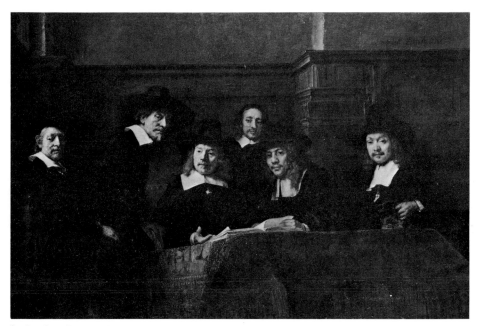

89. Rembrandt:
The Syndics of the Cloth Drapers' Guild, 1661/2.
Amsterdam, Rijksmuseum

level of the heads; and the upper one runs along the edge of the wainscoting. But here again Rembrandt avoids all formal rigidity. These repeated horizontals are broken by sharp deviations on all three levels. The sharpest is in the group itself, in the strong curve of the heads on the left. With a kind of contrapuntal effect, this movement is echoed by the slight rise in the upper horizontal on that side. While this style of composition is similar to the relief-like manner of grouping favoured by artists who worked in the classical tradition, there is an increased effect of space and atmosphere by Rembrandt's use of chiaroscuro and colour. The harmonies are definitely on the warm side. A flaming red in the rug on the table, which is the most outstanding accent, is interwoven with golden tints. Golden browns reappear in the background, in the panels of the wall, and within these warmly coloured surroundings the strong blacks and whites in the men's costumes have a noble and harmonious effect.

The traditional interpretation of the *Syndics* is that the men were shown seated on a platform, before the assembly of the Drapers' Guild whose governors they were, and that they are giving to the assembly — unseen by the viewer – an account of the year's business. The syndic seated near the centre of the picture makes a gesture with his right hand which most seventeenth-century observers understood immediately; the gesture was a standard one employed by orators demonstrating evidence. H. van de Waal[27] has shown, however, that such annual gatherings and accounts were not usual among the guild; and that therefore the often repeated interpreta-

tion that the syndic on the left is rising to deal with someone making a disturbance in the audience must be wrong. But even if this assumption is discarded, the fact remains that the rising man's posture is a very momentary one. In addition, they all look at one point. It cannot be denied that the rising man adds substantially to the illusion that the group is reacting spontaneously to somebody in front of them. And since this object of attention cannot be somebody in an imaginary assembly, it must be the entering spectator. So Rembrandt was not only concerned with giving an ordinary illusion of a gathering, but dramatizes it slightly by aiming at the very moment of the spectator's appearance. Such pointed illusionism would have endangered a lesser master. Not so with Rembrandt. He always endowed his group portraits with dramatic tension, and here the mature Rembrandt successfully combined it with the general impression of tranquillity. While the momentary diversion from their work brings an animating element into the syndics' gathering and configuration, it is still the profound characterization of the group and of each individual which prevails.

Side by side with portraiture, history painting remained Rembrandt's most productive field during the mature period. In genre painting and in landscape there are only a few works, but these, like the powerful picture of a *Slaughtered Ox* (1655, Paris, Louvre) and *The Mill* (Washington, National Gallery), are remarkable for their originality. Among the historical paintings relatively few represent scenes from classical mythology and history; the vast majority have biblical subjects. Of classical subjects, the *Aristotle with the Bust of Homer*, the *Alexander*, and the *Homer*, made for export to Sicily, have already been mentioned. Other impressive single figures are the late representations of *Lucretia* (1664, Washington, National Gallery; 1666, Minneapolis,

Institute of Art). The greatest of all his works representing a scene from ancient history is the *Conspiracy of Julius Civilis* (1661/2, Stockholm, National Museum) [90], also already referred to.

When the great classicistic town hall was built in Amsterdam in the 1650s, the city fathers agreed to decorate the lunettes of its great corridors [313] with episodes from the story of the revolt of Julius Civilis, the Batavian, who led an insurrection against the Romans in A.D. 69. The choice of subject was not an unusual one. Seventeenth-century men frequently made parallels between episodes from the Bible or ancient history and events of national history. For Dutchmen, their successful revolt against Spain, initiated under the leadership of William the Silent, was prefigured by Julius' rebellion; according to Rembrandt's contemporaries, Julius was the prototype of William. Rembrandt's pupil Govert Flinck, not the master himself, was originally asked to execute this vast project. Flinck prepared sketches, and on 28 November 1659 was commissioned to execute twelve pictures for the gallery of the town hall. Eight lunette paintings were to represent scenes from the revolt of the Batavi, and four others were to show heroes who performed noteworthy deeds for their country, as David and Samson did among the Hebrews and Marcus Curtius and Horatius Cocles for the Romans. Thus biblical and classical patriots, as well as early national heroes, were chosen as prefigurations of the recent victory of the Dutch over the Spanish monarchy. Flinck died on 2 February 1660 before he could make much progress on the scheme. The commission was then distributed among several artists. Jan Lievens and Jacob Jordaens were asked to paint scenes early in 1661, and probably in the same year Rembrandt received his order to paint the first episode of the story of the revolt. According to Tacitus (*Historiae*, IV, 13), the conspiracy began when Julius Civilis, the mighty chieftain who was disfigured by the

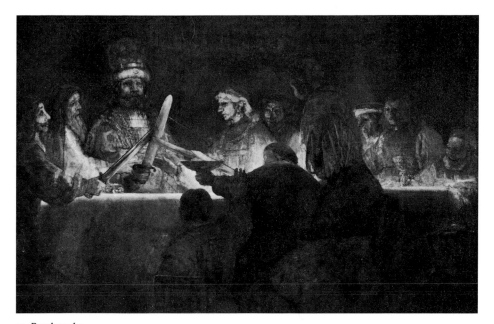

90. Rembrandt:
The Conspiracy of Julius Civilis, 1661/2.
Stockholm, National Museum

loss of one eye, 'summoned the chief nobles and the most determined of the tribesmen to a sacred grove. Then, when he saw them excited by their revelry and the late hour of the night, he began to speak of the glorious past of the Batavi and to enumerate the wrongs they had suffered, the injustice and extortion and all the evils of their slavery.' Julius Civilis' impassioned speech inciting his countrymen to revolt 'was received with great approval, and he at once bound them all to union, using the barbarous ceremonies and strange oaths of his country'. The night scene made by the acknowledged master of nocturnal painting shows the Batavi taking an oath on Julius Civilis' sword. This idea was an original one; Tacitus' reference was merely to 'barbarous ceremonies and strange oaths'. Although the sword oath was

not unknown in the seventeenth century – both Vondel and Shakespeare make reference to it – other artists who represented this subject showed the Batavi sealing their oath with a hand-shake. Rembrandt's colossal picture (it filled a space about 18 ft by 16 ft) was in the town hall by 21 July 1662. Shortly after it was mounted, it was removed, and it was never returned to the lunette for which it was designed. By 1663 its place had been taken by a painting by Juriaen Ovens, a weak pupil of Rembrandt's, who completed the composition Flinck left un-finished at his death. Ovens' picture is still *in situ*. Rembrandt's picture was cut down, probably by the master himself, to make it more saleable. Rembrandt made some changes in the fragment, which is only the central group of the original picture, to make it a

91. Rembrandt: Preparatory drawing
for the Conspiracy of Julius Civilis, 1661.
Munich, Staatliche Graphische Sammlung

unified whole. A single precious preliminary drawing[28] (1661, Munich, Graphische Sammlung [91] gives us an idea of his majestic conception for one of the most monumental historical pictures ever painted. Rembrandt's preparatory drawing shows that he set the night scene in a huge vaulted hall with open archways, and not in the sacred grove which Tacitus described. The change in setting was an important one, enabling Rembrandt to give his composition the architectonic grandeur and spaciousness which helped to emphasize the drama of the scene. Earlier masters of European monumental wall decoration often used architectural settings to attain similar effects. Rembrandt's unique achievement – if we can judge from the small sketch and the fragment of the picture – was to subordinate the architecture to his dramatic chiaroscuro and phosphorescent colouring. Thus for the first time an artist achieved monumentality in a large wall painting primarily by pictorial means. In the preparatory drawing the dis-

tribution of light and shade is of great importance for the total effect, and in the fragment of the painting, which has lost its architectural setting, the eerie light and shadow and the iridescent greyish blues and pale yellows are even more important in bringing out the mysterious barbaric character of the conspiracy.

One cannot help wondering what the gallery of the town hall of Amsterdam would look like if Rembrandt had been commissioned in 1661, when he was at the peak of his power, to paint all the pictures of the series. If he had received the commission, he surely would have created a great climax of monumental Baroque painting. His series would be as famous as the grand-scale compositions Rubens painted for Marie de Medici, and perhaps even more impressive. Apparently the city authorities had no idea of the opportunity they missed. Even the single work they commissioned from Rembrandt did not remain in place. Why was it removed? The answers which have been given to this question are not above dispute, and unfortunately the relevant documentary evidence is meagre and vague. A lengthy contract signed by Rembrandt on 28 August 1662 states that one of his creditors shall receive one-quarter of everything which Rembrandt should earn on the 'painting delivered to the town hall, and of any amounts on which he (van Rijn) has claim, or stands to profit by repainting [*verschildering*] or might in any other way be benefited, however this might befall'. If this document refers to the Julius Civilis painting,[29] it seems that the city officials wanted some changes made in the picture. We can only conjecture what adjustments might have been asked for. However, it is not difficult to imagine that the picture did not suit men who followed the classicistic vogue which became popular in Holland around the middle of the century. Identification with the heroes of one's national history was an acceptable idea, but Rembrandt's conception of the ancient heroes was probably

too brutal to suit all the city fathers of Amsterdam. Learned critics could also argue that Rembrandt failed to meet one of the principal tenets of classistic art theory in a history painting designed for the most important building of the Netherlands: he showed men as they are, instead of as they ought to be. Moreover, his critics could maintain that he lacked decorum.[30] They probably stated that Rembrandt should have depicted the one-eyed Julius Civilis in the way that Apelles, the renowned painter of Antiquity, painted King Antigonos, who was also blind in one eye. Apelles devised a means of hiding the king's infirmity by presenting his profile, so that the absence of the eye would be attributed merely to the position of the sitter and not to a natural defect. But there is also reason to believe that some of Rembrandt's contemporaries were not disturbed by his departure from the generally accepted notions about history painting. After all, he was given the commission; and in 1661 no one in Amsterdam could have been very surprised that Rembrandt did not concoct a conventional classical confection for the town hall. However, there was apparently enough powerful opposition to manage to have the work replaced by Ovens' dull composition.

It is to the biblical pictures that we must turn to see Rembrandt's greatest contribution during his mature period. The deepening of the religious content of these works is connected with some shift in his choice of biblical subjects. During the thirties Rembrandt had used the Bible as a source for dramatic motifs; for example, the *Blinding of Samson*. In his middle phase he turned to more calm and intimate subjects: the *Sacrifice of Manoah*, the *Reconciliation of David and Absalom*, and scenes from the life of the Holy Family. At the beginning of the mature period the figure of Christ becomes pre-eminent. Scenes taken from the life of Jesus, quiet episodes of His youth, His preaching and the deeds of His

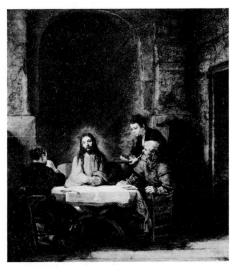

92. Rembrandt: Christ at Emmaus, 1648. *Paris, Louvre*

early manhood, and His resurrection form the main subject of the biblical representations. The emergence of the mature style is marked by works like *Christ at Emmaus* (1648, Paris, Louvre) [92], in which Rembrandt expresses the character of Jesus without any concrete action or noisy stage-like effect. A moment before He was merely a man about to break bread with two pilgrims. Now He is the resurrected Christ whose tender presence fills the room. Without any commotion, Rembrandt convinces us that we are witnessing the moment when the eyes of the pilgrims are no longer 'held, that they should not recognize Him'. A great calm and a magic atmosphere prevail, and we are drawn into the sacred mood of the scene by the most sensitive suggestion of the emotion of the figures, as well as by the mystery of light which envelops them. The monumental architectonic setting lends grandeur and structure to the composition, and the powerful emptiness of the architectural background is enlivened by the fluctuating, transparent chiaroscuro

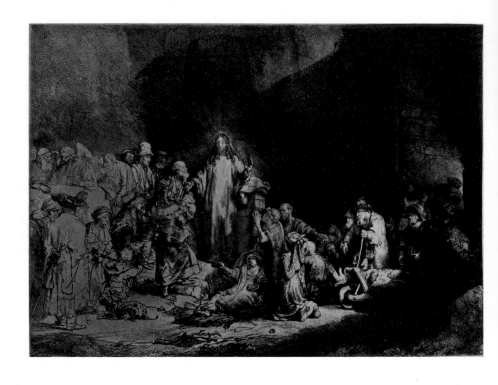

93. Rembrandt: Hundred Guilder Print, *c.* 1648–50. Etching

and the tender spiritual character of the light around Christ Himself. A simple pathos and a mild, warm feeling emanate from His figure. Nothing could be farther from the conspicuous theatricality of the works of the thirties.

There is good reason to connect Rembrandt's tender conception of Christ during his mature period with the teachings of the Mennonite sect. According to Baldinucci, one of the artist's seventeenth-century biographers, Rembrandt was a Mennonite, and it is known that he was in close contact with Cornelis Anslo, a famous Mennonite preacher of Amsterdam. In 1641 Rembrandt made an etching (Bartsch 271) of Anslo, and in the same year he made the impressive double portrait of the preacher and a woman (see p. 107, illustration 69). In Rembrandt's day the Mennonite sect was a liberal one which discarded the sacerdotal idea, accepted no authority outside the Bible, limited baptism to believers, and held to freedom of conscience. Silent prayer was a feature of their worship. They emphasized precepts which support the sanctity of human life and man's word and, following the Sermon on the Mount, they opposed war, military service, slavery, and such common practices as insurance and interest on loans. Compared with the severe Calvinists, the Mennonites represented a milder form of Christianity in which, according to the literal sense of the Sermon on the Mount, the leading principle was 'Love thy neighbour'. This spirit permeates Rembrandt's most famous etching, the so-called *Hundred Guilder Print* [93], which can be dated about 1648–50. Rembrandt began to make studies for this celebrated print earlier, but in its main types and in its final decisive achievement the etching belongs to the beginning of the mature period. The popular title, which is found in the literature as early as 1711, is derived from the high price the print is said to have fetched at a sale. According to an anecdote recorded by the eighteenth-century art dealer and collector P. J.

Mariette in his *Abecedario* it was Rembrandt himself who paid this sensational price for an impression of his own print. The etching illustrates passages from Chapter 19 of the Gospel of St Matthew. Rembrandt treated the text with liberty; he merged the successive events into a simultaneous one, with Christ in the centre preaching and performing His miracles. According to the text, Christ had come from Galilee, a large multitude following, and He began to preach, healing the sick. The crowd look to the Lord, waiting for their turn to be healed. Near the centre, to the left, a young mother with a child advances to Jesus. St Peter interferes, restraining her, but Christ makes a counter-movement. It is the moment when he says the famous words: 'Suffer the little children, and forbid them not, for of such is the kingdom of heaven.' In addition, this chapter of St Matthew contains the story of the rich youth who could not decide whether or not to give his possessions to the poor and follow Christ's teachings. The young man is seen sitting to the left, in rich attire. Here too, on the upper left, are the Pharisees, arguing among themselves, but not with Jesus, as in the text. A warmth of feeling seems to emanate from Him, spreading balm on the suffering souls of the sick, the poor, and the humble. The spell of devoutness and the intimate spiritual union of the composition are mostly due to a general atmosphere of wondrous light and shade that hovers and spreads over the whole scene. It is a light that by its infinitely subtle gradations and floating character transforms the transcendent sphere into reality. A miracle which binds visible energies with the invisible and the sublime is performed before our eyes.

The types of the Pharisees in the *Hundred Guilder Print* are of a more genuine Jewish countenance than those Rembrandt represented in his early works. Late in the forties he began to watch Jewish people more carefully, and to

characterize them more deeply than before. Rembrandt had the opportunity to study the Jewish population of Amsterdam. From the time he purchased his large house in the Jodenbreestraat in 1639 until he was forced to sell it in 1656 he lived on the edge of the largest Jewish community in Holland. Among his Jewish acquaintances were the distinguished Rabbi Manasseh ben Israel, and the physician and writer Ephraim Bonus; he made portraits of both men. His intense familiarity with the physiognomies of the Spanish Jews (the Sephar-

authentic in his biblical representations. He found among them inspiration for mildly passive and emotional characters, and he also studied the harder and more intellectual types, who show the perseverance of the Jews and furnished models for his figures of the Pharisees. The painting of *King David* (1651, New York, Louis Kaplan Collection) was probably derived from a study of a Jew. Even more remarkable is the series of portraits of Jesus made around the same time which are based on Jewish models [94]. Rembrandt, it seems, was

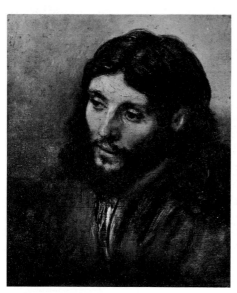

94. Rembrandt: Head of Christ, c. 1648-50. *Berlin-Dahlem, Staatliche Museen*

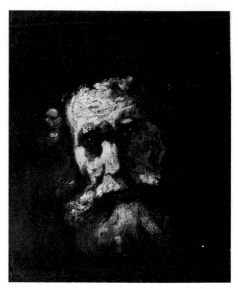

95. Rembrandt: Study for St Matthew, c. 1660. *Bayonne, Museum*

dim) and the Eastern Jews (the Ashkenazim), who were allowed to live in Amsterdam in relative freedom during the seventeenth century, helped him to enrich his biblical representations. His interest in them was not merely a romantic and pictorial one. To Rembrandt the Jews were the people of the Bible, and with his deepening realism he wanted to become more

the first artist to derive his Christ-type from a personal study of Jews. How intently he continued to observe their physiognomies is seen in the set of four small oil sketches [95] (Bredius 303; the others are Bredius 302, 304, 305) made as preparatory studies for the head of St Matthew in the famous picture at the Louvre, dated 1661 (Bredius 614).

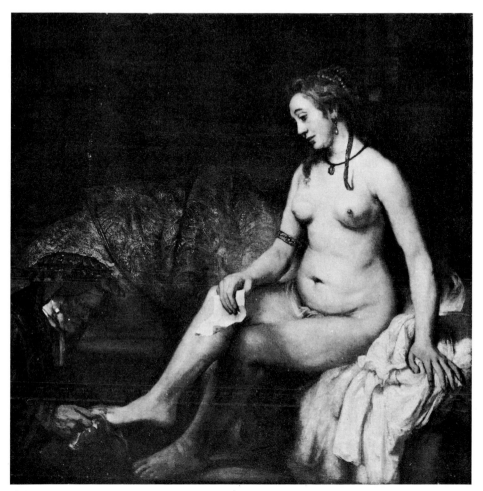

96. Rembrandt: Bathsheba, 1654.
Paris, Louvre

Although a basic change in his Christian attitude does not occur, the spirit of Rembrandt's religious works shifts about the middle of the 1650s. As early as 1653 his religious art begins to show a more gloomy cast. In contrast to the mild, harmonious tenor of the works made at the beginning of the mature period, a sombre atmosphere now prevails. It is hard to relate this shift to the teachings of a specific religious sect. The new mood can no longer be connected with the doctrines of the Mennonites. Rembrandt probably based his profound and highly personal interpretations of Scripture in his late biblical pictures upon his own experiences and his deepened sense of reality. Realism had long been the domain of

Dutch art: but it was only the late Rembrandt who could extend it to the reality of the innermost life, to the invisible world of religion. One can notice the beginning of the new tragic mood in the monumental etching of the *Three Crosses* of 1653 (Bartsch 78), where the emphasis is on the suffering of Christ, on the drama of Golgotha, and the mystery of His sacrifice. It is true that scenes from the youth of Christ, His miracles, and the events following the Resurrection continue to appear in the etchings and drawings; but in the paintings themes from the Old Testament become more frequent, and they seem to be imbued with a sombre undertone. This is the mood of the lifesize painting of *Bathsheba* (1654, Paris, Louvre) [96]. Hendrickje probably served as the model for the picture. Bathsheba, the beautiful wife of Uriah, is shown holding the letter which King David sent commanding her to come unto him (2 Samuel 11). She will comply with David's wishes, but tragedy is inevitable. David will arrange for Uriah to be killed, and the child conceived by Bathsheba in adultery will be struck by the Lord and will die. Rembrandt captures every overtone of the tragic Bible story - from the pain of consciousness of sin to the desire of the flesh - in the tension he builds up between Bathsheba's reverie and the warmth and weight of her nude body. Most marvellous is the soft and mellow painting of the flesh. The expression of its solid form, which anticipates the heaviness of Courbet's nudes, is combined with the unmatched brilliance and breadth of treatment of the late works. As always, the formal qualities are linked with naturalness. The effect of David's letter upon Bathsheba is shown in the inclination of her head and her meditative mood, which is expressed in a wonderful relaxation throughout the whole figure. Her attitude reveals the forms of her body with great clarity, and her position is almost inscribed within a triangular scheme. A classical touch is also noticeable in the tec-

tonic quality of the figure, which has a static fullness and calm. But the intent of the picture has nothing to do with the classical idea of the nude. Raphael, Titian, or Rubens painted the female nude to show their conception of ideal feminine beauty. Theirs was a delight in the body made exquisitely perfect. Rembrandt's *Bathsheba* was primarily painted to show the mood and innermost thoughts of a woman. There is no precedent for his conception.

One of Rembrandt's most moving religious works is *Jacob blessing the Sons of Joseph* (1656, Kassel, Staatliche Gemäldegalerie) [97], which was painted in the year he was forced to sell his house and treasures. This important picture, which is one of his largest biblical paintings, reflects nothing of that personal tragedy. It is relatively serene - the blond tonality contributes much to this effect - yet profoundly spiritual. The scene represents the last hours of the old and almost blind patriarch Jacob. Joseph has brought his two young sons, Manasseh and Ephraim, to be blessed by his father. The children kneel in childish awe and curiosity. Jacob laid his right hand upon the head of fair Ephraim, the younger son, first. When Joseph saw this 'it displeased him and he held up his father's hand, to remove it from Ephraim's head unto Manasseh's', who was entitled to the blessing (Genesis 48). But the ancient Jacob refused to change his benediction, and prophesied that the younger son would be greater than the older. According to tradition, Ephraim symbolized the coming of the Christian faith, while Manasseh stood for the Jews. Rembrandt showed the moment when Joseph tried to guide his father's hand to the older boy's head. But it is too late. The blessing of Ephraim takes place. God's will is done. Jacob gently pushes back Manasseh with the back of the fingers of his left hand[31] [98]. Asnath, Joseph's wife, stands apart with a wonderful expression of motherly feeling about the deep significance of the event. There is very little action in the

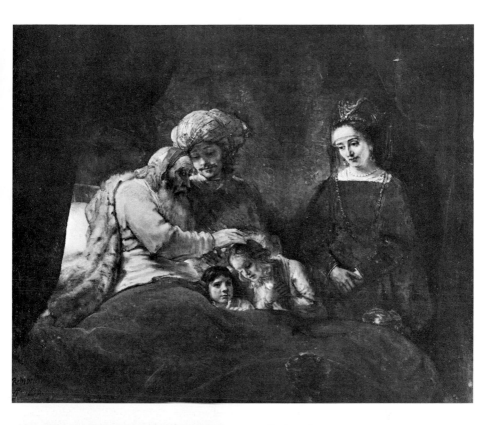

97. Rembrandt:
Jacob blessing the Sons of Joseph, 1656.
Kassel, Staatliche Gemäldegalerie

98. Detail of 97

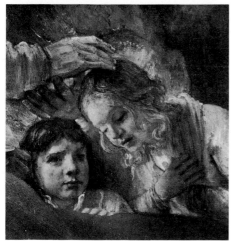

picture – so little that any other Baroque painter would have been embarrassed by the subject as it appears here, and would have turned it into something more dramatic by exterior agitation. But to the mature Rembrandt it was natural to neglect such Baroque conventions and to concentrate on the inner life of the figures, on their spiritual bond, during this sacred scene.

From the late fifties onwards, Rembrandt preferred to represent moments of heavy

gloom, tragic upheaval, and of solemn pathos in human life, especially in the lives of great sinners or great worshippers. The aged Rembrandt is conscious, more deeply than before, of the fearful destiny to which many may be doomed and of the imminent terror that may at any moment engulf him. But as the *Prodigal Son* (c. 1669, Leningrad, Hermitage) [101], one of his latest works, and perhaps his greatest, shows, he also penetrates more profoundly the idea of God's grace by which repentant man may be forgiven and saved.

The picture of *Saul and David* (The Hague, Mauritshuis) [99] shows the king haunted and depressed by heavy melancholy. He hopes to find some relief and consolation in the music made by young David playing the harp. We see the healing influence of music in the fact that King Saul is wiping a tear from his eye with the dark curtain. But at the same time a sinister feeling seems to stir within him. The king is possessed by hatred and jealousy against his young rival, whose growing fame is beginning to outshine his own. Saul's uncovered eye, wide open and darkly gleaming, betrays the approaching eruption. His right hand begins to move and will in a moment hurl the lance at David. It is the inner conflict in the king's mind

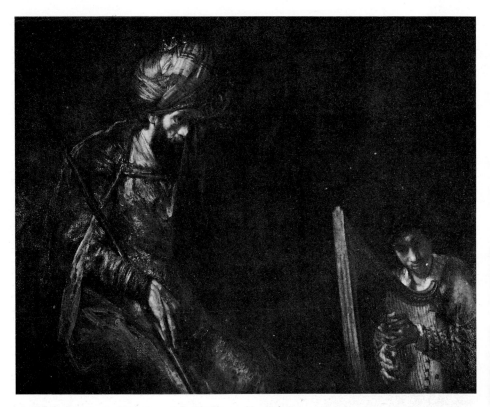

99. Rembrandt: Saul and David, *c.* 1658. *The Hague, Mauritshuis*

100 (*opposite*). Rembrandt: The Denial of St Peter, 1660. *Amsterdam, Rijksmuseum*

which the artist reveals. We feel the heavy burden of destiny that is imposed on the man by an unseen higher power. This deeper significance is expressed in the picture by pictorial undertones. Shades of black deepen the shadows and add force to the gloom of the colours, among which a glowing red and golden yellow in the king's attire are prominent. Even the brocade and jewellery share in the mood of the picture. We may say now that Rembrandt has become more conscious of the formidable side of God as expressed in this Old Testament story. The dominating expression, however, is the profound human aspect of the story,

not a theological one. It is a sympathetic and powerful exposition of the doomed hero's inner conflict in his hour of trial. And when we turn to a subject from the New Testament of about the same period, the *Denial of St Peter* (1660, Amsterdam, Rijksmuseum) [100], we gain a similar impression. Here not an inveterate sinner like Saul is represented, but a repentant one who will be saved. Yet St Peter is also doomed to show human fallibility at his hour of trial. As Christ has foretold, he fails his crucial test and denies his Lord out of fear for his own life. Again Rembrandt's interpretation excels by sympathetic human insight

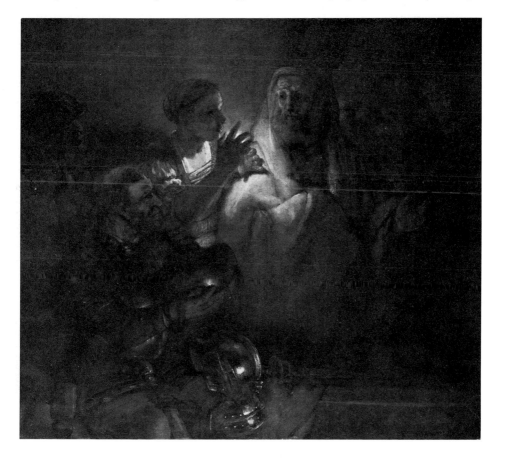

into the chief actor's inner conflict at the moment when his faith has weakened. In this composition everything hinges upon the expression of St Peter, from whom an answer is expected. The questioning maid focuses the light upon his face and looks into his eyes with searching attention. Her features show decision, in contrast to the apostle's embarrassment. The faces of the two grim warriors on the left are equally searching. These three figures form a wedge directed at St Peter and symbolize a powerful challenge to the steadfastness of his faith. In the rear we see Christ turning back at this moment, as if aware of Peter's trial and failure.

During the last years no basic change occurs in Rembrandt's style; this explains occasional uncertainty about the dating of such prominent pictures as the *Saul and David* and the *Christ at the Column* (Darmstadt, Hessisches Landesmuseum). His expressive power, however, grows until the very end. The boldness and freedom of his brushwork are at a peak in the great works of the later sixties. Very few artists - one thinks of Michelangelo, Titian, Goya - offer the same spectacle of an ever-increasing power of expression which culminated at the end of their lives.

Rembrandt's final word is given in his monumental painting of the *Return of the Prodigal Son* [101]. Here he interprets the Christian idea of mercy with an extraordinary solemnity, as though this were his spiritual testament to the world. It goes beyond the works of all other Baroque artists in the evocation of religious mood and human sympathy. The aged artist's power of realism is not diminished, but increased by psychological insight and spiritual awareness. Expressive lighting and colouring and the magic suggestiveness of his technique, together with a selective simplicity of setting, help us to feel the full impact of this event. The main group of the father and the Prodigal Son stands out in light against an enormous dark surface. Particularly vivid are the ragged garment of the son, and the old man's sleeves, which are ochre tinged with golden olive; the ochre colour combined with an intense scarlet red in the father's cloak forms an unforgettable colouristic harmony. The observer is roused to a feeling of some extraordinary event. The son, ruined and repellent, with his bald head and the appearance of an outcast, returns to his father's house after long wanderings and many vicissitudes. He has wasted his heritage in foreign lands and has sunk to the condition of a swineherd. His old father, dressed in rich garments, as are the assistant figures, has hurried to meet him before the door and receives the long-lost son with the utmost fatherly love. The occurrence is devoid of any momentary violent emotion, but is raised to a solemn calm that lends to the figures some of the qualities of statues and gives the emotions a lasting character, no longer subject to the changes of time. Unforgettable is the image of the repentant sinner leaning against his father's breast and the old father bending over his son. The father's features tell of a goodness sublime and august; so do his outstretched hands, not free from the stiffness of old age. The whole represents a symbol of all homecoming, of the darkness of human existence illuminated by tenderness, of weary and sinful mankind taking refuge in the shelter of God's mercy.

101. Rembrandt: The Return of the Prodigal Son, *c.* 1669. *Leningrad, Hermitage*

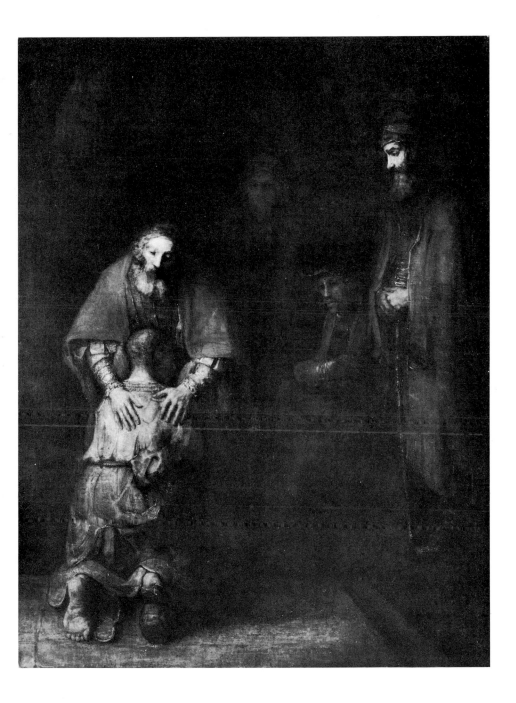

THE REMBRANDT SCHOOL

Rembrandt's impact upon the artists of his time was unique. Students worked with him during every phase of his career, and there are strong reflections of his style in the work of artists who never entered his studio. He had more pupils and close followers than any of his contemporaries. Names of more than fifty are known,[1] and a host remain unidentified. Contemporary drawings depict Rembrandt surrounded by pupils in his studio, and it is said that at one time he had to convert a warehouse into a school in order to handle the great number attracted to him. According to Sandrart, who was in Amsterdam from around 1637 until 1645, when Rembrandt was at the height of his popularity, his pupils brought him in a large income. Sandrart wrote that almost innumerable scholars from good families paid Rembrandt 100 florins annually, and he earned about 2,000 to 2,500 florins every year from the sale of work made by each of them. The practice of selling student work was not an unusual one. According to the rules of the guild, an apprentice was not allowed to sign his work and whatever he made belonged to his master. But Sandrart, who was the kind of man who liked to count other people's money, probably exaggerated what Rembrandt earned from his students' production. The meagre documentary evidence about his income does not support Sandrart's estimate. One of the rare bits is a memo Rembrandt scribbled on the back of a drawing he made just around the time Sandrart arrived in Amsterdam which states that he received 19 guilders, 6 stuivers for the sale of two works by his pupil Ferdinand Bol, and 5 guilders for one by the unidentified Leendert Cornelisz. van Beyeren.[2] If these were

average prices for pieces turned out in Rembrandt's studio, it is hard to see how he could have earned much from the sale of his students' work.

There was a good precedent among Renaissance and Baroque painters for large workshops. The most celebrated one of the seventeenth century belonged to Rubens. However, there are important differences between the studios managed by Rubens and Rembrandt. Most of Rubens' commissions were for colossal wall and ceiling decorations designed for churches and palaces. He also decorated huge temporary structures made for pageants, festivals, and the triumphal entries of royalty. Rubens did not paint these numerous monumental works single-handed: he employed a team of collaborators to help him, and he equitably adjusted his prices according to how much he or his assistants did on a work. It was, of course, necessary for his helpers to subordinate their style to his, and it was his moral responsibility to see that the finished product was worthy of his shop. As court painter, Rubens did not answer to the Antwerp guild. He also employed a staff of graphic artists to make engravings after his original compositions. He himself hardly etched or engraved. His engravers had to follow his style, not their own. In contrast, the members of Rembrandt's studio had much more freedom. It is true that traces of the hand of some of Rembrandt's pupils can be found in a few of the early etchings which the master signed (see pp. 148-9), and also that the very uneven printmaker Joris van Vliet may have actually been employed by Rembrandt in the early 1630s to reproduce some of the master's paintings. But

the greatest etcher who ever lived did not make a practice of having assistants reproduce his paintings or work on his plates. Rembrandt conceived of etchings as independent works of art, not as reproductions of his own compositions made in other media by closely supervised helpers. Moreover, Rembrandt did not receive many commissions which would normally have required assistants.

In the *Night Watch* and the *Conspiracy of Julius Civilis* - large pictures for which he could have used help - there is no evidence that a hand other than the master's touched the original work. Rembrandt did not need, or want, the kind of collaborators some of his contemporaries and many of his predecessors used. His production and studio practice were not the type that forced his pupils to become subservient to his style. Nevertheless, as we mentioned above, the artists who worked with him immediately fell under the influence of his powerful personality, and could not help adopting his style when they entered the studio.

Rembrandt's own numerous drawings show that he constantly made variations on the themes of his finished paintings and etchings, and that he produced many more ideas for pictures than he could execute. These must have been an endless source of stimulation for his students while they were close to him. He was not the kind of man to hoard ideas. He had too many. He must have been pleased to see some of them worked up into a more complete state, and his tremendous energy enabled him to correct and retouch the efforts of his students, as well as continue his own prodigious output. Drawings made by his students reveal how frequently he altered and corrected their essays. It is difficult to determine how many Rembrandt school pictures are based upon the master's own inventions, but the number is probably high, and in a few cases a definite connexion can be established. A contemporary engraving which is copied after

the painting of *Anna and the blind Tobit* in the National Gallery in London is inscribed 'Rembr. van Rijn fecit'; however, the painting itself was executed by Gerrit Dou around 1630, when he was Rembrandt's apprentice, and only retouched in a few spots by Rembrandt. The Rembrandt school piece (probably by Govert Flinck) of the *Sacrifice of Isaac* at the Pinakothek in Munich is based upon Rembrandt's picture of the same subject dated 1635, now at Leningrad (Bredius 498), and his drawing at the British Museum (Benesch 90). The inscription in Rembrandt's hand at the bottom of the Munich picture (*Rembrandt verandert En overgeschildert. 1636*) announces that the master was not satisfied with his pupil's results, and that he changed and retouched the work. In his day, as in ours, knowledge that the master touched up a student's work made it more valuable. This is one reason why the students' paintings he corrected were carefully described as 'van Rembrandt geretukeert' ('retouched by Rembrandt') in the 1656 inventory made of his effects.

Rembrandt seems to have been the kind of creator who needs a retinue. From the very beginning he had pupils, and he was never without some. Dou, who entered his studio as early as 1628, based the style he successfully used for a lifetime on the minute and finely executed pictures which Rembrandt produced in the few years of his Leiden period. Rembrandt's magnetic personality exerted equal force from this early date until his last years. Different pupils may be assigned to each epoch of his career. His genius was too strong to permit any of them to keep abreast of him. Generally they were satisfied with a short stay. They learned his current mode and adopted the motifs he favoured when they entered his studio.

Apparently Rembrandt did not try to discourage his pupils from imitating him. Of course, seventeenth-century artists, critics, and

collectors did not place the same premium upon originality that men of later times did, and there can be no question that many of his pupils did their best work when they were closest to their master. From what we can tell, Rembrandt either made no effort, or was unable, to bring out their individuality. In this respect he was quite different from Frans Hals. Without literary evidence it would not be possible to tell that Adriaen van Ostade and Philips Wouwerman were Hals' pupils. With Rembrandt it was otherwise. Close contact with him always left an unmistakable mark. Rembrandt overwhelmed his pupils. He crushed some. This may be one of the reasons why so many abandoned their Rembrandtesque manner soon after they left his atelier. The unmistakable mark was not indelible, and in most cases rejection followed seduction. Followers of Caravaggio, the other great innovator of Baroque painting, reacted in the same way. There were, however, some notable exceptions among Rembrandt's pupils. Gerbrandt van den Eeckhout, who probably entered Rembrandt's studio in the late 1630s and who was described by Houbraken as Rembrandt's 'great friend', made one of his most Rembrandt-like works as late as 1667 (*Peter healing the Lame*, San Francisco, M. H. de Young Memorial Museum) [113], and Arent de Gelder, who came to Rembrandt around 1660, continued to show the master's late manner well into the eighteenth century.

THE LEIDEN PERIOD

The most important artist to consider in connexion with Rembrandt during the Leiden years is Jan Lievens (1607–74), who was a gifted etcher and designer of woodcuts as well as a painter. He was not Rembrandt's pupil, but his close friend. The young artists probably shared the same studio and models for a time. Impressive proof of Lievens' talent is the small group of works attributed to Rembrandt by some and to Lievens by others. As early as 1632 it could happen that the hands of the two artists were confused. In an inventory made in that year of Frederick Henry's effects at Noordeinde there is listed 'Simeon in the Temple, holding Christ in his arms done by Rembrandt or Jan Lievensz.'. The matter is complicated by the fact that the two friends worked on each other's pictures. The *Portrait of a Child* (Amsterdam, Rijksmuseum) is signed 'Rembrandt geretucee . . . Lieve . . .' ('Lievens retouched by Rembrandt'), and the *Portrait of an Old Man* (Bredius 147), which is now in the Fogg Art Museum at Cambridge, Massachusetts, is clearly dated 1632 and is moreover monogrammed by Rembrandt, but shows unmistakable signs of Lievens' soft, silky touch.

Lievens, who was a year younger than Rembrandt, was more precocious than his friend. He also had a considerable head-start on Rembrandt as a student of art. At the age of eight, Lievens began a two-year apprenticeship in his native town with the minor Leiden painter Joris van Schooten, and from about 1617 to 1619 he was with Lastman in Amsterdam. After this training the twelve- or thirteen-year-old boy began to work as an independent artist. A contemporary reports that around this time he made copies after a *Democritus* and a *Heraclitus* by Cornelis Ketel which connoisseurs could not distinguish from the originals, and that in 1621 the fourteen year old youth made an impressive portrait of his mother.[3] Thus Lievens was already an accomplished technician before Rembrandt left the university of Leiden about 1620/1 to begin his apprenticeship. About four or five years had to pass – a considerable span of time among boys – before Rembrandt was able to match his friend's performance. Lievens had a talent for working on a lifesize scale, and he probably stimulated Rembrandt to paint the large *Feast*

of Esther (Raleigh, North Carolina Museum of Art) [45] soon after he began to work independently. As we have noted, Rembrandt seems to have recognized at this stage of his career that he was more successful when he worked on a small scale, and as far as we know he did not try lifesize compositions of more than one figure again until he had moved to Amsterdam. Lievens, however, continued to work on a large scale, and he is at his best in portraits

102. Jan Lievens: Constantin Huygens, *c.* 1626/7. *Douai (on loan to the Rijksmuseum, Amsterdam)*

such as the introspective one of *Constantin Huygens* painted about 1626/7 (Douai, Musée de Douai, on loan to the Rijksmuseum) [102]. Around this time Lievens also made lifesize genre pieces which are early examples of Utrecht Caravaggism in Leiden (*Boy blowing on a burning Coal* and *Boy lighting a Candle*, both in the Muzeum Narodowe in Warsaw). The round, inflated forms in these early pictures remain characteristic of Lievens' work throughout his career.

Constantin Huygens' acute observation that the young Rembrandt surpassed Lievens in his ability to express emotion in a small, carefully worked out picture, but that Lievens was superior in grandeur of invention and boldness, is supported by the paintings the young friends made during their Leiden period. In Lievens' *Raising of Lazarus* (1631, Brighton, Sussex, Art Gallery) [103], the dramatic mood, the dark grey tonality, the minute technique, and the individual types recall Rembrandt's painting of the same subject (Bredius 538), but in his search for monumentality Lievens exaggerates the theatrical aspects of the scene. At this stage of their careers Rembrandt had already surpassed Lievens in power of concentration, incisive characterization, and in his ability to relate tightly and convincingly the single parts by the organization of the chiaroscuro effect. Lievens' large compositions (*Job on the Dung Heap*, 1631, Ottawa, National Gallery of Canada) and portraits of picturesque types (*Head of an Old Man*, Brunswick, Herzog Anton Ulrich Museum) show some of the superficial smoothness which increases during the following years. Even when he is closest to Rembrandt his paint is less dense than his friend's and he never attains his modelling power.

The close connexion between the works of the two Leiden painters was broken after Rembrandt moved to Amsterdam late in 1631, or early in 1632. It is said that Lievens left Holland in 1631 for a visit to England, where he remained for about three years, and from there he went to Antwerp, where he settled. He is known to have been in Antwerp from 1635 until 1644. There he fell under the influence of Van Dyck's portraits and Rubens' subject pictures. A small group of landscapes, which reveal the impact of both Rubens and Brouwer upon him, is his most striking contribution during his Flemish period. After he had settled again in the Netherlands in 1644, he adopted

103. Jan Lievens: The Raising of Lazarus, 1631.
Brighton, Art Gallery

the style of the fashionable Amsterdam por-
traitists. He also received numerous important
commissions for historical and allegorical pic-
tures.[4] All the late large compositions continue
to show the elegance, smoothness, and light
colours of his Flemish experience. Whether
Lievens made contact with his boyhood friend
during the last phase of his career is not known,
but it is certain that the art of the two masters
had developed by then in completely different
directions.

On 14 February 1628, Gerrit Dou, the pupil
who heads the long list of those who studied
with Rembrandt, began a three-year apprentice-
ship. When Dou entered Rembrandt's studio
he was just approaching his fifteenth birthday;
his master was not yet twenty-two years old.
Dou was born in 1613 in Leiden, the son of a
glassmaker and engraver. He first worked
with his father, and from 1625 to 1627 was a
member of the glaziers' guild. It is tempting
to conclude that the high polish and shiny

surfaces characteristic of his pictures are somehow connected with his first trade. Under the influence of Rembrandt's early style, Dou initiated the Leiden tradition of small, minutely finished pictures, which continued well into the nineteenth century. In a way it can be considered a continuation of the microscopic tradition started by the Van Eycks. The secret of Dou's success, and that of his followers, is the simple pleasure men receive from seeing the world meticulously reproduced in small, with perfect craftsmanship. During his lifetime he was one of the best-paid artists in Holland, and he quickly acquired an international reputation. Pieter Spiering, the minister to The Hague from Sweden, paid him 1,000 guilders annually to obtain first choice of works destined for Queen Christina's collection. Spiering, it should be added, was more impressed than the queen was with Dou's paintings. She characteristically refused to take advice, and returned ten of Dou's pictures to her agent in 1652. In 1660 the States of Holland selected his *Young Mother* (1658, The Hague, Mauritshuis) [104] as one of the precious gifts to Charles II on the occasion of the Restoration. Of this picture John Evelyn wrote that it was painted 'so finely as hardly to be distinguish'd from enamail'. The following year one of his paintings was in Leopold Wilhelm's collection in Vienna. In 1665, a Leiden collector, Johan de Bye, rented a room in his native town where he exhibited twenty-seven of Dou's pictures. De Bye's cabinet, which consisted exclusively of works by Dou, was one of the first museums dedicated to exhibiting the production of a single artist. During the eighteenth century and the early part of the nineteenth century, collectors continued to compete for his paintings, which consistently fetched higher prices than Rembrandt's. Dou's popularity began to wane only after 1860, when the Impressionists were beginning to teach critics and collectors how

104. Gerrit Dou: Young Mother, 1658.
The Hague, Mauritshuis

exciting pictures which lacked a high finish could be.

Young Dou admired and imitated his teacher as closely as he could. He frequently used Rembrandt's models and paraphernalia. A comparison of his *Portrait of Rembrandt's Mother* (Amsterdam, Rijksmuseum) [105] with Rembrandt's own portraits of her shows the master's superiority and the pupil's limitations. The face Dou painted is like a mask; it has a frozen surface which appears to have been over-exposed to the light. From the very beginning, Dou was particularly fond of minute still-life accessories and genre details. He frequently over-emphasized these, and thereby lost the tension and coherence of Rembrandt's early compositions. This is seen if the portrait he made of Rembrandt in his workshop (Richmond, Cook Collection) is compared with Rembrandt's *Self-Portrait in His Studio*,

105. Gerrit Dou: Portrait of Rembrandt's Mother, c. 1630. *Amsterdam, Rijksmuseum*

now at the Museum of Fine Arts, Boston (*c.* 1629; Bredius 419). In both pictures the artist stands before his easel, but only in the Rembrandt are we struck by the boldness with which the mighty dark form of the easel is placed in the immediate foreground as a dramatic repoussoir for the small figure of the painter. This daring accent almost throws the picture out of balance, yet the psychological and pictorial interest in the figure is sufficient to restore it.⁹ Dou's version loses the drama and the mystery of Rembrandt's little masterpiece. He is unable to use chiaroscuro for clear spatial distinctions and for expressive purposes. He lacks Rembrandt's power of concentration, and the final effect of his attempt to enrich his work by the addition of details is a series of digressions.

After Rembrandt left for Amsterdam, Dou set himself up as an independent master in Leiden, where he remained for the rest of his life. He declined an invitation from Charles II to visit England. During the thirties he abandoned the warm browns and dark tonality of his early work for cooler and paler colours. At this time he also refined his technique and perfected the smooth, enamel-like surfaces which are the hallmark of his work. Dou became notorious for his diligence and patience. When he was praised for the care with which he painted a broom about the size of a fingernail, he replied that he still had three days' work to do on it, and he is reported to have spent five days on the under-painting of one hand of a woman who sat for a portrait. Though he must be credited for setting the long-lived Dutch vogue for small, carefully finished portraits, it is not difficult to understand why he was never in great demand as a portraitist – particularly since he charged by the hour (six guilders). He was also finicky about his tools and the conditions under which he worked. He ground his colours on glass, made his own brushes, and never started to work on his panels until he felt that the dust in his studio had settled. Apparently he was even unable to find a Dutch woman who would meet his exacting standards for cleanliness and tidiness; he never married. Dou had cases made for his pictures in order to protect them, and he sometimes painted their covers. His *Vanitas* still life at Dresden was the lid of a case made to contain his picture of a *Boy and a Girl in a Wine Cellar* in the same museum. Dou's perseverance and careful industry frequently resulted in over-refinement, and his attention to detail, particularly in his larger compositions, which became more frequent after 1650, tends to isolate the forms and fails to convey a broader sense of unity within his works.

Dou's range of subjects was a wide one. In addition to genre scenes he painted pictures of saints, animals (*Goat in a Landscape*, Amsterdam, Wetzler Collection), and still lifes. Once he adopted a motif, it attained popular approval

and a long life. The one exception is his nudes. He was one of the few seventeenth-century Dutch painters who depicted them. Dou also popularized the compositional device of a figure engaged at some occupation at a window. The earliest dated one is the *Girl chopping Onions* (Buckingham Palace) of 1646. Soon after, it occurs frequently in the Leiden School. The window frames quickly become more elaborate, bas-reliefs are introduced under the sills, and the windows are draped with curtains. Dou can also be credited with starting a vogue around the middle of the century for small pictures of nocturnal scenes lit by candle-light or lanterns, which usually throw a harsh red light. In this group the incident depicted – children at school, card players, a group around a table, a dentist at work, a girl leaning out of a window – is always more important than the dramatic potential of the chiaroscuro.

Dou's success attracted many pupils and followers. The best known are Gabriel Metsu, Frans van Mieris the Elder, Quiringh Brekelenkam, Pieter van Slingeland, and Godfried Schalcken; the last-named specialized in the type of night scene which Dou had popularized. Another pupil was his nephew and follower Dominicus van Tol.

Rembrandt's other Leiden pupils and followers are of less artistic importance than Dou. About a score of them can be counted. Most of them are mediocre; some are simply atrocious. They are, however, of interest because they show how rapidly and emphatically the young Rembrandt left an impression upon the artists who saw his work. The numerous contemporary copies of Rembrandt's Leiden pictures (as many as six versions of *Judas returning the Pieces of Silver* [52] are known) testify to his early popularity. This is one of the reasons why Rembrandt's followers must be studied. It is necessary to become familiar with the artists in his entourage in order to distinguish the work of the master from that of his followers. Isaac

Jouderville (1613-45/8) began a two-year apprenticeship with Rembrandt about January 1629; a record of payment for Jouderville's tuition substantiates Sandrart's report that Rembrandt received 100 guilders per year from his students.[6] Like some other members of the Leiden circle, Jouderville may have continued to have contact with Rembrandt during his first years in Amsterdam. Jouderville's rare works are mostly lifesize portraits which imitate those Rembrandt made around 1630. A signed one is in Dublin (no. 433), and a grimacing head in the Bredius Museum, The Hague, has been called Jouderville's *Self-Portrait*. A group of similar portraits monogrammed J. D. R. have been assigned to Jacques de Rousseaux (*c.* 1600-before 3 May 1638); *An Apostle* (1630, The Hague, Bredius Museum) shows the curious irregularity of the eyes and the exaggerated wrinkles characteristic of his work.

Jan Joris van Vliet (*c.* 1610-?), who probably entered Rembrandt's studio around 1630 or 1631, is important as an etcher; no painting can be attributed to him with any certainty. He made about a dozen etchings after Rembrandt's pictures between 1631 and 1634. His copies, in turn, were immediately copied by foreign engravers, and they helped Rembrandt to acquire an international reputation with extraordinary rapidity. Van Vliet also made a few etchings after Lievens' and Joris van Schooten's works. Nothing is known about his activities after 1635, the date of his latest print. The high standard of Van Vliet's early etchings (*Baptism of the Eunuch* and *Lot and his Daughters*, both dated 1631 and both after lost works by Rembrandt) suggests that they were executed under Rembrandt's close supervision. Perhaps, as indicated above, the young Rembrandt had the idea of using Van Vliet as an assistant, and even considered employing him to make reproductions of his works. Rembrandt's large etchings of the *Raising of Lazarus* (1632;

Bartsch 73), the *Descent from the Cross* (1633; Bartsch 81, II), and the *Ecce Homo* (1635; Bartsch 77) all show that they were made with the help of an assistant or assistants, but there is no consensus among experts about who besides Rembrandt worked on them. Coarse etchings of beggars by Van Vliet indicate that he was stimulated by Rembrandt in some of his independent works. The etchings which show nothing of Rembrandt's influence – for example, his series of tradesmen – are crude, and they are primarily of interest as social documents.

Small biblical and allegorical pictures by Jacob de Wet (1610-71), Jacob van Spreeuwen (1611-?), and Willem de Poorter (1608–after 1648) can also be connected with Rembrandt's last years in Leiden and first years in Amsterdam, but it is not known if these artists actually worked in Rembrandt's studio. De Poorter's still-life paintings of flags and military equipment piled in dramatically lit grottoes (1636, Rotterdam, Boymans-Van Beuningen Museum) hover between the works of Rembrandt and Bramer, without ever capturing the intensity of the former or the fantasy of the latter. Works by the Haarlem painter Pieter de Grebber (*c*. 1600-1652/3) and some wild ones by the Dordrecht artist Benjamin Gerritsz. Cuyp (1612-52) can also be connected with Rembrandt's Leiden years and with the beginning of his activity in Amsterdam.

THE FIRST AMSTERDAM PERIOD

More students as well as patrons flocked to young Rembrandt as soon as he settled in the great metropolis. A period of study with him seemed to assure success. Govert Flinck (1615-60), Jacob Adriaensz. Backer (1608-51), and Ferdinand Bol (1616-80), who all worked with Rembrandt in the thirties, made brilliant careers for themselves, and around the middle of the century most citizens of Amsterdam would have agreed that they had surpassed their master. Backer and Flinck were the first to manifest the impact of Rembrandt's new style. Both studied with the painter, dealer, and Mennonite preacher Lambert Jacobsz. (before 1600-1637) in Leeuwarden before they left for Amsterdam to begin work with Rembrandt. Leeuwarden, one of the principal cities of Friesland, never became an artistic centre, but it would be erroneous to think of it as a provincial place where nothing was known about the contemporary international art scene. Lambert Jacobsz., father of the successful portraitist Abraham Lambertsz. van den Tempel, is said to have been in Italy and to have studied with Rubens. He was also familiar with the work of the Utrecht Caravaggesque painters as well as Lastman and Moeyaert. Friesland's leading portraitist, Wybrand de Geest (1592-after 1660), had been to France and Rome, where he made copies of Caravaggio's pictures. There is an interesting link between De Geest and Rembrandt. De Geest married Hendrickje van Uylenburgh, the sister of Rembrandt's wife Saskia, and the cousin of Hendrick Uylenburgh, a dealer and painter who ran a kind of 'academy' in Amsterdam where young artists made copies of pictures. We have heard that Rembrandt lived in Uylenburgh's house from 1631/2 until 1635. During these years Rembrandt was too well established to undertake hack work for Uylenburgh, but he probably had a studio in Uylenburgh's picture factory, and it is not difficult to imagine him establishing close contact with the aspiring artists who worked for Uylenburgh. Copies were made of Rembrandt's pictures in Uylenburgh's shop which were sent to the provinces to be sold. An inventory made of Lambert Jacobsz.'s effects in 1637 at Leeuwarden lists six copies of pictures by Rembrandt.[7]

Backer, who was only two years younger than Rembrandt, was probably an accomplished painter by the time he left Leeuwarden, and his stay with Rembrandt must have been a

short one. If the signature and date of 1633 on the *Elevation of the Cross* (Bauch no. 23) can be trusted, Backer was probably a free master by 1633, and the composition of that work suggests that he was familiar with the *Elevation of the Cross* Rembrandt painted during the same year for Frederick Henry. It is also clear that Backer was able to absorb aspects of Rembrandt's style without lapsing into slavish imitation. Italianate and Flemish elements in this early work are more pronounced than the Rembrandtesque ones. It is in Backer's commissioned portraits, not his history pictures, that Rembrandt's influence is felt most strongly. This is not extraordinary. It is difficult to name a portraitist who worked in Amsterdam after Rembrandt arrived there who was not affected by his portrait style. Backer, who became a portrait specialist, got a good start by closely following his teacher's example, and as in the case of so many other of Rembrandt's pupils, some of his works have passed for originals of the master. Even after a careful study of pictures by Rembrandt and his pupils which are accepted as authentic works by generations of critical connoisseurs, it is still sometimes difficult to make a firm attribution. A good example is the famous unsigned portrait of *Elizabeth Bas* (Amsterdam, Rijksmuseum). Until 1911, when it was ascribed to Ferdinand Bol, it was considered by most students a characteristic Rembrandt. Absence of vigour and breadth supports the attribution to Bol. But in 1926 another scholar argued that *Elizabeth Bas* was painted by Backer and retouched by Rembrandt, and in 1960 a third expert suggested that the old attribution to Rembrandt is the correct one.[8]

An undisputed work by Backer is the beautiful *Portrait of a Boy* (1634, The Hague, Mauritshuis) [106] painted in shades of grey. Its quiet restraint, the smooth, thin paint, and the ornamental brushwork are all characteristic of Backer. The immediacy of Backer's *Johannes*

106. Jacob Backer: Portrait of a Boy, 1634.
The Hague, Mauritshuis

Uyttenbogaert (1635, Amsterdam, Remonstrants-Gereformeerde Gemeente) and the strong sculptural effect of the preacher's head are unthinkable without Rembrandt. However, the diffusion of interest created by the steady light, which shines with equal intensity on the head and hands and upon the carefully worked out still life, is something that Rembrandt would have avoided.

Backer achieved success quickly. In 1633 he was commissioned to make a group portrait of the *Regentesses of the Amsterdam Orphan Home*, which is still *in situ*. He made three more large group portraits during the course of his short career (1638; 1642; *c*. 1650). Like most Amsterdam portrait painters, Backer fell under the spell of Van der Helst during the forties, but the warmth of his palette during the last decade of his life indicates that he continued to study Rembrandt's works. During his last

107. Govert Flinck: Samuel Manasseh ben Israel, 1637. *Stichting Nederlands Kunstbezit (on loan to the Mauritshuis, The Hague)*

years Backer was commissioned to make some large mythological and allegorical pictures; these were chiefly designed as chimneypieces.

Govert Flinck, who was born at Kleve in the Lower Rhine district, was originally apprenticed to become a silk merchant. He was allowed to switch careers when Lambert Jacobsz. visited Kleve and agreed to take the boy north to Leeuwarden with him. Flinck probably found Backer already at work in his new master's studio. If we can trust Houbraken, Backer and Flinck left for Amsterdam together. There is evidence that Flinck lived in Uylenburgh's Amsterdam house. Houbraken states that Flinck spent a year with Rembrandt and learned to imitate his style so closely that some of his pictures were mistaken for authentic Rembrandts and sold as such. His earliest dated works, which are inscribed 1636, show that Flinck was really very clever at imitating

the lively chiaroscuro of Rembrandt's early Baroque phase. His portrait of *Samuel Manasseh ben Israel* (1637, Stichting Nederlands Kunstbezit, on loan to the Mauritshuis, The Hague) [107], is one of his best approximations of Rembrandt. Flinck as a colourist tends to be more variegated and brilliant than his teacher. In *Isaac blessing Jacob* at the Rijksmuseum [108] (the signature and date of 1638 disappeared during the course of a recent cleaning), his masterpiece in the Rembrandtesque style, the deep reds, violets, and golden yellows establish a colour harmony which is quite original. His conspicuous realism is also a personal touch. The things he represents have an over-distinctness compared to Rembrandt. He was less able to subordinate parts of his composition to a higher principle and he did not grasp the function of Rembrandt's halftones, which create a transition between forms, relating them to the whole work. Flinck followed the pattern which became a standard one for so many of Rembrandt's pupils. In the forties he abandoned his teacher's manner – Houbraken reports that he did it with much difficulty – for a lighter style of painting. The change brought him great popularity and wealth, and he is reputed to have formed a remarkable collection of Italian art. He won more patronage from the ruling circles of Amsterdam than any of his contemporaries. Flinck painted three large group portraits for militia companies (1642; 1643; 1648), and he was commissioned to portray the heroes Admiral Tromp and Admiral de Ruyter, as well as the poet Joost van den Vondel; Rembrandt rarely portrayed such distinguished personages. As far as we know, Flinck never painted landscapes, genre scenes, or still lifes. He had a higher goal. He wanted to be known as a history painter. No Dutch seventeenth-century artist with a similar ambition had better support. Flinck worked for Amalia van Solms (*Allegory in Memory of Prince Frederick Henry*, 1654, Amsterdam,

108. Govert Flinck: Isaac blessing Jacob, *c.* 1638.
Amsterdam, Rijksmuseum

Rijksmuseum), and he received the lion's share of commissions to decorate the new town hall. In 1656 he was asked to paint -*Solomon praying for Wisdom*, and around the same time he executed *Manius Curius Dentatus* for the same building. In 1659 he was asked to make twelve additional pictures for the town hall illustrating the history of the struggle between the Batavians and the Romans. Flinck died two months after he received this colossal commission, the most important given to any seventeenth-century Dutch painter. It was then distributed among a group of artists. The city officials asked Rembrandt to make only one painting for the series: the *Conspiracy of Julius Civilis* [90]. As we noted in our discussion of Rembrandt's mature phase, his painting was removed from the town hall shortly after it had been installed. The preliminary water-colour sketch which Flinck had prepared for this scene was reworked in oils by Juriaen Ovens, another Rembrandt pupil, and it is still in place. Employing Ovens saved the Amsterdam authorities a sizeable sum of money. It is not known what they agreed to pay Rembrandt, but Flinck was to receive 1,000 guilders for his composition; Ovens was paid 48 guilders for completing Flinck's provisional sketch.[9]

Ferdinand Bol, one of Rembrandt's most productive pupils, probably worked with him from about 1635 to 1640; his earliest extant dated painting is inscribed 1642 (*Old Woman*, Berlin-Dahlem, Staatliche Museen), and so is his earliest print. Early portraits by Bol are very similar to the commissioned works Rembrandt made in the late thirties and early forties – we have already noted that *Elizabeth Bas*, once attributed to Rembrandt, was probably done by Bol – and in them he successfully incorporates the transparent chiaroscuro of Rembrandt's middle period. Bol frequently posed his sitters, who usually show the placid side of their personalities in his pictures, at an open window. A characteristic example is the *Portrait of a Young Man at a Window* (Frankfurt, Städelsches Kunstinstitut) [109]. In his later career, when he turned to the popular

lighter tonality, the faces of his models look pasty, and the highlights on the red velvet he loved to paint appear to have been dusted lightly with talcum powder. In a subject picture like the *Jacob's Dream* (Dresden, Gemäldegalerie) [110] Bol captures something of the mood and even the spiritual character of Rembrandt's art; but the elegant and too noble attitude of the angel, with its long limbs and aristocratic gesture, shows a kind of affectation which is foreign to Rembrandt. By the 1650s it is impossible to mistake a Bol for a Rembrandt. His pictures become smoother, and bland. During these years Bol made portraits of the most famous citizens of the day (e.g. *Admiral de Ruyter*, 1667, The Hague, Mauritshuis) and received commissions for the decoration of the town hall in Amsterdam. He also worked for the municipal authorities of Leiden

109. Ferdinand Bol: Portrait of a Young Man at a Window, *c.* 1645.
Frankfurt, Städelsches Kunstinstitut

110. Ferdinand Bol: Jacob's Dream, *c.* 1645.
Dresden, Gemäldegalerie

and Enkhuizen. Godfrey Kneller, who became a leading portrait painter in England, probably studied with him during the sixties. Bol apparently abandoned his career as a painter after his marriage in 1669 to a wealthy merchant's widow. As an etcher and draughtsman we know him best from his earlier period, when the strong Rembrandtesque character can easily lead to confusion with the master's work.

Works by Gerrit Willemsz. Horst (c. 1613-1652), Jan Victors (1619/20-1676 or later), and Lambert Doomer (1622/3-1700) suggest that they were Rembrandt's pupils in the late thirties or early forties. Horst and Victors are best known for their rather clumsy large genre and historical pieces; the latter's pictures have a pasty quality and predominantly an olive-green or olive-brown tonality. Doomer was primarily a landscapist; his paintings are rare, but he was a productive draughtsman. Most major collections have examples of the drawings he made on a trip to France (1645/6) or on his travels along the Rhine. Doomer was probably at work in Rembrandt's studio around 1640, when the beautiful portraits of his parents were painted by Rembrandt (now divided between the Metropolitan Museum, Bredius 217, and the Hermitage, Bredius 357). Doomer's mother bequeathed the two companion pieces to him on the condition that he make copies of them for each of his two brothers and three sisters.

During his first Amsterdam period Rembrandt's subjects and style inspired a number of artists who never studied under him. The one who was most strongly influenced was Salomon Koninck (1609-59), who had been Claes Moeyaert's pupil and was a member of the guild in Amsterdam as early as 1630. By 1633 Koninck began to adopt Rembrandt's strong chiaroscuro, baroque compositions, types, and trappings in his paintings of picturesque philosophers and rabbis and in his large biblical compositions. Moeyaert and the Delft master Leonaert Bramer, who were both older than Rembrandt, were also tempted to emulate Rembrandt's production of the 1630s. In Haarlem Adriaen van Ostade made creative use of Rembrandt's chiaroscuro effects in the little genre pictures he painted in the thirties. Ostade's rare landscapes (Amsterdam, Rijksmuseum; Rotterdam, Van der Vorm Foundation) and those made by Simon de Vlieger (1601-53) show that the landscapes Rembrandt painted in the late thirties affected Dutch landscapists before the paint on them was dry.

THE MIDDLE PERIOD

Carel Fabritius, who was, by far, Rembrandt's most gifted and original pupil and whose very rare paintings form an important link between the art of Rembrandt and Vermeer, had a tragically short career. He was born in 1622 at Midden-Beemster, a small town about twenty miles north of Amsterdam. In his youth he was a carpenter; hence his cognomen Fabritius (also Fabricius). He probably worked with Rembrandt during the early forties. By 1650 Fabritius had settled in Delft, where he initiated the famous school of genre painting in which Vermeer became the outstanding figure. The works he made in Delft anticipate a great deal of Vermeer's pictorial taste and charm, and before he perished at the age of thirty-two in the disastrous explosion of a gunpowder magazine at Delft in 1654 he produced works which stimulated Pieter de Hooch and Emanuel de Witte, as well as a host of minor artists. In the *Raising of Lazarus* (signed and dated 1642; Warsaw, Muzeum Narodowe), his earliest dated painting, Christ's emphatic gesture and the composition of the work demonstrate the pupil's dependence upon Rembrandt's early representations of the same theme. The excited crowd, which includes a portrait of Rembrandt, and the warm tones show close familiarity with the *Night Watch*, but in spite of all the agitation, Fabritius never

approached Rembrandt's unerring sense for dramatic action or his teacher's narrative power. Rembrandt would never have made Christ perform His miracle by directing His command to Lazarus' feet. During the forties Fabritius painted small, penetrating studies of old men (Groningen; The Hague; Paris) which are similar to Rembrandt's oil sketches of the period. His sensuous and defiant *Self-Portrait* (c. 1645/50, Rotterdam, Boymans–Van Beuningen Museum) [111] shows him as

111. Carel Fabritius: Self-Portrait, c. 1645/50.
Rotterdam, Boymans-Van Beuningen Museum

an accomplished and independent master. It also indicates how rapidly Fabritius developed a personal style. The broad, fluctuating manner of painting and the heavy, pasty paint are derived from Rembrandt's technique. However, Fabritius preferred to put a dark figure against a light background, whereas Rembrandt

had a predilection for the opposite arrangement. Along with bright backgrounds Fabritius favoured cool silvery colours applied in flat, mosaic-like touches instead of Rembrandt's warm brown tonality; the shimmering daylight in the Rotterdam *Self-Portrait* is a clear sign of the direction Fabritius' art was to take. The significance of his late works for the Delft School is discussed in the following chapter.

Samuel van Hoogstraten (1627–78), an interesting man, but an artist of minor importance, was a member of Rembrandt's atelier while Carel Fabritius was studying with the master. Later Hoogstraten went abroad and visited Vienna, Rome, and London, and he finally settled in Dordrecht, his native town, where he became a Provost of the Mint. He had greater success as a theorist than as a practitioner, and is best known as the author of *Inleyding tot de Hooge Schoole der Schilder Konst* (1678), one of the few handbooks on painting published in Holland during the seventeenth century. His book is of special interest because he reports conversations he and his fellow students (Carel Fabritius and Abraham Furnerius) had when they were Rembrandt's pupils. He also records one of the rare extant statements Rembrandt made to a pupil. Hoogstraten wrote that when he was in Rembrandt's atelier he troubled his master with too many questions concerning the origin of things. Rembrandt sensibly silenced his pupil when he replied: 'Take it as a rule to use properly what you already know; then you will come to learn soon enough the hidden things about which you ask'. Hoogstraten's early paintings, like the *Self-Portrait with a Vanitas* (1644, Rotterdam, Boymans–Van Beuningen Museum), show a close affinity to his master. As a draughtsman he imitated Rembrandt more successfully than in painting, and his drawings have sometimes been confused with his teacher's. He tried to emulate the breadth of Rembrandt's late draughtsmanship, but a close examination reveals that his

outlines are dry and somewhat geometrical, the faces are without expression, and the chiaroscuro lacks Rembrandt's vibrancy. Hoogstraten's painting of *Doubting Thomas* (Mainz, Museum) of 1649 exhibits the strong influence of his teacher, but by the 1650s Hoogstraten had abandoned Rembrandt's way of painting and adopted a dry, illusionistic style which gained him success as a portraitist and genre painter in his later years. In 1651 he travelled to Vienna, where he was decorated by the emperor, probably for pedantically completed pictures like *A Man at a Window* (1653, Vienna,

112. Samuel van Hoogstraten: A Man at a Window, 1653. *Vienna, Kunsthistorisches Museum*

Kunsthistorisches Museum) [112]. It is the familiar, pathetic story of how yet another pupil gained more success than his teacher as soon as he turned away from the teacher's art. Hoogstraten, however, continued to hold Rembrandt's work in high esteem. Drawings which can be assigned to the 1650s still emulate

Rembrandt's draughtsmanship and we have heard that in his *Inleyding tot de Hooge Schoole der Schilder Konst* he gave praise to the *Night Watch* for its specific qualities. Hoogstraten is known for his special interest in problems of perspective and illusionism. He made peepboxes (examples are in the National Gallery, London, and the Detroit Institute of Arts)[10] and *trompe l'œil* decorations for homes. His friend Carel Fabritius, as well as other artists of his generation, shared these interests.

Gerbrandt van den Eeckhout (1621-74) was also a follower of Rembrandt's style during the middle period. Judging from his paintings, especially his religious pictures and portraits, he worked with Rembrandt during the late thirties and early forties. Eeckhout's development is not easy to follow because he gave in to various influences and is rather rich in subject matter which shows at times a different character from Rembrandt. Even during his youth, while he made Rembrandtesque portraits, he painted some in the modish manner of Van der Helst. Around 1650 he depicted genre scenes which anticipate Pieter de Hooch. His later pictures of daily life show the influence of Ter Borch and Ochtervelt. Some Italianate character can also be found in his work (*Boaz and Ruth*, 1651, Bremen, Kunsthalle). As late as 1656, in *Jeroboam's Sacrifice* (Leningrad, Hermitage), he falls back on the theatrical realism and obtrusive illusionism of Lastman. However, Eeckhout has the distinction of coming close to his master's mature art in his late paintings. He did so in *Peter healing the Lame* (1667, San Francisco, M. H. de Young Museum) [113], one of his finest works, and achieves a truly Rembrandtesque effect with his chiaroscuro and colour.

Houbraken reports that the remarkable landscape painter and very prolific draughtsman Philips Koninck (1619-88) was Rembrandt's pupil. This may be the case. We know that he settled in Amsterdam in 1641 after studying

painting with his brother Jacob. The powerful flat landscapes he began to make towards the end of the 1640s of panoramas of a vast distance, with a view of an imposing, heavily clouded yet lucid sky which casts shadows over the country-side, are organized with a chiaroscuro effect that recalls the art of Rembrandt [114]. Like many of Rembrandt's followers, Koninck is as dependent upon Rembrandt the draughtsman as upon Rembrandt the painter. He adopts Rembrandt's sketchy penmanship of around 1640 in his landscape drawings, but he is never able to make the space as convincingly con-tinuous and he lacks the more subtle gradations of Rembrandt's aerial perspective and pictorial brilliance. His figure drawings, which some-times recall Van Dyck's swift line, have little human interest; the figures become schematic and miss Rembrandt's structural quality. Koninck also won fame in his day as a por-traitist and genre painter. Vondel praised his history pictures and portraits, and never men-tioned the landscapes for which he is best remembered today. Koninck apparently painted little during the last decade of his life, perhaps because he was well-to-do. He was one of the

113. Gerbrandt van den Eeckhout: Peter healing the Lame, 1667.
San Francisco, M. H. de Young Memorial Museum; Gift of Mr and Mrs George I. Cameron

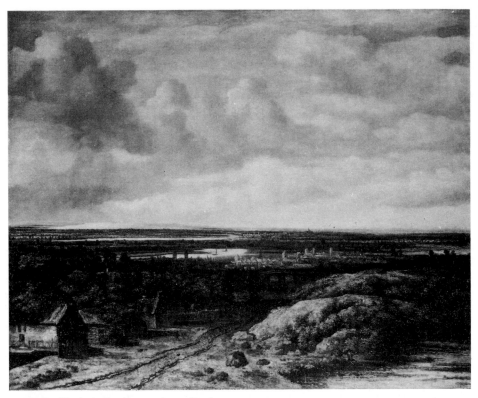

114. Philips Koninck: Farmhouses along a Road,
1655. *Amsterdam, Rijksmuseum*

few seventeenth-century Dutch artists who had a comfortable income; it is difficult to ascertain whether it was derived from his work as an artist or profit from the hostel and shipping line he owned.

Another landscapist indebted to Rembrandt is Abraham Furnerius (*c.* 1628-1654), whose landscape drawings are easily confused with those of Philips Koninck. Furnerius, who was Koninck's brother-in-law, was Rembrandt's pupil when Carel Fabritius and Hoogstraten studied with him. None of Furnerius' paintings have been identified. The rocky, barren views made by Johannes Ruischer (*c.* 1625-after 1675) and Roeland Roghman (*c.* 1620-1686)

were inspired by Rembrandt as well as Hercules Seghers. Roghman was never Rembrandt's student, but he was his intimate friend – indeed they were on such good terms that Rembrandt refused the opportunity to entice pupils away from him. Anthonie van Borssum's (1629/30-1677) vigorously drawn landscapes indicate that he was familiar with Rembrandt's studies of the countryside made about 1645-50. Drawings and etchings by Pieter de With (active *c.* 1650-1660) suggest that he may have been one of the pupils who had the pleasure of accompanying the mature Rembrandt on the sketching trips which he made to draw from nature.

Rembrandt's cousin, the minor Leiden artist Carel van der Pluym (1625-72), worked with the master during the forties. Van der Pluym painted small pictures of old philosophers, scholars, and Vanitas themes – the stock-in-trade of Leiden artists – which earlier critics would have called clumsy and which modern specialists have admired for their primitive charm. Van der Pluym was one of the many seventeenth-century Dutch artists who had another occupation. He was the municipal plumber of Leiden.

A group of foreign artists also had contact with Rembrandt during this period. The most original was the German Christoph Paudiss (c. 1618-1666/7),[11] who was probably with the master around 1642. His transformation of Rembrandt's dark chiaroscuro and warm palette is best seen in his still lifes, which are characterized by lost contours, a soft, diffused light, and a distinctive colour harmony of cool grey, greens, rose, and a silvery yellow. A few paintings support the contention that the German artist Juriaen Ovens (1623-78) was also in Rembrandt's atelier around 1642; he is, however, usually closer to Van Dyck than to Rembrandt. Ovens is best remembered because he finished Flinck's version of *The Conspiracy of Julius Civilis* which, as we have heard, was substituted for Rembrandt's masterpiece in the town hall of Amsterdam. Other German artists who had brief contact with Rembrandt during the 1640s include the Bremen painter Franz Wulfhagen (1624-70) and Michael Willmann (1630-1706).[12] The Danish artist Bernhardt Keil (1624-87) studied with Rembrandt from about 1642 until 1644. During the following three years he worked for Uylenburgh, without losing contact with Rembrandt. He is reported to have painted altarpieces and lifesize genre scenes in Holland; none of these have been identified. In 1651 he left Amsterdam for Italy, where he spent the rest of his life. His Italian pictures, which show no sign of Rembrandt's influence, were grouped together by Roberto Longhi[13] as the works of 'Monsù Bernardo', the name given to Keil in Italy. If the attribution Longhi gave to this group of pictures is correct, Liss, Feti, and Strozzi inspired Keil in Italy, not Rembrandt. Keil is also remembered because he gave Filippo Baldinucci the data for the informative pages he published in 1686 about Rembrandt's life, character, and art in *Cominciamento e progresso dell'intagliare in rame*, the first extensive historical treatise on the history of engraving and etching.

THE MATURE PERIOD

The sobriety and dark tonality of Frans Hals' late portraits, the grandeur of the landscapes Jacob van Ruisdael painted after the middle of the century, and the rich chiaroscuro of Willem Kalf's monumental still lifes suggest that Rembrandt's mature style made a profound impression upon some of Holland's most creative artists; but precisely how much of the similarity of mood and spirit of their works is a consequence of the influence of Holland's greatest artist and how much is the result of a shared national or period style is a question easier to pose than to answer. One thing, however, is patent. The mature Rembrandt continued to attract to his studio young students who became his close followers. The best known is Nicolaes Maes (1634-93). As in the case of the majority of Rembrandt pupils, it is not known when Maes was sent to work with the master, or how long he stayed with him. Only a few pictures made before Maes left Amsterdam and returned to his native Dordrecht in 1653 can be identified. The most interesting is the large *Christ blessing Children*[14] (London, National Gallery); the arrangement of the lifesize figures into a diagonal group in this work is also characteristic of the early drawings attributed to Maes. His secure reputation as an outstanding Rembrandt pupil and as one of

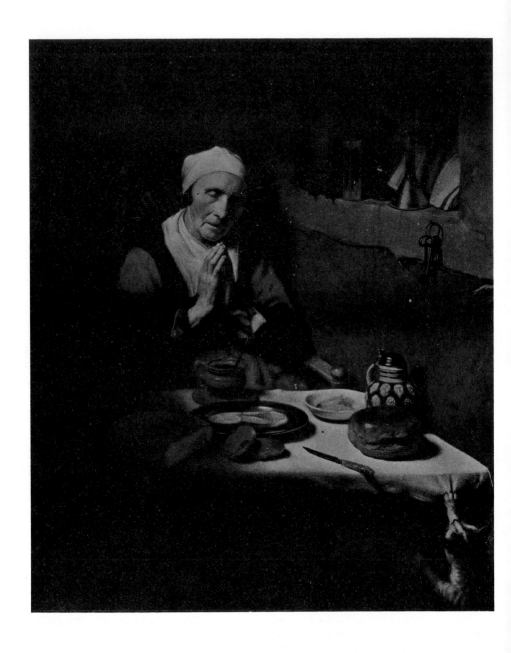

115. Nicolaes Maes: An Old Woman saying Grace, *c*. 1655. *Amsterdam, Rijksmuseum*

Holland's best known genre painters rests upon the pictures he made from around 1655 until 1660 of the domestic life of women and children. The finest of these capture aspects of Rembrandt's tenderness and intimacy. Maes has a predilection for illustrative detail, such as a cat stealing the fish dinner of a pious old woman saying grace [115], or a crying boy who has been spanked because he dared play his drum in a room where an infant is asleep. The solidity and sincerity of his painting prevents these motifs from slipping into *Kitsch*.

A typical work of Maes' early period is the *Young Girl leaning on a Window Sill* (*c.* 1653, Amsterdam, Rijksmuseum) [116]. The type is

116. Nicolaes Maes:
Young Girl leaning on a Window Sill, *c.* 1653.
Amsterdam, Rijksmuseum

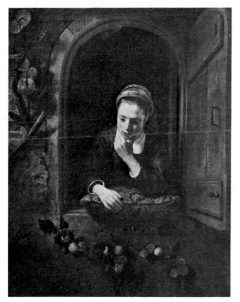

clearly derived from pictures such as Rembrandt's *Young Girl at a half-open Door* (Bredius 367) of 1645. Maes adopts Rembrandt's warm harmonies of red and yellow, black and

white within a golden chiaroscuro. He has, however, introduced his own elaborate and decorative setting. His pictures of young mothers suckling their infants in a modest interior, which are secularizations of Rembrandt's intimate Holy Family motifs, seem to have had great appeal to the popular taste. In these works Maes makes good use of Rembrandt's warm chiaroscuro, but in his hands it becomes slightly harder. The sunlight which streams into the rooms is often intense and flattens out the forms. Towards the end of the 1650s his pictorial treatment becomes broader and more decorative, but he begins to lose the finer gradations of his earlier works and stresses colourful and precious material. During the 1650s Maes also made a few Rembrandtesque portraits (*Jacob de Wit*, 1657, Dordrecht, Museum) which have a warmth and impressive depth of tonality. After 1660 his style changed radically. He abandoned Rembrandt's manner for a lighter and more elegant mode. Around this time he became a portrait specialist. This aspect of his production is discussed in the section on the late-seventeenth-century portrait (see pp. 321-2).

Barent Fabritius (1624 73), the younger brother of Carel Fabritius, reflects the deepened chiaroscuro and colourism of Rembrandt's works of around 1650. This suggests that Barent may have been Rembrandt's pupil during the early years of the master's mature period, but it is possible that this uneven artist succumbed to Rembrandt's powerful influence without entering his studio. The suggestion that one of Rembrandt's talented pupils – perhaps Eeckhout or Maes – was his teacher is also plausible. Barent's development is difficult to follow. There is no steady evolution in his work. He is an example of a gifted artist who was easily stimulated by others. However, during the very first years of his career he seems to have been impervious to the work of one important artist: his brother Carel. Barent's earliest works, which

can be dated around 1650, have nothing to do with the light tonality and the broad touch characteristic of Carel's rare masterpeices made around the middle of the century. Only after Carel's death in 1654 do Barent's works begin to show a similarity to his brother's. The striking *Portrait of a Young Man* (perhaps a self-portrait; 1650, Frankfurt am Main, Städelsches Kunstinstitut), Barent's earliest dated picture, is bolder in conception than in execution. It sets the key for much that follows. His *Peter in the House of Cornelius* (1653, Brunswick, Herzog Anton Ulrich Museum), which is a portrait of the Fabritius family in the guise of a biblical subject (Acts 10:25), has the distinctive relief-like composition and figures with oval heads which he favoured. *Elkana with his two Wives* (1655, Turin, Galleria Sabauda) is a curious combination of a biblical theme conceived *à la* Rembrandt set in a Delft interior.

In the *Portrait of W. L. van der Helm and his Family* (1656, Amsterdam, Rijksmuseum) the influence of the Delft painters is even more evident. His *Self-Portrait as a Shepherd*, painted about 1658 (Vienna, Akademie der bildenden Künste) [117], finally shows the impact of his brother's art. In brief, Barent never developed a truly personal style. His three pictures illustrating parables (1663, Amsterdam, Rijksmuseum) have strong archaistic elements in them; the *Naming of St John* (Frankfurt, Städelsches Kunstinstitut) is based on Rembrandt's inventions; and four ceiling paintings of *The Seasons* (1669, Haarlem, Frans Hals Museum), made for an estate near his birthplace Midden-Beemster, are a feeble reflection of the illusionistic Baroque ceilings executed by painters who worked for the great courts of Europe.

Little is known about the life of Willem Drost,

117. Barent Fabritius: Self-Portrait as a Shepherd, *c.* 1658. *Vienna, Gemäldegalerie der Akademie der bildenden Künste*

118. Willem Drost: Bathsheba, 1654. *Paris, Louvre*

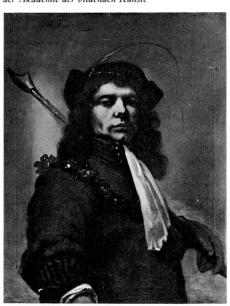

but judging from his works – only about half a dozen can be assigned to him – he was probably in touch with Rembrandt during the first half of the 1650s. His *Bathsheba* (1654, Paris, Louvre) [118], painted in the same year as Rembrandt's picture of the same subject, was certainly inspired by Rembrandt's masterwork [96]. Upon the basis of Drost's small *œuvre* one can say that a light, velvety quality, slightly reminiscent of Bol, and regular, diagonally hatched strokes are characteristic of his work. Others who adopted Rembrandt as a model during his last phase include Constantijn Daniel à (or van) Renesse (1626–80), best known as an etcher and draughtsman; Abraham van Dijck (*c.* 1635–1672), a specialist in genre pictures of old men and women; Heyman Dullaert (1636–84), who is better known for his poetry than for his rare paintings; the fashionable portraitist Jacobus Levecq (1634–75); Johannes Leupinius (*c.* 1646/7–1693), a professional surveyor who made landscapes in Rembrandt's style; and finally Rembrandt's son Titus.

The last important pupil to work with Rembrandt was Arent de Gelder (1645–1727), one of his most gifted and devoted followers. De Gelder retained distinct traces of Rembrandt's style until the end of his long career, and he was the only Dutch painter who continued to work in Rembrandt's manner during the eighteenth century. The *Portrait of a Man holding the Hundred Guilder Print* (Leningrad, Hermitage) has been generally accepted as De Gelder's self-portrait and as his homage to his teacher, but even if we ignore the fact that the Leningrad portrait does not show a cross-eyed man – we are told that De Gelder bore his affliction with good humour – the evidence for this identification is flimsy. If it was not Rembrandt but another man who dared bid one hundred guilders for the artist's most famous etching, could the Leningrad picture be a portrait of that courageous collector holding his prize impression of the print?

De Gelder's contemporaries recognized him as Rembrandt's best pupil and closest follower. They also considered him an eccentric who never grasped the importance of the elegant mannerisms of Louis XIV's court painters and who obstinately clung to the old mode of using broken dabs of colour when others had adopted the smooth surfaces popularized by Adriaen van der Werff. His fame was only local, and he had no influence on the course of Dutch painting. Soon after his death he was virtually forgotten, and interest in him revived only during the last decades of the nineteenth century, when painters and critics began to prefer the mature Rembrandt to the young one. It was at this time that Rembrandt's late pupils became more popular than the early ones.

De Gelder first studied the fundamentals of art in his native town of Dordrecht with Samuel van Hoogstraten. About 1661 he was sent to Amsterdam to work with Rembrandt. Houbraken, who knew De Gelder and who wrote his *Groote Schouburgh* in Dordrecht while De Gelder was still living, stated that he was sent to learn Rembrandt's way of working because his style was still very fashionable at that time – substantial proof from a good witness that the old Rembrandt was not a forgotten figure. De Gelder remained with Rembrandt for two years before returning to Dordrecht. From the time Dou was apprenticed to Rembrandt in 1628, every talented youngster sent to work with Rembrandt must have had mixed feelings of inadequacy, confusion, and fear, as well as a desire to learn, emulate, and surpass, when he came into personal contact with Rembrandt's art and powerful personality. We can only guess what De Gelder's reactions were during his apprenticeship when he saw Rembrandt paint the *Syndics*, the *Conspiracy of Julius Civilis*, and the series of *Evangelists* and *Apostles*. However, we do know that the experience was an unforgettable one. De Gelder not only continued to follow Rembrandt's manner long after it was

119 (*below*). Arent de Gelder: The Way to Golgotha, *c.* 1715. *Munich, Ältere Pinakothek*

120 (*opposite*). Arent de Gelder: The Family of Herman Boerhave, *c.* 1722. *Amsterdam, Rijksmuseum*

considered *passé*, but he also adopted some of his master's habits. His early biographers report that, like Rembrandt, he collected old costumes, footgear, weapons, armour, and all kinds of bric-à-brac and junk as props for his pictures. De Gelder's early works are clearly based upon Rembrandt's. The *Ecce Homo* (1671, Dresden, Staatliche Kunstsammlungen) is a variation on one of the early states of Rembrandt's great etching of the same subject dated 1655 (Bartsch 76). De Gelder's later compositions follow the tendency of the time and are more open; the less successful ones have a jerky and broken quality. The *Ecce Homo* shows De Gelder's characteristic predilection for picturesque types and fantastic oriental trappings which frequently evoke the world of Scheherazade more than that of Scripture. From the beginning De Gelder made biblical pictures of half-length, lifesize figures set before a dark background. His impressive *Abraham entertaining the Angels* (Rotterdam, Boymans–Van Beuningen Museum), which as late as 1890 was

still accepted as an authentic work by Rembrandt, must have been one of the earliest of this type. It is as a colourist that De Gelder is most fascinating; and here too he takes his lead from Rembrandt. He began to paint with Rembrandt's late colours and fluctuating manner, but following the trend of late-seventeenth-century art, his colouristic harmonies soon lighten. He achieved various textures by applying paint with his thumb, fingers, and palette knife as well as his brush, and relied more frequently than Rembrandt did upon obtaining effects by scraping or scratching into the wet paint with the butt end of his brush. He added pearly white, yellow, blue, orange, green, and violet to his palette, and with these colours produced sparkling effects which sometimes anticipate Goya. In his later biblical pictures De Gelder's types are frequently brimful of good humour and sometimes rather coarse. Contemporary Dutchmen who had cultivated a taste for decorum in painting must have complained that he used the same models for *Lot*

and his Daughters and the *Holy Family*. His best known religious pictures are the *Scenes from the Passion* which he painted around 1715 [119]. The series originally was of twenty-two pictures; twelve are known today (seven in the Aschaffenburg Museum; three at the Ältere Pinakothek, Munich; two in the Rijksmuseum, Amsterdam). De Gelder's lively portrait of *The Family of Herman Boerhave* (*c.* 1722, Amsterdam, Rijksmuseum) [120], the distinguished Leiden physician who introduced the system of clinical instruction at medical schools, shows his stature as a portraitist. In this late work by Rembrandt's last pupil there is not a trace of the contrived poses so popular among eighteenth-century portrait painters. The affectionate glances that father, mother, and daughter exchange, and the wonderful invention of their joined hands would have won approval from De Gelder's master, who was able to teach his best students naturalness, sympathy, and human warmth, as well as drawing and colouring.

GENRE PAINTING

It is curious that most European languages use the French word *genre*, which means 'kind', 'sort', or 'variety', to categorize the type of painting that depicts scenes of everyday life. Precisely when or how this special usage became current has not been determined. Diderot still debated the proper definition of the category of genre painting in his *Essai sur la peinture* published in 1796, and as late as 1846 the editor of the English translation of Kugler's *Handbuch der Geschichte der Malerei*, which contains one of the first comprehensive surveys of Dutch painting, felt it necessary to offer an apology for using a term that 'is really more negative than positive, and is generally applied to works of a small scale which do not fall into any definite class'. However, he added, as many have since, 'It is convenient, and although not English, has been adopted without hesitation in the text.' It seems that seventeenth-century Englishmen sometimes called genre pictures 'drolleries', but Dutchmen of the period had no generic name for the branch of painting their countrymen developed into a speciality. When the Dutch wanted to refer to a painting of daily life, they merely described it. There are, for example, seventeenth-century references in Dutch sources to a *geselschapje* (usually translated as 'merry company'), a *buitenpartij* (roughly, a picnic), a *bordeeltjen* (a bordello scene), and a *beeldeken* (a picture with little figures), but the Dutch had no term for the class as a whole. In this case, as in most matters concerning Dutch painting, in the beginning was the picture, not the word.

Artists had painted scenes of everyday life since Renaissance times, but during the fifteenth and sixteenth centuries such pictures were seldom made for their own sake. They were painted as parts of cycles of the seasons or months, or were made to point a moral, illustrate a proverb, convey an allegorical idea, or illustrate a passage from the Bible. An important group of Baroque artists – and once again Caravaggio led the way – broke with this tradition when they depicted anonymous people doing ordinary things just for the sake of showing man's actions in his milieu. Seventeenth-century Holland produced more and better artists dedicated to this kind of painting than any other nation. We can only conjecture about the causes for this enormous production, but there is ample evidence that a large public in the United Netherlands appreciated genre painting. We also know that the prices they paid for it were relatively low.

A word of caution is necessary about the interpretation of Dutch genre pictures. The titles given to them in museums and private collections are frequently inaccurate, because we have forgotten how hardy the ancient tradition of painting pictures with a moral or didactic purpose was. At first glance some Dutch pictures appear to be a mirror of reality, but upon closer study one discovers that they have allegorical or symbolic meaning. Scores of Dutch pictures which represent people smelling flowers, looking for fleas, fighting, singing, or eating may be pure genre scenes, but it is also possible that they belong to an allegorical series of the 'Five Senses'. In a few cases what looks like a crowded 'Merry Company' scene is, in fact, a representation of all of the five senses in one painting. Variations on the activities which

were depicted to represent the senses appear to have been infinite, and some are better conceived by the reader than discussed in this text. Pictures of cooks, fishermen, hunters, bird-catchers can be *genre pur*; they may also represent the 'Four Elements'. Sometimes it is difficult to decide precisely what the artist had in mind. Are Frans Hals' companion pieces of a *Boy drinking* [26] and of a *Boy holding a Flute* (both now at Schwerin) representations of 'Taste' and 'Sound' which belong to an allegorical series of the 'Five Senses', or are they merely pictures of the spontaneous joy of children? Is Vermeer's *Woman weighing Pearls* [149] nothing but a scene in a Dutch interior, or is it, as we shall discuss below, a reminder to the onlooker to think about the vanity of all earthly treasures? Other examples of ambivalent meaning can be cited. This ambiguity underlines the connexion of Dutch painting with the venerable Christian tradition, which judges all human activity from a moral point of view. It is possible to moralize about all man's actions and possessions, and indeed about all creation. Seventeenth-century Dutchmen did not overlook this possibility. It is not, however, necessary to devote a separate chapter to seventeenth-century Dutch allegorical painting in order to discuss the pictures based on scenes of daily life which have such overtones. The principal significance of those which still have allegorical or symbolic meaning – and the group includes portraits, landscapes, still life, as well as genre – does not lie in their emblematic character or their connexion with the familiar warning *memento mori*: their importance is a more revolutionary one. They can be grouped with the modest scenes of everyday life which were painted for their own sake, because, like them, they show that the merit of a picture is not necessarily dependent upon its subject, and that an artist's creative energy can turn a simple, ephemeral, or even a mean motif into a masterwork.

GAY LIFE AND BARRACK ROOM SCENES

In his pioneer studies on Dutch painting, Wilhelm Bode considered Frans Hals the originator and creator of the whole category of gay life and low life genre painting. Subsequent research has shown that Bode was wrong. Seventeenth-century Dutch genre painting has its roots in an older tradition, and by the time Frans Hals began to produce his characteristic pieces, this category of painting was flourishing simultaneously in Haarlem, Amsterdam, and Utrecht. It is true that Hals gave a most decisive impulse to the whole category by his powerful temperament and brilliant pictorial treatment; but few Dutch genre painters can be called his followers. It is one of the peculiarities of Dutch painting that the so-called 'Little Masters' often show a good deal of individuality and originality, and cannot be classified as mere imitators of the great ones.

Around the beginning of the century two trends of Dutch genre painting can be distinguished which are closely connected to earlier Netherlandish painting. The practitioners of both, like the sixteenth-century artists who were pioneers in the field, were not genre specialists. Specialization became widespread only after 1625. One type – which quickly came to a dead end – derives from the large pictures painted by Pieter Aertsen (1509-75) and his nephew and close follower, the Antwerp painter Joachim Bueckelaer (*c.* 1530-1573). These pictures frequently represent rather solemn, gesticulating lifesize figures in a kitchen or a market crowded with fruit, vegetables, meat, poultry, fish, and game. A biblical event is sometimes depicted in the background. The idea of placing a scene from Scripture in the distance, where it is dwarfed by an over-stuffed foreground, is the characteristic Mannerist trick of inversion. A small group of Dutch painters continued to work in

the Aertsen–Bueckelaer tradition well into the seventeenth century, but, with the exception of Cornelis van Haarlem, they are of minor importance. It is not possible to trace a connexion between Aertsen's monumental kitchens and Bueckelaer's markets and the achievements of either the great or little masters of Dutch genre painting. Large-scale genre pieces, like large-scale still lifes, which were also derived from the Aertsen–Bueckelaer tradition, are the exception in Dutch art. They were always more popular in Flanders than in Holland. It is worth noting that Aertsen had an international following about the time a few *retardataire* seventeenth-century Dutch artists were painting in his style. Distinct traces of his motifs can be seen in the work of Italians in Bologna and Cremona, and some of the *bodegones* and religious paintings made by the young Velazquez suggest that he was familiar with pictures by Aertsen or his followers.

The other type of genre painting has its roots in the panoramic scenes depicted by

Pieter Bruegel the Elder and his school. It was brought to the north by a wave of Flemish immigrants, who played an important part in establishing the Dutch school of landscape painting, as well as in setting the principal direction of the genre specialists. The versatile Mannerist Van Mander, who belongs to this group, has already been mentioned, and mythological scenes in arcadian settings by other Dutch Mannerists also helped establish motifs which became the stock-in-trade of Dutch genre painters. A leading figure in the transition from the Mannerist tradition to the new realism in genre painting was David Vinckboons (1576–1632), one of the most popular and prolific painters and print designers of his time. Good proof of Vinckboons' debt to Bruegel is the debate which scholars still hold about whether some pictures should be attributed to Pieter Bruegel the Younger, whose art was a shadow of his great father's, or to Vinckboons. Vinckboons' family had settled in Amsterdam by the time he was fifteen years old,

121. David Vinckboons: Kermis, *c.* 1610.
Dresden, Gemäldegalerie

and he apparently spent the rest of his life in Holland. His works indicate that he had contact with Gillis van Coninxloo, the gifted Flemish landscape painter, who also immigrated to Amsterdam. Vinckboons was one of the artists who helped to forge the new landscape style, but in the final analysis his interest was man, not nature. His genre pictures range from early multi-coloured ones of large crowds strolling through gardens and Bruegel-like kermis scenes [121], to those made in the last years of his life which show a close view of a single couple in a landscape. There are contemporary references to a lost picture by Vinckboons dated 1603 of a large crowd watching a lottery held at night illuminated by lights and lanterns – yet another example of the interest in nocturnal effects before the return of Caravaggio's followers to Holland. The works Vinckboons made during the first decade of the century frequently have a moralizing character, and he employed traditional allegorical subjects such as 'Death surprising Lovers in a Landscape'. For a few years before and after the Truce signed in 1609 he made pictures showing the plight of those who were plundered during the war and satires of the Spanish invaders, but these subjects are as exceptional in his *œuvre* as they are in the art of his contemporaries. The momentous events of the time play an insignificant role in the history of seventeenth-century Dutch art. The artists who are reputed to have used the world around them as their subject were not concerned with every aspect of it. It is noteworthy how many genre painters use the same themes. Banquets, tric-trac players, musicians, drinkers were favourite subjects from the beginning, and were used throughout the century. On the other hand, some motifs were seldom represented. Vinckboons made a few pictures of wretched beggars and blind hurdy-gurdy men early in his career, and during the following decades Adriaen van de Venne (1589–1662), whose style was also based upon

Bruegel's, made *grisailles* of the destitute and maimed which have a moralizing character. However, paintings of the gay life of cavaliers and their fashionable women companions – the so-called 'Merry Company' pictures – were much more popular than those showing the predicament of the poor. Vinckboons' earliest dated painting of an outdoor banquet is inscribed 1610 (Vienna, Akademie).

Pictures of elegant young people dancing, drinking, and making love to the accompaniment of music could also have a didactic purpose. Late-sixteenth-century illustrations of *Mankind before the Flood* and *Mankind awaiting the Last Judgement* (Matthew 24: 37–9) show that such scenes could be seen in this light. One of the earliest paintings of this type is the *Banquet in a Park* painted about 1610 (formerly Berlin, Kaiser-Friedrich Museum, no. 1611, destroyed in the Second World War) [122], and attributed to Frans Hals. The painting is based upon a print Vinckboons designed for an episode in the *Life of the Prodigal Son* which was engraved in 1608. The riotous bordello scene from the parable of the Prodigal Son is one of the ancestors of Dutch 'Merry Company' pictures. The complicated origins of this theme can also be found in sixteenth-century representations of the Feast of the Gods, and ultimately it can be traced to fifteenth-century prints and *plaisance* tapestries of love scenes in gardens. The lost Berlin picture still shows a Mannerist heritage. The scattered vistas into the distance, the spotty illumination, the use of diagonals and zigzags to entangle figures and space in a complicated way, the ornamental treatment of the foliage, and, not least, the affected attitudes of the young ladies and their companions, all relate the picture to the last phase of Mannerism. The fresh, painterly treatment and a certain closeness to works by Hals' teacher Van Mander argue for Hals' authorship. But, as we noted in our discussion of Hals, if he painted

122. Frans Hals (attributed to):
Banquet in a Park, c, 1610.
Formerly Berlin, Kaiser-Friedrich Museum (destroyed)

the picture, it is unique in his long career. As far as we know he did not make another small-scale painting of elegant figures in a landscape or an interior. This subject was developed into a special category at Haarlem by Frans Hals' brother Dirck, and by his contemporaries Esaias van de Velde and Willem Buytewech.

Esaias van de Velde (*c.* 1591–1630), who is best-known for his realistic landscapes, which served as a point of departure for his pupil Jan van Goyen, also painted a few pictures of gallant companies feasting in a garden. He arrived in Haarlem in 1610, an exciting time for a budding artist to settle there. During the same year Frans Hals joined the Guild of St Luke; two years later, Esaias van de Velde,

Willem Buytewech, and Hercules Seghers were inscribed as guild members. Esaias probably studied with Vinckboons in Amsterdam; he made a pen drawing after one of Vinckboons' 'Merry Company' scenes in a park, and two of his own pictures of outdoor banquets (1614, The Hague, Mauritshuis; 1615, Amsterdam, Rijks-museum) are done in the spirit and technique of the popular Amsterdam master. In 1618 Esaias left Haarlem for The Hague, where he spent the rest of his career. The stay of Willem Buytewech (*c.* 1591/2–1624) at Haarlem was equally short; there is no evidence that he was there before 1612, and it is certain that he settled once again in his native town of Rotterdam in 1617.

Buytewech, who was nicknamed 'Geestige Willem' (witty or ingenious Willem), was not very active as a painter. Only about ten pictures can be attributed to him, and these were all made during the last seven or eight years of his short life. Buytewech had close contact with Frans Hals: according to an old inventory reference, both artists worked on the same picture; they used the same models; and Buytewech even copied some of Hals' works. But he never acquired Hals' fluency or boldness in the use of fat oil paint. Compared with Hals, the efforts of Buytewech are tight and his touch is minute. Nevertheless, 'Geestige Willem' painted enough to justify the claim that he established the important category of the 'Merry Company' in an interior. An excellent example of the type is the picture painted c. 1617-1620 in the Boymans-Van Beuningen Museum [123]. The fat Falstaff type who wears a garland of sausages is the same model who appears as Peeckelhaering in Hals' *Shrovetide Revellers* [20] painted a few years earlier. Buytewech's work already shows the Early Baroque phase of Dutch painting. The figures are much more sculptural than those by Vinckboons or Esaias van de Velde, and are depicted close to the spectator, with a detailed realism. The colours have become bright and show a touch of plein-airism, although there is too much local colour - particularly pinks, yellows, and blues - to produce complete unity and harmony. Buytewech was not yet the type of narrow specialist who developed in the following generation. His subject matter included religious themes, allegorical motifs disguised as scenes from everyday life, book illustrations, and charming landscapes as well as genre scenes, all

123. Willem Buytewech: Merry Company, c. 1617-20. *Rotterdam, Boymans-Van Beuningen Museum*

this largely in graphic art. He proved himself remarkable as a draughtsman and a graphic artist. Among his most engaging etchings is a series of cavaliers of different nations, designed as fashion plates. After the Spanish fashion had dominated the whole of Europe in the second half of the sixteenth century, the French elegance of the court of Louis XIII, best represented in Callot's precious etchings, began to fascinate the well-to-do people of Holland, who had not yet developed their own burgher taste. Buytewech's costume designs charmingly reflect the foppish affectation of the young men who already enjoyed the fruits of the heroic fight of their fathers for liberation from Spain. His use of the etching needle is ingenious. Simple lines and sketchy shading suggest movement and daylight not so far from Frans Hals' impressionistic conception. In his pen-and-brush drawings one feels even more of this engaging master's gift and charm. His enchanting drawing of an *Interior with two Women sewing before a Fireplace* (Hamburg, Kunsthalle) shows a freshness and refinement which holds its own at the side of any great draughtsman, and a mood which anticipates the intimate domestic scenes by Pieter de Hooch.

Buytewech's inventions left a strong impression upon a number of contemporary painters in Haarlem. After he left for Rotterdam in 1617 Hendrik Gerritsz. Pot (*c.* 1585–1657) and Isack Elyas (active *c.* 1620–1630) continued to make small genre scenes in carefully worked-out interiors which show their debt to 'Geestige Willem'. Hendrik Pot also tried his hand at large-scale genre scenes (*Merry Trio*, 1633, Rotterdam, Boymans-Van Beuningen Museum) which reveal that he wanted to emulate Frans Hals. The spirited German artist Johann Liss[1] (*c.* 1595–*c.* 1629/30), who stayed in Holland about 1615 before going on to Paris and then to Venice, was as impressed by Buytewech's society pieces as he was by Frans Hals, Vinckboons, and the

older Haarlem Mannerists. Buytewech also had a decisive influence on the art of Dirck Hals (1591–1656). Dirck's nicely coloured social scenes, all on a small scale, show some dependence on the art of his brother, but no mistake can be made about his identity. The symmetrical arrangement of the large groups of gallant companies Dirck depicted in interiors and parks, the shallow space he used, and his elegant types, indicate that he owes more to Buytewech than to Frans Hals. The similarity between the two also explains why the early works of Dirck and Buytewech are sometimes confused. However, it is not difficult to recognize Dirck's pictures. His figures are never as slim or graceful as Buytewech's, and they wear a smile or grin on their cat-like faces, which have little in common with Buytewech's more subtle characterizations. Dirck's colours are gay and pleasant: yellow, bright blue, pink, green, and golden brown predominate. His silver lighting and crisp touch are obviously inspired by Frans' greater art. In his fine oil sketches on paper (an outstanding one is in the collection of Frits Lugt, Paris) which are studies for his gay-life compositions, Dirck seems to surpass himself. But the type is undoubtedly his. Dirck's sketches, with their sharp impressionistic manner, are certainly not very far from Frans, and perhaps they show Frans' manner of drawing. It is hard to believe that his less-gifted brother invented this technique.

Around 1630 Dirck abandoned the crowded compositions of the 1620s for small ones showing the simple activities of one or two figures in an interior. His palette, following the trend of the time, became more monochromatic and subdued. Greys, olive greens, and dark browns set the key, and chiaroscuro effects play an important compositional and expressive role in these more modest works. *A Woman tearing up a Letter* (1631, Mainz, Gemäldegalerie) [124] gives a good idea of the new mood, and, in an unexpected way, a

124. Dirck Hals: Woman tearing up a Letter, 1631.
Mainz, Gemäldegalerie

premonition of what Vermeer and his contemporaries were to achieve about a generation later. However, it would be erroneous to conclude that Dirck Hals and his contemporaries (Judith Leyster, Jan Miense Molenaer, Pieter Codde, Willem Duyster), who made similar pictures about 1630-5, blazed the way for the next generation of Dutch genre painters. There is little connexion between this group of minor artists and Vermeer, Jan Steen, Metsu, and the leading painters of the Leiden School. The masters of the great age of Dutch genre painting found their inspiration elsewhere. Only Ter Borch and Pieter de Hooch are exceptions; a relation can be established between their early works and the guardroom scenes by Duyster and a few Amsterdam painters. Moreover, by the end of the 1630s Dirck Hals and other artists of his generation were once again depicting grimacing crowds in awkward 'Merry Company' scenes and failed to attain the high pictorial quality they achieved during the first half of the decade. Their late works can hardly be called inspiring.

When Jan Miense Molenaer (c. 1609–1668) restrains his predilection for clowning, he is an attractive little master of the period [125]. He is frequently called a pupil of Frans Hals, but this period. His range of subject and style is a wide one. He made successful pictures which use Honthorst's artificial light effects (*Allegory of Taste*, 1634, Brussels, Museum), and in a

125. Jan Miense Molenaer: The Artist's Studio, 1631.
East Berlin, Staatliche Museen

it is not known if he was ever apprenticed to the master. His *Merry Company at a Meal*, dated 1629 (Worms, Heylshof), shows his debt to the laughing figures Hals painted during the same decade, but he made no attempt to imitate Hals' vigorous brushwork. In 1629 Molenaer also painted small pictures of full-length figures in interiors (*Two Boys and a Girl making Music*, London, National Gallery) which are closer to Dirck Hals than they are to Frans. During the thirties he continued this type, and his finest genre pieces date from series of five peasant scenes which represent the *Five Senses* (1637, The Hague, Mauritshuis) he leans heavily upon Brouwer. Molenaer's coarse *Denial of St Peter* (1636, Budapest, Museum) is represented as a daylight scene in a peasant tavern, and in the following year he painted the meticulously finished *Family Party* (1637, Amsterdam, Rijksmuseum), a group portrait of wealthy burghers in a well-appointed, probably imaginary interior which shows the influence of the popular Amsterdam portraitist Thomas de Keyser. In 1636 Mole-

naer married Judith Leyster (1609–60), a talented painter who was one of Hals' most successful followers. She must have been rather precocious; she is cited as one of the artists working in Haarlem in Ampzing's history of that city written in 1627. In the following year her parents moved to a town near Utrecht. This may explain why some of her early works (e.g. *Democritus and Heraclitus*)[2] show the impact of the Utrecht *Caravaggisti*. In 1629 her parents moved to Zaandam, about ten miles from Haarlem, and it was around this time that she began to make pictures which are so close to Frans Hals that some of them still pass under his name. A comparison of the copy of Hals' *Lute Player* in the Rijksmuseum, Amsterdam, attributed to her, with the original in the Alain Rothschild Collection in Paris shows how cleverly she could copy Hals' works, but the picture also reveals her limitations. It is only in a few passages that she can keep up with Hals' spontaneous treatment; in others she is dry and conventional. She also fails to capture the bulk and movement of Hals' musician and, although her brushwork sometimes approaches the master's manner, it lacks personality and never expresses all his essential qualities. When she is on her own, as in the lifesize *Jolly Toper* (Amsterdam, Rijksmuseum) which is monogrammed (her monogram includes a star which is a play on 'Ley/sterre' = lodestar) and dated 1629, her shortcomings are obvious. She sticks more to the form in the ordinary sense, with more local colour and less of the atmospheric quality and play of light which fuse figure and space and animate the surfaces of Hals' works.

Judith Leyster did not consistently work in Hals' manner. She painted a few still lifes, and as early as 1630 she began to make small genre pictures similar to those by Dirck Hals and Molenaer. During this period it is sometimes difficult to distinguish her work from Molenaer's. They frequently used the same studio

props and the same models. Perhaps they even worked on each other's pictures. Judith combined the artificial light effects Honthorst popularized with the subjects used by the painters of interiors, and like her husband she is more pleasing in her little paintings than in her big ones. The *Young Flute Player* (Stockholm, National Museum) [126] shows her at her best. The brushwork here has become less distinctive, but the subtle gradations in value on the light-grey wall and the colouristic harmony of the boy's red hat, olive-green jacket, violet trousers, and mottled green chair make an exquisite effect.

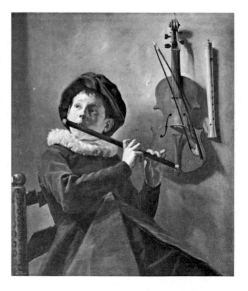

126. Judith Leyster: The Young Flute Player, *c.* 1630–5. *Stockholm, National Museum*

127 (*opposite*). Willem Duyster: A Night Scene in an Interior, *c.* 1632. *Philadelphia Museum of Art, J. G. Johnson Collection*

In 1637 Judith and Molenaer are recorded as living in Amsterdam, and the couple remained there for more than a decade before settling again in the vicinity of Haarlem. Judith produced very little during the last half of her life. Molenaer continued to be prolific, but around 1640 his paintings underwent a change and become dull and monotonous. He fell under Ostade's influence, but fails to capture any of his model's psychological insight or power of design in his paintings of crowds of peasants in large interiors. In these late works Molenaer's paint becomes more liquid, and a rather uniform brown takes the place of the blond tonality he used earlier. His pictures of the period are sometimes confused with those by his follower Egbert van Heemskerck (1634/5–1704). Since the decline in the quality of the work of both Molenaer and his wife takes place shortly after they were married, it is tempting to conclude that their marriage impaired their artistic powers. The idea, however, can be rejected. We have already noted the singular fact that other Dutch genre painters of the same generation lost their strength after 1635. Willem Duyster (b. 1599?), a specialist of guardroom scenes, probably the most gifted of the group, was never put to the test: he died in 1635.

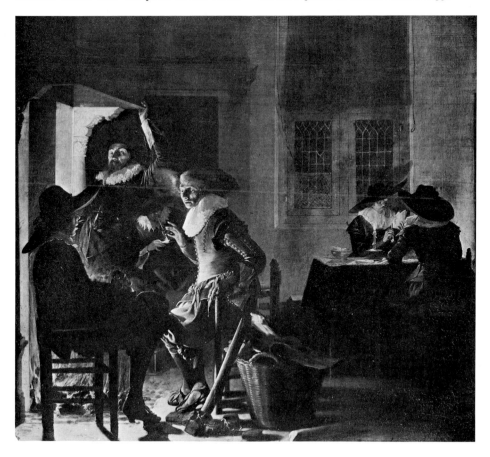

Compared with other countries, Holland suffered little from the cruel events of the Thirty Years War. The small, wealthy nation was able to employ mercenary troops to protect its borders. Members of the militia companies of Dutch cities, whose group portraits were painted so frequently, seldom saw action. When they went out on an expedition it was usually to relieve a garrison of mercenaries engaged to do the actual fighting. Of course the troops were not always on the alert, and they spent their off duty time in taverns, where they became familiar figures. A group of Dutch painters specialized in painting the life of these soldiers. Scenes of plunder and battle were depicted, but the ancient battle of the sexes, where the field of action was a room in an inn or a barrack, and in which the outcome of the struggle is not much in doubt, was more frequently represented. Other popular subjects were soldiers playing cards or tric-trac, or quietly smoking. In general, scenes with little movement or overt action were preferred. These painters had a special feeling for tonal values, and their pictures take on a certain still-life quality. In their half-dark interiors the light glitters over uniforms, and a fine subdued play of colours, mostly broken and harmonized by delicate half-tones, betrays the Dutch gift for intimate pictorial qualities and a subtle rendering of textures. Some even anticipate the achievement of the society painters of the following generation, when well-to-do burghers rather than soldiers and their friends became the favoured subject of the genre painters. Specialists in this category worked in Amsterdam, Utrecht, Delft, but seldom in Haarlem. The leading ones in Amsterdam were Willem Duyster and Pieter Codde. What sets Duyster's rare pictures apart from those made by his contemporaries is his distinct chiaroscuro and the refinement of his colours. He was also better able than any of them to convey the fascinating visual drama which can take place

when people do little more than confront each other. It is difficult to think of a painter of his time who surpasses his penetrating characterization of the personalities of the men gathered round a fireplace in the modest nocturnal scene in the Johnson Collection, Philadelphia [127] (versions also in the Hermitage, Leningrad, and formerly in the W. Dahl Collection, Düsseldorf). Duyster's approach is always original. He transformed the models for his family groups into nervous figures with soulful eyes, and it is not difficult to understand why his small, dignified portraits of full-length single figures seen against dark backgrounds served as the point of departure for Ter Borch's great accomplishment in this field.

Pieter Codde was born in Amsterdam in 1599 (Duyster was probably born there too); he

128. Pieter Codde: A Smoker, c. 1630-5.
Lille, Musée des Beaux-Arts

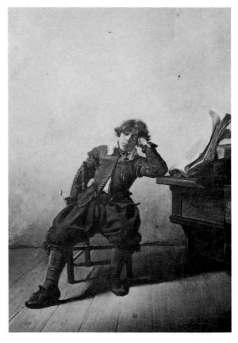

painted portraits and gay life scenes as well as military subjects. His tiny picture of *A Smoker* (Lille, Musée des Beaux-Arts) [128], painted in shades of silvery grey and ochres, is a kind of secularization of Dürer's *Melancholia*. It is more appealing than his more ambitious genre compositions, where he gives way to his preference for rather coarse and plump types, over-glossy textures, and exaggerated highlights. The rooms Codde represents are always of less interest to him than the people he placed in them, and although he lived long enough to see the accomplishment of the great Dutch painters of interiors – he died in 1678, three years after Vermeer – he never attempted to emulate their achievements. Codde was capable of making radical adjustments in his style. We have heard that he was the Amsterdam painter who was commissioned to finish Frans Hals' group portrait of the *Meagre Company* (1637, Amsterdam, Rijksmuseum) when Hals refused to continue to work upon the picture. The part of the lifesize group portrait which Codde executed follows Hals' manner.

Pieter Quast (1606–47), who was a prolific draughtsman, can be classed with the Amsterdam painters of military subjects. He also painted coarse peasant scenes, and was one of the few who made pictures illustrating proverbs in the style of Adriaen van de Venne. Jacob Duck (1600–60) represents the guardroom tradition in Utrecht. He prefers large crowds gathered in spacious halls and exploits all the tricks known to the artists of his time to create the illusion of space: curtains or large objects in the foreground to set the front plane, an emphasis on the orthogonal lines made by the tiles or boards on the floor, vistas into rooms beyond the one in which the main action takes place, and aerial perspective. If mutual influence is a criterion, he was as unimpressed by the Utrecht followers of Caravaggio as they were by him. His subjects range from boorish episodes in taverns to the lovely picture of a woman ironing in a kitchen (Utrecht, Centraal Museum). The Delft portraitist Antonie Palamedesz. (1601–73) repeatedly made social scenes of groups of officers in gay company. The window which is the source of the light that gives his pictures their blond tonality is frequently visible. The dominant hues in his pleasantly coloured pictures are a blue and yellow of low intensity. Scarce works by Jacob van Velsen (d. 1656) are in the style of the earlier genre pieces by Palamedesz.; Velsen's *A Music Party* (1631, London, National Gallery) once bore a false Palamedesz. signature.

PEASANT AND LOW LIFE SCENES

A discussion of Dutch paintings of peasants should begin with Adriaen Brouwer, who, for good reason, is usually classified as a Flemish artist.[3] He was born in 1605/6 in Oudenaarde, near the Dutch border, lived in Flanders for the greater part of his life, and died in Antwerp in 1638. Moreover, from the beginning to the end of his brief career he shows the daring touch and tendency to movement and action in his compositions which are qualities we like to consider Flemish rather than Dutch. Why, then, include him in a history of Dutch painting? The fact that he worked in Holland during his early period and that this experience was significant for both his own achievement and the development of seventeenth-century Dutch genre painting justifies brief mention of him here. Like all great artists, he is not easy to pigeon-hole. Certainly there are Flemish qualities in his style, but he shows the warmth, intimacy, and subtlety of tonal treatment which in general distinguish Dutch from Flemish painting. Equally important is the fact that Holland did not yet have a special school of low life genre painting by the early 1620s. The moralizing efforts of Vinckboons and Adriaen van de Venne in this branch during the first decades of the century failed to inspire any

significant artists to follow their lead. It was due to Brouwer's activity that the category quickly gained such wide popularity among Dutch as well as Flemish artists and collectors. Adriaen van Ostade became Brouwer's most famous successor in Holland; David Teniers carried on his tradition in Flanders.

Brouwer's first teacher was his father, who made tapestry cartoons at Oudenaarde. Nothing he painted before he moved to Holland is known, but he seems to have arrived in the north as an accomplished painter who was familiar with Pieter Bruegel the Elder's work. He probably had contact with followers of Bruegel before he left Flanders. The precise date of Brouwer's arrival in Holland is not documented. There is, however, evidence that he was in Haarlem and Amsterdam in 1625 and 1626, and reason to believe that he was in Hals' circle as early as 1623 or 1624. In 1626 he was a member of 'De Wijngaertranken', the Haarlem chamber of rhetoricians to which Hals belonged, and there are contemporary references to him as 'Adriaen Brouwer Harlemensis' and 'Schilder van Haarlem'. Houbraken thought he was born in Haarlem. But even if we had no information about his connexions with Haarlem, the vivid brushwork which animates all his little paintings and the portrait-like character of some of his genre pieces would suggest that he had contact with Frans Hals. The date of his departure from Holland is also unknown. In the winter of 1631-2 he was back in Antwerp, where he became a master in the guild. He apparently spent the rest of his life in Antwerp. Whether he died so young as the result of the dissolute life his early biographers describe, or was stricken by the plague which ravaged Antwerp in 1638, the year of his death, is a matter of conjecture.

In early works like the *Pancake Man* (Philadelphia Museum of Art, J. G. Johnson Collection) [129], Brouwer is still inspired by the art of Bruegel, the founder of the category of peasant subjects; the crudeness of the gnome-like

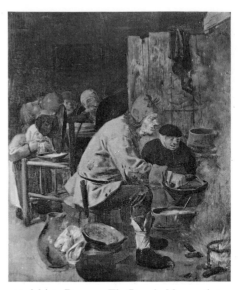

129. Adriaen Brouwer: The Pancake Man, *c.* 1625. *Philadelphia Museum of Art, J. G. Johnson Collection*

types and the vivid local colour prove that. The drawing and the highlights are somewhat hard and sharp, and the types are created without much individualization. Yet we already feel Brouwer's keen observation and biting humour. Brouwer stands out from the beginning as a man who was completely at home with the most common people. This distinguishes him from his countryman Teniers, who remains a neutral spectator or even shows a condescending attitude when he represents himself as a gentleman visiting a village kermis. Brouwer, it seems, shared the pleasures of the people in his genre pictures. According to literary sources he was a Bohemian with an informal, genuine, and humorous personality. His hatred for social hypocrisy has given rise to many stories and legends about his disorderly life. He is reputed to have been invited to grace a wedding because he had acquired a fine suit. After everyone had commended his rich apparel, he poured a dish

of gravy upon his clothes, saying that it was proper to bestow the good cheer upon his suit, since it was for its sake and not his own that he had been invited. De Bie, a contemporary Flemish writer, tells us that Brouwer made most of his quick drawings on the spot in pot houses and often paid his bills with his sketches. He was, in fact, constantly in need of money.

Under the influence of the Dutch environment Brouwer became one of the finest *valeur* painters of all times. Before he left Holland he began to give his figures more individuality, and developed strikingly original configurations for his compositions. Whether he represents a group engaged in violent action [130] or merely brings figures together who share a common mood, there is always a clear focus on the essential point. By the end of the 1620s the varied colours of his early manner give way to a single focal accent: a warm red or green, a golden yellow, or a faded blue. The rest of the picture is brushed in with warm translucent greys and browns, and the whole effect has become more atmospheric. Continuous space is suggested by subtle tonal adjustments and sensitive and economic accentuation. Everything is well blended into the atmosphere of the whole. The full appreciation of the spatial and psychological accents, the tonal refinement, the colouristic organization, and the delightful play of cool and warm tones in Brouwer's precious little masterpieces can hardly be reached without seeing the originals. After Brouwer returned to Antwerp his groups became more compact, his touch broader – although it never attains the breadth of Frans Hals – the atmospheric quality even greater, and the tonality more luminous. His power of

130. Adriaen Brouwer: Fighting Card Players, *c.* 1630–5. *Munich, Ältere Pinakothek*

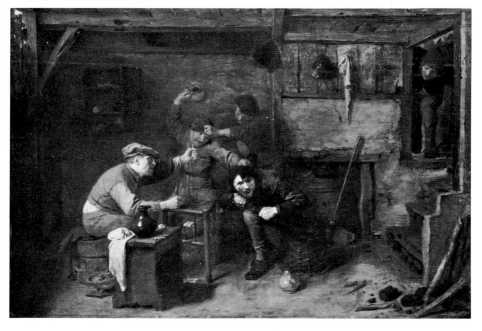

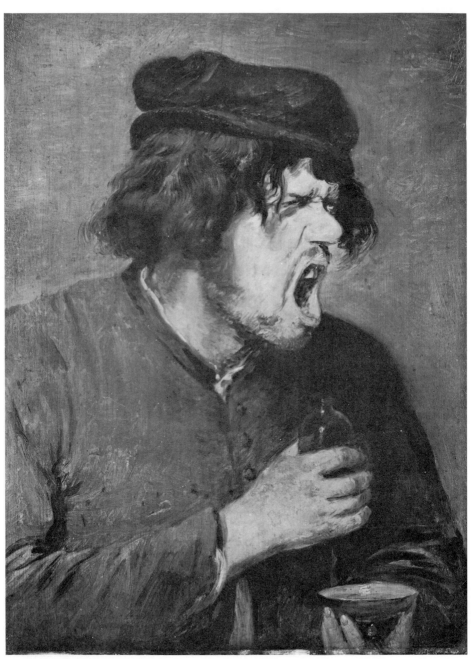

131. Adriaen Brouwer: The Bitter Draught, *c*. 1635–8. *Frankfurt, Städelsches Kunstinstitut*

expression is also increased. The physiognomies in the *Bitter Draught* [131] and the *Operation on the Back*, both in the Städelsches Kunstinstitut, Frankfurt am Main, are not matched before Daumier. Brouwer's originality is also shown in his landscapes, which influenced the interesting ones Lievens painted in Antwerp. They belong to his last years, and are equalled in poetic mood and pictorial charm only by the landscape paintings of Rubens and Rembrandt. Both these great masters eagerly collected Brouwer's work. Rubens owned seventeen of his paintings, and Rembrandt acquired six, a copy of one of his

paintings, and a sketchbook. Since Rembrandt's early energetic penmanship shows a debt to Brouwer, he probably began to collect Brouwer's rapid and suggestive drawings from the very beginning. Adriaen van Ostade and Jan Steen are the other important Dutch painters who were inspired by Brouwer. Among the minor ones, only Cornelis Saftleven (1607/8–1681) and Hendrick Sorgh (1610/11–1670), both of whom belong to Rotterdam and made peasant interiors early in their careers, are of some significance. Brouwer's fame did not diminish until the early nineteenth century, but with the rise of Impressionism, and due to

132. Adriaen van Ostade:
Carousing Peasants in an Interior, *c.* 1638.
Munich, Ältere Pinakothek

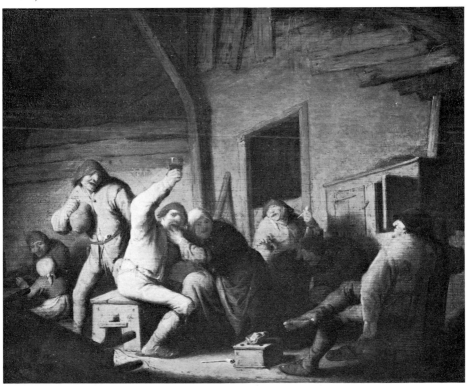

Bode's research work, Brouwer came to the foreground again. His pictures are exceedingly rare, and one must be aware of the danger that many of them were already copied in his own time – so deceptively that even Rubens had to ask for a certificate of authenticity from Brouwer himself in order to guarantee one of his purchases.

Houbraken wrote that Brouwer and the Haarlem painter Adriaen van Ostade (1610–85) were pupils of Frans Hals at the same time. His statement may be correct. There is no difficulty in imagining young Ostade, who was the son of a weaver, at home in Hals' circle. However, neither the subjects nor the style of Ostade's early paintings have much to do with Hals. Perhaps his response to Hals was a slow one. The small, portrait-like genre pieces Ostade made in the late forties show a debt to the compositions which Hals used for the half-length genre pictures he painted in the twenties, when Ostade was supposedly his pupil. It is noteworthy that Ostade only turned to this schema after Hals himself had ceased to make genre paintings. Ostade did peasant scenes throughout his long and productive career. His first manner combines Brouwer's influence with that of Rembrandt's early chiaroscuro effects. Pictures of lively and slightly grotesque peasants carousing in disorderly hovels are characteristic of his boisterous work of the 1630s [132]. Ostade also used peasant scenes to illustrate the five senses (1635, Leningrad, Hermitage). In works made early in the thirties the subtle play of colours, particularly light blue, light grey, rose, and violet, is more important in unifying his pictures than the rather bizarre chiaroscuro pattern. Later in the decade a tonal design begins to organize the surface and depth of his pictures. There is less local colour, and the light and shadow, which is concentrated in large areas, becomes more Rembrandtesque. In the forties his interiors

gain in spaciousness and atmosphere. Some pictures of crowds gathered before inns and landscapes also date from this decade. By the middle of the century Ostade had changed to a more idyllic style. His figures became calmer and more respectable [133]. There is a new emphasis on local colour and an orderly arrangement. The reason for the shift in Ostade's mood has not been established, but it is probably related to a change in his clientele, to his own conception of himself, and his ideas about his task as an artist. In this connexion his *Self-Portrait with members of the De Goyer Family* (The Hague, Bredius Museum), painted about 1650, is revealing. Hendrick de Goyer, who held responsible offices as a public official in Holland and who also received a gold medal and chain from the king of France, is seated on the right. De Goyer's wife is shown holding a piece of paper, and his famous sister-in-law, Catherina Questiers, is the sympathetic fat woman who has the place of honour. Well-educated and talented, Catherina Questiers, whose accomplishments were praised in verse by Huygens and Vondel, was famous in Dutch intellectual and artistic circles. Ostade stands respectfully and respectably on the right. He appears to be at home in the quiet atmosphere of the house. It is not hard to accept the fact that this is a self-portrait of an artist who no longer painted the rowdy brawls of peasants.

In 1657, after Ostade was converted to Catholicism, he married a wealthy Catholic woman from Amsterdam. Ostade was well-to-do before his marriage, and he continued to enjoy a comfortable income until the end of his life. His output was tremendous, and he must have been well paid for his work. More than eight hundred of his paintings and about fifty etchings are known. His numerous drawings, which are sometimes delicately tinted with watercolour, are found in most collections. Ostade's late pictures of well-mannered

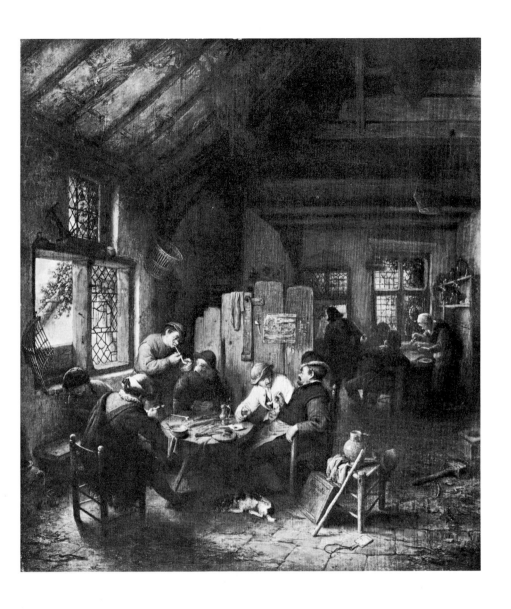

133. Adriaen van Ostade: Men and Women in a Tavern, 1660. *Dresden, Gemäldegalerie*

farmers in comfortable surroundings were not the depiction of a dream world. Even before the Treaty of Münster was signed in 1648, bringing the Eighty Years' War with the Spanish to a successful end, Dutch burghers and peasants began to profit from the general wealth of the nation. Contemporary travellers to Holland frequently comment on the widespread prosperity. The mature Ostade painted the simple joys and comforts of the ordinary Dutchmen of his day, and apparently these were the people who adorned their houses with his paintings. With the departure from Brouwer's style, Ostade's peasants lose a good deal of their former vitality, but his painting always remains on a high level and he definitely retains a certain charm until the very end. His good-natured humour, as well as his painterly refinement, make all his works attractive. During the eighteenth century, when collectors were impressed by the realism of his Dutch peasants and apparently enjoyed them as a refreshing contrast to the elegant figures who people Rococo paintings, Ostade was as highly esteemed as Rembrandt. This accounts for the great number of his works found in the princely collections built up during the eighteenth century. He still appealed to collectors of the nineteenth century, who liked his intimacy and subtle painterly qualities, but with the advent of Impressionism his popularity waned. Though his etchings have been carefully studied and catalogued, it is significant that no substantial monograph has been devoted to his paintings, and he was not honoured with a one-man show until 1960, when an exhibition was organized in the Soviet Union to celebrate the 350th anniversary of his birth.

Adriaen van Ostade's principal pupil was his brother, Isaack van Ostade. Judging from what Isaack produced during his short career, he was even more talented than Adriaen. Isaack was born at Haarlem in 1621 and died there in 1649. His earliest dated work is inscribed 1639, and few of his pictures can be assigned an earlier date; thus he only painted for about a decade, but what he accomplished during those years is more impressive than what Adriaen did during his first ten years as an independent master. Isaack's early works are very much like those painted in the thirties by his elder brother, but his peasants are less energetic and his colours are warmer than Adriaen's. It is sometimes difficult to distinguish their hands at this stage; perhaps they are another pair who worked upon each other's pictures. But Isaack soon went his own way. He specialized in rather large-scale summer and winter views of Holland which are generally crowded with people. They are a wonderful combination of genre and landscape painting, and his representations of the silvery light of a warm summer day or the atmospheric subtleties of a grey winter sky match those painted by the

134. Isaack van Ostade: Rest at the Farm House, 1648. *Haarlem, Frans Hals Museum*

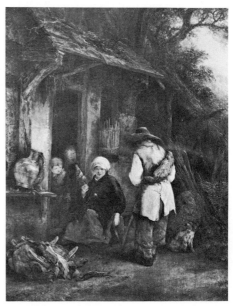

best landscapists of his day. His favoured motif is the activity in front of a house [134] or a roadside inn when travellers stop for rest and refreshment. This was a subject which Philips Wouwerman also painted frequently; even the white horse which became Wouwerman's trademark is found in Isaack's pictures. It is difficult to say if one of these two Haarlem artists, who were almost exact contemporaries (Wouwerman was only two years older than Isaack), should be given credit for popularizing this theme or if it was the result of their joint efforts.

Cornelis Bega (1631/2-1664) also studied with Adriaen van Ostade, and worked in his tradition. Bega's pictures of life in peasant kitchens and taverns sometimes capture psychological undercurrents which his teacher missed. His use of chiaroscuro to silhouette light figures against a dark background in his etchings is quite original, and the tonality of some of his prints anticipates in a surprising way the effects Goya achieved in his graphic work. Cornelis Dusart (1660-1704), whose style can be deceptively close to Adriaen van Ostade's light and colourful late manner, must have entered Adriaen's studio during the last years of the master's life. He is more satirical and coarser than Adriaen, and shows a pronounced tendency towards caricature. Dusart worked as an assistant, helping Ostade to paint his pictures, and after Adriaen's death he acquired some of his teacher's works in progress and finished them. He also completed paintings Isaack van Ostade left unfinished at the time of his death in 1649. These pictures, which were begun at least eleven years before Dusart was born, must have belonged to Adriaen, and they probably fell into Dusart's hands in 1675, when the old Ostade died. They are an interesting indication of studio practice during a period when the premium on originality which later ages insist upon was not yet universally endorsed.

THE SCHOOL OF DELFT

Jan Vermeer

Frans Hals, Rembrandt, and Vermeer, the three greatest painters in Dutch art, follow each other at intervals of about twenty-five years. One is, therefore, tempted to consider them as representatives of three successive generations. But only Frans Hals and Vermeer can be called typical of their time. Rembrandt, with his introverted and highly spiritual character, is unique and cannot be accepted as typical of his generation. Hals, in the first phase of his career, is certainly a strong representative of the gay realism and optimism characteristic of Holland during the early decades of the century, when the truce with Spain gave the Netherlands de facto recognition among the family of nations and the country began to experience a great economic boom by the extension of its colonial trade and possessions. At that time Dutchmen seemed filled with pride, self-confidence, and the spirit of action. Vermeer's art reflects the happiness and the self-contained character of the Dutch bourgeoisie after their aggressive spirit had somewhat calmed down, and they began to relax and enjoy the fruits of their fathers' and grandfathers' activities. Dutch life shortly after the middle of the century is distinguished by a quiet, peaceful and domestic atmosphere which Vermeer, better than anyone else, depicted in his beautiful interiors.

A comparison of Rembrandt's etching called Dr Faustus (1650-2; Bartsch 270) [135] and Vermeer's Geographer (Frankfurt, Städelsches Kunstinstitut) [136] emphasizes the basic differences between Rembrandt and Vermeer. Rembrandt stands out as an extreme individualist; Vermeer is more representative of the Dutch national character. The subjects of both works are similar. Rembrandt's Faustus - the title is questionable[4] - shows a scholar at

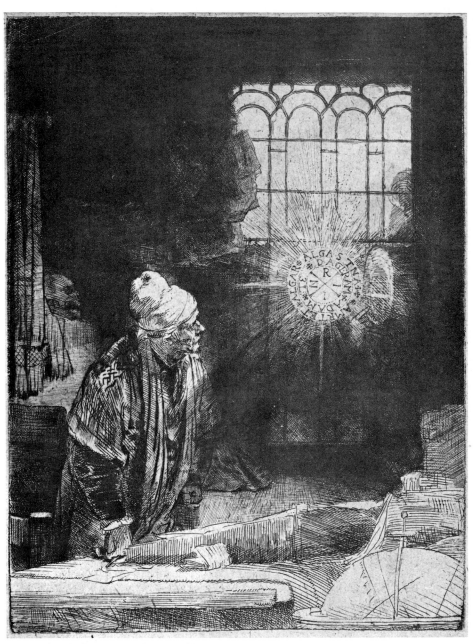

135. Rembrandt: Dr Faustus, 1650–2. Etching

the moment when a supernatural appearance (with definite Christian symbols in it) attracts his attention and causes him to interrupt his work and rise from his desk. The picture by Vermeer represents a geographer who also stops his work for a moment of meditation. One realizes at once that Rembrandt's conception of a scholar contains supernatural elements, and we are made aware of the mysteries inherent in the spiritual world, whereas Vermeer's subject seems to be a perfect representation of an exclusively rational mind. If we want

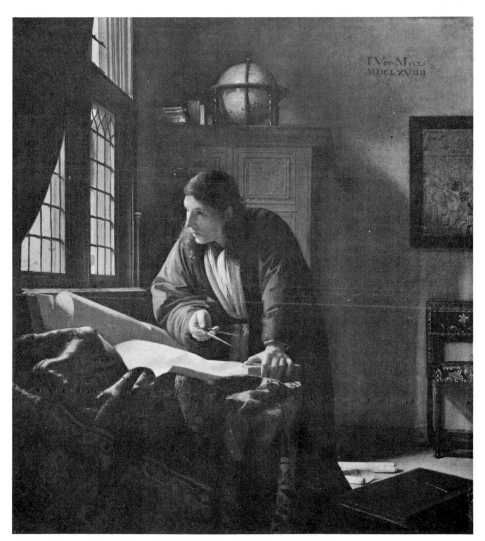

136. Jan Vermeer: Geographer, 1669(?). *Frankfurt, Städelsches Kunstinstitut*

to draw a parallel in the field of contemporary philosophy, it is a contrast similar to one between Pascal and Descartes. With Rembrandt, the light is arbitrary, expressive of a spiritual content beyond the power of man; the space is subordinated to the chiaroscuro device, and its rational construction is less essential than the expression of some deeper emotional content. Something of the dynamic spirit of the Baroque is also inherent in Rembrandt's chiaroscuro, although here, in his mature style, it is fused with compositional elements of a classical character. Vermeer's representation shows, on the other hand, a consistent naturalistic lighting that lends solidity to the form and clarity to the space. The space is clearly constructed, and the position of every object is crystal-clear. The design lacks any dynamic element. Reason dominates the emotion and keeps the vision under sober control. The moment Vermeer chose in the life of the geographer is a short one, but the transitory aspects have been subdued. Vermeer's composition has become more tectonic, his technique less arbitrary and spontaneous, and his brushwork less personal. The Baroque impulses of the preceding generations cooled, not only in Holland, but throughout the continent. Vermeer's picture dates from the period when Poussin was acknowledged as a leading figure of European painting.

Vermeer owes much in this phase of his art to Carel Fabritius, the link between him and Rembrandt. Fabritius' great accomplishment was to transform Rembrandt's chiaroscuro into a more natural daylight atmosphere. His early work has been discussed above in the chapter on the Rembrandt school, and, as we have already noted, Fabritius was one of the rare artists who had enough strength and personality not to succumb to Rembrandt's overwhelming genius. If we compare Rembrandt's *Man wearing a gilt Helmet* (Berlin-Dahlem, Staatliche Museen) [77] with Fab-

ritius' *Soldier* (Groningen, Museum) [137], which was probably painted in the late forties, when Fabritius was not yet completely free from Rembrandt's influence, we can already

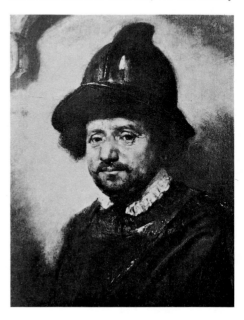

see great differences. Fabritius is more interested in surface treatment than in spiritual depth and the exploration of meditative and introvert moods – though in the final analysis, it is Rembrandt, not Fabritius, who attains the richest pictorial effects. Rembrandt's mastery of what could be achieved by juxtaposing passages of heavy impasto with thin glazes of oil paint was never matched. Fabritius, even when he is close to Rembrandt, has a flatter and less complex treatment and shows a tendency to lighten his backgrounds. His interest in the atmospheric effects of clear daylight and his luminous tonality become more dominant after he settles in Delft around 1650, but he always retains, in his lifesize as well as his tiny pictures, the breadth and quality of Rembrandt's mature work. Very few of Fabritius' works

137 (*opposite*). Carel Fabritius: A Soldier, *c.* 1648.
Groningen, Museum voor Stad en Lande

138 (*above*). Carel Fabritius: The Goldfinch, 1654.
The Hague, Mauritshuis

have survived. Perhaps many were destroyed in 1654, the year he himself tragically perished in a gunpowder explosion which devastated much of Delft. His little *View of Delft* (1652, London, National Gallery), which was probably a panel for a peep show, manifests his interest in perspective effects, an interest which Vermeer shared during much of his career. The *Goldfinch* (The Hague, Mauritshuis) [138] and the *Soldier sitting on a Bench* (Schwerin, Staatliches Museum), both painted in the year of his death, are a premonition of Vermeer's best qualities in the fine, cool harmony of colours as well as the sense of classic composition and the firm handling of the brush. The distance from them to a work such as Vermeer's *Woman reading a Letter* (Amsterdam, Rijksmuseum) [139] is not very great.

The *Woman reading a Letter*, painted about 1665, is a mature work and shows all Vermeer's essential qualities. His art has the charm and simplicity of a flower. We enjoy it, it seems, without effort. He is the darling of the art-loving public, gaining their hearts without much comment or advertisement. Yet this simplicity and easy attraction can be deceptive. These qualities are, in fact, the result of an intense intellectual effort and a superb control over all the artistic means. A very deliberate selection, concentration, and organization orders his modest pictures. In the Amsterdam painting we see a woman – perhaps an expectant mother – reading a letter. Her open mouth and lowered eyes subtly indicate this activity. She fills the room with her quiet, happy existence. It is the sympathetic arrangement of forms which essentially contributes to this effect. Figure and objects are seen from near by, but in a definite order and harmony. Light and atmosphere allow a clear existence of forms in space. The accurate rendering of tones in the shadows is not unimportant in producing this effect. A cool colour harmony with a predominant blue in the woman's gown, con-

139. Jan Vermeer: Woman reading a Letter, *c.* 1665. *Amsterdam, Rijksmuseum*

trasted with fine yellow accents and softened by the silvery daylight, appeals to our sense of beauty and contributes essentially to the balanced mood of the whole. A design quality of unusual strength and clarity coincides with the clear spatial organization. Nothing remains accidental or unrelated. Rectangular and round forms, diagonals and verticals, the subtle light accents and value contrasts all have their definite function within the whole. There is a most happy equilibrium of all essential formal elements. We are impressed by the artist's architectural sense, by his full expression of form, and by his pictorial sensitivity. It is an art which is classic in its perfect balance and clarity. In contrast to all the minor Dutch genre painters who are preoccupied with painting the texture of stuffs, there is an overall relationship of design which, through its breadth, has a distinct appeal to the modern eye and lends a certain monumentality to all Vermeer's rare genuine works.

Vermeer did not immediately reach the subtle perfection of the sixties, and his style changed again in his later years. It should be emphasized that establishing his development presents some knotty problems, and not all students of his work have arrived at the same conclusions.[5] Little is known about his life that would help to date his pictures accurately. Less than forty paintings can be attributed to him and only two are dated: these are *The Procuress* of 1656 (Dresden, Gemäldegalerie) [141] and *The Astronomer* of 1668 (Paris, private collection) [140]. There is no graphic work to which one can turn; as far as we know he made no prints, and no drawings can be ascribed to him with certainty. Not a single letter or note written by Vermeer has survived, and contemporary sources tell us little. Dirck van Bleyswijck, who published the voluminous *Beschryvinge der Stadt Delft* in 1667, when Vermeer was at the height of his powers, mentions him only briefly, but in complimen-

140. Jan Vermeer: The Astronomer, 1668. *Paris, private collection*

tary terms. In the section on the artists of Delft this local chronicler noted the year of Vermeer's birth. Nothing more. Van Bleyswijck does, however, publish a section on Carel Fabritius, the Phoenix, who was snatched from life and fame in 1654 by the 'Delft Thunderclap', and adds that lucky Delft has Vermeer, 'who masterly his path doth tread'. Houbraken, the major source for material on seventeenth-century Dutch artists, does not even give Vermeer's name in his three-volume history published in 1718–21. The main evidence for a chronology of Vermeer's work lies in the pictures themselves, in the logical development of certain motifs and problems, and in the analogies which can be established between his small *œuvre* and the general trend of Dutch painting.

Vermeer was born at Delft in 1632, the year which witnessed the birth of Spinoza, John Locke, and Christopher Wren. His father was a weaver and an innkeeper who may have

occasionally done some art dealing. After his father's death Vermeer took over the tavern, and also worked as an art dealer and valuer. He married a woman from a Catholic family in 1653 and was probably converted to Catholicism at that time. Leonaert Bramer is known to have argued on Vermeer's behalf with the young artist's future mother-in-law.[7] This close personal connexion has led some students to suggest that Bramer was Vermeer's master, but the plain fact is that we do not know with whom he studied. It was Fabritius' art that had the most important influence upon him; but we must bear in mind that this impact becomes evident only after Fabritius perished. There is no trace of his style in Vermeer's earliest known works. At the time of Vermeer's death in 1675 he owned three pictures by Carel Fabritius. Of course these works may have been part of his stock as an art dealer, but it is also likely that he personally collected and treasured the works of his great predecessor.

Vermeer entered the Guild of St Luke at Delft in 1653, and he was elected an official of the Guild four times; so he enjoyed some reputation among the artists of the community. It seems that he was always in need of money, since he repeatedly borrowed large and small sums. Though his pictures were comparatively highly priced, he did not earn much, because his way of working was obviously very slow and deliberate. A slow rate of production is the best explanation for the rarity of his works. Vermeer's burden was not eased by his need to support a household of twelve persons, his wife and his eleven children, of whom eight were still under age when he died. In 1676, a few months after Vermeer's death, his widow petitioned the court for a writ of insolvency and declared that her husband had earned almost nothing during his last years because of the war with France, and that he had only losses as an art dealer. The court appointed the Delft scientist Anthony van Leeuwenhoeck,

whose pioneer work with the microscope was to earn him the title of the 'father of microbiology', as executor of Vermeer's bankrupt estate. There is no evidence that Vermeer and Leeuwenhoeck were close friends, but it is noteworthy that these two distinguished citizens of Delft were born at the same place and virtually at the same hour – their baptisms are registered on the same page of the record of the New Church of Delft – and that both rank, thanks to their extraordinary gifts, with the rare men about whom Leeuwenhoeck himself once said: 'Through labour and diligence [they] can discover matters which were thought inscrutable before.'

One record shows how highly priced Vermeer's pictures were in his own lifetime. The French amateur Balthazar de Monconys, when passing through Delft in 1663, called at Vermeer's house. The artist was absent, and the collector complained that there was not a single painting available in his studio. The only picture by Vermeer that he was able to see belonged to a baker in the neighbourhood, who had paid 600 guilders for it. De Monconys found this price highly exaggerated, considering that there was only one figure represented in the picture. In 1696 twenty-one of Vermeer's paintings were sold at an anonymous auction sale. This was the largest stock ever found in the possession of a single collector. One assumes that the owner was a Delft amateur who had brought most of Vermeer's pictures into his possession.[8] The majority of the best pictures by Vermeer known to us were included in this sale, and many of those which have turned up in recent decades, which were not in this auction, are questionable.

Vermeer's development spans a period of about twenty years. Since only two paintings are dated, it is impossible to date each of his pictures precisely, but it is possible to distinguish three broad phases in his work. In the first, from about 1655 to 1660, the influence of

the Utrecht Caravaggists is obvious at the beginning, but soon afterwards the impact of Carel Fabritius' art is evident. During the middle phase, which extends through the sixties, Vermeer develops his classic genre painting in cool harmonies of which we have discussed an outstanding example. His brief late period is characterized by an exaggeration of the perspective and of decorative elements, and also by a certain hardening of his pictorial effects. Not all these characteristics appear together in each late work, but at least one or two are evident.

Vermeer's lifesize *Procuress* (1656, Dresden, Gemäldegalerie) [141], the earliest extant signed and dated work, is a firm point of departure for an appraisal of his achievement. There is more action in it than there will be in the later paintings. The subject, size, and decorative splendour are all closely related to pictures the Utrecht *Caravaggisti* painted a generation earlier. Additional evidence that Vermeer was

141. Jan Vermeer: The Procuress, 1656.
Dresden, Gemäldegalerie

familiar with their work is the fact that he placed Baburen's painting of the same theme [17] in the background of two of his pictures. It appears in his *Concert* at the Isabella Stewart Gardner Museum in Boston and in the *Lady seated at the Virginals* in the National Gallery, London. The chiaroscuro effect and the warm colour harmony of reds and yellows of Vermeer's *Procuress* indicate, on the other hand, a connexion with works painted in the early fifties by Rembrandt and his followers (Maes and Barent Fabritius). It has been suggested that the smiling man on the left is a self-portrait. If so, it is the only time Vermeer allows us to approach him on such intimate terms. There are, however, personal qualities in the Dresden picture that we shall meet again and which we may call characteristic: a still-life beauty, the colour accord of blue and yellow (which is here only a partial effect), and the broad, painterly treatment.

Two works can be dated a year or so earlier than the *Procuress* of 1656: *Diana and her Companions* (The Hague, Mauritshuis) and *Christ at the House of Mary and Martha* (Edinburgh, National Gallery of Scotland) [142]. Both show a Baroque fullness and exuberance which was soon to give way to a greater simplicity and clarity, and to an architectural feeling with a predilection for straight lines. These are the only extant biblical and mythological scenes by Vermeer. Parallels can be pointed out between the heavy paint, warm colours, beautiful light, and the figure types of these history pictures and Italian Early Baroque painting, but there is no need to assume that Vermeer made a trip south. As we have heard earlier in our discussion of Rembrandt, it was not difficult for a seventeenth-century Dutch artist to become familiar with Italian painters without leaving his homeland. With *A Girl asleep at a Table* (New York, Metropolitan Museum) [143], which was probably painted shortly after the Dresden *Pro-*

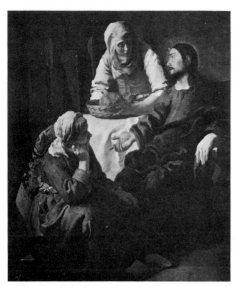

142. Jan Vermeer:
Christ at the House of Mary and Martha, *c.* 1655.
Edinburgh, National Gallery of Scotland

143. Jan Vermeer:
A Girl asleep at a Table, *c.* 1657. *New York,
Metropolitan Museum of Art, Altman Bequest*

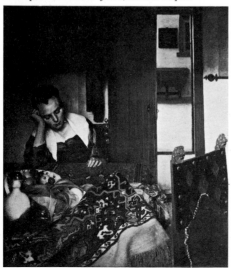

curess, Vermeer comes to his favourite subject: the quiet existence of a single figure within a mildly lit interior seen from close by. The quietness in the New York picture is of a special type. The lovely sleeping girl is drunk, as her untied collar, the disorder on the table, and the wine pitcher discreetly indicate. Vermeer, like Dutch artists before and after him, used a sleeping girl to moralize on the evils of drink: 'Wine is a mocker, strong drink is raging, and whosoever is deceived thereby is not wise' (Proverbs 20:1). But unlike so many of his contemporaries, Vermeer did not represent a slattern in order to make his point, and it is his sense of decorum which made later critics, who assumed that Dutch painters merely depicted what they saw, overlook the didactic aspect of the painting.[9] A certain diffusion of interest in the picture is created by the vista into another room. Except for a reference in the 1696 sale to a lost Vermeer of 'A gentleman washing his hands, in a room with a through view with pictures, artistic and unusual', the painting in the Metropolitan Museum is the only one we know by the artist which employs this device that Pieter de Hooch and other artists of the Delft School used so frequently.

The general direction of Vermeer's development during the three phases of his career is perhaps seen best of all if we examine the relation of figures and space in his pictures. In the early *Soldier and a laughing Girl* (*c.* 1657, New York, Frick Collection) [144] there is a lack of all-round spatial clarity, and the emphasis is upon the figures and the anecdote. During his middle period Vermeer achieves, as we have seen in the Amsterdam *Woman reading a Letter* [139], an uncanny balance between all elements, in particular between figures and space. The harmonious organization justifies the name of classic for this and other masterworks Vermeer painted during the sixties. In his late phase perspective effects predominate more than before [154-6], but, of

course, the figures still exist and lend human content to the interior. It is often a characteristic of Late Baroque art to extend the field of vision into landscape and landscape architecture. Figures, buildings, and trees can shrink to tiny details within a mighty perspective. Jacob van Ruisdael's flat landscapes are an example of this Late Baroque tendency. Its perfect expression is found in the grand perspectives at Versailles, where views to a distant horizon are often dominated by the sky with its infinite height.

As in the case of Rembrandt in the transition from his flamboyant Early Baroque style to the restraint and breadth of his mature years, we can observe that Vermeer had visual experiences in the open air which widened his sense of space, clarified his pictorial conception, and added to his atmospheric quality. Ony two of his landscapes – or more accurately, cityscapes – are known. The earlier (c. 1660) and smaller of the two is the close view of a *Street in Delft* (Amsterdam, Rijksmuseum) [145], which shows Vermeer as the discoverer of the beauty of some simple houses. In spite of the closeness, the view is spacious by the appearance of the sky and an intense suggestion of atmosphere. In its strong, yet soft harmonies of the grey and vermilion of the brick buildings and window shutters, of the black and white around the doors, and the blue, red, and yellow accents in the passageway and on the figures, the 'Straatje' – as the Dutch call it – is a colouristic jewel. (The foliage of the trees, originally green, now looks blue by the partial disappearance of the yellow, which was once combined with the blue to make green – this change, however, is not a discordant note.) The silvery tonality and the tectonic feeling for composition predominate here. Besides, the picture excels by its wonderful velvety texture. It is a masterpiece which embodies all of Vermeer's visual endowment, and in its simplicity and colouristic charm reflects the gentle,

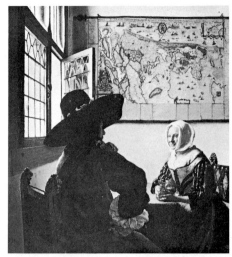

144. Jan Vermeer:
A Soldier and a laughing Girl, c. 1657.
New York, Frick Collection

145. Jan Vermeer:
A Street in Delft, c. 1660.
Amsterdam, Rijksmuseum

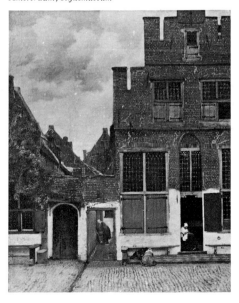

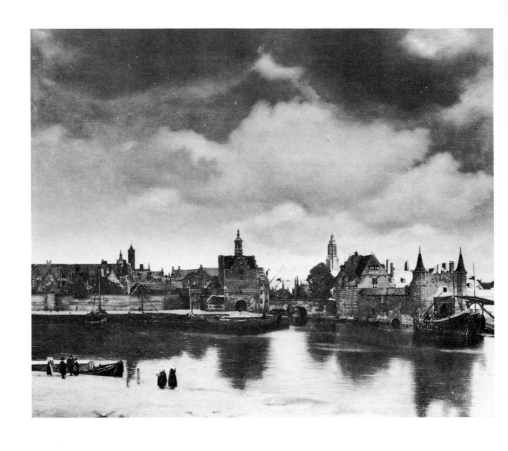

146. Jan Vermeer: View of Delft, *c.* 1662. *The Hague, Mauritshuis*

homely spirit of Dutch bourgeois life. In the famous *View of Delft* (The Hague, Mauritshuis) [146], which is much larger, Vermeer created one of the most colourful and original landscapes in the history of European painting. Its design quality and decorative beauty are as outstanding as the truth in the rendering of light and atmospheric life. Depth and height have been achieved without any conspicuous diagonals. Here, the clouds and the lighting, the aerial perspective and the ingenious device of the reflections of the buildings in the water reaching out towards the foreground create the impression of a wide open space – and the strip of sunlight that hits the rear buildings as well as the brightening of the clouds towards the hidden horizon loosen the town from the sky. It may be springtime. In any case the weather is typical of the windy climate of Holland, where rain and sunshine alternate quickly and cloud formations are often of an extraordinary grandeur and lucidity, contrasting in their shining whiteness with a fresh patch of blue sky here and there. Vermeer the colourist speaks here as impressively as in his most beautiful interiors. With the exception of Aelbert Cuyp, no other landscape painter of the seventeenth century dared to use in open-air painting such strong decorative colours; copper-red and blue, grey and ochre, silver-white and black predominate. Yet there is not a single hard edge at any place. Every form is surrounded by atmosphere and every colour properly related to the whole both in value and intensity. Thoré-Bürger, who resuscitated Vermeer in a fundamental study published in 1866,[10] declared, when he saw the *View of Delft* on his first trip to Holland, that it was a greater work than Rembrandt's *Anatomy Lesson of Dr Tulp*, and that 'pour obtenir une photographie de tel Van der Meer j'ai fait des folies'.

The originality of the *View of Delft* makes it hard to place in Vermeer's chronology. There is no precedent for its simplicity and freshness of vision. The technique, however, gives us a clue. In the *View of Delft* Vermeer is in full control of his technique, which can be broad and almost impasto in passages, and also smooth and transparent. The first characteristic, the broad impasto touch, prevails in his earlier work; the latter, the smooth and transparent one, in his mature period. Vermeer is seen between these two extremes in the *View of Delft*. In it he makes extensive use of a kind of *pointillé* technique, which spreads thick bright points as highlights over a dark area. This device, which Vermeer favoured in the early sixties, gives the illusion of glittering light without changing the basic value of the form. In all Vermeer's more mature paintings we feel the structural significance of a coherent tonal value that underlies and carries the composition. The *pointillé* technique allows Vermeer to lighten passages, to increase the illusion of glittering daylight and atmosphere, and to produce textural effects without destroying or changing too much of the underlying tonal design.

The Kitchen Maid (Amsterdam, Rijksmuseum) [147 A, B] can be dated shortly before 1660, when Vermeer began to concentrate upon single figures, which are still somewhat overpowering in their plastic existence. Sir Joshua Reynolds considered this forceful genre painting one of the best Dutch pictures he saw on his trip to Holland in 1781, and nineteenth-century artists from Millet to Van Gogh were impressed by its vigorous paint, powerful realism, and rich texture. The paint is rather thick and grainy, the impasto heavy, and Vermeer's *pointillé* technique already begins to play an important role [147B]. Yellow (the cook's blouse) and blue (her apron, the lining of her sleeves, the cloth, and the Nassau stoneware pitcher on the table) predominate, but the colours are still on the warm side and the

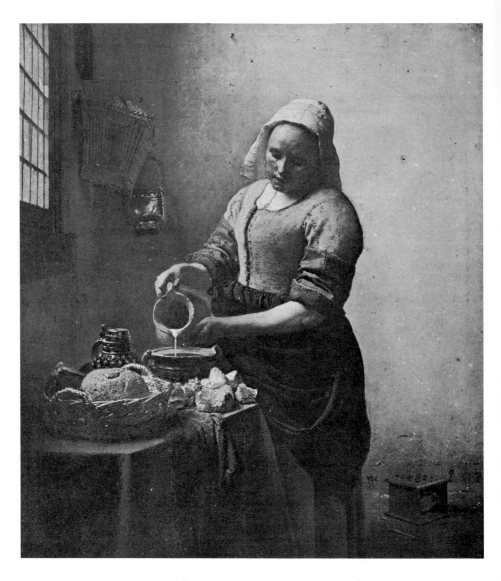

147 A, and B (*opposite*). Jan Vermeer: The Kitchen Maid, *c*. 1658. *Amsterdam, Rijksmuseum*

shadows brownish. During the sixties the blue and yellow accord continues to be the dominant one, but the tonality becomes distinctly cooler. *The young Woman with a Water Jug* (New York, Metropolitan Museum) [148] clearly shows Vermeer's mature style of the sixties. He abandons

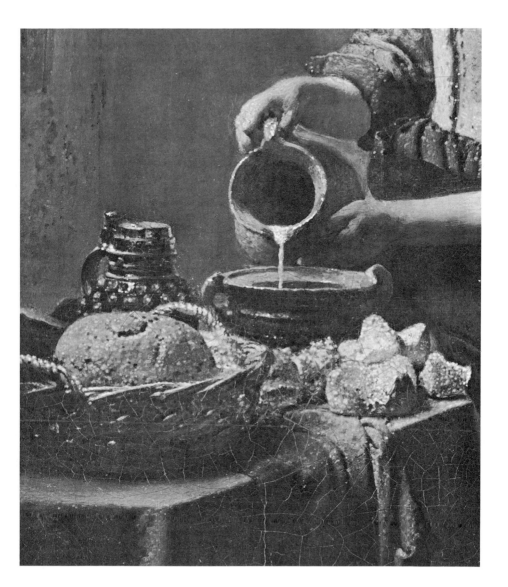

the Baroque chiaroscuro of his early period in favour of a full daylight brightness, and changes from a warm tonality to a cool accord. There is an increase in simplicity, order, and harmony. The space is organized with greater clarity, there is a finer modulation of values, with more transparency in the shadows, and greater consideration is given to the effects of reflected light. *The young Woman with a Water Jug*, like the *Woman reading a Letter* in Amsterdam, allows us to study Vermeer at the height of his art, where his accents on form and

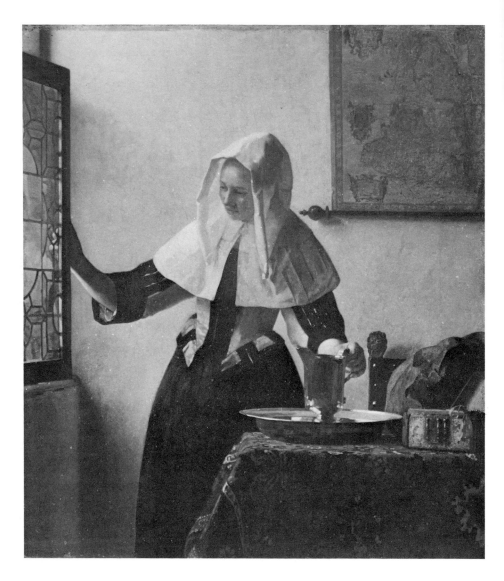

148. Jan Vermeer:
The young Woman with a Water Jug, *c.* 1665.
New York, Metropolitan Museum of Art

149 (*opposite*). Jan Vermeer: Woman weighing Pearls,
c. 1665. *Washington,
National Gallery of Art, Widener Collection*

silhouette, on space and surface design, on
light and colour were most selective and full
of formal significance. An uncanny balance
is struck between the animate and inanimate
in this perpetuation of a transitory moment.
It is the kind of Vermeer which Proust loved,

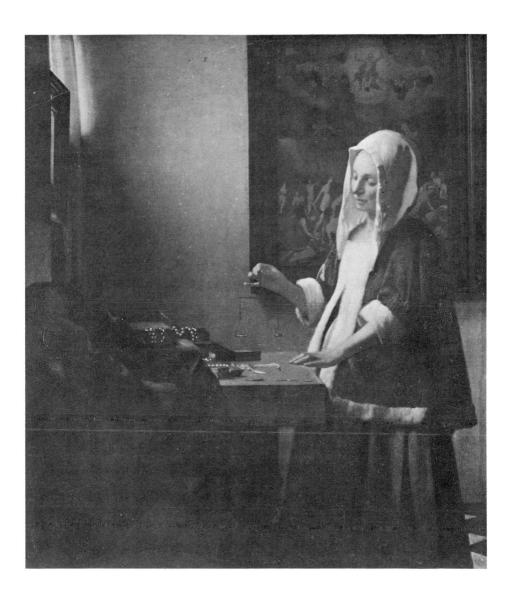

and, as in the master novelist's work, detail fascinates us and contributes to the expressive grandeur and exquisite beauty of the total design.

The *Woman weighing Pearls* (Washington, National Gallery of Art, Widener Collection) [149] also has the naturalness and the noble simplicity of the classic middle period. Here, too, every detail is significant and indispensable. The light is mild and harmonious. Again the figure, her mood and her delicate action dominate the interior and fill it with a gentle

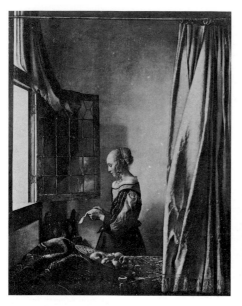

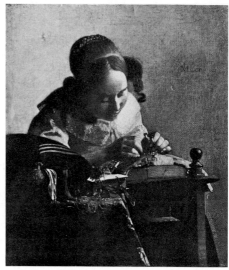

150. Jan Vermeer:
Lady reading a Letter at an open Window, *c.* 1658.
Dresden, Gemäldegalerie

151. Jan Vermeer: Lace Maker, *c.* 1665-8.
Paris, Louvre

152. Jan Vermeer: Head of a Girl, *c.* 1665.
The Hague, Mauritshuis

153. Jan Vermeer: Girl with a Flute,
c. 1665-70. *Washington, National Gallery of Art,*
Widener Collection

atmosphere. The subdued centre of the composition is the hand holding the scales, and by very subtle compositional means Vermeer focuses our interest on this action without distracting too much from her whole appearance. It has been suggested that this picture is a Vanitas allegory.[11] This may well be the case, since allusions to the ephemeral nature of life and worldly goods were common in the seventeenth century. The principal clue to the allegorical meaning would be the picture of the 'Last Judgement' which hangs behind the woman. Vermeer probably wanted the viewer to reflect upon the material treasures being weighed, and the weighing of souls on Judgement Day. A comparison of the *Woman weighing Pearls* with the *Lady reading a Letter at an open Window* (Dresden, Gemäldegalerie) [150], which dates from the end of Vermeer's early period, is instructive. In the earlier work the relation between figure and space is still indeterminate, the light, which is almost sunlight, is more intense, and the colours are warm, with

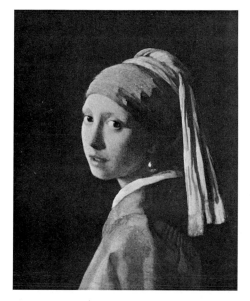

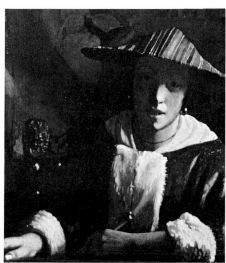

much gold and red. The paint is grainy and heavy compared to the smooth, thin paint of the Washington picture. Young Vermeer still revels in the reflections in the window, the still-life arrangement on the table, and the *trompe l'œil* effect of the glittering curtain, and he is still a bit obvious in his intentions.

Whether he paints a dark figure against a light background, as in the serene *Lace Maker* (Paris, Louvre) [151], or a light figure against a dark one, as in the *Head of a Girl* (The Hague, Mauritshuis) [152], during his classic phase, the harmony is the same, and the light is of equal beauty and mildness. He builds up his form now with a kind of square touch. His shadows become transparent by reflected light and allow the most wonderful modelling. Form and texture, colour and *valeur*, design and spaciousness are in perfect balance. Thoré-Bürger called the *Head of a Girl* at The Hague 'La Gioconda du Nord'. She does have a mysterious charm, an almost Leonardesque softness and tenderness, and so does the mild

harmony of the colours. Jan Veth, a distinguished Dutch painter and critic, expressed well the peculiar quality of the light and the mother-of-pearl tonality, when he said that the substance of the paint seems as if it is made of crushed pearls melted together. Among Vermeer's heads of young girls his *Woman with a Red Hat* (Washington, National Gallery of Art, Mellon Collection) and *Girl with a Flute* (Washington, National Gallery of Art, Widener Collection) [153] excel by an almost exotic flavour, which can perhaps be explained by the contact the Dutch had with the Far East through their colonies. During this period they also decorated their Delft ware in a manner which foreshadows the eighteenth-century taste for chinoiseries. These tiny heads show the master's touch in the quality of the paint, in the handling of light and colour, and in the structural qualities of the composition. In their rich, decorative character they follow rather than precede the classic simplicity of the *Head of a Girl* at The Hague; yet with all

their richness, the originals show clarity in their spatial definition, and atmosphere surrounds the form. They have a gem-like preciousness which is rarely as dense as it is here, and which gives these masterpieces an outstanding position in Vermeer's work. It seems reasonable to assume that they were painted about the end of the middle period and are not far from 1670. They show more of the *pointillé* technique than the *Head of a Girl* at The Hague, but this factor does not always help to date a picture accurately. From the end of the fifties onwards – that is, from *The Kitchen Maid* at the Rijksmuseum – Vermeer uses this device, and it can still be found here and there in paintings from his last years. However, in the late works it loses some of its pictorial softness and produces a kind of hard, porcelain-like brilliance.

If our conception of Vermeer's development is correct, paintings such as *The Concert* (Boston, Isabella Stewart Gardner Museum), *Lady at the Virginals with a Gentleman listening* (London, Buckingham Palace) [154], and also *The Studio*, or more properly the *Allegory of the Art of Painting* (Vienna, Kunsthistorisches Museum) [155] belong to the end of the middle, or the beginning of the late period. The perspective is much emphasized, and the effect of space dominates over the figures, which recede more into the distance. The colour shows rich gradations in fine cool harmonies, and the light is still most subtle and becomes intense in the distance, in contrast to a darker foreground. This contrast helps to increase the effect of depth. The fascinating splendour of the Vienna picture still shows the master at the height of his powers, but the noble simplicity of his classic middle phase is replaced by a richer, an almost over-rich design. Vermeer remains inimitable as a colourist and luminarist. The subject of the *Art of Painting* has been frequently discussed. The idea that Vermeer, in his discreet manner, portrayed himself from

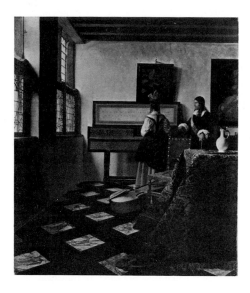

154. Jan Vermeer: A Lady at the Virginals with a Gentleman listening, *c.* 1668-70. *London, Buckingham Palace*

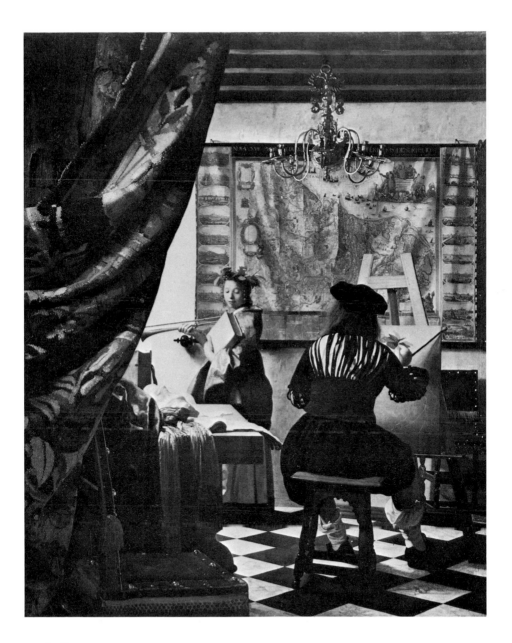

155. Jan Vermeer:
Allegory of the Art of Painting, *c.* 1670.
Vienna, Kunsthistorisches Museum

the rear, painting Clio, the muse of history, is attractive, but it seems doubtful whether a seventeenth-century Dutch artist would represent himself in a fanciful 'Burgundian' costume. The picture is probably meant as a glorification of the art of painting, not as a self-portrait. As early as 1676 the artist's widow entitled it *The Art of Painting (De Schilderconst)*; she made no reference to it as a portrait of her deceased husband. For us the miraculous illusion Vermeer creates of an artist at work in a luminous interior is more expressive of the power of the art of painting than any armoury of traditional Baroque allegorical trappings.[12]

The Letter (Amsterdam, Rijksmuseum) [156] can be dated about 1670 or even a little later. Here all the characteristics of the late style are distinct. The perspective is forced, and the somewhat sensational background illumination strongly contrasted with the shadowed and crowded foreground for the sake of an increased effect of depth. Vermeer handled the same theme a few years earlier in *A Maid handing a Letter to her Mistress* (New York, Frick Collection) [157]. The overpainted opaque background in the Frick picture has been removed, and the relationship between the figures and the space is now in perfect balance. Compared to the later conception, it has a monumental simplicity. The total effect of the Amsterdam *Letter* is over-rich; yet a great many of Vermeer's old characteristics remain. The colour harmony of the blue apron worn by the maid, and the yellows of the jacket and skirt of the matron, are still beautiful, as is the tonal design. Another late picture, the *Allegory of the Catholic Faith* (New York, Metropolitan Museum), hardly adds to Vermeer's fame. Religious allegories of the late seventeenth century are rarely impressive, and Vermeer was somewhat at a

156. Jan Vermeer: The Letter, *c.* 1670. *Amsterdam, Rijksmuseum*

157. Jan Vermeer: A Maid handing a Letter to her Mistress, *c.* 1665. *New York, Frick Collection*

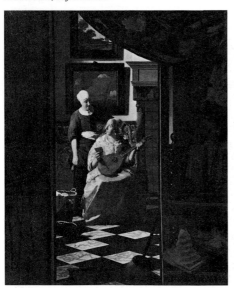

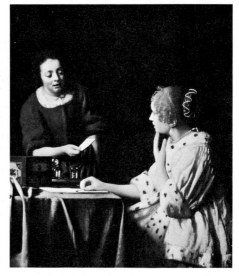

loss with the subject, which looks contrived. Only in the lighting, the colouring, and the paint does one recognize Vermeer's art, but the picture has a hard, enamel-like brilliance which generates little enthusiasm. The invention for the representation of the allegorical figure is not Vermeer's. He followed instructions published by Cesare Ripa in his popular handbook *Iconologia*. Evidence of a weakening of his creative power in his late period is also seen in the forced expressions on the faces of his figures (*A Girl with a Guitar*, London, Kenwood House) and in a general preoccupation with the over-rich effects made popular throughout Europe by Louis XIV's court painters. It seems that the decline of Dutch art after 1670 was so general that even a genius of Vermeer's stature was affected by it; but we know too little about his life and last years to be able to explain fully what happened in his latest works.

Pieter de Hooch

Pieter de Hooch was an exact contemporary of Vermeer. He was born only three years earlier, that is, in 1629. It is not known when he died, but the last date upon a picture which can be ascribed to him is 1688[13]; thus he outlived Vermeer by more than a decade. De Hooch's art is much more uneven than Vermeer's. He created masterworks only during a brief period in Delft, from around 1655 until about 1662. The relationship between Vermeer and Pieter de Hooch is still a matter of conjecture. It seems that De Hooch anticipated certain elements of Vermeer's mature period, but later came under the influence of Vermeer's stronger personality. In any case, up to the middle of the sixties De Hooch shows considerable character of his own, and it was perhaps due to contact with the art of Carel Fabritius and other congenial Delft painters that his genius flared up so suddenly. Later, after he moved to Amsterdam, he quickly lost his inspiration and charm, and it was not

long before he sank to the role of a second-rate painter.

The earliest date on a picture by De Hooch is 1658. By this time he was in his middle and best phase. Unlike the case of Vermeer, a rather large group of pictures can be assigned to an early period. These youthful works [158] are mostly barrack-room scenes in a chiaroscuro style reminiscent of the low-life episodes represented by the Amsterdam painters of soldiers and girls such as Codde and Duyster. None show signs of the influence of the Haarlem landscapist Nicolaes Berchem, who, Houbraken says, was his teacher. A strong chiaroscuro prevails during this first phase, the technique is liquid, and here and there it rises to an impasto touch. The marked diagonal configuration of the figures is Baroque, and the preoccupation with space construction which stamps his more characteristic works is not yet

158. Pieter de Hooch: Backgammon Players, *c.* 1653. *Dublin, National Gallery of Ireland*

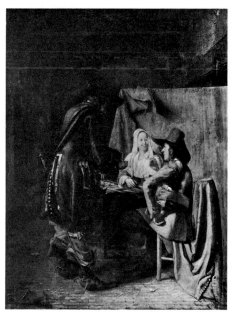

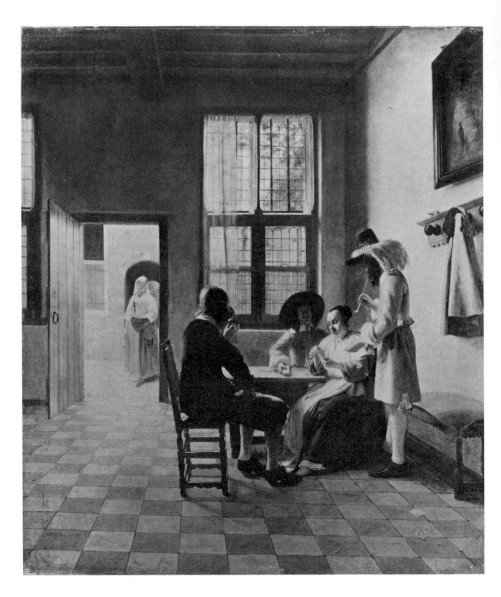

evident. This early period extends from around 1647 until about 1654. In 1653 De Hooch is mentioned as the servant of a merchant who lived in Delft and Leiden. In 1655 his employer owned ten of his paintings, and in the same year De Hooch entered the Guild at Delft. His classic middle period begins around this time. He now paints well-to-do burghers and their servants in a brighter and more colourful manner.

A juxtaposition of Pieter de Hooch's *Card Players* (1658, London, Buckingham Palace) [159] and Vermeer's *Woman drinking with a Man* (Berlin–Dahlem, Staatliche Museen) [160], painted a few years later, helps to clarify the differences between the two masters when they were at the high points of their careers. Three factors stand out in De Hooch's art during his Delft period. One is an elaborate space construction with emphasis on rectangular forms which often frame figural motifs, heightening the expression of their movement – or lack of movement. Frequently a door is left open to allow a look into the next room or a courtyard. The rather rigid space construction seems necessary for the support of the figures, which show little body and articulation compared with Vermeer. The second characteristic

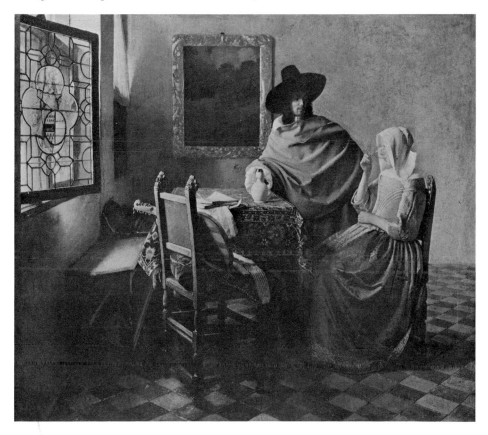

159 (*opposite*). Pieter de Hooch: The Card Players, 1658. *London, Buckingham Palace*

160 (*above*). Jan Vermeer: A Woman drinking with a Man, *c*. 1665. *Berlin-Dahlem, Staatliche Museen*

is De Hooch's light, which, like Vermeer's, is also daylight, but warmer, more sunny and intense, leading to deeper contrasts with the shadows. De Hooch makes ample use of these contrasts for the pictorial animation of his compositions. He does not shrink from deep black shadows in fully sunlit interiors, nor from strong chiaroscuro effects in the open air. As a rule, Vermeer has one constant light source – usually from the left; De Hooch employs several, and they are not always followed up with equal consistency. Reflections interfere and make the play of light more vivid and emotionally richer. Finally, in accordance with his warmer and more glowing sunlight atmosphere, De Hooch's colours too are warmer, deeper, and often of an extraordinary brilliance and intensity. Deep reds prevail, with contrasting blacks, blues, greys, and yellows. His colour scale is richer than Vermeer's, and he places an emphasis on all sides of the colour circle. Vermeer, however, is more consistent in the handling of colour intensities and *valeurs*, with full consideration of their modification by light, shadow, and aerial perspective. Vermeer's emotional and pictorial restraint is a sign of power and mastery. It indicates a supreme taste as well as intellectual superiority. Pieter de Hooch, on the other hand, can move us by the emotional effect and beauty of his light and colour, by a tender feeling which his figures radiate.

Perhaps he learned his perspective from Carel Fabritius, who was highly praised by his contemporaries for painted peep boxes which depend upon perspective tricks for their effect. In any event, De Hooch appears to have mastered the representation of figures in elaborate space constructions, while Vermeer was still primarily concerned with vigorous figure painting. Vermeer probably welcomed what he could learn from Pieter de Hooch when he began to try to bring figures and space into

a clearer and more proper arrangement. We have already seen how Vermeer mastered this problem and developed it in his own way in his later period.

The glory of De Hooch's genre painting is largely founded on his enchanting representations of homely scenes in which a mother or maid and a child appear in an interior or a courtyard in some harmless occupation [161]. These works, which strike a tender note, free from sentimentality, make us understand why his reputation is unshakable. Children play an important role in Pieter de Hooch's pictures; as far as we know, Vermeer, the father of eleven, never painted a child. The *Mother beside a Cradle* (Berlin-Dahlem, Staatliche Museen) [162] shows some influence of the Rembrandt school, in the warmth and depth of the colouring, in the golden tonality, in the broad treatment of the figures, and in the impasto passage on the white fur. The intense reddish-orange of the woman's bodice, of the skirt hanging on the wall, and of the cradle cover are contrasted with the blue and grey in her coat, the bed curtain, the floor tiles, and the jug on the right. In *The Pantry* (Amsterdam, Rijksmuseum) [163], the prevailing colour accord in the figures is an orange-brown and bluish grey, whereas the same colours reappear in the rear room slightly faded, because they are in an intensified light. It is as if the painter traced the origin of the sunshine back to the source, or at least to the spot where it has its highest intensity. Every corner of the picture lives pictorially and is sensitively related to the whole.

De Hooch's device of opening the vista from one room to another, or from a courtyard into a house, and then again from there into the street is not a mere play with perspective: it adds a pictorial and psychological note of some significance. De Hooch sensed that in daily life one often experiences a pleasant relief when a

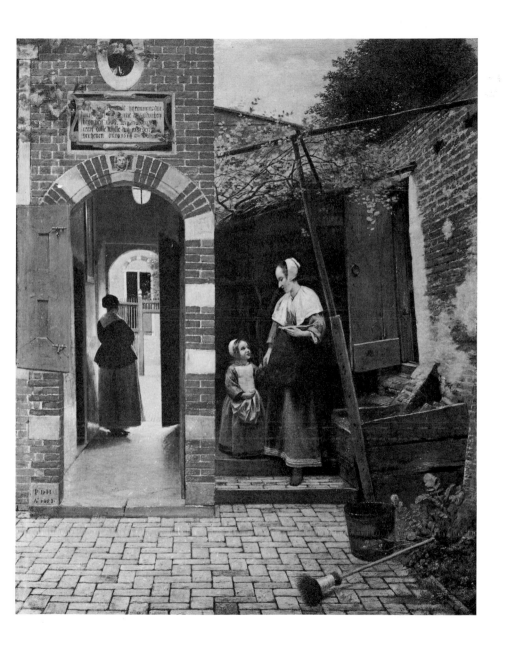

161. Pieter de Hooch: A Maid with a Child in a Court, 1658. *London, National Gallery*

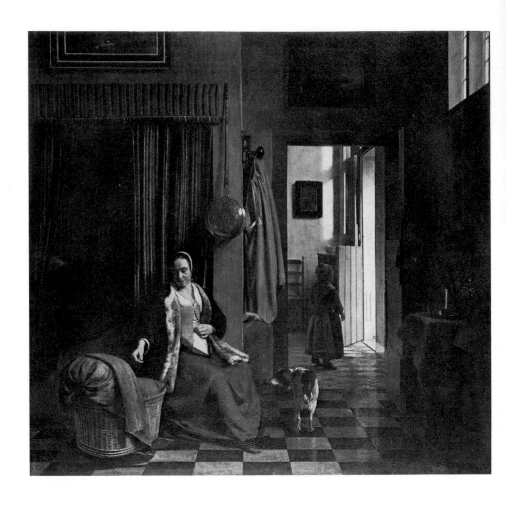

162. Pieter de Hooch: A Mother beside a Cradle, *c.* 1659–60. *Berlin–Dahlem, Staatliche Museen*

relationship between indoor and outdoor space is established by the widened outlook and by the enrichment of light and atmosphere which it brings.[14] In this, as well as in other respects, De Hooch shows his own character. We see in his work that the domestic culture of the Dutch burghers was not confined to their small houses, but extended to their trim gardens and their neat courtyards. De Hooch represents with equal success out-of-door scenes in which the light has often the same warm quality and the colours show the same deep glow as in his interiors.

During the early sixties, presumably around the time when he moved to Amsterdam, De Hooch's figures gain a little more power and body, and his colour and chiaroscuro increase in warmth. The change in his figure style reflects Vermeer's influence. However, as a colourist he is closer to Rembrandt's pupil Nicolaes Maes than to Vermeer. The full character of the figures in the *Woman peeling Apples* (*c.* 1663, London, Wallace Collection) [164] and the concentration on the motif so close to the spectator without distracting side views shows the impact of Vermeer's art. The theme of the picture seems to have been derived from Maes, who worked in Dordrecht, which is not far from Delft. But it is in Amsterdam, not Delft, that Maes' influence upon De Hooch becomes most obvious; yet De Hooch's style always remains sufficiently his own. Maes' chiaroscuro has a more Baroque character, in the tradition of Rembrandt, and he is seldom able to suggest the intensity and flow of light as it animates an interior. Maes also slips easily into artificial gestures and attitudes. The relation between a mother and child by Maes lacks the human charm and naturalness of Pieter de Hooch's figures, who remain absorbed in their own simple activities and are completely unaware of the onlooker. De Hooch's early Amsterdam works still have great power, and he

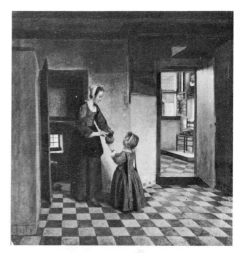

163. Pieter de Hooch: The Pantry, *c.* 1658.
Amsterdam, Rijksmuseum

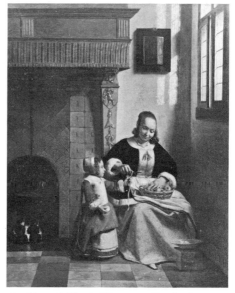

164. Pieter de Hooch: Woman peeling Apples,
c. 1663. *London, Wallace Collection*

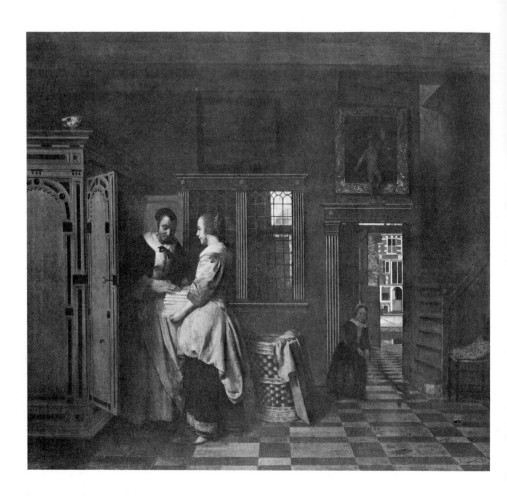

retains a good deal of his former qualities. He succeeds in giving the routine work of the Dutch housewife [165] a poetical charm through his warm-hearted approach and his fine sense of composition and pictorial beauty. All the virtues of the Dutchwoman, her care and love of a neat and proper arrangement of things, are brought out with touching sincerity. Only in the late sixties does De Hooch's style definitely change and his art lose its previous attraction. As with Vermeer, the simplicity of the interiors

shifts to a somewhat pompous taste with many decorative elements; gilt leather coverings and heavy silk curtains replace whitewashed walls. The fashions established by Louis XIV began to invade Holland before the French army actually arrived. It was the time when French taste and French culture began to dominate the Continent. Since the Dutch burghers' houses offered few motifs of splendour and pomp, the late De Hooch sometimes placed his groups in the marble halls of the recently built town hall

165. Pieter de Hooch: The Linen Cupboard, 1663.
Amsterdam, Rijksmuseum

166 (*below*). Pieter de Hooch: The Burgomaster's
Room in the Amsterdam Town Hall,
c. 1666-8. *Lugano, Thyssen-Bornemisza Collection*

[166]. Once in a while the former beauty of his
interiors seems to revive, particularly in dark
pictures which are illuminated by a shaft of
sunlight, but if we look closely, the even touch
of the late works lacks finer gradations. The
human content as well as the pictorial animation
are gone. Musical parties in richly appointed
interiors are frequent. The stiff ladies are now
dressed in silk and velvet, and deficiencies in
drawing and construction become more ap-
parent because the colour has lost its warmth

and glow. The palette has darkened, the light is
cold and without vibration. It has been suggested
that De Hooch's decline was part of the general
downward trend of Dutch art and culture at
the end of the century, but some personal weak-
ness may also be responsible for it. In any case,
if we think of Pieter de Hooch as one of the
loveliest Dutch masters, we have in mind the
glorious paintings from his Delft years, which
live on in our memory, while his late works are
forgotten as soon as we turn away from them.

De Hooch was often imitated by other painters
in Delft and Amsterdam, and since his own
original works decline in his later period, his
followers come at times pretty close to him, and
now and then it is difficult to distinguish hands.
Those whose works have been confused with
his include Pieter Janssens Elinga (active *c.*
1650-1670), Jacobus Vrel (active 1654-62),
Hendrick van der Burch (active *c.* 1650-1670),
Ludolf de Jongh (1616-79), and Esaias Boursse
(1631-72), but now the artistic personalities
and special charms of these minor artists are
more or less clear. A host of other painters who
made views of interiors and street scenes can be
associated in one way or another with the
school of Delft. They are rarely without some
quality, and all of them show a certain standard
of pictorial refinement and intimate realism.
But even the best of them (Jacob Ochtervelt,
1634-82[15]; Cornelis de Man, 1621-1706; Mi-
chiel van Musscher, 1645-1705), who now and
then strive to attain the effects achieved by
Vermeer and Pieter de Hooch by borrowing
motifs and compositional devices from the
masters, never approximate their classic works.

GERARD TER BORCH
AND OTHER PAINTERS OF DOMESTIC LIFE

There are, apart from Vermeer and Pieter de
Hooch, outside the school of Delft, several
distinguished genre painters of domestic life.
Who were the great ones among them? The

evaluation of the Dutch masters has changed considerably since the middle of the nineteenth century. Thoré-Bürger, the rediscoverer of Vermeer, suggested that after Rembrandt the outstanding painter was Ter Borch. Fromentin, in his famous *Les Maîtres d'autrefois* of 1876, claims that the greatest figure of the Dutch school after Rembrandt was Jacob van Ruisdael. Around 1900 the sensitive Dutch critic and artist, Jan Veth, wanted to raise Aelbert

Cuyp to rank with the highest. Others, who had learned to appreciate the qualities of Impressionist painting, singled out Frans Hals, and there were also some who gave preference to Vermeer and Pieter de Hooch. Bode, in his *Rembrandt und seine Zeitgenossen* published in 1906, finds that all these critics are right, that each master of the Dutch school is, in his own way, so perfect that it is a matter of individual taste whether precedence is given to one or the other – Rembrandt alone is excepted. Since these critics presented their estimations we have, perhaps, learned to make sharper distinctions about greatness in art, not uninfluenced by the new points of view of modern painting. We raise Vermeer above the other genre painters, yet in landscape the high level of Jacob van Ruisdael and Aelbert Cuyp remains uncontested.

Gerard ter Borch (1617–81) was born at Zwolle and lived for most of his life at Deventer, a small town which never became the centre of a school of painting. During the thirties and forties he travelled extensively in Europe, and his knowledge of the world is sensed in the delicate psychology and noble restraint of his art – qualities that add an attractive note to his domestic genre scenes and portraits. His exquisite taste is seen in the picture which is best known by its popular title *The Parental Admonition* (Berlin–Dahlem, Staatliche Museen [167]; another version is at Amsterdam, Rijksmuseum). The first reference to this title is found on an eighteenth-century engraving of the work made by J. G. Wille, and it was used by no less a person than Goethe in a charming passage in *Die Wahlverwandtschaften* in which he notes the delicacy of attitude of the figures. He remarks how the father quietly and moderately admonishes his daughter, who is

seen from behind. The woman in black, sipping from a glass, Goethe interprets as the girl's mother, who lowers her eyes so as not to be too attentive to the 'father's admonition'. This moralizing title, however, is erroneous and not in accordance with Ter Borch's usual themes. The most recent biographer of the artist interprets the picture in the opposite sense, as a brothel scene, assuming that the seated gentleman holds a coin in his right hand, offering it to the girl.[16] In fact, traces of this coin are still noticeable, but most of it is erased, probably by a former owner before Goethe's time, to remove an embarrassing allusion. Ter Borch's psychology is so delicate that the ordinary scenes he repeatedly painted are raised to the level of highly civilized life. That Goethe's interpretation was possible at all shows the refinement of Ter Borch's treatment. In spite of his mistake, Goethe had the right feeling for the way Ter Borch treated his subjects. Psychologically and pictorially he has a gentleman's touch and delicacy. The young girl is seen from behind: thus her face is averted. The only flesh visible is her neck, which is modelled with sensitive silvery grey shadows. We have, however, opportunity to admire the silver-grey satin and black velvet of her gown. When even the mature Vermeer is compared with Ter Borch, he is found less sophisticated and more direct in his psychology. Vermeer is also broader in his touch and more powerful in the integration of the two- and three-dimensional aspects of his design. Ter Borch's minuteness and nicety of handling concentrate largely on painting stuffs. The dim light and the subdued chiaroscuro do not allow a forceful grasp of the whole field of vision. The light comes mostly from the front and stops at the glossy surfaces of the costumes and other textures. In Ter Borch's dim backgrounds the tones become dull and the surfaces flat. There is something of the refinement of the fifteenth-century Netherlandish painters in the intimacy of his details

167. Gerard ter Borch: 'The Parental Admonition', *c.* 1654/5. *Berlin–Dahlem, Staatliche Museen*

and the subtle minuteness of handling, but this is achieved at the expense of the broader design relationships. Vermeer has his eye much more upon the whole picture, on the organization of tone and colour and their interaction, for the sake of a clear spatial effect and balanced composition. Ter Borch continues to show his superiority in psychological subtlety even when his subject is an obvious one. In the *Gallant Officer* (Paris, Louvre) [168] the soldier offers pieces of money to a young lady who is charming in type and dress. Her reaction is not surprise; she is, however, not very happy either. The interior is distinguished by a rich marble chimneypiece. Again the stuff painting is par-

ticularly excellent, as is the rendering of the facial expressions and the fine draughtsmanship and subtle lighting of the hands; also the still life on the table.

Ter Borch, who began his training under his father, Gerard ter Borch the Elder (1584-1662), was a gifted child. His earliest extant drawing, made when he was eight years old, represents a subject which became one of his *leitmotifs*: the rear view of a figure. By 1634 Ter Borch was in Haarlem. His first paintings show that he began as a painter of barrack-room scenes, as did De Hooch. *Soldiers in a Guard Room* (*c.* 1638-1640, London, Victoria and Albert Museum) [169] surpasses his prototypes in this

169. Gerard ter Borch: Soldiers in a Guard Room, *c.* 1638-40. *London, Victoria and Albert Museum*

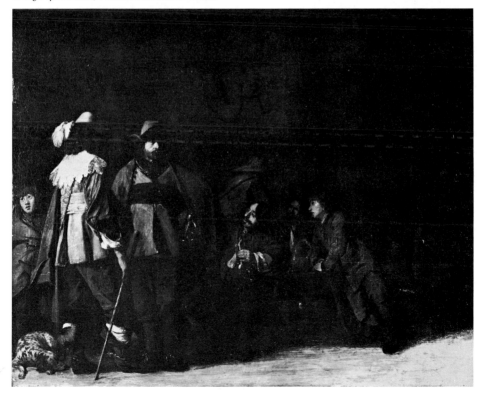

branch of painting in its fine gradations of greys, yellows, and blues, and in sensitive *valeur* painting, in which Ter Borch excels from the beginning. In 1635 he was in London, and there is some evidence that he was in Rome around 1640. During the forties he began to make extraordinary miniature portraits. One of the most touching is his tiny portrait of *Helena van der Schalke as a Child* (Amsterdam, Rijksmuseum) [170], which holds its own when hung next to the pictures Hals and Rembrandt made of children. Sometimes Ter Borch's small portraits recall the psychological penetration Velazquez achieved in his lifesize works. This parallel is not an unreasonable one; Ter Borch visited Spain during his travels, where he painted a portrait of Philip IV. A famous picture is *The Swearing of the Oath of Ratification of the Treaty of Münster* (1648, London, National Gallery) [172]. It was made in Westphalia while the negotiations for the peace

treaty signed between Holland and Spain – which ended the Eighty Years' War and gave the Netherlands her independence – were in progress and the treaty was finally consummated. The small painting, which measures about 18 in. by 23 in. and contains over fifty portraits of plenipotentiaries and their retinues, as well as the artist's self-portrait, reproduces the ceremony with extraordinary accuracy. It is one of the rare pictures made of a contemporary historical event in seventeenth-century Dutch painting. As we noted in our discussion of Rembrandt's *Julius Civilis*, Dutch artists were usually asked to represent parallel scenes from Scripture, classical antiquity, or from their own early national history, not actual contemporary events. Ter Borch was apparently unable to sell his painting of one of the most important episodes in the history of the Dutch people. The picture seems to have been in his possession at the time of his death. One reason

170. Gerard ter Borch: Helena van der Schalke as a Child, *c*. 1644. *Amsterdam, Rijksmuseum*

171. Gerard ter Borch: Portrait of a Man, *c*. 1663-4. *London, National Gallery*

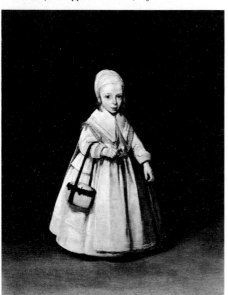

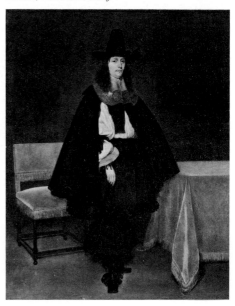

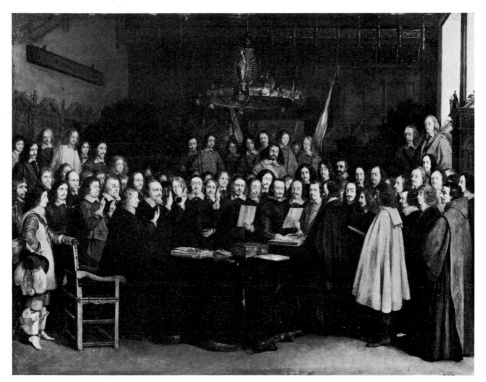

172. Gerard ter Borch: The Swearing of the
Oath of Ratification of the Treaty of Münster, 1648.
London, National Gallery

may have been the price Ter Borch asked for the work. Houbraken reports that he demanded 6,000 guilders for it (about 4,500 guilders more than Rembrandt received for the *Night Watch*) and that, because he was offered less, he kept it.

Ter Borch finally settled in Holland around 1650, and a few years later he made Deventer his home, where he continued to paint miniature-like portraits of great reserve and decorum until the end of his career. He specialized in small full-lengths in interiors which are always painted in a subdued tonality. Their restrained nobility distinguishes them from those made by the early minor masters [171]. Ter Borch's fame, however, rests mainly upon the genre pictures he made after the middle of the century. He is a master of subtle narration who can charge every episode with subdued tension. Few genre painters ever revealed more delicately the character of three individuals and their relation to each other as they ostensibly go about their business of making music in a drawing-room (*The Music Lesson*, Cincinnati, Art Museum) [173]. His rendering of simple themes, such as the one of a boy who has put aside his school work in order to concentrate upon delousing a patient dog, shows the same uncanny knowledge of people as his more ambitious pieces. In contrast to Pieter de Hooch, Ter Borch maintains his fine taste and

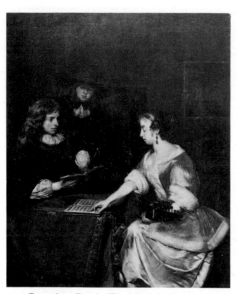

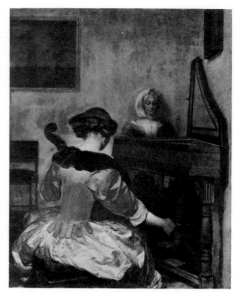

173. Gerard ter Borch: The Music Lesson, *c.* 1675.
Cincinnati, Art Museum

174. Gerard ter Borch: The Concert, *c.* 1675.
Berlin-Dahlem, Staatliche Museen

craftsmanship until the very end. Some of the late works seem to show a sign of Vermeer's influence – the fullness and clarity of the foreground figure playing the cello in *The Concert* (Berlin–Dahlem, Staatliche Museen) [174] and the bright illumination of the room recall the Delft master; but it is also possible that the two artists arrived at similar solutions independently. In any event, in the Ter Borch, the exquisite and minute treatment of materials, textures, and stuffs with the most intricate light accents is completely his own. The spatial relationships are not grasped with Vermeer's sureness, and the composition lacks the Delft painter's masterly consideration of the surface plane and the adjustment of the spatial accents to the overall design. It will be noted that the figure playing the harpsichord has no Ter Borch character. Originally this figure represented a man. Ter Borch subsequently transformed the man into a woman, and a whimsical

restorer, who worked on the picture at the end of the nineteenth century, because it was in a bad state, changed the woman's gown and gave the model his wife's features.[17]

Ter Borch never attracted a flock of students. The most important one was Caspar Netscher (1635/6(?)–1684). Netscher, who studied with him at Deventer and quickly learned his technique of rendering the texture of costly materials, made clever copies of his teacher's works; his signed copy, dated 1655, of Ter Borch's so-called *Parental Admonition* is at Gotha. Netscher continued to make small genre scenes during the sixties. *The Lace Maker* (1664, London, Wallace Collection) [175] shows what heights he could reach. It also suggests that he was affected by the school of Delft. Netscher settled at The Hague in 1662, where he was soon in demand in court circles as a portraitist. By 1670 he had virtually abandoned genre painting and specialized in making small-scale

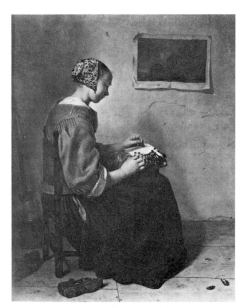

175. Caspar Netscher: The Lace Maker, 1664.
London, Wallace Collection

Mauritshuis) or by Jan Steen and Nicolaus Knüpfer (e.g. his *Prodigal Son*, Leningrad, Hermitage). It was only after Metsu had settled in Amsterdam that he adopted the Leiden *Feinmalerei* technique and became a prolific painter of the well-to-do bourgeoisie with a fine sense for tonal gradations and, at times, a beautiful colourist. Though he often achieved a pictorial refinement which equals Ter Borch's, he remains an uneven painter who was undecided in his colouristic taste. His technique is more liquid than Ter Borch's and has a little more surface movement, but he lacks the delicacy and originality of Ter Borch's psychological interpretations.

Metsu adopted the device of representing figures behind a window frame which Gerrit Dou popularized, but in Metsu's pictures, as is natural in this phase of Dutch art, the effect is broader and more classical. Dou shows his debt

half-length portraits of the aristocracy, with special care given to the elegant clothes worn by his patrons (see p. 322 and illustration 256).

Gabriel Metsu (1629–67) was born at Leiden, and is said to have been a pupil of Gerrit Dou. He was active in Leiden during most of his career, but, like Pieter de Hooch and many others from provincial centres, he was finally attracted by Amsterdam. He had settled in the great metropolis by 1657 and spent the rest of his life there. Metsu's artistic development is much more unpredictable than that of most of his contemporaries, and his chronology is difficult to establish. His early Leiden works, which include rather broadly brushed religious and allegorical pictures, as well as genre paintings, do not show signs of Dou's influence or the high finish and polished manner associated with the Leiden School. They have more in common with works by Jan Baptist Weenix (e.g. Metsu's *Allegory of Faith*, The Hague,

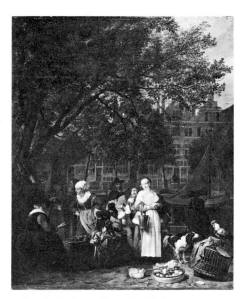

176. Gabriel Metsu: Vegetable Market at Amsterdam, *c.* 1660–5. *Paris, Louvre*

to Rembrandt's early chiaroscuro and colour even in his late pale paintings, and his touch remains minute. He also keeps a Baroque intricacy of design. Among Metsu's most delightful and rarest paintings are his scenes of outdoor markets. The quarrelling woman and the forward young man flirting with a maid in his *Vegetable Market at Amsterdam* (Paris, Louvre) [176] are unusual notes in his *œuvre*. His genre figures as a rule have finer manners. Steen's boisterousness or Frans van Mieris' lack of decorum is seldom found in his work. Most of Metsu's paintings are domestic scenes. In some the influence of Vermeer and Pieter de Hooch can be detected, but Metsu lacks the refreshing naïveté of De Hooch's Delft works, not to mention Vermeer's mastery. In his famous *Sick Child* (Amsterdam, Rijksmuseum) [177], which because of its motif and general

prettiness is one of his most popular pictures, we see a young woman holding a child who may be slightly ill, or who is perhaps a bit spoiled and dreaming up new demands to make of its custodian. Both the fullness of the figures and the composition recall Vermeer, but the red and blue of the woman's clothes lack the sensitive adjustment of intensities to *valeurs* in the interest of clear spatial relationships. In *The Lady at the Harpsichord* (Rotterdam, Van der Vorm Foundation) the figure is close to Vermeer, and the interior with its vista through an open door and its rectangular accents recalls De Hooch. The lady is seated at the instrument, but not playing. She turns towards her lap-dog – a constant accessory in Metsu's interiors – and speaks to it. The motif is not a very ingenious one. Metsu tries to be pleasant, but frequently lacks the natural touch. Children, not dogs, are

177. Gabriel Metsu: The Sick Child, *c.* 1660.
Amsterdam, Rijksmuseum

178. Gabriel Metsu: The Letter Reader, *c.* 1662–5.
Blessington, Ireland, Sir Alfred Beit

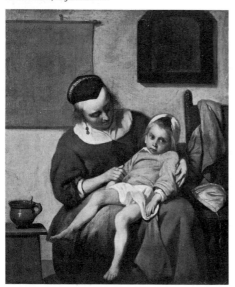

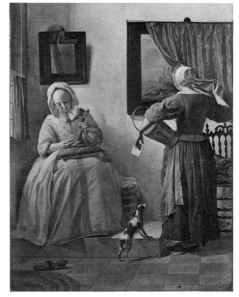

used by Pieter de Hooch to divert the onlooker. Vermeer had the courage to rely repeatedly upon the power of simple motifs. Metsu's picture shows virtues in costume painting, in the silvery-blue dress of the woman at the harpsichord, which rival those painted by his greater models. *The Letter Reader* (Blessington, Ireland, Sir Alfred Beit) [178] has the pleasant subject of a young lady sitting at a window reading a message while a servant waits and looks at a marine painting on the wall, lifting its curtain. The Dutch often protected their paintings with curtains, either to keep off the light and dust, or to look at them only occasionally, as is the way of the Chinese and Japanese. Perhaps this practice comes from the fine feeling that a work of art cannot be looked at continually. The maid in the picture is not deeply interested. Hers is a very momentary movement. There is again an influence of Vermeer in the silvery daylight flowing over the lady, in the blue and grey of the maid's dress, and in the way the figures are set against the light wall, but Metsu is not able to make full use of Vermeer's subjects. Too much goes on without convincing interrelationships, and small details such as the shoe, the cork, and the rug on the floor have not been integrated into the total design. Metsu's *Man Writing* (Blessington, Ireland, Sir Alfred Beit) is less cluttered and more successful than *The Letter Reader*. The work shows the wealth of the Dutch burghers around 1660, their love of comfort and beautiful materials, and the heavily carved gilt Baroque frame around the landscape painting on the wall behind the handsome young man makes clear that not all seventeenth-century Dutch pictures were enclosed in rectilinear black ebony mouldings. Metsu made a few small-scale group portraits of elegantly dressed families in carefully worked out interiors (*The Geelvinck Family*, Berlin-Dahlem, Staatliche Museen) which are decorative in their effect and full of nice details, but when compared with a painting such as Rembrandt's late *Family Portrait* at Brunswick, the title of 'little master' for Metsu is both reasonable and justified.

Quiringh Brekelenkam (active 1648-1667/8) worked in Leiden, where he was influenced by Dou's subjects and by Metsu's lively touch and intense colours. His best picture is *The Tailor's Shop* (1661, Amsterdam, Rijksmuseum), and it is a mystery how a painter who found so much quiet poetry in the humdrum activity of an artisan's shop could produce so many weak pictures. Of greater importance than Brekelenkam is Frans van Mieris the Elder (1635-81), who after Dou is the principal representative of the Leiden school of *Feinmalerei*. Apparently by the time he was born his parents stopped keeping track of the number of children they produced; he is vaguely mentioned as one of the last of twenty-three. Mieris studied with Dou, and the latter acknowledged him as the 'crown prince of his students'. The characterization is still valid. Mieris fell heir to Dou's technique and compositions. Like his teacher, he was extremely popular with the collectors of his time. He was honoured by visits from the grand duke of Tuscany, and the Archduke Leopold Wilhelm invited him to work at his court in Vienna. He turned down the offer and, as far as we know, spent his life in his native town. Only what he painted after 1657 is well documented. His last works date from the late fifties and early sixties. A review of them brings to mind the works of many of his contemporaries, although Mieris always manages to keep his own personality. The refinement of technique in Mieris' *The Doctor's Visit* (1657, Vienna, Kunsthistorisches Museum [179]; another version is in Dublin) is characteristic of what Dou gave his pupils, but even at this early stage Mieris preferred to work with less elaborate chiaroscuro effects than Dou. The complicated

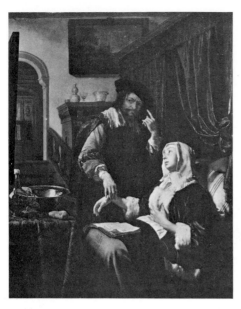 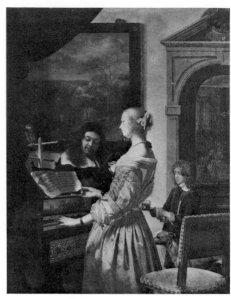

179 (*above*). Frans van Mieris the Elder:
The Doctor's Visit, 1657.
Vienna, Kunsthistorisches Museum

180 (*above, right*). Frans van Mieris the Elder:
The Duet, 1658.
Schwerin, Staatliches Museum

181 (*opposite*). Frans van Mieris the Elder:
The Oyster Meal, 1659.
Leningrad, Hermitage

space construction of *The Duet* (1658, Schwerin, Staatliches Museum) [180] shows that he as well as the artists of the Delft School was probably influenced by Nicolaes Maes' genre scenes. This small, light-filled painting is a high point in Mieris' career, but even here the limitations of the respectable craftsman are evident. As in so many of his works, the group is nicely arranged, but it is not thoroughly thought out in space: the clarity is limited to the front plane, while the rear planes are somewhat neglected. Mieris' colours are stronger than those used by his contemporaries, yet there is no foundation for the statement that they glow because Mieris painted on a gold ground. In *The Oyster Meal* (1659, Leningrad, Hermitage) [181] the dark background, the splendour of the silk and satin, and even the back view of the head of the girl in the middle all recall Ter Borch's scenes of domestic life. The psychological subtlety in this fine piece is unique in Mieris' production; he is usually

more obvious in showing the relationship of his characters to each other. Mieris frequently expresses hearty good humour, and he can also be gross, but he always keeps control of his great technical skill. During the late sixties and the last decade of his life, Mieris' colours became harder and his compositions more schematic. Two of his sons painted. Works by Jan (1660-90) are rare. Those made by Willem (1662-1747) are similar to his father's, but his over-scrupulous attention to detail makes them tiresome. Willem's son Frans van Mieris the Younger (1689-1763) painted in a watered-down version of his grandfather's style.

JAN STEEN

Jan Steen was extremely productive. Hundreds of his paintings with entertaining motifs have survived, and they can be seen in most European museums. He is, however, poorly represented in the United States, where his works were never sought after by the men who built the great American picture collections. Perhaps a painter who constantly pokes fun at virtuous frugality was not serious enough for them. He is the humorist among Dutch painters. Schmidt-Degener – and before him Thoré-Bürger – compared him with Molière, and suggested that the lavishness of Steen's pictures would have met with the great French dramatist's approval: 'Flaubert reminds us that Molière could not rest satisfied with one single apothecary's assistant. He had of necessity to bring a whole battalion of them on the boards, each one armed with his purgative apparatus.' Nature may be content with little, as the moralizing inscription 'Natura paucis contenta' reminds us on Steen's picture of *Cincinnatus and the Plate of Turnips*, but Steen filled every nook and cranny of his picture of this story with turnips, onions, and pumpkins. Cincinnatus, the 'grey dictator, wallows in them . . . the art of Steen revels in profusion'.[18]

The Dutch are rightly proud of Steen, and love his kind of humour. His name is still proverbial in the Netherlands, where a 'Jan Steen household' is to this day an epithet for a lively and untidy home. Steen's exuberant lavishness is also his limitation. His wit often fascinates, but he can bore us by overdoing his points and by becoming repetitious with his jests, tricks, and ironical hints. Not all of the 800 pictures attributed to him are of equal quality. A wisely chosen group of a few dozen could prove that Steen was a superb master. Another group could force one to the erroneous conclusion that he was a sloppy hack. A redeeming feature of his authentic works is his pictorial sparkle. Steen has something of Hals' vivid touch, but his technique, though fresh and lively, is more minute. Something of Steen's Leiden heritage always remains with him. He also seems to have derived some inspiration from Brouwer for his frequent representations of inn scenes, and, as many of

182. Jan Steen: Self-Portrait playing the Lute,
c. 1661-3. *Lugano, Thyssen-Bornemisza Collection*

his self-portraits reveal, Steen, like Brouwer, was a kind of Bohemian. In his *Self-Portrait* [182] in the Thyssen-Bornemisza Collection, Lugano, we can enjoy his wit and animated treatment. Steen, who had close contact with theatrical companies, presents himself dressed in the archaic costume worn by actors of the day who played the role of lovers. He used stock types from the repertoire of the Italian Commedia dell'Arte in many of his pictures, and he also showed Dutch amateur actors from the local chambers of rhetoricians in action. He frequently included himself as a mirthful participant in his rhetorician groups. Steen's conception of himself was a varied one. He could portray himself as a respectable burgher who could have easily asked Bartholomeus van der Helst to paint his portrait. His self-portraits show him as a young, light-

hearted profligate and as a debauched old roué cheated by a strumpet, and he included himself, as well as three generations of his family, in crowded paintings of popular festivals.

Steen was born at Leiden, the son of a brewer. When he was inscribed at Leiden University in 1646 he was said to be twenty; thus he was born in 1625 or 1626. It is not known how long he was at the university, but it seems that he had enough schooling to acquire a smattering of Latin and familiarity with classical authors. From the time he was a student he was always on the move. Something made him restless, and it is as difficult to associate him with a single Dutch town as it is to keep track of his peregrinations. The one city he studiously avoided was Amsterdam. As far as his paintings are concerned, Rembrandt never lived. Steen's works support Weyerman's contention that his first teachers were Nicolaus Knüpfer, the Leipzig artist who settled in Utrecht, Adriaen van Ostade at Haarlem, and Jan van Goyen at The Hague. He apparently settled at Leiden about 1645, and from this time until about 1660 he frequently made the ten- or twelve-mile trip from his birthplace to The Hague and to Delft. In 1649 he married Jan van Goyen's daughter at The Hague, and he had his residence there for the next few years. With the help of his father, he leased the brewery 'The Snake' at Delft from 1654 to 1657, the very years in which Vermeer and Pieter de Hooch were laying the foundations for their great achievement. Steen must have been aware of the early accomplishments of the Delft masters. His unusual portrait of the so-called *Burgomaster of Delft and his Daughter* (1655, Penrhyn Castle, Bangor, Lady Janet Douglas-Pennant Collection) has some of the lightness and fine detailed observation of a Pieter de Hooch, but his ties with that city can be over-emphasized. There is no evidence that he settled at Delft. From 1656 to 1660 he lived

at Warmond, near Leiden, and it was the Leiden painters whose influence upon Steen was decisive during these years. Around this time Steen was apparently more attracted to Frans van Mieris the Elder than he was to Dou, the head of the Leiden school. A comparison of Mieris' *The Doctor's Visit* (1657) [179] with Steen's attractive *Girl with Oysters* (The Hague, Mauritshuis) makes the connexion between the two artists clear. Steen, whose picture was painted about 1660, goes even farther than Mieris in abandoning Dou's chiaroscuro. In 1661 Steen settled at Haarlem, and in the same year he became a member of the guild there. He had associations with Haarlem throughout the sixties, and his greatest pictures, which masterfully combine a detailed treatment with breadth, were made during this phase of his career. One likes to imagine that at this time Steen established close contact with the aged Frans Hals. Perhaps he did. There is no question that the pictures by Haarlem's greatest artist had an impact upon him, and it seems that Steen collected Hals' paintings; Hals' *Peeckelhaering*, now at Leipzig, hangs on the walls of two of the interiors Steen painted: *The Baptism* (Berlin-Dahlem, Staatliche Museen) and *The Doctor's Visit* (London, Apsley House). In 1670 Steen returned to Leiden, where he remained until he died in 1679. He continued to work in a fine and broad manner until the end, and a few of his pictures have the smooth surfaces favoured by so many late-seventeenth-century Dutch painters. During his last years he held responsible positions in the artists' guild at Leiden, but he did not sever his connexions with the brewers. In 1672 he received a licence to operate a tavern in the town.

There is in Steen's work a tremendous variety of lively scenes in interiors and out of doors, as well as allegorical and religious themes. His birds and animals are as finely painted as those made by the Dutch specialists in this branch. Steen also made a few commissioned portraits, which are marked by a genre character. The early works, which can be dated in the late forties, are mostly open-air scenes with crowds of rather grotesque little figures. The *Winter Landscape* (c. 1650, Skokloster, Sweden, Baron Rutger von Essen Collection) suggests that around this time he studied the landscapes of Isaack van Ostade more closely than those by his father-in-law Jan van Goyen. Steen always kept a fine feeling for the atmospheric effects of the outdoors, but he never had the true instinct of a landscape painter. For him, nature never exists independent of man. The *Skittle Players outside an Inn* (c. 1660–3, London, National Gallery) [183] charms by its distinct feeling for the air and light of a summer day. It is a colouristic marvel, with pinks, greys, blacks, and whites set into the green surroundings. *The Poultry*

183. Jan Steen: Skittle Players outside an Inn, *c.* 1660–3. *London, National Gallery*

184. Jan Steen: The Poultry Yard, 1660.
The Hague, Mauritshuis

misfortune, sympathy, or obliviousness are all seen in *The Schoolmaster* (Dublin, National Gallery), and it is not surprising that Steen painted at least six pictures of the Feast of St Nicholas, the festival traditionally dedicated to Dutch children. On the eve of 5 December, St Nicholas comes to the Netherlands from Spain to leave appropriate gifts in the shoes of children. The good ones receive cakes, sweets, and toys; the naughty ones get canes. The finest version of this theme is in the Rijksmuseum [185]. A complicated play of diagonals binds the family of ten together – from the heap of special pastries to the man pointing to the chimney on the right, where St Nicholas made his entry, and from the carved table covered with sweets up to the girl holding the shoe with the distressing birch-rod. Figures which lean in one direction are balanced by those leaning in the other; foreground and background, right and left are held together by gestures, glances,

185. Jan Steen: The Feast of St Nicholas, *c.* 1667.
Amsterdam, Rijksmuseum

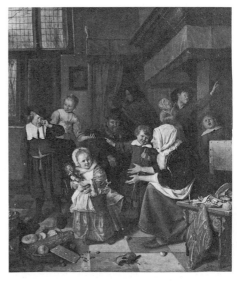

Yard (1660, The Hague, Mauritshuis) [184] is a portrait of the ten-year-old Jacoba Maria van Wassenaer, who is shown offering milk to a lamb. She is flanked by two servants in a yard full of domesticated prize-birds. The tonality and slightly scattered arrangement already suggest the lightness and openness of eighteenth-century compositions. The portrait of the shy little maid, who is oblivious to the cackling around her and the admiring glances of the barnyard help, shows what a master Steen was at portraying children. No painter surpasses his representation of the wide range of their actions and emotions from the time they are in swaddling clothes until they must be categorized as young men or women. The subtleties of the expression on the faces and in the demeanour of children experiencing pain, dumb wonderment, malicious joy at another's

and expressions which give the painting familial as well as pictorial tautness. The smiling boy who points to the shoe makes the onlooker part of this family scene by smiling directly out at him. The colouristic effect is brilliant, and does not lack unification or become too diffuse, as is sometimes the case in Steen's work. It must have been works of this calibre which prompted Sir Joshua Reynolds, who was still firmly rooted in the classicist tradition of art theory, to write in 1774 of Jan Steen: '. . . if this extraordinary man had had the good fortune to have been born in Italy, instead of Holland, had he lived in Rome instead of Leyden, and been blessed with Michael Angelo and Raffaelle for his masters, instead of Brouwer and Van Gowen; the same sagacity and penetration which distinguished so accurately the different characters and expression in his vulgar figures, would, when exerted in the selection and imitation of what was great and elevated in nature, have been equally successful; and he now would have ranged with the great pillars and supporters of our Art. . . .'[19]

Steen moralized more than most Dutch genre painters. Allusions to old proverbs, aphorisms, emblems, literature, and the theatre abound in his work. In *The Morning Toilet* (1663, London, Buckingham Palace) [186] a skull, a lute, and a music-book – conventional Vanitas symbols – are lying on the threshold of a bedroom where a lovely young lady is pulling on her stockings. Steen's numerous pictures of doctors' visits to young ladies are not commentaries on the social conditions of the times, but are meant to be illustrations of the kind of sickness which medicine can never cure. All these maidens suffer from love, and on the walls, in the background of these pictures, there is usually a conspicuous painting representing a love scene to make clear the significance of the motif. Steen was able to tell this story repeatedly, with wit and irony. His literary bent seldom gets the upper hand. The doctors,

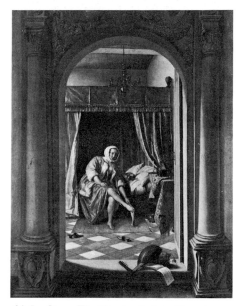

186. Jan Steen: The Morning Toilet, 1663.
London, Buckingham Palace

who play an indispensable role in these pictures, are usually represented as quacks dressed in the garb used for the stage. Again Molière comes to mind. Their anachronistic black costumes always make an effective contrast with the light colours worn by the women they are never able to cure. Much of Steen's moralizing is based upon familiar platitudes. 'Easy come, easy go' was a favourite. He frequently includes an inscription in his paintings to make his meaning clear. The one tacked above the dead-drunk couple in his *After the Drinking Bout* (Amsterdam, Rijksmuseum) is the old saw, 'What use are candles and spectacles if the owl refuses to see?' Many of his exuberant pictures of families around a festive table, where grown-ups, children, and animals make an ingenious hotchpotch, are also designed to illustrate well-known proverbs. The most

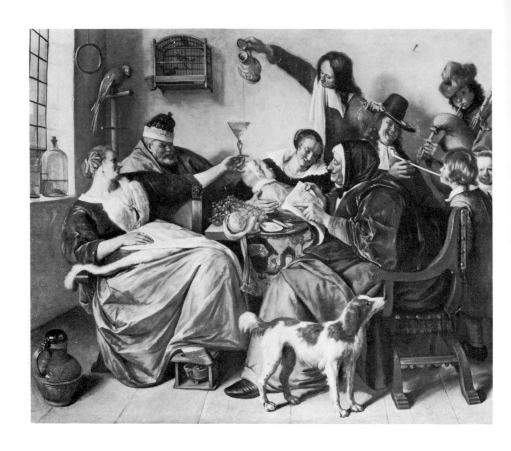

187. Jan Steen: Merry Company ('The young ones chirrup as the old ones used to sing'), *c.* 1663.
The Hague, Mauritshuis

common is 'The young ones chirrup as the old ones used to sing'. This is the subject of the group eating, making music, drinking, smoking, laughing, and shouting in the picture at the Mauritshuis [187]. Here Steen has represented his own noisy family; he introduced himself giving his son a pipe. The old woman sings the song written on the sheet of paper she holds:

As we sing you'll have to chirrup,
It's a law the whole world knows.
I lead, all follow suit,
From baby to centenarian.

In this major work, which is large in size and broader in execution than most, there is an abundance of animating details. It can be dated around 1663, when Steen was in Haarlem and had the opportunity to study at first hand a number of Frans Hals' pictures. The tonality is light, and the dominant hues are Steen's favourite ones: violet, rose, salmon-red, pale yellow, and bluish-green. These, of course, have nothing in common with Hals' late sober palette. Steen avoids regularity and rectangular construction in the composition and indulges in diagonals, zigzags, pointed oblique accents – as Hals did – to give the suggestion of movement and animation, and of a continuous medley.

More than sixty religious pictures can be attributed to Steen, who remained a Catholic all his life. These were made from the beginning until the end of his career. Most of his biblical pictures are treated as genre subjects, and Steen, who could seldom restrain himself, included comical incidents in them. As one might predict, scenes from the Passion did not attract his attention. His favourite subject was the Marriage at Cana, which he painted at least half a dozen times. If his biblical paintings are judged, as they usually are, by the criteria used by the Tribunal of the Inquisition which condemned Veronese for introducing in his *Feast in the House of Simon* an apostle cleaning his teeth with a toothpick and other secular elements, they will be condemned. There are,

however, a few exceptions. His *Adoration of the Shepherds* (Amsterdam, Rijksmuseum) has a genuine human warmth and tenderness without a trace of the sensual or the burlesque found in some of his other scenes from Scripture. *Christ at Emmaus* (Amsterdam, Rijksmu-

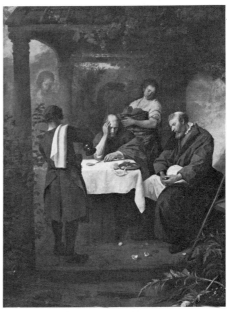

188. Jan Steen: Christ at Emmaus.
Amsterdam, Rijksmuseum

seum) [188] is usually dismissed straightaway, because it does not match Rembrandt's mature rendering of the subject [92]. No one would argue that it does. However, more than one interpretation of the scene from St Luke is possible. Steen's conception may lack the profundity of Rembrandt's, but it is, nevertheless, a most personal and original one. Instead of showing the moment when Christ reveals himself to wide-eyed and gesticulating disciples, as Caravaggio, Rubens, and the young Rembrandt did, Steen represented a scene after the Revelation. Christ is only seen in the door,

vanishing like an apparition. A disciple, not Christ, is the centre of the composition. The boy pouring wine, who has his back turned towards us, is as unaware of the onlooker as he is of what has just occurred. The maid and the two disciples seem to be stunned by the mystery, and the half-peeled lemon on the table and the crumbs and broken eggshells on the floor, which are Steen's constant props for banquets and brawls, here lend credibility to a miracle.

During the 1670s, when Steen returned to Leiden and was apparently active as an innkeeper, he continued to be a prolific painter. Large subject pictures and genre scenes, as well as tiny, carefully finished paintings, were made during his last years. Traces of the influence of the Louis XIV style can be recog-

nized in his subjects, the increasing elegance, and his occasional use of glossy paint, but his mischievous wit and good humour are not affected at all. In the *Two Men and a young Woman making Music on a Terrace* (London, National Gallery) [189], which has considerable charm in the arrangement of the couple against the open sky – the man in the centre is dressed in the costume of Pantalone, a figure from the Commedia dell'Arte – there is already a premonition of Watteau's elegant idylls. This eighteenth-century note is not unique in his late works. The *Nocturnal Serenade* (Prague, Národni Gallery), which can be dated about 1675, shows a whole group dressed and masked as Italian comedians; the theme is one Rococo painters were to use frequently. The slightly elongated proportions of Steen's masquers

189. Jan Steen: Two Men and a young Woman making Music on a Terrace, c. 1670. *London, National Gallery*

are already closer to those used by eighteenth-century artists than to the ones employed by his own contemporaries. In one of Steen's latest dated works, *The Garden Party* (1677, formerly Amsterdam, L. Rozelaar Collection) [190], the dionysiac energy of the early pictures has diminished. The scene, which is set against a ruddy sunset, was once considered a refined presentation from the life of the Prodigal Son – the theme which was the source for motifs used by so many of the first generation of seventeenth-century Dutch genre painters. But the picture is, in fact, a view of the garden which belonged to a patrician family of Leiden. The stately home in the background has been identified as the residence of the Paedts family.[20] Figures strolling in the garden are dressed in the costume of the day, and two young ladies are playing a kind of golf which was popular at the time. However, the fact remains that this is not a literal representation of a Leiden garden party which took place in 1677. Fantasy mixes with reality here. The amorous couples can hardly be considered portraits of members of a regent family of Leiden. The principal lover, who is receiving wine, as well as the prominent musicians, are dressed in theatrical costumes. Characters from the make-believe world of the theatre have assumed greater importance than the Dutch burghers in their garden. With a little more magic – or, stated more prosaically, with a more unified conception – we are not very remote from Jean-Antoine Watteau's wondrous *fêtes champêtres*, where reality mingles with dreams and fantasies become real.

190. Jan Steen: The Garden Party, 1677. *Formerly Amsterdam, L. Rozelaar Collection*

LANDSCAPE

In the vast production of seventeenth-century Dutch painting the predominant subjects are landscape, genre, and portraiture. The greatest talents of Dutch art expressed themselves in these branches of painting. Still lifes, street views, and church interiors enjoyed a vogue, and there was also some religious, mythological, and historical painting, but none of these were large categories. To be sure, Rembrandt and his school devoted much of their work to religious subjects; but in this respect, as in so many others, Rembrandt and his close followers were exceptions rather than typical representatives of Dutch art and taste. Portraiture, genre, and landscape are indeed the most significant subjects, and each of them shows a great deal of variation. In the first category it was not only the single portrait, but various kinds of group portraits which the Dutch cultivated. There were regent pieces, anatomy lessons, and shooting companies. In genre painting we observe even greater variety. The low-life or peasant scenes, the gay-life and the military scenes, the domestic life of the well-to-do, each had its own rich development and attracted such great talents as Frans Hals, the young Brouwer, Fabritius and Vermeer, Pieter de Hooch, Ter Borch, and Steen. With landscape, too, there was a great deal of variety and specialization within the general category. Flat landscape, dunes, river scenes, forests, even the more hilly countryside towards the Flemish and the German borders were represented, and some of these subjects developed continuously as separate categories. The winter landscape has to be added, and also the landscape with animals. All aspects of the Dutch countryside and nature were considered worth rendering. We even find specialists in sunset pictures and in moonlight scenes, but without the sentimental flavour of the nineteenth century. A group called the Italianate painters (see pp. 296 f., 303 ff.) introduced southern motifs and the pastoral mood of Claude Lorrain to Dutch art, but they, too, were true Dutchmen, since they mostly painted these motifs on the basis of their own visual impressions in Italy, and substituted shepherds and herdsmen of the Campagna for the biblical and mythological figures that people so many of Claude's idyllic landscapes.

It seems that, to appeal to their countrymen, Dutch landscapists had to be close to nature. This tendency can be traced back to the work of the fifteenth-century Netherlandish masters, who gave equal attention to details in landscape, to flowers, rocks, trees, brooks, and even in some degree to the sky. Michelangelo, if we can believe Francesco da Hollanda, once mocked the interest of the Early Netherlandish painters in landscape. He is supposed to have said, 'They paint in Flanders only things to deceive the external eye, things that gladden you and of which you cannot speak ill. Their painting is of stuffs, bricks and mortar, the grass of the fields, the shadows of trees, and bridges and rivers, which they call landscapes, and little figures here and there; and all this, although it may appear good to some eyes, is in truth done without reasonableness or art, without symmetry or proportion, without care in selecting or rejecting, and finally without any substance or verve . . .'. Kenneth Clark correctly appraised Michelangelo's prejudice against Early Netherlandish painters when he noted that the Italian High Renaissance master was

so steeped in Neo-Platonism, and struggled with an ideal of art so strenuous and exalted, that the mere pleasure of perception seemed to him beneath contempt, and he could therefore justifiably ignore the flowers and meadows of Flemish painters as suitable for women – especially very old or very young ones – for monks and nuns, and also for certain noble persons who have no ear for true harmony.[1]

Things changed after the time of Michelangelo. Seventeenth-century Dutch landscapists and their French contemporaries Claude Lorrain and Nicolas Poussin raised landscape painting to a category of real power. Claude and Poussin still inherited a great deal from the classical tradition. The Dutch, on the other hand, were the first to teach that nature in all its varied aspects has a grandeur and intimacy of its own which can be appreciated outside the rigid boundaries of classicism. They showed that there is a pictorial charm in nature which only painters can bring out and convey. It is no accident that the great *plein-air* artists of the nineteenth century turned to the Dutch masters time and again for inspiration, and singled out their achievement as a justification for their own approach to nature.

During the first decades of the twentieth century, when the Expressionists, Cubists, and abstract painters made their revolutionary innovations, there was a rather derogatory interpretation of Dutch painting and its general character. Many artists and critics challenged the view, which was still taken as a matter of course up to the time of Cézanne, Van Gogh, and Gauguin, that painting reflects an artist's visual impressions of life and nature. The opinion was frequently expressed that seventeenth-century Dutch burghers, devoid of any higher ideal and given to the enjoyment of material life, were fully satisfied with the mere illusionistic rendering of their surroundings. It was argued – and the argument is still heard – that Dutch art, which is nothing else but a mirror of reality, can hardly be called art in the highest sense.

This judgement is unjust, at least with regard to the great masters among the Dutch. The critics who hold this opinion overlook two essential points. One is that the Dutch painters approached reality with a naïveté and purity of sense, and even an awe and devotion, that were almost religious, and cannot be called completely devoid of any ideal or spiritual value. A landscape by Jan van Goyen or Jacob van Ruisdael, a genre painting by Vermeer or Pieter de Hooch, a still life by Willem Kalf convey to us more than a naked representation of reality. The same religious undertone that still flavours the great rational conceptions of seventeenth-century pantheism is felt in the deep devotion of the masters of Dutch painting to their subjects. The other point overlooked is that the quality of formal organization and the degree of expressive value in a work of art play a more important role in determining its level than either a representational or anti-representational programme. The Expressionists and their followers, and then to a greater degree the Cubists and abstract artists, stigmatized representational art – that is, art which is chiefly concerned with visual reality – by calling it 'imitative', in contrast to their own efforts, which they called 'creative', since they aimed at the expression of inner or imaginary experiences rather than the rendering of outward vision. No one denies the significance of the new conceptions of the great pioneers of modern art, but identification of realistic with imitative, and of expressionistic or abstract with creative, confuses the issue. An artist who is concerned with what he sees in the world around him can be creative. One need only think of Vermeer and Jacob van Ruisdael. The artist must find proper pictorial means for his task in order to build up a work of an original and expressive organization. Only then does he deserve the title of master. Selecting and rejecting from

the infinite aspects of nature is involved, as well as a great deal of transformation. In short, the best masters among the Dutch show considerable painterly imagination in their realistic rendering of landscape. They also express a universal feeling, although none of them reaches the deep spirituality of Rembrandt's art.

If we turn to the more specific artistic features of Dutch landscape, we may say that the Dutch developed in the course of the seventeenth century a type of landscape in which both atmospheric life and an impressive spaciousness became the dominating features. They developed this programme gradually, and remained limited to a conception which is unmistakably derived from the appearance of the Dutch countryside and the Dutch sky. In the discussion of this development it will be noticed that the classifications used can also be applied to the development of other categories of Dutch painting; for example, to genre or still life. It is a classification which reflects the general trend of Dutch painting during the seventeenth century. Individual artists express themselves differently within these common trends. To get the total picture of this great age, or indeed of any period, we must time and again consider both aspects: the common phenomena, or the style of the period, and the style of individual artists. They are interconnected, and the relative independence of the great artists should never deceive us about this fact. To show the style of a phase we make a cross section of the period, lining up representative works of art of a given time. For the individual we must trace his development. On the whole an individual artist is connected primarily with one phase, in spite of his going through various periods. Generally the time an artist enters early manhood is most decisive for the total character of his art. Thus in our discussion of Dutch landscape, we have taken Van Goyen and Salomon van Ruysdael as representatives of the monochromatic style of the thirties and early forties, and Jacob van Ruisdael and Aelbert Cuyp as representatives of the next, the classic phase, although all of them, as we shall see, reflect the style of more than one phase in their total production.

MANNERISTS

Van Mander noted in his *Schilderboek* that he did not know a better landscape painter in his time than Gillis van Coninxloo, whose manner of painting is now beginning to be followed in Holland, and he added, though some nurserymen do not like to acknowledge it, Dutch trees which were always a bit barren are now beginning to grow like his. Van Mander did not exaggerate. Coninxloo was the most important landscapist who worked in Holland during the first decade of the century. This Mannerist painter was a Fleming by birth (b. 1544), who left his native town Antwerp in 1585 to escape religious persecution by the Spanish. With a group of other Flemish painters he settled at Frankenthal, a little place near Frankfurt, where a colony of landscape artists gathered under his leadership. In 1595 he moved to Amsterdam, where he lived until his death in 1606. Thus, his career in Holland was a brief one. His earliest known works – nothing is dated earlier than 1588 – are bird's eye panoramic views of craggy mountain ranges and river valleys in the tradition of Patenir and Bruegel. An illustrative tendency still prevails. Nature is a stage for biblical or mythological scenes. It is a place where exciting or astounding events occur. Space is not yet rendered as a powerful unity animated by atmosphere. The early Coninxloo still used the traditional device employed by sixteenth-century Netherlandish painters: he sets off successive planes by dividing his landscape into three distinct colouristic sections: warm brown for the foreground; shades of green for the middle distance;

and cool blue tones for the background. His piling up of meticulously rendered details also recalls an earlier tradition. Like most Mannerists, he is prepared to manipulate light and shadow with great freedom. The dramatic character of his landscapes generally depends upon arbitrarily relieving broad masses of light by large contrasting areas in shadow. The dark parts are usually trees in the foreground used as stage wings to frame the composition with ornamental foliage. Coninxloo's originality is best seen in his late paintings of majestic forests (c. 1600, Vienna, Kunsthistorisches Museum) [191], which look like places where dramatic things will happen. But now there is little action in his gigantic groves. The men and animals in them are completely dwarfed by primeval trees. It was, therefore, the late Coninxloo who broke with the anthropocentric

tradition of Netherlandish landscape painting and made the romantic mood evoked by luxuriant nature his subject. These tendencies were not lost in the further development of Dutch art. Hercules Seghers, who was Coninxloo's pupil, Rembrandt, and Jacob van Ruisdael – the more romantic and imaginative minds among the Dutch landscapists – borrowed elements from the fantastic panoramas and forests painted by Coninxloo and his followers, but transformed them into the more solid character of their period.

Coninxloo's principal followers were David Vinckboons and Roelant Savery, who were also born in the South Netherlands and emigrated north. As we have heard, the popular Amsterdam master Vinckboons remained fundamentally a genre painter. Huge crowds generally play an important role in his panoramic

191. Gillis van Coninxloo: View of a Forest, c. 1600. *Vienna, Kunsthistorisches Museum*

vistas. It is his late pictures of woods and heroic oak trees which earn him a place in even a cursory discussion of Dutch landscape painting. They became less schematic than Coninxloo's, and have a suggestion of the light and air which was to fill the landscapes of the Dutch painters of the following generation. Roelant Savery (1576–1639), who was born at Courtrai, was called to Prague about 1604 by Rudolph II. While in the emperor's service he travelled in the Tyrol and made drawings of mountain scenery which are among his most attractive works, and he used these as a source for his compositions during the rest of his career. After working for the court in Vienna for a time he finally settled at Utrecht in 1619. Most of his landscapes include a whole Noah's ark of wild and domesticated beasts. Savery also represented the now extinct dodo. It appears

in the lower right of his fantastic *Landscape with Birds* [192] now at Vienna. Savery probably drew it from life, since the dodo was brought to Holland soon after 1598, when the Dutch took possession of Mauritius, the island the bird once inhabited.

The versatile and long lived Utrecht master Abraham Bloemaert (cf. pp. 30–1 above) made landscapes in the Mannerist tradition too. The figures in his designs for engravings of biblical and mythological scenes executed during the first decades of the century are usually subordinated to dramatic and ornamental landscapes. In some of his bucolic pictures he abandoned the high point of view used so frequently by the Mannerists, and focused his attention upon a clump of gnarled trees, or a tumbledown farmhouse – themes which Van Goyen and Salomon van Ruysdael later favoured.

192. Roelant Savery: Landscape with Birds, 1628.
Vienna, Kunsthistorisches Museum

193. Abraham Bloemaert: Farmhouses and Peasants, 1650. *East Berlin, Staatliche Museen*

Many of these motifs are based upon studies from nature, but when Bloemaert composed a landscape painting he relied upon the Mannerist schemes he had mastered in his youth. They can still be seen in his *Farmhouses and Peasants* painted as late as 1650 (East Berlin, Staatliche Museen) [193], in the ornamental design of the branches and foliage, the pale colours, and the large, dark figures in the foreground which mark the front plane and create the illusion of great depth by making a sharp contrast with the small objects in the middle distance and in the background. Bloemaert, who successfully mastered so many styles, never grasped – or refused to use – the great discovery of Dutch landscape painting; namely, that changes in the *valeurs* and intensity of colours – even a single one – can create a greater illusion of space and atmosphere than the whole bag of Mannerist tricks. But his country scenes always have a decorative charm and sometimes anticipate the bucolic idylls painted by Rococo artists. Boucher recognized Bloemaert as a sympathetic spirit, and in his early pastorals openly re-used his motifs.[2]

We have already noted the importance of Adam Elsheimer, the foreigner who, next to Caravaggio, exerted the greatest impact on seventeenth-century Dutch painting (see p. 31). This German master probably had close contact with the Frankenthal landscape painters in his youth. He was born at Frankfurt, i.e. near the place where Coninxloo and other Flemish landscapists had settled after immigrating from Antwerp. His early works show a connexion with Coninxloo's ornamental treatment of foliage and the fantastic character of the older painter's forest scenes. The

Mannerist elements in Elsheimer's pictures were replaced by a new simplicity shortly after he had settled in Rome around 1600 and felt the impact of Caravaggio's powerful art. Landscapes by the Flemish painter Paul Brill (1554–1626), who also settled in Rome, stimulated him too, but he was most impressed by Caravaggio's chiaroscuro and tried to achieve similar effects in small nocturnal scenes. In his rare Roman landscapes, where the massive, rounded forms of dark trees are frequently set against a bright sky which spreads a tender light over the earth, southern monumentality is infused with northern intimacy. Elsheimer established a type of classical landscape different from Annibale Carracci's more constructed and architectural compositions. Annibale's landscapes inspired Poussin; Elsheimer's art stimulated Claude and the Dutch landscapists, who responded to his delicate light and calm lyrical moods. Some of Elsheimer's pictures were engraved by the gifted amateur Count Hendrick Goudt (1585–1648) of Utrecht, one of Elsheimer's patrons in Rome. Goudt's seven plates after Elsheimer, which are the main basis for this mysterious artist's reputation, popularized his achievement in Holland. Goudt's print of *Tobias and the Angel* (1608) [194] is a beautiful example of his reproduction of Elsheimer's landscape art. The swelling rhythm of the rounded masses of the trees receding into the distance gives an effect of great spaciousness, and the very delicate illumination of the landscape and the reflections in the water contribute to the idyllic mood of the whole. A group of young Dutch artists responded to these qualities of Elsheimer's landscapes. Those who had contact with Elsheimer in Italy are discussed above (p. 31 ff.). Hercules Seghers, Willem Buytewech, and Jan van de

194. Hendrick Goudt:
Tobias and the Angel, 1608. Engraving

Velde, who never crossed the Alps, also show the impact of Elsheimer's art, and a generation later it served as a source of inspiration for some of Rembrandt's landscape paintings and drawings. Elsheimer was most original as a draughtsman. His handling of pen and brush is amazingly free, and his chiaroscuro effects go far beyond Caravaggio, anticipating Rembrandt in their bold interpretation of light and shadow.

EARLY REALISTS

When discussing realism in connexion with seventeenth-century Dutch landscapists, it is important to bear in mind that these artists hardly ever painted their pictures out of doors. The practice of making paintings in the open air became common only during the nineteenth century. In earlier times landscape paintings were nearly always composed in studios. To be sure, since the Renaissance, drawings had been done from nature, and the versatile Goltzius made a handful of extraordinary small pen sketches of the dunes around Haarlem which anticipate the panoramic views painted by Philips Koninck. But drawings of this type are exceptional, and they did not serve as the basis for paintings. They were made for the artist's own private pleasure or instruction. Seventeenth-century Dutch landscape specialists drew from nature much more often than their predecessors, and they frequently used motifs sketched in the countryside as raw material for their paintings; but, like their forerunners, they worked up their pictures in their studios, where they relied upon modifications of old schemes as well as their own inventive power and imagination to transform a sketch into a finished painting.

In this phase artists still felt that nature needs animation by human figures and action, although religious or allegorical scenes are rarely used. Unification begins to develop in the works of Hendrick Avercamp (1585–1634) and Esaias

van de Velde (c. 1590–1630) through atmosphere and a coherent spaciousness, but their forms are still rather thin and their figures are sharply silhouetted with only cautious pictorial touches. Carefully executed details play an important role in this early realism, which has a certain freshness and crispness. The influence of the Flemish – particularly Jan Bruegel – can still be felt. As we have seen, Flemish émigrés were the leading landscapists in Holland when Avercamp and Esaias van de Velde began to paint, but even the earliest works of these Dutch artists show the beginning of that subtle atmospheric life which was to become so characteristic in the future. This effect is brought out with a watercolour brightness and lucidity. Their pictures are generally many-coloured and have a gaiety kindred to Frans Hals' works of the early twenties. However, Hals has more vigour and advances more boldly towards Baroque unification than these little masters.

Avercamp, also called 'de Stomme van Kampen' (the Mute of Kampen) because of his disability, spent most of his life in the small quiet town of Kampen on the eastern side of the Zuider Zee. Residence relatively far from the principal artistic centres of the Netherlands helps to explain why this delightful artist, who discovered the pictorial qualities of flat landscapes and was the first to specialize in winter scenes of outdoor sport and leisure, had little influence on the development of Dutch landscape painting. Avercamp's pictures peopled with motley crowds skating, sledging, golfing, and fishing on the frozen canals of Holland [195] fascinate social historians as well as art historians. The latter sometimes find him a troublesome painter, because it is difficult to trace his development. The plain fact seems to be that he did not have a very marked one. From the very beginning he could paint a landscape with a high horizon, a great accumulation of detail, and a number of light colours (*Winter*

195. Hendrick Avercamp: Winter Scene on a Canal. *Toledo, Ohio, Toledo Museum of Art, Gift of E. D. Libbey*

Landscape, 1608, Bergen, Norway, Museum), or one with a low horizon, few details, and vivid colours in the foreground which lighten as they recede to the distance (*Winter Landscape*, 1609, formerly Lugano, Rohoncz Collection).[3] The two possibilities existed simultaneously and could be used at will until the end of his career, depending on either the artist's or his patron's predilections. Hendrick Avercamp's nephew Barent Avercamp (1612/13–1679) closely imitated his uncle's works during the early years of his career, without attaining the finer qualities of his model. Arent Arentsz., called Cabel (*c.* 1585/6?–1635), whose works are sometimes confused with Hendrick Avercamp's, also specialized in painting the flat landscape of Holland. His colours are darker and more vivid than Hendrick's delicate hues, and the figures in Cabel's pictures – they are frequently fishermen or waterfowl hunters – are somewhat larger and cruder.

In 1610 Esais van de Velde settled at Haarlem, the most exciting centre of artistic activity in the Netherlands during the second decade of the century. He remained there until 1618,

when he moved to The Hague. Esaias' early works are a *mélange*. Traces of the style of Coninxloo and Vinckboons are evident, as well as signs of the influence of Jan Bruegel, De Momper, Lastman, and Pynas. About 1612–14 Esaias made a series of eight etchings of Dutch motifs which use the low point of view and triangular compositional schema favoured by Elsheimer. They are the earliest examples of the translation of the German master's style into Dutch art. He probably learned about Elsheimer's works from Goudt's prints. A few years later Buytewech followed Van de Velde's lead, and made landscape drawings and etchings based upon the stylization Elsheimer invented. Jan van de Velde (1593–1641), the cousin of Esaias, made prints in a similar vein. Cornelis Vroom (*c.* 1590/1–1661) also painted modest little pictures (*Landscape with a River by a Wood*, 1626, London, National Gallery) which show the impression of the art of Elsheimer and anticipate in a remarkable way the works of Jacob van Ruisdael. Neither Buytewech nor Jan van de Velde seems to have been specially interested in landscape painting.

Esaias van de Velde, on the other hand, continued to paint scenes of nature until the end of his career. He also represented genre scenes and cavalry skirmishes. By about 1615 Esaias was making pictures with an unprecedented freedom and simplicity of spatial setting such as his *Winter Landscape* (formerly Lucca, Mansi Collection) which abandon the bird's eye view, the stage wings on either side of the composition, and the wealth of accessories favoured by his predecessors and contemporaries.[4] In this picture the principal motif of the bare trees is placed in the centre of the middle distance, and the composition has been left open on either side. The small and insignificant figures trudging through the snow are the Holy Family making its flight into Egypt. It was most unusual to place this event in a snow-covered landscape. Esaias' *View of Zierikzee*[5] (1618, Berlin-Dahlem, Staatliche Museen) [196] unifies the foreground and background of a landscape even

more successfully by subtle shifts in *valeurs*, from the strip of land and water in the foreground to the city silhouetted against the light horizon. The picture not only gives a premonition of the convincing space construction and tonal painting adopted by the next generation, but even of Vermeer's *View of Delft* [146]. During the following decade Van de Velde's touch became more fluid and his palette more monochromatic (*Dunes*, 1629, Amsterdam, Rijksmuseum). The tradition he established during his brief career was carried on by Jan van Goyen, but not until this outstanding pupil had spent a full decade retracing the steps of his master.

HERCULES SEGHERS

Hercules Seghers was the most inspired and original landscapist working in Holland during the first decades of the century. He was probably

196 (*opposite*). Esaias van de Velde: View of Zierikzee, 1618. *Berlin-Dahlem, Staatliche Museen*

197 (*below*). Hercules Seghers: Mountain Landscape, *c.* 1630–5. *Florence, Uffizi*

born at Haarlem about 1589–90, studied with Coninxloo in Amsterdam, and entered the Guild of St Luke at Haarlem in 1612. Like his close contemporaries Avercamp and Esaias van de Velde, he shows a certain dependence upon the Flemish tradition of landscape painting. He seems to have been impressed by De Momper and Savery as well as by Coninxloo, but he was more inspired by the fantastic and visionary aspects of Mannerist and *Flamisant* landscape painting than he was by its realism. To be sure, during the course of his rather brief career – he disappears from the scene *c.* 1635 – he made realistic as well as imaginary views; however, the latter comprise most of his *œuvre*. Few Dutch painters explored the haunting world he discovered, and only Rembrandt and Jacob van Ruisdael evoke moods similar to his.

There are contemporary reports concerning Seghers' poverty, melancholic disposition, and grief which drove him to drink. These stories may be exaggerated, but it seems that he never enjoyed wide popularity during his lifetime. An Amsterdam dealer had thirty-seven of Seghers' paintings in his possession in 1640, and there are records of about a dozen more at this early date. Today only about fifteen can be attributed to him. The extreme rarity of his works and knowledge that more existed have led some critics to ascribe paintings by his followers to the master himself.[6] The high quality of his authentic works can be seen in the *Mountain Landscape* (Florence, Uffizi) [197]. The vast panoramic view of a valley flanked by a great mountain range is a sign of his descendance from the Mannerists, but his touch is more vigorous, and his work suggests a greater closeness to nature. The drama of light and shadow in the sky and upon the plain is his own invention. Rembrandt, who was deeply impressed by Seghers' works, owned eight of his paintings and bought one of his etched plates which he

reworked (*The Flight into Egypt*, Bartsch 56, altered from Seghers' *Tobias and the Angel*, which in turn is a free copy of Goudt's engraving of Elsheimer's painting of *Tobias and the Angel*). Rembrandt's painted landscapes of the late thirties have a Segheresque character in their fantastic mood and deep brown tonality, and for a long time many of Seghers' landscapes were ascribed to Rembrandt. The powerful *Mountain Landscape* in the Uffizi was attributed to him until 1871, when Bode recognized it as a Seghers. The confusion is easy to understand. No work by Seghers shows more clearly Rembrandt's debt to him, and some specialists maintain that Rembrandt actually retouched the landscape; they see the younger painter's hand in the figures and cart on the left of the picture, the mountains on the right, and in part of the sky. Seghers also painted imaginary views of the flat Dutch countryside and at least one topographical view (*The Town of Rhenen*, Berlin–Dahlem, Staatliche Museen). These achieve a powerful and unified spaciousness,

and establish Seghers as one of the founders of panoramic landscape in the Netherlands. A chronology of his rare paintings is difficult to establish, but it seems that towards the end his compositions gain in firmness and monumentality. Their brown tonality enlivened by green and blue in the farther distance closely connects Seghers to the tonal phase. He retained the predilection landscapists of his generation had for a horizontal format, and always emphasized the vastness of the earth more than the vault of the heavens. The high skies in his paintings of a *View of the Town of Rhenen* and *View of a Dutch Town on a River* (Berlin–Dahlem, Staatliche Museen) were added by another painter who wanted to make the pictures conform to the taste of a later age.[7]

Seghers is equally well known for his graphic work, which is remarkable for its imaginative quality, originality of motifs, and power of treatment and design. He etched both realistic and romantic scenes, the latter prevailing, with mountain views, waterfalls, desolate valleys,

198. Hercules Seghers: The Valley Landscape with a Tree Railing. Etching. *Berlin–Dahlem, Kupferstichkabinett*

rocky slopes, mostly bare of human figures and of an imposing, almost primeval solitude [198]. Characteristic details are single decayed pine trees and lonely rocks. His vigorous and somewhat grainy line is well suited to suggest weather-worn surfaces of rocks and ruins. A crumbling edifice which reminds men of the transitory nature of their life and accomplishments was one of his favourite motifs. It has been maintained that some of his etchings of ruins were done in Italy, or etched from studies made there. But ruins could be studied in the Netherlands too. Moreover, Seghers was as capable of imagining them as he was of imagining mountain ranges and precipitous cliffs. Sometimes he found inspiration in the work of other artists. His etchings of a *Double-Arched Ruin* (two impressions in the Museum at Düsseldorf) and his *Landscape with Roman Ruins* (Springer 50) are both based upon Willem van Nieuwlandt's print of Roman ruins published in 1618.[8] He also made creative copies after works by Hans Baldung Grien and Elsheimer.

Seghers probably spent much time and effort in experimenting with ways of making colour prints from etched plates, but they are colour prints in the most limited sense. He used only one plate, but printed on a coloured surface (paper or linen). Thus his etchings were limited to two colours, that of the ink and that of the paper. Sometimes the surface was coloured only after the print had been pulled. With this technique he produced extraordinary variations on a theme; white or yellow ink on a dark ground transformed a daylight scene into an eerie nocturnal view. If he wanted more colour, and he frequently did, he touched the print with oil or watercolour, and in this way he also achieved radically different effects from the same etched plate. An etching such as *The Big Ships* (Springer 57), which modern observers find especially appealing because of the economy of line and the great expanse of white paper,

was probably intended for extensive hand colouring. Elaborate colour printing which could dispense with hand work was possible only after the German graphic artist Jacob Christoffel Le Blon (1667-1741) had invented a technique in the eighteenth century which used a different plate for each of the primary colours. Christoffel's invention was based on Newton's colour theories, which were published in 1669, long after Seghers' death. Seghers constantly experimented with graphic techniques. He made counter-proofs; that is, he placed a sheet over his original etching while the ink on it was still wet in order to produce a reverse impression. He also obtained unusual effects by working with a special kind of soluble ink, and apparently was the first graphic artist to use aquatint.[9] No Dutch etcher continued his novel technical experiments.

Seghers' etchings are almost as rare as his paintings. About fifty prints can be attributed to him, and only about 165 impressions are known. The print room of the Rijksmuseum at Amsterdam owns almost one-third of these. Most of the impressions now at the Rijksmuseum belonged to the Amsterdam lawyer Michiel Hinloopen (1619-1708). Soon after his death they became the property of the municipality of Amsterdam. If Hinloopen had not brought so many of Seghers' etchings into his possession, today we would probably know next to nothing about Seghers' awesome achievement as a graphic artist.

TONAL PHASE

Constantin Huygens must have been one of the better judges of painting in seventeenth-century Holland. We have already noted that an entry in a journal he kept about 1629-30 shows that not long after the greatest Dutch painter had picked up his brushes, Huygens recognized Rembrandt's genius, and at the same time he was able to make a penetrating distinction

between the qualities of Rembrandt as a history painter and those of the young master's close friend Jan Lievens. Huygens' understanding of what Dutch landscape painters were doing was equally shrewd. He wrote in his journal that the young Netherlandish landscapists of his day lackèd nothing to show the warmth of the sun and the movement caused by cool breezes. In the representation of such things, he maintained, the new generation will surpass its teachers. Later critics have endorsed Huygens' judgement. About the time Huygens wrote, Jan van Goyen, Salomon van Ruysdael, and Pieter de Molyn, the leading members of the group of artists who brought pictorial realism in Dutch landscape to a climax, were just beginning to paint pictures where the impression of nature dominates over the human figure. They discovered means to suggest atmosphere as the most animating element. The Dutch sky begins to play a dominant role in their works, and a humid atmosphere throws a veil about everything, creating an almost monochrome grey or greyish-green tonality with transparent browns in the shadows. Van Goyen and Ruysdael began to build up their pictures with detached touches of paint. It seems that the windy Dutch climate inspired them to use fluid, impressionistic brush strokes. Molyn never matched their vivid fluidity, but he was the first to make a significant break with the style of the early realists.

Pieter de Molyn (1595-1661) was born in London. Neither the date of his emigration to Holland nor the name of his teacher are known. There is no documentary evidence for the assertion found in the early literature that he studied with Frans Hals. In 1616 he joined the Guild at Haarlem, where he spent most of his life. His earliest works show the influence of Mannerists such as Bloemaert, but much more important for him, as it became for Van Goyen and Salomon van Ruysdael, was the impact of Esaias van de Velde's art. Van de Velde was active in Haarlem when Molyn joined the guild there. Not much later, Molyn probably met Van Goyen, who was sent to Haarlem around 1617 to study with Van de Velde. Molyn's innovations are first seen in his modest Dunes, dated 1626 (Brunswick, Herzog Anton Ulrich Museum) [199], which abandons the device of breaking up a landscape into many layers. Scattered details seen from a low point of view have been subordinated to large areas of light and shadow, and the scene has been unified by prominent diagonals which lead the eye over the dunes past the small figures into the distance. In 1626 Molyn also made a series of four landscape etchings using the diagonal schema which became so popular during the following decade. For the next few years (Landscape, 1628, Prague, National Gallery; Landscape, 1629, New York, Metropolitan Museum) Molyn made pictures of the dunes and flat Dutch landscape which are equally original, but his inventive power spent itself rather rapidly. During his maturity he seems to have been more active as a draughtsman than as a painter, and he frequently repeated motifs used early in his career. Most of his lively chalk drawings of landscapes, which are usually signed and dated, were apparently designed as finished works, not as preliminary studies for paintings.

Jan van Goyen was made of different stuff. This great painter and prolific draughtsman was born at Leiden in 1596. He began his apprenticeship at the age of ten and studied with six different masters. However, only Esaias van de Velde, with whom he spent a year at Haarlem, had decisive influence upon him. Van Goyen settled in The Hague in 1631, and had connexions there until his death in 1656. He was a restless soul, travelling frequently about the Netherlands, and like many Dutch painters he did not exclusively devote himself to his craft. He was a picture dealer, a valuer, arranged auction sales, and also speculated in

199. Pieter de Molyn: Dunes, 1626.
Brunswick, Herzog Anton Ulrich Museum

tulip bulbs, land, and houses. His sketchbooks, which are full of vivid rapid chalk drawings of canals and dunes made from nature, also contain plans for dividing up plots of land. In spite of all his financial activities Van Goyen was constantly in money difficulties and died insolvent. As an artist he occupied a respected place in the painters' guild at The Hague, and in 1651 was commissioned by the municipality to paint a panoramic view of the town for the Burgomaster's room at the Stadhuis. Dated pictures by Van Goyen are known from 1620 until the year of his death in 1656. His earliest works are so close to Esaias van de Velde's that it is sometimes difficult to distinguish their hands. Like Van de Velde, he used both a round and an oblong format for small panoramic views of Dutch villages and country roads,

crowded with illustrative details. The atmospheric treatment in these colourful early works is insignificant, the foliage is ornamental, and there are glittering highlights reminiscent of the Mannerists. In the late 1620s Van Goyen shifted to simpler motifs – a few cottages along a village road or in the dunes [200] – and he achieved unification and depth by a leading diagonal and by a tonal treatment that subdues the local colour and is expressive of atmospheric life. His palette turned monochromatic, with browns, pale greens, and yellows.

In the course of the 1630s Van Goyen became the leading master of the tonal phase. His technique grew bolder and more vivacious, the space opened up, and atmosphere predominated. Water begins to play a more important role, as in the *River Scene* of 1636

200. Jan van Goyen: Dunes, 1629. *Berlin-Dahlem, Staatliche Museen*

201. Jan van Goyen: River Scene, 1636. *Cambridge, Massachusetts, Fogg Art Museum*

(Fogg Art Museum, Cambridge, Massachusetts) [201]. This picture shows the diagonal recession characteristic of the thirties, and an all-over airiness that grows in transparency towards the far distance, with its brightened horizon. Sailing boats are sketched in, wet in wet, with the lightest touch. A fine tonal harmony is achieved by the subdued contrast of greys and silvery whites against pale yellows and browns.

The tonal trend continues into the 1640s, bringing still increasing spaciousness and fluidity. Van Goyen's technique often shows an open interplay of over- and underpaint, and the quick, whirling strokes make the vibration of the moist air almost physically felt. Side by side with river scenes, seascapes with choppy little waves appear. Often we meet wide views over the flat country that are lit by streaks of sunlight. A good number of city views occur, and they are set into the wide context of the Dutch countryside, like the beautiful *View of Leiden* of 1643 (Munich, Ältere Pinakothek) [202]. In this fanciful view (the artist placed Leiden's famous St Pancras church alongside an imaginary wide, winding river) we see how the horizontal begins to dominate over the diagonals at this time. The subdued colouristic touches of yellows, greens, and browns become more luminous, and the sky brightens up. Winter landscapes are not the least remarkable at this phase. Their crowds of people skating or moving over the ice in horse-drawn sleighs show Van Goyen's vivid draughtsmanship at its best.

In the 1650s he – like Salomon van Ruysdael – did not remain uninfluenced by the new classical trend, but he never moved away from

202. Jan van Goyen: View of Leiden, 1643.
Munich, Ältere Pinakothek

the monochrome impressionism of his middle period. Some tectonic accents, with verticals opposing horizontals, enter his compositions. The clouds become more voluminous and his touch a bit more forceful. But it is largely the deepening of his tonality that enlivens his late work, by stronger contrasts of dark accents in the foreground against the luminous openings in the sky and bright reflections on the surface of water. All of this can be seen in one of his latest works, the river scene at Frankfurt of 1656 [203], the year of his death. In his last years Van Goyen rivalled Aelbert Cuyp in the glow and force of luminaristic phenomena without adopting the more colourful palette of the younger master.

Salomon van Ruysdael (1600/3?-1670), who was a few years younger than Van Goyen, shares with him – as we have heard – the fame of tonal landscape in Holland, though he moved more slowly and differed considerably from Van Goyen's vivacious temperament. But Ruysdael's charm is undeniable, and the calm lyricism as well as the pictorial subtlety of his river scenes are not easily forgotten. In his landscape production he is less versatile and more uniform than Van Goyen, although for a while, and rather late in his career (from about 1659 to 1662), he tried his hand at a different subject matter, painting some still lifes and hunting trophies.

Ruysdael was born at Naarden in Gooiland. During his early years he was known as Salomon de Gooyer (i.e. Salomon from Gooiland); he was inscribed in the guild at Haarlem in 1623 with this name. He frequently experimented with the spelling of the name Ruysdael, but he never spelled it Ruisdael, the orthography used

203 (*opposite*). Jan van Goyen: River Scene, 1656. *Frankfurt, Städelsches Kunstinstitut*
204 (*below*). Salomon van Ruysdael: River Scene, 1632. *Hamburg, Kunsthalle*

by his more famous nephew, Jacob van Ruisdael. Salomon spent his life at Haarlem. His teacher is unknown, and he seems to have been slow in finding his way. The influence of Esaias van de Velde is unmistakable in his earliest dated painting, the *Horse Market at Valkenburg near Leiden* of 1626 (formerly The Hague, N. van Bohemen Collection), and in the winter scenes of the following year. He then fell under the influence of Pieter de Molyn, and it was only about 1630 that he finally worked out a personal style.

It was early in the thirties that Ruysdael, like Van Goyen, discovered the picturesque beauty of river scenes [204], and he rivals Van Goyen in his fine tonal treatment, subduing the local colours and making us feel the moist atmosphere of Holland in monochromatic harmonies. Salomon also uses the diagonal scheme in his com-

positions. The bodies of water he paints are less agitated, but pictorially animated by the reflections of the trees, and the sky seems slightly thinner. Ruysdael's tonality often tends to the cool side in his delicate greens, yellows, and greys. His touch is more minute than Van Goyen's and slightly schematic, yet he has the capacity to create poetical moods by his pictorial refinement as well as by his stillness and the sincerity of his vision. These various differences between the two masters are not very pronounced during the thirties, and during the early years of the decade they can come so close to each other that some confusion has occurred in the attribution of their paintings. This similarity disappears about the middle of the 1640s, when a new force and beauty marks Salomon's turn to the later phase of his art (*Halt at an Inn*, 1649, Budapest, Museum of

205 (*below*). Salomon van Ruysdael: Halt at an Inn, 1649. *Budapest, Museum of Fine Arts*

206 (*opposite*). Aert van der Neer: Winter Landscape. *Amsterdam, Rijksmuseum*

Fine Arts) [205]. He, too, never fully adopted the more classical style of the younger generation, but he shows stronger signs of its influence than Van Goyen. The heroic tree motif, which Salomon's nephew Jacob raised to an outstanding feature in his art, now appears prominently in his paintings, strengthening the compositions by vertical accents. They form a glowing dark contrast against a colourful sunset sky. His trees never gain much body, and remain thin and feathery in his early minute manner, but they function beautifully in the total pictorial effect, which can gain an extraordinary splendour by the colours of the sky with streaks of pink and blue, violet and grey. The air is shiny, and more activities go on than before both on the land and on the water. Max

J. Friedländer must have had works of this period in mind when he said: 'The weather in Van Goyen's pictures always makes one think: it will soon rain. Ruysdael's pictures make one feel it has rained, and a fresh wind has driven the rain away.'

As we have noted, at the beginning of the sixties Salomon painted some still lifes. In these works he always represented objects set on a marble table-top. Probably he painted the artificial marble he had invented, which according to Houbraken could not be distinguished from the real thing. Salomon's last decade does not bring any new ideas to landscape painting. He held on to the compositional devices of the 1650s, but his pictorial effects hardened and the tonality turned a bit darker.

Aernout (Aert) van der Neer (1603/4-1677), a contemporary of Salomon van Ruysdael, specialized in moonlight and winter landscapes – subjects which are particularly suitable for the monochromatic mode. Van der Neer apparently came to painting rather late. His first dated painting is a genre piece done in 1632 and his earliest known landscape is dated 1635. According to Houbraken he was a steward (*majoor*) in the service of a family at Gorinchem before he moved to Amsterdam some time in the early thirties, where he finally dedicated himself to painting. The choice did not make his life an easy one. Neither winter nor moonlight pictures fetched high prices during the seventeenth century. Van der Neer opened a tavern in Amsterdam in 1659; it failed, and he

was bankrupt in 1662. But it seems that financial difficulties had little effect upon his art. The standard he maintained is consistently high. He apparently was unable to paint with the ease and facility of Van Goyen or Ruysdael. One never gets the impression that he worked rapidly. His method was more deliberate; it is the approach of a shy and humble man who never lost his awe before nature. In some ways he remained old-fashioned. Virtually all his paintings are imaginary Dutch landscapes seen from a rather high point of view, and he seldom composes without the diagonal shores of a river or a frozen canal to help create the illusion of space. Van der Neer is a master in the subtle rendering of grey winter skies when they throw pink, light blue, and silver reflec-

207 (*below*). Aert van der Neer: River Scene by Moonlight. *Amsterdam, Rijksmuseum*

208 (*opposite*). Frans Post: São Francisco River and Fort Maurice, 1638. *Paris, Louvre*

tions on the ice and the snow-covered ground [206]. But he is also remarkable in, and best known for, his moonlight scenes [207], which display the finest nuances of nocturnal lighting in the sky and on the ground, and where he knows how to enliven the darks by delicate tints of blue and reddish brown, maintaining both transparency and colour harmony in the general darkness. These nocturnal scenes must be examined in the original in order to appreciate the inventive way he exploits the brown ground of his panels. His technical ingenuity can also be seen when he scratches into the wet paint with the butt end of his brush or palette knife to achieve subtle monochromatic effects.

A lesser known but interesting artist is the Frisian painter Jacobus Sibrandi Mancadam (*c.* 1602-1680), who was forgotten until the twentieth century, when a new appreciation of the formal values of art directed admirers of Dutch painting to, the lovely light browns, ochres, pale yellows, rose-colours, and greens of his highly personal palette. Most of Mancadam's pictures represent shepherds and herdsmen with the flocks among fanciful craggy rocks, weathered trees, and classical ruins. His works, however, never acquire the joyful, idyllic quality of the more famous Italianate Dutch painters. There is no evidence that he visited Italy. Mancadam also painted a few pictures of the Dutch countryside; his panoramic view of *Peat-Cutting at Groningen* (Groningen, Museum) is one of the rare seventeenth-century Dutch pictures of men at work on the land.

Frans Post (*c.* 1612-80), brother of the architect Pieter Post (cf. pp. 399 ff.), is another landscapist resuscitated during our time. His works have a special historical interest. From 1637 to 1644 he made views of Brazil. These are the first landscapes painted in the New World by a European, and are precious documents of a seventeenth-century Dutchman's

reactions to a strange continent inhabited by wild natives and exotic plants and beasts. Frans Post was one of the artists in the retinue of Count Johan Maurits of Nassau-Siegen, the illustrious soldier and statesman who was sent to establish a secure footing for the Dutch West India Company in the north-eastern part of Brazil. Thanks to the success of Maurits' expedition, the artists and scientists who accompanied him had an opportunity to make studies under his enlightened patronage. Post's simple and direct approach is best seen in the *São Francisco River and Fort Maurice* (1638, Paris, Louvre) [208], and the rather naïve quality of his pictures has earned him the title of the 'Douanier Rousseau' of the seventeenth century. Upon his return to Holland in 1644 he settled at Haarlem, where he continued to represent the New World with the help of his early studies. In 1648 he painted a *Sacrifice of Manoah* (Rotterdam, Boymans–Van Beuningen

Museum) set in a Brazilian landscape, complete with palms, cacti, and an armadillo; the figures in this painting are not by Post, and have been attributed by some to Bol and by others to Flinck. Post's late views of Brazil lack the fresh originality of the ones painted on the spot. He remained impervious to contemporary developments in Dutch landscape painting, and frequently resorted to the old-fashioned devices of organizing a bird's eye view by a dark framing of the foreground, and use of a brown–green–blue colour scheme to achieve the suggestion of a vast space. Albert Eckhout (active 1637– d. after 1664) also accompanied Johan Maurits to Brazil, where he made paintings, drawings, and watercolours of the natives and the flora and fauna. He is even more of a 'primitif' than Post. Johan Maurits gave a series of Eckhout's paintings to Frederick III of Denmark in 1654.[10] These include some full-length, lifesize portraits of Tupi and Tapuya Indians (Copenhagen,

Ethnological Museum) which show the considerable adjustments a Baroque artist had to make when he painted American Indians from life in order to fit seventeenth-century ideas of the noble savage.

CLASSICAL PHASE

During these years, a new generation of Dutch artists achieved a more monumental landscape. Nature still dominates the scene, but an increased power of stylization makes it speak with

greater force. The previous tonal phase, with all its admirable qualities, its true rendering of atmosphere, its lively and suggestive painterly touch remained somewhat pale and weak through the lack of strong contrasts and structural accents within the composition. The younger generation wanted something more grandiose. It builds up its pictures in vigorous contrasts of solid forms against the airy sky, of light against shade, of cool against warm colours. It created a synthesis of the tectonic and the fluid, of static and dynamic elements,

209. Jacob van Ruisdael:
Windmill at Wijk, c. 1665.
Amsterdam, Rijksmuseum

and of colouristic and atmospheric accents. With a kind of heroic spirit, these masters singled out a windmill, a tree, or an animal and raised it with a monumental feeling to a significant and representative motif seen against the sky. These invigorated motifs become the focus of the composition. They keep the whole design in a state of high tension and hold everything rhythmically and emotionally related to it. Thus in Jacob van Ruisdael's *Windmill at Wijk* [209], painted about 1665, the sky responds in its cloud formations to the mighty wings of the windmill, and in Aelbert Cuyp's *Hilly Landscape with Cows and Shepherds* [210], painted about the same time, the strong horizontal of the standing cow is echoed in the hazy distance of the rolling country and lends firmness and structure to the whole design. As in Rembrandt's mature phase, which is contemporaneous, these landscapes show classical elements which strengthen the compositional power. Horizontals and verticals are co-ordinated with the Baroque diagonals, which are still alive and help to create a mighty

210. Aelbert Cuyp: Hilly Landscape with Cows and Shepherds, *c.* 1665. *New York, Metropolitan Museum of Art, Altman Bequest*

spaciousness. The atmospheric quality is as important as ever in uniting the whole impression. Light breaks now with greater intensity through the clouds, and the clouds themselves gain in substance and plasticity. The sky forms a gigantic vault above the earth, and in Ruisdael's *Mill at Wijk* it is admirable how almost every point on the ground and on the water can be related to a corresponding point in the sky. Before such examples of Dutch landscape painting in its mature period it is evident that the terms realistic, imitative, lacking in ideal content, hardly touch the significance of these masterpieces. The force of stylization, or put another way, the power of expressive organization, is as remarkable as the depth of feeling before nature and the pictorial beauty.

The foremost artist of this phase is Jacob van Ruisdael (1628/9–1682). He was born at Haarlem, the son of the framemaker and painter Isaack van Ruisdael. No pictures can be attributed with certainty to the father; it is, therefore, not possible to say what Jacob learned from him. Jacob became active as an independent master when he was only eighteen years old, that is, about 1646. At this time the influence of his uncle Salomon van Ruysdael, Cornelis Vroom, and the minor Haarlem painter Willem (Guillam) du Bois is evident. In 1648 Ruisdael was inscribed as a member of the Haarlem Guild. He went abroad in the early fifties and painted in the border region between Holland and Germany, where his romantic sense was attracted by the rolling, wooded country with castles and streams. He was, however, equally susceptible to the Dutch countryside, especially the sand dunes and the bright atmosphere near Haarlem, which he also portrayed during these years. Both trends, the romantic and the realistic, remained strong after he moved to Amsterdam about 1656. Here his waterfalls met with a certain popular success, but he continued also to the very end

to paint views of the flat Dutch country in its different aspects.

Little is known about Ruisdael's private life. He was ill in 1661 when he made his will in favour of his old impoverished father. It seems that Ruisdael recovered from his illness, since he shows a renewed strength in the second half of the sixties. Houbraken reports that he started as a surgeon before he began painting. Recent research has revived the old story,[11] but the record is unconvincing. Ruisdael's painterly production begins too early to allow for training as a surgeon who, according to Houbraken, performed successful operations in Amsterdam. His artistic development is so continuous and his production so extensive that it is difficult to think that there was time for a second profession, and it is even harder to believe that the Jacobus Ruÿsdael [*sic*] who took a medical degree at the university of Caen in Normandy in 1676 (the name is listed in the *series nominum doctorum* at Amsterdam, but was subsequently scratched out) is identical with Holland's greatest landscape painter, who died in 1682. Houbraken's remarks about Ruisdael's ill-luck throughout his life have not been substantiated. There is no reason to make a connexion between his poverty and ill health and the sombre mood of his landscapes. Not enough is known of his personal life to make the correlation. The story that Ruisdael died miserably in the poor-house at Haarlem is based upon a mistaken identity; it was his cousin who died there. Contemporary records show that the artist was not without means and earned fair prices for his pictures.

Ruisdael is one of the exceptional painters who appears on the scene as a complete master. In the early works made at Haarlem in about 1646–9 there is no fumbling or groping. On the contrary, from the beginning he surpasses his models by his ability to enlarge a detail of nature into a central motif (*Dunes*, 1646, Leningrad, Hermitage). The sand-dunes and clumps of trees around his native town which

were his favourite subjects during these years are rendered with loving care and meticulous attention to detail. These early compositions excel by a great power of concentration and by their vigorous accents and strong coherence. Jacob's paint does not have the thin, vibrant quality of Salomon or of Van Goyen. He uses a heavier paste, which gives his foliage a new rich quality, and one senses that sap flows through the branches and leaves. The people who figure in the early landscapes are not busy working, like those found in pictures by Salomon van Ruysdael and Van Goyen: they appear to stroll contemplatively, or sit and take in the

view. There is a convincing impression of depth, but the emphasis is not upon the distant view. Trees, not yet the clouds, are Ruisdael's early heroes. From the moment he picked up his brushes, Ruisdael saw trees as personalities (*Trees in a Dune*) [211]. The artist makes us feel the vital force of their organic growth and the incessant movement which gives them their form. They are mightily rooted in the ground, and their trunks bend in and out, as if they are full of energy, while the branches reach out into space with expansive power. There is both three-dimensional and atmospheric life; the silhouettes are never hard or

211. Jacob van Ruisdael: Trees in a Dune, *c.* 1647. *Paris, Louvre*

212 (*below*). Jacob van Ruisdael: Bentheim Castle, 1653. *Blessington, Ireland, Sir Alfred Beit*

213 (*opposite*). Jacob van Ruisdael: Jewish Cemetery, *c.* 1660. *Dresden, Gemäldegalerie*

schematic, but always interesting, and also convincing in their transitions to the air and sky.

During Ruisdael's *Wanderjahre* from about 1650 to about 1655, the heroic quality of his landscapes increases. The forms become larger and more massive. Giant oaks as well as shrubs acquire an unprecedented abundance and fullness. Colours become more vivid, space increases in both height and depth, and there is an emphasis on the tectonic structure of the compositions. These changes are in accordance with the general shift in the style of Dutch painting around 1650. Ruisdael was probably also stimulated by Jan Both, Berchem, and

Asselyn, who had been to Italy and who returned with word about Claude's classical landscapes. There is reason to believe that Ruisdael travelled in Germany with Berchem about 1650. However, a fundamental difference exists between Ruisdael and the Italianate Dutch landscape painters. The latter, following Claude's example, but never able to approximate him, tried to establish an idyllic mood by permeating their landscapes with southern light and atmosphere and generalizing the forms in nature to conform with their pictorial needs. The problem Ruisdael posed for himself was a more original and difficult one. He strove

to achieve heroic effects without making allusions to the South and Antiquity, or sacrificing the individuality of a single tree or bush.

The diagonal composition of his mighty view of *Bentheim Castle* (1653, Blessington, Ireland, Sir Alfred Beit) [212] recalls the compositional schemes used by the generation of his teachers, but the great clarity of the flourishing foliage in the foreground, the wealth of detail on the compact mass of the hill beyond, the strong colours, and the energy of the brushwork are characteristic of this imposing stage of Ruisdael's development. Around the same time he made views of dense forests and woods which

have a similar closely knit effect. Ruins sometimes play a prominent role, and gloomy skies set a melancholy mood. Ruisdael's rare ability to create a compelling and tragic mood in nature is best seen in his famous *Jewish Cemetery* (Dresden, Gemäldegalerie [213]; an earlier version is in the Detroit Institute of Arts).[12] The painting is a symbol of the transience of all earthly things. The masterliness of the composition lies in the artist's clear and concentrated presentation of this idea. The eye focuses on the three graves in the middle distance, where the light is centralized. They are a truthful picture of the actual graves as they can

still be seen in the cemetery at Oudekerk on the Amstel, while the surroundings are a romantic invention by the artist. All secondary themes – the shattered ruin of a church in the background, the rainbow, and the dim, dark foliage – are foils or accessories to the main motif. The barren beech tree gestures towards the tombs more clearly than any human figure could. It is no accident that works of this kind made their greatest impression during the romantic period. Of the *Jewish Cemetery* Goethe wrote in 'Ruisdael als Dichter': 'Die Grabmäler sogar deuten in ihrem zerstörten Zustande auf ein Mehr-als-Vergangenes: sie sind Grabmäler von sich selbst' (Even the tombs in their ruined condition point to the past beyond the past: they seem to be tombs of themselves).

After Ruisdael had settled in Amsterdam about 1656 his compositions broadened, and a certain heaviness in the foreground disappeared. The opening of the view suggests that he was impressed by Philips Koninck's panoramic views, but the fresh atmospheric effect, the brilliant glittering daylight which brightens the landscapes, the reflections and vivid colours in the shadows are completely personal. In the late fifties Ruisdael also began to represent waterfalls in mountainous northern valleys. Northern motifs were popularized in Holland by Allart van Everdingen (1621-75), who probably studied with Roelant Savery and then with Pieter de Molyn. Everdingen travelled to Sweden with a patron in 1640 and returned to the Netherlands with numerous Scandinavian themes: mountains, firs, log huts, and waterfalls. Everdingen incorporated these northern motifs into his drawings and etchings during the forties, and in the fifties waterfalls appear in his paintings. Ruisdael's earliest dated northern landscape is of 1659 (Leningrad, Hermitage), and only in the sixties did the waterfalls become an important theme in his *œuvre*. These northern views with torrential falls, gigantic

rocks, and fallen logs sometimes appear contrived. Not so the large forest scenes, which are among Ruisdael's most personal creations. In the *Marsh in the Woods* (c. 1665, Leningrad, Hermitage) [214], powerful trees form a mighty group around a lonely pond. The decayed ones speak with their winding branches as vividly as those in full growth, as if the artist wanted to say that both life and death have their share in an undiluted image of nature. There is more spaciousness now than there was in the earlier phase of the fifties. One can look into the distance under the trees, and the sky plays a more pronounced role. There is air all round, and the local colour, which was very distinct in the bluish green of the fifties, is somewhat neutralized by a greyish tint in the bronze-brown foliage. In this particular case Ruisdael based his composition on a design of Roelant Savery which was accessible through the engraving of Egidius Sadeler. Yet the transformation of the Mannerist's work into his heroic Baroque terms is more significant than the dependence on it. Ruisdael did not accept the bizarre and ornamental play with nature's forms. He created an archetype of the loneliness and grandeur of nature.[13]

Of about the same time and equally imposing are the *Windmill at Wijk*, mentioned above, and many first-hand views of the Dutch landscape in its various aspects. The sea, the shore, the vast fertile plains now become important subjects side by side with the woods and waterfalls, and they are always seen under a majestic sky. Whether his flat landscapes, which continue into the seventies and mostly show Haarlem in the distance, are small, medium-size, or large, his master hand is felt in the strength and simplicity of the composition [215]. Though Ruisdael's personal mood is always unmistakable, no one has given a truer expression to the Dutch countryside in its modest grandeur. Winter landscapes also occur, and they are not

214. Jacob van Ruisdael: Marsh in the Woods, *c.* 1665. *Leningrad, Hermitage*

215. Jacob van Ruisdael: View of Haarlem, *c.* 1670. *Amsterdam, Rijksmuseum*

the least remarkable. An example is the one in Amsterdam (*c.* 1670, Rijksmuseum) [216] where forbidding black clouds hang over a forlorn snow-covered scene, an extremely moving and stark symbol of sadness and imminent tragedy.

could not escape the general decline of Dutch art at the end of his career.

Meyndert Hobbema (1638–1709) was Ruisdael's most talented pupil and follower. In 1660 Ruisdael stated that Hobbema 'served and learned with me for a few years' in Am-

216. Jacob van Ruisdael: Winter Landscape, *c.* 1670.
Amsterdam, Rijksmuseum

About the middle of the seventies Ruisdael's art weakened considerably. His forms became thin, his compositions loosened, the mood turned idyllic. Very little of the old power remained, and one gains the definite impression that this great landscapist, too,

sterdam, but it seems that during his youth Hobbema was also stimulated by Salomon van Ruysdael, Cornelis Vroom, and perhaps Anthonie van Borssum (1629/30–1677). The small, light-coloured pictures Hobbema made from about 1658 (*River Scene*, 1658, Detroit

217. Meyndert Hobbema: Landscape with Trees and a Causeway, 1663. *Blessington, Ireland, Sir Alfred Beit*

Institute of Arts, is his earliest extant dated work) until about 1661 show little of the coherence and energy which characterize Ruisdael's works. Only about 1662 is the influence of the older master evident. Hobbema's *Forest Swamp* of 1662 at Melbourne (another version at Lugano) is actually based upon one of Ruisdael's early etchings, and other works of this time show Ruisdael's motifs.

In 1663 Hobbema's style gained more independence (*Landscape with Trees and a Causeway*, 1663, Blessington, Ireland, Sir Alfred Beit) [217] and, during this and the following years up to 1668, he created a series of masterpieces which gave him an outstanding position side by side with Ruisdael among the great landscapists of Holland. His outlook on nature is less brooding, more sunny and vivacious than Ruisdael's. While the latter favoured compactness of form and composition, Hobbema's tree groups are less tightly built, and their silhouettes are rather feathery. He likes to open up his compositions with various outlooks into a shiny distance, and his luminous skies of an intense white and blue permeate the whole with sparkling daylight. Hobbema's painterly touch is more fluid, and the colours are richly varied in an interplay of bright green and light brown, fine greys and reds. Often an appealing blond tonality prevails, and one can understand that at the turn of the last century, when the impressionistic taste dominated,

218. Meyndert Hobbema: The Water Mill, *c.* 1665. *London, Wallace Collection*

works by Hobbema fetched sensational prices. Yet Ruisdael is the more resourceful artist. His moods are deeper, his compositions more powerful, and he shows a much wider range of subject matter. Hobbema's favoured motifs are water mills [218], forest scenes opened by roads and glistening ponds, or fairly flat landscapes with scattered tree groups.

Hobbema's art almost came to a standstill in 1668, when he married the kitchen maid of an Amsterdam burgomaster and received the well-paid position of a wine gauger of the Amsterdam octroi. Ruisdael was a witness at this marriage, and one can assume that the two men remained in friendly contact. Hobbema's new position, which he held until the end of his life, probably prevented him from taking up his brush more than occasionally. The few works which are known of this later period show his compositions broken up into too many detailed vistas. The trees acquire an almost linear sharpness, and the pictorial effect hardens. Yet there is one great exception which almost seems a miracle, because in this work Hobbema not only revives his old grandeur, but surpasses himself as a composer and painter of the Dutch countryside. This is the rightly famous *The Avenue, Middelharnis* [219] of 1689 in the National Gallery, London. It does not take away from the glory of this picture that Hobbema was once again inspired by a Ruisdael composition.

219. Meyndert Hobbema: The Avenue, Middelharnis, 1689. *London, National Gallery*

The older master's majestic *Wheatfields* (New York, Metropolitan Museum) [220] gave him the idea of the central position of a strongly foreshortened road in a wide, flat landscape.

the '8' was somewhat indistinct. However, after its recent cleaning it is certain that the figure 1689 is correct, and there is, in fact, the exalted spaciousness which often characterizes

220, Jacob van Ruisdael: Wheatfields, *c.* 1670. *New York, Metropolitan Museum of Art, Altman Bequest*

In both pictures this motif focuses the interest on the distance and centralizes the whole composition. But Hobbema altered the effect considerably by the addition of high, thin trees which carry the interest to his inimitable sky. Hofstede de Groot was so enchanted by this picture that he ranked it immediately after the *Syndics* by Rembrandt. He could, however, not imagine that it was painted in 1689, after Hobbema had been unproductive for more than twenty years. So he read the date as 1669, since

the Late Baroque, and also a kind of elegance in the elongated, slender trees that goes with the taste of this advanced phase. As for the revival of Hobbema's best pictorial faculties at this stage, it is unusual, but we can say that there is a lighter touch than we find in his work of the sixties. Whatever the rational explanation of the style and date of this masterpiece might be, it is the swan song of Holland's great period of landscape painting which fully deserves its high reputation.

Aelbert Cuyp (1620-91) lived and worked in his native town of Dordrecht, where he was highly respected and belonged by his marriage in 1658 to the well-to-do. He owned a fine house at Dordrecht as well as a country seat near by. Like Hobbema, he painted little during the last decades of his life. His first teacher was probably his father, Jacob Gerritsz. Cuyp (1594-1651/2), who is best known as a portraitist. Only a few portraits by Aelbert in his father's manner are known. His early *Landscape with Cattle* (1639, Besançon, Museum) probably reflects Jacob Gerritsz.'s style. By 1641 Aelbert was painting panoramic views of the Dutch countryside in the monochromatic mode of Van Goyen, but the young Cuyp favoured a distinct yellow tonality as against Van Goyen's greyish and brown hues. More important for Cuyp's subsequent development was the impact of the Dutch landscapists who brought an Italianate style from Rome back to Holland. It seems that Cuyp himself never travelled to the south. Since very few of Cuyp's landscapes are dated, it is difficult to say precisely when the characteristic golden light, reminiscent of the Campagna the artist apparently never saw, replaces the earlier paler one, and when mountain ranges, herds of cattle, and figures conspicuously set off against a sky begin to play an important role in his compositions. The dated *Landscape with Shepherds making Music* of 1646 (formerly Count Suboff, Moscow; now Leon Sergold, New York) gives a clue.[14] Cuyp's favourite motifs and rudiments of his later style appear, and there is already an indication of a turn towards the tectonic compositions which other Dutch artists favoured around this time. The rock motifs in the picture of 1646 appear to be derived from the first generation of Italianate landscape painters (Poelenburgh, Breenbergh). A few years later, Jan Both, the leading representative of the second generation of Italianate painters, became Cuyp's principal source of inspiration.

Cuyp's *Landscape with two Horsemen* (Amsterdam, Rijksmuseum), which upon the basis of stylistic criteria can be dated about 1648, shows how rapidly he assimilated Both's motifs and light. From this time onwards golden sunlight becomes the all-pervading element in Cuyp's paintings. It spreads warmth and beauty over the Dutch countryside, where sturdy animals – most often cows – take the place of human heroes. They stand or rest in

221. Aelbert Cuyp: Cattle.
Budapest, Museum of Fine Arts

complete harmony with nature, breathing the invigorating air of the never-distant sea (*Cattle*, Budapest, Museum of Fine Arts) [221]. Cuyp also made paintings of the lively activity on the great rivers of the Netherlands [222], most often the wide Merwede that forks at Dordrecht into the North Maas and Lower Maas. It was Dordrecht's location at this juncture that made it one of the principal cities of the country until traffic on the Maas was diverted to Rotterdam. Cuyp's river scenes are usually set late in the afternoon and are seen against the sun-drenched sky that sparkles and glistens on the calm water. He knew Dutch river life intimately. He travelled along the Rhine, the Maas, and the Waal making numerous drawings of huge sailing vessels, small craft, rafts, and also views of the

222. Aelbert Cuyp: The Maas at Dordrecht. *London, Kenwood House, Iveagh Bequest*

223. Aelbert Cuyp: Evening Landscape with Horsemen and Shepherds. *London, Buckingham Palace*

land from the water. He was equally at home working on a large or a small scale, and could fill a canvas with the massive dark hull and rigging of a clumsy passage boat making way to a pier or with decorative and elegant silhouettes of colourful figures on horseback riding into the evening sky [223]. In grandeur of composition Cuyp often matches Ruisdael and the best of Hobbema's work. As a colourist he seems even superior by the glow and richness of his warm palette both in his land and sea pictures. Abraham van Calraet (1642–1722) of Dordrecht was Cuyp's close follower. Confusion between the two is compounded by the signature 'A. C.' found on Abraham van Calraet's views of Dordrecht, horsemen, and still lifes; it is sometimes erroneously accepted as Aelbert Cuyp's own monogram.

In the work of Paulus Potter (1625-54), as in Cuyp's, views of nature and animals are seen for their own sake, and not as a backdrop for human action. Potter can paint equally well the bright sunlight and the cool air, but his real fame lies with his penetrating portraits of animals. His best known work is the lifesize *Young Bull* of 1647 at the Mauritshuis, The Hague [224], an unusual heroization of a single animal, a counterpart to the monumental trend of Ruisdael and Cuyp. During the nineteenth century, this work by the young Potter ranked close in fame to the *Night Watch*. John Smith, who compiled the first *catalogue raisonné* of the works of the outstanding Dutch artists, wrote in 1834 that such 'is the magical illusion of this picture, that it may fairly be concluded, that the painter has approached as near perfection

224. Paulus Potter: The Young Bull, 1647.
The Hague, Mauritshuis

as the art will ever attain'. Later generations have been less captivated by Potter's fidelity to nature when he worked lifesize. Although the shapes of the farmer, the tree, and the bull against the light sky are impressive and the textures of the animals have been convincingly represented by the use of an original impasto which approaches relief, the entire foreground of this huge canvas – it measures 8 ft by 12 ft – seems airless. Atmosphere enters the picture only in the lovely distant view on the right, where a sunny light plays upon the cattle in the meadows and on the woods. Potter is most successful on a small scale, and his cabinet pieces show him at his best [225]. His career was short. He died at the age of twenty-eight. His early works are rather dry and show the influence of Moeyaert and Uyttenbroeck, who painted cattle in their biblical and mythological pictures. Potter tried his hand at a few subject paintings (*Orpheus taming the Animals*, 1650, Amsterdam, Rijksmuseum), but they are not as successful as his straightforward scenes of cows, goats, sheep, and pigs, which show a sensitivity to the various ways in which farmyard animals behave at different times of the day as well as to the different quality of light in the morning or at dusk. His great talent was recognized by his contemporaries. He worked for the house of Orange at The Hague, and in 1652 Dr Nicolas Tulp persuaded him to leave The Hague for Amsterdam, where the famous doctor became his mentor. Tulp had an eye for young talent. Two decades earlier he had asked the twenty-six-year-old Rembrandt to paint the *Anatomy Lesson* which established Rembrandt's reputation in the great metropolis (see p. 88). In 1653 Potter painted a lifesize equestrian portrait which has been traditionally identified as Dr Tulp's son Dirck[15] (Amster-

225. Paulus Potter: Men and Cattle at a Stream, 1648. *The Hague, Mauritshuis*

dam, Six Collection). The portrait proves that Potter was no exception to the rule that seventeenth-century Dutch painters never match the lifesize equestrian portraits of Velazquez, Rubens, or Van Dyck. Even the horse in Rembrandt's only lifesize equestrian portrait, now in the National Gallery in London (Bredius 255), looks wooden when compared to those painted by Flemish and Spanish Baroque masters.

The most successful Dutch painter of horses was the prolific Philips Wouwerman of Haarlem (1619–68). He rarely painted large pictures: his speciality was small-scale genre scenes which included horses – battles, skirmishes, encampments, scenes at a smithy or in front of an inn. His early works show some affinity with Pieter Verbeecq (c. 1610/15–c. 1652–4), a specialist in small pictures of horses in a landscape, and Jan Wijnants (active 1643–d. 1684), who made landscapes of the sand dunes around Haarlem. Wouwerman, like so many Haarlem artists, is said to have been Frans Hals' pupil. Much more decisive for his development was the work of Pieter van Laer, called Bamboccio, whose works are discussed below (cf. p. 300). Van Laer returned to Haarlem in 1638 after more than a decade in Rome. At Haarlem, he continued to paint the little pictures of the outdoor life of ordinary people which he had popularized in Italy. Wouwerman used similar motifs, but the range of his subjects was wider and he was much more prolific than Bamboccio. He also had a more elegant and decorative touch, which helps to account for his great success [226]. His fluid and airy treatment and his fine cool harmonies make Wouwerman's works particularly attractive. He died wealthy, and during the eighteenth century became one of the most highly esteemed Dutch painters.

226. Philips Wouwerman: Halt of a Hunting Party. *Dulwich College Picture Gallery*

227 (*above*). Adriaen van de Velde: The Farm, 1666. *Berlin-Dahlem, Staatliche Museen*

228 (*opposite*). Adriaen van de Velde: The Beach at Scheveningen, 1658. *Kassel, Gemäldegalerie*

No princely collection was without a Wouwerman, and the large ones had them by the dozens; the Hermitage at Leningrad owns more than fifty, the Dresden Gallery more than sixty.

Adriaen van de Velde (1636-72), who was even more versatile than Wouwerman, also painted small landscapes in which animals and figures play an important role. Bode rightly wrote of the 'Sunday atmosphere' (*Sonntags-stimmung*) of his pictures of the Dutch country-side, and of the precious holiday peace that spreads over his meadows, seen in the bright sparkle of sunny days softened by the haze of the near-by sea [227]. Adriaen was probably

a pupil of his father, the marine painter Willem van de Velde the Elder (and the elder brother of Willem van de Velde the Younger); then he studied with Wijnants at Haarlem, where he was also influenced by Wouwerman. Some of his bucolic landscapes, with neat shepherds and cattle in a peaceful southern setting, filled with warm light and shadow under vivid blue skies, suggest that he had been to Italy. The clear outline of his figures and his sculpturesque feeling for form, which are seen in his etchings and drawings as well as his paintings, also argue for first-hand contact with classical art. However, like Cuyp, Wouwerman, and other Dutch painters, he apparently assimilated these quali-

ties from the work of his countrymen who had made the journey across the Alps. Adriaen van de Velde also painted religious and mythological compositions and winter scenes, and was frequently called upon to animate his contemporaries' pictures with his exquisite figures. Adriaen's *staffage* appears in paintings by Jacob van Ruisdael, Hobbema, Koninck, Van der Heyden, and Wijnants. His own most original pictures are his rare beach scenes, which capture the lucidity of the moist sea air and have a freshness and rarely matched plein-air effect (for example *The Beach at Scheveningen* of 1658, which is now in the Gemäldegalerie at Kassel) [228].

229. Willem van de Velde the Younger: The River IJ at Amsterdam, 1686. *Amsterdam, Rijksmuseum*

MARINE PAINTING

Since the life of every Dutchman is inextricably linked with the sea, it is not difficult to understand why marine painting is so popular in Holland. Dutchmen live and work on drained and reclaimed land, and from the earliest times their economy has been based on seafaring. Fishing laid the foundation for their prosperity. During the seventeenth century, when the Netherlands was the richest and most powerful nation in Europe, the wealth of the country came primarily from overseas trade. A painting made in 1686 of the crowded harbour at Amsterdam by the best-known Dutch marine painter, Willem van de Velde the Younger (*The River IJ at Amsterdam*, Amsterdam, Rijksmuseum) [229], gives an excellent idea of Holland's famous sea traffic. In Van de Velde's picture the 'Golden Lion', once the flagship of Admiral Tromp, dominates the wide harbour – the River IJ was over a mile wide at this point – and in the background coasters and ships designed for European waters, as well as the India run, can be recognized. Not a single foreign flag flies from the forest of masts in Van de Velde's painting. This is probably an exaggeration. Holland's control of shipping during the seventeenth century was extraordinary, but it was never an absolute monopoly. It is, in fact, difficult to obtain a trustworthy estimate of the size of the Dutch fleet during the seventeenth century. Colbert's estimate, made in 1655, that the Dutch had fifteen or sixteen thousand ships sailing under their flag is a gross overestimation, but his guess indicates what a rival nation thought about the size of the Dutch fleet when it ruled the Seven Seas. Reliable figures are only available for the Baltic trade. Publication of the

Sound Toll Registers shows that in 1580 more than 50 per cent of the ships passing through the Sound came from ports in the Netherlands. The number steadily increased, and by 1650, during the course of five months, of 1,035 ships sailing into the Baltic from the North Sea, 986 were Dutch.[1] Grain from the Baltic area, the granary of Europe, was transported in Dutch ships to the Mediterranean. Dutch vessels traded everywhere. They were found in north European waters, in Hudson's Bay, the West Indies, and Brazil, and the Dutch established themselves in Africa, the East Indies, China, and Japan. Dutchmen who were proud of their merchant fleet and of the powerful navy that protected it made a favourable clientele for great talents such as Willem van de Velde the Younger and Jan van de Cappelle, who specialized in painting ships and the sea. Marine painting became one of the most popular specialities. Van Goyen, Cuyp, and Ruisdael tried their hand at it, and even Rembrandt was once attracted to the subject in his *Christ on the Sea of Galilee* (1633, Boston, Isabella Stewart Gardner Museum).

The patrons of the marine painters must have been critical and discriminating. Most of them knew much about the sea and sailing vessels. In 1693, near the end of his life, Van de Velde the Younger concisely summarized the problems which confront a sea painter in a note inscribed on one of his drawings now at the British Museum (no. 29): 'There is much to observe in beginning a painting; whether you will make it mostly brown or mostly light; you must attend to the subject, as the air and the nature of its colour, the directions of the sun and wind, whether the latter be strong or

moderate, are to be chosen as may seem best. Then the sketching of the ordnance or ships under sail. . . .' This succinct statement is one of the rare known comments by an important Dutch artist about his work. We can be certain that Van de Velde's patrons, in turn, carefully studied and commented upon the way in which he and other Dutch sea painters depicted different hulls under sail, complicated rigging, the movement of the waves, the direction of the sun, the intensity of the wind, and even 'the air and the nature of its colour'.

The preoccupation of Van de Velde the Younger with atmospheric effects was not shared by the earlier masters. This is not surprising, since Dutch marine painting shows the same general stylistic development as landscape painting. The early realist tradition is best

represented by Hendrick Cornelisz. Vroom of Haarlem (1566-1640), father of the landscapist Cornelis Hendricksz. Vroom. Hendrick Vroom has been rightly called the founder of European marine painting. To be sure, artists before Vroom painted marine pictures – for example, Bruegel's *Storm at Sea*, now in Vienna – but Vroom was the first man to specialize in this branch of painting. After extensive travels in Europe as a faience painter, Vroom settled in his native town of Haarlem about 1590, where he made most of the works which brought him fame and wealth. His pictures, which are usually large, are primarily portraits of ships, fleets, and battles. The sea and atmospheric effects were of secondary interest to him. A characteristic work is his bird's eye view of the *Battle of*

230. Hendrick Vroom: The Battle of Gibraltar, 25 April 1607. *Amsterdam, Rijksmuseum*

Gibraltar, 25 April 1607 (Amsterdam, Rijksmuseum) [230]. A Dutch man-of-war and an exploding Spanish flagship fill the foreground. The picture is crowded with multi-coloured detail. The block and tackle, men and gear flying through the air and scattered over the water are best studied with a magnifying glass. During the course of his long career there is not much change in Vroom's style. In his panoramic pictures the sea is usually a vivid green in the foreground and a light blue in the background, the waves and whitecaps are schematic designs, and the skies are little more than blue and grey backdrops. Vroom was also a successful tapestry designer. His most famous set, a group of ten representing the *Defeat of the Spanish Armada by the English Fleet*, hung in the old House of Lords until it was destroyed by fire, with that building, in 1834. The Amsterdam painter Aert van Antum (active *c.* 1604-1618) and Vroom's pupil Cornelis Claesz. van Wieringen (*c.* 1580-1633) both made pictures of ships in Vroom's meticulous manner.

The crowded marines by Adam Willaerts (1577-1664) begin to show a shift in style. His paintings, which usually squeeze in large crowds of people on a shore, as well as rocky mountains dotted with pine trees and goats, have a lower point of view, and, compared to Vroom's multi-coloured paintings, they are muted. But it is Jan Porcellis (*c.* 1584-1632) who marks the transition from early realism to the tonal phase. This outstanding artist was born at Ghent and worked in many places. He was active in Rotterdam, Middelburg, London, Antwerp, Haarlem, and Amsterdam and finally

231. Jan Porcellis: Rough Weather, 1629. *Munich, Ältere Pinakothek*

settled at Zoeterwoude, where he died in 1632. Porcellis can be credited with changing the subject as well as the style of marine painting. Ships never play the predominant role in his pictures. His principal concern is with atmosphere, overcast skies and choppy seas. *Rough Weather*, signed and dated 1629 on the tag on the painted window sill (Munich, Ältere Pinakothek) [231], shows the radical break Porcellis made with the earlier tradition. Four-fifths of the painting have been devoted to the ominous sky. Fresh winds toss the small ships and agitate the water. The simple fishing boats and sloops, which have taken the place of Vroom's famous three- or four-masted merchant ships and naval vessels, have been subtly organized according to the diagonal trend of Baroque compositions. Porcellis' touch, which is still somewhat thin, creates a fine

overall atmosphere and a delicate harmony in greyish tones. He still uses rather minute brush strokes, but not to delineate precise details of the ships. His remarkable achievement was recognized in his own time. He was praised by his contemporaries as the greatest marine painter of the age, and both Rembrandt and Van de Cappelle collected his works. Porcellis' son Julius (*c.* 1609-45) adopted his father's style, and sometimes it is difficult to differentiate their hands. Porcellis also had contact with Van Goyen; the latter sold him a house in Leiden in 1629. Five or six years after this transaction took place, Van Goyen's marine pictures began to show the influence of the depth and height of Porcellis' towering skies and his monochromatic mode.

Continuity of space in Porcellis' work is not yet fully mastered. He tends to jump a little too

232 (*opposite*). Simon de Vlieger: Calm Sea, 1649. *Vienna, Kunsthistorisches Museum*

233 (*below*). Jan van de Cappelle: The State Barge saluted by the Home Fleet, 1650. *Amsterdam, Rijksmuseum*

fast over the middle distance, relating the large dark foreground forms directly to the tiny boats in the background. Porcellis' follower Simon de Vlieger (*c.* 1600–1653) begins to clarify space over wide expanses of calm water; however, this only occurs in his late seascapes (*Calm Sea*, 1649, Vienna, Kunsthistorisches Museum) [232]. In his early pictures De Vlieger concentrates upon ships and fantastic rock formations lashed by colossal waves. The winds abate only in his later works. De Vlieger was a special favourite of Admiral Sir Lionel Preston, author of *Sea and River Painters of the Netherlands in the Seventeenth Century*, published in 1937. Subsequent research has outdated parts of Admiral Preston's book, but his keen appreciation of the achievement of Dutch painters of the sea, based on his own experience as a sailor, is of lasting interest.

According to Preston, 'There is no one who makes the grey North Sea as real as De Vlieger can, or gives such life and movement to ships. In his pictures we feel the breeze freshening – a Sou'wester brewing – clouds rush past the sun, to throw patches of light on the sea and illuminate a large ship heeling to the wind. In a moment the ship will be in shadow and the sea re-lit by everchanging gleams of brilliance. . . . No sea painter has exceeded his powers of aerial perspective nor of those delicate gradations of colour, where in sombre key the contrasts between deep and shallow water are shown by the sun's reflections. There can be no sailor, particularly among those who spent the Great War in the North Sea, who will not appreciate and understand the truth which came from the brush of De Vlieger.' De Vlieger's impact on Dutch marine

painting was great. He helped to form the style of Willem van de Velde the Younger, Hendrick Dubbels' (c. 1620-1676) early works are based on his, and the self-taught Amsterdam master Jan van de Cappelle learned much from studying and copying his works.

Jan van de Cappelle (c. 1624-1679) belongs to the generation of Ruisdael and Cuyp. His compositions, like theirs, gain strength and monumentality by the union of tectonic and dynamic features, and are classic in their perfection [233]. He calms the agitated seas painted by Porcellis and young Simon de Vlieger. Few of Van de Cappelle's marines are sea paintings in the strict sense of the word: most of them represent the mouths of wide rivers or quiet inner harbours, where groups of ships lie at anchor in mirror-smooth waters. Masts make a pattern of verticals which is co-ordinated with the horizontals of hulls and the low horizon. The haze found in works by earlier marine painters lifts, and the middle distance acquires more real existence between the foreground forms and the minute details of the far distance. Space opens up widely, yet the design is well balanced and maintains a powerful coherence as a whole. Essential qualities of Van de Cappelle are his full cloud formations, the wonderful transparency of his shadows, and the subtlety of his colourful reflections in calm waters. Early morning or evening are his favourite hours. He was not a man to paint sea battles. His is a holiday mood: cannons salute, drums roll, pennants fly, and noble personages ride in richly carved and gilded barges. Not many of his works are dated, but it is reasonable to assume that his simple compositions done in silvery greys, which recall Porcellis and De Vlieger, belong to an early phase, and the more complex, colourful works were done after 1650. He also painted some beach scenes and winter landscapes. These, like his marines, render nature with a wonderful feeling for the pictorial qualities of Holland's sea atmosphere, with its heavy clouds and translucent air. Van de Cappelle did not devote all his time to painting: he also ran his family's profitable dye-works. At his death he was worth a fortune of more than 90,000 guilders, and owned substantial holdings in real estate and a pleasure yacht (from which he probably made sketches for his marine paintings), as well as one of the greatest art collections of his time. He collected vast quantities of works by other seascapists. He had in his possession nine of Simon de Vlieger's paintings and more than 1,300 of his drawings, and sixteen paintings by Porcellis, as well as ten paintings and over 400 drawings by Van Goyen. Van de Cappelle also owned paintings by Rembrandt, Rubens, Hals, Van Dyck, Brouwer, Hercules Seghers, and Avercamp, and he acquired more than 500 drawings by Rembrandt.[2]

The first half of the production of Willem van de Velde the Younger (1633-1707) still belongs to the classic phase of Dutch marine painting. In his *Cannon Shot* (Amsterdam, Rijksmuseum) [234] – which can be dated about 1660 – he created a grand and well-balanced composition comparable to those by the great landscapists and genre painters of that period. Here a man-of-war is the hero, although not in action and only discharging a salute. The warship is powerfully placed on the right of the picture, and its bright drooping sails are shimmering in the sunlight. The vapour of the shot in the centre of the middle distance directs the view into the transparent far distance, where smaller craft by their horizontal position counter the mighty vertical of the big ship. Soft tonal contrasts, as well as distinct colour accents, co-operate with the linear effects of the tackle to build up a pictorially rich, yet simple and striking design. The lines of the rigging are remarkable both in their precision and in the sensitiveness with which they are drawn. They are never harsh and always well adjusted to the aerial perspective. In spite of his long

234. Willem van de Velde the Younger: The Cannon Shot, *c.* 1660. *Amsterdam, Rijksmuseum*

activity, Van de Velde never became mannered or artificial. He is a more versatile sea painter than Van de Cappelle. He represented ships in violent storms as well as sailing vessels in a dead calm, and an examination of his *œuvre* shows that he made studies of virtually every type of vessel afloat. His extensive productivity in England made him the best known marine painter there. But it was not only for this reason that he was adored by Turner and the early-nineteenth-century plein-airists.

Willem van de Velde the Elder (1611–93), a marine painter best known for his 'grisailles' (pen drawings of ships on the white ground of a panel or canvas), was the father of Willem the Younger and Adriaen van de Velde. Willem the Younger probably studied with his father before going to Simon de Vlieger. Father and son sometimes sailed with a naval fleet to procure accurate information and make precise preparatory drawings. Some of their studies were made from a galliot during the heat of a naval battle. The rare, rather dry paintings by Willem the Elder can hardly be confused with his son's magnificent marines, and his drawings never acquire the delicate atmospheric quality which characterizes those by the more gifted younger Willem. Both Van de Veldes made highly finished portrait drawings of ships which are useful to naval historians for information about the precise rig and build of seventeenth-century vessels. No artist surpassed them in showing the way a hull settles in the water. Willem the Elder always gives a better account of ships than the sea. A contemporary rightly praised him for his 'infinite neatness' and noted: 'For his better information in his way of Painting, he had a Model of the Masts and Tackle of a Ship always before him, to that nicety and exactness that nothing was wanting in it, nor nothing unproportionable. This Model is still in the hands of his Son.'[3] The Van de Veldes were active in Amsterdam until the troubled year of 1672, when war with

England was resumed and the French invaded Holland. Late in 1672 or early in 1673 they moved to England, where they settled and quickly found favour with Charles II and the duke of York. In 1674 the king instructed the Admiralty that Willem the Elder should be granted one hundred pounds annually 'for taking and making drafts of sea fights', the son to receive the same sum for 'putting the said drafts into colours'. The Van de Veldes did not completely switch their allegiance to England. Both travelled to Holland, and they made pictures for the Dutch market as well as the English. The marines that Willem the Younger painted during the last decades of his career do not have the consistent high quality of those made before he emigrated to England. There is often more agitation, but the pictorial touch becomes rigid. Most of his late canvases are official portraits of ships and naval engagements. In these works, more attention is paid to the demand for a clear accurate record of an event at sea than to atmospheric effects and light. There is, however, no loss in the quality of his drawings, and he continued to make exquisite studies of ships, the sea, and the sky until the very end. Gilpin wrote in 1791 that an old Thames waterman recalled how he used to take Willem the Younger out in his boat on the Thames in all kinds of weather to study the appearance of the sky: 'These expeditions Vanderveldt called, in his Dutch manner of speaking, *going a skoying*.'[4] Willem the Younger had many followers. There are vague contemporary references to two sons (Cornelis, Willem III) who are said to have painted marines, but his principal imitators are found among the eighteenth-century English marine painters.

Ludolf Bakhuizen (1631–1708) became the outstanding seascapist in the Netherlands after the Van de Veldes had moved to England. He is the last representative of the great tradition of Dutch marine painting, for eighteenth-

century Dutch artists did even less of conse-
quence in this category than in the others they
practised. Bakhuizen's style is based on the work
of his teacher Hendrick Dubbels and Van de
Velde the Younger. But neither he nor other
specialists (Lieve Verschuur, c. 1630-1686;
Abraham Storck, 1644-after 1704) who worked
during the last decades of the century were able
to maintain the high standard set by Van de
Cappelle and Willem the Younger. In the late
marines, exaggerated contrasts and over-agita-
tion take the place of the subtle co-ordination
and classic simplicity of the fifties and sixties.
The perspective effect is overdone, and the
tonal design hardens. As in the work made at the
beginning of the century, novelties and illustra-
tive tendencies become more important than
the impression of nature. Too many things
happen in the late seascapes. Stormy seas and
dramatic skies compete as rivals for our
attention, and a minute realism overburdens
the sailing craft with detail.

THE ITALIANATE PAINTERS

Seventeenth-century Dutch artists discovered the beauties of Italian motifs seen in the warm shimmering light of the south, as well as the more homely ones of their own spacious landscape. The painters of Italian scenes do not enjoy great popularity in our time, but during the seventeenth and eighteenth centuries, when the classicist and idealistic aesthetic was generally accepted and Claude and Poussin were ranked without question as the greatest European landscapists, they were more highly esteemed than Dutchmen who made views of their native countryside. Houbraken tells us that in his day the Italianate landscape painters were more popular than the ones who belonged to the national school, and no eighteenth-century collector preferred an Avercamp, a Van Goyen, or even a Jacob Ruisdael, to a Both or a Berchem. It is noteworthy that at that time more engravings were made after Berchem's works than those of any other Dutch artist. Most Dutch Italianate landscape painters were also etchers, and their own prints helped to spread their name and fame during epochs when the graphic arts were widely collected and appreciated. Herman van Swanevelt, the minor Dutch classical landscapist who is almost a forgotten figure today, made over a hundred etchings, which were highly treasured long after they were made. Thomas Girtin made copies of them during the course of his brief career, and Goethe wrote that he admired the lyrical restraint of Swanevelt's etchings of classical ruins even more than Piranesi's dramatic views. A different point of view was expressed by Constable in 1836, when he argued that Both and Berchem, the most popular Dutch Italianate landscapists for more than

two centuries, were, in fact, poor artists. This position was a radical and unpopular one in 1836. Constable said: 'Both and Berchem, who, by an incongruous mixture of Dutch and Italian taste, produced a bastard style of landscape, destitute of the real excellence of either. . . . Their art is destitute of sentiment or poetic feeling, because it is factitious, though their works being specious, their reputation is still kept up by the dealers, who continue to sell their pictures for high prices.' After his lecture, one of Constable's listeners, a gentleman possessing a fine collection of pictures, said to him: 'I suppose I had better sell my Berchems.' To which Constable replied: 'No, sir, that will only continue the mischief, *burn them*.'[1]

Constable's belief that landscape painting not based on real life or a visual experience is insincere, and his struggle to obtain recognition for his own paintings, which do not rely upon bucolic vignettes from Tivoli or Arcadia to enhance their effect, help to explain his low estimate of the Italianate Dutch artists. By the end of the nineteenth century his point of view was generally accepted. Constable's landscapes, as well as those by the Barbizon painters and the Impressionists, helped the public to find qualities in pictures of humble Dutch scenes which earlier generations had overlooked. Dutch painters of idyllic scenes in Italy fell from favour. Canvases by Both, Berchem, and Dujardin, once more sought after than works by Rembrandt, Frans Hals, or Vermeer, were relegated to attics and storerooms.

In recent years there has been a revival of interest in these Dutch artists who worked in Italy or came under Italian influence. Impetus

was given by the re-appraisal of Caravaggio's achievement, which showed that his Dutch followers made a distinct contribution of their own (see pp. 36 ff.). It is now seen that Caravaggio's style and spirit even permeated the art of Hals, Rembrandt, and Vermeer, who had no direct contact with the great Lombard. Other Dutch painters who were influenced by the Italian scene are worth studying. They introduced new motifs and beautiful painterly effects in more than a few minor masterpieces. They also contributed to the development of artists such as Cuyp, Jacob van Ruisdael, and Salomon van Ruysdael. The charge that they are insincere Dutchmen because they were inspired by what they saw in Italy instead of in their native land can be dismissed. A reaction to what is seen in the south can be as genuine as one experienced in the north. The quality of an artist's experience and his ability to convey it in his work is of greater consequence than the geographical location which inspired it.

THE FIRST GENERATION OF ITALIANATE
LANDSCAPISTS AND SOME REPRESENTATIVES
OF THE CLASSICAL TRADITION

We have already stressed the importance of Elsheimer's poetic little pictures, particularly his landscapes, for the Dutch artists who worked in Italy during the first decade of the century. Elsheimer's influence was also decisive upon Cornelis Poelenburgh (c. 1586-1667) and Bartolomeus Breenbergh (c. 1599-1655/9), two outstanding figures of the first generation of Dutch Italianate landscape painters. Poelenburgh lived in Italy from c. 1617 to 1625; Breenbergh was there for a decade from 1619 to 1629. Though neither artist had first-hand contact with Elsheimer, who died in 1610, the German master's exceedingly rare works could still be seen in Italy. Copies of them by Poelenburgh have been identified. The two Dutch artists were also attracted to the late works of Paul Brill (1554-1626),[2] the Flemish landscapist who, under the influence of Annibale Carracci and Domenichino, abandoned the abrupt transitions of his early Mannerist pictures for more compact compositions. The paintings and drawings Poelenburgh and Breenbergh made in Italy are very similar. Both artists used cool colour harmonies in their well-balanced landscapes, and they made frequent use of imposing classical ruins and mythological personages to help evoke a heroic past [235]. Breenbergh, it seems, was more versatile than Poelenburgh, and his most original creations are the fresh, carefully observed pen-and-wash drawings of the intense sunlight and transparent shadows of the Campagna. These works anticipate the luminous daylight drawings Claude made after his second arrival in Rome in 1627. Indeed, some are so dangerously near to the French landscapist's sketches that they have been mistaken for his work. The drawing of *Ruins near Porta Metronia, Rome* (Oxford, Christ Church Library) [236] has been catalogued as a Claude in spite of a perfectly genuine signature by Breenbergh.[3] His drawings are also akin to the sun-drenched landscapes of more than a generation later by the brilliant Dutch amateurs Jan de Bisschop (1628-71) and Constantijn Huygens II (1628-97).

Poelenburgh achieved greater fame than Breenbergh, and he attracted a large number of followers, who used his polished style for arcadian landscapes populated with the same hefty nude nymphs he favoured. His native town was Utrecht, and, like many Italianate Dutch painters, he studied there with Bloemaert. None of the works Poelenburgh made during the first years of his career have been identified; two drawings inscribed 'in Roomen 1620' (Paris, Bibliothèque Nationale, no. c8769, and École des Beaux-Arts, Catalogue, 1950, no. 451) are the earliest dated works which have been ascribed to him.[4] Poelenburgh settled at Utrecht after his return from Italy and became

235. Cornelis Poelenburgh:
Rest on the Flight into Egypt, *c.* 1620–5.
Cambridge, Massachusetts, Fogg Art Museum

236. Bartolomeüs Breenbergh ·
Ruins near Porta Metronia, Rome. Drawing.
Oxford, Christ Church Library

a leading artist of the city. When Rubens
visited Utrecht in 1627, Poelenburgh was
selected to be his guide. Poelenburgh's enamel-
smooth works were particularly popular in
aristocratic circles. Before he left Italy he
worked in Florence for the grand duke of
Tuscany, and in 1637 he was invited by Charles
I to London, where he painted pictures for
the king.

Herman van Swanevelt is still a shadowy
personality. He was born at Woerden near
Utrecht; the date remains unknown. By 1623
he was in Paris, and he is said to have lived
in Rome about 1627–8 in the same house with

Claude Lorrain. For a long time he was banished to the limbo assigned to Claude's followers. However, a fresh examination of his scarce early works – made primarily because of an interest in the unsolved problem of Claude's early development – indicates that during the beginning of the 1630s his development runs parallel to Claude's, and in some ways even anticipates it. The central composition, the golden evening light, and even the rather clumsy figures of Swanevelt's earliest dated painting, *The Departure of Jacob* of 1630 (The Hague, Bredius Museum), are Claudian *avant Claude*. It has also been noted that Claude based his view of the *Campo Vaccino* (Paris, Louvre) of 1636 on Swanevelt's picture of the same site dated 1631(?) in the Fitzwilliam Museum at Cambridge. In this case, Claude's dependence upon the Dutch painter can be exaggerated; both paintings are topographical, and the similarity may have been dictated by the commission. In the late 1630s Swanevelt's dependence upon Claude becomes marked. He left Rome and settled in Paris in the early 1640s, where his paintings and etchings helped to popularize classical landscape in the north. He made a few trips to his birthplace Woerden before his death in 1655, and, when in Holland, this protean pioneer of the 'ideal' landscape also painted 'Dutch' scenery.

Another original Dutch artist who was in Italy in the 1620s was Paulus Bor (d. 1669), who returned to his native town of Amersfoort, near Utrecht, in 1628 with a very personal Italianate style. His so-called *Enchantress* (Metropolitan Museum of Art) [237] is characteristic of the draped women who play an important role in his religious, allegorical, and pastoral compositions. They are plump, neckless, and rather lethargic. Bor's forms are clear, smooth, and rounded, and he used colour harmonies of deep green, saffron yellow, greys, and rich silvery white. While in Italy he studied Caravaggio's work, and his soft rhythms, mild

237. Paulus Bor: The Enchantress, *c.* 1640(?).
New York, Metropolitan Museum of Art

light, and beautifully painted stuffs suggest that he paid even closer attention to Caravaggio's follower Orazio Gentileschi. During the 1630s he felt the impact of the young Rembrandt's powerful chiaroscuro. It is significant that this charming, but somewhat awkward artist became one of the principal painters of large-scale interior decorations in the Netherlands – a measure of the strength and quality of the decorative tradition in Holland during the first half of the century. When, after 1635, the Stadholder Prince Frederick Henry needed artists to decorate his new palaces at Honselersdijk and Rijswijk (cf. pp. 392–4), Paulus Bor was one of those to whom he gave commissions. The prince also employed his court painter Gerrit van Honthorst, a man with more impressive credentials. Others given

commissions include Christiaen van Couwenbergh of Delft (1604-67), who travelled in Italy before 1625, and a group of Haarlem painters with classical tendencies: Frans de Grebber (1573-1649) and his son Pieter de Grebber (c. 1600-c. 1653), Pieter Soutman (c. 1580-1657), as well as the stadholder's architect Jacob van Campen (1595-1657) – hardly a team to rival what Rubens painted for the courts of Europe. Prince Frederick Henry and his advisers were well aware of this. The Prince collected as many works by Rubens as he could, and even while at war with Spain, he gave commissions to Rubens and his followers.[5]

Since the palaces of Honselersdijk and Rijswijk are destroyed, we can only conjecture about the effect their painted galleries, ceilings, and staircases produced. Meagre surviving evidence indicates that the decorations were ultimately based on North Italian illusionistic wall decoration (see, for example, the drawing of musicians and other figures leaning over a balustrade attributed to Bor at the Rijksprentenkabinet, Amsterdam, which is a design for or after a ceiling painted at Honselersdijk). This kind of wall decoration was introduced to the Netherlands by Honthorst shortly after he returned to Holland from Italy in 1620, but the vogue for illusionistic wall and ceiling decorations never became widespread. Only a few minor artists made them – e.g. the Utrecht painter Jan Gerritsz, van Bronchorst (c. 1603-1661); two of his Concerts, dated 1644, which are lifesize scenes of figures at a balustrade in frog's eye perspective, are at Brunswick.

Only one intact interior gives us an idea of Dutch large-scale painted wall decorations: the Oranjezaal [238, 316] in Huis ten Bos at The Hague.[6] It is a valuable document of the taste of aristocratic circles in Holland around the middle of the century, and lends strong support to the view that Dutch painting found its highest expression in easel pictures and not in ambitious decorative schemes. Huis ten Bos

(House in the Woods) was begun in 1645 by Princess Amalia van Solms, the wife of Prince Frederick Henry. The Oranjezaal (the Hall of the House of Orange), the main room of the house designed by Pieter Post in the manner of a Palladian villa (cf. p. 400), is a high central

238. Huis ten Bos, Oranjezaal.
Engraving by F. Molenaar

hall built in the shape of a cross crowned by a lantern and dome. After the death of Frederick Henry in 1647, Amalia van Solms decided to have the huge room decorated as a memorial to her husband. Its elaborate allegorical scheme was devised by Constantijn Huygens, the prince's devoted secretary, and was clearly intended to compete with contemporary Baroque decorations such as Rubens' glorious Marie de Medici series in Paris. Huygens was satisfied with the results achieved. He wrote that the decoration at Huis ten Bos surpassed 'beaucoup d'autres entreprises illustres qu'on rencontre dans les plus grandes cours de la Chrestienté'. Subsequent appraisals have been more critical.

The principal commission for the Oranjezaal was given to the Flemish artist Jacob Jordaens.

It represents, in a painting about twice the size of the *Night Watch*, the *Triumph of Prince Frederick Henry* [cf. 316]. The Flemish painters Willeboirts Bosschaert and Gonzales Cocques also painted pictures for the Oranjezaal. In addition, nine Dutch painters, who either had close contact with Flemish art or were familiar with classicistic trends, received commissions. The most attractive and original artist employed on the project was Caesar Boëtius van Everdingen (1606–78), brother of the landscapist Allart van Everdingen. The refined, generalized forms, clear outlines, and sensitivity to the effects of light of his *Four Muses with Pegasus in the Back-*

239. Caesar van Everdingen: The Four Muses with Pegasus, *c.* 1650. *The Hague, Huis ten Bos*

ground [239] shows what sets him apart. His rare still-life pictures, such as the *Bust of a Roman Woman*, monogrammed and dated 1665 (Vorden, A. Staring Collection), are less cluttered and

even more attractive than his allegorical paintings. Caesar van Everdingen, who was born at Alkmaar, never travelled to Italy. There is reason to believe that he acquired his interest in representing idealized female and male nudes and classical subjects at Haarlem, where the themes, if not the style, popularized at the end of the sixteenth century by Goltzius, Van Mander, and Cornelis van Haarlem, died hard. The Haarlem classicists Pieter de Grebber and Salomon de Bray (1597–1664) were also called upon to help in decorating the Oranjezaal, and Pieter Soutman and Theodor van Thulden (1606–69), Dutch artists who collaborated with Rubens, were honoured with commissions too. The four other North Netherlandish painters represented at Huis ten Bos are Honthorst, Van Campen, Van Couwenbergh, and Lievens. It will be remembered that about 1630 Huygens singled out the two young friends Jan Lievens and Rembrandt as the beardless Dutch artists who would soon surpass the achievements of the High Renaissance masters. About two decades later Huygens gave Lievens, who had been to Antwerp, where he acquired a Flemish manner, a commission for a painting in the Oranjezaal. Huygens did not even put Rembrandt's name on a list he made of artists worthy of consideration for the project. He must have realized that the style of the mature Rembrandt was too personal for the ensemble he wanted to create in honour of his prince.

PIETER VAN LAER (BAMBOCCIO) AND HIS FOLLOWERS

The leader and principal member of the group of painters called the *Bamboccianti* is the Haarlem painter Pieter van Laer (*c.* 1592–1642), the first artist to specialize in painting the street life of Rome.[7] He arrived in Rome about 1625, where he was nicknamed Bamboccio because of his deformed body (*bamboccio* means awk-

ward simpleton or puppet). The name was used by hostile classicist critics as a disparaging label for his followers (*Bamboccianti*), who adopted his subjects and style. Their pictures of scenes in front of inns, life at the market, landscapes with cattle and shepherds, fighting brigands, beggars, and street musicians were termed *bambocciate*. From Van Laer's time until late in the nineteenth century the term was synonymous with low-life genre painting.

Contemporary reports indicate that Van Laer was a modest, charitable man. Sandrart, who knew him well, wrote that he tended to be melancholic and eased his soul by making music. He was particularly fond of the violin. His striking self-portrait in profile (Rome, Galleria Pallavicini) shows that he made no attempt to minimize his uncomely features. Bamboccio's crippled body did not warp his spirit. His sympathetic paintings of the poor and humble never show a trace of bitterness or irony. Although it is risky to read too much into the expression of a portrait, in Van Laer's *Self-Portrait* it seems safe to detect a twinkle in the artist's eye and the beginning of a smile on his lips. His contemporaries report that although he was introspective, he liked fun. While he was in Rome he became one of the leaders of the *Schildersbent* (band of painters), a fraternal organization founded in 1623 by Netherlandish artists for general merriment and mutual assistance.[8] The society had no fixed pro-gramme and no written laws. Members of the group called themselves *Bentvueghels* (birds of a flock) – during the nineteenth century they would have been called Bohemians. New members of the group were baptized with wine and received their *Bent* name from a mock priest. Most of the Dutch artists who travelled to Rome joined the group, and their *Bent* names probably offer a clue to their character as well as their appearance: Poelenburgh was called 'Satyr'; Breenbergh was nicknamed 'The Ferret' (*Het Fret*); Swanevelt was known as

'Hermit' (*Heremiet*); Paulus Bor as Orlando. A banquet followed the baptism, and when the festivities were over the *Bentvueghels* and their friends marched to the 'Grave of Bacchus', which was, in fact, the red porphyry sarco-phagus of the youngest daughter of the Em-peror Constantine, at that time in the church of S. Costanza, a few miles outside Rome, and now in the Vatican Museum. Here the party continued. The whole ceremony was a mockery of the initiation given to new members of the Order of the Golden Fleece. After periods of greater and lesser artistic activity and bacchic irregularities, the *Bentvueghels* were finally pro-hibited by a papal decree in 1720 that forbade ceremonies which could be interpreted as a mockery of the sacrament of baptism.

Van Laer's artistic development is not clear, and little is known about his early years at Haarlem. His style suggests that he had some contact with Esaias van de Velde. At Haarlem he probably also found Frans Hals a sympa-thetic spirit. He left his native city in 1623, and after stops in France and northern Italy settled in Rome. The influence of Caravaggio's naturalism and chiaroscuro is unmistakable in his small pictures. Unfortunately the dark passages in many of his works have become rather opaque and are difficult to penetrate. The focused light and strong sculptural feeling of his *Cake Vendor* (Rome, Galleria Nazionale) [240] show his debt to Caravaggio's lifesize can-vases. However, the plein-air effect in Van Laer's work is more pronounced than it is in Cara-vaggio's pictures. Passeri, the unsympathetic seventeenth-century Italian critic who con-demned the subjects Bamboccio painted, rightly admitted that Van Laer was able to represent the absolute truth in its purest essence, so that his pictures look like an open window.

What distinguishes Van Laer from so many of his followers is the dignity he found in the humble people he painted. He does not idealize them or their way of life. He avoids the

240. Pieter van Laer, called Bamboccio:
The Cake Vendor. *Rome, Galleria Nazionale*

picturesque and anecdotal aspects of the
activities of the Italian lower classes which
appealed to northern artists and travellers of a
later day. Tragic overtones, similar to those
found in Louis le Nain's paintings of peasants,
are not uncommon. Collectors and artists
quickly responded to Bamboccio's works. It
seems that even an artist of Velazquez's stature
was fascinated by Van Laer's accomplishments.
Velazquez's *Fight over a Game of Cards before
the Spanish Embassy*[9] (Rome, Galleria Palla-
vicini), which can be dated about 1629, the
year he travelled to Rome, and the *Wild Boar
Hunt* (London, National Gallery), painted in
Madrid during the 1630s, show Bamboccio's

influence. The group around Van Laer also
included Claude Lorrain. Sandrart reports that
he made an excursion from Rome to Tivoli to
draw or paint landscapes with Claude, Poussin,
and Van Laer. The figures of sailors, herdsmen,
and dancers that Claude painted in the 1630s
reveal some of the results of his contact with the
Bamboccianti. Closer followers of Van Laer
were the Italian Michelangelo Cerquozzi (1620-
60) and the Fleming Jan Miel (1599-1663).[10]
In 1638 Van Laer left Rome and returned to
Haarlem, where he died four years later. At
Haarlem, the young Wouwerman was in-
fluenced by his work, but the Caravaggesque
aspects of Bamboccio's style escaped him.

Dutch artists of a younger generation who continued working in Bamboccio's style in Rome after he left include Thomas Wijck (*c.* 1616–1677), Dirk Helmbrecker (1633–96), and Johannes Lingelbach (1622–74). Of far greater talent was the Fleming Michael Sweerts, who was born in Brussels in 1624. He spent about a decade of his bizarre career in Rome (*c.* 1646–1654/6). By 1656 he was back in Brussels, where he planned to establish a drawing academy. Sweerts' stay in Amsterdam is only documented for the year 1661, but judging from his *Self-Portrait* (?) (Oberlin, Allen Art Museum), which can be dated about 1658 and shows the strong influence of Van der Helst's swagger and colour, he had arrived by that year. In any event, his stay in Holland was brief. He left for the Orient in 1661 with a group of missionaries, who soon reported that 'the mission was not the right place for him, nor he the right man for the mission'. He was dismissed

241. Michael Sweerts: Portrait of a Boy, *c.* 1660. *Hartford, Wadsworth Atheneum*

and died at Goa in 1664. Sweerts' tender pictures of the life of women and children, of artists at work, and his scenes set in the streets of contemporary Rome are based upon Van Laer's art, but the bitter-sweet mood and restrained lyricism of his paintings, as well as his colour harmonies of fine blues, violets, greys, and browns, are completely his own. He sometimes reaches surprising heights. The mild light, purity of colour, and clarity of forms of his *Portrait of a Boy* (Hartford, Wadsworth Atheneum) [241] anticipate the quiet beauty of the portraits of young girls that Vermeer painted during his classic phase.

THE SECOND GENERATION
OF ITALIANATE LANDSCAPISTS

By the time Both, Berchem, Jan Baptist Weenix, and Dujardin, the leading landscapists of the second generation of Italianate Dutch painters, came to Rome, Claude Lorrain and the *Bamboccianti* had evolved their distinctive styles. The young Dutch masters learned much from them. It is wrong, however, to view their works as close imitations of Claude or Pieter van Laer. Each of these painters had a strong artistic personality, and after a brief acquaintance their pictures are unmistakable.

Jan Both, in many ways the most gifted member of the group, had a short life. The date of his birth is unknown; it was not 1610, as older texts state. There is reason to believe that he was born in 1618, or perhaps as late as 1622. He died in 1652. During the course of his short career he evolved a personal conception of Italian landscape which helped to mould northern Europe's ideas about the Roman Campagna for two centuries. Both's native town was Utrecht, where he studied with Bloemaert. His older brother Andries Both (*c.* 1612–1641) was also an artist and a Bloemaert pupil. Andries was in Italy as early as 1632. The drawing he made that year in Venice of a

Dentist at Work (Leiden University, Prenten-kabinet, no. 116) shows that he had a predilection for Bamboccio's subjects before he settled in Rome. Jan followed his brother to Italy, perhaps in 1637 – the precise date of his arrival there is unknown. From 1639 to 1641 the brothers lived together in Rome. They left in 1641 for Venice, where Andries was drowned in an accident. Jan returned to Utrecht in the same year and remained there until his own premature death.

Dated pictures by Jan Both are exceedingly scarce. Of over 300 paintings listed in Hofstede de Groot's catalogue of Both's *œuvre*, only eight are dated. They are of little assistance in working out his development. Moreover, not all the dates are legible or reliable. Wolfgang Stechow, who has done most in modern times to rehabilitate the reputation of the Italianate landscapists, noted that the painting which Hofstede de Groot listed as signed and dated 1640, is neither signed nor dated, nor is it by Jan Both.[11] Nothing is known about Both's artistic accomplishment before he left for Rome, and not a single picture can be securely identified as a work painted in Italy. Sandrart, who knew the brothers, gives us some idea about their activities in Rome. He writes that they made landscapes in Claude's style and followed Bamboccio in their smaller pictures. According to Sandrart, Jan painted the landscapes and Andries filled them so neatly with people, animals, and birds that the pictures looked as if they were painted by one hand. A picture that may show the collaboration of the brothers is the *Capriccio with Figures in the Forum Romanum* (Amsterdam, Rijksmuseum) which is signed 'Both'. The light, open composition already distinguishes this capriccio from those Claude made during the 1630s The rather squat figures going about their humdrum business in the foreground are similar to others by Andries (see the drawing, now in the Witt Collection, London, signed and dated 'A Both

F Roma, 1637'). On the other hand, the landscape and rearrangement of the ruins of the Forum Romanum and the luminous atmosphere which pervades them can only be attributed to Jan. The possibility that Jan was responsible for the entire work, and based the figures on Andries' drawings, should not be excluded.

Sandrart writes that Jan Both painted landscapes of the morning hours, when the dew still lies on the fields, and the sun peers over the mountains, and that the brothers made such wonderful representations of noon, evening, and sunset that it is possible to recognize almost every specific hour of the day as well as appropriate characteristics of the fields, mountains, and trees. This emphasis on the specific qualities of light and nature is one of the significant differences between Both and Claude Lorrain. To be sure, Claude also made careful studies of sunlight and atmosphere, and his discovery that light could be the predominant means of unifying a landscape is rightly considered one of the great innovations in the history of western painting. But Claude's light nearly always plays upon an imaginary world, not a naturalistic one. Claude primarily used the Campagna as a setting for biblical and Ovidian themes. For Both it was the land of modern idylls. His large *Italian Landscape with Artists sketching* [242] shows the kind of everyday theme he preferred. An artist chats with a shepherd, modest travellers and their mules make their way along a winding path, and two men watch the evening sky. Men, animals, and the finely observed detail of wild flowers, luxuriant shrubs and trees are integrated into the grandiose southern landscape, which has been unified by a complex interweaving of diagonals and the warm golden light. The huge scale of the painting (187 cm. by 240 cm.; *c.* 6 ft by 8 ft) is not unusual in Both's *œuvre*. He is one of the rare Dutch landscape painters whose large pictures are not inferior in quality to his small ones. Compared to Both's paintings,

242. Jan Both:
Italian Landscape with Artists sketching.
Amsterdam, Rijksmuseum

the large-scale views of Italy made by late-seventeenth-century Dutch landscapists look like wallpaper.

Soon after Jan Both had settled at Utrecht in 1641 a widespread vogue for Italianate landscapes began in Holland, and his views of the south inspired Dutch painters who never travelled to the Campagna to paint pictures of it. Strong reflections of Both's golden Italian light are also found in the works of artists who represented the Dutch countryside. Both's influence upon the development of Cuyp's mature style was decisive, and his impact on Jacob van Ruisdael and Salomon van Ruysdael's late work is also evident. But his activity as a teacher was apparently not very extensive. Houbraken notes that Barend Bispinck was his pupil. None of Bispinck's paintings have been identified; close investigation of some of the weaker works now attributed to Both may reveal this follower's hand. Willem de Heusch (1625–92) was also Both's close follower.

Nicolaes (or Claes) Berchem, who popularized pictures of Italian pastoral and arcadian scenes, was born at Haarlem in 1620, the son of Pieter Claesz., the famous still-life painter. Houbraken states that Berchem studied with his father, Van Goyen, and four other painters. If the statement is correct, none of them had much influence upon him. During the course

243 (*below*). Nicolaes Berchem: Italian Landscape with a Bridge, 1656. *Leningrad, Hermitage*

244 (*opposite*). Jan Baptist Weenix: Figures in an Italian Landscape with Ruins. *Detroit, The Detroit Institute of Arts*

of his long and extremely prolific career he painted biblical and mythological themes, views of harbours, winter scenes, battles, and some genre scenes, as well as the Italian landscapes for which he is so justly famous, but he apparently never tried his hand at still-life painting, the subject which was his father's speciality. Berchem entered the Haarlem guild in 1642, and during the course of that year left for Italy with his cousin(?) Jan Baptist Weenix. He remained there for about three years making numerous studies of folk types, animals, and nature. These sketches served him for the rest of his life. He was back in Haarlem by 1646, and soon after he tried his hand at a few lifesize

compositions (*The Education of Bacchus*, 1648, The Hague, Mauritshuis; *The Rape of Europa*, 1649, Leningrad, Hermitage) which show the influence of the Flemish decorative tradition then popular in court circles. One wonders why he was not chosen to help in decorating Huis ten Bos; much weaker talents than Berchem were given commissions for the Prince of Orange's memorial during these very years. Berchem is said to have visited Italy again in the 1650s; the assertion that he travelled to Italy once more in 1673 is wrong. By 1677 he had moved to Amsterdam, where he spent the last six years of his life. About 800 paintings, 500 drawings, and more than 50

etchings support the statement that he worked constantly from morning until night. He also painted figures in the landscapes of other artists; they appear in pictures by Jacob van Ruisdael, Hobbema, Jan Hackaert, and others. *The Portrait of a Lady and Gentleman in a Landscape* (Rijksmuseum, Amsterdam) is a joint work by Dou, who painted the couple, and Berchem, who did the landscape and dog; both artists signed the picture. Berchem was extremely popular and well-paid during his lifetime, and in the following century, when pastoral scenes became even more popular, his fame increased. He was a particular favourite of eighteenth-century French collectors. J. B. Descamps has

nothing but praise for him in his *La Vie des peintres* published in Paris in 1754, while in the same breath he dismisses Berchem's father, the master of monochrome still-life painting, as 'a mediocre artist who only painted fish, desserts, sweets, cakes, and some gold or porcelain vases'. In Descamps' time no one questioned the assumption that an artist who painted live cows in a bucolic setting was a more noble representative of the art of painting than one who made pictures of dead herrings.

Berchem's pictures have a more pronounced pastoral character than Both's. Shepherds and buxom shepherdesses tending their flocks and herdsmen guarding their cattle receive pro-

minent places in his works. His lively figures are seen in sparkling Italian light among ancient ruins [243], fording rivers, or set against magnificent panoramic views of vast Italian valleys and mountain ranges. Wisps of white cloud float in dazzling blue skies, and bits of vividly coloured clothing worn by milkmaids and travellers brighten the cool greens of his landscapes. Berchem's mood is a gay one. His peasants enjoy a life of innocence and happiness among their animals. It is a dream world which appealed to a public that found arcadia a refuge from worldly cares and responsibility. The mood of Berchem's pictures justifies the claim that he – who died in 1683, the year Watteau was born – is one of the precursors of the Rococo. Berchem's success stimulated a number of close followers. Karel Dujardin was his pupil. Pieter de Hooch, Jacob Ochtervelt, and Justus van Huysum – artists who soon went their own way – also studied with him.

Jan Baptist Weenix (1621-60?), who travelled to Italy with Berchem, was one of the most versatile of the Italianate painters. He is best-known for his views of the Campagna [244] and Italian harbour scenes, but he also painted portraits and indoor genre scenes as well as some remarkable still lifes with dead game. His son and pupil Jan Weenix (1642-1719) made a speciality of pictures of hunting trophies. Jan Baptist Weenix arrived in Rome in 1642-3, where he enjoyed the patronage of Cardinal Giovanni Battista Pamphili, who became Pope Innocent X in 1644. Weenix apparently adopted the Italian form of his Christian name to honour his patron. Before he left for Italy he called himself Johannes; after he returned to Holland, about 1646/7, he invariably signed himself Gio(vanni) Batt(ist)a Weenix. In the Bent he was nicknamed Ratel (Rattle) because of a speech defect. His sunny landscapes and views of the shores of the Mediterranean are frequently more fanciful than those painted by his contemporaries. Well-dressed cavaliers and

ladies ride or stroll near prominent fortresses, colonnades, pyramids, and antique columns. Weenix's shepherds, knife-grinders, and pedlars do not have the melancholy air of Pieter van Laer's figures, and he never uses Bamboccio's dark Caravaggesque manner. His paintings are light in tonality, and though he favours flaming reds, bright yellows, vivid greens and blues, he is never garish. For Weenix's still lifes of dead game see pp.342-3.

Large-scale ruins also play an important part in the Italian landscapes and harbours painted by Jan Asselyn (c. 1615-52). Asselyn, who was given the cognomen Crabbetje (Little Crab) because of a deformed hand, was probably in Italy in the 1630s and remained until the middle of the forties. Houbraken rightly states that Asselyn was one of the first to bring the pure and light manner of Claude to Holland. He is more uneven than Jan Baptist Weenix, but the warm, luminous light in his exquisite Ruined Roman Bridge with Peasants fording a River (Woburn Abbey, Duke of Bedford Collection) [245] matches the best work produced by the Bentvueghels. His well-known Threatened Swan (Amsterdam, Rijksmuseum), a picture of a swan defending its nest against a dog swimming towards it, was transformed at a later date into an allegory on the vigilance of the Grand Pensionary Johan de Witt (see p. 16), and the following words were added: beneath the swan, 'De Raadpensionaris' (the Grand Pensionary); on one of the eggs in the nest, 'Holland'; and above the dog, 'De viand van de Staat' (the enemy of the State). Asselyn's pupil Frederick de Moucheron (1633-86) also made a name as a painter of decorative Italian landscapes. The figures in Moucheron's pictures were frequently painted by Berchem, Adriaen van de Velde, or Johannes Lingelbach, three painters who specialized in painting figures and animals for other artists.

In many ways Karel Dujardin (c. 1622-78) is the most Dutch of the Italianate painters. His

245. Jan Asselyn:
Ruined Roman Bridge with Peasants fording a River.
Woburn Abbey, Duke of Bedford

bucolic landscapes are done on a small scale, and have an intimacy lacking in pictures made by his countrymen who used a larger format and more ambitious motifs. Dujardin probably studied with Berchem before 1643, since Berchem was in Rome by that year. His earliest known work dates from 1641 (known only from an aquatint by Cornelis Apostool, published in *Beauties of the Dutch School*, 1795). It is a shepherd scene, a theme which remains a favourite until the end of his career. He was probably in Rome during the late 1640s, and although Houbraken writes that Dujardin did not join the *Schildersbent*, he acquired a *Bent-name*: *Bokkebaart* (Goatsbeard). Houbraken notes that he does not know if the name was given to him because he shaved irregularly, or out of anger. A few of Dujardin's etchings

show the influence of Claude, but more important for his development was the impact of the *Bamboccianti* painters. He may have worked in Haarlem with Van Laer before he entered Berchem's studio, and thus have acquired something of Bamboccio's style even before he went south. By 1650 Dujardin was back in Amsterdam. From about 1650 to 1652 he was in Paris; the *Morra Players* of 1652 (Cologne, Wallraf-Richartz Museum) indicates that genre pictures by the versatile French painter Sébastien Bourdon impressed him too. During the next few years Dujardin's art took an unexpected turn. Instead of settling down in Holland to paint views of the Campagna and the *vita popolare* of Rome, as most Italianate Dutch painters did after their trips to Italy, Dujardin made pictures of the Dutch countryside which

are closely related to Paulus Potter's carefully executed small paintings of cattle in sunny meadows and woods (*The Peasant on his Farm*, 1655, Amsterdam, Rijksmuseum; *Farm Animals in the shade of a Tree, with a Boy and a sleeping Herdswoman*, 1656, London, National Gallery). During this phase it is sometimes difficult to distinguish the hand of Potter from Dujardin's. By the end of the 1650s Dujardin began once again to paint modest Italian pastoral scenes and *Bambocciate*. His *Young Shepherd* (The Hague, Mauritshuis) [246], which can be dated in the early 1660s, shows him at his best. The theme is simple. A young boy lies on his back playing with his dog. The sheep, the old grazing horse, and the basket and keg appear to lie about in a haphazard fashion. In a black and white reproduction, only the mountains tell us that this is not a Dutch scene, but when the original is viewed, warm Italian air and the strong evening light of the south permeate the scene. It was the kind of painting which must have appealed to Dutchmen who had once felt the hot Italian sun on their backs, and now and then welcomed a reminder of it. Dujardin enjoyed a vogue among the ruling classes of Amsterdam during the sixties. He painted handsome portraits of famous citizens in the style of Van der Helst. His portrait of the *Governors of the Amsterdam Spinhuis* (House of Correction) of 1669 (Amsterdam, Rijksmuseum) ranks with the best

late Dutch group portraits. He also painted elegant and highly finished religious and allegorical pictures. Around 1675 Dujardin made a second trip to Rome. *The Shepherds' Camp,* inscribed 'Roma 1675' (Antwerp, Museum), indicates that during this last phase he found inspiration from the landscapes painted in Rome by Poussin's follower Gaspar Dughet. Dujardin did not return to Holland; he died in Venice in 1678.

Adam Pynacker (1622–73) is said to have spent three years in Italy. Though no documentary evidence supports the statement, the subtly observed reflections of the light clouds in the rosy sky upon the calm water of his masterwork *Barges on a River* (Leningrad,

Hermitage) [247] suggest that he had first-hand contact with the landscape of Italy. The Leningrad picture is unique in his *œuvre*. More characteristic are paintings of prominent white birches, elegant reeds, and clumps of thistles streaked with silvery light, seen against distant views of blue mountains. After working at Delft and Schiedam, Pynacker settled in Amsterdam, where he produced large decorative hangings for patrician houses. He was not as successful with a broad brush as he was with a fine one. His large pictures are rather empty, and in his last years the colours become harsh and metallic.

The youngest notable painter of this generation is Jan Hackaert (1628–99), who travelled extensively in Switzerland and Italy from about 1653 to about 1658. His panoramic view of *Lake Trasimeno* (Amsterdam, Rijksmuseum), which dispenses with the architectural props used by other Italianate landscapists, shows his exquisite response to the impressive mountains and golden sunlight of Umbria. His *The Ash Tree Lane* in the same museum indicates that Hackaert was equally sensitive to the light and atmosphere of Holland. The soft light and delicate foliage of his slender trees would not look out of place in an eighteenth-century *fête galante*.

246 (*opposite*). Karel Dujardin: Young Shepherd, early 1660s. *The Hague, Mauritshuis*

247 (*above*). Adam Pynacker: Barges on a River. *Leningrad, Hermitage*

CHAPTER II

PORTRAITURE

The visual arts are as important as any other original source for humanists and social historians. Portraiture is a case in point. A portrait is a primary document about man's behaviour and environment. It reveals not only the exterior of a person and his character, but also something substantial about the sitter's social position, his attitude and setting. This is the case even when a single person is represented against a plain, neutral background. Bearing and dress, glances and gestures, manners, indeed a man's whole character is formed in reaction to a definite environment. Consequently, every portrait is bound to reflect qualities of man as a social being.

Another point merits close attention. A portrait always reflects both the objective data presented by the sitter and the subjective interpretation of the artist. The degree of objectivity and subjectivity in a portrait will of course vary during different epochs and with individual artists. Therefore, if we try to concentrate on the objective content we must be on guard not to confuse arbitrary interpretation with the facts the portraitist faced. We may never get the objective facts with scientific accuracy - they are always tinged with the artist's personality as well as the depth and control we have of our own knowledge of the sitter, the portraitist, and the environment in which they lived - but we can recognize that during some ages there is more concern with the actual appearance of the features of an individual than in others.

If we turn to portraiture of the early phase of the Renaissance, particularly in the north of Europe - such as that of Jan van Eyck and Memling - we find that it retains a medieval flavour.

It still reflects the ideals of a feudal society which restrained the free expression of the individual through the medieval concept of the world with strict subordination of man's thought and action to the supreme position of religion. Individuality is expressed by the close objective rendering of externals, but the restriction laid upon individuals by the spiritual power of the Church and the strict social order is strongly felt. The submission of man to God is the important concern, not the elevation of man to the fullest consciousness of his own power. These portraits appear severe and limited in expression. Not only is the sitter's mouth sealed, but the portraitist is reluctant to tell us much about human relationships.

Jakob Burckhardt's famous and much debated thesis that the culture of the Renaissance is marked by the liberation of the individual in society is best borne out by the portraits made by Titian. Titian's patrons confront us with personalities of vigour and free bearing. They appeal to us as men who have come to power, not so much on the basis of their social standing, but rather by their individual merits and achievements. Though they move with dignity and restraint, we do not feel any serious restriction made upon them by their social setting. However, they seem to exist in a well-regulated world, where ideals of order, beauty, and heroism are alive and exert a considerable influence on man's action and achievements. The great individual stands out from society, but at the same time appears to be its natural product, expressing in his existence the elevated ideals of Renaissance culture.

The situation changes in the Baroque period. Aristocracy by birth rather than aristocracy by

intrinsic force and personality seems stressed by Baroque court portraitists. The creations of Van Dyck, the Baroque court portraitist *par excellence*, all appear to belong to the same race of courtiers and reflect the ideals of elegance and class consciousness which marked his highly privileged clientele. They considered themselves superior by birth, and appear to look down upon people of lower degree. Yet they seem to lack inner strength, the very qualities which might justify a feeling of superiority. Van Dyck was in complete sympathy with his high-born patrons. He also had the rare ability to endow even an ugly sitter with beauty and yet achieve a likeness, a talent of inestimable value to a portrait specialist. His kind of interpretation fulfils most successfully the claims of a pretentious patronage. A courtly atmosphere is also evident in Velazquez's portraits, but so is the restraining effect of Spanish etiquette. The objective character of Velazquez's portraits is stronger than Van Dyck's. He was less of a flatterer. He records with sincerity, yet with discretion and restraint. We are made to feel something of the ceremonial air of the court of Spain, in which the king was a superior being and where too much individuality was never allowed to come to the fore. Velazquez shows us personality as through a veil. He seems to take a special spiritual distance from his subject which is great enough to subdue an excessively pointed characterization of either the individual or his social background.

After the courtly atmosphere of Van Dyck and Velazquez, contact with the jovial and unrestrained clientele of Frans Hals is like a breath of fresh air. Hals made most of his patrons look genuinely friendly. They seem to greet their fellow-citizens and seldom appear to have great spiritual or social ambitions. There is force and naturalness in their personalities, but without the distinction, heroic atmosphere, and tension found in High Renaissance portraits.

Hals expressed with quick vitality the extrovert character of his countrymen, and even invigorated their personalities by his own mighty temperament and genius. In contrast to Hals, Rembrandt – in particular the mature Rembrandt – gives little indication of a sitter's social attitude. Does this mean that as far as characterization is concerned they are incomplete portraits? Hardly. His portraits are still comprehensive, but they have acquired a new accent. He concentrates upon a different kind of life: it is that which goes on in his subject's thoughts and feelings. It is a life that seems remarkably independent of man's environment. Social status matters little for this kind of deep characterization. As we have seen, Rembrandt creates the proper atmosphere for introspection by his original use of chiaroscuro, and the costumes he uses in his art are frequently a means of creating a mood rather than a record of conventional dress. It is scarcely necessary to add that Rembrandt's emphasis upon contemplative humility was not a return to a late medieval or Early Renaissance attitude. His sitters seem as free from theological restrictions as they are from social ones.

The minor Dutch masters of portraiture are never as exuberant as Hals, or as introspective as Rembrandt. Because of the lack of outstanding qualities, their work is probably a more reliable index of the average Dutch puritanical environment and social atmosphere, which showed a taste for the homely and domestic even in the case of prominent patrons. Dutch aristocrats as well as burghers appear with little ease or elegance, but with a certain justifiable pride and personal independence, and, as with all seventeenth-century Dutch painting, there is always a decent standard of pictorial execution and craftsmanship.

During the first decades of the century there were centres of portraiture at Delft and at The Hague with Michiel Jansz. van Miereveld (1567–1641) and Jan Anthonisz. van Ravesteyn

(*c.* 1570-1657) as the outstanding names. Both artists inspired a host of minor painters. Their portraits are dry visual reports, competent in draughtsmanship and with only a moderate decorative effect. Costumes, armour, and faces are rendered with the same meticulous care and reliability. Miereveld was, it seems, prepared to make some adjustment in the features of a countenance to satisfy a foreign client. A contemporary tells us that when Miereveld received commissions from Frenchmen, he painted them 'with an abundance of benignity'.[1] Though Ravesteyn can be a little more elegant than Miereveld and his painting is sometimes thinner, it is not always easy to separate their hands. Miereveld enjoyed a greater reputation – particularly among court circles in The Hague – and he kept a workshop busy making portraits of members of the house of Orange-Nassau [248] and other noble families. As we have

248. Michiel van Miereveld:
Prince Frederick Henry.
Amsterdam, Rijksmuseum

already heard (see p. 31), Joachim Sandrart reported that he painted over 10,000 portraits during his lifetime. His son-in-law Willem Jacobsz. Delff (1580-1638) made a career of engraving copies after them. The matter-of-fact pictures that Miereveld produced seemed to be precisely what Dutch aristocratic circles wanted. When Gerrit van Honthorst, who belonged to a younger and less provincial generation, began to paint portraits for the court at The Hague in 1637, he was as stiff and impersonal as his predecessors. Miereveld's pupil Paulus Jansz. Moreelse (1571-1638), who was also active as an architect (cf. p. 391) and a painter of subject pictures, practised his master's portrait style in Utrecht with equal dexterity and rather less severity. Daniel Mijtens (*c.* 1590-1647), born in The Hague, carried Miereveld's style to England, where he entered the service of the earl of Arundel in 1618 or earlier, and then was in the employ of Charles I. Before the arrival of Van Dyck in 1632, Daniel Mijtens was the best portraitist in London.[2]

Around the same time Werner van den Valckert (*c.* 1580-after 1627?), Nicolaes Eliasz. called Pickenoy (1590/1-1654/6), and Thomas de Keyser (1596/7-1667) represent portraiture in Amsterdam. Until young Rembrandt's arrival there they were the most sought after portraitists of the principal city of the Netherlands. Thomas de Keyser, son of the Amsterdam architect and sculptor Hendrick de Keyser, is the most interesting member of this group. His *Anatomy Lesson of Dr Sebastian Egbertsz.* [249], painted in 1619 as a chimneypiece for the chamber of the surgeons' guild of Amsterdam, is an excellent example of early-seventeenth-century group portraiture, a genre which had found special favour in the Netherlands since the late fifteenth century. We have already discussed the unique and original contributions Frans Hals and Rembrandt made in this important branch of Dutch painting. The successful group portraitist must not only make a likeness of

249. Thomas de Keyser: Anatomy Lesson of Dr
Sebastian Egbertsz., 1619. *Amsterdam, Rijksmuseum,
on loan from the City of Amsterdam*

each individual: he must show something of
the nature of the group and the relationship of
the individuals to it. On the whole, Dutch
portraitists placed a far greater emphasis on
individual likeness than on the character of a
group. This is understandable. Group portraits
were made to decorate buildings of the organiza-
tions which commissioned them. This was
flattering for the people represented. A place
in a group portrait was a kind of social award for
their activity. It also meant that each sitter
expected full measure. A portraitist of De
Keyser's stature gave it to them, but as his
Anatomy Lesson shows, it was done at the ex-
pense of the structural unity of the group. The
single portraits in the work are only connected

in a loose and superficial fashion. The skeleton
in the centre has the effect of an accessory rather
than the object on which the attention of the
members of the group should be concentrated.
In fact, the attention of the syndics of the
surgeons' guild is divided; some turn towards
the spectator, others face the lecturer. Another
characteristic of this early-seventeenth-century
group portrait is the relief-like arrangement,
without much effect of depth. Comparison of
De Keyser's *Anatomy Lesson* with Rembrandt's
famous *Anatomy Lesson of Dr Tulp* of 1632 [53]
immediately impresses us in favour of Rem-
brandt, as it must have impressed his contem-
poraries, by the dramatic action which the
young painter fresh from Leiden gave to the

subject (see p. 88). De Keyser also painted
militia pieces. His group portrait of the
Company of Captain Allart Cloeck of 1632
(Amsterdam, Rijksmuseum) shows a new clarity
in the grouping of sixteen full-length figures.
The civic guards are set in a row with only
slight distinctions in space. The artist accen-
tuated the middle group by placing it in front of
the other guardsmen, who appear to be on the
way to join their officers. Nevertheless, the
result is not very satisfactory. There is no indi-
cation of a unity between the sixteen figures,
and De Keyser's attempt to combine a hori-
zontal setting with the effect of depth by
placing symmetrical groups at various distances
fails by its stiffness. Comparison of De Keyser's
militia piece of 1632 with the brilliant order,
high standard of characterization, and pictorial
animation Frans Hals achieved in group por-
traiture as early as 1616 [22] or with the
brilliant impressionistic effects and suggestion
of momentary life in Hals' civic guard pictures
of the 1620s [30] makes it difficult to understand
why De Keyser did not borrow more than an
isolated attitude or gesture from Hals. Perhaps
De Keyser himself sensed his limitations. He
is most successful and original in his small-
scale full-lengths of one or two figures (*Con-
stantin Huygens and his Secretary*, 1627, London,
National Gallery) [250] and small equestrian
portraits, a type he popularized. He also painted
a few subject pictures. After 1640 De Keyser
became active as a stone merchant and mason,
and virtually stopped painting. Dirck Dircksz.
Santvoort (1610/11–1680) continued to work
in the style of De Keyser at Amsterdam long
after Rembrandt appeared on the scene. The
naïve charm of Santvoort's figures, whose
faces appear to be made of highly polished
ivory instead of flesh, sets them apart from the
average conscientious portraits of the time.

Good representatives of the general level of
portraiture around the middle of the century

250. Thomas de Keyser:
Constantin Huygens and his Secretary, 1627.
London, National Gallery

are Johannes Cornelisz. Verspronck (1597–
1662) and Bartholomeus van der Helst (1613–
70). Both were born in Haarlem. Verspronck,
a pupil of his father Cornelis Engelsz. (1575–
1642/53), remained in Haarlem all his life. His
style is based on Hals' closed and well-balanced
compositions of the 1630s, but he never
attempts to emulate Hals' touch or tempera-
ment. He is best as a portraitist of women and
children. Exceptionally attractive is his *Portrait
of a Girl in a light blue Dress* (1641, Amsterdam,
Rijksmuseum) [251]; however, even in this
appealing work we feel that he follows Dutch
precedent and does not attempt to make the
young girl more beautiful than she actually
was. A marked change in the Dutch portraitist's

conception of his task becomes apparent in the work of Barthomoleus van der Helst. His portraits take on some of Van Dyck's elegance, which began to affect Dutch art about 1640

[252]. Adriaen Hanneman (1601–71) returned to The Hague with Van Dyckian motifs about 1637, after more than a ten-year stay in England, and the portraits he and his pupils

251 (*above*). Johannes Verspronck: Girl in a light blue Dress, 1641. *Amsterdam, Rijksmuseum*

252 (*above, right*). Bartholomeus van der Helst: Portrait of the Painter Paulus Potter, 1654. *The Hague, Mauritshuis*

253 (*right*). Bartholomeus van der Helst: The Company of Captain Roelof Bicker and Lieutenant Jan Blaeuw, 1639–43. *Amsterdam, Rijksmuseum, on loan from the City of Amsterdam*

made helped to set the new fashion. Cornelis Jonson van Ceulen (1593–1661/2) can also be credited with helping to popularize Van Dyck's airs and liquid touch in the Netherlands. Jonson, born in London of Netherlandish parents, emigrated to Holland in 1643. He had settled in Amsterdam by 1646, where he found sitters for his pale interpretation of Van Dyck's dazzling style.

Van der Helst had moved from Haarlem to Amsterdam by 1636. In the following year, at the age of twenty-four, he was commissioned to paint his first group portrait, the *Regents of the Walloon Orphanage* (1637, Amsterdam, Walloon Orphanage), a work which shows the influence of the dry manner of Nicolaes Eliasz., who was probably his teacher. Around this time Van der Helst also borrowed motifs, but not spirit, from Rembrandt and Hals. In 1639 he began his first large group of civic guards, *The Company of Captain Roelof Bicker and Lieutenant Jan Michielsz. Blaeuw on the Occasion of the Arrival of Maria de Medici in Amsterdam* [253]. By the time it was finished in 1643 Van der Helst's reputation was clinched,

and he soon succeeded Rembrandt as the favourite portraitist of the city. Most of his patrons, as well as those of his talented follower Abraham van den Tempel (1622/3–1672), were wealthy members of the regent class, admirals, or military heroes; Dutch theologians and scholars were less fascinated by his manner. Van der Helst's fame did not diminish during the eighteenth century. When Sir Joshua Reynolds visited the City Hall in Amsterdam in 1781 he found Van der Helst's group portrait of *Captain Bicker's Company* far superior to Rembrandt's *Night Watch* [67], which hung in the same building. Of *Captain Bicker's Company* Reynolds wrote '[it] is, perhaps, the first picture of portraits in the world, comprehending more of those qualities which make a perfect portrait than any other I have ever seen. . . . Of this picture I had before heard great commendations; but it as far exceeded my expectation, as that [*Night Watch*] of Rembrandt fell below it. So far, indeed, am I from thinking that this last picture deserves its great reputation, that it was with difficulty I could persuade myself that it was painted by Rembrandt. . . .'[3] Like

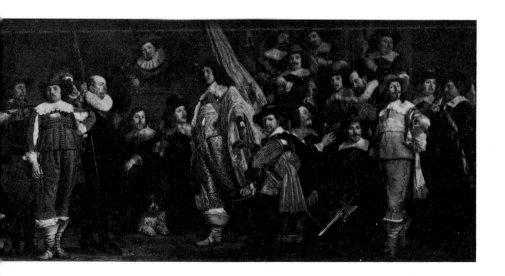

many others, Reynolds was impressed by the swagger, the fine colouring, and the clarity with which each of the thirty-two figures in Van der Helst's group are rendered. He was apparently blind to Rembrandt's new solution to the complicated problem of painting a group portrait of civic guards. Rembrandt – as we have shown before – decided to unite all the figures in the *Night Watch* in one concentrated action dramatized by the power of his chiaroscuro as well as by a great diversity of movement, instead of merely painting a collection of single likenesses, in a loose composition. In a way Rembrandt's radical solution annulled the original purpose of group portraits of militia companies, which was to represent the likenesses of a large group of individuals, and transformed it into a historical painting of unmatched dramatic character and pictorial glamour.

Though we know that the *Night Watch* was not refused by the men who commissioned it, apparently neither the artists nor the citizens of Amsterdam were impressed by it. No group portraitist tried to emulate Rembrandt's revolutionary achievement. Govert Flinck's *Company of Captain Albert Bas and Lieutenant Lucas Conijn* dated 1645 and Van der Helst's *Banquet of the Civic Guards to celebrate the Conclusion of the Peace of Münster* of 1648 (both in the Rijksmuseum) were still clearly and sharply delineated group portraits. The interest of the average Dutch artist in detailed portrayal, and the inclination towards brighter colouring which became popular during the forties by the influence of Van Dyck's followers, came to the fore and found favour with the public. Moreover, the moment had arrived when portraits of large bands of civic guards were superfluous. With more peaceful times the companies were not disbanded, but it was no longer such a special honour to be a member or officer of a militia company. When Van der Helst painted group portraits for the *Amsterdam Handbow*

Archers' Guild in 1653, the *Musketeers* in 1655, and, in the following year, the *Crossbow Archers' Guild*, he was commissioned to limit his portraits to the four governors of each company. Rank and file members and officers of low rank are dismissed. The governors are dressed as regents, not military men, and are seated round a table inspecting in an ostentatious manner the costly treasures of their guild (1653), eating oysters (1655), or busy with paper work (1656). These group portraits help us to see the high plane Rembrandt attains in the *Syndics of the Drapers Guild* of 1661/2 [89]. Rembrandt's subject is the same, a group of men seated round a table, but we must not let the simplicity and the evident naturalness of the *Syndics* allow us to overlook the superiority of his artistic achievement. There is no precedent for the depth of his characterization of the individual sitters. The problem of unifying the six men into a group has also been given a perfect solution. We have already discussed how Rembrandt provides a momentary tension and an easy, natural rhythm for the group by slight actions and movements. Rembrandt knows well how to restrain the realistic effects, which are so obtrusive in Van der Helst's groups, by binding together the whole by a well-balanced design and a convincing atmosphere. Of course, in the *Syndics* Rembrandt could hardly represent his models in complete isolation and in the introverted attitude he used in his late single portraits: group portraiture only makes sense when contact between the members of a group is established. Rembrandt not only establishes the necessary spiritual and pictorial bond, but he creates one which raises the mood of the group portrait to a new level. The work remains the climax of Dutch group portraiture. With the exception of Frans Hals' late regent pieces, all that follows in this category is insignificant.

From an artistic point of view, the regent pieces painted during the last decades of the

century bring little that is new. They are mostly a repetition of the colourful and pretentious manner of Van der Helst's late works. Even the gifted Jan de Bray (*c.* 1627–1697), whose vigorous single portraits of the early sixties [254] show that he learned at Haarlem from

254. Jan de Bray: Andries van der Horne, 1662.
Lisbon, Mrs E. S. de Hortega

Frans Hals how to neglect detail in order to concentrate upon expression, quickly adopted the smooth, llimpid manner of Van der Helst and lost his strong personal touch.

The development of Nicolaes Maes (1634–93) tells the story of Dutch portraiture after 1660. Maes' precocious achievement as a gifted Rembrandt pupil has already been discussed. His fame rests primarily on his genre paintings of the intimate life of women and children made during the fifties. During the same decade he also made some portraits in Rembrandt's style, but he was never able to create a lively interplay of tones by breaking up large areas of light and

shadow as his master did, and the design of his early portraits, like the psychology, becomes over-simplified. However, both Maes and his clients were satisfied with his skill, and about 1660 he virtually abandoned genre painting and became a portrait specialist. His style also changed radically. Houbraken succinctly summarizes the shift. He wrote that Maes 'learned the art of painting from Rembrandt but lost that way of painting early, particularly when he took up portraiture and discovered that young ladies especially preferred white to brown.' Maes adopted the bright colours and studied elegance of Flemish artists and the popular late-seventeenth-century French court painters with such success that during the nineteenth century some historians argued that there must have been two Dutchmen named Nicolaes Maes: one who made Rembrandtesque genre pictures, and another who made fashionable portraits which are closer to Rigaud than to Rembrandt. Houbraken, who was a citizen of Dordrecht and well informed about his fellow townsmen, wrote that Maes made a journey to Antwerp to see paintings by Rubens and Van Dyck and that he met Jordaens there. It has been suggested that this trip accounts for the change in Maes' style; but it is not necessary to see a connexion between Maes' second manner and a trip to the South Netherlands. Maes could have learned that ladies prefer to be painted in light instead of shadow from Lievens, Flinck, Bol, and other Dutch artists who made the discovery before he did. It was also possible for him to acquire Van Dyckian airs without leaving Holland. We have already seen that the Flemish master's manner had been introduced to the Netherlands before Maes held a brush in his hand, and after the death of Hanneman and Jonson, Jan de Baen (1633–1702) continued to practise it with great success at The Hague. Moreover, there is reason to believe that Maes made his journey to Antwerp between 1665 and 1667; the shift in

his style occurs around 1660. Maes achieved great popularity among his contemporaries, who were beginning to emulate French taste and who were less reluctant than their grandfathers to show pride and wealth. In 1673 he moved from Dordrecht to Amsterdam, where he spent the last two decades of his life. His late portraits show his elegantly dressed patrons in a bright steady light, usually against the rosy glow of a dark garden [255]. Succulent brushwork and the sense that he is presenting a lively likeness (Houbraken actually claimed that Maes painted better likenesses than any painter who worked before or after him) distinguish him from other stylish portraitists of the period.

The career of Caspar Netscher (1635/6(?)–1684) is similar to Maes'. He started as a painter of genre and subject pictures and then turned almost exclusively to portraiture. The style of his small, highly finished pictures primarily derives from Gerard ter Borch, his ingenious teacher, whose fine small-scale portraits were frequently imitated but never equalled (see p. 223 ff.). In 1662 Netscher settled at The Hague, where he became fashionable. In his little half-lengths Netscher gave special attention to the accurate representation of costly clothes, and followed the international Late Baroque vogue of placing his courtly models against the background of a park decorated with sculpture [256]. Netscher's small-scale and meticulous execution had great appeal and stimulated a number of minor eighteenth-century Dutch portraitists. His sons Theodoor (1661–1732) and the more talented Constantijn (1668–1723) are among his closest imitators, but neither captures his allure. Netscher was able to learn some things from Ter Borch, but he failed to pass on to his sons what he had acquired from the outstanding Dutch master of portraits 'in little'.

255. Nicolaes Maes: Portrait of a Man, c. 1670–5.
Hannover, Niedersächsische Landesgalerie

256. Caspar Netscher: Maria Timmers, 1683.
The Hague, Mauritshuis

ARCHITECTURAL PAINTING

Architectural painting, which was developed as a special branch by Netherlandish artists, offers a great variety of subjects. The two main ones, interiors and street scenes, originated in Flanders. As early as the fifteenth century the Van Eyck brothers used church interiors as a setting for their religious pictures, and the crowded action in Pieter Bruegel's paintings, made more than a century later, frequently takes place in a street or town square. In these works, however, the figures are never subordinated to the architecture. Seventeenth-century Dutch painters were the first to minimize the importance of people in architectural settings in order to emphasize the beauty and power of buildings as an independent subject. Their greatest contribution was the portrayal of church interiors. In these they discovered extraordinary pictorial attraction when the play of sunlight and shadows enlivens the silent space with an almost mystical mood, and a sensitive eye can find tonal configurations of an unforgettable grandeur.

Interest in independent architectural subjects begins in the Late Mannerist period under strong Flemish influence. Among the first to specialize in this branch was Hans Vredeman de Vries (1527-after 1604), a painter, architect, and prolific designer of architectural and ornamental pattern books (cf. pp. 376-7). Today his paintings are rare (cf. *A Park around a Palace, with Lazarus in the Foreground*, Amsterdam, Rijksmuseum). Vredeman de Vries is best-known for the perspective handbooks he compiled. The most popular was *Perspective, Id est, Celeberrima ars . . .*, published in two parts at The Hague and Leiden in 1604-5. It contains studies of fantastic Renaissance palaces, courts, and gardens and was frequently used by later artists for their imaginary architectural paintings. Hendrick van Steenwijck the Elder (*c.* 1550-1603), a pupil of Vredeman de Vries, was an equally influential figure. He was born in Holland, but was active in Flanders. His son Hendrick van Steenwijck the Younger (*c.* 1580-before 1649) received training from his father in Antwerp, then moved to Germany and finally settled in England. The style and subjects of father and son are similar. Their views and interiors, stressing perspective and variety of architectural invention, inspired most of the painters of the transitional period. The addition of agitated figures, usually by another artist – a practice continued throughout the century – adds an illustrative quality. Generally the Steenwijcks' pictures are small and executed in a miniature fashion on copper. Distinct outlines characterize the drawing, and their bright colours are somewhat hard. They favoured contemporary Northern Renaissance architecture for their views of palaces; churches, even imaginary ones, were usually done in the Gothic style. As early as 1573 Steenwijck the Elder painted the *Cathedral at Aachen* (Schleissheim), one of the earliest known examples of its kind. He also made views of the immense nave of Antwerp Cathedral. But such actual church portraits are unusual – most of the interiors are imaginary views. As a rule they represent the church as seen from the nave, and always show it from above – the bird's eye view also adopted by landscapists active during this period. A high point of view enabled them to exercise their interest in perspective effects leading to an exaggerated distance, and to show as much as possible of the interior, richly decorated in

contrast to the bareness of Dutch Protestant churches in the next generation. Small figures are spread over the nave and aisles, with an intention to show some biblical episode or merely to entertain and lead the eye into the distance. Sometimes the interiors are enlivened by effects of artificial light. The Steenwijck tradition was continued in Antwerp by the Flemish painters Pieter Neefs the Elder (c. 1578-1656/61) and his son Pieter Neefs the Younger (1620-75). In Holland, Hendrick Aerts (active c. 1600) painted imaginary churches and architectural scenes which look plausible until the spaces he constructed are analysed. Bartholomeus van Bassen (?-1652) and Dirck van Delen (1605-71) also painted fantastic church interiors with impossible detail, and highly ornate Renaissance palaces in Steenwijck's style. One other artist can be mentioned in connexion with this phase of Dutch architectural painting. He is Rembrandt. The architectural settings of many of his biblical paintings are as fantastic as the buildings constructed by the early specialists. But Rembrandt never paints a church interior for its own sake, or merely to create a perspective effect. His fanciful structures (e.g. *The Presentation in the Temple*, 1631) [51] are always subordinated to the biblical figures, and the lofty imaginary spaces are co-ordinated with chiaroscuro effects to heighten the dramatic action and intensify the mood of scenes from Scripture.

The first artist to abandon the fanciful tradition was Pieter Jansz. Saenredam (1597-1665). When he appears on the scene, true realism enters Dutch architectural painting. He specialized in faithful representations of specific buildings; hence his title, the 'first portraitist of architecture'. He was born at Assendelft, near Haarlem, the son of the Mannerist engraver and draughtsman Jan Saenredam. When he was still a child, Pieter's widowed mother moved to Haarlem, where he spent the rest of his life. He studied there from 1612 to 1622 with Frans Pietersz. de Grebber. During these years he met the great architect Jacob van Campen, who was also a painter, and he continued to keep in touch with the man who was to design the new town hall of Amsterdam. Van Campen may have inspired him with his own architectural drawings. Saenredam also worked with the Haarlem architect-painter Pieter Post. According to Cornelis de Bie, who published the first biography of Saenredam in 1662, the artist entered the Haarlem Guild of St Luke in 1623, but 'only about 1628 devoted himself entirely to painting perspectives, churches, halls, galleries, buildings and other things from the outside as well as the inside, in such a way, after life, that their essence and nature could not be shown to a greater perfection. . .'.[1] There can be no quarrel with the estimate de Bie made of Saenredam's achievement, and his statement about the artist's beginnings as an architectural painter is not contradicted by the evidence now available: Saenredam's earliest dated church interior 'after life' is inscribed 1628 (*St Bavo*, Private Collection). The artist made short trips to Utrecht, Alkmaar, 's Hertogenbosch, Rhenen, and other Dutch towns to make drawings of public buildings and churches which served as preliminary studies for his paintings. Saenredam's working methods generally consisted of three stages. First he made a careful sketch on the site. This study was then used as the basis for an exact, rather large construction drawing executed with the aid of measurements and plans. Finished drawings were kept on file as part of the stock to which he turned when he was ready for the final stage: an oil painting on panel. The main outlines of his architectural paintings are frequently transferred by tracing from his construction drawings. A description of his working procedure makes it appear mechanical, and the reader may think it suitable for the production of architectural renderings, not works of art. However, a look at

Saenredam's paintings proves that this is not the case. None of his paintings – about fifty are known – can be categorized as tinted perspective studies. The unmistakable clarity of his vision and the intensity of his scrupulous observation, as well as a sensitive tonality, mark every one. Only in a few cases did Saenredam paint pictures of sites or buildings he had never seen. His rare views of Rome (e.g. *View of the Colosseum*, 1631, with figures by Pieter Post, Kettwig-Ruhr, H. Girardet Collection) were not made in Italy, but were based upon sketches taken from Maerten van Heemskerck's famous Roman sketch book. He was once the owner of this precious album, now one of the treasures of the Kupferstichkabinett in Berlin.[2]

Saenredam was a hunchback. Perhaps it was his physical deformity that made him a recluse, and he found solace in making architectural drawings unsurpassed in their accuracy. In any event, he was a paradigm of Dutch neatness and precision. There was also something of the archaeologist and antiquarian in his make-up. His paintings based upon Heemskerck's sixteenth-century views of Rome are faithful replicas. When he made changes in a drawing of an old church he is known to have written a careful note on the sheet to inform the onlooker that his drawing is not a completely faithful

257. Pieter Saenredam:
St Mary's Square and St Mary's Church at Utrecht,
1663. *Rotterdam, Boymans-Van Beuningen Museum*

document of what he saw on the spot. The inscriptions on his drawings as well as the works themselves support the impression that Saenredam must have been an unusually careful and conscientious worker who loved minute detail. The lengthy inscription on his drawing of the *Old Town Hall of Amsterdam* (Haarlem, Teyler Foundation) sounds a little pedantic to modern ears, but it is characteristic of his approach. It reads: 'I made this sketched drawing from a big and neat drawing, which I had drawn from life as perfectly as possible on a medium sheet of paper 15½ inches kermer foot measurement high and about 20 inches of the same measurement wide in the year 1641 on the 15th, 16th, 17th, 18th, 19th, and 20th of July working on it assiduously from morning till night. . .'. Sixteen years elapsed before the drawing was used as the basis for his painting of the *Old Town Hall* now at the Rijksmuseum. The length of time between preparatory drawing and painting is not unusual for Saenredam. The preliminary drawing for his view of *St Mary's Square and St Mary's Church at Utrecht*, dated 1663 (Rotterdam, Boymans–Van Beuningen Museum) [257], was finished in 1636. Although a quarter of a century separates the preparatory stage from the finished work, only minor adjustments were made: Saenredam changed the figures, removed two trees and a small barn which obscured part of the wide façade, and made the tower less squat. As one might predict, there is very little change in his style. The expert draughtsmanship is seen from the beginning to the end. The subtle daylight atmosphere and tonal unity of the view of *St Mary's Square* of 1662 is evident in works painted three decades earlier. His *Interior of the Choir of St Bavo* (1660, Worcester, Mass., Art Museum) [258], a view of the great church of Haarlem which he frequently painted and where he is buried, shows how suitable his delicate blond tonalities and the neatness and transparency of his technique were for the

representation of Dutch Protestant churches. The majestic whitewashed interior has been stripped of all decoration. Its bareness emphasizes its structural power. The only furnishings are choir stalls, a simple pulpit, the brass choir lectern, a chandelier, an escutcheon,

258. Pieter Saenredam:
Interior of the Choir of St Bavo at Haarlem, 1660.
Worcester, Massachusetts, Art Museum

and a memorial tablet. Saenredam shows us more of the choir than we could possibly see from a single point of view. This was deliberate: it enabled him to increase our sense of the vastness of the imposing interior. Three small figures in the choir and a single one in the triforium gallery also help to set the scale. In this interior Saenredam's fine geometric sense and love of plain surfaces – aspects of his style which are so appealing to our eyes – find their full expression. Only Carel Fabritius and Vermeer were capable of finding such painterly

259. Gerard Houckgeest:
Interior of the New Church at Delft, 1651.
The Hague, Mauritshuis

qualities in the rough surfaces of a plain white-washed wall.

Two Haarlem artists, Job Berckheyde (1620-93) and Isaac van Nickele (active 1659-1703), made church interiors which vaguely recall Saenredam's style; they, however, never match their model.

About 1650 the most interesting developments in architectural painting took place in Delft, where a new phase began with the church interiors by Gerard Houckgeest and Hendrick Cornelisz. van Vliet, and finally reached its climax in the works of Emanuel de Witte. Stylistic affinities with interiors painted in Delft later in the decade by Pieter de Hooch and Vermeer are apparent, and Vermeer's own exceptional masterpieces in this branch of painting – *The Street in Delft* [145] and *The View of Delft* [146] – can be viewed as part of the new movement. Gerard Houckgeest (*c.* 1600-1661) began as a painter of fantastic church interiors; he was probably a pupil of Van Bassen. By the middle of the century he broke with the old-fashioned tradition and

began to paint portraits of specific churches. His favourite subjects were the Old Church and the New Church at Delft. His *Interior of the New Church at Delft*, dated 1651 (The Hague, Mauritshuis) [259] shows the change from Saenredam's delicate monochromatic mode. There is a striking gain in pictorial contrast. Bright rays of sunlight now enter the interior and relieve the powerful plasticity of the columns. Our position in the church has shifted. We are given a view from the side, instead of the traditional place near the centre of the nave at right angles to a wall. The new position creates intricate diagonal views. There is also a reduction in the number of motifs; Houckgeest emphasizes one by underplaying others. A massive column is given the central position close to the viewer, and the tomb of William the Silent, the best known monument in all the Netherlands, has been subordinated to it. People in the church now do more than give us an idea of the height of the interior: they take an active part in its life, and their clothes provide bright red and vivid yellow colour accents. Hendrick Cornelisz. van Vliet (1611/12–1675) appears on the scene at Delft, his native town, as a mediocre portrait painter. He began to specialize in architectural painting in the early fifties apparently under Houckgeest's influence. His style is similar to Houckgeest's, but weaker and less imaginative in suggesting the spaciousness of an interior. Anthonie de Lorme (*c.* 1610–1673) began as a painter of imaginary church interiors, but soon concentrated upon portraits of the St Laurens Church at Rotterdam in the style of De Witte.

Consideration of Emanuel de Witte (1616/18–1692), who represents the acme of architectural painting in the Netherlands, underlines the limitations of treating the history of seventeenth-century Dutch painting by subjects. De Witte was also a history painter and a portraitist, he depicted harbour scenes, and his genre pictures are as notable as his well-known

260. Emanuel de Witte: Fish Market, 1672.
Rotterdam, Boymans-Van Beuningen Museum

261. Emanuel de Witte: Interior of a Church, 1668.
Rotterdam, Boymans-Van Beuningen Museum

church interiors. Only De Witte was able to record the small drama that can occur at the commonplace encounter of a fish vendor and her pretty, well-dressed customer [260]. This versatile artist was born at Alkmaar, the son of a schoolmaster, and is said to have studied at Delft under the little-known still-life painter Evert van Aelst. He was active at Delft from about 1641 to about 1651. A *Danaë*, dated 1641 (Amsterdam, Willem Russell Collection), is his earliest known work. A few other subject pictures can be placed in the forties as well as a pair of small portraits (dated 1648) now in Rotterdam. Apparently he only turned to architectural themes around 1650. His new interest was probably stimulated by the example of Houckgeest and Van Vliet. By 1652 he had settled in Amsterdam, where he spent the rest of his life. He had a difficult character, and although he won recognition during his lifetime, he found existence bitter. About 1660 he indentured himself to an Amsterdam notary, agreeing to give him everything he painted in return for board and lodging and 800 guilders

per year. As in so many of De Witte's affairs, litigation arose out of this arrangement. Debts plagued him during his last decades, and he ended his life by suicide. His unstable personality may explain the uneven quality of his production. It is noteworthy that not a single drawing can be attributed with certainty to his hand.

De Witte was inspired by the buildings of Amsterdam – for example, the Old Church, the lofty New Church, and the interior of the Portuguese Synagogue of that city. However, only a few of his architectural paintings are faithful reproductions of his models.[3] He did not share Saenredam's objectivity and love of archaeological correctness. He frequently re-arranged architecture to increase the spatial effect or massiveness. He also painted purely imaginary interiors of Gothic and Renaissance churches, and designed churches using elements taken from well-known Dutch buildings. But he always convinces us, in an uncanny way, that he has painted a view of a real church – additional proof of the powerful inventiveness and imagination of Holland's greatest masters. It is a surprise to learn that the *Interior of a Church* (1668, Rotterdam, Boymans-Van Beuningen Museum) [261] is one of De Witte's

compilations and not a view of a known building. The windows at the end of the long nave and the organ on the left are based on what De Witte saw at the Old Church in Amsterdam; the massive columns – but not the capitals – were modelled after the huge piers at St Bavo in Haarlem. The round arches and vaults, and the late afternoon sunlight which glows through the building, are purely imaginary. Distances are still clear, yet darkness will soon fall over this articulated play of forms. And this great artist not only could create majestic church interiors giving the convincing impression of reality; he also endowed them with a profound personal mood. His tonal

design organizes the picture plane in a slightly geometrical fashion and substantially contributes to the articulation of the spatial effect.

It is not difficult to imagine Mondrian nodding with approval at the light and shadow patterns found in these seventeenth-century compositions. De Witte's own contemporaries recognized that he was the best architectural painter of his day. In 1662 he was praised by the poet Jan Vos, along with Rembrandt and other leading painters, as one of the artists who would spread Amsterdam's fame as far and wide as her ships travelled the seas. Comparison of his works with those by Houckgeest and Van Vliet show his richer and more interesting

262 (*below*). Gerrit Berckheyde: The Market Place and St Bavo at Haarlem, 1674. *London, National Gallery*
263 (*opposite*). Jan van der Heyden: The Heerengracht at Amsterdam. *Wassenaar, Sidney J. van den Bergh*

pictorial qualities. Though he never uses their exaggerated perspectives and illusionistic tricks, he creates more powerful spatial effects. The movements and gestures of the figures are appropriate to the silence suggested by his dark interiors. Not infrequently the motif of a gravedigger is added to the casual visitors in elegant costumes. In general, there is the same noble restraint as in Pieter de Hooch's best genre pieces, Kalf's still lifes, and the grand solemnity and deeply melancholy mood of Ruisdael's forest scenes.

Another representative of this generation, which is distinguished by pictorial power and vigour of sculptural accents, is Gerrit Berck-heyde (1638–98). He specialized in small pictures of the streets, canals, and squares of his native town of Haarlem, and of Amsterdam. Gerrit was probably a pupil of his elder brother Job Berckhcyde. Both brothers travelled to Germany in their youth and worked at Cologne, Bonn, and for the Elector Palatine at Heidelberg. After they returned to Haarlem – Gerrit entered the guild in 1660 – they lived in the same house. Gerrit's view of the *Market Place and St Bavo at Haarlem* (1674, London, National Gallery) [262] is a good example of the new increase in chiaroscuro and colouristic intensity. He is always robust, and not much above the average in pictorial sensitiveness. A

limited atmospheric quality and a slight dryness and harshness prevail, but the firm coherence of his design, as well as his vigorous delineation, leave us with a sense of satisfaction.

Jan van der Heyden (1637-1712) is one of the most enchanting masters of this group [263]. He was mainly active in Amsterdam, where he took more than a pictorial interest in the great metropolis. He organized street lighting and supervised improvements in the fire brigade; the fire hose is said to be his invention. His illustrated work on the fire hose, *Beschrijving der nieuwlijks uitgevonden en geoctrojeerde Slangbrandspuiten*, was published at Amsterdam in 1690. Van der Heyden primarily painted views of towns and streets, and apparently travelled in the Southern Netherlands and Germany to gather material. He also painted purely imaginary views (*An Architectural Fantasy*, London, National Gallery). As with Ter Borch, a quality of early Flemish painting seems to reappear: exquisite refinement without prettiness. Van der Heyden is a fine composer who keeps great structural clarity. While every single brick is readable, the total impression still dominates through a broad as well as minute disposition of lights and darks, and atmosphere is felt as pervading the whole space and softening the exact delineation. As we shall see, his attractive works were the principal inspiration for eighteenth-century architectural painters. His followers, however, were unable to strike the balance Van der Heyden maintained between a rich painterly quality and architectural precision. Among eighteenth-century artists one must turn to Canaletto to find his equal.

STILL LIFE

Still-life painting is a less conspicuous theme than portraiture or landscape painting, but it is equally typical of Dutch taste and pictorial genius. It reflects the seventeenth-century Dutchman's love of intimate domestic culture, so different from the courtly atmosphere of the Baroque in other countries. No other period or country produced still lifes in such quantity or quality, and no other branch of painting reveals more clearly the Dutch devotion to the visible. It is appropriate that our English word 'still life' derives from the Dutch word *stilleven*. The Dutch themselves only began to use the word *stilleven* about 1650. Before that time they referred to 'still standing objects' (*stilstaende dingen*) or merely labelled their subjects 'breakfast' (*ontbijt*), 'banquet' (*bancket*), 'fruit piece' (*fruytagie*), and so on. However, the special interest of the Netherlander in still-life motifs has a long history. As in so many other categories of their painting, it can already be recognized in fifteenth-century Netherlandish art. The objects used to furnish interiors in altarpieces by the Van Eycks and Roger van der Weyden multiply, and these artists treat a vase of flowers, fruit, tableware, a chandelier, books, and even a pair of slippers with unprecedented care and charm. Sometimes their modest accessories were not merely painted for their own sake; they signify something. For example, the lilies in a vase, the immaculate towel hanging from a rack, and the ewer and basin found so frequently in fifteenth-century representations of the bedroom of the Virgin are references to the Virgin's purity. But it is evident that there had to be an interest in such objects before they could be given a prominent place in religious pictures.

Delight in representing flowers, food, and household equipment continued in the north during the sixteenth century. They are given an important position in pictures of the Virgin and Child, in biblical scenes which show a meal, and in group portraits of a militia company or of a family round a table. *Vanitas* still lifes were sometimes painted on the back of portable altars to remind men of the ephemeral nature of life and all our earthly pleasures. Common *vanitas* motifs were a skull and a snuffed-out candle, with the familiar admonition *memento mori* added. During the second half of the sixteenth century the Amsterdam painter Pieter Aertsen and his nephew Joachim Bueckelaer painted monumental market and kitchen scenes which at first glance appear to be pure still lifes, but closer inspection usually reveals a tiny biblical episode in the background. It is hard to suppress the feeling that the religious subjects in their paintings were merely added to satisfy clients who wanted a little more than an abundant display of meat, fish, fruit, and vegetables. Their type of still life was developed in Flanders during the seventeenth century in the hands of Frans Snyders and other members of Rubens' school. Exuberant figures and lively animals play an important part in these sumptuous and decorative Flemish works, and under the influence of Rubens, inanimate as well as animate objects acquire verve and vitality. In the Northern Netherlands the development took a different turn. There still-life pictures represented this category in a purer sense. They are not combined with live figures and become more intimate and restrained. During the course of the century different types of still life evolved. Some artists became specialists, and

many others, including Rembrandt, Dou, Salomon van Ruysdael, and Metsu, tried their hand at this branch of painting. There were those who painted flower pieces and those who represented fruit, there were specialists in simple breakfasts, in opulent banquet tables, in game, and in fish still lifes. The moralizing tradition of the *vanitas* still life continued, and the seventeenth-century craze for emblems induced some to paint still-life motifs designed to be enjoyed by the clever observer who could supply the appropriate motto and epigrammatic stanza. The content of seventeenth-century Dutch still lifes was never chosen at random. Each type has its own iconography: the shells which decorate flower paintings never appear in a breakfast piece, a twisted lemon peel can be found on a banquet table, but not in a fish still life, and the props used for *vanitas* still lifes were well fixed.

One of the oldest types is the flower piece. Once established, it never lost its popularity – it is appropriate that among the masterpieces of Van Gogh, the greatest modern Dutch master, his paintings of sunflowers are special favourites. The Dutch are still the most flower-loving people in the world. Today, when flowers may be had on every street corner of the Netherlands for a small price, Dutchmen rushing home from their offices pick up a bouquet as well as a newspaper. Flowers are also an important part of the Dutch economy; bulbs remain a primary Dutch export commodity.

It seems that flower painting was established as an independent category in the Netherlands during the third quarter of the sixteenth century, with the rise of a widespread interest in gardening and the cultivation of exotic flowers. Renaissance and Baroque gardens were a kind of outdoor *Kunst- und Wunderkammern*, and we can assume that even before the seventeenth century, when the Dutch became Europe's leading horticulturists, there

were Netherlandish botanists and amateur gardeners who enjoyed possessing beautiful permanent records of familiar and strange blossoms. Perhaps there is a grain of truth in the legend that the flower piece was invented when a lady asked an artist to paint some rare blossoms for her because she was unable to acquire them. Literary sources give us the names of a few late-sixteenth-century flower painters. Van Mander is said to have painted flower pieces, and he himself informs us that bouquets were depicted by his friend Cornelis van Haarlem as well as by Pauwels Coecke van Aelst and Lodewyck Jansz. van den Bosch. No flower pieces by these painters are known, but Van Mander's description of Van den Bosch's works gives an idea of them. Van den Bosch, wrote Van Mander in 1604, showed flowers 'in a glass of water, and on which he spent so much time, patience and care that they seemed entirely natural. He also painted the heavenly dew on flowers and plants, and furthermore all kinds of insects, butterflies, small flies and similar things . . .'. Paintings which fit this description are known by artists who worked in the Netherlands during the first decades of the seventeenth century. The principal member of this group is Ambrosius Bosschaert the Elder (1573–1621), the founder of a dynasty of fruit and flower painters.

Bosschaert the Elder was born at Antwerp and emigrated with his family to Middelburg, where he was mainly active. During his lifetime Middelburg, ancient capital of the province of Zeeland, was second in importance only to Amsterdam. Though Bosschaert never won the international reputation earned by his Flemish contemporary Jan Bruegel, he was extremely successful, and in 1621, the year he died, he was able to command 1,000 guilders for a large flower piece painted for a member of Prince Maurice's retinue. This fee was a high one, but not out of line for work done by accomplished

Dutch flower painters. They were, in fact, among the best paid artists of their time. In 1606 Jacques de Gheyn received 600 guilders for a flower piece painted for Marie de' Medici, and De Gheyn's son is said to have refused to part with another one by his father for over 1,000 guilders. A characteristic Bosschaert is the *Bouquet in an arched Window* (The Hague, Mauritshuis) [264]. Jacques de Gheyn and

264. Ambrosius Bosschaert the Elder:
A Bouquet in an arched Window, *c.* 1620.
The Hague, Mauritshuis

Roelant Savery painted similar multi-coloured bouquets in niches, but only Bosschaert showed flowers against an open vista. The painting is done in the tradition of the miniaturists, with exquisite attention to detail. Baroque chiaroscuro is still absent. Each bloom in the typically symmetrical arrangement is given equal attention and is minutely analysed in an even light.

L. J. Bol, author of the closest study made of Bosschaert and his followers, writes of the artist's inspired patience, and he rightly compares Bosschaert's floral arrangements to contemporary Dutch group portraits. The flowers in Bosschaert's bouquets are like 'individual portraits placed beside and above each other, each being given its full pound of recognizability. No single one is subordinated, or sacrificed for the sake of composition, lighting, atmosphere or tonality. . . . A striving after lucidity and exactitude sometimes leads, with Bosschaert, to hyper-realism: no flower is thus left in the shadow, every corolla emerges clear and radiant, in its own local colour, in the same "impartial" light. All subjects appear simultaneously in the foreground, in a unity of time, place and "action" enforced by the painter: a successful *tour de force*.'[1]

Analysis of the flower pieces made by Bosschaert and other flower painters of his time reveals that their bouquets were seldom painted from life. They were assembled from a number of independent studies which serve as patterns. The pictures frequently show blossoms which bloom at different seasons of the year, and it is not unusual to find the same flower, shell, or insect in more than one picture. Bosschaert's type of flower piece remained popular until after the middle of the century. His most interesting follower is his brother-in-law Balthasar van der Ast (1593/4-1657), who manages to avoid the hard, metallic quality of so many others influenced by Bosschaert. Van der Ast's paintings are more varied than Bosschaert's, and they frequently include lively lizards and toads. His particular speciality is the still life composed exclusively of shells. Other painters who continued the Bosschaert tradition are his three sons, Ambrosius (1609-45), Johannes (1610/11-?), Abraham (1612/13-1643), and the Haarlem painter Hans Bollongier (1610-44 or later).

Paintings of food laid out on a table were also popular from the beginning of the century. Floris van Dyck (1575-1651), Floris van Schooten (active *c.* 1610-1655), and Nicolaes Gillis (active *c.* 1620-30) were early specialists of this category. All three worked at Haarlem, but interest in this subject was not confined to Haarlem, or indeed to painters working in Holland. In every country of Europe Early Baroque artists reacted more spontaneously to the visual world than their predecessors did, and there are Flemish, French, German, Spanish, and Italian still-life painters who share the stylistic and iconographic features found in Floris van Dyck or Van Schooten. To be sure, national differences remain. The Flemish love of abundance never disappears, and a geometric rigour sets off French table pieces from Dutch ones. But all early-seventeenth-century still-life painters of food depict objects from a high point of view, to show as much as possible of the surface of a table, a vantage point – as we have heard – similar to the one used by contemporary landscape, marine, and architectural painters. Symmetrically arranged platters of fruit, nuts, sweets, as well as glasses, jugs, and knives, are spread upon a flat tablecloth. The inanimate objects appear to pose in a steady light, showing how carefully every surface and texture has been scrutinized and how faithfully everything has been rendered. It is perhaps difficult for us to imagine the amazement and sheer delight seventeenth-century observers took in the skill of artists who could represent delicious food with such exactitude: our eyes have been numbed by reproductions of colour photographs of food in countless advertisements designed to sell packaged edibles.

A unique contribution was made by the Dutch still-life painters who appear on the scene around 1620. Their work corresponds to the tonal trend of the landscapists of Van Goyen's generation. Pieter Claesz. (1597/8-1661) and Willem Claesz. Heda (1599-1680/2),

popularizers of the breakfast piece, are the principal representatives of this phase. Claesz., the father of Nicolaes Berchem, was born at Burgsteinfurt in Westphalia; Heda's origins are obscure. Both were primarily active at Haarlem and underwent similar stylistic developments. Their early works show the influence of the older still-life painters, but they soon limited themselves to the description of a simple meal set near the corner of a table – some bread and cheese, a herring on a pewter dish, a glass of beer or wine, perhaps a silvery pewter vessel, and a white crumpled tablecloth – just enough to suggest a light breakfast or snack [265]. These objects, which always look as if they had been touched by someone who is still close by, are no longer treated as isolated entities: they are grouped together, forming masses along a single diagonal axis. But more important, Claesz. and Heda reacted to the comprehensive forces of light and atmosphere which envelop us and the things with which we live, and they found means to express their reactions to these forces as accurately, immediately, and intensely as possible. As a result, they seem to animate their simple subjects. With a new pictorial mode, they achieve a more dynamic spatial and compositional treatment. The foreground of their unpretentious arrangements becomes spacious, and there is clear recession. Instead of vivid local colours, monochromatic harmonies with sensitive contrasts of *valeurs* of low intensity are favoured, without, however, a loss of the earlier regard for textural differentiation. From the point of view of composition and of colouristic, tonal, and spatial treatment the perfectly balanced still lifes by Claesz. and Heda are among the truly satisfying Dutch paintings made during the century. Claesz. has a coarser and more vigorous touch than Heda – perhaps he was inspired at Haarlem by Frans Hals' powerful brushwork. Claesz. was also a man of more simple tastes than Heda. Heda depicts oysters

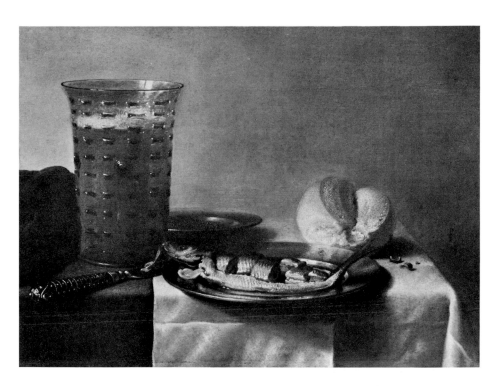

265. Pieter Claesz.: Still Life, 1636.
Rotterdam, Boymans-Van Beuningen Museum

266. Willem Heda: Still Life, 1648.
Leningrad, Hermitage

more frequently than herrings, and after 1640 his compositions become larger, richer, and more decorative [266]. To obtain a more monumental effect, Heda abandons the traditional horizontal format for a vertical one. Ornate silver vessels and costly *façon de Venise* glasses intensify the contrasts of *valeurs*, and touches of colour provided by the pink of sliced hams and ripe fruit are combined with an increased chiaroscuro.

The monochromatic style was also practised by Jan Jansz. der Uyl (1595/96-1640), Jan Jansz. van de Velde (1619/20-1663 or later), and a group of Leiden artists. The Leiden painters specialized in *vanitas* still lifes. Their pictorial arrangements of books and writing

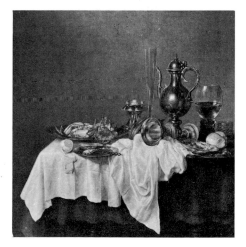

materials, rare and precious objects, musical instruments, pipes, snuffed candles, timepieces, and above all a skull, were read by their contemporaries as symbols of transience and the vanity of all earthly life. These motifs were an adequate expression of the intellectual atmosphere of the university town. Harmen Steenwijck (1612-after 1664) was the leading exponent of this category, and reflections are also seen in Rembrandt's Leiden pictures of scholars or saints in dimly lit interiors surrounded by books and other paraphernalia of the academic profession.

Jan Davidsz. de Heem (1606-1683/4), who was to win an international reputation as one of the greatest European still-life painters, also spent a brief time in Leiden. He was there from about 1625 to about 1629. His favourite theme during his Leiden years was a pile of old and well used books, signs of the vanity of the scholarly life. The fine greys and ochres of these *vanitas* pictures already show the exquisite sensitivity to colour which helped to establish his fame. De Heem worked in many styles. His youthful pictures of flowers, fruit, and shells are in the manner of his teacher Balthasar van der Ast, and he also painted simple, restrained still lifes which show his mastery of the chiaroscuro and the subtle tonal treatment of Claesz. and Heda. In 1636 he moved to Antwerp and became a citizen in 1637. There he spent most of his long life. Sandrart writes that De Heem moved to Antwerp from his birthplace Utrecht because 'there one could have rare fruit of all kinds, large plums, peaches, cherries, oranges, lemons, grapes, and others in finer condition and state of ripeness to draw from life . . .' This may be the case. In any event, it was at Antwerp that De Heem found his special province. There he painted his famous flower pieces and abundant displays on tables piled high with baskets of huge, expensive fruit, and glistening lobsters, also decorated with exquisite

trappings, precious metal vessels, and delicate glassware. He is one of the rare Dutchmen who captured some of the exuberance of Flemish Baroque painting, and his colouristic splendour rivals that of the native Flemings. The success of these pictures won him many imitators both in Flanders and the Netherlands. The difficult task of separating his work from that of his followers has not yet been fulfilled; his son Cornelis de Heem (1631-95) can come dangerously close to his father. Jan Davidsz. de Heem's works were also frequently copied during the eighteenth and nineteenth centuries. Matisse made a copy about 1895 after the large composition in the Louvre [267]. He sold this copy, then bought it back and used it as an inspiration for his *Variation on a Still Life by De Heem* (1915-17, Chicago, Mr and Mrs Samuel A. Marx Collection). Though Matisse's *Variation* on De Heem shows an unmistakable debt to the Dutch painter's composition, it has been completely translated into his own personal style, one which even versatile De Heem would have had trouble in adopting. If De Heem could have heard Matisse speak about still-life painting in 1908, he probably would have been baffled by the statement: 'to copy the objects in a still life is nothing'. On the other hand, neither De Heem nor his contemporaries would have insisted that 'to copy the objects is everything'. They probably would have wondered, and not disagreed, if they could have heard Matisse maintain that a still-life painter 'must render the emotion they [the objects] awaken in him. The emotion of the ensemble, the interrelation of the objects, the specific character of each object – modified by its relation to the others – all interlaced like a cord or a serpent. The tear-like quality of this slender, fat bellied vase – the generous volume of this copper – must touch you. A still life is as difficult as an antique and the proportions of the various parts as important as the propor-

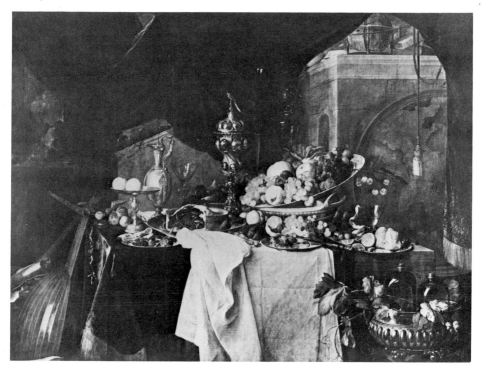

267. Jan Davidsz. de Heem: Still Life, 1640.
Paris, Louvre

tions of the head or the hands, for instance, of the antique.'[2] It is noteworthy that even after the achievement of the great Baroque still-life painters, and after the accomplishment of Chardin, Courbet, the Impressionists, and Van Gogh in this category, Matisse found it necessary to plead that composing a picture of pots and pans is as difficult as working after the ancients. Matisse's argument by implication is an impressive tribute to the longevity of the Renaissance tradition that artists must master the canons of ancient art in order to make figure compositions, the branch of painting earlier critics considered superior to the representation of inanimate objects. As far as we know, no seventeenth-century Dutch still-life master took a stand on this issue. However, one revolutionary Baroque master did. Caravaggio challenged the well-established hierarchy of genres of painting, as well as anticipating Matisse's remarks by three centuries, when he asserted that 'it took as much craftsmanship to paint a good picture of flowers as one of figures'.[3]

The best representative of the classical period of Dutch still-life painting is Willem Kalf. He was born in 1619 in Rotterdam, where he was probably influenced by François Rijkhals, a painter of small peasant scenes which include displays of fruit and vegetables, and of large still lifes of precious objects.[4] From the very beginning Kalf painted similar motifs:

little pictures of kitchens and barns, as well as still lifes of metalwork, glass, and porcelain. More than once the same costly objects appear in Kalf's paintings; since he was a dealer in works of art as well as a painter, most likely he used his stock-in-trade as models. Kalf's earliest phase is a Parisian period; there is evidence that he was in the French capital between 1642 and 1646. It is sometimes said that all his tiny paintings of interiors and farmyard scenes were done during those years, but since three are dated 1652, 1663, and 1670, it is clear that he continued to represent these modest themes after he returned to his native land.[5] Compared to the masterpieces created during his later years, the crowded still lifes made in France of valuable metal objects and fine glassware are disorderly, though an emphasis on vertical and horizontal elements already shows a tendency towards the tectonic compositions that helps to account for the monumentality of his mature works. Even in his youth Kalf was able to impart a mysterious quality to the precious things he painted. Goethe grasped this when he wrote in 1797 of one of Kalf's earliest works (now at Cologne, Wallraf-Richartz Museum, dated 1643): 'One must see this picture in order to understand in what sense art is superior to nature and what the spirit of man imparts to objects when it views them with creative eyes. There is no question, at least there is none for me, if I had to choose between the golden vessels or the picture, that I would choose the picture.'[6]

By 1651 Kalf was back in the Netherlands; he was married at Hoorn in that year to Cornelia Fluvier, a talented diamond engraver, calligrapher, and poet. Vondel composed a poem in honour of the marriage. Kalf, Vondel wrote, likes to paint luxurious banquets, lemons, glass, a nautilus goblet; and just around this time a vogue began in the Netherlands for these rich still lifes, particularly among the wealthy patrician classes of Amsterdam. No painter satisfied the demand better than Kalf. He settled in Amsterdam in 1653, and was active there until his death four decades later, in 1693. The Dutch call luxurious still lifes *pronkstilleven* (*pronk* means show, ostentation). However, with Kalf's sure sense of composition, which is as remarkable as his choice of light and colour accents, his works are never ostentatious, but of a noble restraint. His opulence is tempered by calmness and stability. During the Amsterdam years he reduced the number of objects he represented. He now preferred to show a close view of one or two rhythmically arranged silver or gold vessels, a single precious glass, perhaps an enamelled watch, a bowl, and a few pieces of fruit on a table with a marble or rare wood top [268]. A glowing colourism of great distinction develops, which combines Rembrandt's rich and expressive chiaroscuro with Vermeer's exquisite sense of colour. Kalf's technique also seems to be a combination of Rembrandt's liquid impasto and Vermeer's *pointillé*. Like Vermeer, he gives preference to a blue-yellow accord in his ever-present central motif of a peeled lemon with a blue Delft or China bowl. The rich texture of the carpets on his table also recalls the beautifully painted carpets by Vermeer. Kalf's followers and imitators include Juriaen van Streek (1632–87) and Barend van der Meer (1659–92 or later); Willem van Aelst (1625/6–1683 or later) also occasionally worked in his style.

Kalf's contemporary Abraham van Beyeren (1620/1–1690) is an outstanding master of the large banquet piece. Like Jan Davidsz. de Heem, who seems to have inspired him, Van Beyeren painted sumptuous compositions of lobsters, fruit, and expensive tableware, and included rich draperies and columns to enhance the splendid effect [269]. Van Beyeren, however, never overloads his compositions in the

268. Willem Kalf: Still Life with a Nautilus Cup, *c.* 1660. *Lugano, Thyssen-Bornemisza Collection*

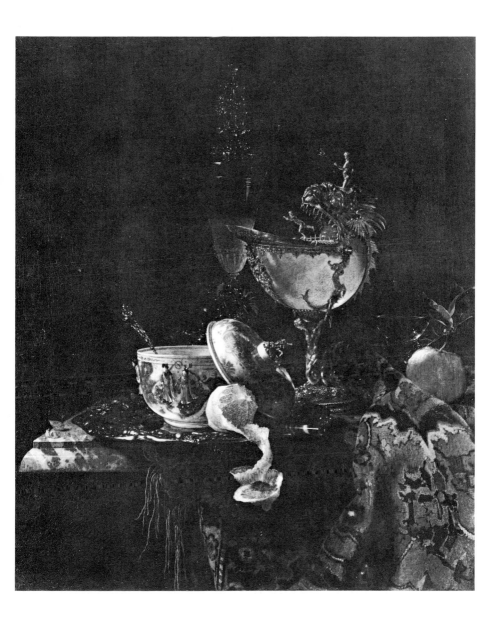

269. Abraham van Beyeren:
Still Life, 1654.
Rotterdam, Boymans-Van Beuningen Museum

way that De Heem does; on the other hand, he seldom shows Kalf's moderation. At his best, he is a subtle colourist who works in a light key, with an appealing free and liquid touch. A soft silvery light unifies his fine colour harmonies, anticipating the palette of eighteenth-century painters. This master of banquet tables also painted fish pieces. The earliest of these is dated 1649 (*Votive Tablet for the Fishermen's Guild*, Maassluis, Groote Kerk), four years before his earliest known banquet picture, a fact which supports the claim that the obscure Dutch fish painter Pieter de Putter was his teacher.[7] Van Beyeren's fish pieces seldom attract as much attention as his sumptuous banquet tables. Most people would rather study a picture of an exquisitely laid table than one of a mess of fish. Since seventeenth-century Dutch fish still lifes are relatively rare, this seems to

have been the case during Van Beyeren's time too. But Van Beyeren's fish pieces are as remarkable as his festive dinner tables. The fish and crustacea he painted always look wet – they appear to have been just taken from the water – and the mother-of-pearl greys of his creatures of the sea, their browns, silvers, and whites are as delicate and finely felt as the colour accords in his more showy pieces. Van Beyeren sometimes painted a view of the sea and a beach in the background of his fish still lifes, and a few marines can be attributed to him.

Not many Dutch artists represented dead game and fowl, perhaps because hunting and shooting was not done in the Netherlands on a large scale. Paintings of hunting trophies were never as popular in the northern provinces as they were in neighbouring Flanders, where royalty conducted grand hunts. Game and fowl still lifes began to appear in Holland only about 1640. Rembrandt made two pictures of this type (*Still Life with a Bittern*, 1637, Bredius 435; *Still Life with Dead Peacocks*, c. 1638, Bredius 436), but it is significant that in both a human figure plays an important part. During this phase of his career Rembrandt demanded more than dead birds and inanimate objects as a theme (the inventory made of Rembrandt's effects in 1656 lists a few other still lifes by him, including some *vanitas* pictures which may date from his Leiden period; none of these works has been identified). Unpretentious pictures of a few small dead birds on a table are known by Elias Vonck (1605-52) and his son Jan (active c. 1630-60), and we have noted that a few game still lifes can be ascribed to Salomon van Ruysdael. He made them late in life, probably under the influence of Jan Baptist Weenix. Weenix painted both modest hunting-trophy pictures and large, decorative ones. One of the finest of all, now at the Mauritshuis in The Hague, represents a single dead partridge hanging from

a nail against a light-grey wall. The convincing plein-air effect, refined painterly treatment, and fine design of the simple motif make it worthy of a place in the museum that houses Fabritius' unrivalled *Goldfinch* [138]. The better known still lifes of dead birds by Willem van Aelst, which include scrupulous studies of guns, leather pouches, powder horns and the like, set on marble slabs, arouse more interest in the appurtenances of the art of shooting than in the art of painting. Jan Baptist Weenix's large-scale *Dead Roebuck* (Amsterdam, Rijksmuseum) with a snarling dog and hissing cat suggests the influence of Snyders. While Weenix never

matches the dynamic movement in the Flemish master's displays, which always look as if they were created to help Diana herself to celebrate the abundance of the hunt, the texture of his paint is soft and beautiful. Jan Weenix (1640–1719), son of Jan Baptist Weenix, closely emulated his father. He specialized in game pieces, usually set in a park seen in the rosy glow of twilight and often embellished with sculpture, ornamental urns, and a view of a palatial house in the background [270]. He also painted huge canvases to decorate whole walls; such a series was painted for the count palatine's castle at Bensberg between *c.* 1710 and 1714 (now

270. Jan Weenix:
Hunting Trophy Still Life.
Formerly Dresden, Gemäldegalerie (destroyed)

Bayerische Staatsgemäldesammlungen). Jan Weenix's popular works helped to set the key for the decoration of stately eighteenth-century Dutch homes.

A special group of artists represented domesticated and wild birds. Strictly speaking their pictures are not still lifes, for they painted live not dead birds, but their emphasis on the textural and colouristic beauty of their subjects gives a still-life character to their works. Their patrons were the rich burghers who lived as landed aristocrats on estates in the country where they kept exotic as well as native fowl. Just as some painters were called upon by

flower fanciers to make portraits of favourite blossoms, others were asked by amateur and professional poultry breeders to paint prize birds and common farmyard specimens. Melchior d'Hondecoeter (1636–95), a pupil of Jan Baptist Weenix, and occasionally the versatile Aelbert Cuyp of Dordrecht, excelled in this branch of painting. Hondecoeter in his extensive work retains a good deal of the best qualities of the great age of Dutch painting [271]. He is both observant and gifted as a colourist, and admirably renders the texture of his feathery creatures. Two curious specialists, who are also difficult to categorize, are Otto Marseus van

271. Melchior d'Hondecoeter:
Fight between a Cock and a Turkey.
Munich, Ältere Pinakothek

Schrieck (1619-78) and Matthias Withoos
(1627-1703). Their dark paintings of under-
growth, wild flowers, thistles, and mushrooms,
animated by phosphorescent butterflies, in-
sects, and lizards, have always appealed to
collectors of highly finished Dutch cabinet
pictures.

During the last decades of the century Dutch
still-life specialists do not lessen in competence
of draughtsmanship or intimacy of treatment,
but their styles lose in grandeur and pictorial
quality. There is a definite change towards the
lighter vein which characterizes the art of the
eighteenth century.

PAINTING: 1675-1800

JAKOB ROSENBERG AND SEYMOUR SLIVE

CHAPTER 14

HISTORICAL BACKGROUND

When Louis XIV signed the Peace of Nijmegen in 1678, he agreed to give up most of the conquests he made after his abortive attempt to crush the republic in 1672. Endorsement of this treaty did not alter the aggressive policy of the king of France. William III's major task (as prince of Orange, captain-general of the Union, stadholder of five provinces of the Netherlands, and then as king of England and leader of the Grand Alliance) remained the same. He had to restrain Louis' imperialism William's brilliant political manoeuvring and military genius met with success. In 1697 Louis, exhausted, signed the Peace of Rijswijk, which gave advantages to the Dutch Republic as well as recognizing William as king of England. It was a defeat for France's military and naval forces, but not for French culture and art On the contrary. During the years of the struggle French taste permeated the art and life of the Netherlands, and this dependence continued throughout the eighteenth century. The impact of French influence was also strengthened by the wave of French Protestants who fled to Holland after the revocation of the Edict of Nantes in 1685. The prince of Orange himself helped to establish French fashion when he employed Daniel Marot, the Huguenot refugee (see pp. 411 ff.). William put Marot to work as early as 1686/7, and he soon made this gifted Frenchman his chief architect, giving him commissions in Holland and at his court in London.

After William III's death in 1702 the old struggle between the patrician oligarchy of the provinces and the supporters of the house of Orange was resumed. The powerful burgher class successfully prevented the stadholderships of five of the provinces, which had been made hereditary in the house of Orange in 1672, from going to William's cousin, Count John William Friso of Nassau, stadholder of Groningen and Friesland. Once again the republic was stadholderless, and it remained so until the Union was threatened by France during the Austrian War of Succession in 1747. In this crisis the Dutch turned, as they had so often in the past, to a member of the house of Orange for military leadership. They elected William IV (1711-51), son of John William Friso, stadholder of all seven provinces and appointed him captain and admiral-general of the Union.

During the stadholderless period between 1702 and 1747, Dutch affairs were in the

competent hands of loyal counsellors such as Anthonie Heinsius, Simon van Slingelandt, and François Fagel, but none of them ever had power to speak with real authority for the Union in the council of Europe. This became evident soon after the death of William III. Though Dutch armies fought bravely in the War of the Spanish Succession, which began in 1702, and had a real share in Marlborough's great victories, the republic was only able to secure a barrier against a renewal of French aggression and some minor commercial advantages when the Peace of Utrecht was signed in 1713. Their interests were, in fact, sorely compromised by the English, who permitted the defeated French to obtain far better terms than they were in a position to demand. The Peace of Utrecht marks a turning point in the history of the republic. During the following decades the Dutch avoided foreign entanglements and their impact on the international political scene soon became of little significance. A desire for peace, comfort, and tranquillity descended upon the country. It seems that rest was needed after so much passion and energy had been spent. National grandeur was now a thing of the past. England quickly took Holland's place as the supreme power on the high seas. Around the middle of the century Frederick the Great rightly compared the former close rivals to a great ship of the line towing a small boat in its wake.

William IV, an intelligent but ineffective figure, accomplished little before his premature death in 1751. His son William V (1748-1806), who assumed his hereditary powers in 1766, was a weakling much influenced by his gifted wife, sister of the king of Prussia, and his counsellor, the count of Brunswick-Wolfenbüttel. These connexions brought in German influence.

During the American War of Independence efforts by the Dutch to remain neutral failed. The arrogant British policy of stopping all neutral vessels on the high seas in order to confiscate goods which could aid her enemies forced the Dutch to join the international coalition against Britain. This action brought the Dutch upon the European stage again. The results were disastrous. The country was totally unprepared for war when it broke out in 1780. Moreover, it was difficult to make preparations or to take any decisive action, because Dutch sympathies were split: William V and his supporters sided with the English; others wanted to aid the rebellious American colonists. The mighty British navy quickly destroyed Dutch commerce and seized her colonial Empire. By the time the Dutch signed the Treaty of Paris with the English in 1784, the republic's economy was shattered. As a result of the humiliating defeat, anti-Orange sentiment in the country increased. William and his family were forced to flee from The Hague. Only after the Prussian army came to his rescue in 1787 was he restored to power. William managed to hold the reins of a shaky government until 1795, when the French revolutionary army conquered the country. Anti-Orangists welcomed the French with ardour, and William V fled to England. This was the pathetic end of the Republic of the United Netherlands. The stadholderate and other traditional offices were abolished and the Batavian Republic, entirely dependent upon France, was founded. The country remained a creature of France's destiny until Napoleon's defeat in 1813.

Costly wars of the late seventeenth and eighteenth centuries exhausted the Government's treasury, but the merchant class did not lose its wealth. Commerce continued to flourish, and Amsterdam held its position as an important trading centre and money market until the disaster of 1780. Under a system of taxation designed to favour the patrician class, it was possible for Dutchmen to accumulate great fortunes without making substantial contribu-

tions to the republic's exchequer. Huizinga finds the label 'Golden Age', which is usually given to Holland's great seventeenth century, a more suitable name for his country's eighteenth century, when plenty of gold pieces lay in Dutch strong boxes. He prefers to relate the seventeenth century to wood and steel, pitch and tar, paint and ink, daring and piety, spirit and fantasy, not to gold.[1]

During the eighteenth century the Dutch continued to show an interest in art and natural science, and they lost nothing of their admirable tolerance. Rationalism and the spirit of the Enlightenment were at home in the Netherlands. The country could boast of distinguished collectors and amateurs. The art market was lively, and connoisseurship was at a high level. Art historical literature began to appear. Arnold Houbraken's fundamental *De Groote Schouburgh*, the most important source on seventeenth-century Dutch painting, was published in 1718-21, and supplements to it were printed soon afterwards. The one compiled by Jacob Campo Weyerman (1729-69) does little more than plagiarize Houbraken, but Jan van Gool's *De Nieuwe Schouburgh* (1750-1) offers new material. Sales catalogues were also collected and reprinted (G. Hoct and P. Terwesten, *Catalogus of naamlijst van Schilderijn met derzelver Prijzen*, 3 vols, 1752-70). However, the fact remains that during this period the creative impulse of the Dutch declined. This began to be conspicuous as early as 1675. After the deaths of Frans Hals (1666), Rembrandt (1669), and Vermeer (1675), the heroic age of Dutch painting was over. Reasons can be given for the rapid decline, but it is also well to remember that a culture rarely maintains the vitality and high artistic standard the Dutch sustained for three generations.

The number of artists who continued to practise the well-established categories of painting did not diminish. The significant change is in the quality of their production. Over-

refinement set in, and work became more homogeneous. Attempts to come to terms with the predominant French style served as a leveller, not a catalyst. The strong individuality which marked the minor as well as the great masters of the earlier period virtually disappeared. No painter of genius thundered upon the scene. Eighteenth-century Holland did not produce a Goya. To be sure, Jacob de Wit and Cornelis Troost, who are justly ranked as the foremost eighteenth-century Dutch artists, stand out as personalities, but their works look provincial when hung alongside those by their great European contemporaries. It can be convincingly argued that even at its highest points, Dutch painting has an insular air. Its commitment to realism always makes it appear somewhat outside the main stream of Renaissance and Baroque art. Dutch artists forfeit some of their authority and poetry when their interest in realism weakens. Intense contact with the visual world appears to be one of their main sources of strength and inspiration. During the last decades of the seventeenth century and during the eighteenth century, this contact was slack. Old forms were often repeated. The weight of tradition and the sense of a great past were felt. Artists seemed to acquire something of the spirit of the Dutch patricians of the period, who were mainly *rentiers*, not *entrepreneurs*. They preferred to live on the dividends of their substantial capital rather than risk new ventures. Even Rembrandt's mature style found no more than one late adherent: Arent de Gelder, who continued to paint colourful variations on his master's manner until his death in 1727. At their best, most eighteenth-century Dutch artists achieve amiable and playful results. The most appealing contributions were made by those who turned to the method used by outstanding Netherlandish artists ever since the fifteenth century. Their rare works are based on a fresh view of life and nature.

THE DECORATIVE TRADITION

There was a limited tradition in seventeenth-century Holland for the use of sets of large paintings as permanent decoration for interiors. As we have heard, Honthorst and Bramer made some, and the Stadholder Prince Frederick Henry and his wife Amalia van Solms commissioned Dutch and Flemish artists to decorate the walls and ceilings of their palaces and country homes. This type of painting became more popular during the last decades of the century. Adam Pynacker and Frederick de Moucheron were employed by wealthy merchants to embellish town houses and country seats with large series of landscapes made in an Italianate style. Decorative game pieces by Hondecoeter and Jan Weenix were also popular. William III stimulated the fashion when he built new country houses at Soestdijk and Het Loo, and by remodelling his palaces at Breda and Honselersdijk as well as those in England.

The most popular decorator during these years was Gérard de Lairesse (1640-1711), who was called the 'Dutch Raphael' and the 'Dutch Poussin' by his over-enthusiastic contemporaries and eighteenth-century admirers. Lairesse was born at Liège, where he received instruction from his father and Bertholet Flémal and was impressed with the importance of studying the classical tradition and the Italian Renaissance masters. In spite of his training, when Lairesse arrived in Amsterdam in 1665 he was attracted by Rembrandt's mature style. He posed for the great master in the year he settled in Holland; Rembrandt's sympathetic portrait of the young artist whose face had been disfigured by disease is now in the Lehman Collection in New York (Bredius 321). Lairesse himself confessed that he ad-

272. Gérard de Lairesse:
Allegory of Amsterdam Trade, 1672.
Ceiling from No. 446 the Heerengracht, Amsterdam.
The Hague, Peace Palace

mired Rembrandt. He wrote: 'I do not want to deny that I once had a special preference for his manner; but at that time I had hardly begun to understand the infallible rules of art. I found it necessary to recant my error and to repudiate his; since his was based upon nothing but light and fantastic conceits, without models, and which had no firm foundation upon which to stand.'[1] The firm foundation upon which Lairesse wanted to build was the set of rules laid down by seventeenth-century French academic theorists. There were precedents for an academic approach in Holland, particularly in architecture. Only a few years before Lairesse arrived in Amsterdam, Constantijn Huygens had praised Jacob van Campen, the architect of the new town hall, as the man 'who vanquished Gothic folly with Roman stateliness and drove old heresy forth before an older truth'.[2] Lairesse wanted to do the same for Dutch painting. He made historical and mythological pictures according to the precepts of academic theory, and won acclaim as a decorator of civic buildings, palaces, and stately homes. He also collaborated with Johannes Glauber (1646-1726), a landscape painter who did arcadian scenes in Gaspar Dughet's style. William III employed Lairesse at Soestdijk and The Hague. He can still be seen to good advantage at The Hague; his most famous work, a series representing scenes from Roman history, is at the Binnenhof of The Hague, and his allegorical cycle celebrating the glories of Amsterdam, formerly ceiling decorations in a great house in that city, is now on view at the Peace Palace [272]. Lairesse worked from the late sixties until he went totally blind about 1690. Even afterwards, he continued to play an important role as an arbiter of Dutch taste by lecturing on academic art theory and practice. Lairesse's faith in his doctrine must have been matched by that of the members of his audience, who were willing to listen to a blind man expatiating on the visual arts. Before his death

Lairesse's talks were collected in two books: *Grondlegginge der Teekenkunst* (1701) and *Het Groot Schilderboek* (1707). Both were translated and frequently reprinted during the eighteenth century. Theodoor van der Schuer (1628-1707) and the brothers Augustinus (1649-1711) and Mattheus Terwesten (1670-1757), who had all received training in Italy, also made large-scale decorative paintings at The Hague, but they add little to the glory of the Dutch school. The Terwesten brothers were also active in Berlin.

Soon after Lairesse's death, Jacob de Wit (1695-1754), the best eighteenth-century Dutch painter to work in the decorative tradition, appeared on the scene. De Wit was born in Amsterdam of Catholic parents. After a brief period of study with Lairesse's pupil Albert van Spiers, he was sent to Antwerp about 1708 to work with Jacob van Hal; his real teachers in Flanders, however, were Rubens and Van Dyck. The studies and careful copies he made of their great altarpieces served him well when he returned to his native country about 1716 and settled in Amsterdam. De Wit was the first Dutch artist since the iconoclastic revolts of the sixteenth century to receive numerous commissions for religious pictures to go into Dutch Catholic churches and chapels. This was possible because during his lifetime the Dutch Catholics began to achieve greater religious freedom: their clandestine chapels could be abandoned, and they were allowed to hold services without interference from the authorities, as long as their church-going was inconspicuous and their chapels were unobtrusive. As late as 1730 a decree warned that 'care should be taken that the meeting places of the

273. Jacob de Wit:
Bacchus and Ceres in the Clouds, 1751.
Ceiling painting.
Heemstede, Huis Boschbeek

Catholics do not have the appearance of churches or public buildings, nor should they strike the public eye'. Congregations were, however, permitted to decorate the interiors of their places of worship, and De Wit became the favourite of the wealthy parishes. He amassed a sizeable fortune and accumulated a distinguished collection of drawings. De Wit's altarpieces and church decorations are based on a combination of the styles of Rubens and Van Dyck. The synthesis is not always a happy one. In his work, Rubens' strength neutralizes Van Dyck's elegance, while Van Dyck's grace tends to destroy Rubens' vigour. On the other hand, some of his straightforward copies after Rubens can be extremely deceptive. De Wit's most original contribution is in the field of ceiling decoration [273]. Here, too, he shows a debt to the Flemish school, particularly Rubens. While he was in Antwerp, he made drawings after the paintings Rubens designed for the coffered ceiling of the Jesuit church of St Charles Borromeus at Antwerp, a cycle which introduced to the Lowlands the Italian tradition of viewing figures on a ceiling as seen from below (*di sotto in sù*). When the ceiling of St Charles Borromeus was destroyed by a disastrous fire in 1718, De Wit's drawings became a valuable document of Rubens' imposing cycle. He made copies in various media of his original drawings of the ceiling; the best set is now at the British Museum. De Wit mastered the representation of figures as seen from below, and favoured the Italian High Baroque tradition of unifying a ceiling into a single picture to create the illusion of a roof open to the sky. His palette is in a higher key than that used by Italian Seicento masters – it is a Rococo palette of light blues, pinks, gold, and white – and the skies in which his figures float are summer skies filled with sparkling light. It is not hard to understand why some of his drawings and oil sketches, which are more spontaneous than his finished paint-

ings, have been mistaken for works by Boucher and Tiepolo. Eighteenth-century Holland gave De Wit little opportunity to practise his art on a large scale, for even the most imposing Dutch buildings were small compared to the palaces and churches decorated during the century in Italy, Germany, and France. He never received a great commission from abroad. Perhaps it is just as well. His monumental composition of *Moses selecting the Seventy Elders* (1737), painted for Amsterdam's Town Hall, is a colossal bore. However, the painted bas-reliefs of putti made as overdoor pieces for the room in the Town Hall where the Moses picture hangs have charm and are of special interest. They are grisaille imitations of marble reliefs, a type of decor popular in the Netherlands since the early Renaissance. No one excelled De Wit in this branch of painting, and his skill as a *trompe l'œil* artist won him an international reputation. De Wit's countrymen honoured him by naming illusionistic pictures of this type '*witjes*' (*wit* means white).

After De Wit's death no Dutch painter of merit carried on his tradition of painting ceilings illusionistically and of composing large sets of decorated panels. The demand for rooms with pictures set into the wainscoting diminished after the middle of the century. The traditional Dutch love of simplicity and distrust of grandeur again came to the fore. Around this time art lovers began to show a greater interest in displaying seventeenth-century easel pictures, as well as contemporary ones, in their homes. A vogue for painted, and then printed, wallpaper also helped to change the fashion. Today little is left of the rooms and stair halls decorated by Dutch artists of the period. Most of the patrician houses, country seats, and public buildings which contained their works have been remodelled or destroyed, and remaining sets have been largely broken and dispersed.

A few artists continued to paint overdoor and overmantel grisailles which reveal an unmistak-

able debt to De Wit. Aart Schouman (1710-92), Dirk van der Aa (1731-1809), and the brothers Abraham (1753-1826) and Jacob van Strij (1756-1815) were among the artists who made *witjes*. Aart Schouman and the Strij brothers, like so many eighteenth-century Dutch artists, were very versatile. The names of these minor artists will appear again in our discussion of eighteenth-century Dutch art as representatives of more than one category of painting.

Schouman, for example, made portraits, genre pieces, landscapes, topographical views, wall-hangings, and copied works by seventeenth-century masters. He was also a printmaker and engraver on glass; his finest works are his pure watercolours of birds and animals. One wonders if he and many of his contemporaries would have achieved more if they had concentrated their energies on a narrow field, in the way that most seventeenth-century Dutch artists did.

GENRE, PORTRAIT, AND HISTORY PAINTING

Most of the painters of cabinet pictures active during the last decades of the seventeenth century represented biblical, historical, and mythological events as well as more modest genre scenes. Few grasped the importance of the precious discovery made by their predecessors: the significance of the insignificant.

To be sure, kitchen maids and lacemakers were still part of their repertoire, but more pretentious themes were attempted with greater frequency. Perhaps these artists had higher ambitions than the earlier specialists. They and their patrons seem to have accepted the academic dogma that the history painter is the only man who can ever attain perfection in the art of painting. If so, the results they achieved did not match their aspirations. They often titillate, but their small pictures never suggest the universal ideals which Renaissance and Baroque art theorists proclaimed were the prerogative of the history painter.

These artists continue the high standards of workmanship, precise drawing, and minute execution of the masters of the Leiden School and of such domestic painters as Ter Borch, Metsu, and Netscher, but in their hands the illustrative tendencies of the earlier painters become more pronounced. Jacob Ochtervelt (1634–82) made interiors in the manner of De Hooch (*Portrait of a Family*, 1663, Cambridge, Massachusetts, Fogg Art Museum), was impressed for a brief period by the paintings of Vermeer, and then turned to scenes of the life of Dutch patricians in the style of Ter Borch. Lovely salmon pinks and silvery greys, and also violets and orange-browns, often distinguish Ochtervelt's palette. On the whole he does not equal Ter Borch's finesse, but he can

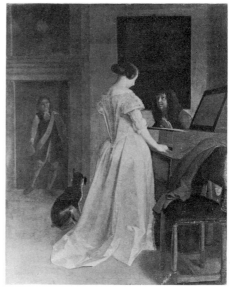

274. Jacob Ochtervelt: The Music Party, *c.* 1678–80. *London, National Gallery*

be remarkable as a colourist and stuff painter [274]. Eglon van der Neer (1634?–1703), son of the landscapist Aert van der Neer, and Jan Verkolje (1650–93) and his versatile son Nicolaas (1673–1746) also carried on Ter Borch's and Metsu's tradition of showing interiors with scenes of the life of the wealthy classes. They did so with some success. A sizeable group of these painters still had contact with the older Leiden masters, i.e. Dou and Frans van Mieris the Elder. As we have noted, the latter founded a dynasty of painters. His sons Jan (1660–90) and Willem (1662–1747) and his grandson Frans the Younger (1689–1763) continued his style, and he was

still imitated during the early part of the nine-
teenth century. Genre pieces by the gifted,
but uneven, Michiel van Musscher (1645–
1705) also show a debt to the elder Mieris.

Godfried Schalcken (1643–1706), one of the
most popular members of the group, worked
with Dou after studying with Hoogstraten.
Schalcken began as a close imitator of Dou, and
won his reputation with candlelight scenes,
usually of coquettish maidens, done in Dou's

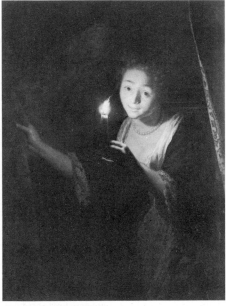

275. Godfried Schalcken:
A young Woman holding a Candle.
London, Buckingham Palace

manner [275]. By 1675 classical themes, which
hardly figure in Dou's *œuvre*, begin to play an
important part in Schalcken's production. His
Lesbia weighing her Sparrow against her Jewels
(London, National Gallery), painted about
1675, is characteristic of the new taste. This
small picture – it measures only $6\frac{3}{4}$ in. by
$5\frac{3}{16}$ in. – is painted on copper, a surface favoured
by these artists and their patrons, who placed a

premium on a high finish. It is a collector's
piece designed to be held in the hand, as well
as viewed on the wall. The subject had special
appeal to an *élite* familiar with the classics. It
is a painted variation on Catullus' love poem
'On Lesbia's dead Sparrow'. The observer
who knows his Catullus will be reminded of
the Roman poet's lines, and may even recog-
nize that Schalcken shows the snowy bosom
which figures in the verse the poet dedicated
to his mistress. Schalcken was eagerly col-
lected during the eighteenth century, and most
of the important picture cabinets formed
during the period contain some of his paintings.
His followers include Karel de Moor (1656–
1738) and the portraitist Arnold Boonen (1669–
1729), who also painted nocturnal scenes with
exaggerated attention to detail.

Around the turn of the century no painter
satisfied the popular demand for small, beauti-
fully finished Dutch pictures better than
Adriaen van der Werff (1659–1722). He
achieved greater fame and fortune than any of
his contemporaries. In 1721 Houbraken called
him the greatest of all Dutch painters. Few
eighteenth-century critics or collectors quar-
relled with his judgement. The prices his
works fetched during his lifetime were higher
than those Rembrandt ever received, and his
high evaluation continued until the middle
of the nineteenth century. Van der Werff
studied briefly with the obscure Rotterdam
genre painter Cornelis Picolet, and for a longer
period with Eglon van der Neer. When he
was seventeen years old he was already at
work as an independent master in Rotterdam,
the city where he spent his productive life. He
was also active there as an architect (see p. 416).
His paintings of the late seventies and early
eighties, which are primarily genre scenes, show
a dependence on the Leiden School. During his
early phase Van der Werff frequently used the
motif of the window niche popularized by Dou.
Around 1685 he began to concentrate upon

276. Adriaen van der Werff: The Holy Family, 1714. *Amsterdam, Rijksmuseum*

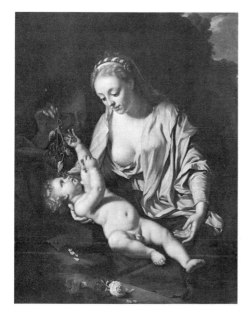

religious, mythological, and pastoral subjects. Success came rapidly. He was soon able to buy a substantial house, which he himself decorated with large bucolic scenes; some of these panels are preserved in the museum at Kassel. He also made portraits in the manner of the French court painters. The double portrait of his wife and child which he displays in his elegant *Self-Portrait* of 1699 (Amsterdam, Rijksmuseum) looks more like a work by Louis XIV's court painter Mignard than a work by a Dutch master. As the medal hanging from a gold chain round the artist's neck indicates, by this time Van der Werff had close connexions with a royal patron. The medal is an effigy of Johann Wilhelm von der Pfalz, the elector palatine, who secured Van der Werff's fortune by employing him in 1696. In the following year Van der Werff was appointed court painter to the elector with an annual stipend of 4,000 guilders, on the condition that he would work for him for six months a year. The elector was an avid collector of Dutch painting of the period. We have already mentioned that he commissioned works from Jan Weenix. He also patronized Eglon van der Neer and the still-life painter Rachel Ruysch. Van der Werff was allowed to continue to paint in Rotterdam, where he made cabinet pieces for the elector and his friends. Van der Werff only made occasional trips to Germany, but in 1703 agreed to work for the elector for nine months a year. In the same year he was given a hereditary knighthood. Handsome princely commissions from other courts of Europe followed. The qualities which won Van der Werff such eminence and popularity can be seen in his *Holy Family* (1714, Amsterdam, Rijksmuseum) [276]. The sentimental action, the statuesque beauty of the figures, and the academic perfection of his drawing as well as his muted palette and porcelain-like finish appealed to his aristocratic clientele. His brother Pieter van der Werff (1665?–1722) was his pupil and collaborator. Pieter made copies of Adriaen's works which in later years frequently passed as authentic pictures by his better known brother. Another artist who worked as a court painter in Germany was Philips van Dijk (1680–1753). He was employed at Kassel by William VIII, landgrave of Hessen. His numerous court portraits show the impact of Adriaen van der Werff's manner, but he never captures his more famous predecessor's elegance. Philips van Dijk's small

genre pieces are in the *Feinmalerei* tradition of the Leiden School.

The most original and interesting eighteenth-century Dutch portraitist and genre painter is Cornelis Troost (1697-1750). He was also proficient with pastels, a medium which was popular throughout Europe during the period. With good reason, Troost is often called the Dutch Hogarth. The artists were exact contemporaries. Both made formal portraits as well as 'conversation pieces', the name given to small-scale group portraits in a social setting.[1] Both won fame for their series of genre pictures, which are commentaries on the life of their times, and for pictures of contemporary theatrical performances. Also both are satirists; but here there is a fundamental difference. Troost is never as critical or aggressive as Hogarth.

Unlike Hogarth, Troost is a humorist without a didactic streak. He does not moralize. In his best known work, done in pastel and gouache, the *NELRI* series (The Hague, Mauritshuis, 1740; the name is derived from the first letters of the Latin inscriptions which accompany the five views of the activities of a group of men enjoying a reunion), we are shown what happens during an evening of revelry and excessive drinking. Instead of moralizing on the evils of drink, as Hogarth was wont to do, Troost's pictures [277] humorously show the physiological effects of inebriation. In this respect his spirit is closer to Jan Steen's than to Hogarth's.

After studying with Arnold Boonen, Troost quickly established his reputation as a portraitist. Though his early lifesize group portraits (*Inspectors of the Collegium Medicum at Am-*

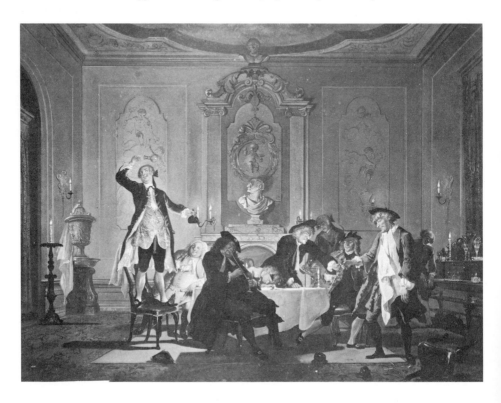

sterdam, 1724; *Governors of the Amsterdam Orphanage*, 1729; both on loan at the Rijksmuseum) are rather stiff and wooden, they have greater vigour than the large groups painted by his contemporaries. More successful are his small-scale portraits. The one of *Jeronimus Tonneman and his Son* (1736, Dublin, National Gallery) [278] ranks with the best. It is a type of portrait which continues the tradition practised by De Keyser, De Hooch, Ter Borch, and Steen. The full-length figures are shown in a familiar setting, engaged in their favourite activities. Judging from the popularity of conversation pieces, the Dutch love of family and household still increased during the eighteenth century. These portraits appealed to the middle class, which was proud of its status and took delight in its accomplishments and possessions.

277 (*opposite*). Cornelis Troost: Rumor erat in Casa (There was a Noise in the House), 1740. *The Hague, Mauritshuis*

278. Cornelis Troost: Jeronimus Tonneman and his Son, 1736. *Dublin, National Gallery of Ireland*

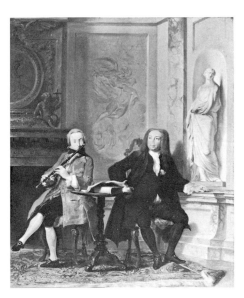

Conversation pieces were equally popular in England, where the middle class rose to a position of even greater power, and some Dutch painters, such as Herman van der Mijn (1684–1741) and his sons Frans (1719–83) and George (1723–63), practised there to help satisfy the English demand. As in seventeenth-century Dutch portraits of this type, it is sometimes difficult to tell whether the interior or garden which serves as a setting for a conversation piece is imaginary or not. It is not known, for example, whether Tonneman's house really was decorated with sculpture, or if it had the fine Louis XIV mantelpiece Troost painted. However, we can be certain that the Tonneman family took pleasure in displaying their edition of Van Mander's *Schilderboek*, which lies on the table, and that Troost made an accurate portrayal of the fashionable clothing and wigs worn by the father and son.

Around the middle of the century a few foreigners were active as portraitists in Holland. Among the most popular were two masters of pastel: the Swiss Jean Étienne Liotard (1702–89), who stayed in Holland from 1755 to 1757 and in 1771–2; and the Frenchman Jean Baptiste Perronneau (1715–83), who visited Holland in 1761–2 and 1772 and returned again in the year of his death. He died in Amsterdam. Reflections of eighteenth-century English portraiture – Reynolds in particular – are also evident during the period. Reynolds' works became widely known by the many mezzotints after them. This English influence is particularly strong in the works of George van der Mijn. Later in the century the English painter Charles Howard Hodges (1764–1837) settled in Amsterdam, where he helped popularize English fashions in portrait painting. German influence was brought to the court circles at The Hague about the same time by Johann Friedrich August Tischbein (1750–1812).

Native portraitists who could be relied upon for truthful portrayals and good conversation

pieces include Jan Maurits Quinkhard (1688-1772), Tibout Retgers (1710-68), Hendrik Pothoven (1725-c. 1795), Wybrand Hendriks (1744-1831), Adriaan de Lelie (1755-1820), and Jan Ekels the Younger (1759-93). Their works continue the seventeenth-century portrait tradi-

279. Jan Ekels: Man sharpening a Pen, 1784. *Amsterdam, Rijksmuseum*

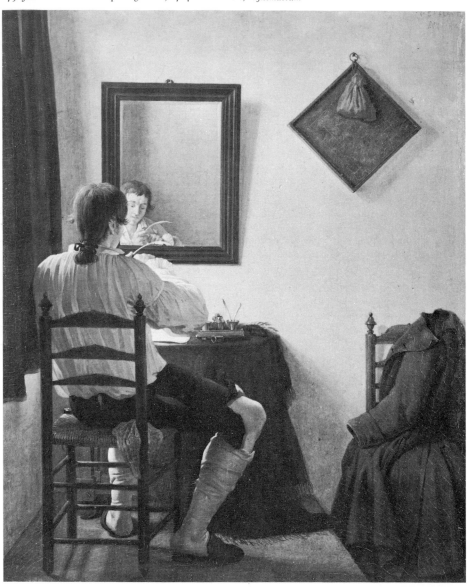

tion of solid craftsmanship. They also made genre pictures of domestic life - the line between a conversation piece and a domestic genre picture is not difficult to cross. Their paintings are generally of greater charm than those by the eighteenth-century epigones of the Leiden School. Jan Ekels' scarce ones are a sign of the marked revival of interest in the great masters of Dutch painting which took place about the end of the century. The simplicity and clarity of his *Man sharpening a Pen* (1784, Amsterdam, Rijksmuseum) [279] recall, in a surprising way, works by Vermeer and Metsu. Few of Ekels' contemporaries matched his sensitivity to light and atmosphere, or manner of treating this favourite Dutch theme without a trace of sentimentality. Ekels' intimate description of the young man's room tells us as much about his personality as the reflection of his face in the mirror. This is a new note. Nineteenth-century painters (Delacroix, Menzel, Van Gogh) were to develop the theme of the interior as a portrait by eliminating the model and only showing the milieu in which an individual lives. An early death prevented Ekels from fulfilling a great promise. Wybrand Hendriks, on the other hand, lived for eighty-six years. During the course of his long career he made landscapes, topographical views, and still lifes as well as portraits and genre pieces. Hendriks' *Interior with a sleeping Man and a Woman mending Stockings* (18 . ., the last two digits illegible; Haarlem, Frans Hals Museum) [280] also recalls the work of Vermeer and Metsu. However, he lacks the subtle tonal control and strong architectural design of his seventeenth-century models. He also relies more heavily upon the anecdotal for effect than his great predecessors did. It is difficult to discard the feeling that Vermeer would have preferred to see a table in the foreground of Hendriks' picture instead of the sleeping old man, whose smoking white Gouda pipe indicates that he has just begun his cat-nap. Hendriks knew seventeenth-century

280. Wybrand Hendriks:
Interior with a sleeping Man
and a Woman mending Stockings, 18--(?).
Haarlem, Frans Hals Museum

Dutch art well. As keeper (1786-1819) of the Teyler Foundation at Haarlem, he was responsible for important additions to that museum's notable collection, and he also made copies after works by leading seventeenth-century Dutch artists. About the same time others were also studying the pictures of Holland's heroic age. The still-life painter Jan van Os (1744-1808) tried his hand at imitating the early marine painters. Abraham van Strij made genre pieces in the style of De Hooch and Metsu, and some landscapes which make patent his close study of Cuyp's work. Johannes Kobell (1778-1814) did landscapes with cattle in the style of Potter. The revival of interest in the old Dutch masters was accompanied by a demand for painted copies of their works, and some excellent ones were made. It takes a practised eye to distinguish a genuine landscape by Cuyp from one of Abraham van Strij's copies.

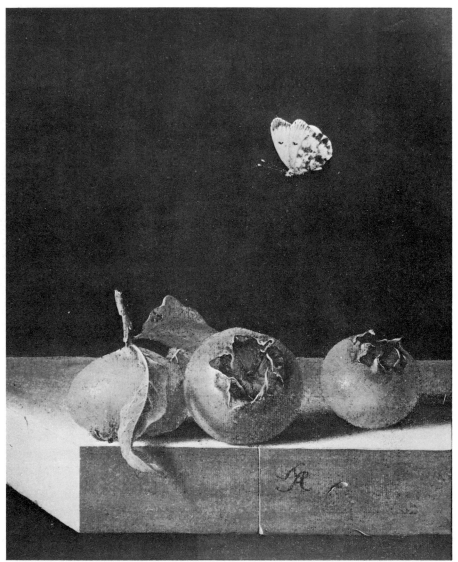

281. Adriaen Coorte: Three Medlars with a Butterfly, *c.* 1705. *The Netherlands, V. de S. Collection*

OTHER SPECIALISTS

The history of other specialists does not need much space. Except for the artists who made the exact drawings and watercolours of birds, plants, insects, and shells which were so popular with the *dilettanti* of the period, the Dutch tradition of painting unpretentious still lifes virtually died during the eighteenth century. Adriaen Coorte, a strong individualist who never adopted the rhetoric of his contemporaries, was one of the last practitioners of this intimate category. He was mainly active round Middelburg. Perhaps working away from the principal art centres helped him keep his private vision intact. His earliest known dated work is inscribed 1683; the latest is dated 1705. The exquisite flowers and fruit, expensive vases and metalware, drapery and linen, and other props found in the over-abundant still lifes painted during his day never appear in his work. Coorte's pictures are always tiny, his subjects and compositions modest. His typical motifs are a bunch of asparagus, a few peaches, or three medlars with a butterfly on a bare ledge [281]. Nothing more. Objects and light are studied intensely, and are painted with a wondrous tenderness which awakens more feelings about the mystery of our relation to the inanimate world than the better known show pieces of the period. Coorte's works apparently attracted no special attention during his lifetime; he was forgotten until twentieth-century critics recognized his quiet achievement.[1]

Coorte is an isolated phenomenon. The main line of eighteenth-century Dutch still-life painting is represented by Rachel Ruysch and Jan van Huysum [282], who both specialized in elaborate flower pictures. They were the most popular still-life painters of the period, and

282 Jan van Huysum: Bouquet of Flowers, 1726.
London, Wallace Collection

their colourful pictures still have a wide appeal. In their hands Dutch flower pieces brighten up again. Their technical perfection and love of minute detail recall the still lifes painted a century earlier by Bosschaert and his followers. However, neither Rachel Ruysch nor Van Huysum arranges blooms into compact, symmetrical bunches in the way that early-seventeenth-century painters did. Their open, asymmetrical bouquets, lively chiaroscuro effects, and delightful ornateness show an unmistakable affinity with Late Baroque and Rococo art. Rachel Ruysch (1664-1750), one of the few women painters of the Dutch school,

came from a distinguished family: her father was Frederik Ruysch, the famous botanist and anatomist; her mother was the daughter of the architect Pieter Post. After studying with the still-life painter Willem van Aelst, she found her way early, and she enjoyed a long and successful career. We have heard that she was one of the favourites of the elector palatine; for three years (1710-13), everything she painted belonged to him. She seems to have worked slowly. Today only about a hundred paintings can be attributed to her. Probably her activities as a wife and mother – she bore ten children – also interfered with her career as a painter.

Jan van Huysum (1682-1749) was a pupil of his father Justus van Huysum the Elder (1659-1716), who was also a flower painter. Van Huysum, called by his contemporaries 'the phoenix of all flower painters', won even greater acclaim than Rachel Ruysch. While he was still alive, eager collectors often paid more than 1,000 guilders for his pictures. Van Huysum also painted a few Italianate landscapes, but his still lifes won him his international reputation. His flower pieces are lighter in key than Rachel Ruysch's, and his colours are cooler, with saturated blues and vivid greens predominating. Elegance and a calligraphic sweep came more naturally to him than they did to her – perhaps because he did not experience an encounter with the classic phase of Dutch Baroque art. Rachel did, being almost a generation older than Van Huysum. Van Huysum is one of the rare Dutch still-life artists who was active as a draughtsman. Some of his drawings appear to be preliminary studies for his flower pieces; others were designed as finished works. All have a spontaneity and a broad, free touch never found in his highly finished, enamel-smooth painting. Van Huysum was also one of the few Dutch still-life specialists who insisted upon working out the details of his paintings from nature. In a letter to one of his patrons he stated that he was unable to finish a picture

because he could not obtain a yellow rose; otherwise he would have completed the painting the previous year. In the same letter he noted that he lacked grapes, figs, and a pomegranate to complete a fruit still life.[2] This probably explains the double dates which appear on some of his still lifes. He is reputed to have been very secretive, and is alleged to have allowed no one in his studio except his only pupil, Margareta Haverman. The story may be apocryphal – it is told about many artists. But there can be no doubt that Van Huysum did not think of himself merely as a painter of pretty, decorative flower pictures. He wanted to instruct the onlooker as well as delight him. The inscription 'Consider the lilies of the field, Solomon in all his glory was not arrayed like one of these' (Matthew 6:28-9) on a jar holding a bouquet of flowers now at the Rijksmuseum (no. 1277) shows that he continued the moralizing tradition of earlier still-life painters. Van Huysum's success attracted numerous close followers, and his style was still in vogue after the middle of the nineteenth century. Imitators include Jan van Os and his more famous son Georgius Jacobus Johannes van Os (1782-1861), the brothers Gerard (1746-1822) and Cornelis van Spaendonck (1756-1840), and Wybrand Hendriks. Van Huysum also inspired generations of decorators of porcelain and crockery.

Eighteenth-century landscape painters and topographical artists also took their cue from late-seventeenth-century painters, and introduced little that was new. Their main model was Van der Heyden. His bright colours, scale, and exactitude were best followed by Jan ten Compe (1713-61) and Paulus Constantin La Fargue (1729-82). Though they lose some of Van der Heyden's atmospheric quality, their unassuming views of towns and the countryside under sunny skies are pleasing. La Fargue is another artist who made copies after the seventeenth-century masters. His speciality was Ruisdael. Judging from the quality of his

drawings after Ruisdael, he had considerable understanding of Holland's greatest landscape painter. But neither La Fargue nor his contemporaries ever put into their own works the intense emotion Ruisdael felt before nature. Their bright tonality and the lightness of accents betray eighteenth-century hands both in their paintings and drawings. Izaak Ouwater (1750-93) concentrated on town views. His *Lottery Office* (1779, Amsterdam, Rijksmuseum) [283] is an exact rendering of the façades of three houses in the Kalverstraat at Amsterdam. Like many eighteenth-century Dutch works, it is best enjoyed with the aid of a magnifying

283. Izaak Ouwater: The Lottery Office, 1779. *Amsterdam, Rijksmuseum*

glass. Though Ouwater's works are a little dry and airless, he always displays a fine sense of design. His faithful renderings of buildings usually have an antiquarian interest which enhances their historical value. The building that the crowd is trying to enter in Ouwater's picture was first inhabited by Clement de Jonghe, who posed for Rembrandt (Bartsch 272) and was a publisher of Rembrandt's etchings. The house on the right was once occupied by Jacob van Ruisdael, the one on the left by Aert van der Neer.

In few countries of Europe were topographical works as popular as they were in the Netherlands during the eighteenth century. Local pride became as strong as family pride. Every city and town boasts scores of topographical artists who rendered historical and picturesque sites with infinite patience. As a rule, their drawings and delicate watercolours are more attractive than their paintings. Reynier Vinkeles (1741-1816), who specialized in views of Amsterdam, is one of the finest. Dirk Langendijk (1748-1805) used topographical settings for his views of contemporary events, especially battles. Langendijk's pictures anticipate the reporting done by nineteenth-century magazine and newspaper illustrators, but they have nothing in common with the passionate works which were produced by his contemporary Goya on similar themes.

Landscapists also made wall-hangings and painted wallpaper. At first arcadian and idealized Italian motifs were most popular, and only late in the century was there a vogue for Dutch scenes. Most of these works have disappeared, but we know that Jurriaen Andriessen (1742-1819), Pieter Barbiers (1748-1842), Jacob van Strij, and Aart Schouman did this kind of work. Andriessen is remembered today for the many prints and drawings which record the life of his time. He can be compared with his contemporaries Rowlandson and Chodowiecki, but he never lapses into the gross farces of the former and is more pungent than the latter. Not infrequently he looks like a forerunner of Constantin Guys. As director of the Drawing Academy at Amsterdam, he exerted great influence on the young artists of his time. His most interesting pupil was Wouter Johannes van Troostwijk[3] (1782-1810), the best landscape painter working in Holland around 1800. Troostwijk also made animal pieces under the influence of Potter, Adriaen van de Velde, and Dujardin, but he gained his main inspiration from working outdoors. His view of the Amsterdam gate The Rampoortje (1809, Amsterdam, Rijksmuseum) [284] shows how fresh his vision was. If he had lived longer, he would probably have been a leading figure. His motto, 'Observe nature', became the watchword for the European painters who made the most significant contributions during the course of the nineteenth century. It would also have been an appropriate one for the outstanding Dutch artists who preceded him.

284. Wouter Johannes van Troostwijk: The Rampoortje, 1809. *Amsterdam, Rijksmuseum*

ARCHITECTURE

E. H. TER KUILE

CHAPTER 18

THE SIXTEENTH CENTURY FROM THE RENAISSANCE

Renaissance forms began to appear comparatively early in the architecture of the Netherlands, that is to say, at the same time as they were gaining ground in the châteaux of the Loire. This is not at all surprising. The Netherlands had been handed over almost complete to the House of Hapsburg as a Burgundian legacy. Politics made the high nobility strongly internationally minded. Busy commercial relations with all Western Europe, and the possession of two languages, made it possible for people to keep in touch with modern tendencies in the leading cultural centres, and made them ready to adopt the new forms.

However, in spite of all the circumstances which favoured the acceptance of the Renaissance and its rich development, there were also strong counter forces which prevented it from expelling Gothic in one great drive. The Netherlands had developed within the framework of the Gothic regional schools, among which the School of Brabant, at the end of the Middle Ages, had attained unusual eminence and had penetrated far beyond the frontiers of the dukedom. It was particularly in the decorative field that this native Gothic had found its own idiom. The Brabant Gothic almost became a national, Netherlands, Gothic, familiar to generations of people, and in it the character of the country had been able to express itself. This Gothic was not to be easily swept away.

The Renaissance, which was accepted from the second decade of the sixteenth century, was above all a matter of externals, of decoration. In this it does not differ from the Renaissance of Spain or of France. That there was little basic development throughout the whole sixteenth century and the beginning of the seventeenth, with one exception, is, however, something more or less peculiar to the Netherlands. Chief among the reasons for this state of affairs were the following: firstly, whereas aristocratic patrons had at the outset been able to promote the new style, after the middle of the sixteenth century – by living beyond their means, and because of the troubles and the wars – they could no longer be patrons on a large scale; secondly, a centre, such as was provided by the monarchy in France, was lacking; and thirdly, commissions were chiefly to be had from the bourgeoisie, whose taste was traditional.

The very first specimens of Renaissance-like forms in building, as in painting, are merely

bastards of Gothic and non-Gothic ornamentation. A typical example is the rood screen of St Maria im Kapitol at Cologne, which was ordered in 1517 from artists of Malines whose names we do not know. It was particularly upon such decorative sculpture that men expended their enthusiasm for what was new. This longing for the new and fear of being regarded as old-fashioned are clearly seen in the terms of the commission of 1519 for the long since vanished choir screen of oak and copper for the cathedral at Utrecht: it was expressly stipulated that the design must not be 'modern', the current term for Gothic, but 'antique', and rich and magnificent at that.

The first known piece of real Renaissance architecture was designed and built during these same years: a portal to an outwork and a gallery for the castle at Breda with which Henry III of Nassau-Breda, one of the principal and richest nobles of the Netherlands,

heralded the large-scale modernization of medieval castles.[1] The gallery on the curtain wall, with its series of transverse roofs which ended against steep pediments with shell motifs, has gone, but the portal, which must have been built between 1515 and 1521, remains [285], even though it was rebuilt in the late seventeenth century and in the process lost many of its characteristic early-sixteenth-century features. However, though the unorthodox steep pediment was replaced by one of classical proportions, the over-slender columns which support the pediment still betray the precious, half Gothic spirit of the period of their origin.

In 1536 Henry III of Nassau-Breda started on the ambitious plan of replacing the old castle itself by a modern palace. The general design seems to have been made by an Italian, Thomas Vincidor, born in Bologna, who had lived in the Netherlands since 1520, principally

285. Breda, castle, entrance of outer ward, 1515/21. Seventeenth-century drawing

286 and 287. Thomas Vincidor:
Breda, castle, begun 1536. Engraving of 1743
and plan of main floor before 1686

in Antwerp. He was not an architect by pro-
fession: he is described explicitly as a painter.

The palace at Breda, as it was designed,
covered a rectangle of 215 ft by 170 ft (65 m. by
50·50 m.) [286, 287]. At the corners of the
entrance side rose slender octagonal towers,
the rear range had a saddleback roof between
two gables. The entrance range and the side
ranges had arcades at the same height whose
delicate arches, on Tuscan columns, opened
towards the courtyard. The rear gallery had a
similar arcade, but behind the arches a colon-
naded hall ran the whole breadth and depth of
the range. Above, the rear range was one
enormous hall. This was reached from the
courtyard by a ceremonial staircase whose
composition was specially fantastic. In accord-
ance with the spirit of the time, much care was
lavished on rich external ornament. This was
particularly concentrated on the gables on the
ends of the rear range, the entrance section,
which also ended in a gable, a continuous
series of tiny gables along the inner courtyard,

and the staircase to which reference has been made. The façades along the courtyard were specially conspicuous on account of their freakish decorative scheme: they had an extraordinary metope frieze above the arcades, and above this were divided by Ionic pilasters between whose capitals and the architrave modillions with volutes were inserted.

The palace was left incomplete in the sixteenth century. The remaining part was added according to the original plan by the King and Stadholder William III at the end of the seventeenth century. Unfortunately, in 1828 the magnificent building was irreparably damaged when it was altered to become the Military Academy.

It is difficult to believe that the palace was really designed by an Italian. The surrounding of the courtyard with arcades cannot be regarded as an Italianism: such arcades, with Gothic detail, had long existed in the Netherlands, for example at the Late Gothic palace of the Marquesses of Bergen op Zoom. The detail is hardly correct, even as compared to Lombard and Venetian, let alone Central Italian, architecture. In particular there is the impossible triglyph frieze in the courtyard. Modillions between capitals and architrave do appear in the fifteenth century in Italy, but are at home rather in the Spanish Early Renaissance. Taking everything into consideration, the designer of the palace must have been an undisciplined eclectic, and no trained architect. In spirit the design is closely related to that of Jan Wallot's[2] highly decorated façade of 1530 for the Greffe at Bruges.

Apart from Vincidor there was another Italian architect working in the Northern Netherlands, about whom we know slightly more. This was Alexander Pasqualini. He, too, was born in Bologna and was not a trained architect. He acquired fame originally as a goldsmith, but is later met in various places as a designer of buildings. From 1549 he was principal archi-

tect of a German prince, Duke William V of Jülich, Kleve, and Berg. His chief work in the Netherlands was the church tower of the little town of IJsselstein in the province of Utrecht, which was begun in or shortly before 1532 [288]. The square lower part is faced with rows of pilasters in an academic way. The lowest octagonal stage is part of the original building, but the two octagons which follow were added, one in the seventeenth century and one in 1927. The work shows a remarkable attempt to treat so essentially medieval a theme as a church tower in the modern manner of the time. It is

288. Alexander Pasqualini:
IJsselstein, church, tower, c. 1532

not uninteresting to compare the tower with that of S. Biagio at Montepulciano, which is about fifteen years older and was built by Antonio da Sangallo the Elder. Both architects were more or less slaves to the system of orders, but whereas Sangallo handled them vigorously, Pasqualini at IJsselstein makes them timid and precious. Yet there is certainly much charm about this preciousness, and a rather touching naïvety. The sharply chiselled detail is not surprising as the work of a designer who was really a goldsmith, but we have to remember that such crisp stonework was done elsewhere in the period, and can also be found in the palace at Breda.[3]

The direction taken by these two Italian masters, particularly Pasqualini, was soon followed by a native mason. In 1546 Willem van Noort designed a new façade for the three houses which together were made into the town hall of Utrecht. Only that for the right-hand house was executed, and unfortunately this important document was removed when a heavy classical façade was built for the whole town hall in 1828. We know what the original looked like, however, from various drawings and prints. It had, at street level, an arcade of columns with a stumpy order of Doric pilasters. The smooth section above showed first a slender composite order of pilasters and then a very stumpy Ionic one, their shafts and friezes richly decorated with grotesque reliefs. The windows had pediments. Unlike the palace at Breda and the tower of IJsselstein, where brick and stone alternate, the façade of the Utrecht Town Hall was entirely built in stone, and the ornamentation was strongly accentuated by colouring and gilding. If one is inclined to consider the three orders very arbitrarily proportioned, it must be remembered that Van Noort was bound by the existing height of the storeys. With this in mind, one can accept his design as the masterpiece of representational Dutch architecture of the mid sixteenth century.

Apart from artists like Vincidor, Pasqualini, and Van Noort, there were everywhere in the third quarter of the sixteenth century artists of less training who were busy with commissions for which correctness of style was considered less important than a fantastic variety of forms. The result was often a sort of Netherlands Plateresque. The most characteristic example of this is the house built about 1545 at Arnhem at the instance of Maarten van Rossum, famous as a military commander under the last two dukes of Gelderland. After all sorts of damage, and a doubtful restoration, the façade of this building, now the town hall, gives only a feeble impression of the extravagant and unplanned, though very picturesque, original design, due to an architect whose name we do not know. The introduction of Renaissance forms in such cases apparently led to a total degeneration of style. The Arnhem house was called the Devil's House because of the figures of satyrs on both sides of the entrance. Another house in the same spirit is that which also belonged to Maarten van Rossum at Zaltbommel, ten miles north of 's-Hertogenbosch. However, this is actually nothing more than the gateway of a castle never built. The quasi-Renaissance decoration is confined to the entrance with its remarkable candelabra-shaped columns and arch-like embellishments above the windows.

Sometimes there is a fantastic mixture of Gothic details and Renaissance decoration. A good example of this is the picturesque Apostolic School at Nijmegen, dating from 1544. Ten years later the same architect, Herman van Herengrave, designed the town hall of Nijmegen [289]. Gothic details have now nearly disappeared, but this does not mean that Herman was master of the new style: the curiously formed pediments above the windows, and the medallions with reliefs on the parapet below the roof are the only manifestations of the Renaissance. The same holds good for the architecture of private houses. No really

289. Herman van Herengrave:
Nijmegen, town hall, 1554

systematic work was done with the apparatus of classical and semi-classical forms before about 1555; there is simply an arbitrary scattering of decoration thought to be modern over the surface of the façade. From the fifties the propaganda work done by a few artists, such as translations of Italian treatises on architecture and series of prints, began to influence the development of architecture. The first of these artists was Pieter Coeck, who was born at Aalst in Flanders in 1502 and died in 1550. He lived in Turkey for a time and afterwards settled in Antwerp, the greatest trade centre of the whole Netherlands, and also the centre of dissemination of the new architectural knowledge. As early as 1539, two years after the first Italian

edition, he published a Flemish translation of Serlio's *Regole sopra le cinque maniere degli edifici*, followed in subsequent years by other parts of the *Architettura*, all with woodcuts after the originals.[4] Undoubtedly this helped to correct current ideas concerning classical and Mannerist architecture. But it would be wrong to regard Pieter Coeck as a fanatical purist: he appears to have had no objection to joining with the Antwerp town clerk, Graphaeus, in publishing a book of prints showing the rich decorations put up in Antwerp in 1549 on the occasion of the entry of Charles V and his son, later Philip II. Along with a few fairly strict structures we find here triumphal arches, etc., which are unparalleled in their unrestrained ornamentation.

For the development of what it has been the custom hitherto to call the Dutch or Flemish Renaissance, but which in accordance with current terminology ought rather to fall under the heading of Mannerism, another important figure was Cornelis Floris de Vriendt (1514(?)–75), the son of a stonemason, who, like Coeck, lived in Antwerp. That he went to Italy is no more than a hypothesis. In 1556 he published a book of prints showing 'grotesque' ornament in all sorts of applications, and in 1557 his *Inventien* of epitaphs and tombs appeared. How well he handled forms can be seen from his famous tabernacle of 1550 in the graceful church of Zoutleeuw (Léau), between Louvain and Maastricht; and to what monumental heights he could bring small-scale architecture we can see from the masterly rood screen in the cathedral of Tournai (Doornik) of 1572. We shall return later on to his purely architectural work.

The man who flooded the world with the greatest series of ornamental and architectural prints was Hans Vredeman de Vries (1527–1606), born at Leeuwarden. He spent much of his time wandering through the Netherlands

290. Hans Vredeman de Vries:
Ideal architecture

and Germany and, unlike Coeck and Floris, was scarcely a creative architect.[5] He publicized Floris' style, but had nothing of his grace and wit. His prints are vulgarizations in the pejorative sense. He produced endless variations on Floris' themes, and on those of the town hall of Antwerp [290]. His *Variae Architecturae Formae* of 1601 is mainly a collection of fantastic compositions with colonnades, arcades, and fountains – impossible daydreams. His influence can be traced far into the seventeenth century.

Between 1561 and 1566 the great town hall of Antwerp was built [291], impressively large for its period, and a building which can be regarded as the principal work of architecture of the sixteenth century in the whole Netherlands. There is still much uncertainty as to how the design was produced, but we can assume that Cornelis Floris was the leading architect involved.

The Antwerp Town Hall shows a masterly control of forms. Externally it appears as a massive block, terminating in an open gallery over which the eaves jut out on all sides. The two storeys above the rusticated base have between the windows pilasters in two orders. The pilasters are rather weak, owing to the fact that they stand on pedestals. However, their very lightness makes them harmonize with the large windows. Above the middle of the front facing the Market soars a high gable, a trium-

phant piece of decoration, which, in a most inorganic manner, has no roof behind. It was undoubtedly put up as substitute for a tower, such as those on the Bruges Cloth Hall and the Brussels Town Hall. Apparently an actual tower was considered to be old-fashioned, but

Netherlands variant of Mannerism, which could be used also for monumental purposes. However, this national Mannerism had no chance of finding expression in any further monumental buildings: for hardly had the town hall of Antwerp been completed than the

291. Cornelis Floris: Antwerp, town hall, 1561–6

a strong vertical emphasis was still felt to be necessary. The centre differs from the wings by the use of arched openings instead of windows and coupled columns for single pilasters. The vigorous treatment is carried on in the gable by means of two prominent obelisks and deep niches for statues. In general it is striking to see the harmony between the monumental proportions of the building and the scale of the details; there is nothing here of the meagreness which had characterized the Netherlands up to then.

The festive façade of the Antwerp Town Hall shows that architects were now at last able to wrest from the treasure of alien forms a truly

duke of Alba marched on the Netherlands and the political and religious wars began which were to continue for many years. The nascent style was thus denied any impressive development, and became principally a middle-class style. That Cornelis Floris could do fine work in this genre, too, was shown by the House of the German Hansa at Antwerp. Built during the period when the town hall was being finished, it was a sober variant of it, without orders. Its axis was emphasized not by a gable but by a traditional tower, slender and graceful.

How great was the impression that the town hall of Antwerp made is evident from the fact that already by 1564 it had inspired the new

292. The Hague, old town hall, 1564

him to make the best of the problem of having to cope with an even number of bays. The ornament still has that precious and chiselled character which Cornelis Floris had already left behind, but which is entirely justifiable in such a miniature building.

Some ten years later, in 1574, Emden in East Friesland, which is not of course in the Netherlands, but which was in those days within the Netherlands orbit, built a town hall which had much more in common with that of Antwerp. The architect, Laurens van Steenwinkel, was indeed from Antwerp. Another town hall which can be considered as an offspring of that of Antwerp was that which an unknown architect[6] put up in 1594 at Flushing, and which could be described as a copy on a reduced scale. It was unfortunately destroyed in the unsuccessful attack on Flushing by the English fleet in 1809.

In the middle-class architecture of the second half of the sixteenth century it is possible to distinguish a trend in which the classical orders are accepted as a starting point for decorative treatment. Already about 1536 the gables which terminated the ends of the rear wing of the castle of Breda included pilasters in their scheme of decoration, but, if we are to judge from old reproductions, there can have been no question of an organic composition. A much more controlled use of the orders can be seen in the façade of a house of 1559 at Groningen, which was demolished about 1900 and rebuilt as part of the Provincial Hall. Orders of Doric, Ionic, and Corinthian columns succeed one another in the traditional manner, but the application of the orders to the gable presented difficulties which the architect was unable to resolve satisfactorily. A parallel stage of development is shown in a façade at Kampen, which probably dates from about 1565. The gable, which is not entirely authentic in its present form, but must be in essentials like the original, is much more harmonious than that at

town hall at The Hague [292]. Its designer, whose name is not known, must have been exceptionally talented. It is an extremely modest building on a corner site. In volume it cannot be compared with the Antwerp Town Hall, but the relationship is unmistakable in such motifs as the top gallery and the central gable which finish the entrance façade. On the street elevation the ground floor is left entirely flat; the upper floor has a row of delicately formed pilasters, and then follow a light and playful decorative scheme of brackets, jutting cornice and a balustrade, and above that the gable with the arcaded gallery in its high bottom storey. The skill of the architect enabled

Groningen. Another splendid example of these pilaster façades is that of the 'House of Charles V' at Zwolle, dating from 1571 [293], but here again the composition of the top shows an unmistakable uncertainty. There is some reason to suppose that the decoration was originally intended for another site, and had to be adapted to the present one. Similarly, the unknown architect who designed the remarkable house called The Three Herrings at Deventer in 1575 [294] put rows of pilasters on his principal façade, but he did not know how to give this a decisive function in the play of

decoration. In the otherwise very harmonious façade of the weigh house at Alkmaar of 1582, the ordering power of the pilaster apparatus is weak too. This façade was unfortunately the victim of sweeping restoration in 1884.

On the other hand, the existence of a faith in correctness is shown by a piece of military architecture, the East Gate at Hoorn, built in 1577 by the Amsterdam architect Joost Jansz. Bilhamer. The outside front, with the vigorously blocked pilasters and the amusing aedicules, shows an engaging eagerness to demonstrate scholarship.

293 (*far left*). Zwolle, 'House of Charles V', 1571

294 (*left*). Deventer, 'The Three Herrings', 1575

295 (*below*). Leeuwarden, Chancellery, 1566–71

296 (*right*). Franeker, town hall, 1591–4

But most buildings kept away from true classical forms and showed an uninhibited play of stone bands and blocks, window arches, volutes, obelisks, masks, cartouches, strapwork, and other decorative motifs enlivening the brick walls. When Philip II commissioned a government building, the Chancellery at Leeuwarden, built in 1566–71 [295], it was given a long frontage which shows no trace of the classical or the Italian; it must be regarded as bastard Gothic or crypto Gothic. But such an extreme instance of the anti-classical is an exception. A building such as the almost con-temporary weigh house in Amsterdam (1563–5), long since demolished, though far from truly Italian, was decidedly more formal and severe.

Among the most elegant gables built in the Netherlands during the second half of the sixteenth century is that of the St Jansgasthuis at Hoorn of 1563. There is here no striving after an academic style. The attraction lies in the workmanlike control of the job and the naïve pleasure in decoration, together with a developed sense of relationships. Compared with this, the façade of Bethlehem House at Gorinchem, dating from the same year, is

really wildly fantastic. In the end the town hall of Franeker, dating from 1591-4 [296], shows that Netherlands architecture did achieve integration, even if of an undoctrinaire kind.

Though church architecture was in general neglected in the sixteenth century, important work was done in the field of towers. It was mostly a question of finishing or raising existing towers by a transparent spire of wood, hung with lead or slate. A Late Gothic tradition, represented most gracefully in the tower of St Bavo at Haarlem (1517-20), was carried on here, details of form which were too emphatically Gothic being excluded. The most impressive monument is the upper part of the tower of the Oude Kerk at Amsterdam [297], built between 1565 and 1566 to designs by Joost Jansz. Bilhamer, who has been mentioned before. Another successful and rather more restful variant is the top of the tower of the weigh house at Alkmaar, dating from the years 1597-9.

297. Joost Jansz. Bilhamer:
Amsterdam, Oude Kerk, tower, 1565-6

THE CLIMAX OF MANNERISM IN THE FIRST DECADES

OF THE SEVENTEENTH CENTURY

When, about 1600, the Northern Netherlands began to form a separate nation, there was a final rich burgeoning of that Mannerism whose development during the sixteenth century has been sketched in the preceding chapter. At this point there appeared two personalities who were recognized in their own day, as now, as the leading masters. One was Lieven de Key, the municipal architect of Haarlem; the other was Hendrick de Keyser, who had the same post in Amsterdam. De Key's work was almost entirely confined to Haarlem, while De Keyser obtained several commissions outside his own town. De Key was a stonemason and architect, but De Keyser was also a sculptor of great importance (see p. 419). Though one cannot call them men of true genius, both were undoubtedly highly talented: other architects working in the same period were far inferior, and these two are the only names which count in the north during the first twenty years or so.

Lieven de Key was born at Ghent about 1560. He worked for some years in England before entering the service of Haarlem in 1591, and he continued in his official functions there until his death in 1627. It seems that, as a basis for his own, he went to a decorative style which had been developed by his predecessor Willem den Abt, of which the façade of the St Jorisdoelen is a fine example. If we consider that De Key was originally a stonemason, it is not surprising that he attached a great deal of importance to ornament. The commissions he obtained gave him little chance to create spatial architecture of any significance, and it is difficult to tell

whether he had any particular gift for such work.

De Key's most successful works are undoubtedly the Haarlem Meat Hall (1602–3) and the tower of the Nieuwe Kerk (1613). The scheme of the Meat Hall [298] has nothing new about it: the idea of a rectangular block with a high roof between two steep gables could not be more traditional. But De Key

298. Lieven de Key: Haarlem, Meat Hall, 1602–3

succeeded in turning the traditional scheme into something which is at once contemporary and intensely personal by means of a masterly decorative treatment which combines tautness and vigour with a playful opulence, culminating in the gables of the long side elevation. What specially distinguishes him from the sixteenth-century architects who had dealt with the problem of the decorative treatment of gables is that he increases the ornamentation in richness and detail from the bottom of the building to the top. This applies also to the tower of the Nieuwe Kerk [302], basically a traditional building. Here also the vigour of De Key's design created a decidedly new situation, and he seems, too, to have entirely fulfilled his own personality. He was less able to express his ideas in two other buildings, the new façade for the medieval town hall of Leiden (1597) [299] and the weigh house at Haarlem (1598). Both are earlier, and so it may be that he had not yet fully developed his style.[1] As a matter of fact it is an open question whether, and if so to what extent, the weigh house was actually built by De Key. His responsibility for it has been denied, and no explicit proof exists. But one cannot but agree that there are elements in it which are typical of De Key's work, and it must be remembered, too, that it did not look quite so curiously classical when the roof was still surrounded by a light balustrade.

Hendrick de Keyser (1565-1621), originally a stonemason like De Key, but above all an important sculptor, had perhaps less of De Key's ornamental inventiveness. As an architect he was decidedly more versatile, and the commissions he received in a rapidly expanding Amsterdam gave him the chance to show his powers. We are well acquainted with his significance as an architect because a younger contemporary, the painter and architect Salomon de Bray, published under the name *Architectura Moderna* a book with a series of prints which one can consider to be a more or

299. Lieven de Key:
Leiden, town hall, façade, 1597

less disguised monograph on De Keyser (first edition, 1631).

De Keyser's earliest known work was already an important commission: the Zuiderkerk (South Church) at Amsterdam, begun in 1606 [300]. It was certainly not a simple task to design a Protestant church. De Keyser cherished no revolutionary ideas: he designed a pseudo-basilica according to the vernacular Late Gothic scheme as a plain Gothic rectangle with two non-projecting transepts and without a choir,

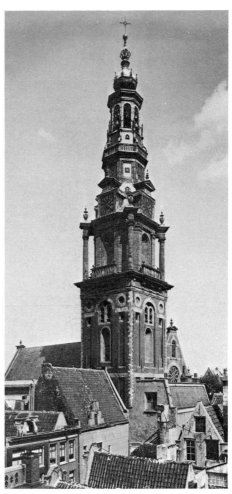

and used the formal language of his own day. A more original Protestant church in the shape of a domed octagon had already been built in the North Brabant town of Willemstad in 1597. De Keyser met with a number of difficulties over the detail of his Zuiderkerk; the Tuscan order was not particularly suited to a building with a wooden tunnel-vault and tie-beams. But he showed himself a great master in the fine tower, which was completed in 1614 [301]. If

300 and 301 Hendrick de Keyser: Amsterdam, Zuiderkerk, begun 1606, and tower, completed 1614

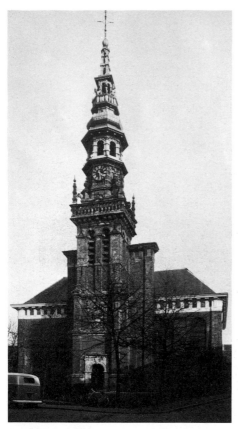

302. Lieven de Key:
Haarlem, Nieuwe Kerk, tower, 1613

one compares this with the contemporary tower which Lieven de Key built for the Nieuwe Kerk at Haarlem [302], one sees that one is a piece of fantastic whimsy, the other all harmonious grace.

At the end of his life De Keyser designed a much more important church than the Zuiderkerk – the Westerkerk (West Church), also in Amsterdam [303, 304]. This was begun in 1620. The plan is again a perfect rectangle with two transepts, but the Westerkerk is truly basilican. One sees that De Keyser had now become an experienced architect. The design

is as fluent as the previous one was laboured. The cool elegance of the spaces is to a remarkable degree similar to the spirit of Florentine Mannerism. In his maturity De Keyser had outgrown the picturesque 'Dutch Renaissance' style, and we can see that the next phase, that of Dutch Classicism, was now in the making.

Before and between these two churches come a number of less important works and one big commission, that for the Amsterdam Exchange (1608–11) [305]. There is nothing strikingly original about this: he repeated with little variant Gresham's London Exchange, which had been built in 1566 by the Antwerp architect Hendrik van Passe, and which he had made a special journey to see. It is indeed remarkable that this London Exchange was still regarded, after more than forty years, as modern enough to be copied, but this fact only illustrates the state of affairs by which in half a century there was almost no architectural development or renewal.

The remaining work of De Keyser we need only glance at here. He designed many varieties of gabled houses (among them 'Bartolotti's house', nos. 170–172 Herengracht, Amsterdam[2]); he put gay pinnacles on the towers of the old fortifications of Amsterdam, among them the well-known Mint Tower; and he rebuilt the town hall of Delft, which had been burned down, with a façade which is very whimsical, inorganic, and really Mannerist, in a style reminiscent of the remarkable and arbitrary notions of French architects of the school of Jacques Androuet du Cerceau.[3] Indeed, French influence can certainly be traced in De Keyser's later work, perhaps as a result of his preliminary studies for the tomb of William the Silent at Delft (see p. 420).

De Keyser stood in a closer relationship to the international tendencies of his day than De Key, and in his own way sought a certain classicism. After the town hall of Leiden De

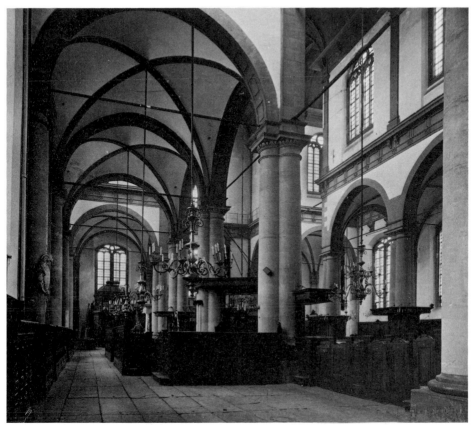

303 and 304. Hendrick de Keyser: Amsterdam, Westerkerk, begun 1620

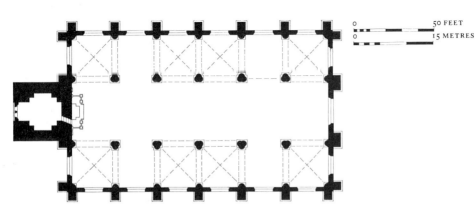

50 FEET

15 METRES

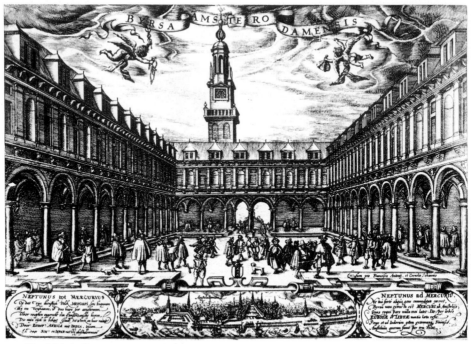

305. Hendrick de Keyser:
Amsterdam, exchange, 1608–11. Engraving

Key did not touch adaptations of the orders, while De Keyser went on using them, albeit without much emphasis. De Key represents the one-sidedness of Netherlands architecture, which offered little chance of renewal; De Keyser saved it from dangerous isolation. De Keyser exercised more influence both in the county of Holland and in the other provinces of the United Republic. He himself designed the cupola on the tower of St Lebuinus at Deventer (Overijsel), and his style can also be recognized in buildings such as the weigh house at Nijmegen (Gelderland) and the town hall of Klundert (North Brabant) [306].

Other buildings in the Northern Netherlands at the beginning of the seventeenth century do not rise above the level of ordinary

306. Klundert, town hall, 1621

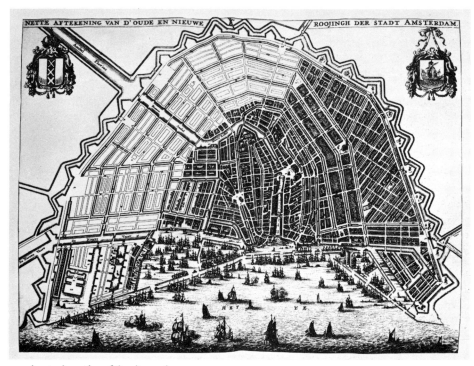

307. Amsterdam, plan of the city *c.* 1650

routine work, despite picturesqueness and a sound feeling for proportions. A typical example of the provincial architect is Emond Hellenraedt, who worked at Zutphen and its neighbourhood in the province of Gelderland. As the municipal architect of Zutphen he designed the tower of the Wijnhuis, which is a typical example of his gifts and his limitations. He is thought to be responsible for the rich gable of 3 Lange Hofstraat at Zutphen and for the fine façade next to the town hall at Deventer. He certainly designed the town hall of Lochem, which has suffered from alterations and unsatisfactory restoration. A similar figure in Overijsel was Thomas Berentsz, who in 1615 modernized very elegantly two medieval town gates at Kampen. To his brother Jan Berentsz

we may very likely ascribe the exceptionally gaily ornamented Hoofdwacht (Corps-de-Garde) by the church of St Michael at Zwolle.

The picture of building in this period would be incomplete, however, if we omitted all mention of one unusually monumental piece of town planning, the large-scale extension of Amsterdam in the form of a half moon round the old centre [307]. In 1613 work was begun on a design which perhaps was made by the municipal carpenter, Hendrick Staets. The plans were so extensive and far-reaching that half a century elapsed before their execution was completed.

The principal theme was a ring of concentric main canals with broad quays on either side – the Herengracht, the Keizersgracht, and the

Prinsengracht – cut by a pattern of radial streets. It is not often that a town has been enlarged so sensitively as to increase its characteristic beauty. Its great charm is in the noble dimensions of the canals, in the wonderfully successful relation between the breadth of the water and of the quays on either side and the height of the buildings. Where the canals turn, one gets the most exciting views. Amsterdam's aldermen built their stately houses particularly on the Herengracht and the Keizersgracht, and in comparison with other European capitals much has been preserved. Amsterdam can be compared to Venice not only for its water but also for its wealth of old houses. The houses, however, belong for the most part to the later seventeenth and the eighteenth centuries.

THE SEVENTEENTH CENTURY AFTER THE DEATH OF

HENDRICK DE KEYSER AND LIEVEN DE KEY

In 1625 Prince Maurits died, the man under whose military leadership the Northern Provinces had been able to maintain and consolidate their freedom after the secession of the Southern territories. His death brought to an end a period which in every way was a continuation of the sixteenth century, and thereupon began a new era in which the youthful and prosperous Republic made its own national way of life. The new Stadholder Frederick Henry did not follow Maurits' rather withdrawn way of life as an unmarried soldier, but surrounded himself with a court after his marriage and took pleasure in building himself palaces. A new bourgeois aristocracy, filled with a sense of its own significance, set the tone in the towns. A few families belonging to the medieval nobility maintained or made for themselves a leading position in the state, serving it as statesmen or as ambassadors. The courts of the stadholders of the most important provinces, the urban patricians, and the nobles desired to be housed with a dignity that could only be expressed in classical terms. The quaint native tradition of the sixteenth century was no use to such ambitions.

While in the Southern Netherlands the new trends appeared chiefly in ecclesiastical architecture, secular architecture was their field in the North. Not many monumental churches were built in the Republic. They were all Reformed, except in Amsterdam, where the Lutherans were also allowed to build to a considerable extent, and even the Jews were permitted to erect stately synagogues.

Architecture flourished more than ever in the west, in Holland and Zeeland, where there was most prosperity. The towns of the other provinces followed on a much more modest scale, and gave the major commissions to architects from Holland. It was also generally architects from Holland who supplied the designs for the country houses of the nobility; the other provinces made practically no further contribution to the development of architecture.

Painters had an important influence in the deflection of architecture towards more classical attitudes, particularly those painters who were more or less academically trained, who tried to obtain and maintain contacts with the Italian-directed international taste, and who themselves belonged to the settled bourgeoisie.

The first of them was Paulus Moreelse (1571–1638), a member of the Council of his native town, Utrecht, who was acquainted with prevailing notions on art outside his own country through a stay in Italy (see p. 31). The only building which can be ascribed to him with any certainty is the St Catherine's Gate at Utrecht of 1621–5, alas no longer preserved and known to us only from drawings and prints [308]. With this he introduced the international Italianate style of his time into the Republic, though naturally it was coloured by Netherlands ideas.[1] The outer elevation was the most important. The middle section, which projected, showed very vigorous coupled Tuscan columns with heavily embossed shafts on both sides of the arch. In contrast to the exceptionally three-dimensional handling of the lower section,

the upper story was more flatly treated with Tuscan pilasters. The lower side parts had rounded outer corners with a rather whimsical use of orders. On the town side there was a skilful variation with pilasters instead of columns. What was particularly impressive about St Catherine's Gate, as far we can judge from the measurements taken before it was demolished, was the plasticity of the whole, the bold treatment of the lower middle part, and the sensitive modelling of the surface in the curved side parts. Here was a revolutionary building, a piece of Early Baroque blended with reminiscences of Sanmicheli and Jacopo Sansovino. However, this does not mean that the gate was a masterpiece: the upper storey has a certain hesitancy about it, and the top is weak because the elements here are on too small a scale.

Moreelse did not establish any school with this architectural debut. It is possible that he had

a hand in the Meat Hall at Utrecht, dating from 1637, which still exists. The façade, restfully proportioned, with its pediment in the middle and the volutes on either side looks from a distance like an Italian church front. But that is all. It was not in academic Utrecht, but in Holland, in court circles at The Hague and in metropolitan Amsterdam, that the change, instigated by Haarlem's Italism, developed into the restrained classicism which was to be the generally accepted style of the Republic.

Perhaps the most important element in this final break with tradition was Frederick Henry's passion for building, which was under way even before he succeeded Maurits in the stadholdership. French inspiration was undeniable at first. One explanation for this is perhaps that Frederick Henry, the son of William the Silent and Louise de Coligny, was himself in sympathy with French ideas. His first building was a country house, Hon-

308. Paulus Moreelse:
Utrecht, St Catherine's Gate (demolished), 1621-5

selersdijk, not far from The Hague, which he began in 1621 in replacement of a medieval castle. The house consisted of three residential ranges round three sides of a courtyard. The fourth side was closed by a gallery with a Tuscan arcade, over which was a terrace with a balustrade. In an atavistic fashion there were slender octagonal towers at the outer corners of the residential ranges. A more modern note was struck by the balcony on columns which extended in front of the central pavilion, and by the side ranges ending in massive four-sided pavilions which were linked by the gallery range. These heavy corner pavilions were clearly a reminiscence of French palaces such as the Luxembourg in Paris, begun in 1615. The façades were almost entirely flat, enlivened only by windows at regular intervals with alternate triangular and segmental pediments. The interior was well balanced and comfortably laid out, with a wide entrance hall and a

broad staircase behind. Towards the middle of the seventeenth century the octagonal corner towers were replaced by four-sided pavilions, and the old-fashioned little gable of the entrance pavilion by a broad pediment. There is nothing left of it today: in 1816 the neglected palace was demolished.

We do not know who designed Honselersdijk in this momentous style transitional to classicism. Its example was soon followed. In 1629 the painter-architect Salomon de Bray of Haarlem, an academic artist of limited powers, provided Warmond, a manor house near Leiden, with a new entrance range, of which the façade was adorned with pilasters and a broad pediment, the first big pediment we know of in the Republic. A modernization about 1780 left nothing of the work of De Bray.

In 1630 Frederick Henry started a second country palace, Rijswijk, just outside The Hague [309]. Alas, this landmark in architec-

309. Rijswijk, palace, begun 1630.
Drawing by J. de Bisschop

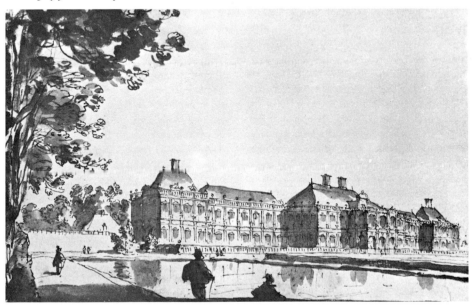

tural development in the Netherlands also does not survive. Rijswijk was laid out in accordance with the French pavilion system, not, however, in the traditional manner with a courtyard, but, like the Tuileries in their fragmentary state, as one long range. The central block, which contained the principal rooms, was linked to square pavilions by gallery ranges. At the back of the central block was a projection of three bays with arcading on the ground floor and the first floor. The flat roof of this formed a terrace with a balustrade, from which there was a wide view – a real belvedere. Altogether there was a very strongly three-dimensional articulation. Baroque elements are entirely lacking. The façades were still treated very much in the Renaissance manner with two orders of pilasters, blocked below, and smooth on the second tier. There was a balustrade along the eaves of the steep pavilion roofs, and the windows between the pilasters had alternating pediments. Though the new style is still only tentative, it is present. We can perhaps best grasp this by comparing Rijswijk with a wholly Dutch building of a generation earlier such as the castle of Frederiksborg north of Copenhagen, which was built mostly in 1602–8. From such a comparison, Frederiksborg emerges as a triumph of the older romantic picturesque style, with its animated skyline and strong vertical accents. The architects of Frederiksborg were the two brothers Steenwinkel from Antwerp. Unfortunately no one knows who designed Rijswijk.

After long, hesitating preparation, the decisive impulse which gave a definitive shape to Dutch Classicism was supplied by the Haarlem painter-architect Jacob van Campen when he designed, in 1633 or shortly before, the little palace in The Hague called the Mauritshuis [310, 311].[2] This was for Johan Maurits van Nassau, a relation of Frederick Henry and a successful general, afterwards governor of the Dutch colony in Brazil. Van Campen (1595–1657) was that rare case, an artist of considerable social standing, owner of an estate in the province of Utrecht, a man of erudition, and at least as far as architecture was concerned a man of taste and originality who proved capable of giving a lead. He was not, however, an easy man to work with; the correspondence of Constantijn Huygens, the influential secretary of Frederick Henry, wit and dilettante in the best sense of the word, mentions Van Campen's difficult temper.

The Mauritshuis was not Van Campen's first architectural effort. In 1625 he had built on the Keizersgracht in Amsterdam a double house for the brothers Koymans. Its relatively broad façade consisted of two tiers of pilasters: first an Ionic order in eight bays, and above a Corinthian order. The motif of the gable is abandoned: the front of the house was finished off by an attic with low windows. The monumentality for which the architect was striving is achieved in the strong horizontal emphasis and the avoidance of the traditional gables, but the scale is still small and the whole effect rather timid.

When Van Campen built the Mauritshuis all timidity was gone. Here was a man who knew how to design a palace with astonishing assurance. The front and rear façades, though differently handled, both have a centre of ordinary sandstone marked by a pediment. The rear façade to the water is by far the more harmonious. How can we explain this development? A journey to Italy, referred to by the untrustworthy Campo Weyerman, is as unproven as the early journey of Brunelleschi to Rome. The Mauritshuis remains a phenomenon in North Netherlands architecture which must arouse as much surprise as admiration. To judge it one must remember that it has suffered by the removal of the monumental chimneys on the hipped roof and by the jarring replacement of the windows in the nineteenth century.

Palladianism is a term that has often been used in connexion with Dutch Classicism.

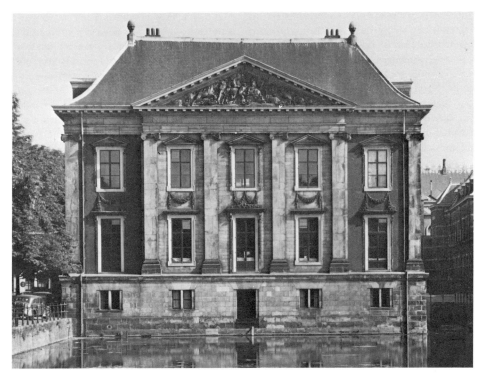

310 and 311. Jacob van Campen: The Hague, Mauritshuis, designed *c.* 1633, rear façade and plan of first floor

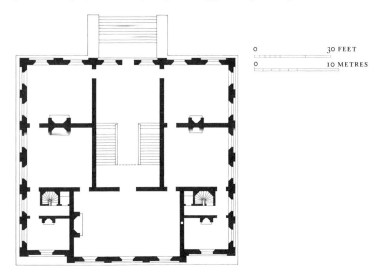

0 30 FEET

0 10 METRES

It is not, in my opinion, a very suitable one for the style of Van Campen and his followers. A giant pilaster order Palladio seldom used, and his style is much more many-sided and conveys an entirely different atmosphere from that of the Netherlands. An integral part of Dutch buildings is their steep roofs, whose impressive surfaces determine the shape of the buildings as much as the roofs of such French buildings as the châteaux of Maisons and Vaux-le-Vicomte.

A building on which he was working at the same time as the Mauritshuis – the now vanished house belonging to Constantijn Huygens in The Hague – shows that Van Campen's architecture was much nearer in spirit to that of Levau and François Mansart than to Palladio.[3] The 'corps de logis' was separated from the street by a courtyard with low projecting wings on either side. The three centre bays, in a very French way, were decorated with two orders of pilasters – Ionic below and Corinthian above – with a pediment. When Van Campen built a town palace for Frederick Henry in the Noordeinde at The Hague in 1640 the type was the same, but the dimensions were larger, the side wings were as high as the central block, and the two orders of

312 and 313. Jacob van Campen:
Amsterdam, Royal Palace (former town hall),
begun 1648, façade and plan of main floor

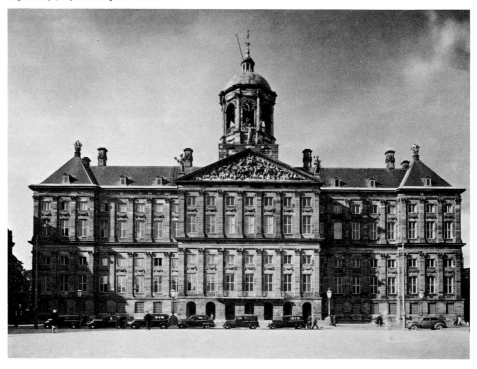

pilasters were carried along all the façades. The arcaded galleries in the wings are a happy motif. Unfortunately, the palace suffered severely from drastic modernization at the beginning of the nineteenth century. Recently the façade has been restored. A remarkably vigorous treatment distinguishes the Accijnshuis at Amsterdam of 1637, wrongly attributed to Van Campen: a modest office building marked by a giant order and heavily accentuated portals.

Van Campen was fortunate in getting many and important commissions: palaces, town gates, the Amsterdam theatre of 1637[4] (a very modest building), a church such as the Nieuwe Kerk at Haarlem, which I shall consider when I am dealing with church architecture, and finally his masterpiece, the town hall of Amsterdam, which has now served as the royal palace for nearly a century and a half [312, 313]. Begun in 1648, when the war with the Spanish ended with a formal recognition of the independence of the Republic, it is, in its monumental proportions and its astonishing wealth of decoration, a unique creation in the Europe of the mid seventeenth century, and the grandest town hall up to that time.[5]

The building has an original plan: an oblong of four ranges round two courtyards separated

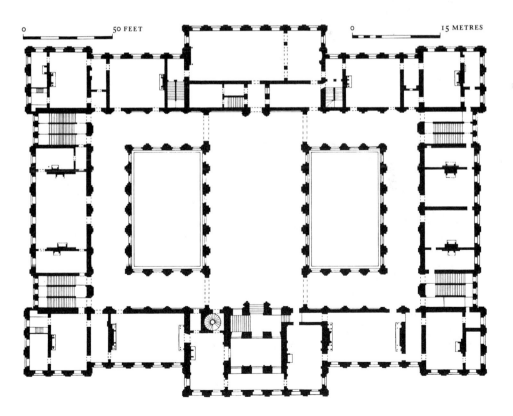

O 50 FEET O 15 METRES

314. Jacob van Campen: Amsterdam, Royal Palace (former town hall), begun 1648, central hall

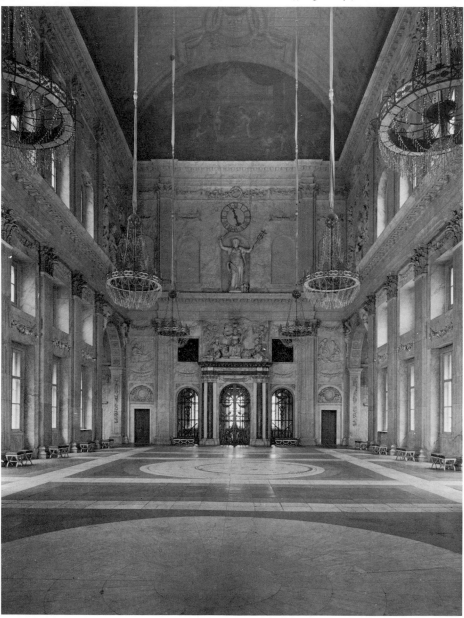

by an immense central hall, a 'salle des pas perdus' [314]. Stately corridors lead from this hall round the two courts and give access to the halls and offices of the piano nobile. Four identical staircases are placed in the two short ranges. A gallery for the second storey figured in the original design, but was not finally built. The general arrangement of the rooms is original and in many respects admirable. The two courtyards have no more importance than to serve as light-wells, and are not accessible from the main floor, in contrast to the Mediterranean tradition. Another special feature is the insignificance of the entrance: the Hall of Judgement for the pronouncing of death sentences, symbol of the city's judicial power, lies where one would expect to find a vestibule. Rather narrow spaces lead round the Hall of Judgement to an equally narrow and badly-lit staircase; then one is suddenly in the soaring space of the central hall. Obviously this plan was dictated by practical considerations, the idea being to avoid the possibility of turbulent crowds getting inside unchecked. The magnificent bronze gates are even provided with gunports for muskets to defend the entrances. The United Netherlands was an aristocratic republic, like Venice, and not a democracy in accordance with modern ideas.

The exterior of the former town hall shows its designer's concern to articulate the mass of the building. He introduced four projecting pavilions at the angles and an equally projecting broad centre on both the long sides. The angle pavilions almost look like towers. The vertical emphasis is remarkably strong: the rhythm of windows and pilasters placed in tiers, one close above the other; the steep roofs, particularly on the angle pavilions; and the large cupola which rises above the pediment of the front, all point upward. The distances between the centre and the angle pavilions on the front and at the rear are short. All this is very un-Italian.

The decoration of the exterior is somewhat over-detailed and on a rather small scale, and that results in a certain monotony. The luxuriant sculpture by Flemish masters which adorns the interiors of the Hall of Judgement, the central hall, and the galleries is in striking contrast with the small-scale treatment of the façades. In the Hall of Judgement the sculpture almost dominates the architecture. The principal sculpture in the galleries is concentrated in the corners, where it catches the eye from a distance. Van Campen, a painter by origin, had also drawn up an ambitious programme of painted decoration for the interior; it was, however, by no means fully carried out, as a result of the difficulties which arose between client and architect. As time went on relations between the dilettante Van Campen and the municipal architect Daniel Stalpaert, who was responsible for the execution of the designs, must have become extremely bad, and as early as 1654, long before the building was finished, Van Campen withdrew entirely from the whole undertaking.

The characteristic Dutch Classicism with its stately orders of pilasters, as inaugurated by Van Campen, flourished until about 1670. The three principal masters who worked in this style, though each in his own idiom, are Pieter Post (1608-69), Arent van 's-Gravesande (d. 1662), and Philips Vingboons (1614-78). Apart from these there were Pieter Noorwits, who was a brother of Arent van 's-Gravesande, Justus Vingboons, brother of Philips, and Willem van der Helm, the municipal architect of Leiden. It seems the best plan to deal with their secular work here, and their ecclesiastical work separately.

Pieter Post started as the right-hand man of Jacob van Campen, assisting him at the Mauritshuis, the palace in the Noordeinde at The Hague, and the Amsterdam Town Hall. After a time he developed his own busy practice

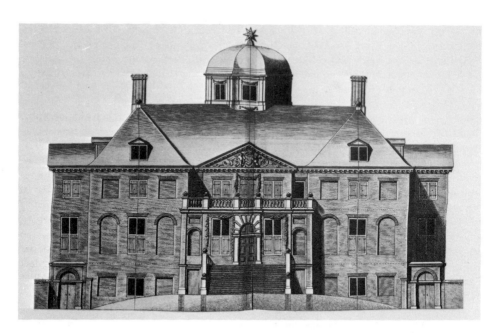

315 and 316. Pieter Post:
The Hague, Huis ten Bos, begun 1645.
Engraving of façade, and interior of
the Oranjezaal, decorated by Jordaens and others

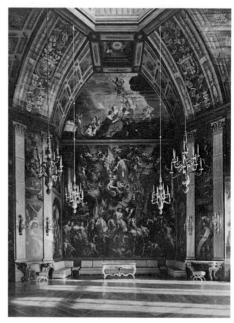

for the court of the stadholder, for administra-
tive bodies, and for private persons. Post lacked
the boldness of Van Campen. His vision was
limited, and he had nothing at all of the older
architect's grand manner. One of his best-
known works is the Huis ten Bos near The
Hague, begun in 1645 as a 'villa suburbana'
for Amalia van Solms, the wife of Frederick
Henry [315]. It is a very simple brick palace
of which the centre is a large cruciform domed
hall, decorated under the direction of Van
Campen with paintings in memory of Amalia's
husband, who died in 1649 [316]. As far as is
known Van Campen only concerned himself
with the painting of the great hall, known as the
Oranjezaal, and had nothing to do with the

house itself. From outside one does not see that the central hall rises right up into the roof: only a modest cupola emerging from the roof betrays its existence. In the eighteenth century the building was enlarged by a sandstone front pavilion and side wings. They make Post's original creation, once a paragon of a well-proportioned country house, almost unrecognizable.

The Oranjezaal is a cross with arms all the same length and canted at the corners. One cannot avoid feeling that the hall in this form was more or less forcibly thrust into a house which was not built for it. The ceiling of the hall is strange. Above the cornice follows a coving, and then four flat ceilings in the arms of the cross, leaving an octagonal opening in the middle from which the cupola rises. The resulting spatial composition is both surprising and impressive.

Post was at his best in sober brick buildings, without or with hardly any orders. An attractive example of this type was the shot foundry of the States of Holland in The Hague (1665), a pleasing utilitarian building which was destroyed in the Second World War. He only once succeeded in achieving harmony in a design on a monumental scale. This was the weigh house at Leiden, begun in 1657. The façade is entirely in sandstone. The lower part, corresponding to the actual space where the weighing was done, is rusticated and acts as a podium for an upper storey with a Doric order of pilasters, surmounted by a triangular pediment. Both proportions and details are exceptionally successful, and the only criticism one might make is that as a podium the ground floor is rather high compared with the upper elevation. When Post made another weigh house ten years later for Gouda, the vigorous boldness shown at Leiden was lacking.

Post's most ambitious work was the town hall of Maastricht, begun in 1659. It is a square block, standing on its own in the centre of the market place, and built entirely of grey limestone.[6] The main front has two tiers of pilasters along its whole length, while the other façades have pilasters only in the centre. The core of the block contains an exceptionally large hall, which rises into the roof and is a double cube. The rear half with its massive, almost Romanesque arches is surmounted by an octagonal dome and carries a clock tower. Round the hall are galleries giving access to the various rooms. There is a certain *grandezza* about the centre of the front with its heavy arcades, but the great hall within shows a lack of harmony between the enormous heavy arches in the rear and the over-light wooden galleries of the front part. Post was happier in designing less ambitious interiors, such as that for the hall of the Rhineland Polder Authority House at Leiden. Here the walls are panels of gilt leather separated by Ionic pilasters, and the ceiling has a painted elliptical tunnel-vault of timber construction.

The work of Arent van 's-Gravesande is limited in quantity but high in quality. The first building which, according to trustworthy evidence, was designed by him is the St Sebastiaansdoelen in The Hague, of 1636. The well-proportioned façade towards the Hofvijver has an order of four giant Ionic pilasters and a pediment in the middle. It is remarkable that he was able to use Van Campen's style convincingly so soon after the Mauritshuis was begun. His cloth hall at Leiden of 1639 is a variation on the theme of Huygens' house in The Hague [317]: here, too, is a courtyard with low projecting wings in front of the main building itself, of which the centre has four giant Ionic pilasters carrying a pediment. Whereas Huygens' house showed a certain hesitation and timidity, the Sebastiaansdoelen has an easy elegance. Van 's-Gravesande was by this time settled in Leiden as municipal

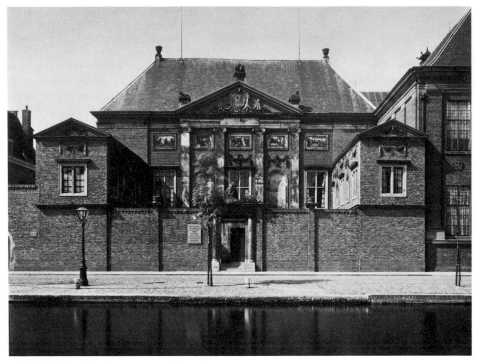

317. Arent van 's-Gravesande:
Leiden, cloth hall, 1639

architect, and had a private practice too. A fine example of his elegance of design is the Bibliotheca Thysiana at Leiden. It has a façade whose lower storey is treated as a plain podium for the delicate Ionic order of pilasters of the first storey. Other buildings dating from his years in Leiden which may be ascribed to him include the Hofje van Brouchoven, with an almost funny adaptation of a giant order of pilasters for a central pavilion of extremely modest proportions. His principal work in Leiden was the Marekerk, which will be discussed later (p. 407).

Philips Vingboons built houses for prosperous merchants in Amsterdam, and a number of country houses for patricians and members of the nobility as far away as the provinces of Groningen and Overijsel. As a Roman Catholic, he was probably not employed to design public buildings and Reformed churches. One certainly cannot compare the Amsterdam merchants' houses with the sumptuous palazzi of seventeenth-century Venice, but there is one exception: the Trippenhuis, a double house built in 1662 for the two brothers Trip [318]. It has an impressive, broad sandstone façade with giant Corinthian pilasters, garlands between the windows, and a richly ornamented cornice. The elaborate ornamentation is remarkably un-Baroque, sharp and linear. However, the Trippenhuis was not designed by Philips Vingboons, but by his brother Justus, who

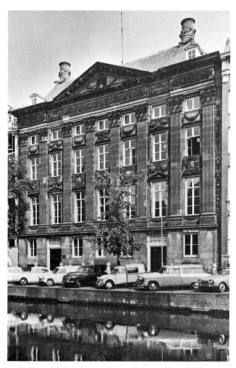

318. Justus Vingboons:
Amsterdam, Trippenhuis, 1662

later went to Stockholm and there designed the elevations of the Riddarhus, also with giant pilasters and garlands.

When we look through the charming books of engravings in which the work of Philips Vingboons is illustrated, we are struck by the versatility with which he contrives to vary the forms for narrow and broad town houses, and for large and small country houses. Sometimes they are gaily furnished with pilasters, sometimes austere, in the manner of Pieter Post, who succeeded best in achieving balance in unambitious buildings. Just once Vingboons turned out a truly monumental design: it is the block of three houses in Amsterdam for Oetgens van Waveren, dated 1639, which have

long since been demolished. He reserved giant orders in general for country houses; for broad town houses he usually preferred pilasters in two tiers to emphasize the centre part. He also liked gables with pilasters, three windows wide, an arrangement already old and one that Hendrick de Keyser had used in the house of Hans van Wely (now demolished). Vingboons retained the scheme, but composed more exactingly and detailed more finely. It is remarkable that a man of such talent, who built houses for such a prosperous private clientele, should have received no major commissions for public buildings. He certainly had ambitions in the direction of monumental architecture. In the first part of his engraved *œuvre*, which appeared in 1648, appears a very monumental country house with a vigorously treated broad façade. It was never built. In the same collection is a design for the town hall of Amsterdam, but this was more than he could manage. The corner pavilions with their domes above and over-heavy cornices do not fit in well with the centre, which has, however, looked at by itself, a charming front and is crowned by an exceptionally elegant bell-tower. We do not know what Philips Vingboons may have been able to do in the field of spatial design.

Among the most important secular buildings of Dutch Classicism one merits special attention, the former Schieland Polder Authority House, now the Historical Museum, at Rotterdam. It was designed in 1662 by the Rotterdam amateur Jacob Lois, probably with the help of Pieter Post. It has suffered much from restoration after a fire in the last century, when the original high roof was replaced by a very ugly one. No other façade of the standard pilaster type has such high relief. The porch might almost be called Baroque. Most of the other work of the period, however, differs little from that of the masters already discussed. Only the municipal architect of Leiden, Willem

van der Helm (d. 1675), shows some originality in certain aspects of a few buildings. They are occasionally to some extent influenced by Gothic precedent.

About 1670 the shape of things began to change. The pilaster style, which till then had seemed *de rigueur* for all monumental buildings, and which had spread beyond the frontiers of the Republic, particularly to Westphalia, fell into disuse. Among the last examples are the town hall of 's-Hertogenbosch (Bois le Duc) as it was modernized in 1670, probably by the Rotterdam architect Claes Persoons, and the court house at Leiden of 1671 by Willem van der Helm. The extremely sober and flat style which had sometimes been used by Post and Vingboons for modest buildings spread more and more and became fashionable even for the most ambitious enterprises. However, this does not mean that there were no changes in this style. The surfaces of the façades were treated with increasing subtlety so as to emphasize their flatness. It is important in this connexion that the details of the windows changed. Until after the middle of the seventeenth century the mullion-and-transom-cross type of window was generally used. The mullions and transoms consisted mostly of heavy wood painted white, forming strongly marked crosses against the leaded panes of glass. About the middle of the century a tendency began to replace this antiquated type by one of a more unified and restful character, using thin wooden glazing-bars instead of lead, reducing the big cross-bars in section, and moreover setting back the whole casement, which formerly was placed flush with the wall surface. This process had begun as soon as strong monumental notions began to percolate into Dutch Classicism, and the first examples are in the original windows of the palace at Amsterdam (now all gone) and in those of the weigh house at Leiden. The ultimate solution was the adoption about 1680 of the sash-window, which, especially when set well back, heightens the monumentality of the brick walling. The odd thing is that this architecture of extremely flat walls pierced by wholly unadorned windows is the first expression of Baroque feeling in the Northern Netherlands. It is Baroque in so far as, by means of exaggerated simplicity, the impression of absolute unity is forced on us. The masses dominate, and no details can speak by themselves.

The tight classicism of the last three decades of the seventeenth century is a very impersonal style. It is not easy to recognize the various architects by their work because the decorative elements have become both sparse and uniform.

One of the principal architects in the style was undoubtedly Daniel Stalpaert (1615-76), whom we have already mentioned in connexion with his work on the town hall of Amsterdam. A masterpiece in the flat style is his Marine Arsenal at Amsterdam (1655), a splendid piece of well-thought-out utilitarian architecture.[7] A fellow-worker in the same style was Adriaen Dortsman (d. 1682), the architect of patrician houses in Amsterdam and of the Nieuwe Lutherse Kerk there, which will be discussed later. There is a proud austerity about the unornamented façades and steep roofs of Amerongen, a country house in the province of Utrecht, which was begun in 1676 by Maurits Post, the son of Pieter Post, who died young in 1677. He also worked for the Stadholder William III, who was to become king of England: he built the palace of Soestdijk in the province of Utrecht, remodelled in the Palladian style in the early nineteenth century, and his spirit can be seen at Zeist, a country mansion near Utrecht of *c.* 1686, and in the palace of Het Loo, of *c.* 1685-1687 (later altered) in the province of Gelderland.

But not everybody was happy with so unornamented a style; there was also a slightly more emotional Dutch Baroque which tended to look for monumental effects in stone. The pilaster

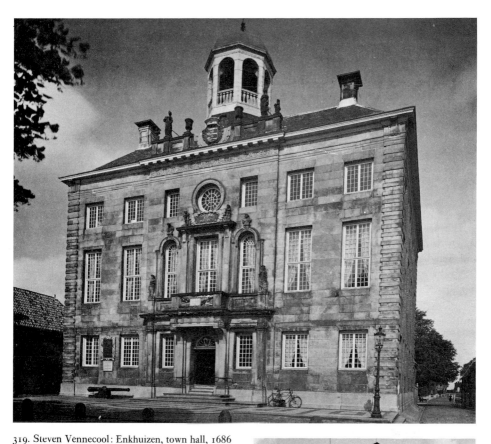

319. Steven Vennecool: Enkhuizen, town hall, 1686

320. Steven Vennecool: Middachten, château, 1695

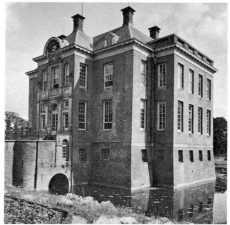

style remained in the background, however. When the Amsterdam architect Steven Venne-cool (1657–1719) built the handsome town hall of Enkhuizen[8] with its sandstone façade (1686) [319], he used smooth rustication, a few arched windows, and a well-marked balcony above the entrance. Another example of this style is the manor house of Middachten [320], and an even more characteristic one the town hall of Deventer (1693) by Jacob Roman (1650–1715/16), the architect to the stadholder.

The ecclesiastical architecture of Dutch Classicism markedly prefers centralized plans. A typical example from the beginning of the period is the village church of Renswoude (province of Utrecht), built in 1639. The plan is that of a Greek cross with short arms. Each arm is screened off by two slender Ionic columns, which help to carry a high, square drum from which rises the octagonal dome. The exterior shows an effective development of the masses culminating in the dome, while the interior, though certainly not without charm, has some clumsinesses, which may point to a division of hands between the man who made the design, and who may well have been Jacob van Campen himself, and the man who carried it out.

Van Campen certainly did design the Nieuwe Kerk at Haarlem of 1645 [321, 322], built against the tower which De Key had added to a former medieval church. The plan is a classical one: a cross with equal arms inscribed in a square. Four Ionic pillars and columns between these pillars and the outside walls separate the cross from the four corner squares. The cross is roofed by two interpenetrating wooden tunnel-vaults, and the four corner squares have flat ceilings. There are only four Ionic columns, not eight. The other four columns, on the longitudinal axis, undoubtedly existed in the original design, but were omitted in order to give unimpeded views of the pulpit. There appears in this as in so many cases a conflict between a rigorously centralized plan and the requirements of church services. It was not possible to put the pulpit in the middle; it had to be placed in an arm between two of the square piers. The exterior is unattractive and blocky because the

321 and 322. Jacob van Campen:
Haarlem, Nieuwe Kerk, 1645

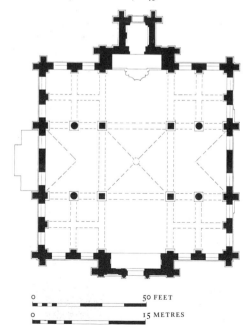

0 50 FEET

0 15 METRES

cross shape is hardly expressed, but the carefully planned relations and the restfulness of the interior show that an architect of real talent was concerned with it.

The lack of articulation which spoils the exterior of the Nieuwe Kerk at Haarlem was avoided in later churches with the same plan by making the corner squares much lower than the cross. Examples are the village church of Oudshoorn in the province of South Holland (1657) and the Oosterkerk (East Church) at Amsterdam (1669). We do not know the architect of either: it could have been Daniel Stalpaert or Adriaen Dortsman.

Arent van 's-Gravesande took quite a different direction when he built the Marekerk at Leiden in 1639 [323]. The type shows a resemblance to that of S. Maria della Salute in Venice by Baldassare Longhena, begun eight

323. Arent van 's-Gravesande:
Leiden, Marekerk, begun 1639

years previously. We do not know if 's-Gravesande knew Longhena's church; it is more likely that he was acquainted with that of Scherpenheuvel near Louvain.[9] In any case, it seems advisable not to press the comparison with the Venetian church too far. The Marekerk consists of an octagonal domed space with a wooden turret, and a lower ambulatory. Strong Ionic columns carry the high, well-lit drum of the dome. The corners of the drum are supported by incurved buttress walls. The dome is entirely of wood, and the ambulatory has a flat ceiling. The Marekerk is no great masterpiece; it is a truly bourgeois interpretation of an aristocratic idea. But it has a certain greatness all the same, and the interior with its enormous columns is certainly impressive. In 1646 the Oostkerk at Middelburg was begun: it was a variant on the Marekerk type. It appears that a design by Pieter Post in collaboration with Bartholomeus Drijfhout was followed, which was later modified by 's-Gravesande. The general plan is grander, and has a tendency towards the Baroque. It differs from the Marekerk in that at Middelburg the domed part has almost entirely swallowed up the ambulatory; on the outside, the roof of the wooden dome rises straight from the attic of the wall, and inside the dome rests upon eight Ionic columns standing in the corners close to the walls. There is some distant similarity to the baptistery of the cathedral at Florence. The top is a lantern with large arched windows. The architects were not very successful in the decoration of the exterior; the assembly of motifs is really quite incongruous.

Once again a dome, this time completely circular, was chosen as the dominant element of a Protestant church: in the Nieuwe Lutherse Kerk at Amsterdam [324], the work of Adriaen Dortsman (1668), an architect of considerable talent. Up to a point this is a synthesis of the two churches of Leiden and Middelburg. The dome is surrounded by an

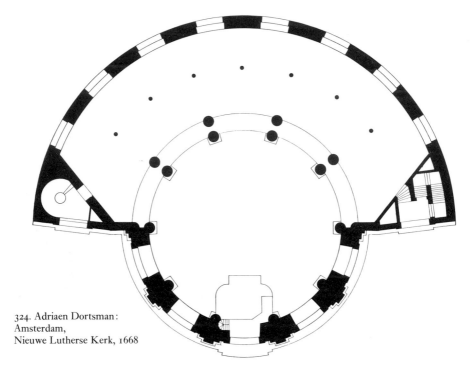

324. Adriaen Dortsman:
Amsterdam,
Nieuwe Lutherse Kerk, 1668

ambulatory along only half its periphery; the other half rises straight from the ground. The out-and-out central plan, hardly reconcilable with the requirements of the services, has been given up. The half of the church with the ambulatory is hidden by the surrounding buildings; the other half rises above the quay-side of the canal. Dortsman's treatment of this elevation is masterly, and shows that we have left classicism and have reached a late-seventeenth-century Baroque. The meagre order of pilasters of the Middelburg church has given way to a very broad and strong treatment: on a base with banded rustication stands an order of sturdy clustered pilasters with a heavy Doric entablature. Above the attic rises the wooden dome, covered on the outside with copper, and crowned with a glazed lantern. The rectangular windows are of monumental size and – an exception in these regions – have moulded surrounds. This is a building into

whose creation has gone a true feeling for three-dimensionality, expressed in a Baroque way and with undeniable power. Unfortunately, the interior was altered after a fire in 1822, and now gives an impression of coldness.

An unusual type is the Nieuwe Kerk in The Hague, begun in 1649 by Pieter Noorwits (d. 1669), brother of Arent van 's-Gravesande, and Van Bassen (d. 1652), municipal architect of The Hague [325]. The plan can be described as a rectangle, of which the long sides are twice the length of the short. The short sides each have a polygonal apse, while the long sides each have two. The pulpit and baptismal screen, the focal point of the service, are placed in the piece of flat wall in the middle of one of the long sides. This means that the conflict between the architectural space and the liturgical use reveals itself emphatically. The exterior is most picturesque, through its remarkable assembly of angles, through the interplay of the six apsidal

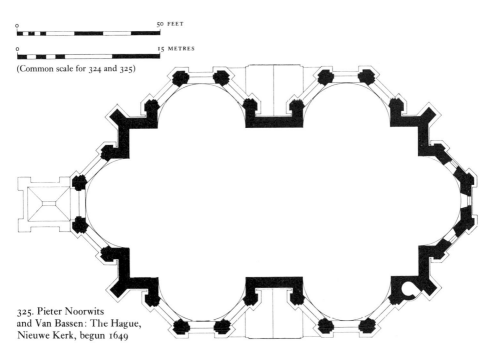

o ┃━━━━━━━━━━━━━━━━━━ 50 FEET

o ┃━━━━━━━━━━━━━━━━━━ 15 METRES

(Common scale for 324 and 325)

325. Pieter Noorwits
and Van Bassen: The Hague,
Nieuwe Kerk, begun 1649

roofs with the main roof, through the vigorous use of pilasters, and through a charming little wooden turret that rises from the ridge of the roof. The interior is much less successful: the unbroken space is rather bare and is narrowed in the middle in a very unsatisfactory manner. The present panelling of the wooden vault with its Gothic decoration is of the nineteenth century.

A successful variant on the Nieuwe Kerk in The Hague is Pieter Post's village church of Woubrugge east of Leiden (1652). The long sides of the rectangle here each have only one apse, and as they are set out as three sides not of an octagon but of a dodecagon, they are much less deep. From the point of view of space the little church of Woubrugge is much more successful because of these changes than its larger forerunner at The Hague. Another variant is the design of Willem van der Helm for the Waardkerk at Leiden (1663), which was never

completed and has now entirely disappeared. He gave two apses each only to the long sides and wanted to build a tall tower against one of the short sides, which certainly was not a happy idea.

The latest religious building of the period to be mentioned here is the monumental Synagogue of Portuguese Jews at Amsterdam, designed in 1671 by Elias Bouman, a triumph of the spirit of toleration, if not in the Republic, then certainly in the Amsterdam city council. It is one vast rectangular hall, covered by three wooden tunnel-vaults, equal in width, which rest on two architraves, each borne by two tall Ionic columns. This synagogue inspired Emanuel de Witte to paint one of his most striking interiors, in this case faithful to the architectural reality (now Amsterdam, Rijksmuseum; cf. p. 329). The exterior of the great brick block is skilfully articulated by flat lesenes in a successful relationship with the windows.

THE FIRST HALF OF THE EIGHTEENTH CENTURY

By the beginning of the century both the national Baroque of the Southern Netherlands and the Classicism of the Northern Provinces with its aftermath of studied sobriety were at the end of their possibilities of development. At that moment, as it happened, a new impetus came from the France of Louis XIV. The man to whom this new impetus was due is the French ornamentist and architect, Daniel Marot. Being a Huguenot, he went to the Republic on the revocation of the Edict of Nantes in 1685, or in the following year, where he was much respected as someone with a thorough mastery of the

326. Daniel Marot:
The Hague, Binnenhof, Trêveszaal, 1696–8

contemporary French decorative style. He became interior architect to William III, for whom his work included the interior and the park of Het Loo, and for whom he also worked for some years in England. In 1696–8 the audience chamber of the States-General, the so-called Trêveszaal in the Binnenhof at The Hague, was built in accordance with his plans [326]. In the end he designed whole buildings as well as interiors. The first which can possibly be ascribed entirely to him was De Voorst, a country house two miles east of Zutphen in Gelderland, which was begun in 1695 or shortly after for Joost van Keppel, Earl of Albemarle, the proud favourite of William III. It was ravaged by fire in 1944, but has been restored since.

De Voorst is a tight, block-like house of sandstone with a curious curved pavilion roof, linked by two arched quadrant colonnades to wings flanking the courtyard. It is particularly the relationship between the various elements which points to French inspiration; in the treatment of detail the architect kept pretty closely to the flat style of Maurits Post and Jacob Roman. Indeed, there is quite a possibility that Roman may have collaborated closely with Marot. Marot's full emergence as an all-round architect took place after a stay in Amsterdam in 1715 and the following years, on receiving important commissions at The Hague. To this period belongs the Schuylenburg house, converted into the German Embassy (1715), whose stately sandstone façade reveals a blending of the late-seventeenth-century tradition with the ornamental tendencies of the Louis XIV style. Grooved joints over the whole front break the smoothness, and flowing decoration gives relief

to the entrance, with its balcony and window above. A stylish Baroque attic finishes it off. Marot did not break with the native tradition, but he manipulated it in a new lively decorative sense.

His personal touch is still more obvious in the Hôtel van Wassenaar at the inner corner of the Kneuterdijk at The Hague. Here is the true ornamentalist, with his alternation of moulded stone and brickwork, blocked pilasters, accentuated window surrounds, 'congélations', frieze with Louis XIV brackets, an attic with vases, masques, and volutes – in fact, everything that belongs rather to the inside than to the façade – but harmonized into a rich and luxuriant whole. It is mature Louis XIV decoration, somewhat heavy, almost cumbersome. The

plan of the house is remarkable and clearly shows Marot's French training. Marot at his best also appears in the façade of the Hôtel Huguetan in The Hague, now the Royal Library (1734) [327]. The side ranges were added later. The sandstone façade is elaborately decorated, all its parts full of liveliness. Slim rusticated lesenes accentuate the height, and a new motif is the grand arch above the portal which holds an ornamental window. Two Baroque figures frame the coat of arms above the cornice. There are fine staircases in the Hôtel Schuÿlenburg and in the Royal Library, with a wealth of stucco work. Marot was only once engaged in religious architecture: when he designed the Portuguese Synagogue in The Hague in collaboration with the amateur Felix

327. Daniel Marot: The Hague,
Royal Library (formerly Hôtel Huguetan), 1734,
wings by Pieter de Swart, 1761

du Sart. It was a good piece of work, fitting more or less into the late-seventeenth-century Dutch style.

The Marot style was taken up rapidly in the Republic, especially for interiors. The lively façades he created had for the most part only an indirect effect: it was not as a rule a question of immediate copying, but certainly of a liberating reaction against late-seventeenth-century rigidity. Specially decorative examples are some façades in Amsterdam such as Herengracht 475, the new wing of the town hall and the Ministry of Foreign Affairs in The Hague, and the palatial educational establishment of the Renswoude Foundation at Utrecht.[1] As Marot's biographer Ozinga has clearly shown, his style was already out of fashion in France in about 1715; but throughout his long life he remained faithful to variations on what had been modern in his youth.

The emphatically Baroque style of Marot also found followers in the Southern Netherlands. The Antwerp sculptor-architect Jan Peter van Baurscheit the Younger (1699–1768), son of the sculptor of the same name, was strongly influenced by him. He was indeed in immediate contact with Marot, for whom he carried out sculpture on the Royal Library at The Hague.[2] The first buildings by Van Baurscheit seem however to have been designed for Zeeland. It is certain that he was responsible for the rich façades of the Beeldenhuis at Flushing and of the Provincial Library at Middelburg of 1733 (destroyed in the Second World War).

THE SECOND HALF OF THE EIGHTEENTH CENTURY

During the second half of the eighteenth century[1] the country sought inspiration from contemporary French architecture, without abandoning all native traditions. The results were not very impressive. There were no rich abbeys in the Republic with big commissions to offer, such as Dewez had in the Austrian Netherlands. Neither the central nor the provincial administration thought of starting important and grand buildings. The court of Willliam IV, who had become stadholder of all the provinces after 1747, and that of his successor William V were certainly important for the development of architecture, but there was no question of new palaces for the stadholder himself. No more was done than an enlargement of the stadholder's quarters in the Binnenhof in The Hague (see below). There were no municipal building projects either, though Rotterdam, at the height of its prosperity in the eighteenth century, could have followed the example of Amsterdam in the seventeenth century.

328. Pieter de Swart: The Hague, Royal Theatre (former Nassau Weilburg Palace), *c.* 1765

It was already possible in the first half of the eighteenth century to detect a tendency to less Baroque forms, particularly in such a town as Rotterdam. Here Adriaen van der Werff (1659–1722), known best as a painter of smooth academic compositions (see p. 358), worked in the same spirit as an architect. The distinguished house at Boompjes 77 and his exchange, begun in the year he died, were both destroyed in 1940. They showed how he sought a reticent and dignified style, preferring rusticated sandstone façades. However, the seventeenth-century tradition is strong in the mass and composition of his exchange, with its corner pavilions which were covered with low, curved pavilion roofs.

Fresh contact with French architecture was assured in the third quarter of the century by Pieter de Swart, who had been able to study in Paris, his expenses being paid by William IV.[2] His first project, about 1760, was a number of wealthy houses at The Hague, on the Lange Vijverberg and Voorhout. Shortly before 1770 he designed the Nassau Weilburg Palace there, which was later converted into the Royal Theatre [328]. Like the entrance range of the palace at Brussels, built by Faulte ten years before, the front of the theatre is concave, but the style is much more advanced, and is in fact a most refined example of the Louis XVI style *avant la lettre*. His ease in managing French forms was shown by De Swart in the Delft Gate at Rotterdam, built in 1765–73 and destroyed in 1940. On top of a vigorously treated base with round corners stood a lighter, playfully decorated storey. It is instructive to compare this with Moreelse's St Catherine's Gate at Utrecht (p. 391), and to notice the similarity in scheme and the difference in treatment. Decorative sculpture, typically French in its arrangement, filled the front compartments of the upper storey.

Monumental architecture in stone in the classical style remained rare. A dull example is the new stadholder's quarters in the Binnenhof at The Hague, by the German architect F. L. Gunckel (1777). Only once was something achieved which fully represented the Louis XVI spirit: the 'villa suburbana' Het Paviljoen at Haarlem of about 1785, built for the Amsterdam banker Henry Hope. The architect, as I have recently argued,[3] was Leendert Viervant, who had previously designed the library of the Teyler Museum and Teyler's Almshouse, both at Haarlem. He was confronted with an awkward problem: the site proved too cramped for an easy layout of the villa. Two wings, a western one originally serving as residential quarters and a more extensive one to the south, intended chiefly for Henry Hope's art gallery, meet at right angles, and the entrance range protrudes obliquely in the corner between them.

Obviously the architect was aware that he could not hope to achieve coherence. So for external display he singled out, giving them magnificent columns of rendered brick, two disconnected parts: the entrance block in the courtyard with its slightly convex front, and the south façade [329]. The impressiveness of the latter he enhanced by extending the ground floor all along the piano nobile to form a terrace, which is reached by ramps curving round the sides of the forecourt. To avoid the rigidity of the mighty portico columns by then already fashionable he gave the central block two tiers of coupled columns, leaving the walls on both sides plain but for the telling gallery windows, and reverted to the rules of the Orders by providing the salient angle pavilions with coupled pilasters.

The talents of Leendert Viervant appear the more outstanding when they are compared with those of his uncle, Jacob Otten-Husly, winner of two competitions for important buildings, and about fourteen years his senior. Otten-Husly designed the town halls of Weesp and Groningen, and the building for Felix Meritis, a scientific society, in Amsterdam. The

329. Leendert Viervant: Haarlem, Het Paviljoen, *c.* 1785

latter was erected in 1787 and the following years. The town hall of Weesp is traditionally Dutch in design, and very tame. The town hall of Groningen, which was built with some changes after Otten-Husly's death, is undeniably stately, with its portico of four detached giant columns and the sandstone pilasters along the rest of the façades, but it is so full of reminiscences of Dutch seventeenth-century Classicism that it can hardly be called a modern building for its time. But Felix Meritis is untraditional. Its massive five-bay façade has four truly enormous engaged columns and high arched windows on the principal floor. Here there is a most emphatic attempt to achieve a fashionable Classicism, and as a result of this the façade is entirely out of keeping with the other houses to left and right along the Keizersgracht.

The work of Jan Giudici, who was born in Lombardy but went to live in Rotterdam while still young, has a strong Dutch bourgeois character. His most successful work was the Roman Catholic Rosaliakerk of 1774, which was entirely destroyed in May 1940. The church, being Catholic, had to be kept hidden, and so its importance was confined solely to the interior, a cool, classicist version of the chapel of Versailles. His former Exchange and the St Jacobsgasthuis, both at Schiedam, close to Rotterdam, are typical Dutch bourgeois adaptations of the Louis XVI style.

In the last decades of the eighteenth century the architecture of the Republic lost its old energy and close contact with the rest of Europe. Only in the marshy regions along the Zaan in North Holland do we find professional native architecture with Rococo and Louis XVI motifs used to adorn the shapely gables of timber houses.

SCULPTURE

E. H. TER KUILE

CHAPTER 23

THE FIRST HALF OF THE SEVENTEENTH CENTURY

By far the most important of the sculptors of the first half of the seventeenth century in the North was Hendrick de Keyser (1565–1621), whose architectural work we have already discussed (p. 384).

Like his architectural work, De Keyser's sculpture was entirely rooted in the tradition of the sixteenth century. In his sculpture, however, he had more contact with international tendencies, and it can be said with some truth that it is related to Italian Mannerism. But the relationship appears marginal as soon as one compares his work with that of a really internationally orientated compatriot such as Adriaen de Vries. Working in the Northern Netherlands, De Keyser was still in relative isolation, whereas De Vries, working almost entirely abroad, belongs so much to the rest of Europe that he need not be discussed here.[1]

We know practically nothing about De Keyser's work before his fortieth year. His personality as an artist is revealed to us first by the fine bust of an unknown man, dated 1608, in the Rijksmuseum at Amsterdam, which is a portrait in the best sense of the word and full of psychological realism [330]. The loosely arranged drapery falls in folds which continued

330. Hendrick de Keyser: Unknown man, 1608. *Amsterdam, Rijksmuseum*

to be typical of De Keyser's work. This style of folds almost dominates the statue of St John which de Keyser carried out about 1613 for the rood screen of the cathedral of 's-Hertogenbosch (Bois le Duc), and which has been in the Victoria and Albert Museum since 1870. His work is primarily decoration, and one suspects that imagination was not De Keyser's strong point. This is confirmed when we see his masterpiece, the sumptuous tomb of Prince William I in the Nieuwe Kerk at Delft, commissioned by the States-General in 1614, and not entirely completed at De Keyser's death.

The general design of the monument harks back to that of Henri II by Primaticcio, in St Denis, but in place of the heavy forms of the prototype there is a light and excessively decorated arcaded pavilion which encloses a very sensitive recumbent figure of the prince, executed in marble [331], at its head his seated

331. Hendrick de Keyser:
Effigy from the tomb of Prince William I, c. 1618.
Delft, Nieuwe Kerk

figure in bronze, at its feet a bronze Fame. This Fame obviously has its prototype in the Fame of Pierre Biard for the tomb of Marguerite de Foix, now in the Louvre. As at St Denis, bronze statues of the four cardinal virtues stand at the corners. However, the Puritan spirit in the Republic demanded that Virtues and Fame should not be portrayed naked or half naked, after the French example.

The bronze figures can only be appreciated as decoration. They are uninspired as far as pose and expression of features is concerned, and they are not very elegant. The reclining marble figure is sheer sculpture, and sculpture of high quality. The tenderly carved marble expresses peaceful sleep, and here De Keyser combines a firm sense of style with a masterly expression of texture. The tiresome mannerism of the drapery folds in his bronze figures is forgotten here. De Keyser could only use his talent to the full in portraiture; in imagination he was deficient.

The only public statue produced under the Republic dates from 1618. It is the bronze Erasmus at Rotterdam, which survived the disaster of 1940. The attitude of the scholar in his ample robe, striding along deep in his book, and the monumental folds of the robe, in which the clichés of his earlier style are overcome, show De Keyser at the height of his powers; but the face is empty and without expression.

De Keyser formed no school of importance, though a few artists were trained in his studio. Among them was Gerard Lambertsz., who in 1619, as chief apprentice to De Keyser, executed the stone statues of gods which the king of Denmark had ordered for the new gallery of the castle of Frederiksborg. Of the series only a few, and those in poor condition, have survived. Judging by photographs, they are not in the typical De Keyser style, but have an ease and naturalness of pose which is remarkable if one thinks of the more or less contemporary Virtues of the tomb at Delft. One gets the impression

that Lambertsz. was a man of talent, though we know hardly anything for certain about his other work. This is important when we come to consider the mysterious sandstone Frenzy from the former madhouse, now in the Rijksmuseum at Amsterdam [332]. It is a dramatic representation of a naked woman pulling out her hair in a state of frantic despair. The realism is terrifying. On the four sides of the pedestal are fine masks of madmen. It has been suggested that this is De Keyser's work, but it is difficult to find a place for it in his *œuvre*.[2] The details of the pedestal indicate the North Netherlands as its place of origin. If that is so, then Lambertsz. is a strong candidate. Perhaps he died young, and so was unable to leave further evidence of his style.

Other pupils of De Keyser were Nicholas Stone, the English sculptor who became his son-in-law, and De Keyser's sons Pieter and

332. Gerard Lambertsz.(?): Frenzy.
Amsterdam, Rijksmuseum

Willem. The most important of these, at any rate as far as quantity of work goes, is Stone. The fact that in 1606 or 1607 Hendrick de Keyser went to London in order to study the London Exchange when commissioned to make plans for the new Exchange at Amsterdam is thought to have occasioned young Stone to become his pupil. In 1613 Stone married De Keyser's eldest daughter and then returned to England, where he settled in London and became the leading sculptor of his generation.[3] Pieter de Keyser continued his father's studio. He must have executed the *gisant* of Admiral Piet Hein in the Oude Kerk at Delft (1626), and, like his father, he received commissions for Scandinavia, principally the monument of Erik Soop and his wife in the cathedral of Skara in Sweden (1637). Both are essentially imitative. Willem de Keyser carved the reliefs of naval battles on the monuments of Admirals Tromp Senior at Delft and Jan van Galen at Amsterdam, which show technical accomplishment but little else.

If we ask what meaning sculpture had for the fashionable circles of the Republic in the second quarter of the seventeenth century, we must first remember that much of what was created, or at least collected, has disappeared, or is outside the country. But we know something about the sculpture collected by the Stadholder Frederick Henry. Artus Quellin[4] of Antwerp was one of his favourite artists. In 1634, that is before his stay in Italy, he delivered statues of Mars and Venus to the stadholder. They are lost. In 1640 he supplied another three statues. Another sculptor who obtained commissions from the prince was François Dusart or Dieussart, born in French Flanders and educated in Rome.[5] After working for Charles I of England he went to the Republic in 1641, where he made a number of statues of members of the house of Orange. Four of them were in the palace at Berlin. On stylistic grounds, the statues for the tomb of the Governor Charles Morgan (d. 1642) in the Grote Kerk at Bergen

333. François Dieussart(?):
Tomb of Charles Morgan, d. 1642.
Bergen op Zoom, Grote Kerk

op Zoom have been attributed to Dieussart [333]. It is rather arid naturalistic work, except for the head of the sorrowing widow.

The fact that foreigners such as Quellin and Dieussart found employment at the court of Prince Frederick Henry shows that it was not easy to find good sculptors in the country itself. What we know of the work of native artists is hardly above the level of good craftsmanship. Examples are the figures on the north pediment of the Mauritshuis and on the pediment of the Oude Hof in the Noordeinde, both at The Hague. The sculpture of the pediment of the Oude Hof was executed in 1645 by Pieter 't Hooft, who came from Dordrecht, and there is every reason to believe that he also worked on the Mauritshuis. The composition in both cases is remarkably painterly, and it is thus possible that the designs were furnished by Jacob van Campen, who of course was a painter as well as an architect. The quality is poor.

THE SECOND HALF OF THE SEVENTEENTH CENTURY

AND THE EIGHTEENTH CENTURY

The classical style in architecture, which appeared shortly after 1630 and quickly developed, needed imperatively the complement of monumental sculpture. Also the impressive monuments which were thought proper for famous admirals and members of the aristocracy demanded artists who could carry out representational commissions of this kind. The position faced in painting, when it was decided to fill the Oranjezaal in the Huis ten Bos with heroic canvases, also affected sculpture: adequate talent was lacking for this work, and there was an appeal to artists in the Spanish Netherlands, where representational work was carried out in a Baroque spirit which was much appreciated in the Northern Netherlands even if they could not produce it themselves.

The great work that led to the invasion of the Republic by sculptors from the Southern Netherlands was the town hall of Amsterdam. Literary taste demanded that symbols and allegories should represent the majesty of authority, the weight of the Law, the cardinal Virtues, and the triumph of trade and the merchant navy. Thus, in the oppressive Hall of Judgement, allegories and scenes from the bible and ancient literature, and symbolical figures striking in their emphatic modelling, confronted those who entered with dire Guilt and powerful Justice. The reliefs in the big Burgerzaal represent the city administration and the avenging might of law. At the ends of the galleries, catching the eye from a distance, are eight high-relief figures of Roman gods, whose significance is connected with the functions of the rooms; a series of other reliefs and much decoration contain the most far-fetched allusions. All the sculpture in the interior was carried out luxuriously in marble, within an architectural framework of marble wall facing.

Outside, the carved figures of the two central pediments are executed in Belgian limestone. On the front pediment is the personification of the city, to whom sea gods render homage. In the rear pediment she is being honoured by the four continents. Standing on the front pediment are bronze figures of Peace, Prudence, and Justice, and at the back a huge Atlas between personifications of Moderation and Vigilance.

We can see from this summary how sculptors from the Southern Netherlands had unlimited opportunities in the Republic to apply their talents to a programme of secular iconography, whereas in the Spanish Netherlands they were principally limited to religious themes. This is not only true of the Amsterdam Town Hall: the numerous monuments chiefly executed by Rombout Verhulst[1] and his colleagues present, apart from portraits of the dead and reliefs of naval battles, nothing but allegories and symbols outside specifically Christian iconography.

The South Netherlands sculptor chiefly responsible for the overwhelming magnificence in marble and bronze of the Amsterdam Town Hall was Artus I Quellin from Antwerp (1609-68),[2] who had worked in Rome, probably in close contact with his fellow countryman François du Quesnoy, nicknamed Il Fiammingo.[3] In 1646 Quellin was already in the Republic, engaged apparently in enlarging his connexions before the final plans for the town hall had been drawn up. When he came to

Amsterdam in 1647 it was probably in con-
nexion with a definite commission to do some
decoration for the town hall, and soon after the
decision must have been made to ask him to
take charge of all the sculpture. The vast extent
of this work made it necessary for him to settle
in Amsterdam, and he lived there for fourteen
years before returning to Antwerp.

So a large studio had to be set up in Amster-
dam. His principal collaborators were his
kinsman Artus Quellin II (1625-1700) and
Rombout Verhulst from Malines (1625-96),
but they worked side by side with Northern
Netherlanders such as Willem de Keyser, son
of Hendrik de Keyser, and Bartholomeus
Eggers. Among the first works of Quellin's
studio was the Hall of Judgement. Its climax is
the marble justices' bench along the long wall.
At the back are three large reliefs: in the
middle the Judgement of Solomon; to the left
Seleucus, who had one eye put out to allow his
son, who had been condemned to have both
eyes put out, to keep one; and on the right
Brutus, who allowed justice to proceed when
his sons were condemned to be beheaded for
high treason. The reliefs are separated from
each other by two pairs of naked caryatids,
holding up the cornice in attitudes of sub-
mission. In the reliefs, painterly illusion is
accompanied by a somewhat painful realism,
which is probably to a large extent due to the
prevailing taste in the Northern Netherlands.
The nudes with their luxuriant forms are a
happy contrast with the dry narrative reliefs.
The figures of Justice and Prudence in the
niches opposite are of a classical dignity.

The years 1650 to 1657 saw the galleries
furnished with sculpture. Here as well as in
the Hall of Judgement it is almost impossible
to tell what is the work of Artus I himself. The
figure of Venus [334] and two allegorical reliefs
bear the signature of Rombout Verhulst. They
are undoubtedly among the best works in the
galleries, though Venus' expression lacks mean-

334. Rombout Verhulst: Venus, 1650/7.
Amsterdam, Royal Palace (former town hall)

ing. It must not be forgotten, however, that
Verhulst was only about thirty then, and at the
beginning of his career.

Quantities of figures fill the pediments of the
front and rear. The great height from the
ground makes it difficult to judge these lime-
stone reliefs, which seem to have suffered
badly from the weather, and were restored in
1913 and the following years. For this reason it
is useful to study the terracotta models in the
Rijksmuseum [335]. The composition is cer-
tainly not entirely successful, and the central
figure of the personification of Amsterdam is
not sufficiently prominent; but some of the
sections are delightful, and the command of
the human body in every sort of pose is truly
masterly. The draped symbolical female bronze
statues on the pediments, in which one may
perhaps detect the influence of François du

335. Artus I Quellin: Model for the east pediment of the Amsterdam Royal Palace (former town hall), c. 1655. *Amsterdam, Rijksmuseum*

Quesnoy, are exceptionally noble, and the heroic character of the bronze Atlas which dominates the façade at the back is wholly convincing.

While he lived in Amsterdam, Quellin did other work besides that for the town hall. He made fine portrait busts of various leading figures in the Republic, among them the Burgomaster Andries de Graaf (1661), now in the Rijksmuseum, and the statesman Johan de Witt (1665), now in the museum at Dordrecht. It has been rightly remarked that Quellin did not attempt any acute psychological portraits, but gave representative likenesses. This is nothing against the busts: it was undoubtedly the intention of the men who ordered them and of the artist himself that they should be stylized portraits created with good taste rather than striking insight.

Rombout Verhulst must have cut adrift from the town hall studio long before the work was completed. He finally settled in The Hague, where he died in 1698. After he had done a quantity of decorative sculpture for Leiden, including some for Pieter Post's weigh house, he was in demand everywhere in the Republic for monumental commissions. He was outstandingly the sculptor of the large monuments erected after the middle of the seventeenth century to commemorate famous admirals and other distinguished men. Among the most important of these monuments are those for Johan Polyander van Kerchoven in the Pieterskerk at Leiden (1663) [336], for Willem van Lyere in the church of Katwijk, for Carel van In- en Kniphuisen at Midwolde (province of Groningen), for Adriaan Clant at Stedum (also in Groningen), for Willem Josef baron van

336. Rombout Verhulst: Monument to Johan Polyander van Kerchoven, 1663. *Leiden, Pieterskerk*

Gendt in the cathedral at Utrecht, and for Admiral Michiel de Ruyter in the Nieuwe Kerk at Amsterdam (completed in 1681). It is known that he did not necessarily execute the whole monument himself, so that he cannot be held immediately responsible for weaknesses such as those found in the De Ruyter monument, with its very flat side parts. His gifts for inventive imagination were not above average, and there is a certain monotony in his motifs. It is not possible to follow a clear line of development through his extensive range of work. He always remained the same perfect master in the same limited genre, exciting our admiration by his sensitive handling of physiognomy and of hands and robes, and by the noble attitudes of his figures.

After Artus I Quellin had gone back to Antwerp in 1665, Verhulst was the only first-class sculptor in the Republic. His rival Bartholomeus Eggers, who was probably born in Amsterdam, tried to work in his style, but if one looks at his pompous figure of Admiral Jacob van Wassenaer-Obdam in the Grote Kerk in The Hague, the principal figure of an odd group, his artistic weakness is evident. Pieter Xavery from Antwerp, who worked in Leiden between 1670 and 1674, did not get farther than good workmanship in the pediment sculpture for the house called De Vergulde Turk and for the former law courts in Leiden, and in the terracotta models of his that we know.

The preponderance of sculptors from the Southern Netherlands in the middle of the seventeenth century continued into the eighteenth. The Antwerp architect Jan Pieter van Baurscheit the Younger, whose architectural activities have already been mentioned, did reasonably good decorative work. Jan Baptist Xavery, who also came from Antwerp, settled in The Hague after studies in Italy, and died there in 1742. He did the big marble allegory of Faith under the organ of the Grote Kerk at Haarlem (1735) [337], an example of Rococo

elegance with draped female figures against a background of relief. The same Rococo spirit can be seen in the relief of Daphne and Apollo in the Royal Academy at Amsterdam. There were also French sculptors active in the Northern Netherlands, such as Jacques Cresant from Abbeville, who settled in 1728 in Utrecht.[4] Falconet settled in The Hague in 1778 for a few years, with his talented daughter-in-law Marie Anne Falconet-Collot. She made charming if representational portrait busts of the Stadholder William V and his wife Wilhelmina of Prussia, and probably also the bust of Pierre Lyonet, a scholar, all three in the Mauritshuis at The Hague. The presence of all these foreigners is characteristic of the situation: after Hendrick de Keyser there were no important native sculptors left in the Northern Netherlands.

337. Jan Baptist Xavery: Allegory of Faith, 1735. *Haarlem, Grote Kerk*

LIST OF THE PRINCIPAL ABBREVIATIONS

USED IN THE TEXT, NOTES, AND BIBLIOGRAPHY

A.Q.	*The Art Quarterly*
Bartsch	Adam Bartsch, *Le Peintre Graveur*. 21 vols. Leipzig, 1854-76
Benesch	Otto Benesch, *The Drawings of Rembrandt*. 6 vols. London, 1954-7
B.M.	*The Burlington Magazine*
Bredius	A. Bredius, *The Paintings of Rembrandt*. New York, 1942; 3rd ed., revised by H. Gerson, London and New York, 1969
Bull. K.N.O.B.	*Bulletin van de Koninklijke Nederlandse Oudheidkundige Bond*
G.B.A.	*Gazette des Beaux Arts*
HdG	C. Hofstede de Groot, *Beschreibendes und kritisches Verzeichnis der Werke der hervorragendsten holländischen Maler des XVII. Jahrhunderts*. 10 vols. Esslingen a.N., 1907-28. English translation of vols 1-8 by E. G. Hawke, London, 1908-27
Jahrb. P.K.	*Jahrbuch der preussischen Kunstsammlungen*
Mon.	*De Nederlands(ch)e Monumenten van Geschiedenis en Kunst*. Utrecht and The Hague, 1912-
N.K.J.	*Nederlands Kunsthistorisch Jaarboek*
O.H.	*Oud-Holland: Nieuwe Bijdragen voor de Geschiedenis der Nederlandsche Kunst. Letterkunde. Nijverheid. enz.*

NOTES

Bold numbers indicate page reference

PART ONE: PAINTING 1600–1675

CHAPTER 2

15. 1. The authors are particularly indebted to Johan Huizinga's 'Nederland's Beschaving in de zeventiende Eeuw', in *Verzamelde Werken*, II, *Nederland* (Haarlem, 1948), 412 ff.
19. 2. Richard Carnac Temple (ed.), *The Travels of Peter Mundy in Europe and Asia: 1608–1667*, IV: *Travels in Europe: 1639–1647* (London, printed for the Hakluyt Society, 1925), 70.
3. E. S. de Beer (ed.), *The Diary of John Evelyn* (Oxford, 1935), 39.
20. 4. The precise number is difficult to establish because a record of baptism, marriage, or burial in a Reformed church is not necessarily proof of Protestantism; the place where these rites were performed was sometimes prescribed by the municipal authorities. For a discussion of other aspects of this knotty problem cf. Seymour Slive, 'Notes on the Relationship of Protestantism to Seventeenth Century Dutch Painting', *A.Q.*, XIX (1956), 3 ff., and J. Bruyn, *Rembrandt's Keuze van bijbelse Onderwerpen* (Utrecht, 1959).

CHAPTER 3

22. 1. Karel van Mander, ed. Hanns Floerke, *Het Leven der Doorluchtighe Nederlandtsche en Hooghduytsche Schilders* (Munich and Leipzig, 1906), II, 314, writes of Cornelis' displeasure with portrait commissions; the same author (*ibid.*, 194 f.) describes Ketel's tricks with his feet.
2. The sources and history of Mannerist art theory are discussed fully by Erwin Panofsky, ' "Idea": ein Beitrag zur Begriffgeschichte der älteren Kunstliteratur', *Studien der Bibliothek Warburg*, V (Leipzig-Berlin, 1924); 2nd revised ed., Berlin, 1960.
23. 3. The anonymous biography of Van Mander appended to the second edition of the *Schilderboek* (Haarlem, 1618) is the source for the little we know from a contemporary about the Haarlem 'academy'.

The biographer writes that shortly after Van Mander came to Haarlem in 1583, he and Goltzius and Cornelis van Haarlem founded 'een *Academie,* om nae 't leven te studeeren, Karel wees haer de Italiaensche Maniere, ghelijck 't aen den *Ovidius* van *Goltzius* wel te sien is en te mercken is . . .' (*ibid.*, appendix, unpaginated). Otto Hirschmann, 'Karel van Manders haarlemer Akademie', *Monatshefte für Kunstwissenschaft*, IX (1918), 213 ff., and Albert Dresdner, 'Noch einmal Karel van Manders haarlemer Akademie', *ibid.*, 276 f., rightly pointed out that this 'academy' could not have been an art school. They maintained that it must have been the equivalent of a life-class where artists could gather and draw from life and probably study casts after ancient sculpture. Their conclusions were generally accepted until E. K. J. Reznicek, *Die Zeichnungen von Hendrick Goltzius* (Utrecht, 1961), I, 215 ff., noted that the report of Van Mander's anonymous biographer is contradicted by much of what we know about Goltzius' activities. Reznicek writes that it is hard to believe Goltzius began to work from living models soon after 1583, since it was around this time that he adopted his wild anti-classical style based on Spranger's Mannerism. From 1584 to 1588 he was farthest from 'nature'. It is also noteworthy that during these years he virtually gave up portraiture. There is some evidence that he began to study from live models shortly before 1590 and only around 1600 do we find his studies of the nude which break the way for those made by De Gheyn, Rembrandt, Backer, and Flinck. Reznicek also states that it is hard to conceive of an organized group working from the nude in the Dutch society of the time. Moreover, Goltzius is known to have worked in secret. He did not like to show anybody an unfinished work: hardly the man to sit with his colleagues and draw from a posed model. Reznicek suggests that perhaps the clue to the meaning of the word 'academie' in the brief passage is found in the fact that it is mentioned in the same breath with Goltzius' illustrations for Ovid, which, according to the biographer, show that Van Mander taught his young friends the 'Italian manner'. It is possible that the 'academy' refers to lessons or lectures that Van

Mander gave the Haarlem artists on 'the Italian manner' of composing pictures and literally following a text. Goltzius' Ovid illustrations are indeed based on Venetian schemes (Veronese, Tintoretto) and follow Ovid's text faithfully. For a brief account of less problematic academies founded in Holland after the middle of the seventeenth century see Nikolaus Pevsner, *Academies of Art: Past and Present* (Cambridge, 1940), 129 ff.

4. For the training of Dutch artists, studio practice, and the history of the painters' guild see Hanns Floerke, *Studien zur niederländischen Kunst- und Kulturgeschichte* (Munich-Leipzig, 1905); W. Martin, 'The Life of a Dutch Artist in the Seventeenth Century', *B. M.*, VII (1905), 125 ff., 416 ff.; VIII (1905–6), 13 ff.; X (1906–7), 144 ff.; G. J. Hoogewerff, *De Geschiedenis van de St Lucasgilden in Nederland* (Amsterdam, 1947).
28. 5. Goltzius probably tried his hand at oils earlier. There is a reference by Van Mander to a grisaille which can be dated in the early eighties; cf. Reznicek, *op. cit.*, 8 f. It is, however, true that he only began to concentrate on painting around 1600. Failing eyesight – the result of years of close work with engraver's tools – and acceptance of the theoretical idea that painting was superior to the other arts help to explain the switch; see E. K. J. Reznicek, 'Het Begin van Goltzius' Loopbaan als Schilder', *O.H.*, LXXV (1960), 30 f.
31. 6. Joachim von Sandrart, ed. A. R. Peltzer, *Academie der Bau-, Bild- und Mahlerey-Künste* (Munich, 1925), 171.
7. Cf. E. Hempel, *Baroque Art and Architecture in Central Europe (Pelican History of Art)* (Harmondsworth, 1965), 57–60.
32. 8. Ruth Saunders Magurn (trans. and ed.), *The Letters of Peter Paul Rubens* (Cambridge, Mass., 1955), 54.
9. The artists apparently made their headquarters in the house of Hendrik de Raeff, a pharmacist of Delft who settled in Rome; cf. G. J. Hoogewerff, 'Hendricus Corvinus (Hendrik de Raeff van Delft)', *Mededeelingen van het Nederlandsch Historisch Instituut te Rome*, 2nd ser., IV (1936), 91 ff.; X (1940), 123 ff.
38. 10. *The Crowning with Thorns*, London art market, published as a work by Terbrugghen painted in Italy *c.* 1610–14 (Benedict Nicolson, 'Second Thoughts about Terbrugghen', *B.M.*, CII, 1960, 466), was correctly identified by Roberto Longhi (*Paragone*, 1960, no. 131, 57 ff.) as a copy of a work by Moïse Valentin made after 1620.
42. 11. F. Grossmann, 'A Painting by Georges de la Tour in the Collection of Archduke Leopold Wilhelm', *B.M.*, C (1958), 86 ff., discusses La Tour's connexions with Terbrugghen and cites the literature on this relationship.

CHAPTER 4

48. 1. Seymour Slive, 'Frans Hals Studies: I, Juvenilia', *O.H.*, LXXVI (1961), 173 f. Also see p. 170, below.
2. There are a handful of references in old inventories to Hals' religious pictures (cf. HdG, *Frans Hals*, III, 9, nos 1–8). His *St Luke* and *St Matthew* were discovered by Irene Linnik and published by her: 'Newly Discovered Paintings by Frans Hals', *Iskusstvo* (1959), no. 10, 70 ff. (Russian text) and in *Soobcheniia Gosudastvennogo Ermitazha*, XVII (1960), 40 ff. (Russian text). The pictures are now in the State Museum, Odessa. Also cf. Seymour Slive, 'Frans Hals Studies: II, *St Luke* and *St Matthew* at Odessa', *O.H.*, LXXVI (1961), 174 ff.
50. 3. Cf. Alois Riegl's fundamental 'Das holländische Gruppenporträt', *Jahrbuch der kunsthistorischen Sammlungen des Allerhöchsten Kaiserhauses*, XXIII (1902), 71 ff. (reprinted Vienna, 1931) for a comprehensive treatment of Dutch group portraiture.
54. 4. The problem of Hals' drawings remains unsolved. Not a single one can be attributed to him with certainty. In our opinion, the best contender, the chalk drawing at the British Museum (no. 1891.7.13.16), which has been published as a preparatory study for Hals' *Portrait of a Man* at Leningrad (cf. I. Q. van Regteren Altena, 'Frans Hals Teekenaar', *O.H.*, XLVI, 1929, 148 ff., and again in *Holländische Meisterzeichnungen des siebzehnten Jahrhunderts*, Basel, 1948, no. 16), is a copy after the painting by another hand.
5. It should be noted that Hals inscribed a date on only one of his group portraits: *The Banquet of the Officers of the Haarlem Militia Company of St George* of 1616 [22]. All the other militia company and regent pieces are dated on the basis of tradition. However, since good documentary and stylistic evidence supports the traditional dates, they are accepted in the text.
6. Published by W. von Bode, *Studien zur Geschichte der holländischen Malerei* (Brunswick, 1883), 41 f.
7. Cf. A. Bredius, 'Heeft Frans Hals zijn Vrouw geslagen?', *O.H.*, XXXIX (1921), 64, and his 'Archiefsprokkels betreffende Frans Hals', *O.H.*, XLI (1923–4), 19.
55. 8. For the close relation of Jan's works of the 1640s to his father's portraits of the same decade cf. Seymour Slive, 'Frans Hals Studies: III, Jan Franszoon Hals', *O.H.*, LXXVI (1961), 176 ff.
60. 9. Cf. C. J. Holmes, 'Recent Acquisitions by Mrs C. P. Huntington from the Kann Collection', *B.M.*, XII (1908), 198 ff.

62. 10. Sir Joshua Reynolds, ed. Robert E. Wark, *Discourses on Art* (San Marino, 1959), 109.
66. 11. See Note 4 above.

77. 1. J. Orlers, *Beschrijvinge der Stadt Leyden*, 2nd ed. (Leiden, 1641), 375, is the principal source for the early life of Rembrandt. The biography is transcribed in C. Hofstede de Groot, *Die Urkunden über Rembrandt (1575-1721)* (The Hague, 1906), no. 86. Also cf. Seymour Slive, *Rembrandt and his Critics* (The Hague, 1953), 35 ff.
79. 2. The attribution of this work to Rembrandt has been disputed. Some students ascribe it to Jan Lievens; others see it as a joint effort by the two friends. For a discussion supporting the attribution to Rembrandt and for references to other opinions cf. Seymour Slive, 'The Young Rembrandt', *Allen Memorial Art Museum Bulletin, Oberlin College*, XX (1963), 139 ff.
3. First published by H. Gerson, 'La Lapidation de Saint Étienne peinte par Rembrandt en 1625', *Bulletin des Musées et Monuments Lyonnais*, III (1962-6), no. 4, 57 ff. The date on Rembrandt's *David presenting the Head of Goliath to Saul* (Basel, Kunstmuseum) has also been read as 1625. W. Martin, 'Uit Rembrandt's leidsche Jaren', *Jaarboek van de Maatschappij der Nederlandsche Letterkunde te Leiden* (1936-7), 62, note 2, wrote that he saw the David painting shortly after it was discovered, and before it was cleaned. He asserts that at that time it was clearly inscribed 1625. If Martin's memory served him well, the Lyon picture is not the only work by Rembrandt dated 1625. But the reliability of Martin's memory has been questioned by Bredius (p. 21, no. 488), who read the date on the Basel picture as '1627 (?)' and adds 'The date can no longer be clearly read'. Kurt Bauch, *Der frühe Rembrandt* (Berlin, 1960), 119, has no doubt about the date on the Basel painting. He reads it as 1627 and adds 'das Datum ist völlig klar lesbar'.
80. 4. A second, more highly finished version of the Kassel *Self-Portrait* appeared on the market in 1957. Kurt Bauch, 'Ein Selbstbildnis des frühen Rembrandt', *Wallraf-Richartz-Jahrbuch*, XXIV (1962), 321 ff., published the new version as the original, and asserts that the Kassel painting is a copy. The authors of this text are of the opposite opinion. In their view weaknesses in the modelling of the form, an indecisive touch, slack outlines, and the lack of integration of the scratches in the wet paint with the brushwork show the hand of a copyist working after the formidable Kassel *Self-Portrait*.
81. 5. Cf. Ludwig Münz, 'Rembrandt's Bild von

Mutter und Vater', *Jahrbuch der kunsthistorischen Sammlungen in Wien*, L (1953), 141 ff.
85. 6. *De Jeugd van Constantijn Huygens door hemzelf beschreven*, trans. and ed. A. H. Kan, with an essay by G. Kamphuis (Rotterdam, 1946), is an annotated Dutch translation of the Latin MS. of the autobiography. Also cf. Seymour Slive, 'Art Historians and Art Critics – 11: Huygens on Rembrandt', *B.M.*, XCIV (1952), 261 ff., and H. E. van Gelder, 'Const. Huygens en Rembrandt', *O.H.*, LXXIV (1959), 174 ff.
88. 7. W. S. Heckscher, *Rembrandt's Anatomy of Dr Nicolaas Tulp: An Iconographic Study* (New York, 1958), attempts to reinterpret the picture on the basis of extensive research on the history and meaning of anatomical demonstrations. The authors of this text reject most of Heckscher's extraordinary conclusions (also see the critical reviews by C. E. Kellett, *B.M.*, CI, 1959, 150 ff., and J. Richard Judson, *The Art Bulletin*, XLII, 1960, 305 ff.). We cannot accept his assertion that two of the figures in the *Anatomy* (the one farthest left and the topmost one) are not by Rembrandt. We also find Heckscher's interpretation of the painting unconvincing. He maintains that Rembrandt depicted Tulp and the men around him in an anatomical theatre at a public nocturnal dissection illuminated by artificial light, and suggests that the artist showed the actual Amsterdam theatre where such public demonstrations were performed in the evening. These spectacles were known to have been witnessed by 200 to 300 people, and Heckscher adds that we must try to visualize the presence of a numerous audience in Rembrandt's painting: 'We cannot doubt its presence as we fasten our attention on Dr Tulp; he clearly addresses himself to persons outside his inner circle. His eyes roam over that part of the created illusion that we may describe as "our side" of the picture plane' (p. 5). Visual evidence contradicts these interpretations. First of all, the picture is a day scene, not a nocturnal one. It is an error to assume that Rembrandt reserved strong chiaroscuro effects for events seen at night (this false assumption helps account for the popular, but erroneous title of Rembrandt's most famous picture; *The Night Watch*; cf. pp. 102-4). The dramatic contrasts of light and shadow and the cool colour accord, relieved by the bright accents of the faces and the warmth of brownish shadows, in *Tulp's Anatomy Lesson* are found in all Rembrandt's commissioned portraits of the period. These devices, as well as the same palette, are used, for example, in his double portrait of the *Shipbuilder and his Wife* of 1633 (London, Buckingham Palace), where the artist includes the large window which is the source of the daylight streaming into the picture. Secondly, the fanciful interior of the Tulp picture has more in common with the fantastic

architecture the young artist invented for his pictures than with any Dutch interior which can be cited. And finally, did Rembrandt, as Heckscher holds, paint Tulp addressing a large audience? Tulp's expression and gesture make this an improbable thesis. On the contrary, he is 'a most convincing representation of a scholar absorbed in his subject' (see p. 88 above). Rejection of Heckscher's view does not, however, rest only upon a subjective interpretation of Tulp's attitude. In the review mentioned above, C. E. Kellett offers excellent reason to believe that Rembrandt portrayed Tulp demonstrating a dissection at a private, not a public, anatomy. The latter were commonly concerned with the dissection of the three principal cavities of the body, and did not begin with the dissection of the forearm and hand. Tulp probably made a dissection of this part of the body either after, or more likely before, a public demonstration. Rembrandt, we can assume then, was commissioned to make a record of Tulp at a private dissection for a few friends. This conclusion is supported by Heckscher's own analysis of the records of the Guild of Surgeon-Anatomists in the Amsterdam Archives. Heckscher points out that only two of the men represented in the painting were foremen of the Guild in 1631–2, and he rightly concluded that the painting cannot be a traditional group portrait of the foremen of the Guild, but must have been commissioned privately. Kellett offers additional evidence to support the view that the group portrait commemorates a private dissection, and not a public one. He observes that the great folio volume propped up at the feet of the corpse is not a copy of Vesalius, as earlier students maintained, because there is no comparable Vesalian plate. Kellett discovered a convincing source in Adrian van der Spieg(h)el's (Adrianus Spigelius) *Anatomy* (Venice, 1627, plate 22, figure 2), and reasonably suggests that Spieg(h)el's book is the reference work Tulp and his friends studied during this private demonstration of the anatomy of a hand and forearm. Medical students have noted that there are errors in the way Rembrandt represented the cadaver's dissected arm; for discussions and suggested explanations for the errors see A. Querido, 'De anatomie van de anatomische les', *O.H.*, LXXXII (1967), 128 ff. and G. Wolf-Heidegger and Anna Maria Cetto, *Die anatomische Sektion in bildlicher Darstellung* (Basel–New York), 308 ff.

89. 8. Identified by I.H.v.E(eghen), 'Marten Soolmans en Oopjen Coppit', *Amstelodamum*, XLIII (1956), 85 ff.

91. 9. Kurt Bauch, 'Rembrandts Christus am Kreuz', *Pantheon*, XX (1962), 137 ff., published a *Crucifixion* by Rembrandt dated 1631, now in the parish church at Mas d'Agenais near Agen. He notes that the picture may in some way be related to the Passion series painted for the prince because of its similar size and shape. A Crucifixion does indeed belong to a Passion series. There is, however, no reference to it in old inventories.

93. 10. H. Gerson, transcription Isabella H. van Eeghen, translation Yda D. Ovink, *Seven Letters by Rembrandt* (The Hague, 1961), is an exemplary publication of all the letters. The letters are all reproduced in it, the transcription corrects some of the earlier readings, the English translation is fluent, and the introduction and notes explain their significance.

11. For an extensive bibliography on this point and an analysis of linguistic material supporting H. E. van Gelder's interpretation see Lydia de Pauw-De Veen, 'Over de Betekenis van het Woord "Beweeglijkheid" in de zeventiende Eeuw', *O.H.*, LXXIV (1959), 202 ff. John Gage, 'A Note on Rembrandt's "Meeste Ende die Naetuereelste Beweechgelickheijt" ', *B.M.*, CXI (1969), 381, shows that Franciscus Junius' discussion of the representation of the passions in *Painting of the Ancients* (London, 1638) closely parallels Rembrandt's use of the phrase.

94. 12. The subject has also been interpreted as a representation of other classical figures (Venus; Messalina, the wife of Claudius), and as a biblical figure (Sarah; Rachel; Hagar; Leah). For a complete bibliography see W. F. Lewinson-Lessing a. o., *Meisterwerke aus der Eremitage* (Prague, 1962), no. 72. J. I. Kuznetzow, 'Nieuws over Rembrandt's Danae', *O.H.*, LXXXII (1967), 26 ff., presents evidence which indicates that Rembrandt made alterations in the painting during the 1640s.

13. Thanks to Frits Lugt's ingenuity; see his *Mit Rembrandt in Amsterdam* (Berlin, 1920; Dutch ed., 1915).

102. 14. See Wolfgang Stechow, 'Rembrandt and Titian', *A.Q.*, V (1942), 135 ff., and E. Maurice Bloch, 'Rembrandt and the Lopez Collection', *G.B.A.*, XXIX (1946), 175 ff.

15. A full and informative report on the recent restoration, as well as earlier ones, was published by A. van Schendel and H. H. Mertens, 'De Restauraties van Rembrandt's Nachtwacht', *O.H.*, LXII (1947), 1 ff. The literature on other aspects of this masterpiece fills a number of shelves. For a comprehensive bibliography see D. Wijnbeek, *De Nachtwacht* (Amsterdam, 1944), 204–8; also see the literature on the *Night Watch* cited in the Bibliography, p. 461 below. Fundamental research on the documents and the history of the work was done by F. Schmidt-Degener. His findings appear in 'Het genetisch Probleem van de "Nachtwacht"', *Onze Kunst*, XXVI (1914), 1 ff., 37 ff.; XXIX (1916), 61

ff.; XXX (1916), 29 ff.; XXXI (1917), 1 ff., 97 ff.; 'De Ringkraag van Ruytenburch', *Onze Kunst*, XXXIII (1918), 91 ff.; 'De Compositie-Problemen in verband met Rembrandt's Schuttersoptocht', *Verhandelingen der Koninklijke Nederlandsche Akademie van Weten-schappen*, afd. Letterkunde, nieuwe reeks, XLVII, 1 ff., reprinted in *Verzamelde Studiën en Essays van Dr F. Schmidt-Degener*, 11, *Rembrandt* (Amsterdam, 1950), 135 ff. In spite of Schmidt-Degener's ingenious efforts and the work of many other students, the *Night Watch* still poses some unanswered questions. The exact circumstances of the commission are not known, but the generally accepted idea that it was made to commemorate the part played by Captain Cocq's company in the celebration of Marie de Medici's entry into Amsterdam in 1638 is plausible. Does Rembrandt's revolutionary transformation of the traditional way of portraying a militia company have a special meaning? W. Gs Hellinga, *Rembrandt fecit 1642* (Amsterdam, 1956), offers the latest attempt to answer this question. Hellinga reads the *Night Watch* as a gigantic Baroque allegory inspired by Vondel's drama *Gijsbrecht van Amstel*. In his monograph he accounts for every detail and allusion in the picture by connecting it with Vondel's play. He concludes that Rembrandt personified Amsterdam's hero Gijsbrecht in Captain Cocq, and that the group portrait proclaims the triumph of Amsterdam. In the opinion of the authors of this text, the general character of Rembrandt's art speaks against Hellinga's interpretation. Compared to his contemporaries, Rembrandt had little taste for this kind of allegorical treatment. It is also significant that there is not a single contemporary reference to this aspect of the *Night Watch*. In addition, an inscription on a water colour copy of the group portrait in an album which belonged to Captain Cocq himself, and which can be dated about a decade after the work was completed, flatly states that it represents the captain giving his lieutenant orders to march with his company. There is no reference to Gijsbrecht van Amstel. To be sure, it can be argued that Rembrandt's contemporaries did not think that the most spectacular of all Dutch paintings needed a gloss, because allegorical works of art were so common at the time. But the silence of Rembrandt's pupil Samuel van Hoogstraten about this explanation of the *Night Watch* in his *Inleyding tot de Hooge Schoole der Schilder-Konst* published in Rotterdam in 1678 is harder to explain. In his book Hoogstraten praises the artistic qualities of the work (see p. 104). However, there is not a word in Hoogstraten's theoretical treatise, which is crammed full of references to symbolism, about the allegorical meaning of his teacher's militia piece.

104. 16. Van Hoogstraten, *op. cit.*, 176.

107. 17. See Fritz Saxl, *Rembrandt's Sacrifice of Manoah (Studies of the Warburg Institute*, IX*)* (London, 1939).

18. J. A. Emmens, 'Ay Rembrandt, Maal Cornelis Stem', *N.K.J.*, VII (1956), 133 ff., has made the best analysis of these frequently quoted lines by Vondel.

19. The couple was identified by Isabella H. van Eeghen, *Een Amsterdamse Burgermeestersdochter van Rembrandt in Buckingham Palace* (Amsterdam, 1958).

109. 20. The subject has also been interpreted as the *Parting of David and Jonathan*. The work was acquired by Peter the Great in 1716 from the Amsterdam collector J. van Beuningen under the title 'David and Jonathan'. Also cf. W. F. Lewinson-Lessing, 'David and Jonathan', *Soobcheniia Gosudarstvennogo Ermitazha*, XI (1957), 97 (Russian text).

117. 21. The double portrait may be a commissioned work representing an actual couple, alluding to a biblical pair such as Jacob and Rachel or Isaac and Rebecca; the latter subject is represented in a closely related drawing (New York, W. H. Kramarsky Collection; Benesch 988). As Arthur van Schendel, director of the Rijksmuseum, kindly informed us, recent X-rays show that the figures were originally seated as we see in the drawing. This change might explain the slightly ambiguous position of the figures. It is only vaguely indicated that they are standing. For a discussion of the pictorial tradition of representing a couple in biblical disguise see Jakob Rosenberg, *Rembrandt: Life and Work*, revised ed. (London, 1964), 128 f.

118. 22. For a discussion of documents which throw light on the unsavoury story of the artist's relations with this woman, see H. F. Wijnman's note 40, 147 ff., in C. White, *Rembrandt*, trans. J. M. Komter (The Hague, 1964); D. Vis, *Rembrandt en Geertje Dircx* (Haarlem, 1965); H. F. Wijnman, 'Een episode uit het leven van Rembrandt: De geschiedenis van Geertje Dircx', *Jaarboek Amstelodamum*, LX (1968), 103 ff. The identification by D. Vis, *op. cit.*, of two portraits by Frans Hals as portraits of Rembrandt and Geertghe is unconvincing.

119. 23. The inventory is transcribed in C. Hofstede de Groot, *op. cit.* (Note 1, above), 189 f., no. 169.

120. 24. A. Welcker, 'Titus van Rijn als Teekenaar', *O.H.*, LV (1938), 268 ff.

124. 25. Frits Lugt, 'Rembrandt's Man with the Magnifying Glass', *Art in America*, XXX (1942), 174 ff., identifies the sitter as the Amsterdam silversmith Jan Lutma the Younger. Though this identification is more reasonable than others which have been offered (Spinoza, Titus, or the distinguished Portuguese Jew Miguel de Barrios), it is not completely convincing.

The striking resemblance between the man and his wife and the couple represented in Rembrandt's so-called *Jewish Bride* should be noted.

26. The X-rays were published by A. van Schendel, 'De Schimmen van de Staalmeesters, Een rontgenologisch Onderzoek', *O.H.*, LXXI (1956), 1 ff.

125. 27. H. van de Waal, 'De Staalmeesters en hun Legende', *O.H.*, LXXI (1956), 61 ff.

128. 28. Four drawings, now at Munich, have been related to the painting. Cornelius Müller-Hofstede, 'HdG 409, Eine Nachlese zu den Münchener Civilis-Zeichnungen', *Konsthistorisk Tidskrift*, XXV (1956), 42 ff., convincingly demonstrates that the one reproduced here is the only original one. For the view that the other three are authentic see Benesch 1058, 1059, 1060.

29. The possibility that the document refers to another painting commissioned for the town hall and subsequently rejected should not be ruled out. The artist's *Tribute Money* of 1655 (Bredius 586), *Quintus Fabius Maximus* of 165(?) (Bredius 477), and *Moses showing the Tables of the Law* of 1659 (Bredius 527) may have been originally designed to decorate the town hall; cf. A. Heppner, 'Moses zeigt die Gesetzestafeln bei Rembrandt und Bol', *O.H.*, LII (1935), 241 ff.

129. 30. See H. van de Waal, 'The Iconological Background of Rembrandt's Civilis', *Konsthistorisk Tidskrift*, XXV (1956), 11 ff.

134. 31. See Wolfgang Stechow, 'Jacob blessing the Sons of Joseph, from Early Christian Times to Rembrandt', *G.B.A.*, XXIII (1943), 204 ff.; Jakob Rosenberg, *op. cit.* (Note 21, above), 224; Herbert von Einem, *Rembrandt: Der Segen Jakobs* (Bonn, 1950); and Ilse Manke, 'Zu Rembrandts Jakobsegen in der Kasseler Galerie', *Zeitschrift für Kunstgeschichte*, XXIII (1960), 252 ff., who has rightly observed the position of Jacob's left hand. The authors made the same observation on a recent visit to the museum at Kassel.

CHAPTER 6

141. 1. See W. Martin, *De Hollandsche Schilderkunst in de zeventiende Eeuw: Rembrandt en zijn Tijd*, 2nd ed. (Amsterdam, 1942), 503 f., note 131, for a comprehensive list of Rembrandt's pupils and followers.

2. C. Hofstede de Groot, *Die Urkunden über Rembrandt (1575-1721)* (The Hague, 1906), no. 39. The inscription is on the verso of a red chalk copy by Rembrandt after Lastman's painting of *Susanna and the Elders* now at Berlin-Dahlem. The drawing is in the Kupferstichkabinett of the same museum (no. 5296; Benesch 448).

143. 3. J. Orlers, *Beschrijvinge der Stadt Leyden*, 2nd ed. (Leiden, 1641), 376.

145. 4. In 1650 Lievens painted a large *Five Muses* for Huis ten Bos; in 1656, he executed *Quintus Fabius Maximus and his Son* for a mantelpiece in the new town hall of Amsterdam – possibly to replace Rembrandt's painting of the same subject (Bredius 477, 165[3], formerly Belgrade, collection of the King of Yugoslavia); in 1661 he was commissioned to make *Brinnio elected Leader of the Canninefates* (Tacitus, *Historiae*, IV, 15), one of the lunette pictures illustrating the history of the Batavi for the Amsterdam Town Hall. Three years later he executed an allegorical picture of *War* for the chamber of the Provincial Assembly at The Hague; and in 1669-70 he made a picture of *Justice* for the Rijnlandhuis at Leiden.

147. 5. Strips were removed from the top and bottom of Rembrandt's *Self-Portrait* in 1925 because it was assumed that they were later additions (cf. C. Hofstede de Groot, 'Rembrandt's Painter in a Studio', *B.M.*, XLVII, 1925, 265 f.). Publication of a photograph of the painting made before the removal of these pieces (cf. Seymour Slive, 'Rembrandt's "Self-portrait in a Studio"', *B.M.*, CVI (1964), 483-6) suggests that the strips were painted by Rembrandt himself, and that the painting originally showed about one-third more of the artist's studio. If this hypothesis is correct, the easel made a less prominent accent. The hypothesis, however, does not detract from Rembrandt's bold originality. There is still no precedent for the way in which the large dark easel is co-ordinated, in the picture's uncut state, with empty space.

148. 6. A. Bredius, *Künstler-Inventare* (The Hague, 1919), pt VI, 1941.

149. 7. H. F. Wijnman, 'Rembrandt als Huisgenoot van Hendrick Uylenburgh te Amsterdam (1631-1635)', in *Uit de Kring van Rembrandt en Vondel* (Amsterdam, 1959), 3.

150. 8. The portrait was attributed to Bol by A. Bredius, 'Did Rembrandt paint the Portrait of Elizabeth Bas?', *B.M.*, XX (1911-12), 330 ff. Kurt Bauch ascribed the work to Backer (*Jakob Backer*, Berlin, 1926, 33 f.). A. Bredius, 'Rembrandt, Bol oder Backer?', *Festschrift für Max J. Friedländer* (Leipzig, 1927), 156 ff., is a defence by Bredius of his attribution to Bol. Eduard Plietzsch, *Holländische und flämische Maler des XVII. Jahrhunderts* (Leipzig, 1960), 179, note 1, foretells 'dass in nicht ferner Zukunft das grossartige Porträt Rembrandt wieder zurückgegeben wird, und zwar vornehmlich auf Grund von seinem "Rembrandt f. 1634" signierten und datierten Bildnis einer 83 jährigen Frau, das sich in der Londoner National Gallery befindet'.

152. 9. H. Schneider, 'Govert Flinck en Juriaen Ovens in het Stadhuis te Amsterdam', *O.H.*, XLII (1925), 217.

156. 10. These peep-boxes as well as others are discussed in S. Koslow, ' "De wonderlijke Perspectyfkas": An Aspect of Seventeenth-Century Dutch Painting', *O.H.*, LXXXII (1967), 35 ff.

159. 11. Cf. E. Hempel, *Baroque Art and Architecture in Central Europe (Pelican History of Art)* (Harmondsworth, 1965), 83.

12. *Ibid.*, 82–3, 146.

13. Roberto Longhi, 'Monsù Bernardo', *Critica d'Arte*, III (1938), 121 ff.

14. For a discussion of the attribution of the picture to Maes and reference to other less convincing ascriptions see Neil Maclaren, *The Dutch School, National Gallery Catalogues* (London, 1960), no. 757, 229 ff. J. Walsh recently discovered and published Maes's *Abraham Dismissing Hagar and Ishmael* which is signed and dated 1653; see *Metropolitan Museum Journal*, VI (1972), 105 ff. It is Maes's earliest known dated work. Walsh maintains that its style makes it difficult to see Maes's hand in the London painting. The date on Maes's *Adoration of the Shepherds* (Montreal Museum of Fine Arts) has also been read as 1653; however, the last digit of the date is not clear. Microscopic examination suggests that it is an '8'; see P. Schatborn, 'A Work of Touching Simplicity', *M: A Quarterly Review of the Montreal Museum of Fine Arts*, II, no. 2, 12 ff.

CHAPTER 7

173. 1. Cf. E. Hempel, *Baroque Art and Architecture in Central Europe (Pelican History of Art)* (Harmondsworth, 1965), 60–1.

176. 2. Published in *O.H.*, XLIV (1927), 233 f.

179. 3. Cf. H. Gerson and E. H. ter Kuile, *Art and Architecture in Belgium: 1600–1800 (Pelican History of Art)* (Harmondsworth, 1960), 143 f.

187. 4. The earliest reference to it as *Dr Faustus* occurs in the list of Valerius Röver's collection in 1731. In the seventeenth century the print was listed as 'A practising Alchemist' (inventory of Clement de Jonghe of 1679; C. Hofstede de Groot, *Die Urkunden über Rembrandt (1575–1721)*, The Hague, 1906, no. 346, 33). A Dutch version of Marlowe's *Dr Faustus* was put on the boards in Rembrandt's time, and he may have been inspired by this production. In any event, the popular image of Dr Faustus is closely associated with the etching, and Goethe's great version of Faust can be connected with it. A comprehensive review of the extensive literature on the print as well as its relation to earlier iconographic and pictorial traditions is found in H. van de Waal, 'Rembrandt's Faust Etching, a Socinian document and the iconography of the inspired scholar', *O.H.*, LXXIV (1964), 7 ff.; however,

his interpretation of the print as a Socinian document remains hypothetical. See also Jakob Rosenberg, *Rembrandt: Life and Work*, revised ed. (London, 1964), 268 f.

193. 5. Recent monographs on Vermeer are given in the Bibliography, p. 467 below. Except for P. T. A. Swillens (*Johannes Vermeer*, trans. C. M. Breuning-Williamson, Utrecht-Brussels, 1950), who rejects the *Diana* at The Hague and *Christ at the House of Mary and Martha* at Edinburgh, and who also wrote that he found it impossible to work out 'a really satisfactory chronological arrangement' (*ibid.*, 50; also cf. 174 ff.), there is general agreement about the artist's authentic early works and his development up to the late fifties. This is not the place to give a detailed account of the way our chronology differs from those adopted by others, but one major difference of opinion should be noted: for reasons given in our text, we date the Buckingham Palace *Lady at the Virginals with a Gentleman listening* and the Gardner Museum *Concert* in the late sixties, and not in the late fifties or early sixties, as others have done.

6. Swillens (*ibid.*, 58 and 176 f.) expresses doubts about the authenticity of the date inscribed on the picture, but autopsy has reassured us that both signature and date are genuine. Only the central Roman numerals of the date (LX) seem slightly strengthened by a later hand, but the whole is convincing, and the condition of the picture is marvellous. A third painting, the Frankfurt *Geographer*, is dated 1669 by a later hand. However, since the Frankfurt picture is so close in style to the *Astronomer* of 1668, all authorities agree that the date is a plausible one for the painting. It could very well have been based upon an original inscription.

194. 7. A. J. J. M. van Peer, 'Rondom Jan Vermeer van Delft: III, Leonard Bramer, Leermeester van Jan Vermeer?', *O.H.*, LXXIV (1959), 241 ff.

8. They apparently belonged to a publisher and bookseller named Jacobus Abrahamsz. Dissius, who lived near Vermeer. See the articles by E. Neurdenburg, 'Johannes Vermeer. Eenige Opmerkingen naar Aanleiding van de nieuwste Studies over den delfsichen Schilder', *O.H.*, LIX (1942), 65 ff., and 'Nog enige Opmerkingen over Johannes Vermeer van Delft', *O.H.*, LXVI (1951), 34 ff. Also A. J. J. M. van Peer, 'Drie Collecties Schilderijen van Jan Vermeer', *O.H.*, LXXII (1957), 92 ff.

196. 9. Cf. S. Slive, 'Een dronke slapende meyd aen een tafel', *Festschrift Ulrich Middeldorf* (Berlin, 1968), 452 ff.

199. 10. W. Bürger (i.e. Étienne Jos. Théoph. Thoré), 'Van der Meer de Delft', *G.B.A.*, XXI (1866), 297–330, 458–70.

204. 11. Herbert Rudolph, '"Vanitas": Die Bedeutung mittelalterlicher und humanistischer Bildinhalte in der niederländischen Malerei des 17. Jahrhunderts', *Festschrift Wilhelm Pinder* (Leipzig, 1938), 408 ff.

208. 12. Identification of the model as Clio was made by K. G. Hultén, 'Zu Vermeers Atelierbild', *Konsthistorisk Tidskrift*, XVIII (1949), 90 ff. The painting has inspired many flights of imaginary interpretation. For a succinct review of them and for an excellent analysis of the painting's meaning, see the study by J. G. van Gelder, *De Schilderkonst van Jan Vermeer*, with a commentary by J. A. Emmens (Utrecht, 1958).

209. 13. Caroline Playter Kulli recently discovered this date on the *Interior of a Dutch House* (Boston, Museum of Fine Arts; Valentiner 122) which had been dated 1670-5 in the earlier literature. She will publish the ramifications of this date for our understanding of De Hooch's last phase in a forthcoming article.

215. 14. See W. R. Valentiner's brief introduction to his monograph on Pieter de Hooch (*Klassiker der Kunst*, 1930) for a keen appreciation of the artist's interiors which offer a vista to the outdoor world.

217. 15. The authors are grateful to Susan Donahue Kuretsky for communicating these newly discovered dates.

219. 16. S. J. Gudlaugsson, *Gerard ter Borch* (The Hague, 1959), I, 96 f.

224. 17. *Ibid.*, 161 ff.

229. 18. F. Schmidt-Degener and H. E. van Gelder, trans. G. J. Renier, *Jan Steen* (London, 1927), 11; Schmidt-Degener's essay in this volume remains one of the best appraisals of the artist.

233. 19. Reynolds, *op. cit.* (Chapter 4, Note 10), 109 f.

237. 20. Cf. F. Schmidt-Degener and H. E. van Gelder, *op. cit.*, 81 f.

CHAPTER 8

240. 1. The translation from Da Hollanda is taken from Charles Holroyd, *Michael Angelo Buonarroti* (London-New York, 1903), 279 f. Kenneth Clark's comments are found in his *Landscape into Art* (London, 1949), 26.

244. 2. Hermann Voss, 'François Boucher's early Development', *B.M.*, XCV (1953), 82.

247. 3. This was pointed out by Wolfgang Stechow, 'Significant Dates on some Seventeenth Century Dutch Landscape Paintings: I, Hendrick Avercamp', *O.H.*, LXXV (1960), 80 ff. Stechow's exemplary publications of signed and dated Dutch landscapes are indispensable tools for establishing the development of this branch of painting.

248. 4. Wolfgang Stechow, 'Esaias van de Velde and the Beginnings of Dutch Landscape Painting', *N.K.J.*,

1 (1947), 83 ff., reproduced p. 93, figure 3; this important untraceable painting is also discussed and illustrated in W. Stechow, *Dutch Landscape Painting of the Seventeenth Century* (London, 1966), 86-7, figure 168.

5. Formerly called a *View of Wezel*; correctly identified as Zierikzee by H. Dattenberg in the exhibition catalogue *Niederrheinansichten holländischer Künstler des 17. Jahrhunderts* (Düsseldorf, 1953), 24.

249. 6. A flagrant example of an expansionist view of Seghers' painted *œuvre* is found in Leo C. Collins, *Hercules Seghers* (Chicago, 1953). The majority of the additions listed in this book must be rejected as unconvincing; see the reviews by J. G. van Gelder, *O.H.*, LXVIII (1953), 156, note 4; Wolfgang Stechow, *The Art Bulletin*, XXXVI (1954), 240 ff.; Seymour Slive, *College Art Journal*, XIV (1955), 304 ff.; Eduard Trautscholdt, *B.M.*, XCVII (1955), 357 f. Trautscholdt's article published in *Thieme-Becker* in 1936 remains fundamental for the study of Seghers.

250. 7. J. G. van Gelder, 'Hercules Seghers Erbij en Eraf', *O.H.*, LXV (1950), 216 f.

251. 8. I. Q. van Regteren Altena, 'Hercules Seghers en de Topographie', *Rijksmuseum Bulletin*, III (1955), 3 f.

9. See Willem van Leusden, *The Etchings of Hercules Seghers and the Problem of his graphic Technique* (Utrecht, 1961), and K. G. Boon, 'Een Notitie op een Seghers-Prent uit de Verzameling Hinloopen', *Rijksmuseum Bulletin*, VIII (1960), 3 f.

261. 10. In 1678 Johan Maurits once again used New World material as a gift for royalty. In that year he presented Louis XIV with a series of about forty pictures of Brazil, as well as some ethnological objects. The gift, which included paintings by both Frans Post and Eckhout, was offered to the French king to serve as a source for a set of tapestries. French designers put it to good use: they made the magnificent set of Gobelins known as the *Anciennes et Nouvelles Indes* (Paris, Mobilier National); see Michael Benisovich, 'The History of the "Tenture des Indes"', *B.M.*, LXXXIII (1943), 216 ff.

264. 11. Kurt Erich Simon, '"Doctor" Jacob van Ruisdael', *B.M.*, LXVII (1935), 132 ff.

267. 12. Jakob Rosenberg, '"The Jewish Cemetery" by Jacob van Ruisdael', *Art in America*, XIV (1926), 37 ff.

268. 13. Jakob Rosenberg, *Jacob van Ruisdael* (Berlin, 1928), 49.

276. 14. Published by Wolfgang Stechow, 'Significant Dates on some Seventeenth Century Dutch Landscape Paintings: III, Aelbert Cuyp', *O.H.*, LXXV (1960), 88.

280. 15. A. Staring has kindly informed us that a radiograph of the portrait shows another and quite different

head underneath the one visible on the painted surface. It is also apparent that a smaller and different coat of arms is under the one on the tree. This evidence indicates that either Potter or another artist transformed a painting of someone else into a portrait of Dirck. The panoramic view of Schwanenburg and the Neustadt of Cleves supports this hypothesis; the Tulp family had no connexion with Cleves. H. Dattenberg, *Niederrheinansichten holländischer Künstler des 17. Jahrhunderts* (Düsseldorf, 1967), 273, tentatively suggests that the painting may have originally been a portrait of Johan Maurits.

CHAPTER 9

285. 1. Figures quoted here are from D. W. Davies' modestly titled *A Primer of Dutch Seventeenth Century Overseas Trade* (The Hague, 1961), 9, which presents an admirable survey of the world activities of Holland's merchant fleet at the time when it was the greatest in Europe. The Sound Toll Registers are published in Nina E. Bang (ed.), *Tabeller over Skibsfart og Varentransport gennem Øresund 1497–1660* (Copenhagen, 1906–33).

290. 2. The inventory of the impressive collection is reprinted in A. Bredius, 'De Schilder Johannes van de Cappelle', *O.H.*, x (1892), 31 ff.

292. 3. B. Buckeridge, in 'An Essay towards an English School' (p. 473), appended to the English translation of R. de Piles, *The Art of Painting* (London, 1706).

4. In the notes to William Gilpin's 'On Landscape Painting, A Poem', in *Three Essays on Picturesque Beauty* (London, 1792), 34.

CHAPTER 10

295. 1. C. R. Leslie, ed. Andrew Shirley, *Memoirs of the Life of John Constable* (London, 1937), 392 f.
296. 2. Cf. R. Wittkower, *Art and Architecture in Italy: 1600–1750 (Pelican History of Art)* (Harmondsworth, 1958), 8.

3. The drawing was published as Breenbergh by A. M. Hind, 'Pseudo-Claude Drawings', *B.M.*, XLVIII (1926), 192.

4. Eckhard Schaar, 'Poelenburgh und Breenbergh in Italien und ein Bild Elsheimers', *Mitteilungen des kunsthistorischen Institutes in Florenz*, IX (1959), 27.
299. 5. See J. G. van Gelder, 'Rubens in Holland in de zeventiende Eeuw', *N.K.J.* (1950/1), 103 ff.

6. J. G. van Gelder, 'De Schilders van de Oranjezaal', *N.K.J.* (1948/9), 118 ff., is the most thorough study of the decorations at Huis ten Bos.
300. 7. Cf. Wittkower, *op. cit.*, 45.
301. 8. G. J. Hoogewerff did much spadework on the

activities of the *Schildersbent* in Rome. His monograph *De Bentvueghels* (The Hague, 1952) summarizes his earlier publications on this interesting group and presents some new material.
302. 9. The attribution of this painting to Velazquez was made by Roberto Longhi, 'La rissa all'Ambasciata di Spagna', *Paragone*, I (1950), 28 ff.; it has been contested by José Lopez-Rey, *Velasquez* (London, 1963), 166, no. 133.

10. Cf. Wittkower, *op. cit.*, 214–15.
304. 11. Wolfgang Stechow, 'Jan Both and the Re-Evaluation of Dutch Italianate Landscape Painting', *Actes du XVII^me Congrès International d'Histoire de l'Art, Amsterdam, 1952* (The Hague, 1955), 428 ff. In his essay 'Über das Verhältnis zwischen Signatur und Chronologie bei einigen holländischen Künstlern des 17. Jahrhunderts', *Festschrift Dr h.c. Eduard Trautscholdt* (Hamburg, 1965), 111, Stechow notes that Jan Both did not leave a single dated work ('Jan Both hat uns nicht einmal einen Fingerzeig gegeben').

CHAPTER 11

315. 1. Samuel van Hoogstraten, *Inleyding tot de Hooge Schoole der Schilderkonst* (Rotterdam, 1678), 44.

2. See O. ter Kuile, 'Daniel Mijtens', *N.K.J.*, xx (1969), 1–106, for a survey and catalogue of his work.
319. 3. Henry William Beechey (ed.), *The Literary Works of Sir Joshua Reynolds* (London, 1890), II, 197. It should be noted that the *Night Watch* was probably in a bad state and disfigured by dirty varnish when Reynolds saw it. He writes: 'It seemed to me to have more of the yellow manner of Boll . . . and appears to have been much damaged'; however, he insists that 'what remains seems to be painted in a poor manner' (*ibid.*).

CHAPTER 12

324. 1. Cornelius de Bie, *Het Gulden Cabinet* (Antwerp, 1662), 246. A painting of *Christ Driving the Money Changers from the Temple*, dated 1626 (art trade, London), attributed to Saenredam was shown at the Saenredam Exhibition, Institut Néerlandais, Paris, Catalogue (1970), no. 56. Since the setting for the scene is an imaginary church interior the date on this hitherto unknown painting does not contradict De Bie's statement that Saenredam only began to paint churches 'after life' in 1628.
325. 2. I. Q. van Regteren Altena, 'Saenredam Archaeolog', *O.H.*, XLVII (1931), 1 ff.
329. 3. The best discussion of De Witte's approach to the buildings he portrayed is found in Ilse Manke, *Emanuel de Witte: 1617–1692* (Amsterdam, 1963).

She rightly concludes that 'Das Verhältnis von Emanuel de Witte zu den vorhandenen Bauten ist das eines Landschaftsmalers zur Natur' (*ibid.*, 44). Also see Arnoldus Noach, *Het Material tot de Geschiedenis der Oude Kerk te Amsterdam* (Amsterdam, 1937), 116 ff., and E. P. Richardson, 'De Witte and the Imaginative Nature of Dutch Art', *A.Q.*, I (1938), 5 ff.

CHAPTER 13

335. 1. L. J. Bol, *The Bosschaert Dynasty* (Leigh-on-Sea, 1960), 20.
339. 2. From 'Matisse Speaks to His Students, 1908: Notes by Sarah Stein', quoted in Alfred H. Barr, Jr, *Matisse: His Art and His Public* (New York, 1951), 552. Matisse's copy and variation on the De Heem are reproduced in Barr's book, pp. 170–1.
3. Giovanni Bottari and Stefano Ticozzi, *Raccolta di lettere* (Milan, 1822), VI, 123: '. . . il Caravaggio disse, che tanta manifattura gli era a fare un quadro buono di fiori, come di figure' (from Vincenzo Giustiniani's letter to Teodoro Amideni).
4. Several of Rijkhals' still lifes were formerly attributed to Frans Hals the Younger on the basis of an erroneous reading of Rijkhals' complicated monogram. A. Bredius, 'De Schilder François Rijkhals', *O.H.*, XXXV (1917), 1 ff., corrected this error.
340. 5. Ingvar Bergström, trans. C. Hedström and G. Taylor, *Dutch Still Life Painting* (London, New York, 1956), 268.
6. Johann Wolfgang von Goethe, *Schriften zur Kunst* (Zürich, 1954), 121, from his MS. 'Zur Erinnerung des Städelschen Kabinetts'.
342. 7. H. Gerson, 'P. Verbeek', *O.H.*, LXXIII (1958), 54 ff., notes that the late dates on fish still lives by P. Verbeek rule out the suggestion made by Bergström, *op. cit.*, 229 ff., that Van Beyeren also studied with Verbeek.

PART TWO: PAINTING 1675–1800

CHAPTER 14

349. 1. Johan Huizinga, 'Nederland's Beschaving in de zeventiende Eeuw', in *Verzamelde Werken*, II, *Nederland* (Haarlem, 1948), 507.

CHAPTER 15

352. 1, Gérard de Lairesse, *Het Groot Schilderboek* (Amsterdam, 1707), book V, chapter 22, 325.
2. J. A. Worp (ed.), *De Gedichten van Constantijn Huygens* (Groningen, 1896), 247. The lines are from

the poem 'Op het Graf vanden Heer Iacob van Campen', written on 1 May 1658.

CHAPTER 16

360. 1. A. Staring broke ground for the history of Dutch 'conversation pieces', as he did for so many other areas of the history of eighteenth-century Dutch art, in *De Hollanders Thuis* (The Hague, 1956). This study includes an introduction in English.

CHAPTER 17

365. 1. See L. J. Bol, 'Adriaen Coorte, Stilleven-schilder', *N.K.J.* (1952), 193 ff.; the catalogue Bol prepared of the exhibition of Coorte's work held at the Dordrecht Museum in 1958; and *idem, Holländische Maler des 17. Jahrhunderts* (Brunswick, 1969), 359–62.
366. 2. Fr. Schlie, 'Sieben Briefe und eine Quittung von Jan van Huijsum', *O.H.*, XVIII (1900), 11.
368. 3. Cf. F. Novotny, *Painting and Sculpture in Europe: 1780–1880 (Pelican History of Art)* (Harmondsworth, 1960), 139.

PART THREE: ARCHITECTURE

CHAPTER 18

372. 1. For the castle of Breda, see *Mon. Baronie van Breda*, 27.
374. 2. Perhaps the same as Jean Mone (see D. Roggen, in *Gentsche Bijdragen tot de Kunstgeschiedenis* (1953), 257).
375. 3. For detailed documentation on Thomas Vincidor and Alexander Pasqualini, see the article by M. D. Ozinga on Renaissance in the Netherlands, *Bull. K.N.O.B.* (1962), columns 9–32.
376. 4. See Georges Marlier, *Pierre Coeck d''Alost* (Brussels, 1966), 379, 380.
377. 5. *Bull. K.N.O.B.* (1961), columns 93–6.
379. 6. As Ozinga *(Oudheidkundig Jaarboek* (1931), 18) has shown, there is no justification for the assumption (as in Vermeulen, *Handboek*, II, 284) that the Utrecht painter and architect Paulus Moreelse made the plans for the former town hall of Flushing.

CHAPTER 19

384. 1. For documentation of the contested authorship of De Key for the Leiden Town Hall and the particularities of its style, see E. H. ter Kuile, in *Bull. K.N.O.B.* (1964), columns 89–106.

386. 2. R. Meischke, 'Het huis Bartolotti en het Huis met de Hoofden', *Liber amicorum J. P. Mieras* (1958), 44–56.

3. Since its recent restoration the town hall has been thoroughly treated by J. J. Terwen and J. Kruger in *Delftse Studiën* (Studies in honour of E. H. ter Kuile) (Assen, 1967), 143 and 373. Terwen deals especially with the proportional system.

CHAPTER 20

391. 1. M. D. Ozinga, 'Paulus Moreelse als Architekt', *Oudheidkundig Jaarboek* (1931), 18, is somewhat critical of the architectural merits of the St Catherine's Gate.

394. 2. For the earlier works of Van Campen see R. Meischke, 'De vroegste werken van Jacob van Campen', in *Bull. K.N.O.B.* (1966), 131. Meischke observed that Van Campen follows Palladio as well as Scamozzi, the former for the basic proportions, the latter for details. In the preceding article Professor Terwen stresses Scamozzi's influence (*ibid.*, 129).

396. 3. For Huygens's house, see G. Kamphuis, 'Constantijn Huygens, bouwheer of bouwmeester', in *O.H.* (1962), 151 (summary in English). Kamphuis stresses the part Huygens himself played in the conception of the house.

397. 4. B. Hunningher has dealt thoroughly with the Amsterdam theatre of 1637 (*N.K.J.* (1958), 109–69). Although he takes it for granted (as I do not) that Van Campen visited Italy, Hunningher points out that in the arrangement of his stage Van Campen seems to ignore everything accomplished by and since Palladio in Italy. Only the shape of the auditorium follows more or less the half-oval of the Teatro Olimpico at Vicenza. Hunningher assumes that the plan of the stage was forced upon Van Campen by the Amsterdam Rhetoricians with their traditional and antiquated vision of the character of theatrical performances. Nevertheless the absolute lack of any Italian influence on the Amsterdam stage confirms my belief that Van Campen never saw Italy. As for the supposed pressure by the Amsterdam Rhetoricians, it is difficult to accept that Van Campen, reputed as a man of obstinate temper, should have surrendered completely to it.

The questions concerning Van Campen and the Amsterdam theatre have recently been reconsidered by W. Kuyper in *Bull. K.N.O.B.* (1970), 99.

5. The latest publication about the building is Catherine Freemantle's monograph *The Baroque Town-Hall of Amsterdam* (Utrecht, 1959). It is almost exclusively devoted to the iconological themes of the sculpture (see the review by C. Peeters in *Bull. K.N.O.B.* (1961), columns 142–52). As for the purely architectural side,

the older publication by the late R. van Luttervelt, *Het Raadhuis aan de Dam* (Amsterdam, 1950), is left wholly unsuperseded by Miss Freemantle's book.

401. 6. *Mon. Maastricht*, 118.

404. 7. The façades were plastered in the nineteenth century.

405. 8. *Mon. Westfriesland*, 32.

407. 9. For Scherpenheuvel, see H. Gerson and E. H. ter Kuile, *Art and Architecture in Belgium: 1500–1800* (*Pelican History of Art*) (Harmondsworth, 1960), 18–19. The Marekerk was planned to have an Ionic portico, for which an engraving in Scamozzi's *Idea* may have served as a model. See J. J. Terwen, 'De ontwerpgeschiedenis van de Marekerk te Leiden', in *Opus Musivum* (Assen, 1964), 231.

CHAPTER 21

413. 1. The building of the Renswoude Foundation in Utrecht, which was begun in 1756 to designs by the local architect Joan Verkerk, no longer shows any Marot style in its interior, but full-blown Rococo. See R. van Luttervelt, in *N.K.J.* (1950/1), 197.

2. For Van Baurscheit the Younger, see Herma M. van den Berg, 'Het Werk van J. P. van Baurscheit de jonge', in *Opus Musivum* (*op. cit.*, Chapter 20, Note 9), 315. Miss van den Berg is inclined to ascribe the façade of the Huguetan House in The Hague to Van Baurscheit, not to Marot, who certainly however worked for the house, but whose designs are not specified in the accounts.

CHAPTER 22

415. 1. Much useful material about this period is given by R. Meischke in *N.K.J.* (1959), 211, in connexion with a consideration of the results of two competitions, those for the town hall of Groningen (1774) and for the academy building of the Felix Meritis Society at Amsterdam (1786).

416. 2. M. D. Ozinga, 'Pieter de Swart', in *Oudheidkundig Jaarboek* (1939), 99. We do not precisely know the years of Swart's birth and death.

3. E. H. ter Kuile, 'Op zoek naar de architekt van Het Paviljoen bij Haarlem', *Bull. K.N.O.B.* (1975), 191–6.

PART FOUR: SCULPTURE

CHAPTER 23

419. 1. For De Vries, see Eberhard Hempel, *Baroque Art and Architecture in Central Europe (Pelican History of Art)* (Harmondsworth, 1965).

421. 2. Juliane Gabriels attributed it to Artus I Quellin. Professor E. Neurdenburg considered it may be the joint work of De Keyser and Gerard Lambertsz.

422. 3. For Nicholas Stone, see Margaret Whinney, *Sculpture in Britain: 1530–1830 (Pelican History of Art)* (Harmondsworth, 1964).

4. For Artus Quellin, cf. H. Gerson and E. H. ter Kuile, *op. cit.* (Chapter 20, Note 9), R. Wittkower, *Art and Architecture in Italy: 1600–1750 (Pelican History of Art)* (Harmondsworth, 1958), and M. Whinney, *op. cit.*

5. For François Dieussart, cf. R. Wittkower, *op, cit.*

CHAPTER 24

423. 1. For Verhulst, cf. H. Gerson and E. H. ter Kuile, *op. cit.* (Chapter 20, Note 9).

2. Cf. Chapter 23, Note 4.

3. Cf. H. Gerson and E. H. ter Kuile, *op. cit.*, R. Wittkower, *op. cit.*, and M. Whinney, *op. cit.*

427. 4. J. Knoef, 'De beeldhouwer Jacobus Cresant', in *O.H.* (1941), 169–77.

BIBLIOGRAPHY

The bibliography is selective. For a complete list of the vast literature the reader should consult H. van Hall, *Repertorium voor de Geschiedenis der Nederlandsche Schilder- en Graveerkunst*, 2 vols, The Hague, 1936-49 (up to 1946), *Repertorium betreffende de Nederlands(ch)e Monumenten van Geschiedenis en Kunst 1901-1960* (periodicals), 4 vols, The Hague, 1940-62, *Repertorium van Boekwerken betreffende de Nederlandse Monumenten van Geschiedenis en Kunst* (up to 1940), The Hague, 1950 (both the latter Repertoria ed. by the Koninklijke Nederlandse Oudheidkundige Bond), and the *Bibliography of the Netherlands Institute for Art History* (1943-).

The bibliography and notes supplement each other: numerous important references only appear in the bibliography, and on the other hand, some studies are only quoted or characterized in the notes.

The bibliographical material is arranged under the following headings:

I. GENERAL

A. GENERAL WORKS

De Nederlands(ch)e Monumenten van Geschiedenis en Kunst, ed. by the Royal Commission for the Description of Monuments of History and Art. 1912-
BARNOUW, A. J., and LANDHEER, B. (eds.). *The Contribution of Holland to the Sciences*. New York, 1943.
 Contains an essay by F. Lugt on Dutch art historians.
SCHMIDT-DEGENER, F. *Verzamelde studies en essays*, I, *Het blijvend beeld der Hollandse Kunst*. Amsterdam, 1949.
 Essays on aspects of Dutch art by a former director of the Rijksmuseum. Vol. II reprints the author's articles on Rembrandt.
SITWELL, S. *The Netherlands*. 2nd ed. London-New York, 1952.
 A study of aspects of art, costume, and social life with a personal appreciation of the achievement of late seventeenth- and eighteenth-century Dutch artists and craftsmen.
Guide to Dutch Art, 2nd ed. The Hague, 1953.
 Brief survey published by the Dutch Government and Printing Office. Appendices include a list of museums and maps of provinces and principal cities.

GELDER, H. E. VAN, DUVERGER, J., a.o. *Kunstgeschiedenis der Nederlanden van de Middeleeuwen tot onze Tijd.* 3 vols. 3rd ed. Antwerp-Utrecht, 1954-6.
Authoritative articles on Dutch and Flemish art from the Middle Ages to modern times.
BROM, G. *Schilderkunst en literatuur in de 16ᵉ en 17ᵉ eeuw.* Utrecht, 1957.
TIMMERS, J. J. M. *A History of Dutch Life and Art.* Translated by M. F. Hedlund. Amsterdam-Brussels, 1959.
General survey, profusely illustrated.
Kunstreisboek voor Nederland. Amsterdam, 1960.
Topography of art and architecture in the manner of Dehio and *Monumentos españoles.*
GELDER, J. G. VAN. 'Two Aspects of the Dutch Baroque: Reason and Emotion', *De Artibus Opuscula XL: Essays in Honour of Erwin Panofsky.* New York, 1961.

B. HISTORICAL BACKGROUND

BAASCH, E. *Holländische Wirtschaftsgeschichte.* Jena, 1927.
GEYL, P. *Geschiedenis van de Nederlandsche stam.* 3 vols. Amsterdam, 1930-7.
The author's *The Netherlands Divided (1609-1648)*, London, 1936 (revised ed., *The Netherlands in the Seventeenth Century*, London, 1961) and *The Revolt of the Netherlands (1555-1609)* are based on the above work.
ROMEIN, J., and SCHAPER, W. B. *De tachtigjarige oorlog: 1568-1648.* Amsterdam, 1941.
RENIER, G. J. *The Dutch Nation.* London, 1944.
BRUGMANS, H. *Opkomst en bloei van Amsterdam.* 2nd ed., revised by A. le Cusquino de Bussy and N. W. Posthumus. Amsterdam, 1944.
CLARK, G. N. *The Seventeenth Century.* 2nd ed. Oxford, 1947.
HUIZINGA, J. 'Nederland's beschaving in de zeventiende eeuw', in *Verzamelde Werken*, II. Haarlem, 1948.
A revised and enlarged version of the author's *Holländische Kultur des siebzehnten Jahrhunderts*, Jena, 1932. Best survey of the culture of the period. English translation in J. Huizinga, trans. by A. J. Pomerans, *Dutch Civilization in the Seventeenth Century and Other Essays*, London, 1968; New York, 1969.
OGG, D. *Europe in the Seventeenth Century.* 5th ed. London, 1948.
ROMEIN, J., and ROMEIN, A. *De lage landen bij de zee.* Utrecht, 1949.
BARBOUR, V. *Capitalism in Amsterdam in the Seventeenth Century (The Johns Hopkins University Studies in Historical and Political Science*, ser. LXVII, no. 1). Baltimore, 1950.

FRIEDRICH, C. *The Age of the Baroque, 1610-60.* New York, 1952.
SLIVE, S. 'Notes on the Relationship of Protestantism to Seventeenth Century Dutch Painting', *A.Q.*, XIX (1956).
FREMANTLE, K. *The Baroque Town Hall of Amsterdam.* Utrecht, 1959.
Includes an excellent survey of the life and culture which produced the great building.
DAVIES, D. W. *A Primer of Dutch Seventeenth Century Overseas Trade.* The Hague, 1961.
KOSSMANN, E. H. 'The Dutch Republic', *New Cambridge Modern History*, V, *The Ascendancy of France, 1648-88.* Cambridge, 1961.
BOXER, C. R. *The Dutch Sea-Borne Empire: 1600-1800.* London, 1965.

II. PAINTING

A. BIBLIOGRAPHIES

HALL, H. VAN. *Repertorium voor de Geschiedenis der Nederlandsche Schilder- en Graveerkunst.* 2 vols. The Hague, 1935, 1949.
The most comprehensive bibliography of Dutch painting and graphic arts from the twelfth century up to 1946.
Bibliography of the Nederlands Institute for Art History, 1. The Hague, 1943-.
With summaries and commentaries in English on Dutch and Flemish art (architecture excluded).

B. SOURCES AND EIGHTEENTH-CENTURY LITERATURE

VAN MANDER, C. *Het Schilder-Boeck* . . . Haarlem, [1603-]1604. The 2nd ed., 1618, includes an anonymous biography of Van Mander.
This handbook for painters contains:
(*a*) 'Den Grondt der Edel vry Schilder-Const . . .'
(*b*) 'Het Leven der oude Antijcke Doorluchtige Schilders . . .'
(*c*) 'Het Leven . . . dees-tijsche doorluchtige Italiaensche Schilders'
(*d*) 'Het Leven der Doorluchtighe Nederlandtsche en Hooghduytsche Schilders'
(*e*) 'Wtleggingh Op den Metamorphosis Pub. Ovidij Nasonis'
(*f*) 'Uytbeeldinge der Figueren . . .'
The entire *Schilderboek* has not been translated. The section on 'Lives of the Netherlandish and German Painters' has been edited and translated into French by H. Hymans, 2 vols, Paris, 1884-5; into German by H. Floerke, 2 vols, Munich-Leipzig, 1906; English (unreliable) by C. van de

Wall, New York, 1936. R. Hoecker, *Das Lehrgedicht des Karel van Mander (Quellenstudien zur holländischen Kunstgeschichte*, VIII), The Hague, 1915, is a German translation of 'The Fundamentals of Painting'; also see O. Hirschmann, 'Beitrag zu einer Kommentar von Karel van Manders "Grondt der Edel vry Schilderconst" ', *O.H.*, XXXIII (1915). H. Noë, *Carel van Mander en Italië*, The Hague, 1954, edits and transcribes the last chapters of Van Mander's lives of the Italian artists. H. E. Greve, *De Bronnen van Carel van Mander*, The Hague, 1903, is an analysis of the sources. Also cf. R. Jacobsen, *Carel van Mander (1548-1606), Dichter en Prozaschrijver*, Rotterdam, 1906.

HUYGENS, C. Fragment of an autobiography. MS. in the Royal Library, The Hague. J. A. Worp published the text in *Bijdragen en Mededeelingen van het Historisch Genootschap*, XVIII (1897).

Important references to painters active in the Netherlands *c.* 1630. See J. A. Worp, 'Constantijn Huygens over de Schilders van zijn tijd', *O.H.*, IX (1891), and A. H. Kan, *De Jeugd van Constantijn Huygens door hemzelf beschreven*, Rotterdam, 1946 (with an essay by G. Kamphuis, 'Constantijn Huygens als Kunstcriticus').

BUCHELL, A. VAN. *Arnoldus Buchelius, 'Res Pictoriae' (Aanteekeningen over Künstenaars en Kunstwerken) 1583-1639*. Ed. G. J. Hoogewerff and I. Q. van Regteren Altena. The Hague, 1928.

Notes on artists and their work kept by an Utrecht jurist during the course of his travels in the Netherlands.

AMPZING, S. *Beschrijvinge ende Lof der Stad Haerlem in Holland*. Haarlem, 1628.

ORLERS, J. J. *Beschryvinge der Stad Leyden*. Leiden, 1642.

ANGEL, P. *Lof der Schilder-Konst*. Leiden, 1642.

An address in 'Praise of Painting'. Cf. P. J. Frederiks, 'Philip Angel's Lof der Schilderkonst', *O.H.*, VI (1888).

PARIVAL, J. DE. *Les délices de la Hollande*. Leiden, 1651.

BIE, C. DE. *Het Gulden Cabinet van de edele vry schilder-const*. Antwerp, 1661.

MONCONYS, B. DE. *Journal des voyages*. 3 vols. Lyon, 1665-6.

FÉLIBIEN, A. *Entretiens sur les vies et les ouvrages des plus excellents peintres . . .* 5 vols. Paris, 1666-88.

BLEISWIJCK, D. VAN. *Beschryvinge der Stadt Delft*. Delft, 1667.

SANDRART, J. VON. *Teutsche Academie*. Nuremberg, 1675-9; Latin ed., 1684.

A. R. Peltzer published an edition (Munich, 1925) with an introduction and extensive notes.

HOOGSTRATEN, S. *Inleyding tot de Hooge Schoole der Schilder-Konst anders de Zichtbaere Werelt*. Rotterdam, 1678.

A handbook for artists by a Rembrandt pupil.

PILES, R. DE. *Abregé de la vie des peintres*. Paris, 1699.

LAIRESSE, G. DE. *Grondlegginge ter Teekenkonst*. Amsterdam, 1701.

LAIRESSE, G. DE. *Het Groot Schilderboek*. Amsterdam, 1707.

Lairesse's handbooks were frequently translated and reprinted. For bibliographical references cf. J. J. M. Timmers, *Gérard Lairesse*, Amsterdam, 1942.

HOUBRAKEN, A. *De Groote Schouburgh der nederlantsche konstschilders en schilderessen*. 3 vols. Amsterdam, 1718-21; 2nd ed., The Hague, 1753.

Indispensable. Principal source for the lives of seventeenth-century Dutch artists. The German translation by A. von Wurzbach (Vienna, 1880) emasculates this fundamental work by expurgating all passages the translator considered philosophical, anecdotal, didactic, or boring. A modern reprint edited by P. T. A. Swillens (3 vols, Maastricht, 1943-53) has handy indices. See C. Hofstede de Groot, *Arnold Houbraken und seine 'Groote Schouburgh'*, The Hague, 1893, for a reliable analysis of the text and Houbraken's sources.

WEYERMAN, J. C. *De levensbeschryvingen der Nederlandsche Kunstschilders*. 4 vols. The Hague, 1729-69.

The author flagrantly plagiarized Houbraken's text and the trustworthiness of his original material is questionable. For a defence of his reliability cf. A. von Wolffers, *L'École néerlandaise et ses historiens*, Brussels, 1888. Also cf. D. J. H. ter Horst, 'De geschriften van Jan Campo Weyermann', *Het Boek*, XXVIII (1944).

GOOL, J. VAN. *De Nieuwe Schouburgh der Nederlantsche Kunstschilders en Schilderessen*. 2 vols. The Hague, 1750-1.

Biographies of eighteenth-century artists; a continuation of Houbraken's *Groote Schouburgh*.

HOET, G. *Catalogus of Naamlyst van Schilderyen*. 2 vols. The Hague, 1752.

Collection of sales catalogues from 1684 to 1752. Continued by P. Terwesten, *Catalogus of Naamlyst van Schilderyen*, The Hague, 1770.

DESCAMPS, J. D. *La Vie des peintres flamands*. 4 vols. Paris, 1753-63.

REYNOLDS, J. (ed.). 'A Journey to Flanders and Holland in the Year 1781', *The Literary Works of Sir Joshua Reynolds*, II. Ed. H. W. Beechy. London, 1890.

Notes on pictures viewed in the Netherlands.

WILLIGEN, A. VAN DER. *Les Artistes de Harlem*. 2nd ed. Haarlem, 1870.

Documents on Haarlem artists.

BREDIUS, A. *Künstler-Inventare: Urkunden zur Geschichte der Holländischen Kunst des XVIten, XVIIten und XVIIIten Jahrhunderts*. 8 vols. The Hague, 1915-22.

Artists' inventories, documents on their lives, and collections.

C. ICONOGRAPHY

MOES, E. *Iconographia Batava.* 2 vols. Amsterdam, 1897–1905.
List of painted and engraved Dutch portraits. A revised and enlarged MS. copy of the work is in the Prentenkabinet of the Rijksmuseum, Amsterdam.

TIETZE-CONRAT, E. 'L'Allegorie dans la peinture classique hollandaise', *G.B.A.*, XVII (1928).

MÂLE, E. *L'Art religieux après le concile de Trente.* Paris, 1932.

GUDLAUGSSON, S. *Ikonographische Studien über die holländische Malerei und das Theater des 17. Jahrhunderts.* Würzburg, 1938.

RUDOLPH, H. '"Vanitas"': Die Bedeutung mittelalterlicher und humanistischer Bildinhalte in der niederländischen Malerei des 17. Jahrhunderts', *Festschrift Wilhelm Pinder.* Leipzig, 1938.
An important paper that calls attention to allegorical meanings in Dutch painting which are easily overlooked by modern observers.

PRAZ, M. *Studies in Seventeenth Century Imagery (Studies of the Warburg Institute, III).* 2 vols. London, 1939–47.
A study of emblem literature with full bibliography.

KNIPPING, J. B. *De Iconografie van de Contra-Reformatie in de Nederlanden.* 2 vols. Hilversum, 1939–40. Revised English translation by the author, 2 vols., Leiden, 1974.
The basic work.

KAUFFMANN, H. 'Die fünf Sinne in der Niederländischen Malerei des 17. Jahrhunderts', *Kunstgeschichtliche Studien.* Breslau, 1944.

WAAL, H. VAN DE. *Drie Eeuwen vaderlandsche Geschieduitbeelding, 1500–1800, een iconologische Studie.* 2 vols. The Hague, 1952.
Illuminating study of Dutch history painting with an important discussion of the commissions for the Amsterdam Town Hall. Includes a full summary in English.

PIGLER, A. *Barockthemen. Eine Auswahl von Verzeichnissen zur Ikonographie des 17. und 18. Jahrhunderts.* 2 vols. Budapest, 1956.
Lists subjects painted by Baroque artists with numerous references to Dutch painters.

Iconographic Index. Published by the Netherlands Institute for Art History. The Hague, 1959–.
A comprehensive iconographical index file of art in the Low Countries made up of coded postcard-size photographs.

HECKSCHER, W. S., and WURTH, K. A. 'Emblem, Emblembuch', *Reallexikon zur deutschen Kunstgeschichte.* Stuttgart, 1959.
Exhaustive article which includes many references to Dutch art.

SLIVE, S. 'Realism and Symbolism in Seventeenth Century Dutch Painting', *Daedalus, Journal of the American Academy of Arts and Sciences* (Summer, 1962).

JONGH, E. DE. *Zinne- en Minnebeelden in de Schilderkunst van de Zeventiende Eeuw,* in the series Nederlands en Belgisch Kunstbezit uit Openbare Verzamelingen, 1967.
On emblematic references in painting of the period.

D. LEXICA

IMMERZEEL, J. *De Levens en Werken der Hollandsche en Vlaamsche Kunstschilders, Beeldhouwers, Graveurs en Bouwmeesters.* 3 vols. Amsterdam, 1842–3.
Alphabetically arranged lexicon of artists; a forerunner of Wurzbach.

KRAMM, C. *De Levens en Werken der Hollandsche en Vlaamsche Kunstschilders . . .* Amsterdam, 1857–64.
Additions to Immerzeel.

WURZBACH, A. VON. *Niederländisches Künstler-Lexikon.* 3 vols. Vienna–Leipzig, 1906–11.
Although superseded in many respects by later publications, it still should be consulted. Helpful bibliographical references and lists of works. The author's outspoken prejudices add to rather than detract from its readability.

THIEME, U., and BECKER, F. *Allgemeines Lexikon der bildender Künste.* 37 vols. Leipzig, 1907–50.
Includes authoritative articles on Dutch artists.

SCHEEN, P. A. *Honderd Jaren Nederlandsche Schilder- en Teekenkunst, de Romantiek met voor-en Natijd (1780–1850).* The Hague, 1946.
Lexicon of late-eighteenth- and early-nineteenth-century artists.

WALLER, F. G. *Biografisch Woordenboek van noordnederlandsche Graveurs.* The Hague, 1938.

BERNT, W. *Die Niederlandischen Maler des 17. Jahrhunderts.* 3 vols. Munich, 1948; vol. 4 (supplement), 1962; 3rd rev. ed., 3 vols. Munich, 1969–70.
Alphabetically arranged collection of reproductions of works by 800 Dutch and Flemish painters, including many lesser-known ones.

JUYNBOLL, W. R., DENIS, V., a.o. *Winkler Prins van de Kunst. Encyclopedie van de Architectuur, Beeldende Kunst, Kunstnijverheid.* 3 vols. Amsterdam–Brussels, 1958–9.
A general encyclopedia of the arts with numerous entries on Dutch artists.

HOLLSTEIN, F. W. H. *Dutch and Flemish Etchings, Engravings and Woodcuts,* 1–. Amsterdam, n.d.
Alphabetically arranged list of works by Netherlandish graphic artists. Illustrated.

E. GENERAL HISTORY OF PAINTING

EYNDEN, R. VAN, and WILLIGEN, A. VAN DER. *Geschiedenis der vaderlandse Schilderkunst sedert de Helft der XVIII Eeuw.* 4 vols. Haarlem, 1816–40.

Discussion of artists active after 1750. The authors also made an attempt to deal with artists omitted or slighted by Houbraken and Van Gool.

SMITH, J. *A Catalogue Raisonné of the Works of the Most Eminent Dutch, Flemish and French Painters.* 9 vols. London, 1829–42.

Antiquated, but of interest as the first catalogue raisonné of works of many of the principal Dutch painters. The basis for Hofstede de Groot's monumental catalogue published in the following century.

NIEUWENHUYS, C. J. *A Review of the Lives and Works of Some of the Most Eminent Painters.* London, 1834.

Includes Dutch artists. Lists current prices.

BÜRGER, W. (Étienne Jos. Théoph. Thoré). *Les Musées de Hollande.* Paris, 1858.

The author is best known for resuscitating Vermeer (*G.B.A.*, II, 1866), but he is equally penetrating in this study on Dutch pictures in the museums of Holland.

HAVARD, H. *L'Art et les artistes hollandais.* 4 vols. Paris, 1879–81.

Consult for material on minor masters: Lingelbach, Palamedes, Camphuysen, Beerstraaten, Delff, *et al.*

FROMENTIN, E. *Les Maîtres d'autrefois Belgique–Hollande.* Paris, 1876.

Frequently translated and reprinted essay on fifteenth- and seventeenth-century Dutch and Flemish masters. *The Masters of Past Time: Dutch and Flemish Painting from Van Eyck to Rembrandt,* with an introduction and notes by H. Gerson, London, 1948, is the best English edition. For a brilliant appraisal of Fromentin's book cf. M. Schapiro, *Partisan Review,* XVI (1949).

BODE, W. *Studien zur Geschichte der holländischen Malerei.* Brunswick, 1883.

An epoch-making work which laid the foundation for subsequent important studies by the author as well as for those made by other specialists in the field.

HOFSTEDE DE GROOT, C. *Beschreibendes und kritisches Verzeichnis der Werke der hervorragendsten holländischen Maler des XVII. Jahrhunderts.* 10 vols. Esslingen a N., 1907–28. English trans. of vols 1–8 by E. G. Hawke, London, 1908–27.

Indispensable, although in need of revision and in some cases superseded by subsequent studies. Includes biographies and lists of pupils and followers as well as references to untraceable or unidentified works.

Vol. 1, Jan Steen, Gabriel Metsu, Gerard Dou, Pieter de Hooch, Carel Fabritius, Johannes Vermeer.

Vol. 2, Aelbert Cuyp, Philips Wouwerman.

Vol. 3, Frans Hals, Adriaen van Ostade, Isack van Ostade, Adriaen Brouwer.

Vol. 4, Jacob van Ruisdael, Meindert Hobbema, Adriaen van de Velde, Paulus Potter.

Vol. 5, Gerard Ter Borch, Caspar Netscher, Godfried Schalcken, Pieter van Slingeland, Eglon Hendrik van der Neer.

Vol. 6, Rembrandt, Nicolaes Maes.

Vol. 7, Willem van de Velde (II), Johannes van de Cappelle, Ludolf Bakhuyzen, Aert van der Neer.

Vol. 8, Jan van Goyen, Jan van der Heyden, Johannes Wijnants.

Vol. 9, Johannes Hackaert, Nicolaes Berchem, Karel du Jardin, Jan Both, Adam Pijnacker.

Vol. 10, Frans van Mieris d.A., Willem van Mieris, Adriaen van der Werff, Rachel Ruysch, J. van Huysum.

BODE, W. *Rembrandt und seine Zeitgenossen.* Leipzig, 1906.

Masterful characterizations of the achievement of leading Dutch and Flemish Baroque painters. English translation and revised 2nd ed. (1907) by M. L. Clarke, *Great Masters of Dutch and Flemish Painting,* London–New York, 1909.

JANTZEN, H. *Niederländische Malerei im 17. Jahrhundert.* Leipzig, 1912.

Short survey, still useful for its clear exposition of stylistic changes.

BODE, W. VON. *Die Meister der holländischen und vlämischen Malerschulen.* Leipzig, 1917.

This classic is a much expanded and partly reworked edition of the author's *Rembrandt und seine Zeitgenossen.* The 8th ed., Leipzig, 1956, has valuable notes by E. Plietzsch.

MARTIN, W. *Alt-holländische Bilder.* Berlin, 1918.

For the collector.

ROH, F. *Holländische Malerei.* Jena, 1921.

FRIEDLÄNDER, M. J. *Die niederländische Malerei des 17. Jahrhunderts (Propyläen Kunstgeschichte,* XII). Berlin, 1923.

Still one of the best general treatments of the subject.

DROST, W. *Barockmalerei in den germanischen Ländern (Handbuch der Kunstwissenschaft).* Wildpark-Potsdam, 1926.

GOLDSCHMIDT, A. 'Style in Dutch Painting in the Seventeenth Century', *A.Q.,* II (1939).

REGTEREN ALTENA, I. Q. VAN. *De Nederlandse Geest in de Schilderkunst.* Zeist, 1941.

On the essential qualities of Dutch painting, by an outstanding Dutch art historian and connoisseur.

BOON, K. G. *De Schilders voor Rembrandt, De Inleiding tot het Bloeitijdperk.* Antwerp, 1942.

Useful short study of the transition from Late Mannerism to realism.

MARTIN, W. *De Hollandsche Schilderkunst in de 17de Eeuw*. 2 vols. 2nd ed. Amsterdam, 1942.
These volumes (*Frans Hals en zijn Tijd* and *Rembrandt en zijn Tijd*) offer a vast amount of material. Extensive notes and profusely illustrated (519 reproductions).

HUEBNER, F. M. *Nederlandsche en Vlaamsche Rococo-Schilders*. The Hague, 1943.
One of the rare monographs on the subject.

Cornelis Troost en zijn Tijd. Exhibition Catalogue. Rotterdam, Museum Boymans, 1946.
Useful brief survey of the eighteenth century.

KNOEF, J. *Tusschen Rococo en Romantiek*. The Hague, 1948.
A collection of essays on Jurriaan Andriessen, Jan Ekels, Adriaan de Lelie, W. J. van Troostwijk, and others active around 1800.

STARING, A. 'Haagsche Hofschilders uit de 18de Eeuw', *Kunsthistorische Verkenningen*, III (1948).

FRIEDLÄNDER, M. J. *Landscape, Portrait, Still-life; Their Origin and Development*. Trans. from the German by R. F. C. Hull. Oxford, 1949.
Essays which include penetrating observations on the treatment of the various categories of painting by the great Dutch masters.

GERSON, H. *De Nederlandse Schilderkunst*. 3 vols. Amsterdam, 1950-61. (*Van Geertgen tot Frans Hals*, vol. 1, 1950; *Het Tijdperk van Rembrandt en Vermeer*, vol. 2, 1952; *Voor en na Van Gogh*, vol. 3, 1961.)
Survey of six centuries of Dutch art by a leading authority. Excellent reproductions.

KNUTTEL, G. WZN. *De Nederlandse Schilderkunst van Van Eyck tot Van Gogh*. 2nd ed. Amsterdam, 1950.

BENTSSON, Å., and OMBERG, H. 'Structural Changes in Dutch Seventeenth Century Landscape, Still-life, Genre and Architecture Painting', *Figura*, I (1951).

MARTIN, W. *Dutch Painting of the Great Period: 1650-1697*. Trans. from the Dutch by D. Horning. London, 1951.
Less satisfactory than the author's other contributions to the history of Dutch painting.

VIPPER, B. R. *The Formation of Realism in Seventeenth Century Dutch Painting* (in Russian). Moscow, 1957.

PLIETZSCH, E. 'Randbemerkungen zur holländischen Malerei vom Ende des 17. Jahrhunderts', *Festschrift Friedrich Winkler*. Berlin, 1959.
An appreciation of late-seventeenth-century painters.

PLIETZSCH, E. *Holländische und flämische Maler des XVII. Jahrhunderts*. Leipzig, 1960.
Written as a supplement to Bode's *Die Meister der holländischen und vlämischen Malerschulen*. Treats painters Bode did not discuss. Lacks documentation. 421 reproductions.

BOL, L. J. *Holländische Maler des 17. Jahrhunderts nahe den grossen Meistern: Landschaften und Stilleben*. Brunswick, 1969.

NASH, J. M. *The Age of Rembrandt and Vermeer: Dutch Painting in the Seventeenth Century*. London, 1972.

1. Mannerism

KAUFFMANN, H. 'Der Manierismus in Holland und die Schule von Fontainebleau', *Jahrb. P.K.*, XLIV (1923).
See the critical review by W. Stechow, *Kritische Berichte zur kunstgeschichtlichen Literatur*, I (1927-8).

ANTAL, F. 'Zum Problem des niederländischen Manierismus', *Kritische Berichte zur Kunstgeschichtlichen Literatur*, II (1928-9).

BAUMGART, F. 'Zusammenhänge der niederländischen mit der italienischen Malerei in der zweiten Hälfte des 16. Jahrhunderts', *Marburger Jahrbuch für Kunstwissenschaft*, XIII (1944).

REZNICEK, E. K. J. 'Realism as a "Side Road or By-way" in Dutch Art', *Studies in Western Art, Acts of the Twentieth International Congress of the History of Art*, II. Princeton, 1963.

Dutch Mannerism: Apogee and Epilogue. Exhibition Catalogue, Vassar College Art Gallery, Poughkeepsie, N.Y., 1970.
Introduction by W. Stechow.

2. Caravaggisti

VOSS, H. 'Vermeer van Delft und die Utrechter Schule', *Monatshefte für Kunstwissenschaft*, V (1912).
Pioneer study that recognized the connexion between the Utrecht school and Vermeer.

FOKKER, T. H. 'Nederlandsche schilders in Zuid-Italië', *O.H.*, XLVI (1929).

SCHNEIDER, A. VON. *Caravaggio und die Niederländer*. Marburg-Lahn, 1933.
First monograph on the subject; reprint, Amsterdam, 1967.

LONGHI, R. Introduction to exhibition *Catalogo Mostra del Caravaggio e dei Caravaggeschi*. Milan, 1951.

GELDER, J. G. VAN. Introduction to exhibition *Caravaggio en de Nederlanden*. Utrecht-Antwerp, 1952.

3. Italianate Painters and the Bentvueghels

BERTOLOTTI, A. *Artisti belgi ed olandesi a Roma nei secoli XVI e XVII*. Florence, 1880.

HOOGEWERFF, G. J. 'De Stichting van de Nederlandsche Schildersbent te Rome', *Feest-Bundel Dr Abraham Bredius*. Amsterdam, 1915.

GERSTENBERG, K. *Die ideale Landschaftsmalerei, Ihre Begründung und Vollendung in Rom*. Halle, 1923.

HOOGEWERFF, G. J. *Nederlandsche Kunstenaars te*

Rome (1600-1725). Studiën van het Nederlandsch Historisch Instituut te Rome, III. The Hague, 1942.
Collection of earlier articles on the subject printed in the *Mededeelingen* of the Dutch Institute at Rome.

BRIGANTI, G. Catalogue of the exhibition *I Bamboccianti* held at the Palazzo Massimo alle Colonne. Rome, 1950.

HOOGEWERFF, G. J. *De Bentvueghels*. The Hague, 1952.
An important contribution which does not exhaust the subject. Selected bibliography of sources and recent literature.

Nederlanders te Rome. Exhibition catalogue. Leiden, University Print Room, 1954.

BRIGANTI, G. 'Bamboccianti', in *Encyclopedia of World Art*, II. New York-Toronto-London, 1956.

ZWOLLO, A. *Hollandse en Vlaamse veduteschilders te Rome: 1675-1725.* Assen, 1973.

F. SOCIAL HISTORY, PATRONS, AND WORKSHOP PRACTICE

GRAM, J. *De Schildersconfrerie Pictura en Hare Academie van beeldende Kunsten te 's Gravenhage: 1682-1882.* Rotterdam, 1882.
History of the oldest academy in Holland.

BREDIUS, A. 'De Kunsthandel te Amsterdam in de XVIIde Eeuw', *Amsterdamsch Jaarboekje* (1891).

FLOERKE, H. *Studien zur niederländischen Kunst- und Kulturgeschichte, Die Formen des Kunsthandels, das Atelier und die Sammler in den Niederlanden von 15.-18. Jahrhundert.* Munich-Leipzig, 1905.
Still the best survey.

MARTIN, W. 'The Life of a Dutch Artist in the Seventeenth Century', *B.M.*, VII (1905); VIII (1905-6); X (1906-7).

SCHOTEL, G. D. J. *Het oudhollandse Huisgezin.* Haarlem, 1868.

SCHOTEL, G. D. J. *Het maatschappelijk Leven onzer Vaderen in de zeventiende Eeuw.* Rotterdam, 1869.
Both studies by Schotel are still indispensable.

MURRIS, R. *La Hollande et les hollandais au XVIIe et au XVIIIe siècles vus par les français.* Paris, 1925.
Discussion of French travel literature with references to works of art. Well documented.

HUDIG, F. W. *Frederik Hendrik en de Kunst van zijn Tijd.* Amsterdam, 1928.
A paper on the prince of Orange's role as a patron.

HOOGEWERFF, G. J. 'Nederlandsche Schilders en Scholing in de 17de Eeuw', *Mededeelingen van het Nederlandsch Historisch Instituut te Rome*, IX (1929).

LUGT, F. 'Italiaansche Kunstwerken in nederlandsche Verzamelingen van vroeger Tijden', *O.H.*, LIII (1936).

MAHON, D. 'Notes on the "Dutch Gift" to Charles II', *B.M.*, XCI (1949); XCII (1950).

PEVSNER, N. *Academies of Art Past and Present.* Cambridge, 1940.
Includes a section on Dutch guilds and academies.

OLDEWELT, W. F. H. *Het St Lucasgilde (Amsterdamsche Archiefvondsten).* Amsterdam, 1942.

HOOGEWERFF, G. J. *De Geschiedenis van de St Lucasgilden in Nederland.* Amsterdam, 1947.

HAUSER, A. *The Social History of Art.* 2 vols. London, 1951.

THIEME, G. *Kunsthandel in den Niederlanden im 17. Jahrhundert.* Cologne, 1959.

BILLE, C. *De Tempel der Kunst of het Kabinet van den Heer Braamcamp.* Amsterdam, 1961.
Thorough study of Braamcamp's (1699-1771) impressive cabinet which gives a vivid picture of patronage and collecting in eighteenth-century Holland. Comprehensive English summary.

ZUMTHOR, P. *Daily Life in Rembrandt's Holland.* Trans. from the French by S. W. Taylor. London, 1962.
Excellent survey of aspects of urban and rural life.

BRUYN, J., and MILLAR, O. 'Notes on the Royal Collection - III: The "Dutch Gift" to Charles I', *B.M.*, CIV (1962).

GELDER, J. G. VAN. 'Notes on the Royal Collection - IV: The "Dutch Gift" of 1610 to Henry, Prince of "Whalis", and Some Other Presents', *B.M.*, CV (1963).

G. COSTUME

THIENEN, F. VAN. *Das Kostüm der Blütezeit Hollands: 1600-1660.* Berlin, 1930.
Standard work.

THIENEN, F. VAN. 'Een en ander over de Kleeding der Nederlandsche Boeren in de zeventiende Eeuw', *Oudheidkundig Jaarboek*, I (1932).

KINDEREN-BESIER, J. H. DER. *Spelevaart der Mode.* Amsterdam, 1950.

THIENEN, F. VAN. *The Great Age of Holland: 1600-60 (Costume of the Western World Series).* London, 1951.
A brief survey.

H. SUBJECT MATTER

1. History
(also cf. entries under C. ICONOGRAPHY)

DOHMANN, A. 'Les Événements contemporains dans la peinture hollandaise du XVIIe siècle' (trans. M. Camus), *Revue d'Histoire Moderne et Contemporaine*, V (1958).

GELDER, J. G. VAN. 'De schilders van der Oranje-zaal', *N.K.J.* (1948-9).

Publication of documents; identification of subjects and artists of the pictures in the Oranjezaal at Huis ten·Bos which was built as a memorial to the prince of Orange.

2. Portraiture

MEIJER, JR. D. C. 'De Amsterdamsche Schutters-Stukken in en Buiten het nieuwe Rijksmuseum', *O.H.*, III (1885); IV (1886); VI (1887); VII (1888).

RIEGL, A. 'Das holländische Gruppenporträt', *Jahrbuch der Kunsthistorischen Sammlungen in Wien*, XIII (1902).

A basic work. It is not necessary to accept the author's ideas about Dutch *Kunstwollen* to profit from his keen observations on the history of Dutch group portraits from Geertgen tot Sint Jans to Rembrandt. Reprinted Vienna, 1931, 2 vols, with notes by L. Münz.

DÜLBERG, F. *Das holländische Porträt des XVII. Jahrhunderts*. Leipzig, 1923.

VRIES, A. B. DE. *Het Noord-Nederlandsch Portret in de tweede Helft van de 16e Eeuw*. Amsterdam, 1934.

Includes a survey of portraitists active *c.* 1600.

STARING, A. *Fransche Kunstenaars en hun Hollandsche Modellen, in de 18de en in den Aanvang der 19de Eeuw*. The Hague, 1947.

On the vogue for French portraitists.

EDWARDS, R. *Early Conversation Pictures from the Middle Ages to about 1730*. London, 1954.

Includes Dutch examples.

STARING, A. *De hollanders Thuis, Gezelschap-Stukken uit drie Eeuwen*. The Hague, 1956.

First-rate monograph on seventeenth- and eighteenth-century conversation pieces, with an essay in English.

WASSENBERGH, A. *De portretkunst in Friesland in de zeventiende eeuw*. Lochem, 1967.

3. Genre

BURCKHARDT, J. 'Über die niederländische Genremalerei', *Vorträge 1844-1887*. Basel, 1919.

BRIEGER, L. *Das Genrebild*. Munich, 1922.

Dutch artists are included in this general history of European genre painting.

BUDDE, I. *Die Idylle in holländischen Barock*. Cologne, 1929.

See the critical review by W. Stechow, *Kritische Berichte zur Kunstgeschichtlichen Literatur*, II (1928-9).

MÜLLER, C. 'De Meesters van het hollandsche Binnenhuis', *Maandblad voor beeldende Kunsten*, VIII (1931).

WÜRTENBERGER, F. *Das holländische Gesellschaftsbild*. Schramberg im Schwarzwald, 1937.

Includes an excellent account of the relation of the early realists to the Late Mannerists.

MULS, J. *De Boer in de Kunst*. Leuven, 1946.

Brief account of the peasant in European art.

BAX, D. *Skilders wat Vertel*. Oxford University Press, 1951.

An inaugural lecture with observations on the connexions between Bruegel's followers and the early genre painters.

PLIETZSCH, E. 'Randbemerkungen zur holländischen Interieurmalerei am Beginn des 17. Jahrhunderts', *Wallraf-Richartz-Jahrbuch*, XVIII (1956).

Mainly on the artists in Hals' circle (Dirk Hals, Buytewech, Leyster, Molenaer, Codde).

KEYSZELITZ, R. Der 'Clavis interpretandi' in der holländischen Malerei des 17. Jahrhunderts. Munich, 1957.

Typewritten thesis on allegories in Dutch genre painting.

JONGH, E. DE. 'Erotica in Vogelperspectief: De dubbelzinnigheid van een reeks 17de eeuwse genrevoorstellingen', *Simiolus*, III (1968-9).

On double meanings in some seventeenth-century Dutch genre paintings.

4. Landscape

JONGH, J. DE. *Het holländsche Landschap*. The Hague, 1903; German ed., 1905.

MICHEL, É. *Les Maîtres du paysage*. Paris, 1906.

PLIETZSCH, E. *Die frankenthaler Künstlerkolonie und Gillis van Coninxloo*. Leipzig, 1910.

BLOCK, I. 'Teekeningen van Esais van de Velde, Jan van Goyen en P. de Molyn', *Oude Kunst*, III (1917-18).

ROH, F. *Holländische Landschaftsmalerei des 17. Jahrhunderts*. Leipzig, 1923.

GROSSE, R. *Die holländische Landschaft Kunst, 1600-1650*. Berlin-Leipzig, 1925.

HAVELAAR, J. *De nederlandsche Landschapkunst tot het Einde der zeventiende Eeuw*. Amsterdam, 1931.

RACZYNSKI, J. A. *Die flämische Landschaft vor Rubens*. Frankfurt am Main, 1937.

Illuminating treatment of the Late Mannerists.

BENGTSSON, Å. *Studies on the Rise of Realistic Landscape Painting in Holland: 1610-1625 (Figura*, III). Stockholm, 1952.

Discussion of the prominent role played by Haarlem landscapists. Cf. critical review by J. G. van Gelder, *B.M.*, XCV (1953), and the author's response, *ibid*.

GOMBRICH, E. H. 'Renaissance Artistic Theory and the Development of Landscape Painting', *G.B.A.*, XLI (1953).

The way art theory helped to create a clientele for early landscapists.

GELDER, H. E. VAN. *Holland by Dutch Artists in Paintings, Drawings, Woodcuts, Engravings and Etchings*. Amsterdam, 1959.

Pictorial survey of six centuries of Dutch landscape art with a brief introduction.

STECHOW, W. 'The Winter Landscape in the History of Art', *Criticism*, II (1960).
Includes Dutch artists.

STECHOW, W. 'Significant Dates on Some Seventeenth Century Landscape Paintings', *O.H.*, LXXV (1960).
Discussion of dated works by H. Avercamp, H. Swanevelt, A. Cuyp, A. Pijnacker. Also see the author's 'Über das Verhältnis zwischen Signatur und Chronologie bei einigen holländischen Künstlern des 17. Jahrhunderts', in *Festschrift Dr. h. c. Eduard Trautscholdt*, Hamburg, 1965, 111 ff.

GERSON, H. Introduction to the catalogue of the exhibition *Landschap in de Nederlanden 1550-1630*. Breda–Ghent, 1961.

BOL, L. J. Introduction to exhibition catalogue *Nederlandse Landschappen int de zeventiende Eeuw*. Dordrecht, 1963.
Nederlands 17ᵉ Eeuwse Italianiserende Landschapschilders. Utrecht, 1965.
Catalogue of exhibition held at Centraal Museum; extensive entries by A. Blankert and H. J. de Smedt.

STECHOW, W. *Dutch Landscape Painting of the Seventeenth Century* (Kress Foundation Studies in the History of European Art, 1). London, 1966.
Indispensable. A comprehensive typological study by the leading specialist; 370 illustrations.

DATTENBERG, H. *Niederrheinansichten holländischer Künstler des 17. Jahrhunderts*. Düsseldorf, 1967.

5. Marine

JANTZEN, H. 'De Ruimte in de hollandsche Zeeschildering', *Onze Kunst* (1910).

WILLIS, F. C. *Die niederländische Marinemalerei*. Leipzig, 1911.
Still the best survey.

PRESTON, L. *Sea and River Painters of the Netherlands in the Seventeenth Century*. London, 1937.

BOL, L. J. *Die holländische Marinemalerei des 17. Jahrhunderts*. Brunswick, 1973.

6. Architecture

JANTZEN, H. *Das niederländische Architekturbild*. Leipzig, 1910.
The basic study, with a discussion of many lesser known architectural painters.

FRITZ, R. *Das Stadt- und Strassenbild in der holländischen Malerei des 17. Jahrhunderts*. Stuttgart, 1932.

7. Still Life

SJÖBLOM, A. *Die koloristische Entwicklung des niederländischen Stillebens im 17. Jahrhunderts*. Würzburg, 1917.

ZARNOWSKA, E. *La Nature-morte hollandaise. Les principaux représentants, ses origines, son influence*. Brussels–Maestricht, 1929.

VORENKAMP, A. P. A. *Bijdrage tot de Geschiedenis van het hollandsche Stilleven in de XVII Eeuw*. Leiden, 1933.

GELDER, J. G. VAN. 'Van Blompot en Blomglas', *E.G.M.*, XLVI (1936).
Important essay on origins.

BADELT, E. *Das Stilleben als bürgerliches Bildthema und seine Entwicklung von den Anfängen bis zur Gegenwart*. Diss., Munich, 1938.

GELDER, H. E. VAN. *W. C. Heda, A. van Beyeren, W. Kalf (Palet Serie)*. Amsterdam, 1941.
Essays on three important masters.

VROOM, N. R. A. *De Schilders van het monochrome Banketje*. Amsterdam, 1945.

LUTTERVELT, R. VAN. *Schilders van het Stilleven*. Naarden, 1947.

GELDER, J. G. VAN. *Catalogue of the Collection of Dutch and Flemish Still-life Pictures, Ashmolean Museum*. Oxford, 1950.

BERGSTRÖM, I. *Dutch Still-life Painting in the Seventeenth Century*. Trans. C. Hedström and G. Taylor. New York, 1956.
The best comprehensive study, with complete bibliography.

STERLING, C. *Still-life Painting from Antiquity to the Present Time*. Trans J. Emmons. Paris–New York, 1959.

GOMBRICH, E. H. 'Tradition and Expression in Western Still-life', *B.M.* (May 1961).

I. RELATIONS WITH FOREIGN COUNTRIES

(also cf. entries under E. *2. Caravaggisti* and E. *3. Italianate Painters and the Bentvueghels*)

GERSON, H. *Ausbreitung und Nachwirkung der holländische Malerei des 17. Jahrhunderts*. Haarlem, 1942.
The basic study, fully documented.

J. ARTISTS IN ALPHABETICAL SEQUENCE

AERTS
Jantzen, H. 'Hendrick Aerts', *Monatshefte für Kunstwissenschaft*, VI (1913).

ARENTSZ. (CABEL)
Poensgen, G. 'Arent Arentsz und sein Verhältnis zu Hendrik Avercamp', *O.H.*, XLI (1923-4).

ASSELYN
Steland-Stief, A. C. *Jan Asselyn*. Amsterdam, 1971.

AVERCAMP
Welcker, C. J. *Hendrik Avercamp 1585-1634*,

bijgenaamd 'de Stomme van Campen', en Barent Avercamp, 1612–1679. Zwolle, 1933.
Monograph with *œuvre* catalogue.

BABUREN, VAN
Swillens, P. T. A. 'De Schilder Theodorus (of Dirck?) van Baburen', *O.H.*, XLVIII (1931).
Gowing, L. 'Light on Baburen and Vermeer', *B.M.*, XCIII (1951).
Slatkes, L. J. *Dirck van Baburen.* Utrecht, 1962.
Monograph and handlist of authentic works. Cf. review by B. Nicolson, *B.M.*, CIV (1962).

BACKER
Bauch, K. *Jacob Adriaensz. Backer.* Berlin, 1926.
The basic study with *œuvre* catalogue.

BAILLY
Boström, K. 'David Bailly's Stilleben', *Konsthistoriskt Tidskrift*, XVIII (1949).
Bruyn, J. 'David Bailly, "fort bon peintre en pourtraicts et en vie coye"', *O.H.*, LXVI (1951).

BAKHUIZEN
HdG. Vol. 7, 'Ludolf Bakhuyzen'.

BAMBOCCIO see LAER, VAN

BERCHEM
HdG. Vol. 9, 'Nicolaes Berchem'.
Sick, I. von. *Nicolaes Berchem; ein Vorläufer des Rokoko.* Cologne, 1930.
Hoogewerff, G. J. 'Wanneer en hoe vaak was Berchem in Italie', *O.H.*, XLVIII (1931).
Schaar, E. 'Berchem und Begeijn', *O.H.*, LXIX (1954).
On a close follower.
Schaar, E. *Studien zu Nicolaes Berchem.* Cologne, 1958.
Kuznetsov, J. 'Claes Berchem and his Works in the Hermitage', in *Iz istorii russkogo i zapadnoevropeiskogo iskusstva [Festschrift for V. N. Lasareff]* (Russian text). Moscow, 1960.

BERCKHEYDE, JOB
Stechow, W. 'Job Berckheyde's "Bakery Shop"', *Allen Memorial Art Museum Bulletin*, XV (1957).

BEYEREN, VAN
Blok, I. 'Abraham van Beyeren', *Onze Kunst*, XXXIII (1918).
Gelder, H. E. van. *W. C. Heda, A. van Beyeren, W. Kalf (Palet Serie).* Amsterdam, 1941.

BLOEMAERT
Müller, C. 'Abraham Bloemaert als Landschaftsmaler', *O.H.*, XLIV (1927).
Delbanco, G. *Der Maler Abraham Bloemaert.* Strassburg, 1928.
Cf. review essay by F. Antal, *Kritische Berichte zur kunstgeschichtliche Literatur*, II (1928-9), and H. Kauffmann, *O.H.*, XLVIII (1931).

BOL
Bredius, A. 'Did Rembrandt paint the Portrait of Elizabeth Bas?', *B.M.*, XX (1911-12).

Bredius, A. 'Self-portraits by Ferdinand Bol', *B.M.*, XLII (1923).
Schneider, H. 'Ferdinand Bol als Monumentmaler im Amsterdamer Rathaus', *Jahrb. P.K.*, XLVII (1926).

BOR
Plietzsch, E. 'Paulus Bor', *Jahrb. P.K.*, XXXII (1916).
Bloch, V. 'Zur Malerei des Paulus Bor', *O.H.*, XLV (1928).
Bloch, V. 'Orlando', *O.H.*, LXIV (1949).
Cf. a note on this article by J. Q. van Regteren Altena, *ibid.*
Gudlaugsson, S. J. 'Paulus Bor als portrettist', in *Miscellanea I.Q. van Regteren Altena*, Amsterdam, 1969.
Attribution of portraits formerly attributed to Jan de Bray to Paulus Bor.

BORCH
HdG. Vol. 5, 'Gerard ter Borch'.
Gudlaugsson, S. J. *Gerard ter Borch.* 2 vols. The Hague, 1959-60.
Exemplary monograph with complete bibliography and critical catalogue raisonné.
Gerard Ter Borch: 1617-1681. Exhibition Catalogue, The Hague-Münster, 1975.

BOSSCHAERT
Bol, L. J. *The Bosschaert Dynasty.* Leigh-on-Sea, 1960.
Standard work on this family of painters. Also cf. the author's articles in *O.H.*, LXX (1955), LXXI (1956).

BOTH
HdG. Vol. 9, 'Jan Both'.
Bruyn, L. de. 'Het Geboorte jaar van Jan Both', *O.H.*, LXVII (1952).
Stechow, W. 'Jan Both and the Re-Evaluation of Dutch Italianate Landscape Painting', *Actes du XVIIᵐᵉ Congrés International d'Histoire de l'Art* Amsterdam, 1952; The Hague, 1955.
Also see W. Stechow, 'Jan Both and Dutch Italianate Landscape Painting', *Magazine of Art*, XLVI (1953), 131 ff.

BOURSSE
Plietzsch, E. 'Jacobus Vrel und Esaias Boursse', *Zeitschrift für Kunstgeschichte*, III (1949).
Brière-Misme, C. 'Bourse', *O.H.*, LXIX (1954).

BRAMER
Wichmann, H. *Leonaert Bramer.* Leipzig, 1923.
Standard work.
Bredt, E. W. (ed.). *Leonaert Bramers Zeichnungen zum Tyl Ulenspiegel.* Leipzig, 1924.

BRAY, JAN DE
Moltke, J. W. von. 'Jan de Bray', *Marburger Jahrbuch für Kunstwissenschaft*, XI-XII (1938-9).
Basic study with *œuvre* catalogue. For the attribution of portraits formerly ascribed to Jan de Bray to Paulus Bor, see the article by S. J. Gudlauggson cited under Bor above.

BRAY, SALOMON DE
Moltke, J. W. von. 'Salomon de Bray', *Marburger Jahrbuch für Kunstwissenschaft*, XI-XII (1938-9).
Basic study with *œuvre* catalogue.
Bloch, V. 'Haarlemer Klassizisten', *O.H.*, XLVI (1940).
On S. de Bray, P. de Grebber, and R. J. van Blommendael.
BREENBERGH
Stechow, W. 'Bartholomeus Breenbergh, Landschafts- und Historienmaler', *Jahrb. P.K.*, LI (1930).
Feinblatt, E. 'Note on Paintings by Bartholomeus Breenbergh', *A.Q.*, XII (1949).
Bautier, P. 'Les Peintres hollandais Poelenburg et Breenberg à Florence', *Études d'Art*, IV (1949).
Schaar, E. 'Poelenburgh und Breenbergh in Italien und ein Bild Elsheimers', *Mitteilungen des Kunsthistorischen Institutes in Florenz*, IX (1959).
Roethlisberger, M. *Bartholomäus Breenbergh, Handzeichnungen*. Berlin, 1969.
Monograph and catalogue.
BRONCHORST
Hoogewerff, G. J. 'Jan Gerritsz. en Jan Jansz. van Bronchorst, Schilders van Utrecht', *O.H.*, LXXIV (1959).
BROUWER
Unger, J. H. W. 'A. Brouwer te Haarlem', *O.H.*, II (1884).
HdG. Vol. 3, 'Adriaen Brouwer'.
Schmidt-Degener, F. *Adriaen Brouwer et son évolution artistique*. Brussels, 1908.
Bode, W. von. *Adriaen Brouwer, sein Leben und seine Werke*. Berlin, 1924.
Still the best monograph.
Höhne, F. *Adriaen Brouwer*. Leipzig, 1960.
Knuttel, G. *Adriaen Brouwer; the Master and his Work*. Trans. J. G. Talma-Schilthuis and R. Wheaton. The Hague, 1962.
BRUGGHEN see TERBRUGGHEN
BUYTEWECH
Goldschmidt, A. 'Willem Buytewech', *Jahrb. P.K.*, XXIII (1902).
Pioneer study.
Martin, W. 'Het schilderde Willem Buytewech?', *O.H.*, XXXIV (1916).
Martin, W. 'W. Buytewech, Rembrandt en Frans Hals', *O.H.*, XLII (1924).
Poensgen, G. 'Beiträge zur Kunst des Willem Buytewech', *Jahrb. P.K.*, XLVII (1926).
Knuttel, G. 'Willem Buytewech', *Mededeelingen van de Dienst voor Kunsten en Wetenschappen der Gemeente 's-Gravenhage*, no. 4, II (1926-31).
Knuttel, G. 'W. Buytewech: van Manierisme tot Naturalisme', *Mededeelingen van de Dienst voor Kunsten en Wetenschappen der Gemeente 's-Gravenhage*, no. 5-6, II (1926-31).

Gelder, J. G. van. 'De etsen van Willem Buytewech', *O.H.*, XLVIII (1931).
For a revision of Van Gelder's catalogue cf. E. Haverkamp-Begemann, 'The Etchings of Willem Buytewech' in *Prints*, New York-Chicago-San Francisco, 1962.
Haverkamp-Begemann, F. *Willem Buytewech*. Amsterdam, 1958.
Standard work with *œuvre* catalogue.
Kunstreich, J. S. *Der 'Geistreiche Willem': Studien zu Willem Buytewech*. Kiel, 1959.
For critique cf. Haverkamp-Begemann's monograph cited above.
Willem Buytewech: 1591-1624. Exhibition Catalogue, Rotterdam-Paris, 1974-5.
CABEL see ARENTSZ.
CAMPEN, VAN
Swillens, P. T. A. *Jacob van Campen*. Assen, 1961.
Standard monograph on his activity as architect and painter.
CAPPELLE, VAN DE
Bredius, A. 'De Schilder Johannes van de Cappelle', *O.H.*, X (1892).
HdG. Vol. 7, 'Johannes van de Cappelle'.
Valentiner, W. R. 'Jan van de Capelle', *A.Q.*, IV (1941).
Identification of Bredius 254 as a portrait of Van de Cappelle by Rembrandt is not convincing.
CEULEN see JONSON VAN CEULEN
CODDE
Dozy, C. M. 'Pieter Codde, de Schilder en de Dichter', *O.H.*, II (1884).
Brandt, Jr P. 'Notities over het Leven en Werk van den amsterdamschen Schilder Pieter Codde', *Historia*, XII (1947)
CONINXLOO, VAN
Laes, A. 'Gilles van Connixloo, renovateur du paysage flamand au XVIᵉ siècle', *Annuaire des Musées Royaux des Beaux-Arts de Belgique*, II (1939).
COORTE
Bol, L. J. 'Adriaen Coorte, Stillevenschilder', *N.K.J.* (1952/3).
CORNELISZ. VAN HAARLEM
Stechow, W. 'Cornelis Cornelisz. van Haarlem en de hollandsche laat-manieristische Schilderkunst', *Elsevier's geïllustreerd Maandschrift*, XC (1935).
Fundamental paper for the history of Late Mannerism as well as Cornelis.
Bruyn, J. 'Een Keukenstuk van Cornelis Cornelisz. van Haarlem', *O.H.*, LXVI (1951).
COUWENBERGH
Gelder, J. G. van. 'De Schilders van de Oranjezaal', *N.K.J.*, II (1948/9).
With an appendix on Couwenbergh and his *œuvre*.

CUYP, AELBERT and BENJAMIN
Michel, É. 'Une Famille d'artistes hollandais. Les Cuyp', *G.B.A.*, VII (1892).
HdG. Vol. 2, 'Aelbert Cuyp'.
Boström, K. 'Benjamin Cuyp', *Konsthistorisk Tidskrift*, XIII (1944).
Gelder, J. G. van, and Jost, I. 'Vroeg contact van Aelbert Cuyp met Utrecht', in *Miscellanea I. Q. van Regteren Altena*, Amsterdam, 1969.
Gelder, J. G. van, and Jost, I. 'Doorzagen op Aelbert Cuyp', *N.K.J.*, XXIII (1972).
Reiss, S. *Aelbert Cuyp*. New York–Boston, 1975.
Brief introduction; summary catalogue.

DOOMER
Bredius, A. 'Lambert Doomer (1622–1700)', *La Revue de l'Art Ancien et Moderne*, XXVIII (1910).
Wortel, T. 'Lambert Doomer te Alkmaar', *O.H.*, XLVI (1929).
Hofstede de Groot, C., and Speiss, W. 'Die Rheinlandschaften von Lambert Doomer', *Wallraf-Richartz-Jahrbuch*, III/IV (1926/7); N.F.I (1930).

DOU
Martin, W. *Gerard Dou*. Translated from the Dutch by Clara Bell. London, 1902.
HdG. Vol. I, 'Gerard Dou'.
Martin, W. *Gerard Dou (Klassiker der Kunst, XXIV)*. Stuttgart-Berlin, 1913.
Standard work.
Snoep-Reitsma, E. 'De Waterzuchtige Vrouw en de betekenis van de lampetkan', in *Album Amicorum J. G. van Gelder*. The Hague, 1973.

DROST
Valentiner, W. R. 'Willem Drost, Pupil of Rembrandt', *A.Q.*, II (1939).

DUJARDIN
HdG. Vol. 9, 'Karel du Jardin'.
Marguery, H. 'Les Animaux dans l'œuvre de Karel Du Jardin', *Amateur*, IV (1925).
Knoef, J. 'Het Etswerk van Karel Du Jardin', *Elsevier's geïllustreerd Maandschrift*, LXXIII (1927).
Brochhagen, E. 'Karel Dujardins späte Landschaften', *Bulletin Musées Royaux des Beaux Arts*, VI (1957).
Brochhagen, E. *Karel Dujardin*. Cologne, 1958.

DULLAERT
Ruys, H. J. A. 'Heiman Dullaert (1636–1684)', *O.H.*, XXXI (1913).

DUSART
Trautscholdt, E. 'Beiträge zu Cornelis Dusart', *N.K.D.*, XVII (1966).

ECKHOUT
Thomsen, T. *Albert Eckhout, ein niederländischer Maler und sein Gönner Moritz der Brasilianer; ein Kulturbild aus dem 17. Jahrhundert*. Copenhagen, 1938.

Gelder, H. E. van. 'Twee braziliaanse Schildpadden door Albert Eckhout', *O.H.*, LXXV (1960).
Gelder, H. E. van. 'Niet Eckhout maar Jasper Becx', *O.H.*, LXXV (1960).

ECKHOUT, VAN DEN
Sumowski, W. 'Gerbrand van den Eeckhout als Zeichner', *O.H.*, LXXVII (1962).

ELIASZ., NICOLAES, called PICKENOY
Six, J. 'Nicolaes Eliasz. Pickenoy', *O.H.*, IV (1886).

ELINGA *see* JANSSENS ELINGA

EVERDINGEN, ALLART and CAESAR VAN
Bruinvis, C. W. 'De Van Everdingens', *O.H.*, XVII (1899).
Kalff, S. 'Twee Alkmaarder Schilders', *Elsevier's geïllustreerd Maandschrift*, LIII (1922).
Granberg, O. *Allart van Everdingen*. Stockholm, 1902.
Bloch, V. 'Pro Caesar Boetius van Everdingen', *O.H.*, LIII (1936).

FABRITIUS, BARENT
Pont, D. *Barent Fabritius, 1624–1673*. Utrecht, 1958.
Monograph with œuvre catalogue and full bibliography.

FABRITIUS, CAREL
HdG. Vol. I, 'Carel Fabritius'.
Wijnman, H. F. 'De Schilder Carel Fabritius', *O.H.*, XLVIII (1931).
Paper on his life and work.
Valentiner, W. R. 'Carel and Barent Fabritius', *The Art Bulletin*, XIV (1932).
Schuurman, K. E. *Carel Fabritius (Palet Serie)*. Amsterdam, 1947.
Boström, K. 'De oorspronkelijke Bestemming van Carel Fabritius' Puttertje', *O.H.*, LXV (1950).
A note showing that Fabritius' *Goldfinch* was probably the door of a small cupboard.
Hulten, K. G. 'A Peep Show by C. Fabritius', *A.Q.*, XV (1952).
Starzynski, J. 'Fabritius-uczen Rembrandta', *Biuletyn Historii Sztuki* (1956).
Study of *Resurrection of Lazarus* (Warsaw) and the *Beheading of St John the Baptist* (Amsterdam); the latter attributed to Flinck and Fabritius.
Wheelock, A. K. 'Carel Fabritius: Perspective and Optics in Delft', *N.K.J.*, XXIV (1973).
Liedtke, W. A. 'The "View in Delft" by Carel Fabritius', *B.M.*, CXVIII (1976).

FLINCK
Scheltema, P. 'Govert Flinck', *Aemstel's Oudheid*, II (1856).
Schneider, H. 'Govert Flinck en Juriaen Ovens in het Stadhuis te Amsterdam', *O.H.*, XLII (1925).
Welcker, A. 'G. Flinck', *O.H.*, LVII (1940).
Gelder, J. G. van. 'Vroege werken van Govert Flinck', *Kunsthistorische Mededeelingen van het*

Rijksbureau voor Kunsthistorische Documentatie, 1 (1946).

Moltke, J. W. von. *Govaert Flinck*. Amsterdam, 1965.

GALEN, VAN

Plietzsch, E. 'Das Gemälde "De Rechtspleging van Graaf Willem de Goede" von Nicolaes van Galen', *Mouseion*. Cologne, 1960.

GELDER, DE

Lilienfeld, K. *Arent de Gelder*. The Hague, 1914.

Basic monograph with *œuvre* catalogue.

Lilienfeld, K. 'Neues über Leben und Werk Aert de Gelder', *Kunstchronik und Kunstmarkt*, XXX (1918/19).

GHEYN II, DE

Regteren Altena, I. Q. van. *Jacques de Gheyn, An Introduction to the Study of his Drawings*. Amsterdam, 1935.

Basic study; also discusses paintings.

Bergstrom, I. 'De Gheyn as a *Vanitas* Painter', *O.H.*, LXXXV (1970).

Judson, J. R. *The Drawings of Jacob de Gheyn II*. New York, 1973.

GHEYN III, DE

Möhle, H. 'Drawings by Jacques de Gheyn III', *Master Drawings*, I (1963).

GOLTZIUS

Hirschmann, O. *Hendrick Goltzius als Maler 1600–1617*. The Hague, 1916.

Hirschmann, O. *Hendrick Goltzius (Meister der Graphik* series). Leipzig, 1919.

Study of the prints.

Reznicek, E. K. J. 'Het Begin van Goltzius Loopbaan als Schilder', *O.H.*, LXXV (1960).

Reznicek, E. K. J. *Die Zeichnungen von Hendrick Goltzius*. 2 vols. Utrecht, 1961.

Indispensable monograph and catalogue of the drawings. Includes a full discussion of the artistic scene in the Netherlands around 1600 and a complete bibliography.

GOUDT

Reitlinger, H. S. 'Hendrik, Count Goudt', *Print Collectors Quarterly*, VIII (1921).

Weizsäcker, H. 'Hendrick Goudt', *O.H.*, XLV (1928).

GOYEN, VAN

Bredius, A. 'Jan Josephszoon van Goyen. Nieuwe Bijdragen tot zijne Biographie', *O.H.*, XIV (1896).

Lugt, F. *Catalogue des œuvres de Jan van Goyen réunies par Fred. Muller & Cie au Musée Communal de la ville d'Amsterdam*. Amsterdam, 1903.

Pioneer work.

HdG. Vol. 8, 'Jan van Goyen'.

Hofstede de Groot, C. 'Jan van Goyen and his Followers', *B.M.*, XLII (1923).

Reynolds, E. J. 'Jan van Goyen and his Followers', *B.M.*, XLII (1923).

Volhard, H. *Die Grundtypen der Landschaftsbilder Jan van Goyens und ihre Entwicklung*. Frankfurt a. M., 1927.

Gelder, J. G. van. 'Pennetegringer af Jan van Goyen', *Kunstmusetts Aarsskrift*, XXIV (1937).

Study of the early drawings.

Waal, H. van de. *Jan van Goyen (Palet Serie)*. Amsterdam, 1941.

The best monograph.

Beck, H. U. 'Jan van Goyens Handzeichnungen als Vorzeichnungen', *O.H.*, LXXII (1957).

Beck, H. U. *Ein Skizzenbuch von Jan van Goyen*. The Hague, 1961.

Dobrzycka, A. *Jan van Goyen*. Poznan, 1966.

Beck, H.-U. *Jan van Goyen: 1596–1656*. 2 vols. Amsterdam, 1972.

Standard monograph and *œuvre* catalogue of paintings and drawings.

HACKAERT

HdG. Vol. 9, 'Johannes Hackaert'.

HALS, DIRCK

Bürger, W. [E. J. T. Thoré]. 'Dirk Hals et les fils de Frans Hals', *G.B.A.*, XXV (1868).

Bredius, A. 'Archiefsprokkels betreffende Dirk Hals', *O.H.*, XLI (1923/4).

HALS, FRANS

1. Documents

Willigen, A. van der. *Les Artistes de Harlem*. Haarlem, 1870.

Revised ed. of the Dutch ed. published in 1866. Systematic review of the documents. Material should be collated with documents published by Bredius.

Bredius, A. *O.H.*, XXXI (1913); XXXII (1914); XXXV (1917); XXXIX (1921); XLI (1923-4).

Transcriptions and discussion of principal documents.

Roey, J. van. 'Frans Hals van Antwerpen: Nieuwe Gegevens over de Ouders van Frans Hals', *Antwerpen*, III (1957).

New documents strongly supporting the hypothesis that Hals was born in Antwerp between 1581 and 1585.

Hees, C. A. van. 'Archivalia betreffende Frans Hals en de Zijnen', *O.H.*, LXXIV (1959).

Documents on the collaboration of Hals and Buytewech and a copy of Hals' *Peeckelharing* made before 17 November 1631.

Valkenburg, C. C. van. 'De haarlemse Schuttersstukken 1: Maaltijd van Officieren van de Sint Jorisdoelen (Frans Hals, 1616). Identificatie der voorgestelde schuttersofficieren', *Haerlem Jaarboek 1958*, Haarlem, 1959; 'De Haarlemse Schutterstukken IV: Maaltijd van officieren van de Sint Jorisdoelen (Frans Hals, 1627); V: Maaltijd van officieren van de Cluveniersdoelen (Frans Hals,

1627); VI: Officieren en onderofficieren van de Cluveniersdoelen (Frans Hals, 1633); VII: Officieren en onderofficieren van de Sint Jorisdoelen (Frans Hals, 1639)', *ibid.*, 1961, Haarlem, 1962.

Publication of documents identifying most of the officers in the group portraits Hals painted of the Haarlem civic guards.

2. *Literary Sources*

Ampzing, S. *Beschryvinge ende Lof der Stad Haerlem in Holland.* Haarlem, 1628.

Schrevelius, T. *Harlemias.* Haarlem, 1648.

Houbraken, A. *De Groote Schouburgh*, I. Amsterdam, 1718.

Weyerman, J. C. *De Levens-Beschryvingen der nederlandsche Konstschilders*, I. The Hague, 1729.

3. *Painting Catalogues*

Moes, E. W. *Frans Hals, sa vie et son œuvre.* Brussels, 1909.

HdG. Vol. 3, 'Frans Hals'.

Bode, W. von, and Binder, M. J. *Frans Hals.* 2 vols. Berlin, 1914.

Although not all the attributions are convincing, still a fundamental study.

Valentiner, W. R. *Frans Hals (Klassiker der Kunst).* 2nd ed. Berlin-Leipzig, 1923.

Based on Bode's work. Valentiner published additions to his corpus in *Art in America*, XVI (1928), XXIII (1935).

Valentiner, W. R. *Frans Hals Paintings in America.* Westport, Conn., 1936.

Trivas, N. S. *The Paintings of Frans Hals.* New York, 1941.

An unsuccessful attempt to establish the canon of Hals' authentic paintings. The author rejected numerous original works from his critical catalogue raisonné when he eliminated about two-thirds of the paintings accepted by Bode and Valentiner.

Slive, S. *Frans Hals.* 3 vols. London-New York, 1970-4.

Monograph and catalogue.

4. *Monographs and Studies*

Bürger, W. [É. J. T. Thoré]. 'Frans Hals', *G.B.A.*, XXIV (1868).

Pioneer study.

Bode, W. *Frans Hals und seine Schule.* Leipzig, 1871.

Bode's dissertation. Reprinted in *Jahrbuch für Kunstwissenschaft*, IV (1871).

Schmidt-Degener, F. *Frans Hals.* Amsterdam, 1924.

Dülberg, F. *Frans Hals: ein Leben und ein Werk.* Stuttgart, 1930.

Baard, H. P. *Frans Hals, the Civic Guard Portrait Groups.* Amsterdam-Antwerp, 1949.

English trans. of the Dutch ed. of 1948. Excellent reproductions of all the civic guard groups.

Linnik, I. 'Newly Discovered Paintings by Frans Hals', *Iskusstvo*, no. 10 (1959) (Russian text).

Publication of Hals' *St Luke* and *St Matthew* at Odessa. Also see Linnik's note in *Soobcheniia Gosudarstvennogo Ermitazha*, XVII (1960) (Russian text).

Jongh, E. de, and Vinken, P. J. 'Frans Hals als Voortzetter van een emblematische Traditie', *O.H.*, LXXVI (1961).

On allegorical meanings in Hals' *Portrait of a Married Couple* (Amsterdam).

Slive, S. 'Frans Hals Studies', *O.H.*, LXXVI (1961). I. Juvenalia; II. St Luke and St Matthew at Odessa; III. Jan Franszoon Hals.

Theil, P. J. J. van. 'Frans Hals Portret van de leidse Rederijkersnar Pieter Cornelisz. van der Morsch alias Piero (1543-1628)', *O.H.*, LXXVI (1961).

On the iconography of the herring held by Van der Morsch.

Frans Hals. Haarlem, 1962.

Catalogue of exhibition held at Frans Hals Museum: introduction, H. P. Baard; catalogue, S. Slive.

Slive, S. *Frans Hals Schützengilde St George 1616.* Stuttgart, 1962.

Brief study of Hals' first group portrait.

Slive, S. 'On the Meaning of Frans Hals' *Malle Babbe*', *B.M.*, CV (1963).

Vinken, P. J., and Jongh, E. de. 'De Boosaardigheid van Hals' regenten en regentessen', *O.H.*, LXXVIII (1963).

A valuable history of the criticism of Hals' late group portraits, but the authors' argument that portraitists cannot portray even an aspect of a sitter's character is not convincing.

Kauffmann, H. 'Die Schützenbilder des Frans Hals', in *Walter Friedlaender zum 90. Geburtstag.* Berlin, 1965.

Grimm, C. 'Frans Hals und seine "Schule"', *Münchner Jahrbuch der bildenden Kunst*, XXII (1971).

For a review of the author's effort to ascribe paintings to the 'Fisherchildren Master', Judith Leyster, Jan Hals, and Frans Hals the Younger see S. Slive, *Frans Hals*, vol. III (1974), 78-9.

Grimm, C. *Frans Hals.* Berlin, 1972.

Includes a chronological list of the works accepted by the author.

HEDA

Gelder, H. E. van. *W. C. Heda, A. van Beyeren, W. Kalf (Palet Serie).* Amsterdam, 1941.

HEEM, DE

Toman, H. 'Über die Malerfamilie De Heem', *Repertorium für Kunstwissenschaft*, XI (1888).

Bergström, I. 'De Heem's Painting of His First Dutch Period', *O.H.*, LXXI (1956).

HELST, VAN DER
Gelder, J. J. de. *Bartholomeus van der Helst*. Rotterdam, 1921.
Monograph with *œuvre* catalogue.
HEYDEN, VAN DER
Breen, J. C. 'Jan van der Heyden', *Jaarboek van het genootschap Amstelodamum*, XI (1913).
Bode, W. von. 'Jan van der Heyden', *Zeitschrift für bildende Kunst*, XXVI (1915).
HdG. Vol. 8, 'Jan van der Heyden'.
Jan van der Heyden, exhibition catalogue. Amsterdam, 1937.
Kleyn, A. R. 'Jan van der Heyden', *Sibbe*, II (1944).
Wagner, H. *Jan van der Heyden: 1637-1712*. Amsterdam-Haarlem, 1971.
HOBBEMA
Michel, É. *Hobbema et les paysagistes de son temps en Hollande*. Paris, 1890.
HdG. Vol. 4, 'Meindert Hobbema'.
Bredius, A. 'Uit Hobbema's laatste Levensjaren', *O.H.*, XXVIII (1910), also cf. XXIX (1911); XXXIII (1915).
Rosenberg, J. 'Hobbema', *Jahrb. P.K.*, XLVIII (1927).
Broulhiet, G. *Meindert Hobbema*. Paris, 1938.
Gerson, H. 'Een Hobbema van 1665', *Kunsthistorische Mededeelingen van het Rijksbureau voor Kunsthistorische Documentatie*, II (1947).
Relation of some pictures to one dated 1665 (Zürich, Ruzicka Collection).
Stechow, W. 'The Early Years of Hobbema', *A.Q.* (Spring 1959).
Imdahl, M. 'Ein Beitrag zu Meindert Hobbemas Allee von Middelharnis', *Festschrift Kurt Badt*. Berlin, 1961.
HONDECOETER
Bredius, A. 'De Schilders Melchior de Hondecoeter en Johan le Ducq', *Archief voor Nederl. Kunstgeschiedenis*, ed. F. D. O. Obreen, V (1882-3).
HONTHORST
Hoogewerff, G. J. *Gherardo delle Notti*. Rome, 1924.
Judson, J. R. *Gerrit van Honthorst*. The Hague, 1959.
Standard monograph and catalogue of the work done in Italy and activity in Holland during the 1620s. Portraits and later works are not discussed.
Millar, O. 'Charles I, Honthorst, and Van Dyck', *B.M.*, XCVI (1954).
Reznicek, E. K. 'Een vroeg Portret van Gerard van Honthorst', *O.H.*, LXX (1955).
Reznicek, E. K. J. 'Hont Horstiana', *N.K.J.*, XXIII (1972).
HOOCH, DE
HdG. Vol. 1, 'Pieter de Hooch'.
Baker, C. H. C. *Pieter de Hooch*. London, 1925.

Valentiner, W. R. 'Pieter de Hooch', *Art in America*, XV (1927).
Valentiner, W. R. 'Dutch Genre Painters in the Manner of de Hooch', *Art in America*, XVII (1928).
Valentiner, W. R. *Pieter de Hooch (Klassiker der Kunst)*. Stuttgart, 1929.
Includes a discussion of his followers.
Thienen, F. van. *Pieter de Hooch (Palet Serie)*. Amsterdam, 1945.
HOOGHE, DE
Henkel, M. D. 'Romeijn de Hooghe', *Maandblad voor beeldende Kunsten*, III (1926).
HOOGSTRATEN
Kronig, J. O. 'Zwei Selbstbildnisse von Samuel van Hoogstraeten', *Kunstchronik*, XXV (1914).
Valentiner, W. R. 'Rembrandt and Samuel van Hoogstraeten', *Art in America*, XVIII (1930).
Richardson, E. P. 'Samuel van Hoogstraeten and Carel Fabritius', *Art in America*, XXV (1937).
On their preoccupation with problems of perspective.
HORST
Bredius, A. 'Gerrit Willemsz Horst', *O.H.*, L (1933).
Valentiner, W. R. 'Zum Werk Gerrit Willemsz. Horst's', *O.H.*, L (1933).
HUYSUM, VAN
Schlie, F. 'Sieben Briefe und eine Quittung von Jan van Huijsum', *O.H.*, XVIII (1900).
HdG. Vol. 10, 'Jan van Huysum'.
Grant, M. H. *Jan van Huysum 1682-1749, including a catalogue raisonné of the artist's fruit and flower paintings*. Leigh-on-Sea, 1954.
White, C. *The Flower Drawings of Jan van Huysum*. Leigh-on-Sea, 1964.
JACOBSZ.
Straat, H. L. 'Lambert Jacobsz, Schilder', *De Vrije Fries*, XXVIII (1925).
Wijnman, H. F. 'Nieuwe Gegvens omtrent den Schilder Lambert Jacobsz', *O.H.*, XLVII (1930); LI (1934).
JANSSENS-ELINGA
Hofstede de Groot, C. 'De Schilder Janssens-Elinga, een Navolger van Pieter de Hooch', *O.H.*, IV (1891)
Brière-Misme, C. 'A Dutch Intimist, Pieter Janssens Elinga', *G.B.A.* (1947.1), (1947.2), (1948).
JARDIN *see* DUJARDIN
JONGH, DE
Haverkorn van Rijsewijk, P. 'Ludolf de Jongh', *O.H.*, XIV (1896).
JONSON VAN CEULEN
Finberg, A. 'A Chronological List of Portraits by Cornelius Johnson or Jonson', *Walpole Society*, X (1921/2).

JOUDERVILLE
Hofstede de Groot, C. 'Isaac de Jouderville, Leerling van Rembrandt?', *O.H.*, XVII (1899).

KALF
Blok, I. 'Willem Kalf', *Onze Kunst*, XVIII (1919).
Gelder, H. E. van. *W. C. Heda, A. van Beyeren, W. Kalf (Palet Serie)*. Amsterdam, 1941.
Gelder, H. E. van. 'Aantekeningen over Willem Kalf en Cornelia Pluvier', *O.H.*, LIX (1942).
Luttervelt, R. van. 'Aanteekeningen over de Ontwikkeling van Willem Kalf', *O.H.*, LX (1943).

KEIL (MONSÙ BERNARDO)
Longhi, R. 'Monsù Bernardo', *Critica d'Arte*, III (1938).
Bloch, V. ' "Monsù Bernardo" in het Mauritshuis', *Maandblad voor beeldende Kunsten*, XXII (1946).

KETEL
Stechow, W. 'Cornelis Ketels Einzelbildnisse', *Z.B.K.*, LXIII (1929/30).

KEYSER, THOMAS DE
Oldenbourg, R. *Thomas de Keysers Tätigkeit als Maler*. Leipzig, 1911.
Standard monograph with œuvre catalogue.

KICK
Bredius, A., and Bode, W. von. 'Der amsterdamer Genremaler Symon Kick', *Jahrb. P.K.*, X (1889).

KNÜPFER
Weizsäcker, H. 'Nikolaus Knüpfer und Adam Elsheimer', *Repertorium für Kunstwissenschaft*, XXI (1898).
Willnau, C. 'Von Elsheimer's Contento zu Knüpfer's Contentement', *Zeitschrift für bildende Kunst*, LXV (1931-2).
Brinkhuis, G. 'Nieuwe Gegevens over den Kunstschilder Nicolaus Knupfer', *Jaarboekje van Oud Utrecht* (1935).
Kuznetsov, J. I. 'Nikolaus Knupfer', *Trudy Gosudarstvennogo Ermitazha*, VIII (1964) (Russian text).
Comprehensive study with œuvre catalogue.

KOBELL
Obreen, F. D. O. 'De hollandsche Tak der Schildersfamilie Kobell', *Archief voor Nederl. Kunstgeschiedenis*, VII (1888-90).

KONINCK, PHILIPS
Falck, G. 'Einige Bemerkungen über Philips Konincks Tätigkeit als Zeichner', *Festschrift für Max J. Friedlaender*. Leipzig, 1927.
Gerson, H. *Philips Koninck*. Berlin, 1936.
Standard monograph with catalogue of paintings and drawings.
Thiel, P. J. J. van. 'Philips Konincks Vergezicht met hutten aan de weg', *Bulletin van het Rijksmuseum*, XV (1967).

LAER, VAN (BAMBOCCIO)
Hoogewerff, G. J. 'Pieter van Laer en zijn Vrienden', *O.H.*, XLIX (1932), L (1933).
Briganti, G. 'Pieter van Laer e Michel Cerquozzi', *Proporzione*, III (1950).
Also cf. entries above under *Italianate Painters and Bentvueghels*.

LAIRESSE
Timmers, J. J. M. *Gerard Lairesse*. Amsterdam, 1942.
Standard work.

LASTMAN
Freise, K. *Pieter Lastman, sein Leben und seine Kunst*. Leipzig, 1911.
Müller, C. 'Studien zu Lastman und Rembrandt', *Jahrb. P.K.*, L (1929).
Rijckevorstel, J. L. A. A. M. van. 'Lastmaniana', *O.H.*, LI (1934).
Sjtsjerbatsjewa, M. 'Pieter Lastman's Gemälde in der Ermitage', *Musée Hermitage*, I (1940); Russian text with a German summary.
Welcker, A. 'Pieter Lastman als Teekenaar van Landschap en Figuur', *O.H.*, LXII (1947).
Bauch, K. 'Frühwerke Pieter Lastmans', *Münchener Jahrbuch der bildenden Kunst*, II (1951).
Walicki, M. 'Lastmaniana', *Biuletyn Historii Sztuki*, XVI (1954).
Bauch, K. 'Handzeichnungen Pieter Lastmans', *Münchener Jahrbuch der bildenden Kunst*, VI (1955).
Bauch, K. 'Entwurf und Komposition bei Pieter Lastman', *Münchener Jahrbuch der bildenden Kunst*, VI (1955).

LEYSTER
Hofstede de Groot, C. 'Judith Leyster', *Jahrb. P.K.*, XIV (1893).
Bredius, A. 'Een Conflict tusschen Frans Hals en Judith Leyster', *O.H.*, XXXV (1917).
Schneider, A. von. 'Gerard Honthorst und Judith Leyster', *O.H.*, XL (1922).
Harms, J. 'Judith Leyster. Ihr Leben und ihr Werk', *O.H.*, XLIV (1927).
Publication of a dissertation in five articles.
Neurdenberg, E. 'Judith Leyster', *O.H.*, XLVI (1929).
Wijnman, H. F. 'Het Geboortejaar van Judith Leyster', *O.H.*, XLIX (1932).

LIEVENS
Schneider, H. *Jan Lievens, sein Leben und seine Werke*. Haarlem, 1932. Reprinted, with a supplement by R. E. O. Ekkart, Amsterdam, 1973.
Standard monograph with œuvre catalogue.
Simon, K. E. 'Beiträge zur Malerei des Rembrandtkreises: 1. Lievens und Ter Brugghen', *Zeitschrift für Kunstgeschichte*, V (1936).
Gerson, H. 'Twee vroege Studies van Jan Lievens', *O.H.*, LXIX (1954).

Michalkowa, J. 'Les Tableaux de Jan Lievens dans les collections polonaises', *Biuletyn Historii Sztuki*, XVIII (1956).

Schendel, A. van. 'Het portret van Constantijn Huygens door Jan Lievens', *Bulletin van het Rijksmuseum*, XI (1963).

Bauch, K. 'I. Zum Werk des Jan Lievens', *Pantheon*, XXV (1967), 160 ff.; II, *ibid.*, 259 ff.

Also see entries under Rembrandt, Leiden Period.

LISS

Steinbart, K. *Johann Liss*. Vienna, 1946.

LYS *see* LISS

MAES

Veth, G. H. 'Aanteekeningen omtrent eenige dordrechtsche Schilders: 18. Nicolaes Maes', *O.H.*, VIII (1890).

HdG. Vol. 6, 'Nicolaes Maes'.

Valentiner, W. R. 'Early Drawings by Nicolaes Maes', *B.M.*, XLIII (1923).

Important. Distinguishes early Maes from Rembrandt.

Bredius, A. 'Bijdragen tot een Biografie van Nicolaes Maes', *O.H.*, XLI (1923/4).

Valentiner, W. R. *Nicolaes Maes*. Stuttgart, 1924.

Useful study for the artist's early activity.

Slive, S. 'A Family Portrait by Nicolaes Maes', *Annual Report of the Fogg Art Museum 1957-1958* (1959).

On a work dated *c.* 1680.

MAN, DE

Brière-Misme, C. L. 'Un Émule de Vermeer et de Pieter de Hooch: Cornelis de Man', *O.H.*, LII (1935).

MANCADAM

Kronig, J. O. 'De Schilder Mancadam', *Onze Kunst*, XVIII (1910).

Heppner, A. 'J. S. Mancadam', *O.H.*, LI (1934).

Wassenbergh, A. 'Landschappen van J. S. Mancadam', *Vereeniging Rembrandt* (1952-3).

Boschma, C. 'Nieuwe gegevens omtrent J. S. Mancadam', *O.H.*, LXXXI (1966).

MANDER, VAN

Valentiner, E. *Karel van Mander als Maler*. Strassburg, 1930.

Regteren Altena, I. Q. van. 'Carel van Mander', *Elsevier's geïllustreerd Maandschrift*, XCIII (1937).

Excellent contribution, stressing the link the artist forms between the Late Mannerists and early realists.

Waal, H. van de. 'Nieuwe Bijzonderheden over Carel van Mander's haarlemsche Tijd', *O.H.*, LIV (1937).

Also cf. entries above under *Sources and Eighteenth Century Literature*.

METSU

Kronig, J. O. 'Gabriel Metsu', *La Revue de l'Art Ancien et Moderne*, XXV (1909).

HdG. Vol. I, 'Gabriel Metsu'.

Plietzsch, E. 'Gabriel Metsu', *Pantheon*, XVII (1936).

Gils, J. B. F. van. 'De Stockholmer "Smidse" van Gabriel Metsu', *O.H.*, LX (1943).

On the picture as an illustration of a proverb.

Regteren Altena, I. Q. van. 'Gabriel Metsu as Draughtsman', *Master Drawings*, I (1963).

Gudlaugsson, S. J. 'Kanttekeningen bij de ontwikkeling van Metsu', *O.H.*, LXXXIII (1968).

Schneede, U. E. 'Gabriël Metsu und der holländische Realismus', *O.H.*, LXXXIII (1968).

Robinson, F. W. *Gabriel Metsu (1629-1667), A Study of His Place in Dutch Genre Painting of the Golden Age*. New York, 1974.

MIEREVELD

Havard, H. *Michiel van Mierevelt et son gendre*. Paris, 1892.

MIERIS (I), FRANS VAN

HdG. Vol. 10, 'Frans van Mieris'.

MIERIS, WILLEM VAN

HdG. Vol. 10, 'Willem van Mieris'.

MOLENAER

Bode, W. von, and Bredius, A. 'Der haarlemer Maler Johannes Molenaer in Amsterdam', *Jahrb. P.K.*, XI (1890).

Bredius, A. 'Jan Miense Molenaer. Nieuwe Gegevens omtrent zijn Leven en zijn Werk', *O.H.*, XXVI (1908).

Thiel, P. J. J. van. 'Marriage Symbolism in a Musical Party by Jan Miense Molenaer', *Simiolus*, II (1967-8).

MOLYN

Granberg, O. *Pieter de Molijn och Spåren af hans Konst*. Stockholm, 1883.

Granberg, O. 'Pieter de Molyn und seine Kunst', *Zeitschrift für bildende Kunst*, XIX (1884).

MOREELSE

Jonge, C. H. de. *Paulus Moreelse Portret- en Genreschilder te Utrecht, 1571-1638*. Assen, 1938.

Monograph with œuvre catalogue.

NEER, AERT VAN DER

Bredius, A. 'Aernout (Aert) van der Neer', *O.H.*, XVIII (1900), XXVIII (1910), XXXIX (1921).

HdG. Vol. 7, 'Aert van der Neer'.

Kauffmann, H. 'Die Farbenkunst von Aert van der Neer', *Festschrift Adolf Goldschmidt*. Leipzig, 1923.

Seifertova-Korecká, H. 'Das Genrebild des Aert van der Neer in Liberec', *O.H.*, LXXVII (1962).

Bachmann, F. *Die Landschaften des Aert van der Neer*. Neustadt an der Aisch, 1966.

NEER, EGLON HENDRIK VAN DER
HdG. Vol. 5, 'Eglon Hendrik van der Neer'.
NETSCHER
Bredius, A. 'Een en ander over Casper Netscher', O.H., v (1887).
HdG. Vol. 5, 'Caspar Netscher'.
OCHTERVELT
Valentiner, W. R. 'Jacob Ochtervelt', Art in America, XII (1923-4).
Plietzsch, E. 'Jacob Ochtervelt', Pantheon, XX (1937).
OEVER, TEN
Plietzsch, E. 'Hendrick ten Oever', Pantheon, XXIX (1942).
Verbeek, J., and Schotman, J. W. Hendrick ten Oever. Zwolle, 1957.
OSTADE, ADRIAEN and ISAACK VAN
Gaedertz, T. Adrian van Ostade. Sein Leben und seine Kunst. Lübeck, 1869.
HdG. Vol. 3, 'Adriaen van Ostade'.
HdG. Vol. 3, 'Isack van Ostade'.
Rovinski, D., and Tchétchouline, N. L'Œuvre gravé d'Adrien van Ostade. St Petersburg, 1912.
Catalogue raisonné which later students have revised. Valuable for its 221 full-size reproductions of successive states of the etchings.
Bode, W. von. 'Die beiden Ostade', Zeitschrift für bildende Kunst, XXVII (1916).
Trautscholdt, E. 'Notes on Adriaen van Ostade', B.M., LIV (1929).
Godefroy, L. L'Œuvre gravé de Adriaen van Ostade. Paris, 1930.
Glück, C. 'Ein vlämischer Kopist Adriaen van Ostades' (Victorijns)', O.H., XLIX (1932).
Scheyer, E. 'Portraits of the Brothers van Ostade', A.Q., II (1939).
Kuznetsov, J. Catalogue of Adriaen van Ostade Exhibition held at the Hermitage (in Russian). Leningrad, 1960.
First-rate introduction and critical catalogue.
OVENS
Schmidt, H. Jürgen Ovens. Sein Leben und seine Werke. Kiel, 1922.
PICKENOY see ELIASZ.
PLOOS VAN AMSTEL
Alten, F. von. Cornelis Ploos van Amstel Kunstliebhaber und Kupferstecher. Leipzig, 1874.
Huffel, N. G. Cornelis Ploos van Amstel en zijne Medewerkers en Tijdgenooten. Utrecht, 1921.
Bye, A. E. 'Ploos van Amstel', Print Collectors' Quarterly, XIII (1926).
PLUYM
Kronig, J. O. 'Carel van der Pluijm. A Little Known Follower of Rembrandt', B.M., XXVI (1914-15).

Bredius, A. 'Karel van der Pluym, Neef en Leerling van Rembrandt', O.H., XLVIII (1931).
POELENBURGH
Frimmel, T. von. 'Cornelis Poelenburg und seine Nachfolger', Studien und Skizzen zur Gemäldekunde, I (1913-15); II (1915-16); IV (1918-19); Neue Blätter für Gemäldekunde, I (1922-3).
Bautier, P. 'Les Peintres hollandais Poelenburg et Breenberg à Florence', Études d'Art, IV (1949).
Schaar, E. 'Poelenburgh und Breenbergh in Italien und ein Bild Elsheimers', Mitteilungen des Kunsthistorischen Institutes in Florenz, IX (1959).
PORCELLIS
Bredius, A. 'Johannes Porcellis, zijn Leven, zijn Werken', O.H., XXIII (1905).
Walsh, J., Jr. 'The Dutch Marine Painters Jan and Julius Porcellis' I. 'Jan's Early Career', B.M., CXVI (1974); II. 'Jan's Maturity and "de jonge Porcellis"', ibid.
POST, FRANS
Smith, R. C., Jr. 'The Brazilian Landscapes of Frans Post', A.Q., I (1938).
Sousa-Leão, J. de. 'Frans Post in Brazil', B.M., LXXX (1942).
Benisovich, M. 'History of the "Tenture des Indes"', B.M., LXXXIII (1943).
On the tapestries made for Louis XIV.
Larsen, E. Frans Post. Amsterdam-Rio de Janeiro, 1962.
Monograph and critical catalogue. The author's thesis that Post's pictorial effects were achieved by his use of a mechanical contraption is not convincing.
POST, PIETER
Gudlaugsson, S. J. 'Aanvullingen omtrent Pieter Post's Werkzaamheid als Schilder', O.H., LXIX (1954).
POT
Bredius, A., and Haverkorn van Rijsewijk, P. 'Hendrick Gerritsz. Pot', O.H., v (1887).
POTTER
Westrheene, T. van. Paulus Potter, sa vie et ses œuvres. The Hague, 1867.
Michel, E. Paul Potter. Paris, 1907.
HdG. Vol. 4, 'Paulus Potter'.
Arps-Aubert, R. von. Die Entwicklung des reinen Tierbildes in der Kunst Paulus Potter. Halle, 1932.
Borenius, T. 'Paulus Potter', B.M., LXXXI (1942).
PYNACKER
HdG. Vol. 9, 'Adam Pijnacker'.
PYNAS, JACOB
Bauch, K. 'Die Gemälde des Jakob Pynas', O.H., LIII (1936).
Bauch, K. 'Handzeichnungen des Jakob Pynas', O.H., LIV (1937).

PYNAS, JAN

Bauch, K. 'Die Gemälde des Jan Pynas', *O.H.*, LII (1935).

Bauch, K. 'Die Zeichnungen des Jan Pynas', *O.H.*, LII (1935).

QUAST

Bredius, A. 'Pieter Jansz. Quast', *O.H.*, XX (1902).

RAVESTEYN

Bredius, A., and Moes, E. W. 'De Schilderfamilie Ravesteyn', *O.H.*, IX (1891); X (1892).

REMBRANDT

1. Bibliography

Hall, H. van. *Repertorium voor der Geschiedenis der nederlandsche Schilder- en Graveerkunst.* 2 vols. The Hague, 1935-49.

Benesch, O. *Rembrandt, Werk und Forschung.* Vienna, 1935.

Bibliography of the Netherlands Institute for Art History, I. The Hague, 1943-.

2. Sources and Documents

Huygens, C. *Autobiography, 1629-31*, MS. published by J. A. Worp, *Bijdragen en Mededeelingen van het historisch Genootschap*, XVIII (1897); also cf. J. A. Worp, *O.H.*, IX (1891) and A. Kan, *De Jeugd van Constantijn Huygens door hemzelf verteld*, Rotterdam-Antwerp, 1946.
Earliest critical estimate.

Orlers, J. *Beschrijvinge der Stadt Leyden.* 2nd ed. Leiden, 1641.
First biography of Rembrandt.

Sandrart, J. von. *Teutsche Academie der Bau-, Bild- und Mahlerey-Künste.* Nuremberg, 1675.

Hoogstraten, S. van. *Inleyding tot de Hooge Schoole der Schilder Konst.* Rotterdam, 1678.

Félibien, A. *Entretiens sur les vies et sur les ouvrages des plus excellents peintres anciens et modernes*, IV. Paris, 1685.

Baldinucci, F. *Cominciamento e progresso dell'arte d'intagliare in rame.* Florence, 1686.
A biography based on information received from Rembrandt's pupil Bernhardt Keil.

Piles, R. de. *Abregé de la vie des peintres.* Paris, 1699.
Of special interest; the author lived for a time in Holland and collected Rembrandt's works.

Houbraken, A. *De Groote Schouburgh*, I. Amsterdam, 1718.
Principal source for later eighteenth-century biographies.

Hofstede de Groot, C. *Die Urkunden über Rembrandt (1575-1721).* The Hague, 1906.
The most comprehensive compilation of documentary data. Indispensable.

Slive, S. *Rembrandt and his Critics: 1630-1730.* The Hague, 1953.
Appraisal of the sources.

Michalkowa, J., and Bialstocki, J. *Rembrandt w Oczach Wsólczesnych.* Warsaw, 1957.
Translation of seventeenth- and early-eighteenth-century sources into Polish. With a commentary.

Gerson, H. *Seven Letters by Rembrandt.* Transcription by Isabella H. van Eeghen, translation by Yda D. Ovink. The Hague, 1961.
Rembrandt's correspondence with Constantin Huygens regarding the Passion series commissioned by the prince of Orange.

Helsdingen, H. W. van. 'Enkele opmerkingen over het Franse zeventiende eeuwse Rembrandt-beeld', *O.H.*, LXXXIV (1969).

3. Painting Catalogues

Smith, J. *A Catalogue Raisonné of the Works of the Most Eminent Dutch, Flemish and French Painters*, VII, *Rembrandt van Rhyn.* London, 1836.
The first comprehensive catalogue of Rembrandt's paintings.

Bode, W. von, and Hofstede de Groot, C. *The Complete Work of Rembrandt.* 8 vols. Paris, 1897-1906.
HdG. Vol. 6, 'Rembrandt'.

Valentiner, W. R. *Rembrandt (Klassiker der Kunst).* 3rd ed. Stuttgart-Berlin, 1908.

Valentiner, W. R. *Rembrandt, Wiedergefundene Gemälde (1910-22) (Klassiker der Kunst).* 2nd ed. Berlin-Leipzig, 1922.

Valentiner, W. R. *Rembrandt Paintings in America.* New York, 1932.

Bredius, A. *The Paintings of Rembrandt.* New York, 1942.
The third revised edition was published by H. Gerson, London-New York, 1969, with many unconvincing rejections.

Bauch, K. *Rembrandt Gemälde.* Berlin, 1966.

4. Etching Catalogues

Gersaint, E.-F. *Catalogue raisonné de tout les pièces qui forment l'œuvre de Rembrandt . . .* Paris, 1751.
First printed catalogue. English trans., London, 1752.

Bartsch, A. *Catalogue raisonné de toutes les estampes qui forment l'œuvre de Rembrandt et ceux de ses principaux imitateurs*, 'Composé par Gersaint, Helle, Glomy et Yver'. Vienna, 1797.

Rovinski, D. *L'Œuvre gravé de Rembrandt.* 4 vols. St Petersburg, 1890.
Full-size reproductions of works by the master and his pupils. Helpful for the distinction of states.

Hind, A. M. *A Catalogue of Rembrandt's Etchings Chronologically Arranged and Completely Illustrated.* 2nd ed. 2 vols. London, 1923; reprint, New York, 1967.

Münz, L. *Rembrandt's Etchings. Reproductions of the Whole Original Etched Work.* 2 vols. London, 1952.

Biörklund, G., with the assistance of Barnard, O. H. *Rembrandt's Etchings True and False.* Stockholm-London-Paris, 1955; 2nd rev. ed., Stockholm-New York, 1968.

A summary catalogue, in a distinctive chronological order and completely illustrated.

Boon, K. G. *The Complete Etchings of Rembrandt.* London-New York, 1963.

White, C., and Boon, K. G. *Rembrandt van Rijn's Etchings: A New Critical Catalogue.* Amsterdam, 1970.

5. Drawing Catalogues

Hofstede de Groot, C. *Die Handzeichnungen Rembrandts.* Haarlem, 1906.

Not illustrated.

Valentiner, W. R. *Die Handzeichnungen Rembrandts (Klassiker der Kunst).* 2 vols. Stuttgart-New York, 1925-34.

Not complete. Landscapes, figure studies, nudes not published. Contains helpful discussion of works by pupils.

Benesch, O. *The Drawings of Rembrandt, A Critical and Chronological Catalogue.* 6 vols. London, 1954-7. 2nd ed., enlarged and edited by Eva Benesch. 6 vols. London-New York, 1973.

A monumental corpus fully illustrated with a critical catalogue and full bibliography. Includes drawings attributed to Rembrandt and copies. Cf. reviews by J. Rosenberg, *The Art Bulletin*, XXXVIII (1956), XLI (1959); E. Havercamp-Begemann, *Kunstchronik*, XIV (1961); J. G. van Gelder, *B.M.*, XCVII (1955), CIII (1961); W. Sumowski, *Wissenschaftliche Zeitschrift der Humbolt-Universität zu Berlin, Gesellschafts- und Sprachwissenschaftliche Reihe*, VI (1956-7), VII (1957-8).

Slive, S. *Drawings of Rembrandt, With a Selection of Drawings by his Pupils and Followers.* 2 vols. New York, 1965.

A newly edited publication based on the facsimile series of 550 drawings edited by F. Lippmann, C. Hofstede de Groot, and others, London-Berlin, 1888-1911.

6. Monographs

Koloff, E. 'Rembrandt's Leben und Werke, nach neuen Actenstücken und Gesichtspunkten geschildert', *Raumers Historisches Taschenbuch*, V (1854). Reprinted (ed. C. Tümpel) in *Deutsches Bibel-Archiv, Abhandlungen und Vorträge*, IV. Hamburg, 1971.

Vosmaer, C. *Rembrandt Harmensz van Rijn, ses précurseurs et ses années d'apprentissage.* The Hague, 1863.

Vosmaer, C. *Rembrandt Harmensz van Rijn, sa vie et ses œuvres.* The Hague, 1868.

Michel, É. *Rembrandt, sa vie, son œuvre et son temps.* Paris, 1893.

Veth, J. *Rembrandts Leben und Kunst.* Leipzig, 1908.

Neumann, C. *Rembrandt.* 2 vols. 4th ed. Munich, 1924.

Weisbach, W. *Rembrandt.* Berlin, 1926.

Hind, A. M. *Rembrandt.* Cambridge, Mass., 1932.

Gelder, H. E. van. *Rembrandt (Palet Serie).* Amsterdam, 1946.

Essays on his portraits, etchings, landscape, Biblical subjects, the *Night Watch*, and his time.

Rosenberg, J. *Rembrandt.* 2 vols. Cambridge, Mass., 1948; second revised ed., London, 1964.

Includes a concordance of the principal catalogues of Rembrandt's paintings with an indication of the author's opinion on authenticity.

Gerson, H. *Rembrandt Paintings.* Amsterdam, 1968.

Haak, B. *Rembrandt, His Life, His Work, His Time.* New York, 1969.

Kitson, M. *Rembrandt.* London, 1969.

White, C. *Rembrandt as an Etcher, a Study of the Artist at Work.* 2 vols. London, 1969.

The best study of the artist's activity as an etcher.

7. Special Studies

A. THE LEIDEN YEARS (1625-31)

Valentiner, W. R. 'Rembrandt auf der Lateinschule', *Jahrb. P.K.*, XXVII (1906).

Veth, J. 'Rembrandt's Aankomst in Amsterdam', *De XXe Eeuw*, XII (1906).

Fraenger, W. *Der junge Rembrandt.* Heidelberg, 1920.

Includes an extensive discussion of Johann Georg van Vliet's relation to Rembrandt.

Müller-Hofstede, C. 'Studien zu Lastman und Rembrandt', *Jahrb. P.K.*, L (1929).

Bauch, K. *Die Kunst des jungen Rembrandt.* Heidelberg, 1933.

Standard work.

Valentiner, W. R. 'Some Early Compositions by Rembrandt', *B.M.*, LXVIII (1936).

Martin, W. 'Uit Rembrandts leidsche Jaren', *Jaarboek van de Maatschappij der nederlandsche Letterkunde te Leiden* (1936-7).

Bloch, V. 'Musik im Hause Rembrandt', *O.H.*, LIV (1937).

Publication of a *Group of Musicians*, 1626. Also cf. E. Kieser, 'Rembrandts musizierende Gesellschaft von 1626 in ihrer psychologischen und historischen Bedeutung', *Die Welt als Geschichte*, IX (1943).

Bauch, K. 'Rembrandt und Lievens', *Wallraf-Richartz-Jahrbuch*, XI (1939).
Important study of the early drawings.

Slive, S. 'Art Historians and Art Critics, II. Huygens on Rembrandt', *B.M.*, XCIV (1952).

Gelder, J. G. van. 'Rembrandts vroegste Ontwikkeling', *Koninklijke Nederlandse Akademie van Wetenschappen. Mededelingen Afd. Letterkunde*, Nieuwe reeks, 16, no. 5 (1953).
With some controversial attributions.

Münz, L. 'Rembrandt's Bild von Mutter und Vater', *Jahrbuch der kunsthistorischen Sammlungen in Wien*, L (1953).

Benesch, O. 'An Unknown Rembrandt Painting of the Leiden Period', *B.M.*, XCVI (1954).
Publication of the *Flight into Egypt* (1627?) at Tours.

Rotermund, H. M. 'Rembrandts Bibel', *N.K.J.* (1953/4).

Knuttel, G. 'Rembrandt's earliest Works', *B.M.*, XCVII (1955).
The author rejects some of the early works other specialists accept as authentic. Cf. the rebuttal by V. Bloch, *ibid.*

Gelder, H. E. van. 'Constantin Huygens en Rembrandt', *O.H.*, LXXIV (1959).

Bauch, K. *Der frühe Rembrandt und seine Zeit. Studien zur geschichtlichen Bedeutung seines Frühstils.* Berlin, 1960.
Excellent monograph on the relation of the master's early works to the art of his time.

Gerson, H. 'La Lapidation de Saint Étienne peinte par Rembrandt en 1625', *Bulletin des Musées et Monuments Lyonnais*, III, no. 4 (1962).
Publication of a signed and dated picture of 1625 at the Museum, Lyon.

Bauch, K. 'Rembrandts "Christus am Kreuz"', *Pantheon*, XX (1962).
Publication of a picture at Le Mas d'Agenais, France, which may have been part of the Passion series painted for the Prince of Orange.

Slive, S. 'The Young Rembrandt', *Allen Memorial Art Museum Bulletin*, Oberlin, Ohio, XX (1963).
Special reference to the first years of his activity as an independent master.

Slive, S. 'Rembrandt's "Self-portrait in a Studio"', *B.M.*, CVI (1964).
Suggests that the small Boston *Self-portrait* of c. 1628 (Bredius 419) is a fragment and offers a reconstruction.

Stechow, W. 'Some Observations on Rembrandt and Lastman', *O.H.*, LXXXIV (1969).

B. FIRST AMSTERDAM PERIOD (1632-9)

Schmidt-Degener, F. 'Een Meeningsverschil betreffende de "Eendracht van het Land"', *O.H.*, XXXI (1913).

Kauffmann, H. 'Rembrandt und die Humanisten vom Muiderkring', *Jahrb. P.K.*, XLI (1920).

Six, J. 'La Famosa Accademia di Eeulenborg', *Jaarboek der Koninklijke Akademie van Wetenschappen te Amsterdam* (1925-6).

Schrade, H. 'Rembrandts "Anatomie des Dr Tulp"', *Das Werk des Künstlers*, I (1939-40).

Bloch, E. M. 'Rembrandt and the Lopez Collection', *G.B.A.*, XXIX (1946).

Regteren Altena, J. Q. van. 'Retouches aan ons Rembrandtbeeld, III: Het genetische Probleem van de Eendracht van het Land', *O.H.*, LXVII (1952).

Bille, C. 'Rembrandt's "Eendracht van het Land" en Starters Wttreckinge van de Borgery van Amsterdam', *O.H.*, LXXI (1956).

Wijnman, H. F. 'Rembrandt en Hendrik Uylenburgh te Amsterdam', *Amstelodamum*, XLIII (1956).

Eeghen, I. H. van. 'Marten Soolmans en Oopjen Coppit', *Amstelodamum*, XLIII (1956).
Identification of Bredius 199 and 342.

Rosenberg, J. 'Rembrandt's Portraits of Johannes Elison and his Wife', *Bulletin Museum of Fine Arts*, Boston, LV (1957).

Heckscher, W. S. *Rembrandt's Anatomy of Dr Nicolaas Tulp. An Iconological Study.* New York, 1958.

Pauw-de Veen, L. de. 'Over de Betekenis van het Woord "Beweeglijkheid" in de zeventiende Eeuw', *O.H.*, LXXIV (1959).

Querido, A. 'De anatomie van de "Anatomische Les"', *O.H.*, LXXXII (1967).
On the anatomical error in the *Anatomy Lesson of Dr Tulp*.

Kuznetzow, J. I., 'Nieuws over Rembrandts Danae', *O.H.*, LXXXII (1967).

Gerson, H. 'Rembrandts portret van Amalia van Solms', *O.H.*, LXXXIV (1969).
Identification of Bredius 99.

Gage, J. 'A Note on Rembrandt's "Meeste Ende die Naetuereelste Beweechgelickheijt"', *B.M.*, CXI (1969).

Kuznetsov, J. I. *Rembrandt's 'Danae': The Riddle of Its Creation* (Russian text). Leningrad, 1970.

C. THE MIDDLE PERIOD (1640-7)

Saxl, F. 'Rembrandt's Sacrifice of Manoah', *Studies of the Warburg Institute*, IX (1939).

Emmens, A. 'Ay Rembrandt, maal Cornelis stem', *N.K.J.*, VII (1956).
Analysis of Vondel's lines on Rembrandt's portrait of Anslo.

Eeghen, I. H. van. *Een amsterdamse Burgermeestersdochter van Rembrandt in Buckingham Palace.* Amsterdam, 1958.
Identification of Bredius 218 and 360.

The Night Watch

Schmidt-Degener, F. 'Een Studie voor de "Nachtwacht" : de Eendracht van het Land', *Onze Kunst,* XXI (1912).

Schmidt-Degener, F. 'Het genetisch Probleem van de "Nachtwacht"', *Onze Kunst,* XXVI (1914), 2; XXIX (1916), 1; XXX (1916) 2; XXXI (1917), 1.

Schmidt-Degener, F. 'De Ringkraag van Ruytenburch', *Onze Kunst,* XXXIII (1918).

Schmidt-Degener, F. 'De Compositie-Problemen in Verband met Rembrandt's Schuttersoptocht', Amsterdam, 1942. *Verhandelingen der Koninklijke Nederlandsche Akademie van Wetenschappen,* afd. Letterkunde, nieuwereeks, 47; reprinted in *Verzamelde Studiën en Essays,* II, Amsterdam, 1950.

Dvořák, M. *Rembrandts Nachtwache.* Vienna, n.d.

Wijnbeek, D. *De Nachtwacht.* Amsterdam, 1944.

Valuable for its exhaustive bibliography.

Schendel, A. van, and Mertens, H. H. 'De Restauraties van Rembrandt's Nachtwacht', *O.H.,* LXII (1947).

Important. Full discussion of the history of the picture and of its restorations.

Martin, W. *Van Nachtwacht tot Feeststaet.* Amsterdam, 1947.

Regteren Altena, I. Q. van. 'Quelques Remarques sur Rembrandt et la Ronde de Nuit', *Actes du XVIIe Congrès International d'Histoire de l'Art.* The Hague, 1955.

Hellinga, W. G. *Rembrandt fecit 1642.* Amsterdam, 1956.

Bauch, K. *Die Nachtwache.* Stuttgart, 1957.

D. THE MATURE PERIOD (1648-69)

Eisler, M. *Der alte Rembrandt.* Vienna, 1927.

Münz, L. 'Rembrandts Alterstil und die Barockklassik', *Jahrbuch der kunsthistorischen Sammlungen in Wien,* IX (1935).

Valentiner, W. R. 'Rembrandt's Conception of Historical Portraiture', *A.Q.,* XI (1948).

Regteren Altena, I. Q. van. 'Retouches aan ons Rembrandtbeeld, 1 : De zoogenaamde Voorstudie voor de anatomische Les van Dr Deyman', *O.H.,* LXV (1950).

Einem, H. von. 'Rembrandt und Homer', *Wallraf-Richartz-Jahrbuch,* XIV (1952).

Benesch, O. 'Worldly and Religious Portraits in Rembrandt's Late Work', *A.Q.,* XIX (1956).

Linnik, I. 'The Subject of a Picture by Rembrandt in the Hermitage Collection', *Iskusstvo,* no. 7, 1956 (Russian text).

Identification of Bredius 531 as *David Sending Uriah to his Death.* Also cf. Linnik, *Soobcheniia Gosudarstvennogo Ermitazha,* XI (1957) (Russian text).

Luttervelt, R. van. 'De grote Ruiter van Rembrandt', *N.K.J.,* VIII (1957).

Identification of the sitter of Rembrandt's only equestrian portrait (Bredius 255) as Jacob de Graeff. See I. H. van Eeghen, *Amstelodamum,* XLV (1958) for identification as Frederick Rihel, and *ibid.* for a reply by Luttervelt.

Valentiner, W. R. 'Noch einmal "Die Judenbraut"', *Festschrift für K. Bauch.* Munich, 1957.

An attempt to identify the couple as Titus and Magdalena van Loo.

Rottermund, H. M. 'Untersuchungen zu Rembrandts Faustradierung', *O.H.,* LXXII (1957).

i. Commissions for Don Antonio Ruffo

Ruffo, V. 'Galleria Ruffo nel secolo XVII in Messina', *Bollettino d'Arte,* X (1916).

Documents concerning Rembrandt's connexion with his Sicilian patron.

Hoogewerff, G. 'Rembrandt en een italiaansche Maecenas', *O.H.,* XXXV (1917).

Rosenberg, J. 'Rembrandt and Guercino', *A.Q.,* VII (1944).

Publication of Guercino's preparatory drawing for a companion piece to *Aristotle Contemplating the Bust of Homer.*

Luttervelt, R. van. 'Rembrandt's Pallas Athene in the Gulbenkian Collection', *G.B.A.,* XCII (1950).

ii. The Polish Rider

Held, J. 'Rembrandt's "Polish Rider" ', *The Art Bulletin,* XXVI (1944).

Ciechanowiecki, A. 'Notes on the Ownership of Rembrandt's "Polish Rider"', *The Art Bulletin,* XLII (1960).

Bialostocki, J. 'Rembrandt's "Eques Polonus"', *O.H.,* LXXXIV (1969).

iii. Commissions for the Town Hall

Schneider, H. 'Govert Flinck en Juriaen Ovens in het Stadhuis te Amsterdam', *O.H.,* XLII (1925).

Heppner, A. 'Moses zeigt die Gesetztafeln bei Rembrandt und Bol', *O.H.,* LII (1935).

Konsthistorisk Tidskrift, nos 1 and 2, XXV (1956). Special issue: 'Rembrandt's Claudius Civilis'.

With important contributions by H. van de Waal, A. van Schendel, C. Müller-Hofstede, L. Münz, C. Nordenfalk, J. H. van Eeghen, and C. Bille.

iv. The Syndics

Schendel, A. van. 'De Schimmen van de Staalmeesters, Een röntgenologisch Onderzoek', *O.H.,* LXXI (1956).

Publication of X-rays.

Waal, H. van de. 'De Staalmeesters en hun Legende', *O.H.,* LXXI (1956).

Hellinga, W. G. 'De Bewogenheid der Staalmeesters', *N.K.J.,* VIII (1957).

Eeghen, J. H. van. 'De Staalmeesters', *O.H.,* LXXIII (1958).

Identification of the syndics.

v. Self-Portraits

Stechow, W. 'Rembrandt-Democritus', *A.Q.*, VII (1944).
 An interpretation of the self-portrait at Cologne (Bredius 61).

Müller-Hofstede, C. 'Das Stuttgarter Selbstbildnis', *Pantheon*, XXI (1963).
 Publication of a rediscovered late self-portrait.

Bialostocki, J. 'Rembrandt's "Terminus"', *Wallraf-Richartz-Jahrbuch*, XXVIII (1966).
 An interpretation of the self-portrait at Cologne (Bredius 61).

Blankert, A. 'Rembrandt, Zeuxis and Ideal Beauty', in *Album Amicorum J. G. van Gelder*. The Hague, 1973.
 An interpretation of the self-portrait at Cologne (Bredius 61).

E. BIBLICAL SUBJECTS

Hofstede de Groot, C. *Rembrandt's Bijbel*. 2 vols. Amsterdam, 1906–10.
 A Dutch translation of the Old and New Testaments illustrated by Rembrandt's works.

Bredt, E. W. *Rembrandt-Bibel*. 4 vols. Munich, 1921.
 Selections from the Bible in German with 270 reproductions of Rembrandt's works.

Stechow, W. 'Rembrandts Darstellungen der Kreuzabnahme', *Jahrb. P.K.*, L (1929).

Stechow, W. 'Rembrandt's Darstellungen des Emmausmahles', *Zeitschrift für Kunstgeschichte*, III (1934).

Waal, H. van de. 'Hagar en de Woestijn door Rembrandt en zijn School', *N.K.J.*, I (1947).

Regteren Altena, I. Q. van. 'Rembrandt's Way to Emmaus', *Kunstmuseets Årsskrift*, XXXV–XXXVI (1948–9).

Rotermund, H. M. 'The Motif of Radiance in Rembrandt's Biblical Drawings', *Journal of the Warburg and Courtauld Institutes*, XV (1952).

Rotermund, H. M. 'Rembrandt und die religiösen Laienbewegungen in den Niederlanden', *N.K.J.* (1952–3).

Rotermund, H. M. 'Wandlungen des Christus-Typus bei Rembrandt', *Wallraf-Richartz-Jahrbuch*, XVIII (1956).

Münz, L. 'Rembrandts Vorstellung vom Antlitz Christi', *Festschrift für Kurt Bauch*. Munich, 1957.

Slive, S. *Rembrandt Bible*. New York, 1959.
 An English translation of the Old and New Testaments illustrated with Rembrandt's works.

Kahr, M. 'A Rembrandt Problem: Haman or Uriah', *Journal of the Warburg and Courtauld Institutes*, XXVIII (1965).

Slive, S. 'An Unpublished "Head of Christ" by Rembrandt', *The Art Bulletin*, XLVII (1965).

Kahr, M. 'Rembrandt's "Esther": A Painting and an Etching Newly Interpreted and Dated', *O.H.*, LXXXI (1966).

Bergström, I. 'Rembrandt's Double Portrait of Himself and Saskia at the Dresden Gallery', *N.K.J.*, XVII (1966).
 On the relation of the work to representations of the Prodigal Son.

Waal, H. van de. 'Rembrandt and the Feast of Purim', *O.H.*, LXXXIV (1969).

Tümpel, C. 'Ikonographische Beiträge zu Rembrandt', *Jahrbuch der Hamburger Kunstsammlungen*, XIII (1968); part II, *ibid.*, XVI (1971).

Tümpel, C. 'Studien zur Ikonographie der Historien Rembrandts', *N.K.D.*, XX (1969).
 Fundamental to the interpretation of Rembrandt's iconography.

F. LANDSCAPE

Eisler, M. *Rembrandt als Landschafter*. Munich, 1918.

Lugt, F. *Mit Rembrandt in Amsterdam*. Berlin, 1920.
 Identification of the sites of Rembrandt's etchings and drawings.

Zilva, C. 'The Landscape Paintings of Rembrandt and Hercules Seghers', *B.M.*, LXXIII (1938).

Regteren Altena, I. Q. van. 'Retouches aan ons Rembrandtbeeld, II: Het Landsschap van der "Goudweger"', *O.H.*, LXIX (1954).

G. TECHNIQUE

Laurie, A. P. *The Brushwork of Rembrandt and his School*. London, 1932.

Rosenberg, J. 'Rembrandt's Technical Means and their Stylistic Significance', *Technical Studies in the Field of the Fine Arts*, VIII (1940).

H. PUPILS AND FOLLOWERS

Hofstede de Groot, C. 'Rembrandt's Onderwijs aan zijne Leerlingen', *Feest-bundel Dr Abraham Bredius*. Amsterdam, 1915.

Falck, G. 'Über einige von Rembrandt übergegangene Schülerzeichnungen', *Jahrb. P.K.*, LIV (1924).

Isarlov, G. 'Rembrandt et son entourage', *La Renaissance* (July–September, 1936).

Münz, L. 'Rembrandts Korrekturen von Schülerzeichnungen nach 1650, oder Rembrandts bewusste Lehre von der Affektgestaltung von Figur und Raum', *Jahrbuch der kunsthistorischen Sammlungen in Wien*, IX (1935).

Münz, L. 'Maes, Aert de Gelder, Barent Fabritius und Rembrandt', *Die Graphischen Künste*, N.F. II (1937).

Wessem, J. N. van. Exhibition catalogue *Rembrandt als Leermeester*. Leiden, 1956.

Gerson, H. 'Probleme der Rembrandtschule', *Kunstchronik*, X (1957).

Gerson, H. 'Rembrandt en de schilderkunst in Haarlem' in *Miscellanea I. Q. van Regteren Altena*. Amsterdam, 1969.

Rembrandt and His Pupils. Montreal, 1969.
Catalogue of an exhibition of paintings; entries by D. G. Carter.

Rembrandt After Three Hundred Years. Chicago, 1969.
Exhibition catalogue of works by Rembrandt and his followers; painting entries by J. R. Judson; drawing entries by E. Haverkamp-Begemann and A. M. Logan.

I. RELATION TO ANCIENT AND RENAISSANCE ART

Saxl, F. 'Rembrandt und Italien', *O.H.*, XLI (1923/4).

Rijckevorsel, J. L. A. A. M. van. *Rembrandt en de Traditie*. Rotterdam, 1932.

Stechow, W. 'The Myth of Philemon and Baucis', *Journal of the Warburg and Courtauld Institutes*, IV (1940–1).

Kieser, E. 'Über Rembrandts Verhältnis zur Antike', *Zeitschrift für Kunstgeschichte*, X (1941-2).

Stechow, W. 'Rembrandt and Titian', *A.Q.*, V (1942).

Rosenberg, J. 'Rembrandt and Mantegna', *A.Q.*, XIX (1956).

Saxl, F. 'Rembrandt and Classical Antiquity', *Lectures*. London, 1957.

Kraft, K. 'Der behelmte Alexander der Grosse', *Jahrbuch für Numismatik und Geldgeschichte*, XV (1965).

Clark, K. *Rembrandt and the Italian Renaissance*. New York, 1968.

J. OTHER SPECIALIZED STUDIES

Neumann, C. *Aus der Werkstatt Rembrandts*. Heidelberg, 1918.
Essays on *Julius Civilis*, drawings, and Rembrandt's relation to sculpture.

Ricci, C. *Rembrandt in Italia*. Milan, 1918.

Charrington, J. *A Catalogue of the Mezzotints after, or said to be after, Rembrandt*. Cambridge, 1923.

Schmidt-Degener, F. *Rembrandt und der holländische Barock*. Leipzig, 1928.

Heppner, A. 'Brouwer's Influence upon Rembrandt', *A.Q.*, IV (1941).

Pinder, W. *Rembrandts Selbstbildnisse*. Leipzig, 1943.
An essay with an over-emphasis on Rembrandt's Germanic character.

Landsberger, F. *Rembrandt, the Jews and the Bible*. Translated by Felix N. Gerson. Philadelphia, 1946.

Scholte, J. H. *Rembrandt en Vondel*. The Hague, 1946.

Schmidt-Degener, F. *Rembrandt und der holländische* II, *Rembrandt*. Amsterdam, 1950.
Collected essays.

Slive, S. 'Rembrandt and his Contemporary Critics', *Journal of the History of Ideas*, XIV (1953).

Gelder, J. G. van. 'Rembrandt en de zeventiende Eeuw', *De Gids* (1956).

Valentiner, W. R. *Rembrandt and Spinoza*. London, 1957.

Bialostocki, J. 'Ikonographische Forschungen zu Rembrandts Werk', *Münchener Jahrbuch der bildenden Kunst*, VIII (1957).

Frey, D. 'Das Fragmentarische als das Wandelbare bei Rembrandt', *Das Unvollendente als Künstlerische Form*. A Symposium ed. by J. A. Schmoll gen. Eisenwerth. Bern-Munich, 1959.

Heiland, S., and Lüdecke, H. *Rembrandt und die Nachwelt*. Leipzig, 1960.

Scheller, R. W. 'Rembrandt's reputatie van Houbraken tot Scheltema', *N.K.D.*, XII (1961).

White, C. *Rembrandt and his World*. London-New York, 1964.
Excellent short study of the artist's life, his friends, and his patrons. Also see the Dutch translation by J. M. Komter with extensive additional notes by H. F. Wijnman, The Hague, 1964.

Erpel, F. *Die Selbstbildnisse Rembrandts*. Vienna-Munich, 1967.

Bauch, K. 'Iconographische Stil', in the author's *Studien zur Kunstgeschichte*. Berlin, 1967.

Robinson, F. W. 'Rembrandt's Influence in Eighteenth-Century Venice', *N.K.D.*, XVIII (1967).

Emmens, J. A. *Rembrandt en de regels van de Kunst*. Utrecht, 1968.
On the development of theories held by seventeenth-century classicistic art critics and their estimate of the artist. Includes an English summary.

Waal, H. van de. 'Rembrandt at Vondel's Tragedy "Gijsbrecht van Aemstel"', in *Miscellanea I. Q. va Regteren Altena*, Amsterdam, 1969.

Held, J. S. *Rembrandt's 'Aristotle' and Other Rembrandt Studies*. Princeton, 1969.
Includes studies of the '*Polish*' *Rider, Juno*, Rembrandt's treatment of episodes from the Book of Tobit and the myth of the *Night Watch*.

Fuchs, R. H. *Rembrandt in Amsterdam*. Trans. by P. Wardle and A. Griffiths. New York, 1969.

Scheller, R. W. 'Rembrandt en de encyclopedische verzameling', *O.H.*, LXXXIV (1969).

Bialostocki, J. 'Rembrandt and Posterity', *N.K.J.*, XXIII (1972).

Rembrandt After Three Hundred Years: A Symposium - Rembrandt and His Followers. Chicago, 1973.
Publication of a symposium held at The Art Institute of Chicago in 1969. Includes papers by J. G. van Gelder, H. Gerson, J. Bruyn, J. S. Held, J. Bialostocki, H. F. von Sonnenburg, J. Rosenberg, J. A. Emmens, C. J. White.

Neue Beiträge zur Rembrandt-Forschung. Edited by Otto v. Simson and J. Kelch. Berlin, 1973.
Publication of a symposium held at Berlin in 1969. Papers by J. Rosenberg, E. Haverkamp-Begemann, R. H. Fuchs, W. Sumowski, J. S. Held, J. Bialostocki, C. Tümpel, J. Q. van Regteren Altena, J. G. van Gelder, H. Gerson, R. W. Scheller, *et al.*

The Pre-Rembrandtists. Exhibition catalogue, E. B. Crocker Art Gallery, Sacramento, California, 1974.
Introduction and catalogue by A. Tümpel; iconographic essay by C. Tümpel.

Waal, H. van de. *Steps Toward Rembrandt; Collected Articles: 1937-1972.* Amsterdam-London, 1974.

RENESSE
Hammen Nicz., J. van der. 'Constantijn Daniel van Renesse (1626-1680)', *Taxandria*, XVII (1910).

RIJKHALS
Bredius, A. 'De Schilder François Ryckhals', *O.H.*, XXXV (1917).

ROUSSEAUX
Bredius, A. 'Le Peintre Jacques de Rousseaux', *G.B.A.*, V (1922).

RUISDAEL, ISAACK VAN
Wurzbach, A. von. 'Der Meister Izack van Ruisdael', *Zeitschrift für bildende Kunst*, XII (1877).
Simon, K. E. 'Isaack van Ruisdael', *B.M.*, LXVII (1935).

RUISDAEL, JACOB VAN
HdG. Vol. 4, 'Jacob van Ruisdael'.
Rosenberg, J. *Jacob van Ruisdael.* Berlin, 1928.
Monograph with critical catalogue raisonné.
Simon, K. E. *Jacob van Ruisdael, eine Darstellung seiner Entwicklung.* Berlin, 1930.
Wijnman, H. F. 'Het Leven der Ruysdaels', *O.H.*, XLIX (1932).
Cf. review by J. Rosenberg, *Zeitschrift für Kunstgeschichte*, II (1933).
Gerson, H. 'The Development of Ruisdael', *B.M.*, LXV (1934).
Simon, K. E. '"Doctor" Jacob van Ruisdael', *B.M.*, LXVII (1935).

The Jewish Cemetery
Rosenberg, J. '"The Jewish Cemetery" by Jacob van Ruisdael', *Art in America*, XIV (1926).
Publication of the versions in Dresden and Detroit.

Zwarts, J. 'Het Motief van Jacob van Ruisdael "Jodenkerkhof"', *Oudheidkundig Jaarboek*, VIII (1928).
Simon, K. E. 'Wann hat Ruisdael die Bilder des Judenfriedhofs gemalt?', *Festschrift für Adolph Goldschmidt*. Berlin, 1935.
Rosenau, H. 'The Dates of Jacob van Ruisdael's "Jewish Cemeteries"', *O.H.*, LXIII (1958).
Dates drawings for the pictures before 1674 and the paintings later.
Slive, S. 'Notes on Three Drawings by Jacob van Ruisdael', in *Album Amicorum J. G. van Gelder*. The Hague, 1973.

RUYSCH
HdG. Vol. 10, 'Rachel Ruysch'.
Grant, M. H. *Rachel Ruysch.* Leigh-on-Sea, 1956.
Šíp, J. 'Notities bij het stilleven van Rachel Ruysch', *N.K.D.*, XIX (1968).

RUYSCHER
Welcker, A. 'Johannes Ruyscher', *O.H.*, XLIX (1932), L (1933), LI (1934), LVII (1940).

RUYSDAEL, SALOMON VAN
Stechow, W. *Salomon van Ruysdael.* Berlin, 1938. 2nd revised and enlarged edition, Berlin, 1975.
Standard work, with critical catalogue.

SAENREDAM
Regteren Altena, I. Q. van. 'Saenredam Archaeolog', *O.H.*, XLVIII (1931).
Swillens, P. T. A. *Pieter Jansz. Saenredam.* Amsterdam, 1935.
Monograph, documents, and catalogue.
Pieter Jansz. Saenredam. Utrecht, 1961.
Catalogue raisonné published on the occasion of an exhibition at the Centraal Museum, Utrecht. Includes essays by P. T. A. Swillens and I. Q. van Regteren Altena.
Schwartz, G. 'Saenredam, Huygens and the Utrecht Bull', *Simiolus*, I (1966-7).

SAVERY
Erasmus, K. *Roelant Savery, sein Leben und seine Werke.* Halle, 1908.
Bialostocki, J. 'Les Bêtes et les humains de Roelant Savery', *Bulletin Koninklijke Musea voor Schone Kunsten, Brussels*, no. 7 (1958).

SCHALCKEN
HdG. Vol. 5, 'G. Schalcken'.

SCHOUMAN
Roever, N. de 'Aert Schouman volgens zijne Aanteekenboekjes', *O.H.*, VI (1888).
Bol, L. J. Introduction to Catalogue *Aart Schouman*. Dordrecht Museum, 1960.

SEGHERS
Bode, W. von. 'Der Maler Hercules Seghers', *Jahrb. P.K.*, XXIV (1903).

Springer, J. *Die Radierungen des Herkules Seghers.*
3 vols. Berlin, 1910-12.
 Catalogue and sixty-six outstanding facsimiles.
Pfister, K. *Herkules Seghers.* Munich, 1921.
Fraenger, W. *Die Radierungen des Hercules Seghers.*
Erlenbach–Zürich, 1922.
Trautscholdt, E. 'Der Maler Herkules Seghers',
Pantheon, xxv (1940).
Knuttel Wzn., G. *Hercules Seghers (Palet Serie).*
Amsterdam, 1941.
Collins, L. C. *Hercules Seghers.* Chicago, 1953.
Haverkamp-Begemann, E. *Hercules Seghers, Museum Boymans Catalogue.* Rotterdam, 1954.
 Excellent exhibition catalogue.
Regteren Altena, I. Q. van. 'Hercules Seghers en
de Topographie', *Rijksmuseum Bulletin*, iii (1955).
Trautscholdt, E. 'Neues Bemühen um Hercules
Seghers', *Imprimatur*, xii (1955).
Leusden, W. van. *The Etchings of Hercules Seghers
and the Problem of his Graphic Technique.* Trans.
St John Nixon. Utrecht, 1961.
Haverkamp-Begemann, E. *Hercules Seghers.* Amsterdam, 1968.
Haverkamp-Begemann, E. *Hercules Seghers: The
Complete Etchings.* Amsterdam, 1973.
 Catalogue raisonné and facsimile reproductions with a
 supplement on J. Ruischer by E. Trautscholdt.
SLINGELAND
HdG. Vol. 5, 'Pieter van Slingeland'.
STEEN
Westrheene Wz., T. van. *Jan Steen. Étude sur l'art
en Holland.* The Hague, 1856.
Marius, G. H. *Jan Steen.* Amsterdam, 1906.
HdG. Vol. 1, 'Jan Steen'.
Antal, F. 'Concerning Some Jan Steen Pictures in
America', *Art in America*, xiii (1925).
Schmidt-Degener, F., and Gelder, H. E. van.
Jan Steen. Trans. G. J. Renier. London, 1927.
Hofstede de Groot, C. 'Jan Steen and his Master
Nicholaes Knupfers', *Art in America*, xvi (1927-8).
Stechow, W. 'Bemerkungen zu Jan Steens Künstlerischer Entwicklung', *Zeitschrift für bildende
Kunst*, lxii (1928/9).
Gils, J. B. F. 'Jan Steen en de Rederijkers', *O.H.*,
lii (1935).
Martin, W. 'Jan Steen as Landscape Painter', *B.M.*,
lxvii (1935).
Jonge, C. H. *Jan Steen (Palet Serie).* Amsterdam,
1939.
Heppner, A. 'The Popular Theatre of the Rederijkers in the Work of Jan Steen and His Contemporaries', *Journal of the Warburg and Courtauld
Institutes*, iii (1939-40).

Simon, K. E. 'Jan Steen und Utrecht', *Pantheon*,
xxvi (1940).
Regteren Altena, I. Q. van. 'Hoe teekende Jan
Steen?', *O.H.*, lx (1943).
Gudlaugsson, S. J. *De Komedianten bij Jan Steen
en zijn Tijdgenooten.* The Hague, 1945.
Gerson, H. 'Landschappen van Jan Steen', *Kunsthistorische Mededeelingen van het Rijksbureau voor
kunsthistorische Documentatie*, iii (1948).
Bijleveld, W. J. J. C. *Om den Hoenderhoef door
Jan Steen.* Leiden, 1950.
Groot, C. W. de. *Jan Steen, Beeld en Woord.*
Utrecht, 1952.
Martin, W. *Jan Steen.* Amsterdam, 1954.
Kuznetsov, J. 'The Paintings by Jan Steen in the
Hermitage', *Yearbook of the Institute for the
History of Art* (Moscow), 1958 (Russian text).
Domela, P. N. H. Catalogue of *Jan Steen Exhibition*,
The Mauritshuis. The Hague, 1958-9.
Stechow, W. 'Jan Steen's Representations of the
Marriage in Cana', *N.K.J.*, xxiii (1972).
STEENWIJCK
Bredius, A. 'De Schilders Pieter en Harmen
Steenwijck', *O.H.*, viii (1890).
SWANENBURGH
Frimmel, Th. v. *Blätter für Gemäldekunde*, ii (1906).
 Publication of signed works at Copenhagen and Augsburg.
Michel, E. 'Jacob Swanenburch, le premier maître
de Rembrandt', *La Chronique des Arts et de la
Curiosité* (1905).
SWANEVELT
Henkel, M. D. von. 'Swaneveld und Piranesi in
Goethescher Beleuchtung', *Zeitschrift für bildende
Kunst*, lviii (1924/5).
Waddington, M. R. 'Herman van Swanevelt in
Rome', *Paragone*, cxxi (1960).
SWEERTS
Martin, W. 'Michiel Sweerts als Schilder. Proeve
van een Biografie en een Catalogus van zijn
Schilderijen', *O.H.*, xxv (1907).
 The first attempt to establish Sweerts' œuvre.
Stechow, W. 'Some Portraits by Michiel Sweerts',
A.Q., xiv (1951).
Kultzen, R. *Michael Sweerts.* Hamburg, 1954.
 Typewritten thesis.
Kultzen, R., and Carpegna, N. di. Catalogue of the
Exhibition *Michael Sweerts en Tijdgenoten.* Rotterdam-Rome, 1958.
Bloch, V. *Michael Swerts.* The Hague, 1968.
 Perceptive essay with note on the artist's relation to
 foreign missions by J. Guennou.
TEMPEL, VAN DEN
Wijnman, H. F. 'De Schilder Abraham van den
Tempel', in *Uit de Kring van Rembrandt en Vondel.*
Amsterdam, 1959.

TENGNAGEL
Schneider, H. 'Der Maler Jan Tengnagel', *O.H.*, XXXIX (1921).
TER BORCH *see* BORCH
TERBRUGGHEN
Longhi, R. 'Ter Brugghen e la parte nostra', *Vita Artistica*, II (1927).
Early appreciation of the artist's importance.
Baker, C. H. C. 'Hendrick Terbrugghen and plein air', *B.M.*, L (1927).
Stechow, W. 'Terbrugghen's S. Sebastian', *B.M.*, XCVI (1954).
Nicolson, B. *Hendrick Terbrugghen*. London, 1958.
The best appraisal of the artist's achievement and a richly documented critical catalogue of his *œuvre*. Comprehensive bibliography.
Longhi, R. 'Terbrugghen e Valentin', *Paragone*, no. 131 (1960).
Nicolson, B. 'Second Thoughts about Terbrugghen', *B.M.*, CII (1960).
TORRENTIUS
Bredius, A. *Johannes Sijmonsz. Torrentius*. The Hague, 1909.
Rehorst, A. J. *Torrentius*. Rotterdam, 1939.
TROOST
Huell, A. ver. *Cornelis Troost*. Arnhem, 1873.
Knoef, J. *Cornelis Troost (Palet Serie)*. Amsterdam, 1947.
Niemeijer, J. W. *Cornelius Troost: 1696-1750*. Assen, 1973.
Authoritative monograph and catalogue.
TROOSTWIJK
Knoef, J. 'W. J. van Troostwijk', *Elsevier's geïllustreerd Maandschrift*, LXXVIII (1929).
UTEWAEL *see* WTTEWAEL
VALCKERT, VAN DEN
Hudig, F. W. 'Werner van den Valckert', *O.H.*, LIV (1937).
VELDE, VAN DE VELDE FAMILY
Bradley, W. A. 'The Van de Veldes', *Print Collectors' Quarterly*, VII (1917).
Michel, E. *Les van de Velde*. Paris, 1892.
Manteuffel, K. Z. von. *Die Künstler Familie van de Velde* Bielefeld Leipzig, 1927.
VELDE, ADRIAEN VAN DE
Michel, E. 'Adrien van de Velde', *L'Art, Revue Mensuelle*, LIII (1892).
Bode, W. 'Adriaen van de Velde', *Die graphischen Künste*, XIX (1906).
HdG. Vol. 4, 'Adriaen van de Velde'.
Gelder, J. G. van. 'Adriaen van de Velde, Christus aan het Kruis', *Kunsthistorische Mededeelingen van het Rijksbureau voor kunsthistorische Documentatie*, I (1946).

VELDE, ESAIAS VAN DE
Block, I. 'Teekeningen van Esaias v. de Velde, Jan v. Goyen en P. de Molijn', *Oude Kunst*, III (1917-18).
Poensgen, G. *Der Landschaftstil des Esaias van de Velde*. Freiburg, 1924.
Stechow, W. 'Esaias van de Velde and the Beginnings of Dutch Landscape Painting', *N.K.J.*, I (1947).
VELDE, JAN VAN DE
Gelder, J. G. van. *Jan van de Velde, 1593-1641, Teekenaar-Schilder*. The Hague, 1933.
Standard monograph and catalogue. Addenda by the author in *O.H.*, LXX (1955).
VELDE, WILLEM VAN DE I AND WILLEM II
HdG. Vol. 7, 'W. van de Velde II'.
Baard, H. P. *Willem van de Velde de Oude, Willem van de Velde de Jonge (Palet Serie)*. Amsterdam, 1942.
Robinson, M. S. *Van de Velde Drawings . . . in the National Maritime Museum*. 2 vols. Cambridge, 1958-74.
VENNE, VAN DE
Franken Dz., D. *Adriaen van de Venne*. Amsterdam, 1878.
Knuttel, G. *Das Gemälde des Seelenfischfangs von Adriaen Pietersz. van de Venne*. The Hague, 1917.
Bol, L. J. 'Een middelburgse Brueghel Groep. VIII. Adriaen Pietersz. van de Venne, Schilder en Teyckenaar: A. Middelburgse periode *c.* 1614-1625; B. Haagse periode 1625-1662', *O.H.*, LXXIII (1958).
VERMEER, JAN (VAN DELFT)
1. Sources
Bleyswijck, D. E. van. *Beschrijving der Stad Delft*. Delft, 1667.
Obreen, F. D. O. 'Iets over den delftschen Schilder Johannes Vermeer', *Archief voor Nederlandsche Kunstgeschiedenis*, IV (1881-2).
Bredius, A. 'Iets over Johannes Vermeer', *O.H.*, III (1885).
Bredius, A. 'Nieuwe Bijdragen over Johannes Vermeer', *O.H.*, XXVIII (1910).
Bredius, A. 'Schilderijen uit de Nalatenschap van den delftschen Vermeer', *O.H.*, XXXIV (1916).
Bouricus, L. G. N. 'Vermeeriana', *O.H.*, XLII (1925).
Boogaard-Bosch, A. C. 'Een onbekende Acte betreffende den Vader van Jan Vermeer', in *Nieuwe Rotterdamsche Courant*, 25 January 1939.
Neurdenburg, E. 'Johannes Vermeer. Eenige Opmerkingen naar Aandleiding van de nieuwste Studies over den delftschen Schilder', *O.H.*, LIX (1942).

Peer, A. J. J. M. van. 'Was Jan Vermeer van Delft Katholiek?', *Katholiek Cultureel Tijdschrift*, II (1946); also cf. *ibid.*, IV (1951).

Neurdenburg, E. 'Vermeer's "Schilderkonst" een raadselachtig Schilderij?', *Maandblad voor beeldende Kunsten*, XXIV (1948).

Neurdenburg, E. 'Nog enige Opmerking over Johannes Vermeer van Delft', *O.H.*, LXVI (1951).

Peer, A. J. J. M. van. 'Drie Collecties Schilderijen van Jan Vermeer', *O.H.*, LXXII (1957).
Important. Discussion of the seventeenth-century inventories of Vermeer's paintings.

Peer, A. J. J. M. van. 'Rondom Jan Vermeer van Delft', *O.H.*, LXXIV (1959).

Peer, A. J. J. M. van. 'Jan Vermeer van Delft: drie archiefvondsten', *O.H.*, LXXXIII (1968).
Documents regarding effects owned by the family of the artist's mother-in-law; his place of residence in Delft; his burial place in the Oude Kerk in Delft.

2. Monographs and Catalogues

Bürger, W. (Étienne Jos. Théoph. Thoré). *Van der Meer de Delft*. Paris, 1866.
Reprint of the articles (*G.B.A.*, XXI, 1866) which established the artist's œuvre. Although not all of the author's attributions are acceptable today, the study remains one of the best accounts. A modern reprint is available in A. Blum, *Vermeer et Thoré-Bürger*, Geneva, 1945.

HdG. Vol. I, 'Johannes Vermeer'.

Plietzsch, E. *Vermeer van Delft*. Leipzig, 1911.

Lazarev, V. N. *Vermeer* (in Russian). Moscow, 1933.

Hale, P. L. *Vermeer*. New ed. completed and prepared for the press by F. W. Coburn and R. F. Hale. London, 1937.

Thienen, F. W. S. van. *Vermeer (Palet Serie)*. Amsterdam, 1939.

Vries, A. B. de. *Jan Vermeer van Delft*. 2nd ed. London-New York, 1948.

Thienen, F. W. S. van. *Jan Vermeer van Delft*. Amsterdam-Antwerp, 1949.

Swillens, P. T. A. *Johannes Vermeer*. Utrecht, 1950.

Gowing, L. *Vermeer*. London, 1952. New ed. New York Evanston, 1970.

Malraux, A. (ed.). *Tout Vermeer de Delft*. Paris, 1952.
Text includes 'Pages sur Vermeer par Marcel Proust'. The chronology based on identification of members of the artist's family is unsuccessful.

Bloch, V. *Tutta la pittura di Vermeer di Delft*. Milan, 1954.

Goldscheider, L. *Jan Vermeer*. London, 1958.

3. Special Studies

Voss, H. 'Vermeer van Delft und die Utrechter Schule', *Monatshefte für Kunstwissenschaft*, V (1912).

Barnouw, A. J. 'Vermeers zogenaamd Novum Testamentum', *O.H.*, XXXII (1914).

Gelder, J. G. van. 'Een Teekening van Carel Fabritius en een Teekening van Johannes Vermeer', *O.H.*, XLVIII (1931).

Heppner, A. 'Vermeer – seine kunstlerische Herkunft und Ausstrahlung', *Pantheon*, XVI (1935).

Huyghe, R. 'Vermeer et Proust', *L'Amour de l'Art* (1936).

Bredius, A. 'A New Vermeer: Christ and the Disciples at Emmaus', *B.M.*, LXXI (1937).
Publication of the notorious Vermeer forgery by Van Meegeren as an authentic work. For a discussion of Van Meegeren's falsifications see P. B. Coremans, *Van Meegeren's Faked Vermeers and De Hoochs: A Scientific Examination*. Translated by A. Hardy and C. Hutt, Amsterdam, 1949.

Hulten, K. G. 'Zu Vermeers Atelierbild', *Konsthistorisk Tidskrift*, XVIII (1949).

Gelder, J. G. van. *De Schilderkunst van Jan Vermeer*. With a commentary by J. A. Emmens. Utrecht, 1958.
A more convincing interpretation of the *Allegory of Painting* at Vienna than the one offered by H. Sedlmayr, 'Der Ruhm der Malkunst Jan Vermeer "De schilderconst"', *Festschrift für Hans Jantzen*, Berlin, 1951, or C. de Tolnay, 'L'Atelier de Vermeer', *G.B.A.* (April 1953). Also cf. K. Badt, *Modell und Maler von Jan Vermeer. Probleme der Interpretation; eine Streitschrift gegen Hans Sedlmayr*, Cologne, 1961.

Slive, S. 'Een dronke slapende meyd aen een tafel', in *Festschrift Ulrich Middeldorf*. Berlin, 1968.

Blankert, A., with contributions by R. Ruurs and W. L. van de Watering. *Johannes Vermeer van Delft: 1632-1675*. Utrecht-Antwerp, 1975.
Monograph and catalogue of the paintings.

VERMEER, JAN (VAN HAARLEM)

Linfert, C. 'Eine Landschaft des Haarlemer Vermeer im Wallraf-Richartz-Museum zu Köln', *Kunstchronik*, LIII (1929-30).

VERSPRONCK

Kalff, S. 'Een haarlemsch Portretschilder uit de gouden Eeuw', *De Nieuwe Gids*, XXXIV (1918).

VINCKBOONS

Coninckx, H. 'David Vinckboons, peintre, et son œuvre et la famille de ce nom', *Annales de l'Académie Royale d'Archéologie de Belgique*, LIX (1907).

Held, J. S. 'Notes on David Vinckboons', *O.H.*, LXVI (1951).

Goossens, K. *David Vinckboons*. Antwerp, 1954.
See review by S. Slive, *The Art Bulletin*, XXXIX (1957).

VLIEGER

Haverkorn van Rijsewijk, P. 'Simon Jacobsz. de Vlieger', *O.H.*, IX (1891), XI (1893).

VLIET
Wiwel, A. J. *Gerard van Vliet*. Amsterdam, 1913.
VOORT
Six, J. 'Cornelis von de Voort. Een eerste Poging tot het terug Vinden van zijn Werk als Portretschilder', *O.H.*, v (1887); also cf. *ibid*, XIX (1911), XXXVI (1918).
VREL
Brière-Misme, C. 'Un Intimiste hollandais: Jacob Vrel', *Revue de l'Art Ancien et Moderne*, LXVIII (1935).
Valentiner, W. R. 'Paintings by Pieter de Hooch and Jacobus Vrel', *Detroit Institute of Fine Arts Bulletin*, IX (1927-8).
Plietzsch, E. 'Jacobus Vrel und Esaias Boursse', *Zeitschrift für Kunstgeschichte*, III (1949).
VROOM
Rosenberg, J. 'Cornelis Hendricksz. Vroom', *Jahrb. P.K.*, XLIX (1928).
Keyes, G. S. *Cornelius Vroom: Marine and Landscape Artist*. 2 vols. (n.p.) 1975.
 University of Utrecht dissertation.
WEENIX
Stechow, W. 'Jan Baptist Weenix', *A.Q.*, XI (1948).
Stechow, W. 'A Wall Paneling by Jan Weenix', *Allen Memorial Art Museum Bulletin*, XXVII (1969).
WERFF
HdG. Vol. 10, 'Adriaen van der Werff'.
Plietzsch, E. 'Adriaen van der Werff', *A.Q.*, XIV (1951).
WET, DE
Chudzikowski, A. 'Les Éléments rembrandtesques dans l'œuvre de Jacob de Wet', *Biuletyn Historii Sztuki*, XVIII (1956).
WIT, DE
Staring, A. *Jacob de Wet*. Amsterdam, 1958.
 Standard monograph.
WITTE, DE
Richardson, E. P. 'De Witte and the Imaginative Nature of Dutch Art', *A.Q.*, I (1938).
Manke, I. *Emanuel de Witte 1617-1692*. Amsterdam, 1963.
 Comprehensive monograph and œuvre catalogue.
WOUWERMAN
HdG. Vol. 2, 'Philips Wouwerman'.
WIJNANTS
Bredius, A. 'Een en ander over Jan Wijnants', *O.H.*, XXIX (1911).
WTTEWAEL
Lindeman, C. M. A. A. *Joachim Anthonisz. Wtewael*. Utrecht, 1929.
 See reviews by F. Antal, *Kritische Berichte*, II (1928/9), and W. Stechow, *Kunstchronik*, LXIII (1929/30).

McGrath, E. 'A Netherlandish History by Joachim Wtewael', *Journal of the Warburg and Courtauld Institutes*, XXXVIII (1975).

III. ARCHITECTURE

A. GENERAL

VERMEULEN, F. A. J. *Geschiedenis der Nederlandsche Bouwkunst*, pt 2, The Hague, 1931; pt 3, The Hague, 1941.
FOCKEMA ANDREAE, S. J., HEKKER, R. C., and TER KUILE, E. H. *Duizend Jaar Bouwen in Nederland*, pt 2. Amsterdam, 1957.
BURKE, G. L. *The Making of Dutch Towns*. London, 1956.
OZINGA, M. D. *De Protestansche Kerkenbouw in Nederland*. Amsterdam, 1926.
SLOTHOUWER, D. F. *De Paleizen van Frederik Hendrik*. Leiden, n.d. [1946].
MEISCHKE, R. *Het Nederlandse Woonhuis van 1300-1800*. Haarlem, 1969.

B. INDIVIDUAL ARCHITECTS

CAMPEN, VAN
Swillens, P. T. A. *Jacob van Campen, Schilder en Bouwmeester*. Assen, 1961.
HART, VAN DER
Swigchem, C. A. van. *Abraham van der Hart 1747-1820, architect, stadsbouwmeester van Amsterdam*. Amsterdam, 1965.
 With a summary in English.
KEYSER, DE
Neurdenburg, E. *Hendrick de Keyser*. Amsterdam, n.d. [1929].
MAROT
Ozinga, M. D. *Daniel Marot*. Amsterdam, 1938.
POST
Blok, G. A. C. *Pieter Post*. Siegen, 1937.

IV. SCULPTURE

A. GENERAL

NEURDENBURG, E. *De 17de-eeuwsche Beeldhouwkunst in de Noordelijke Nederlanden*. Amsterdam, 1948.
GERSON, H., and TER KUILE, E. H. *Art and Architecture in Belgium: 1600-1800 (Pelican History of Art)*. Harmondsworth, 1960.
FISCHER, P. 'Eighteenth-century Dutch Sculpture', *Apollo* (1972), 396.

B. INDIVIDUAL SCULPTORS

KEYSER, DE

Neurdenburg, E. *Hendrick de Keyser*. Amsterdam, n.d. [1929].

VERHULST

Notten, M. van. *Rombout Verhulst*. The Hague, 1907.

LIST OF ILLUSTRATIONS

The drawings (illustrations 287, 304, 311, 313, 322, 324, 325) were made by Peter Darvall from material from the Rijksdienst voor de Monumentenzorg, The Hague. The map was drawn by Paul White and Sheila Waters.

66. Rembrandt: Self-Portrait, 1640. 101·6 × 80cm: 40 × 31½in. *London, National Gallery*

67. Rembrandt: The Night Watch, 1642. 359 × 438 cm: 141¼ × 172½in. *Amsterdam, Rijksmuseum*

68. Rembrandt: The Sacrifice of Manoah, 1641. 242 × 131cm: 95¼ × 51½in. *Dresden, Gemäldegalerie* (Staatliche Kunstsammlungen, Dresden)

69. Rembrandt: The Mennonite Preacher Cornelis Anslo and a Woman, 1641. 172 × 209cm: 67¾ × 82¼in. *Berlin-Dahlem, Staatliche Museen* (Photo Walter Steinkopf)

70. Rembrandt: Nicolaas van Bambeeck, 1641. 106·7 × 83·8cm: 42 × 33in. *Brussels, Musées Royaux des Beaux-Arts* (A.C.L., Brussels)

71. Rembrandt: The Visitation, 1640. 56·5 × 47·6cm: 22¼ × 18¾in. *Detroit, The Detroit Institute of Arts*

72. Rembrandt: The Reconciliation of David and Absalom, 1642. 73 × 61·6cm: 28¾ × 24¼in. *Leningrad, Hermitage*

73. Rembrandt: The Holy Family with Angels, 1645. 118·1 × 91·4cm: 46½ × 36in. *Leningrad, Hermitage*

74. Rembrandt: Two Women teaching a Child to Walk, c. 1640. Drawing. Red chalk. 10·4 × 12·9cm: 4⅛ × 5⅛in. *London, British Museum*

75. Rembrandt: Study of a Lioness, c. 1641. Drawing. Black chalk, wash, heightened with white. 12·7 × 23·8cm: 5 × 9¾in. *London, British Museum*

76. Rembrandt: Old Woman in an Armchair, 1654. 110·5 × 85·1cm: 43½ × 33½in. *Leningrad, Hermitage*

77. Rembrandt: Man wearing a gilt Helmet, c. 1650-2. 67 × 50cm: 26⅜ × 19⅝in. *Berlin-Dahlem, Staatliche Museen* (Photo Walter Steinkopf)

78. Rembrandt: Christ healing a sick Person, c. 1655. Drawing. Pen, ink, wash, white body colour. 18 × 24·7cm: 7⅛ × 9¾in. *Berlin-Dahlem, Kupferstichkabinett* (Staatliche Museen: photo Karl H. Paulmann)

79. Rembrandt. The Jewish Bride, c. 1666. 121·5 × 166.5cm: 47⅞ × 65½in. *Amsterdam, Rijksmuseum*

80. Rembrandt: Family Portrait, c. 1668. 126 × 167cm: 49⅝ × 65¾in. *Brunswick, Herzog Anton Ulrich Museum*

81. Rembrandt: Hendrickje Stoffels, c. 1658-60. 86 × 65cm: 33⅞ × 21⅝in. *Berlin-Dahlem, Staatliche Museen* (Photo Walter Steinkopf)

82. Rembrandt. Titus, 1655. 77 × 63cm: 30⅓ × 24¾in. *Rotterdam, Boymans-Van Beuningen Museum* (Photo A. Frequin)

83. Rembrandt: Aristotle with the Bust of Homer, 1653. 143·5 × 136·5cm: 56½ × 53¾in. *New York, Metropolitan Museum of Art*

84. Rembrandt: Self-Portrait, 1661. 91 × 77cm: 35⅞ × 30⅓in. *Amsterdam, Rijksmuseum*

85. Rembrandt: Self-Portrait, c. 1665-8. 82·6 × 63·5cm: 32½ × 25in. *Cologne, Wallraf-Richartz Museum* (Rheinisches Bildarchiv)

86. Rembrandt: Self-Portrait, 1659. 84 × 66cm: 33¼ × 26in. *Washington, National Gallery of Art*

87. Rembrandt: Jan Six, 1654. 92·1 × 74·6cm: 36¼ × 29⅜in. *Amsterdam, Six Collection* (Lichtbeelden-Instituut)

88. Rembrandt: Woman with a Pink, c. 1665. 112 × 102cm: 44⅛ × 40⅛in. *New York, Metropolitan Museum of Art, Altman Bequest*

89. Rembrandt: The Syndics of the Cloth Drapers' Guild, 1661/2. 185 × 274cm: 72⅞ × 107⅞in. *Amsterdam, Rijksmuseum*

90. Rembrandt: The Conspiracy of Julius Civilis, 1661/2. 196 × 309cm: 77⅛ × 121⅔in. *Stockholm, National Museum*

91. Rembrandt: Preparatory drawing for the Conspiracy of Julius Civilis, 1661. Pen, ink, wash, white body colour. 19·6 × 18cm: 7¾ × 7⅛in. *Munich, Staatliche Graphische Sammlung*

92. Rembrandt: Christ at Emmaus, 1648. 68 × 65cm: 26¾ × 25⅝in. *Paris, Louvre* (Photo Musées Nationaux)

93. Rembrandt: Hundred Guilder Print, c. 1648-50. Etching. 278 × 389cm: 109½ × 153⅛in. (British Museum)

94. Rembrandt: Head of Christ, c. 1648-50. 25 × 20cm: 9⅞ × 7⅞in. *Berlin-Dahlem, Staatliche Museen* (Photo Walter Steinkopf)

95. Rembrandt: Study for St Matthew, c. 1660. 23 × 20cm: 9 × 7⅞ in. *Bayonne, Museum* (Photo Aubert)

96. Rembrandt: Bathsheba, 1654. 142 × 142cm: 55⅝ × 55⅞in. *Paris, Louvre* (Photo Musées Nationaux)

97. Rembrandt: Jacob blessing the Sons of Joseph, 1656. 175.5 × 210·5cm: 69⅛ × 83in. *Kassel, Staatliche Gemäldegalerie* (Staatliche Kunstsammlungen, Kassel)

98. Rembrandt: Jacob blessing the Sons of Joseph, 1656. Detail. *Kassel, Staatliche Gemäldegalerie* (Staatliche Kunstsammlungen, Kassel)

99. Rembrandt: Saul and David, c. 1658. 130·5 × 164cm: 51⅜ × 64½in. *The Hague, Mauritshuis* (Foundation Johan Maurits van Nassau: photo A. Dingjan)

100. Rembrandt: The Denial of St Peter, 1660. 154 × 169cm: 60⅞ × 66½in. *Amsterdam, Rijksmuseum*

101. Rembrandt. The Return of the Prodigal Son, c. 1669. 265·4 × 208·3cm: 104½ × 82in. *Leningrad, Hermitage*

102. Jan Lievens: Constantin Huygens, c. 1626/7. 99 × 84cm: 39 × 33⅛in. *Douai (on loan to the Rijksmuseum, Amsterdam)* (Photo Rijksmuseum)

103. Jan Lievens: The Raising of Lazarus, 1631. 105 × 114·3cm: 41⅜ × 45in. *Brighton, Art Gallery* (Brighton Corporation)

dation Johan Maurits van Nassau: photo A. Dingjan)

139. Jan Vermeer: Woman reading a Letter, *c.* 1665. 46·5 × 39cm: 18¼ × 15⅓ in. *Amsterdam, Rijksmuseum* (Snark International)

140. Jan Vermeer: The Astronomer, 1668. 96 × 73cm: 37¾ × 28¾in. *Paris, private collection*

141. Jan Vermeer: The Procuress, 1656. 143·1 × 130·2cm: 56⅓ × 51¼in. *Dresden, Gemäldegalerie* (Staatliche Kunstsammlung)

142. Jan Vermeer: Christ at the House of Mary and Martha, *c.* 1655. 160 × 136·5cm: 63 × 55¾in. *Edinburgh, National Gallery of Scotland* (National Galleries of Scotland: photo Annan)

143. Jan Vermeer: A Girl asleep at a Table, *c.* 1657. 85 × 73·7cm: 33½ × 29in. *New York, Metropolitan Museum of Art, Altman Bequest*

144. Jan Vermeer: A Soldier and a laughing Girl, *c.* 1657. 50·5 × 46cm: 19⅞ × 18⅛in. *New York, Frick Collection*

145. Jan Vermeer: A Street in Delft, *c.* 1660. 54·3 × 44cm: 21¾ × 17⅛in. *Amsterdam, Rijksmuseum*

146. Jan Vermeer: View of Delft, *c.* 1662. 98·5 × 117·5cm: 38¾ × 46¼in. *The Hague, Mauritshuis* (Foundation Johan Maurits van Nassau: photo A. Dingjan)

147 A and B. Jan Vermeer: The Kitchen Maid, *c.* 1658. Whole picture 45·5 × 41cm: 17⅞ × 16⅛in. *Amsterdam, Rijksmuseum*

148. Jan Vermeer: The young Woman with a Water Jug, *c.* 1665. 45·7 × 40·6cm: 18 × 16in. *New York, Metropolitan Museum of Art*

149. Jan Vermeer: Woman weighing Pearls, *c.* 1665. 42·5 × 38cm: 16¾ × 15in. *Washington, National Gallery of Art, Widener Collection*

150. Jan Vermeer: Lady reading a Letter at an open Window, *c.* 1658. 85 × 64·5cm: 33½ × 25⅜in. *Dresden, Gemäldegalerie* (Staatliche Kunstsammlung)

151. Jan Vermeer: Lace Maker, *c.* 1665-8. 24 × 21cm: 9¼ × 8¼in. *Paris, Louvre* (Photo Musées Nationaux)

152. Jan Vermeer: Head of a Girl, *c.* 1665. 46·5 × 40cm: 18¼ × 15¾in. *The Hague, Mauritshuis* (Foundation Johan Maurits van Nassau: photo A. Dingjan)

153. Jan Vermeer: Girl with a Flute, *c.* 1665-70. 20 × 18cm: 7⅞ × 7in. *Washington, National Gallery of Art, Widener Collection*

154. Jan Vermeer: a Lady at the Virginals with a Gentleman listening, *c.* 1668-70. 73·7 × 63·9cm: 29 × 25¼in. *London, Buckingham Palace* (By gracious permission of Her Majesty the Queen)

155. Jan Vermeer: Allegory of the Art of Painting, *c.* 1670. 120 × 100cm: 47¼ × 39⅜in. *Vienna, Kunsthistorisches Museum*

156. Jan Vermeer: The Letter, *c.* 1670. 44 × 38·5cm: 17⅓ × 15⅛in. *Amsterdam, Rijksmuseum*

157. Jan Vermeer: A Maid handing a Letter to her Mistress, *c.* 1665. 90·2 × 78·7cm: 35½ × 31in. *New York, Frick Collection*

158. Pieter de Hooch: Backgammon Players, *c.* 1653. 46 × 33cm: 18⅛ × 13in. *Dublin, National Gallery of Ireland*

159. Pieter de Hooch: The Card Players, 1658. 76·2 × 66cm: 30 × 26in. *London, Buckingham Palace* (By gracious permission of Her Majesty the Queen)

160. Jan Vermeer: A Woman drinking with a Man, *c.* 1665. 65 × 77cm: 25⅝ × 30⅜in. *Berlin-Dahlem, Staatliche Museen* (Photo Walter Steinkopf)

161. Pieter de Hooch: A Maid with a Child in a Court, 1658. 73·5 × 60·1cm: 29 × 23⅝in. *London, National Gallery*

162. Pieter de Hooch: A Mother beside a Cradle, *c.* 1659-60. 92 × 100cm: 36¼ × 39¾in. *Berlin-Dahlem, Staatliche Museen* (Photo Walter Steinkopf)

163. Pieter de Hooch: The Pantry, *c.* 1658. 65 × 60·5cm: 25⅝ × 23⅞in. *Amsterdam, Rijksmuseum*

164. Pieter de Hooch: Woman peeling Apples, *c.* 1663. 70·5 × 54·3cm: 27¾ × 21¾in. *London, Wallace Collection* (Crown Copyright)

165. Pieter de Hooch: The Linen Cupboard, 1663. 72 × 77·5cm: 28¼ × 30½in. *Amsterdam, Rijksmuseum*

166. Pieter de Hooch: The Burgomaster's Room in the Amsterdam Town Hall, *c.* 1666-8. 113 × 99cm: 44½ × 39in. *Lugano, Thyssen-Bornemisza Collection* (Photo Brunel)

167. Gerard ter Borch: 'The Parental Admonition', *c.* 1654/5. 70 × 60cm: 27½ × 23⅝in. *Berlin-Dahlem, Staatliche Museen* (Photo Walter Steinkopf)

168. Gerard ter Borch: The Gallant Officer, *c.* 1662-3. 67 × 55cm: 26⅜ × 21⅝in. *Paris, Louvre* (Photo Musées Nationaux)

169. Gerard ter Borch: Soldiers in a Guard Room, *c.* 1638-40. 33·3 × 43·5cm: 13⅛ × 17⅛in. *London, Victoria and Albert Museum* (Crown Copyright)

170. Gerard ter Borch: Helena van der Schalke as a Child, *c.* 1644. 34 × 28·5cm: 13⅜ × 11¼in. *Amsterdam, Rijksmuseum*

171. Gerard ter Borch: Portrait of a Man, *c.* 1663-4. 67·? × 51·3cm: 26½ × 21⅜in. *London, National Gallery*

172. Gerard ter Borch: The Swearing of the Oath of Ratification of the Treaty of Münster, 1648. 45·4 × 58·4cm: 17⅞ × 23in. *London, National Gallery*

173. Gerard ter Borch: The Music Lesson, *c.* 1675. 58·1 × 47·3cm: 22⅞ × 18⅝in. *Cincinnati, Art Museum*

174. Gerard ter Borch: The Concert, *c.* 1675. 56 × 44cm: 22½ × 17⅜in. *Berlin-Dahlem, Staatliche Museen* (Photo Walter Steinkopf)

175. Caspar Netscher: The Lace Maker, 1664. 34 × 28cm: 13½ × 11⅛in. *London, Wallace Collection* (Crown Copyright)

213. Jacob van Ruisdael: Jewish Cemetery, c. 1660. 84×95cm: 33⅜ × 37¾in. *Dresden, Gemäldegalerie* (Staatliche Kunstsammlungen, Dresden)

214. Jacob van Ruisdael: Marsh in the Woods, c. 1665. 73·6 × 100·3cm: 29 × 39½in. *Leningrad, Hermitage*

215. Jacob van Ruisdael: View of Haarlem, c. 1670. 43 × 38cm: 17 × 15in. *Amsterdam, Rijksmuseum*

216. Jacob van Ruisdael: Winter Landscape, c. 1670. 42 × 49·7cm: 16½ × 19½in. *Amsterdam, Rijksmuseum*

217. Meyndert Hobbema: Landscape with Trees and a Causeway, 1663. 108 × 128·3cm: 42½ × 50½in. *Blessington, Ireland, Sir Alfred Beit* (Photo T. O'Malley)

218. Meyndert Hobbema: The Water Mill, c. 1665. 69 × 92cm: 27¼ × 36¼in. *London, Wallace Collection* (Crown Copyright)

219. Meyndert Hobbema: The Avenue, Middelharnis, 1689. 103·5 × 140·9cm: 40¾ × 55½in. *London, National Gallery*

220. Jacob van Ruisdael: Wheatfields, c. 1670. 101·3 × 130·1cm: 39⅞ × 51¼in. *New York, Metropolitan Museum of Art, Altman Bequest*

221. Albert Cuyp: Cattle. 59 × 74cm: 23⅓ × 29⅛in. *Budapest, Museum of Fine Arts*

222. Aelbert Cuyp: The Maas at Dordrecht. 97·8 × 136·8cm: 38½ × 54¼in. *London, Kenwood House, Iveagh Bequest* (London County Council)

223. Aelbert Cuyp: Evening Landscape with Horsemen and Shepherds. 101·6 × 151·1cm: 40 × 60½in. *London, Buckingham Palace* (By gracious permission of Her Majesty the Queen)

224. Paulus Potter: The Young Bull, 1647. 235·5 × 339cm: 92¾ × 133½in. *The Hague, Mauritshuis* (Foundation Johan Maurits van Nassau: photo A. Dingjan)

225. Paulus Potter: Men and Cattle at a Stream, 1648. 43·4 × 61·3cm: 17⅛ × 24⅛in. *The Hague, Mauritshuis* (Foundation Johan Maurits van Nassau: photo A. Dingjan)

226. Philips Wouwerman: Halt of a Hunting Party. 53·3 × 81cm: 21 × 31⅞in. *Dulwich College Picture Gallery* (By kind permission of the Governors of Dulwich College)

227. Adriaen van de Velde: The Farm, 1666. 63 × 78 cm: 24¾ × 30⅔in. *Berlin-Dahlem, Staatliche Museen* (Photo Walter Steinkopf)

228. Adriaen van de Velde: The Beach at Scheveningen, 1658. 50·8 × 72·4cm: 20 × 28½in. *Kassel, Gemäldegalerie* (Staatliche Kunstsammlungen, Kassel)

229. Willem van de Velde the Younger: The River IJ at Amsterdam, 1686. 179·5 × 310cm: 70⅔ × 122in. *Amsterdam, Rijksmuseum*

230. Hendrick Vroom: The Battle of Gibraltar, 25 April 1607. 137·5 × 188cm: 54⅛ × 74in. *Amsterdam, Rijksmuseum*

231. Jan Porcellis: Rough Weather, 1629. 18·5 × 24cm: 7⅛ × 9½in. *Munich, Ältere Pinakothek* (Bayerische Staatsgemäldesammlungen)

232. Simon de Vlieger: Calm Sea, 1649. 71 × 92cm: 28 × 36¼ in. *Vienna, Kunsthistorisches Museum*

233. Jan van de Cappelle: The State Barge saluted by the Home Fleet, 1650. 64 × 92·5cm: 25¼ × 36⅜in. *Amsterdam, Rijksmuseum*

234. Willem van de Velde the Younger: The Cannon Shot, c. 1660. 78·5 × 67cm: 30⅞ × 26⅜in. *Amsterdam, Rijksmuseum*

235. Cornelis Poelenburgh: Rest on the Flight into Egypt, c. 1620-5. 33 × 43·2cm: 13 × 17in. *Cambridge, Massachusetts, Fogg Art Museum* (Photo Royal Academy of Arts)

236. Bartolomeus Breenbergh: Ruins near Porta Metronia, Rome. Drawing. 23·1 × 26·3cm: 9⅛ × 10⅓in. *Oxford, Christ Church Library* (Photo O.U.P.)

237. Paulus Bor: The Enchantress, c. 1640(?). 155 × 111·8cm: 61 × 44in. *New York, Metropolitan Museum of Art* (Wildenstein & Co.)

238. Huis ten Bos, Oranjezaal. Engraving by F. Molenaar (Photo Rijksmuseum)

239. Caesar van Everdingen: The Four Muses with Pegasus, c. 1650. 380 × 235cm: 150 × 92½in. *The Hague, Huis ten Bos* (Koninklijk Huisarchief)

240. Pieter van Laer, called Bamboccio: The Cake Vendor. 33 × 32cm: 13 × 12⅝in. *Rome, Galleria Nazionale* (Photo Gabinetto Fotografico Nazionale)

241. Michael Sweerts: Portrait of a Boy, c. 1660. 36·7 × 29·6cm: 14½ × 11½in. *Hartford, Wadsworth Atheneum*

242. Jan Both: Italian Landscape with Artists sketching. 187 × 240cm: 73⅝ × 94½in. *Amsterdam, Rijksmuseum*

243. Nicolaes Berchem: Italian Landscape with a Bridge, 1656. 44·5 × 61cm: 17½ × 24in. *Leningrad, Hermitage*

244. Jan Baptist Weenix: Figures in an Italian Landscape with Ruins. 67·3 × 80cm: 26½ × 31½in. *Detroit, The Detroit Institute of Arts*

245. Jan Asselyn: Ruined Roman Bridge with Peasants fording a River. 83·8 × 118·1cm: 33 × 46½in. *Woburn Abbey, Duke of Bedford*

246. Karel Dujardin: Young Shepherd, early 1660s. 31·2 × 37·6cm: 12¼ × 14¾in. *The Hague, Mauritshuis* (Foundation Johan Maurits van Nassau: photo A. Dingjan)

247. Adam Pynacker: Barges on a River. 43·5 × 35·5cm: 17⅛ × 14in. *Leningrad, Hermitage*

283. Izaak Ouwater: The Lottery Office, 1779. 33·5 × 38·5cm: 13 × 15⅛in. *Amsterdam, Rijksmuseum*
284. Wouter Johannes van Troostwijk: The Rampoortje, 1809. 57 × 48cm: 22½ × 18⅞in. *Amsterdam, Rijksmuseum*
285. Breda, castle, entrance of outer ward, 1515/21. Seventeenth-century drawing (Rijksdienst v.d. Monumentenzorg)
286. Thomas Vincidor: Breda, castle, begun 1536. Engraving, 1743 (Rijksdienst v.d. Monumentenzorg)
287. Thomas Vincidor: Breda, palace, begun 1536. Plan of main floor before 1686
288. Alexander Pasqualini: IJsselstein, church, tower, *c.* 1532 (Rijksdienst v.d. Monumentenzorg)
289. Herman van Herengrave: Nijmegen, town hall, 1554 (Nico Grijpink)
290. Hans Vredeman de Vries: Ideal architecture (Technological University, Delft)
291. Cornelis Floris: Antwerp, town hall, 1561-6 (A. F. Kersting)
292. The Hague, old town hall, 1564 (Rijksdienst v.d. Monumentenzorg)
293. Zwolle, 'House of Charles V', 1571 (Rijksdienst v.d. Monumentenzorg)
294. Deventer, 'The Three Herrings', 1575 (Rijksdienst v.d. Monumentenzorg)
295. Leeuwarden, Chancellery, 1566-71 (Rijksdienst v.d. Monumentenzorg)
296. Franeker, town hall, 1591-4 (Lichtbeelden-Instituut)
297. Joost Jansz. Bilhamer: Amsterdam, Oude Kerk, tower, 1565-6 (Lichtbeelden-Instituut)
298. Lieven de Key: Haarlem, Meat Hall, 1602-3 (Rijksdienst v.d. Monumentenzorg)
299. Lieven de Key: Leiden, town hall, façade, 1597 (Rijksdienst v.d. Monumentenzorg)
300. Hendrick de Keyser: Amsterdam, Zuiderkerk, begun 1606 (Rijksdienst v.d. Monumentenzorg)
301. Hendrick de Keyser: Amsterdam, Zuiderkerk, tower, completed 1614 (Rijksdienst v.d. Monumentenzorg)
302. Lieven de Key: Haarlem, Nieuwe Kerk, tower, 1613 (Rijksdienst v.d. Monumentenzorg)
303. Hendrick de Keyser: Amsterdam, Westerkerk, begun 1620 (Rijksdienst v.d. Monumentenzorg)
304. Hendrick de Keyser: Amsterdam, Westerkerk, 1620. Plan
305. Hendrick de Keyser: Amsterdam, exchange, 1608-11. Engraving (Lichtbeelden-Instituut)
306. Klundert, town hall, 1621 (Rijksdienst v.d. Monumentenzorg)
307. Amsterdam, plan of the city *c.* 1650 (Rijksdienst v.d. Monumentenzorg)
308. Paulus Moreelse: Utrecht, St Catherine's Gate

(demolished), 1621-5 (Rijksdienst v.d. Monumentenzorg)
309. Rijswijk, palace, begun 1630. Drawing by J. de Bisschop (Lichtbeelden-Instituut)
310. Jacob van Campen: The Hague, Mauritshuis, designed *c.* 1633 (Rijksdienst v.d. Monumentenzorg)
311. Jacob van Campen: The Hague, Mauritshuis, designed *c.* 1633. Plan of first floor
312. Jacob van Campen: Amsterdam, Royal Palace (former town hall), begun 1648 (Lichtbeelden-Instituut)
313. Jacob van Campen: Amsterdam, Royal Palace (former town hall), begun 1648. Plan of main floor
314. Jacob van Campen: Amsterdam, Royal Palace (former town hall), begun 1648. Central hall (Lichtbeelden-Instituut)
315. Pieter Post: The Hague, Huis ten Bos, begun 1645. Engraving (Rijksdienst v.d. Monumentenzorg)
316. Pieter Post: The Hague, Huis ten Bos, begun 1645. Oranjezaal, decorated by Jordaens and others (Rijksdienst v.d. Monumentenzorg)
317. Arent van 's-Gravesande: Leiden, cloth hall, 1639 (Rijksdienst v.d. Monumentenzorg)
318. Justus Vingboons: Amsterdam, Trippenhuis, 1662 (Rijksdienst v.d. Monumentenzorg)
319. Steven Vennecool: Enkhuizen, town hall, 1686 (Lichtbeelden-Instituut)
320. Steven Vennecool: Middachten, château, 1695 (Rijksdienst v.d. Monumentenzorg)
321. Jacob van Campen: Haarlem, Nieuwe Kerk, 1645. Plan
322. Jacob van Campen: Haarlem, Nieuwe Kerk, 1645 (Rijksdienst v.d. Monumentenzorg)
323. Arent van 's-Gravesande: Leiden, Marekerk, begun 1639 (Rijksdienst v.d. Monumentenzorg)
324. Adriaen Dortsman: Amsterdam, Nieuwe Lutherse Kerk, 1668. Plan
325. Pieter Noorwits and Van Bassen: The Hague, Nieuwe Kerk, begun 1649. Plan
326. Daniel Marot: The Hague, Binnenhof, Trêveszaal, 1696-8 (Rijksdienst v.d. Monumentenzorg)
327. Daniel Marot: The Hague, Royal Library (formerly Hôtel Huguetan), 1734, wings by Pieter de Swart, 1761 (Rijksdienst v.d. Monumentenzorg)
328. Pieter de Swart: The Hague, Royal Theatre (former Nassau Weilburg Palace), *c.* 1765 (Rijksdienst v.d. Monumentenzorg)
329. Leendert Viervant: Haarlem, Het Paviljoen, *c.* 1785 (Rijksdient v.d. Monumentzorg)
330. Hendrick de Keyser: Unknown man, 1608. *Amsterdam, Rijksmuseum*
331. Hendrick de Keyser: Effigy from the tomb of Prince William I, *c.* 1618. *Delft, Nieuwe Kerk* (Photo A. G. van Agtmaal)

INDEX

References to the notes are given to the page on which the note occurs, followed by the number of the chapter to which it belongs, and the number of the note. Thus, 439(22)[1] indicates page 439, chapter 22, note 1. Principal entries are in **bold** type. Names are indexed under the last element: e.g. Dirk van der Aa will be found under Aa.

THE PELICAN HISTORY OF ART

COMPLETE LIST OF TITLES

* Also published in an integrated edition.
† Published only in an integrated edition.
‡ Not yet published.

ARCHITECTURE IN BRITAIN: 1530–1830* *John Summerson*, 6th ed., *1977*

SCULPTURE IN BRITAIN: 1530–1830 *Margaret Whinney*, 1st ed., *1964*

PAINTING IN BRITAIN: 1530–1790* *Ellis Waterhouse*, 4th ed., *1978*

PAINTING IN BRITAIN: 1770–1890‡ *Michael Kitson and R. Ormond*

ARCHITECTURE: NINETEENTH AND TWENTIETH CENTURIES,* *Henry-Russell Hitchcock*, 4th ed., *1977*

PAINTING AND SCULPTURE IN EUROPE: 1780–1880* *Fritz Novotny*, 3rd ed., *1978*

PAINTING AND SCULPTURE IN EUROPE: 1880–1940* *George Heard Hamilton*, 2nd ed., *1972*, reprinted *1978*

AMERICAN ART *John Wilmerding*, 1st ed., *1976*

* Also published in an integrated edition.
‡ Not yet published.

THE ART AND ARCHITECTURE OF ANCIENT AMERICA *George Kubler*, 2nd ed., *1975*

THE ART AND ARCHITECTURE OF RUSSIA *George Heard Hamilton*, 2nd ed., *1975*

THE ART AND ARCHITECTURE OF ANCIENT EGYPT *W. Stevenson Smith*, 2nd ed., *1965*

THE ART AND ARCHITECTURE OF INDIA: HINDU, BUDDHIST, JAIN* *Benjamin Rowland*, 4th ed., *1977*

THE ART AND ARCHITECTURE OF ISLAM‡ *Richard Ettinghausen and Oleg Grabar*

THE ART AND ARCHITECTURE OF THE ANCIENT ORIENT* *Henri Frankfort*, 4th ed., *1970*, reprinted *1977*

THE ART AND ARCHITECTURE OF JAPAN* *Robert Treat Paine and Alexander Soper*, 2nd ed., *1975*

THE ART AND ARCHITECTURE OF CHINA* *Laurence Sickman and Alexander Soper*, 3rd ed., *1971*

TRIBAL ART‡ *Roy Sieber, Jean Guiart, Frederick Dockstader, and Solange Thierry*